Martin Kemp

THE SCIENCE OF ART

Optical themes in western art from
Brunelleschi to Seurat

YALE UNIVERSITY PRESS·NEW HAVEN AND LONDON

DEDICATED TO THE ROYAL SCOTTISH ACADEMY

Ars sine scientia nihil est

Designed by Elaine Collins

Set in Linotron Bembo
Typeset and printed in Hong Kong through World Print Ltd.

Library of Congress Cataloging-in-Publication Data

Kemp, Martin.
 The science of art.

 Bibliography: p.
 Includes index.
 1. Painting—Technique. 2. Composition (Art).
3. Perspective. 4. Color in art. 5. Nature (Aesthetics)
I. Title.
ND1475.K45 1989 750′.1 ′8 88-33767
ISBN 0-300-04337-6 (cloth)
 0-300-05241-3 (pbk)

Contents

Acknowledgements

Any complex programme of research is inevitably dependent for its completion upon a series of individuals who have facilitated access to the primary and secondary source material. I am not only thinking of owners, curators and librarians, but also of those generations of scholars who have been moved to publish the fruits of their own labours. The indebtedness of the piece of work that follows is even greater than usual, since its range is such that I have needed to pick other people's brains remorselessly—not only through their published work but also through personal contact. The encouragement and generosity of colleagues in drawing my attention to sources and helping me make fewer mistakes has been of immense importance. The list—were my memory to do justice to all those who have helped—would be accordingly enormous. If I mention a few who have given freely of their time and advice, I would ask the forbearance of those who deserve the mentions I have failed to give.

Pride of place must go to Irving and Marilyn Lavin for their friendship during my year at the Institute for Advanced Study at Princeton—Irving for his warmly infectious support and Marilyn for the telling opinions she expressed on reading the first chapter, opinions which benefited all the later sections. The librarians at the Institute and the University of Princeton deserve unreserved thanks, most particularly Mary Schmidt and her staff at the Marquand Library, who dealt with a series of requests and inadvertent irregularities with unfailing patience. A comparable indebtedness should be expressed to the librarians at the Warburg Institute, the Courtauld Institute, Yale University, the Science Museum in London, the National Library of Scotland, and, almost without saying, the University of St. Andrews. To my colleagues in the Department of Art History at St. Andrews I should like to express my deepest gratitude, for the sympathetic climate in which I work and for facilitating my year away, during which Robin Spencer assumed my duties as Chairman and Ann Kettle my responsibilities as Associate Dean.

Of those who contributed in diverse ways to the knowledge which lies behind this book, I am delighted to recall the assistance of James Ackermann, Svetlana Alpers, Clive Ashwin, Michael Baxandall, Karen-edis Barzman, David Bomford, Christopher Brown, Jonathan Brown, John Burnett, Miles Chappell, Filippo Camerota, Maurice Davies, Samuel Edgerton, Alan Ellenius, Judith Field, John Gage, Paolo Galluzzi, Sir Ernst Gombrich, Anne Coffin Hanson, Bert Hanson, Robert Herbert, Thomas Kauffman, Kenneth Keele, Monique Kornell, Miriam Levin, Allison Morrison-Lowe, Joyce Ludmer, Pietro Marani, Roberta Marks, Mara Miniatti, John Onians, Stephen Ostrow, Claire Pace, Carlo Pedretti, Ronald Pickvance, Jane Roberts, Robert Ruurs, Larry Schaaf, Aaron Scheon, Alison Scott, Thomas Settle, Alan Shapiro, Helen Smailes, David Summers, Anna-Maria Petrioli Tofani, Lucia Tongiorgi Tomasi, Kim Veltman, Heather Buckner Vitaglione, John White, Robert Williams, and Richard Woodfield.

To my friends who rightly object to gender-based assumptions in historical writing—to the tendency, for example, for all artists automatically to become 'he'—I can only plead that I could find no ready way of avoiding this fault without making my text seem stilted in itself and out of tone with the written sources in the period.

During the preparation of the book, the secretarial services provided by Rose Murray and her team at the Institute in Princeton were of great value. Dawn Waddell in St. Andrews not only contributed her excellent secretarial services but has, as always, done her best to make my ever-mounting series of commitments manageable. The ordering and gathering together of much of the large body of scattered illustrative material was undertaken with great efficiency by Alexander Kader. William Taylor at Princeton and Peter Adamson at St. Andrews provided vital help with photography.

At all stages of the book's genesis and preparation I have been given unwavering understanding by John Nicoll of Yale University Press, whose list of books testifies more vividly than anything I can say to his qualities as an editor. Alan Crawford's careful scrutiny of my text resulted in numerous improvements, and Elaine Collins has cheerfully shouldered the burden of seeing the book into print. Margaret Walker, with whom I have enjoyed fruitful collaboration in the past, has undertaken the considerable labour of producing the index, with her customary skill. I am equally grateful to Caroline Dawnay, who, as my literary agent, always provides excellent service and advice.

I should also like to express my pleasure on being invited to

become Slade Professor at Cambridge University for 1987–8, during which time I was able to deliver a series of lectures on the theme of this book. I am grateful for the kind reception granted to the airing of my ideas, and particularly for the response from those members of the audience whose background is in the sciences. As ever, Professor Michael Jaffé and Professor George Henderson provided friendship and constructive encouragement, while Downing College provided a congenial home.

Research is an expensive business, and without the support of grant-awarding bodies the project would have been impossible. The travel and research funds of the University of St. Andrews have made cumulative contributions over a number of years. The sustained period of work at Princeton was undertaken with the financial assistance of the Institute itself, the British Academy, the Carnegie Trust for the Universities of Scotland and a generous subvention from the Leverhulme Trust. To my referees, I wish to express my thanks for their effective support. Less obviously quantifiable but absolutely vital has been the supportive context of my family life, provided by Jill, my wife, Joanna and Jonathan, and their grandparents. Scholarship is an obsessive procedure which tries the patience of those who have to watch it in action.

Introduction

This book is founded upon the gross premise—and premises probably do not come any grosser—that there were special kinds of affinity between the central intellectual and observational concerns in the visual arts and the sciences in Europe from the Renaissance to the nineteenth century. The affinities centred upon a belief that the direct study of nature through the faculty of vision was essential if the rules underlying the structure of the world were to be understood. I realise—and the following chapters will make clear—that 'direct study of nature' could embrace an immensely wide range of intellectual and emotional approaches, but I remain convinced that the gross generalisation does hold good if we set this phase of Western art and science beside that from any other region or era, with the notable if partial exception of classical antiquity. I have hesitated to use the word empirical about this phase, since empiricism has come to be associated with a specific, rather circumscribed, model of science, but it would be the right term in its more elastic sense of a form of knowledge ostensibly based upon observation without necessarily stipulating the precise roles of *a priori* and *a posteriori* procedures.

My intention has been to outline what seem to me to be the major profiles of optically-minded theory and practice in art, and to set these profiles beside the geometry of vision and the physics of colour in the history of scientific thought. I should say immediately that I am not attempting a composite history of art and science, nor am I making any claim to have given an adequate picture of either of their separate histories. Indeed, the history of science will appear in a particularly distorted manner, since it will be refracted through the medium of works of art and writings devoted to artistic matters. Rather, my concerns have been to show how a significant number of those involved in art consciously aspired towards goals that we would now regard as scientific in a broad sense, and to examine the extent to which the ideas and practices of such artists and writers were directly or indirectly founded upon scientific concepts. In this examination we must not only look at the obvious model—one in which an artist read some science and tried to use it in works of art—but also remain alert to the deliberate or inadvertent manipulation of scientific ideas to bring them into some kind of desired alignment with pre-established practice. We should also entertain the possibility

that something of an apparently scientific nature may appear in an artist's works independently, or even in advance of, the corresponding science. However, it should become clear that I am sceptical of claims that visual discovery in art played a causative role in any major sense in the scientific revolutions of the period. I have also been concerned throughout to be conscious of trends in art and science that may be chronologically out of step. The fate of Newtonian colour science in art theory and practice is the most obvious case in point.

My method has been to look for direct evidence wherever possible of the relationship between art and science. The most prominent varieties of this evidence consist of the writings by or aimed at artists, the contents of artists' libraries, records of their contacts, and contemporary accounts of their work and ideals. Only occasionally, as in the early section on fourteenth-century perspective and in the discussion of Vermeer and the camera obscura, have I let virtually all the weight of evidence rest on the paintings alone. My concentration on those episodes for which written evidence survives does produce a certain kind of limitation, since the survival of such evidence is inevitably patchy. However, I think it is the only realistic way to proceed with a topic which can only too easily become amorphous and subject to ungovernable flights of speculation.

Even with this built-in limitation, the potential scope of the subject is vast, and has inevitably resulted in the omission of large bodies of relevant material—some omitted consciously and a probably even greater quantity that has escaped my attention. I have tried to concentrate on those episodes in which the science of art has made an impact upon the practice of art at the highest level. I realise that this involves value judgements, and that on the whole these judgements are not of a particularly startling kind. Thus perspective bulks large in Renaissance Italy, while colour theory leads to relatively lengthy discussions of Turner and of French artists in the succession of Delacroix. At least these familiar war-horses will let readers meet some old favourites in a text which is otherwise well stocked with historical figures who will be more or less unknown to many.

In a significant number of the most important episodes other specialist historians of the periods and subjects will know a good deal more than me. That is an inevitable hazard

of covering a broad chronological and geographical range. However, I think that the attempt to cover the range has been revealing, since familiar and well-researched cases, such as Seurat's colour divisionism, can look rather different when set in the broader context. I am also all in favour of the historian chancing his or her arm by framing wide-ranging generalisations on the basis of the evidence as far as it is known and understood. This is not an excuse for the inaccuracies in particulars or generalities that will inevitably appear in this book. Rather it is an acknowledgement that some issues are sufficiently important and 'big' to justify taking the risk of being wrong in a spectacular manner. The historical perception of the relative functions of visual art and optical science during this period is to my mind a sufficiently 'big' issue.

My original conception for this study was even bigger, since I had intended to embrace the organic sciences of anatomy and natural history, concluding with a grand overview of the relative scopes of creativity and exposition in science and art. My revised intention is to study the organic sciences in a companion volume at some future date. I have, however, retained some part of the grand overview, not in terms of a systematic and extended analysis of what can be drawn from the evidence but rather as a personal coda in which I mingle a few unsystematic beliefs and tentative suggestions. I think it is only fair to the reader to give some idea of my personal stance on the kind of questions which the whole enterprise inevitably raises.

The scope of the book also warrants explanation in relation to the term 'art' in its title. As will be apparent even from a cursory survey of the illustrations, this is a book primarily concerned with paintings, in that painting was the medium in which optical themes were expressed most fully. However, other media such as relief sculpture, print-making and photography move into the foreground at various points and do something to justify my use of 'art' in the title. I am not concerned with architectural geometry or optics, and only engage with the optics of illusionistic stage design when it seems unavoidable to do so. I am also conscious that I have not tackled the 'science of art' in as far as it relates to the physical properties of works of art. Perhaps the most serious omission is any sustained discussion of the way in which the chemistry and manufacture of new pigments affected the parameters of illusionistic imitation in painting. This story, however, seemed to be distinctly different in type from my more theoretical concerns and requires to be told by someone more competent to do so.

I think it is fair to issue the reader with some other warnings about some of the most conspicuous features of the book. The most important concerns the status of the illustrative material. Any book illustrations inevitably distort our impressions of the works of art in a way that is crucial for this subject, namely with respect to scale. Thus a great illusionistic room decoration from the Italian seventeenth century appears on roughly the same scale as a Dutch cabinet containing a peep show. I do not subscribe to the view that this difference in scale reflects an essential perceptual dichotomy between Italian and Dutch art, but it is true that works of widely different sizes make very different effects, both visually and emotionally, and that this difference will be lost in illustration.

The problem of scale also causes a practical difficulty with respect to diagrammatic demonstrations. I generally dislike the exposition of paintings through lines drawn on their surface, but for the analysis of their perspectival structures the drawing of lines is inevitable. The lines I have drawn are, on the reduced scale of the illustrations, very crude devices, particularly when dealing with works of large size. A legible pen line drawn, for instance, on the reproduction of a large wall painting will be equivalent to a line some centimetres broad on the scale of the original work. The margins for error become very wide indeed. Even for small-scale works, the possibility of, say, a drawn diagonal passing with marginal asymmetry through the corner of a rectangle is very real. Even the most marginal of such errors can have serious consequences when that feature is extended into other regions of the diagram. And there is not only the possibility of innocent error but also the more serious temptation to fabricate the diagram in such a way as to find what one wants to find. It should also be added that artists were themselves unlikely to have been immune from equivalent mistakes.

A further problem with diagrammatic exposition of perspective is that it is in the geometrical nature of the perspective construction that once it has been established accurately by the simplest means it can provide the basis for an almost infinite series of auxiliary constructions of great complexity. Or, to express it another way, the same geometrical construction of, for example, a tiled floor in perspective, can be achieved in any number of ways. There is a problem of knowing where to start and when to stop in reconstructing the geometrical anatomy of a particular perspective scheme. In attempting to suggest how particular artists proceeded in their paintings I have tried to use the simplest method which is consistent with the contemporary evidence of perspectival techniques. This approach does not guarantee rightness, but it does provide a non-arbitrary way for the historian to proceed.

The main problem with colour practice is rather different. All the paintings considered in this book stand broadly speaking within a representational tradition. This means that the artist's choice of colour is not free. At its most basic, the consequence is that trees need to be greenish and most flesh pinkish. On a more complex level, the artist has to deal with conventional meanings, signs and emotional associations for colour, such as the established blue and red for the Virgin's garments. There was virtually no scope for painting pictures that would be pure 'colour demonstrations', founded in a one-to-one manner upon a theoretical prescription. If we know that a certain artist held that the three primary colours were yellow, red and blue and that he was painting a battle scene which included yellow, red and blue elements, it will be very difficult for the historian to say to what extent the colour theory was the determining factor behind the colouristic scheme of the painting. There is no formula for solving this problem, merely the exercise of intuitive judgement and common sense in each case.

I think my final caution should be in the nature of a schoolmasterly instruction to the reader. Science tends to frighten students of the arts. The sight of a scientific diagram or

calculation will be enough to convince many that they cannot understand it. I do not think that any of the science, diagrammatic or otherwise, in this book is such that it is beyond any reasonably educated reader. The problem, to my mind, is that those accustomed to studying the arts expect to read and take in information at a more-or-less uniform and rapid rate. A scientific diagram or formula is not amenable to that process. A diagram needs to be followed step-by-step passing to the next step only when the former is firmly established. It often proves invaluable to reconstruct the diagram on a separate piece of paper. The reader who wishes to get full value from this book—and who wishes to uncover its mistakes and sleights of hand—should slow down at appropriate points to master the technical material. This is not to say that there is a single way of reading the book. I hope it may be possible and rewarding also to read it as a narrative, taking the technical demonstrations as visual examples and documentation of what is being said in the text, without necessarily grappling with them in detail. I am aware that this is not an easy book, but I remain unapologetic about the need to persist in understand-

ing the difficulties head on, just as the theorists and teachers in this period expected their pupils to work long and hard at the basic rules of imitation.

Finally, I should say a word about the book's role in the current development of its academic area of study. When I first began working in the area of the science of art, the field was relatively underpopulated. Recently, the study of the interactions of the sciences and arts has become a considerable growth area. My feeling is that I am writing this book only just in time. Leave it another five years and it would sink under a deluge of bibliography. I hope it may also be timely in another sense, namely that it will help provide an articulate shape as a basis for discussion before it becomes impossible to see the wood for the trees. Any writer hopes that his or her ideas will meet with more agreement than dissent, but the author of an academic study should be pleased if the whole or parts of that study provide something worth challenging. In a field as broad as mine, I must pin many of my hopes on the latter aspiration.

NOTE TO THE REVISED EDITION

The reprinting has provided the opportunity to correct those misprints and other technical errors that have become apparent since the book was first published in 1990, but not to undertake more substantial revisions. I am grateful to those reviewers, particularly John White and Kim Veltman, who

have drawn attention to some of my more egregious mistakes. I am, for the most part, prepared to stand by my interpretations, while acknowledging that differently motivated approaches to the primary sources will produce different insights.

Part I: Lines of Sight

'Among the studies of natural causes
and laws, it is light that most delights its
students. Among all the great branches
of mathematics, the certainty of its
demonstrations pre-eminently elevates
the minds of its investigators.
Perspective, therefore, should be
preferred above all man's discourses and
disciplines. In this subject the visual
rays are elucidated by means of
demonstrations which derive their
glory not only from mathematics but
also from physics; the one is adorned
equally with the flowers of the other.'

*Leonardo da Vinci in the late fifteenth century, quoting
John Pecham from the thirteenth century.*

Introduction to Part I

Linear perspective is a beguilingly simple means for the construction of an effective space in painting. It was invented, in the form we know it, during the early part of the fifteenth century in Florence. For almost four hundred years from 1500 it served as the standard technique for any painter who wished to create a systematic illusion of receding forms behind the flat surface of a panel, canvas, wall or ceiling. Is there really any more that needs to be said about it, other than to explain the technical procedures needed to achieve the desired effect? Why should it warrant three chapters in the present study, to say nothing of a substantial series of previous books and daunting numbers of specialist articles?

The answer is that the story of its invention raises historical, artistic and scientific issues of great fascination and complexity, that its arrival had radical consequences for the theory and practice of art, and that its subsequent history—down to the present day—has been attended by controversies which centre upon the very nature of visual representation itself.

In attempting to tell this story I will—to use a technological analogy—be concentrating on the initial design of the vehicle and its development to full working order, rather than recounting in detail the activities of those who have subsequently driven it with consummate skill. What follows is not, therefore, a history of pictorial space in art, but will centre on what I judge to be the most significant contributions to the available means of pictorial representation. I will be looking particularly at those episodes which illuminate the relationship between the painters' science and what we would generally regard as the mainstream of scientific thought. The approach will be through the written record, making close and sometimes technical analyses of related works of art. For intellectual and practical reasons this approach entails an acceptance that those artists for whom the written record is silent will tend not to be included, unless their works so openly declare their 'scientific' intentions that they cannot be legitimately ignored. Thus we will find that Raphael, one of the most intellectual manipulators of space in the given context of his various commissions, will receive relatively limited attention. As far as we know he did not directly address the *theory* of the perspective construction itself. In other words, he tends to fall into my category of a superb driver rather than an innovative scientific engineer.

Particular difficulties will be encountered in telling the story after 1600, when the numbers of knowing practitioners and instructional treatises proliferate unmanageably. Here the criterion for individual selection will be that someone who has made a distinctive contribution which is original in itself and strikes some specially important relationship with either scientific theory or a major aspect of pictorial practice. What has been omitted, deliberately or inadvertently, will be all too apparent but I hope the broad picture that emerges will present a fair impression of the ways in which perspective science has reacted on and reacted to a range of ideas outside art, and conducted fertile dialogue with artistic practice.

The first of the three chapters which constitute Part I of *The Science of Art* will concern the invention, consolidation and analysis of perspective from Brunelleschi to Leonardo. The second will look at the main trends and major incidents from the adoption of perspective theory by Northern artists about 1500 to the full-scale mathematicization in Italy about 1600. The third will then follow selected aspects of the mainstream of the perspectival tradition as far as Turner in nineteenth-century Britain.

Before we embark on this exploration, I think it would be helpful to have a foundation in the proceedures and terminology that underlie so much of what follows. Readers who are already familiar with the technical basis of the Renaissance construction and with the associated vocabulary can obviously choose at this point to plunge straight to the opening of the first chapter. However, anyone who feels they would like to acquire a basic grounding—or to refresh their memories—can turn to Appendix I, 'The Basis of the Perspective Construction'.

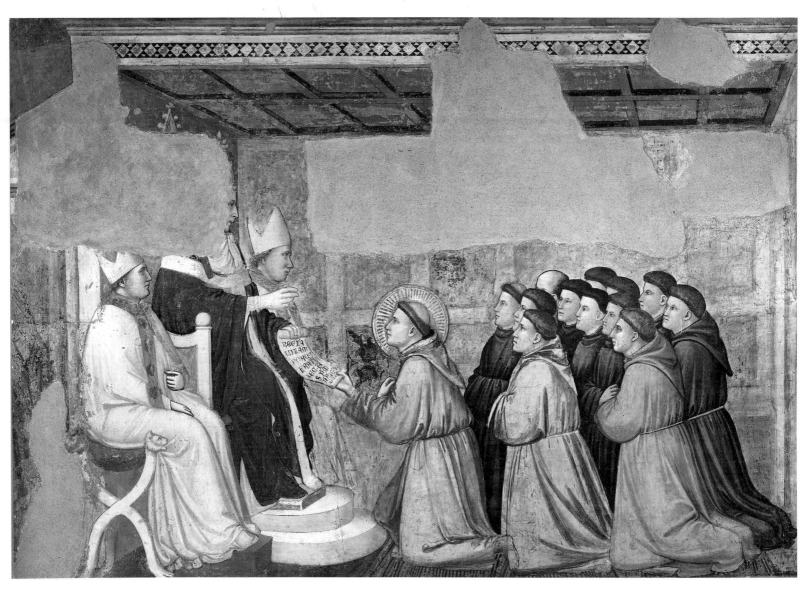

1. Giotto, *Confirmation of the Rule of St. Francis*, c.1325, Florence, S. Croce, Bardi Chapel.

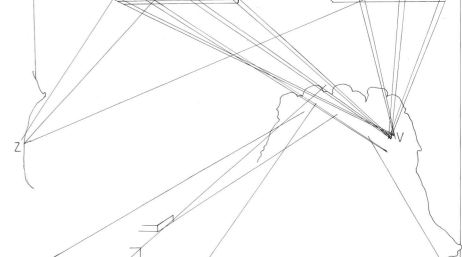

2. Analysis of the perspective of Giotto's *Confirmation of the Rule of St. Francis*.

V—focus of the orthogonals of the coffers
Z—focal area of the diagonals through the coffers

CHAPTER I

Linear perspective from Brunelleschi to Leonardo

INVENTION

Linear perspective was invented by Filippo Brunelleschi. His priority has never been seriously questioned, either at the time or subsequently, though we can be sure that it would have been if anyone had even flimsy grounds for an alternative claim. Recently discovered evidence, in the form of a letter of 1413 that particularly associates Brunelleschi with perspective, suggests that the invention occurred at or before this date.[1] The situation may, therefore, appear to be relatively simple. But behind these facts lie questions of inexhaustible complexity, not only with respect to the historical circumstances which lead to Brunelleschi's invention, but also in relation to the nature of what he actually invented.

Any invention relies upon certain conditions without which it would have been impossible. The first of these is that the end towards which the invention is directed should be considered desirable—in this case that the systematic recording of visual phenomena should be seen as a worthwhile goal. A second general precondition is that the invention should be attainable in terms of the necessary levels of understanding and skill. Underlying these closely associated conditions are a series of historical factors, ranging from the most general aspects of what may be called the 'world view' to the specific circumstances (intellectual and social) of the individual or individuals involved. The handling of such factors will be discussed more fully in the coda at the end of this study; for the moment we are concerned with the relatively specific and immediate factors which gave Brunelleschi the techniques he required. Since we are dealing, first and foremost, with a method for the imitation of measurable space on a flat surface, we may legitimately begin our investigation by asking about the established methods in painting for the achieving of three-dimensional effects.

Fourteenth-century artists in Italy had developed a wide variety of stratagems for the evoking of space and for the depiction of solid forms in a more or less convincing manner. It lies outside the intention of this chapter to give a full review of these pictorial devices, but we do need to define the extent to which the *trecento* artists had adopted systematic techniques based upon rules.[2]

The natural point at which to begin is with the work of Giotto, which bears witness to a sustained, orderly and deeply pondered attention to the representation of figures and space. By the time he came to design the architectual setting for the *Confirmation of the Rule of St. Francis* (pl. 1), he had worked his way through a series of increasingly refined solutions for the creation of different kinds of space to serve particular narrative contexts. It was with interior views of the kind used here that he had moved towards an increasingly perspectival system. His paintings show that he had long since formulated and obeyed general rules which may be summarised as: those lines and planes situated above eye-level should appear to incline downwards as they move away from the spectator; those below eye-level should incline upwards; those to the left should incline inwards to the right; those to the right should incline inwards to the left; there should be some sense of the horizontal division and the vertical division which mark the boundaries between the zones; and along those divisions the lines should be inclined little if at all. Similar rules were to be described three generations later by Cennino Cennini, who regarded himself as a direct heir to the Giotto tradition.[3]

In the *Confirmation* it appears that these general rules are developing into more precise techniques for the depiction of certain regular forms. As far as can be judged in the damaged state of the fresco, the coffers of the ceiling recede towards a point of convergence near the rear of the group of kneeling friars (pl. 2). The convergence is not perfect but it looks too organised to be the result of chance or even 'judgement by eye'. The calculation of the horizontal intervals of the coffers may also have been calculated in a systematic way, but too few clues survive to permit the drawing of confident conclusions.

The idea that Giotto was responsible for the first steps towards a geometrical system near the end of his life is supported by the appearance of a highly developed pattern of convergences for the ceiling coffers in an otherwise routine work by a follower in the Lower Church of S. Francesco at Assisi (pl. 3).[4] In this case, the artist appears to have availed himself of two lateral points precisely at the edge of his fresco (now marked by inset rings) on which to anchor both sets of lateral diagonals. Although more developed geometrically than Giotto's scheme, the space as a whole is much less coordinated and the

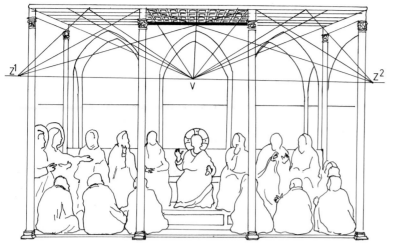

3. Analysis of the perspective of the *Christ Disputing in the Temple* by a follower of Giotto, Assisi, S. Francesco, Lower Church.

V—focus of the orthogonals of the ceiling
Z¹, Z²—lateral focuses of the diagonals of the ceiling design.

motif on the ceiling gives the effect of a technical device rather divorced from the figures below.

It is also important to take into account the location of the frescoes. The painting at Assisi is viewed frontally and is not located at a great height, whereas Giotto's scene is situated high on the right wall of a relatively narrow chapel. The asymmetry of Giotto's scheme may well be a response to our tendency to view the fresco from an angled position close to the entrance from the main body of the church. He has used his special sensitivity to the way in which appearances change from different viewpoints to sugggest that we are witnessing the event not from the centre but from a relatively low position nearer the side wall of the room. This has also the effect of placing us, psychologically, with the kneeling friars in a position subordinate to the main actors in the drama. This sense of the eyewitness character of Giotto's scene reflects one of the major motives behind the new naturalism. This motive was the desire, in a particularly Franciscan spirit, to present the sacred narratives to the spectator on human terms, relating us on an individual and immediate basis to the reality of the great events.

Duccio in Siena (pl. 4) similarly achieved remarkable passages of spatial description, observing the general rules of convergence to achieve schemes which only barely fail to attain geometrical precision and display a responsiveness to subject, scale and location in no way inferior to Giotto's. The particular problems tackled by Duccio in portraying the octagonal building in his *Temptation* will become particularly relevant when we come to look at Brunelleschi's invention.

The subsequent history of the techniques pioneered especially though not exclusively by Giotto and Duccio is not consistent or tidy. The more geometrical technique was not implemented widely. Although it could produce some successful passages of spatial description, it could well seem an unnecessary encumbrance to artists whose main aims and techniques

lay with the composing of effective, functioning, devotional pictures and narratives rather than with clever passages of isolated and perhaps even disruptive design. There are occasional examples of the technique being exploited, and even developed with great brilliance, above all in the work of the Lorenzetti in Siena. Ambrogio, often taken to be the more innovative of the brothers, certainly used the single vanishing point for the main lines in tiled floors with considerable precision, and the underdrawings in his paintings reveal concerted efforts to achieve geometrical control. But none of his works exploit the diagonal points of convergence with complete consistency. He appears to have preferred a less condensed pattern of horizontal divisions than results from the lateral point system. However, his brother Pietro did accomplish in 1342 what must be regarded as the *tour de force* of fourteenth-century perspective. This occurs in his *Birth of the Virgin* (pl. 5), which contains not one but two converging systems of great sophistication (pl. 6).

The tiles in the right panel converge rigorously to a point in the upper right of the central panel. Those few tiles visible in the space near the infant Virgin also appear to centre upon the same point. Two diagonal focuses are observed sufficiently accurately to give us confidence that they played an active role in the constructive process. The point at the left, which lies at the edge of the picture, may have been the one which was actually used, since the other lies off the picture surface. The check pattern on St. Anne's bed cover provides the second system, converging on a point below that of the tile construction and giving a diagonal focus at the right edge of the altar-

4. Duccio, *Temptation of Christ on the Temple* from the *'Maesta'*, 1308–11, Siena, Museo dell'Opera del Duomo.

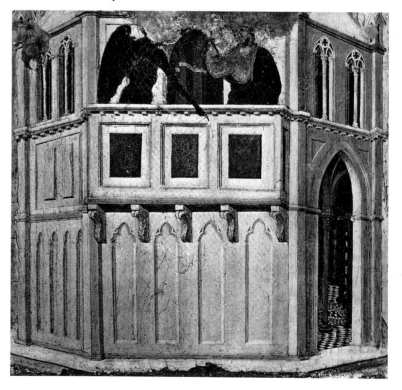

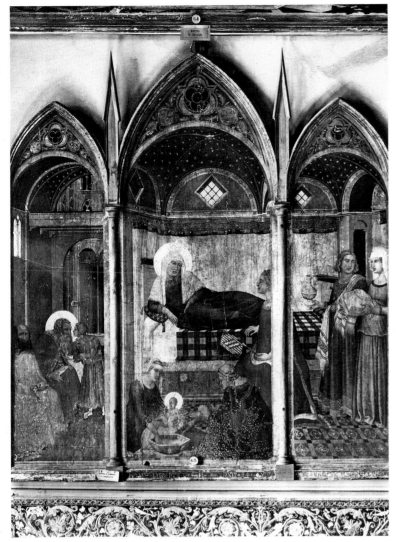

5. Pietro Lorenzetti, *Birth of the Virgin*, 1342, Siena, Museo dell'Opera del Duomo.

6. Analysis of the perspective of Pietro Lorenzetti's *Birth of the Virgin*.

V^1—focus of orthogonals of tiled floor
V^2—focus of orthogonals of pattern of bed cover
Z^1, Z^2—focuses of diagonals of tiled floor
Z^3—focus of diagonals of pattern of bed cover

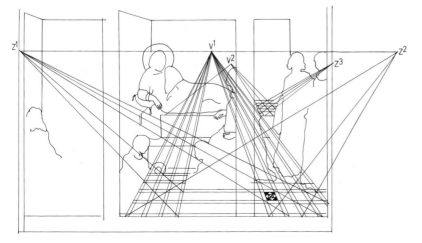

piece. The underdrawing, particularly that incised in the gesso of the right-hand panel, testifies to the immense effort of constructive geometry which has gone into the perspective effects, and into the organisation of the patterns within the tiles, which are based upon a series of three inscribed squares.

Like Giotto, Pietro Lorenzetti has used the system as an integral part of his description of the space in relation to the spectator. He has reasoned that the higher plane of the bed cover is seen at a flatter angle, and has accelerated its perspective accordingly (though incorrectly by strictly perspectival principles). He has used the tile pattern to unify the apparently intransigent spaces of the centre and right panels behind the frame of the triptych while creating an attractive and complicated setting for the unusual subsidiary scene in the left partition. He has also made the asymmetrical views of the rib vaults respond effectively to the off-centre viewing position, though this impression was created on an intuitive rather than calculated basis.

Effective though this system is, it was not supported by any theoretical proof—geometrical or optical—and it remained only one of various means of organising space during the *trecento*. Generally, most artists seem not to have been attracted by a method which promised much labour for an optical reward which was as yet of uncertain value.

The fourteenth-century experiments had helped to show that the systematic description of space was both desirable and possible in certain contexts. But, equally, we can in retrospect see what remained to be accomplished; namely the demonstration of an internally consistent system for all the spatial elements in a picture and, above all, a proof that the system rested upon non-arbitrary foundations. It is at this stage that Brunelleschi enters the story.

Although we will not generally be concerned in this book with the biographical details of its protagonists, an understanding of Brunelleschi's contribution is best approached through some biographical specifics. He was unusually well educated for a practitioner of the visual arts. As the son of a prominent notary he received instruction in the basics of reading, writing and practical mathematics. His earliest biographer also testifies that he was set to the learning of 'letters' (i.e. Latin), in a way which would only normally be required for someone 'who expected to become a doctor, notary or priest'.[5] The profession he entered, however, was that of goldsmithing, that is to say a craft, although one whose grandest practitioners could hope to acquire some wealth and social status. As early as 1404, the year in which he appears to have matriculated as master in the relevant guild, at the age of twenty-seven, he was already being consulted on architectural matters. His early career as an innovative metal-worker and sculptor was increasingly overtaken by his architectural activities. On his first visit to Rome, as described in his biography, he made measured drawings of Roman buildings, using his understanding of standard surveying techniques 'to plot [*congettare*] the elevations', using measurements 'from base to base' and simple calculations based on triangulation.[6] The results were recorded 'on offcuts of parchment . . . by means of squared divisions of the sheets, with arabic numerals and

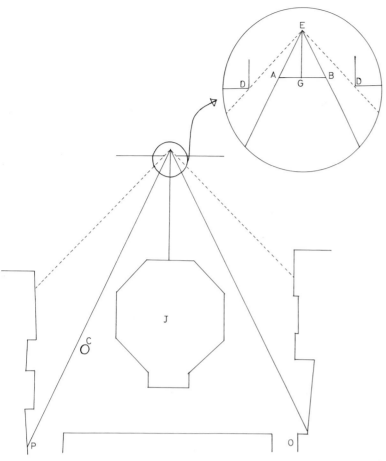

7. Diagrammatic plan of Brunelleschi's situation for his perspective demonstration of the Florentine Baptistery.

J—Baptistery
C—Column of St. Zenobius
P—Canto alla Paglia
AB—panel
D, D—sides of the portal of the Cathedral
O—Volta de' Pecori
E—observer
EG—viewing axis

The dotted lines denote the widest possible angle (90°). The solid lines (EA and EB extended) denote the narrowest practical angle (approx 53°).

8. Diagrammatic reconstruction of Brunelleschi's perspective demonstration of the Florentine Baptistery.

Z^1, Z^2—perspective focuses of side of Baptistery, marking the edges of a panel for a 90° viewing angle.
The inner square corresponds to a 53° viewing angle.

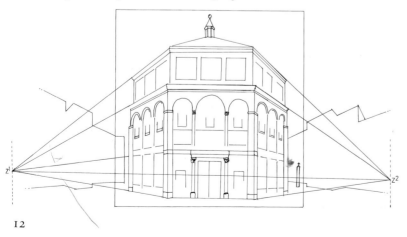

characters which Filippo alone understood'. The basis for such procedures would have been the 'abacus mathematics' he learnt as a boy.

The evidence of the 1413 letter and the account of the early biographer, who is generally identified as Antonio Manetti, agree in dating the discovery of perspective to the earlier phase of Brunelleschi's career, before his work in architecture and technology had assumed a dominating role.

Manetti's account is central to an understanding of the discovery, in that he provides the only eye-witness account of what Brunelleschi actually accomplished. He does so in the form of a description of two demonstration paintings, both of which have long since been lost.[7] The paintings depicted two of Florence's most renowned buildings, the Baptistery of St. John and the government palace (known as the Palazzo de' Signori). From Manetti's descriptions we can deduce reasonably accurately the viewpoints which Brunelleschi adopted for each of his demonstrations, and, since more-or-less the same viewpoints are accessible to a modern-day spectator, we can gain a general idea of what he showed in each painting. It is at this point, however, that the real problems begin.

Manetti's descriptions were not written for the purpose of the precise reconstruction of the panels and he only provides rough parameters within which a variety of reconstructions are possible. More seriously and fundamentally, he provides no indication as to how Brunelleschi achieved his results, beyond indicating by implication that the high degree of optical veracity was accomplished in a systematic manner—that Brunelleschi had achieved what in popular terms is called 'scientific accuracy'.

It seems wisest at this early stage in our story not to become entangled in the technical complexities of what can and cannot legitimately be teased out of Manetti's text, but these matters are important to a full understanding of the birth of perspective, and I have therefore provided a technical outline in Appendix II.[8] Let us for the moment concentrate on what is known with a reasonable degree of probability.

The painting of the Baptistery was executed on a wooden panel which was probably a square with sides a little less than 30 cm or one foot in length. Its main feature was a view of the octagonal Baptistery as seen by Brunelleschi when he was standing 'some three *braccia*' (one *braccio* measures a little over 23 ins. or 58 cms.) inside the main door of the cathedral. His viewing position is indicated on the diagrammatic plan of the piazza in front of the cathedral (pl. 7). The perspectival appearance of the Baptistery in its main outlines can be drawn (pl. 8). Neither the physical location nor Manetti's description of the panel allow us to determine definitely whether Brunelleschi depicted a wide-angle view of what was in front of him—up to a practical maximum of 90°—or a view that was only just wide enough to embrace the Baptistery with a thin slice of the buildings on either side. The wide and the narrow limits for his viewing angle are noted in both diagrams (pls. 7 and 8).

Having painted the vivid patterns of the inlaid marble of the Baptistery in such a way that 'no miniaturist could have done better', Brunelleschi constructed a form of peepshow to heighten its illusion. He drilled a small hole in the panel at a

point equivalent to that at which his line of sight had struck the Baptistery along a perpendicular axis. The spectator was required to peer through this hole from the back of the panel at a mirror held in such a way as to reflect the painted surface (pl. 9). To increase the effect of a magic glimpse of reality 'he placed burnished silver where the sky would be shown' so that the real sky and clouds would have heightened the optical illusion: the spectator would have been forced to view the painted Baptistery from a position generally corresponding to that from which the artist had viewed the real building. The degree of precision with which he intended and succeeded in controlling the spectator's viewing *distance* remains a matter for vigorous debate, and will be assessed in the appendix.

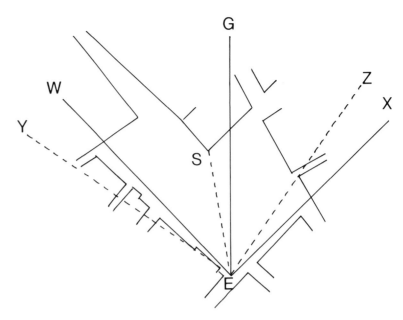

10. Diagrammatic plan of Brunelleschi's situation for his perspective demonstration of the Palazzo de' Signori (Palazzo Vecchio), Florence.

E—viewpoint
ES—axis of sight meeting the corner of the Palazzo Vecchio
YEZ—90° angle for axis ES
EG—axis of sight along diagonal axis of the piazza
WEX—90° angle for axis EG

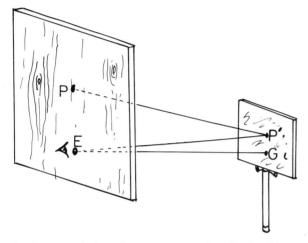

9. Brunelleschi's peep-hole and mirror system for viewing his perspective demonstration of the Florentine Baptistery.

E—eye hole in the panel EG—visual axis
Point P on the painted side of the panel is reflected at point P¹ on the mirror.
Note: the dimensions of the mirror should be half those of the panel to reflect the whole panel.

11. Diagrammatic reconstruction of Brunelleschi's perspective demonstration of the Palazzo de' Signori, Florence.

GT—vertical through axis of sight
Note: the diagonal pavement lines denote the orientation but not the position of the pavement pattern.

The appearance of the Baptistery panel would have recalled earlier attempts to depict octagonal buildings, most notably in Duccio's *Temptation*. An attempt to take up the challenge of specific *trecento* modes of describing forms in space may be adduced even more directly in the case of the second panel, which was executed on a much larger scale and showed the Palazzo de' Signori (now the Palazzo Vecchio) from the diagonally opposite corner of the *piazza* (pls. 10 and 11). Manetti's description again leaves room for a variety of interpretations, but he does convey a clear impression that the angle of view was wide, passing along the sides of the square, and that the Palazzo was the focus of attention. Some impression of its effect may be gained from a fine drawing by Jacques Callot after the end of the next century (pl. 12), although Callot's viewpoint was probably higher than and to the right of Brunelleschi's.

For his Palazzo de' Signori demonstration Brunelleschi did not use a peepshow device—Manetti reasonably says that the panel was too large and cumbersome—but he cut away the area of the sky above the buildings. In addition to enhancing the illusion, this cut-out technique would have permitted the

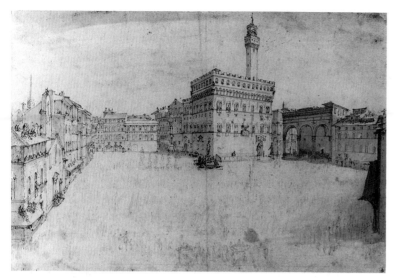

12. Jacques Callot, *Piazza della Signoria*, *c*.1619, Darmstadt, Hessisches Landesmuseum.

verification of the resulting skyline against that of the actual buildings. The picture itself, with the angular disposition of its central feature and its two lateral points of convergence, bears a clear relation to *trecento* methods. Not only had lateral focuses been used, as we have shown, but a number of artists including Giotto and Simone Martini had endeavoured to present buildings in a similarly angular manner. However, the pictorial sources, relevant though they are, do not account for the new element the biographer stressed in Brunelleschi's method; that is to say its scientific consistency. Can we tell by what means this consistency was achieved?

Manetti's account contains no explicit guidelines in answering this question. All the historian can do in these circumstances is to weigh the potentially relevant factors and suggest a working hypothesis. The first thing to be said is that Brunelleschi's method took as its starting point a set of actual buildings, working *from* these towards a perspectival projection. He was not, therefore, creating an independent space on *a priori* principles. He required some method of plotting the salient features of the views on the flat surface of the picture plane, which thus came to function as a kind of window. The problem which now faces us is that the available knowledge and skills provide too many potential sources for his technique.

Historians have at various times postulated that he exploited the skills of mediaeval surveying; relied upon scaled elevations and plans of the buildings; exploited scientific instruments such as an astrolabe to measure visual angles; adapted the geometrical formulas of mediaeval optical science (*perspectiva*); converted the projective techniques used by Ptolemy to map the earth and heavens; and adopted the 'simple' procedure of painting on the surface of a plane mirror. Most of these procedures (reviewed in more detail in the appendix) *could* have worked, and it would be wrong to make too sharp a separation between them, since one may have reinforced or refined another. It may, however, be possible to make a tentative

separation into major formative factors and contingent factors. Under the heading of formative factors I would include the challenge of *trecento* modes, the use of surveying techniques (particularly in the context of urban planning) and the measured recording of plans and elevations. Amongst the contingent factors we should obviously consider a range of techniques from mediaeval and classical science, including optics, astronomy, horology and geography, but it is difficult to see these sciences providing the germinal source for Brunelleschi's ideas. They may all be classified as relevant rather than directly applicable, and they generally come into the technically difficult category. It should be noted that the friend of Brunelleschi, Paolo Toscanelli, who is sometimes credited with introducing the more abstruse sciences to the architect, was only sixteen years old in 1413. Brunelleschi's interest in the optical properties of mirrors may also have arisen from his knowledge of surveying methods. I should say, however, that it does not seem at all likely to me that his procedure actually involved painting directly on a mirror, for a number of practical and intellectual reasons.

Behind these technical factors lie a complex series of social and cultural conditions. The general question of the way in which the science of art can be related to broader social issues will be discussed in the coda at the end of this study—and some specific remarks made about the invention of perspective—but I think it will be helpful at this stage to signal some of the factors that may be adduced. The skills available to Brunelleschi were integral to the growth of practical mathematics in a mercantile society. The compounding of artisan technical knowledge with the more theoretical sciences of the Middle Ages and with ancient learning in the revived texts of Greek and Roman science was to provide a potent mixture in the intellectual revolutions of the Renaissance. Specifically in Florence, the more abstract principles of humanist learning were being brought into especially fruitful conjunction with the practical requirements of civic life. The values of the Ciceronian humanists who lead the city administration aspired towards measured assessment and what may be called the achievement of rational 'perspectives' in judging the nature of man's world and the course of human action. While it is true that we should not look at society, even within Florence itself at this time, as a unified or internally consistent culture in all respects—and it will become clear that I distrust explanations based on simple mechanisms of social causation—there is little doubt that Brunelleschi's measured representation of these two revered buildings was deeply locked into the system of political, religious and intellectual values shared by those who exercised the greatest influence on Florentine civic life in this period.

Even though the rationale behind the invention may be said to reside integrally within Florentine society, the conceptual originality of Brunelleschi's discovery judged in relation to the established forms and functions of art such that it did not take immediate root. We need to wait until the mid-1420s to see the first works fully designed according to the principles of perspective science. I do not think this delay was simply a matter of the invention being too radical in principle. Rather

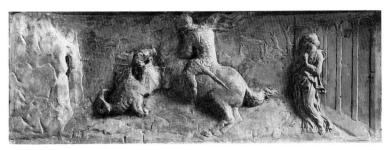

13. Donatello, *St. George and the Dragon*, *c*.1417, Florence, Museo Nazionale del Bargello (formerly on Or San Michele).

14. Analysis of the perspective of Donatello's *St. George and the Dragon*.

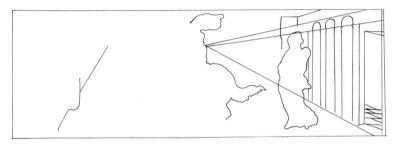

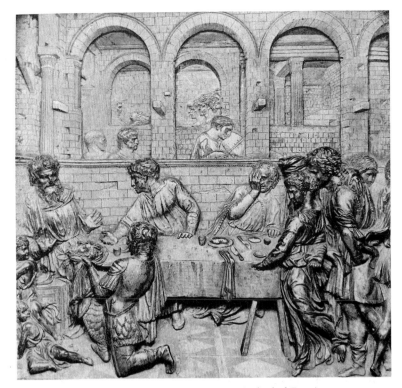

15. Donatello, *Feast of Herod*, 1423–7, Siena, Cathedral Baptistery.

16. Analysis of the perspective of Donatello's *Feast of Herod*.

V^1—focus of orthogonals of tiled floor
V^2—primary focus of orthogonals in upper part of relief
$Z^1 Z^2$—'diagonal' points

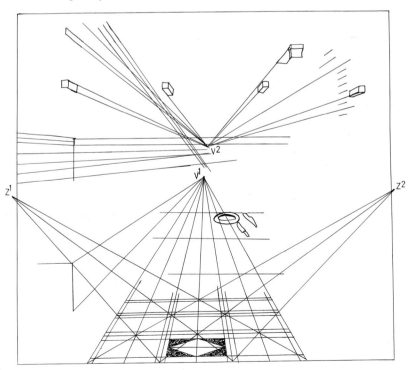

it seems a question of the actual procedures being largely inapplicable to the day-to-day needs of artists at this time. The procedures relied upon existing buildings and, inevitably, resulted in the portrayal of these buildings. Painters were not employed to paint townscapes as such, except in very unusual circumstances, and a set of existing buildings is unlikely to have provided an appropriate or adaptable setting for the religious subject-matter which predominated. The sheer effort involved in making a projection of a given building must have seemed to promise little or nothing which their existing methods could not serve more effectively, adaptably and economically. What was needed was a means of adapting Brunelleschi's procedures to the creation of an imagined space which could act as the servant to the artists' needs. Without such a means, the potential of the invention would remain dormant.

The first notable sign amongst the younger artists of an interest in novel spatial effects occurs in about 1417, in Donatello's marble relief of *St. George and the Dragon*, which was destined for the tabernacle below his sculpture of St. George on Or San Michele (pl. 13).[9] Using an innovatory and extraordinary subtle low-relief style, Donatello has created an unprecedented sense of atmospheric space behind the plane of the marble panel. At this stage, however, the techniques appear to be predominantly suggestive and intuitive rather than geometrically precise. The receding lines of the arcade, in front of which the princess glides, do converge to a definite point behind the saint's back (pl. 14), but most of the other architectural features seem to be judged by eye rather than measurement. The tiles of the pavement within the building are incised freehand and do not conform to a precise system.

There is nothing, in terms of measured perspective, that goes beyond *trecento* methods—but an ambitious mind is obviously at work.

The next significant development appears not to have occurred until the designing of Donatello's bronze relief for the font in the Cathedral Baptistery, (pl. 15), which was probably ready for the final stages of chasing and gilding by 1425.[10] The tiled floor, which provides the stage for the terrible story, is assertively perspectival in effect and does indeed recede to a central point (pl. 16). Each of the tiles is decorated with a diamond pattern and bisected by crossed lines running parallel to the sides of the tile. The manner in which this geometrical pattern is used to set up the receding plane of the floor might reasonably bring to mind the experiments of the Lorenzetti in the 1340s. Indeed, the lateral focus method of the *trecento* masters could readily have been exploited to construct Donatello's floor. The lateral points lie at the edges of the panel, if the basic unit is taken to comprise two of the 'squares' formed by the incised lines within each tile. If each of these 'squares', individually, is taken as the basic unit, or each whole tile, the lateral points will still be apparent, but will be impractically far outside the lateral boundaries of the bronze panel. It can be seen that the diamond motif within each tile can be extracted quite easily from a perspective interlace of the *trecento* type.

Donatello has obviously also made a sustained attempt in the upper part of his composition to produce a coherent space within which to place the musicians and an earlier incident in the narrative, the carrying of St. John's head. A number of prominent features, including the unexpectedly jutting beams on the pillars, run coherently to a reasonably accurate focus—very coherently if we make allowances for the difficulties involved in organising and analysing a relief in the same terms as a flat painting. There are a few 'wild' lines which do not conform, but the prevailing effect is that of a focused scheme. The focus of this upper part is, however, conspicuously above and marginally to the right of the point to which the tile system converges. The two spaces are not, therefore, perspectivally united. Why should this be? Was Donatello unaware, as his *trecento* predecessors had been, that all the features running into the space at right angles to the picture plane should converge to the same point in perspective projection?

There is no certain answer to this question. It is possible to surmise that Donatello deliberately differentiated between the two parts of his story, though not so markedly as to destroy the apparent effect of a single, coherent space. But this supposition means that he was tampering with the rules before we can be sure he understood them. We may grant a great artist that licence, but it is a dangerous way to argue. I am inclined to see the Siena relief as genuinely unresolved. Perhaps this lack of resolution is related to the different way the upper and lower lines have been produced. The shapes in the upper section have been incised in the wax before casting, while the more precise design below is largely the result of later chasing on the surface of the cast bronze.

We may fairly regard Donatello's Siena relief as having specifically taken up the problems tackled by predecessors who had worked in the very city for which his relief was destined.

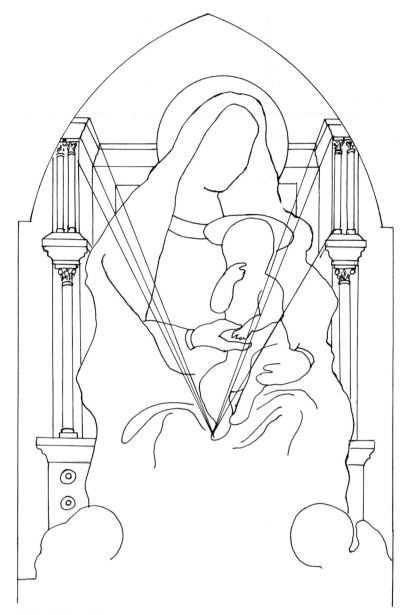

17. Analysis of the perspective of Masaccio's Pisa *Madonna*.

He has attempted to inform their techniques with some knowledge of Brunelleschi's more consistent perspective, but without at this stage achieving a wholly coherent, definitive system. If this scenario is correct, it would make sense to see Brunelleschi becoming reinvolved with perspective in the mid-1420s under the stimulus of the struggles of Donatello and at least one younger artist. It is at this point that Masaccio enters the story.

The young Masaccio had himself been experimenting with systems in which orthogonals converge to a single, central point. His investigation of convergent orthogonals may have started as early as 1422 in the San Giovenale altarpiece, if this can indeed be attributed to Masaccio. We can be certain that by 1426, when he was completing his altarpiece for Pisa, he had adopted a system in which the parallels perpendicular to the picture plane converge to a single point (pl. 17).[11] In the Pisa

Madonna this method is used in an entirely regular manner, though more reticently than in Donatello's relief. In the architecture of the Madonna's throne, so overtly classicising, we may detect Brunelleschi's impact on the young painter, an impact which would help explain the precise perspective.

At this stage, the linear perspective is relatively unassertive. No more than two years later, in his *Trinity* (pl. 18) in Sta. Maria Novella, he openly declared a new kind of perspectival rigour. This fresco stands as an uncompromisingly tough assertion of the intellectual and visual power of perspective, revealing the potential of Brunelleschi's invention when it is placed in the hands of an artist who has its mechanism totally under his control. That this powerful mastery should have been accomplished by a painter who was probably not yet twenty-seven years old, and at such an early stage in the history of perspective, is astonishing.

At the outset of our analysis, it will be wise to concentrate on the upper section of the fresco, that part from the level at which the donors kneel to the top of the painted area. Not only are there more spatial clues in this region, but the condition of the upper part is more reliable, having required less of the restorer's fabrication than the lower area. The most immediately compelling effect is that of the converging orthogonals of the vault, which can be extended—though, as we will see, with some qualifications—to a focus at V, situated a little below the edge of the donor's ledge (pl. 19). This convergence, in itself, does not advance beyond what we have already seen, but the way in which all the other elements in the painted architecture appear to be subjugated to the same discipline shows that we entering a new kind of pictorial world. The composition positively seems to invite analysis, and to encourage the spectator to visualise it as a pre-existing structure with defined plan, elevation and dimensions. A number of attempts have been made to accomplish just such a reconstruction. Probably the two most useful variants are those of Kern (1913) and Janson (1967).[12]

Janson claimed to have corrected Kern's faulty measurements and ingeniously translated his own alternative measurements into Florentine *braccia* and *palmi*. Some detailed corrections to Janson's measurements have been offered by Polzer, but Janson's *palmo* units do seem to offer a workable basis.[13] However, linear meaurements do not in themselves answer the key questions as to what is happening in the space of the painting and what procedures Masaccio may have used. For such reconstructions we have to begin by taking one or more of the forms shown in perspective as the regular spatial unit in order to plot the relative locations of the objects in depth. Any number of potential forms can result in a given configuration on the surface of a painting, but when we look at a painting such as Masaccio's we make an automatic and required assumption that we are seeing regular objects under spatial distortion. To begin precise reconstruction we need to *assume* that a particular feature represents a simple body of precisely known shape, ideally a square or a cube. Kern assumed that the vaulted area is a perfect square and that the spaces under the arches extend it into a regular short-armed cross of the kind shown in plates 20 and 21. Such a configuration is entirely

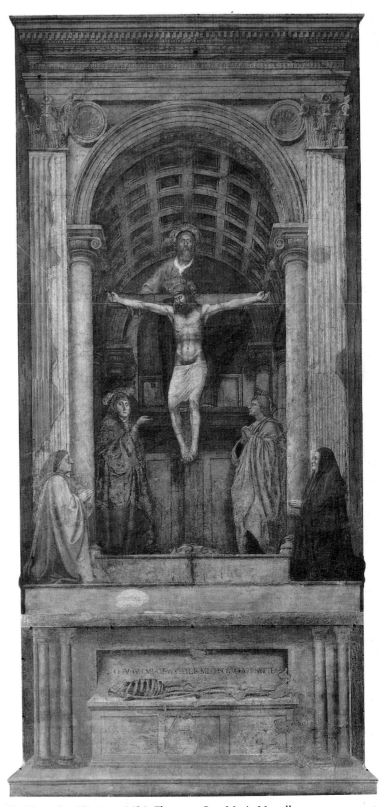

18. Masaccio, *Trinity*, c.1426, Florence, Sta. Maria Novella.

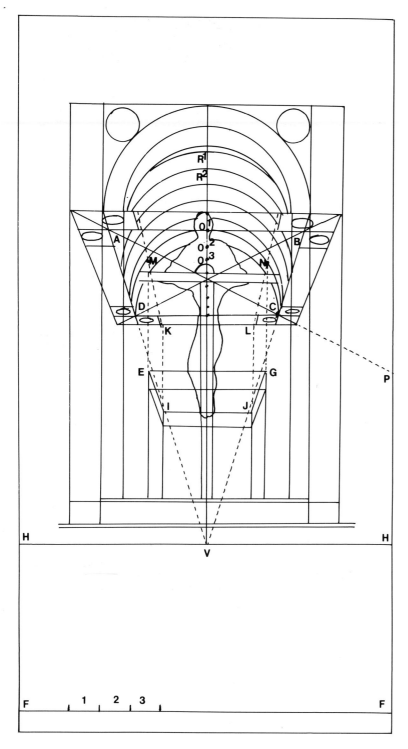

19. Analysis of the spatial construction of Masaccio's *Trinity*.

ABCD—square plan of the vault at the level of the tops of the abacuses
V—point of convergence of the orthogonals
H—horizon F—floor level, with scale of *palmi*
O^1, O^2, O^3 etc.—centres for arcs R^1 (concealed), R^2, R^3 etc.
EG—presumed front corners of 'Christ's Tomb'
IJ—presumed rear corners of 'Christ's Tomb'
KL—width of 'Christ's Tomb' on the rear wall
MN—vertical locations of EG on the plane ABCD
ACP—diagonal through ABCD extended towards its intersection with the horizon H at the 'distance point'
Note: the eight ellipses beside the corners of ABCD are indicative of the positions of the columns, but are not drawn to scale

in keeping with the developing interest in such classical symmetries in Renaissance architectural thought. Janson assumed that the coffers are square, but a series of inconsistencies in his reading of the forms is coupled with an odd plan, in which the vaulted area plus the two lateral arms comprise a square.[14] Both Kern's and Janson's starting assumptions are reasonable, but a choice of starting point has to be made, and Kern's assumption causes fewer subsequent inconsistencies.

At the outset, the reader should be warned that Masaccio's construction is not entirely consistent and regular in all its details and no reconstructive strategy can eliminate all the problems. However, I do believe that the utterly exceptional nature of Masaccio's architectural illusion does require as a conceptual necessity that he had a pre-conceived structure of a regular nature in his mind. The translation of this conceptual structure into a perspective scheme further requires a complex design process in which a series of measured drawings permit the projection of the form on to the surface of the wall. A stereometric diagram of the fresco (pl. 19), concentrating on the horizontal plane running across the tops of the abacuses of the capitals of the columns (i.e. at the level of the springing of the vault) provides some clues as to a possible procedure for Masaccio.

Let us begin by outlining our assumed square, ABCD at this level, where it is most openly apparent. Subdivisions of this square can be used to provide the relative locations for the arched ribs of the vaults and (potentially at least) for the forms immediately below. The diagonals of the square would, for instance, mark the point vertically below the centre of the vault. There are a number of ways in which the central perpendicular through the square could be divided to provide the location for the compass centres in the drawing of the arched vault. Perhaps the most likely, given what we have inferred about Brunelleschi's surveying approach, is the use of an auxiliary construction in which the calculations are made 'from the side' rather than in the manner of the lateral elevation in plate 22. The successive divisions (O^1), O^2, O^3, provide the centres for the drawing of the respective arcs (R^1), R^2, R^3 . . . The surface of the plaster reveals a series of such arcs inscribed in the plaster as the linear armature for the ribs. There is much further evidence of construction work on the wall, in the form of 'snapped' rope lines—made by plucking a taut rope against the wet plaster—together with incised straight lines and arcs.[15] How do these correspond to the constructional scheme I am suggesting?

The surviving evidence suggests that Masaccio used an extraordinary compound of constructional techniques, involving pre-designed elements—for which careful constructional work must have been accomplished separately—and elaborate surface construction in each patch of newly applied plaster. There were also areas of imaginative improvisation which involved compromises with strictly mathematical accuracy. The vault, which represents the greatest perspectival challenge, was almost certainly one of the pre-designed elements, since there is virtually no sign of the constructional armature necessary to facilitate the incising of the arcs and orthogonals in the plaster. The best we can hope to accomplish in such areas is a

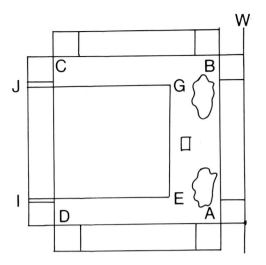

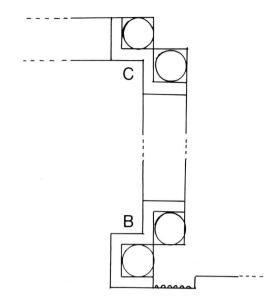

20. Hypothetical plan of the architecture in Masaccio's *Trinity*.

ABCD—square plan of the area covered by the vault
EGJI—presumed plan of 'Christ's Tomb'
W—plane of wall

Note: the elements in front of the wall plane are excluded, because no measured reconstruction is possible.

21. Schematic plan of the rear and front right corners of Masaccio's *Trinity*, showing the relationship of the columns, incomplete abacuses and pilaster.

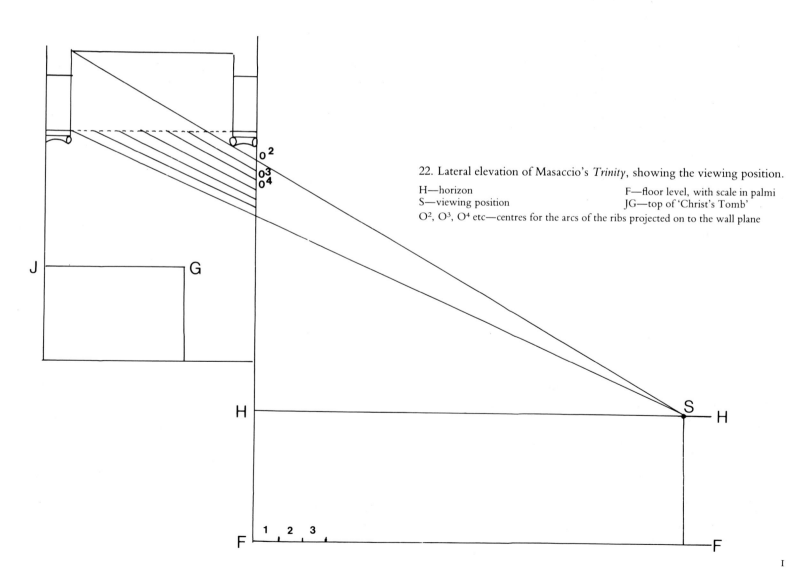

22. Lateral elevation of Masaccio's *Trinity*, showing the viewing position.

H—horizon
S—viewing position
O^2, O^3, O^4 etc—centres for the arcs of the ribs projected on to the wall plane

F—floor level, with scale in palmi
JG—top of 'Christ's Tomb'

plausible if hypothetical reconstruction of a Brunelleschi-style projection of a pre-conceived building onto a plane, perhaps using a plan at the level of the abacuses in the manner suggested above.

Such a plan also permits us to make a plausible guess as to the relative shape and position of the structure on which God the Father stands. If we take its forward right edge EG, as terminating more or less along a vertical line which lies adjacent to the front of St. John's neck, and take its rear width as equivalent to the panel on the back wall, we can reconstruct a feasible shape and calculate the vertical position of its front edge as roughly equivalent to five coffers from the rear arch. If we extend this structure by the extra unit necessary to attach it to the rear wall under the arch, the result is a rectangular form which could well be taken as a grander version of the tomb provided for the skeleton below. The implication that Christ's tomb is present in the Trinity provides an extra complication in the theological interpretation of a fresco which already presents severe problems.

The foregoing analyses convey the impression that Masaccio's fresco is governed by an unwavering geometrical logic. I suspect that this impression is precisely what the artist intended. However, detailed analysis shows that the logic has been subverted by a series of irregularities. A selective list of some of the inconsistencies will give some idea of how numerous and obvious they are.

The curved ribs of the coffers are not symmetrical about the incised arcs supposedly marking their centres.

The second rib (R^2 in pl. 19) appears to be less visible than it should be.

The widths of the lateral coffers immediately above the lateral cornice are conspicuously greater than the set of six coffers above them.

These six central coffers are entirely regular in width, but their orthogonals do not run altogether tidily to the focus V.

The abacuses of the rear columns cannot be made to fit accurately in a regular plan, and appear to have been projected in a way which is, strictly speaking, inaccurate.

The apparently centralised symmetry of God the Father and the crucified Christ is subverted by marginal shifts away from the axis, as in God's head, which is just to the left of centre.

It could be argued that Masaccio had either been consciously casual or made inadvertent errors. However, the nature of a number of the inconsistencies is such as to suggest deliberate choice. The margins of the ribs appear to have been manipulated for visual effect, most particularly to soften the potentially awkward clash of R^2 and the lower edge of the entrance arch. The wider lateral coffers result in the alignment of the orthogonals with Christ's hands in an area of the fresco in which visual discomfort could otherwise arise from the extreme perspectival effects. And the marginal asymmetries soften the mechanical and 'inhuman' rigidity of the spatial mechanics. These instinctive adjustments to geometrical formulas are of the kind we will later see artists making again and again. They are in part a matter of judgement of spatial effects 'by eye' and in part a response to the composition of

forms on the picture surface during the physical execution of the work.

There are a number of other possible contrivances of surface conjunctions in the Trinity. For example, the horizontal (CD) marking the rear of the square from which the vault arises intersects Christ at a third of his height. We will later see Alberti taking this one-third measure—equivalent to one braccio in his system—as the module for his own perspective construction. If this measure is repeated once above Christ's head, it coincides with the horizontal across the tops of the capitals and God's halo. If it is further repeated in succession, above and below, it appears that eight of the measures corresponds to the distance between the horizontal across the bottom of the framing cornice at the top of the fresco and the sill of the donors' ledge below.

I think we need to exercise caution in undertaking this kind of analysis. With sufficiently thick lines and a certain amount of wishful thinking almost anything can be proved. However, the conjunctions do seem to arise so readily that we may be justified in regarding them as deliberately planned. This would be entirely consistent with the notions of proportional measure which played such a central role in Brunelleschi's architectural design. Fortunately there are some confirmatory clues in the fresco itself that Masaccio did establish geometrical divisions on the surface of his works. In addition to the incised lines already noted, there are two indented horizontals close to the knee level of St. John, the more definite of which appears to coincide with the lowest of our eight-part divisions. A series of separate, smaller-scale coordinates have also been used in a different way for the construction of some particularly complex areas of the fresco.[16] Most conspicuous of these is the network of squares used as a guide for the painting of Mary's head, the foreshortening of which had presumably been the subject of a separate constructional study.

A second kind of conjunction may also be mentioned briefly. The point of intersection of the diagonals of the original square coincides with the junction of the shaft and arms of Christ's cross. This point does not mark the position of the cross in depth, but is the consequence of a visual coincidence built into the set of spatial tensions at a crucial point in the composition.

There is one other major consequence of the construction we have undertaken. We are able to calculate the viewing point for the painting. If the diagonal AD through the vaulting square is extended through P to meet the horizontal H through the point of convergence V, the resulting distance between that point and the intersection of the lines will give the viewing distance. This result can be checked by a scaled reconstruction of the lateral elevation (pl. 22), and works out with reasonable accuracy as equivalent to twice the width of the construction on the wall plane, and closely approximates to the width of the aisle of the church. If the front abacuses are used to calculate the distance, a broadly comparable result is achieved, while the anomalous rear abacuses give much too short a distance.

When we turn to the lower part of the picture, we need to make considerable allowances for its condition. About fifty per cent of what is now visible is restoration, including all but

one of the perspective clues. However, this one clue—right orthogonal of the tomb—and the pair of column shafts on the right do suggest that the skeleton lay vertically under the donors' ledge and that this ledge was supported by two pairs of columns, in the manner adopted for the restoration. If correct, this would mean that the donors and the skeleton (and of course we ourselves) occupy the realm in front of the picture plane. I do not think the surviving information is sufficient to make an estimate of how far in front of the plane these elements should be located, but the intended effect is clear. We can conjecture that the height of the spectator's viewpoint above the floor-level was intended to be related directly to the height of the skeletal man who lies in our space; the measurements are close, but the condition of this lower area again prevents certainty, as do doubts about the original floor-level.

Masaccio's differentiation in depth between the all-too-mortal world this side of the plane and the indubitably spiritual realm inhabited by God, Christ, Mary and John is an act of high genius. A new spatial technique has simultaneously been mastered technically and locked into the meaning of the picture in a way which only a few artists have since equalled.

The sheer sophistication of the construction, unmatched in Masaccio's other works, raises the possibility of Brunelleschi's active collaboration. Brunelleschi's system, as we have stressed, depended upon pre-existing structures, and it is easy to imagine that Masaccio's 'chapel' was pre-designed in detail to serve its particular function. The constructional skeleton used to plan the actual painting is, however, overtly geometrical and demonstrates a high level of spatial abstraction. Perhaps there was a genuine two-way collaboration, in which the painter made the vital transition from Brunelleschi's empirical, object-based procedures to a more synthetic, constructional system. In any event, the *Trinity* is deeply infused with Brunelleschian principles, both in the *all'antica* sophistication of its architectural vocabulary and in its underlying sense of proportional design.

I have dwelt at some length on this painting because of its intrinsic importance, artistically and historically, and also because the technical procedures we have been through—for which I ask the reader's forebearance—will have laid the groundwork for an understanding of what follows. After this analysis, I hope, almost anything will seem easy.

CODIFICATION AND THE WRITTEN RECORD

As a precise technique, perspective was obviously amenable to systematic description and, given its actual or potential relationships with existing sciences, it was clearly susceptible to explanation through theory. Not surprisingly, these steps were the next to be taken, though not quite in the tidy way which would make the historian's task easy.

In this section I intend to discuss consecutively the three major contributors to the written codification of perspective before Leonardo, that is to say up to about 1470. In the case of the theory and practice of the third of these authors, Piero della Francesca, this narrative will take us to a date beyond that of various practitioners who will concern us in the subsequent section, including Piero's early colleague, Domenico Vene-

ziano. The advantage in discussing the three theorists together will, I hope, outweigh the slight chronological disjunction which will inevitably occur. I will endeavour to signal clearly when it is taking place.

At this point, as throughout this study, we should bear in mind that the nature of any written account of perspective is bound to reflect the author's intellectual background and immediate purposes. Had the first written explanation of perspective come from a practising artist, it would almost certainly have presented a different character from the first account which is available to us. It was written by a man of letters, Leon Battista Alberti.

Again, some brief biographical details will be useful, since they help us to understand why Alberti and Brunelleschi approached the same question from such different angles. The wealthy Alberti family had been exiled from Florence, and Leon Battista's education was conducted in the great North Italian centres of learning, Padua and Bologna.[17] An initial training in Latin letters led him to the study of law at Bologna and subsequently into moral and natural philosophy. In 1431, at the age of twenty-seven he became one of the secretaries at the Papal court in Rome. He may have met Brunelleschi and Donatello on their respective visits to that city, but it was his return to Florence on Papal duties in 1434 which fully opened his eyes to what his Florentine contemporaries were accomplishing. Unusually for a humanist at this time he showed a natural predilection for the visual arts. This predilection later expressed itself in his design of some of the greatest Renaissance buildings and had already been apparent in his own 'miracles of painting' to which he tantalisingly alluded.[18] His primary attitude, however, was that of someone who approached intellectual disciplines on the basis of deductions from first principles and the ordering of written material according to Ciceronian logic. I do not want to suggest, as some have done, that he lacked an involvement with and genuine understanding of practical needs. Rather, his approach was conditioned by ingrained habits of intellectual deduction.

His seminal if short treatise, *On Painting*, was produced in two versions: a Latin text aimed at men of letters, written in 1435 and subsequently dedicated to Giovanfrancesco Gonzaga of Mantua; and an Italian version prefaced by a dedication in 1436 to Brunelleschi in which he expressed delight at the way in which the great Florentine artists were manifesting 'an innate talent for every worthy enterprise in no way inferior to any of the ancients who gained fame in these arts'.[19] I do not think we should regard the Italian version, *Della Pittura*, simply as a translation of the Latin *De Pictura*, but rather as a parallel conception. His treatise contains the first written account of one-point perspective. His attitude to the making of a picture is founded upon his conviction that 'a painting is the intersection of a visual pyramid at a given distance, with a fixed centre and a defined position of light, represented by art with lines and colours on a given surface'.[20] Although *De Pictura* should not be regarded simply as a handbook of perspective, which is the direct subject of only the first of its three parts, he unquestionably saw the geometrical construction of space as a prerequisite for proper painting. This first section is, therefore,

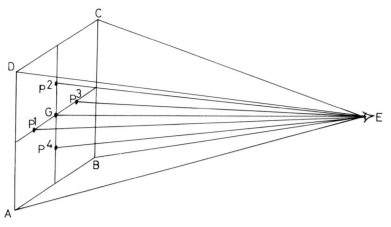

23. Diagram of the visual pyramid of Alberti.

E—eye

EA, EB, EC, ED—extrinsic rays

EG—centric ray

P¹, P², P³, P⁴—intrinsic rays

'completely mathematical, concerning the roots in nature from which arise this graceful and most noble art'.[21]

In keeping with his training in systematic exposition his treatise opens with basic definitions of geometrical terms. He recognised that neither the student of optics nor the painter is concerned with the pure, abstract conceptions of the mathematician, who deals with forms 'totally separated from matter'.[22] When he emphasised that the geometer's point is something which is conceptually indivisible, while the painter's point will merely be a physical 'sign' sufficiently small to be indivisible in practice, he was echoing a traditional distinction. But this difference does not absolve the painter from the demands of geometrical precision, and Alberti proceeds to define the concepts of point, line and plane for the artist, using a nice mixture of Euclidian rudiments and commonsense description. A concave surface, for example, is described as analogous to the inside of an eggshell. Such forms are measured by the eye through the geometrical medium of light. This concept leads naturally to his outline of the science of vision.

His view of the visual process is as unequivocally mathematical as his analysis of the properties of forms. Vision 'operates by means of a triangle, whose base is the quantity seen and whose sides are those same rays which extend from the extreme points of that quantity'.[23] Sets of such triangles in three dimensions comprise a visual pyramid (pl. 23). This notion corresponds to one of the central concepts in the mediaeval science of *perspectiva* as developed by the Islamic philosopher, Alhazen, and his followers in the West.[24] Alberti's Latin text, in particular, reveals some acquaintance with mediaeval optics, using its technical language and making knowing references at various points to the 'opinions of the philosophers', who are clearly recognisable as belonging to the Alhazen tradition, which we will be discussing in more detail later in this section. Much of this technical tone is absent or muted in the Italian version, which was naturally addressed to a different audience. Even in the Latin text he avoids technical questions about the nature of light and the structure of the eye, claiming that they lie outside his immediate needs. He is thus left with the basic pyramid, its apex in the eye and its boundaries formed by 'extrinsic rays', which register the outlines of each form. Inside the pyramid are bundles of 'intrinsic rays', which are responsible for recording the surface qualities of colour, light and shade, etc. At the very centre is the 'prince' of rays which runs perpendicularly between the eye and the object: 'the position and length of the centric ray plays a large role in the certification of sight', jut as it was said to do in mediaeval theories.[25] This capacity means that it provides the strongest discrimination of detail and distance.

Alberti's simplified and adapted account of optical theory is devoted to very different ends from those served by mediaeval optics, since his treatise is not concerned with the natures of the visual process and of the divine geometry of light in themselves, but rather with outlining the implications for the painter of the visual pyramid and its intersection. He defines the painter's intersection as a plane surface on which the images are recorded in their just proportion according to the Euclidean laws of proportional triangles: 'if a straight line intersects two sides of a triangle and . . . is parallel to one of the sides. . . , then the greater triangle will be proportional to the lesser'.[26] This concept of proportionality lies at the aesthetic heart of his system, just as it was later to do in his architectural design. Size in itself is not of prime importance. Relative dimensions are those which matter, and the best proportional scale for visual reference is provided by the most well-known of forms, that is to say by the figure of man, in keeping with Protagoras's saying that 'man is the measure of all things'.[27]

This human scale provides the basis for his construction of perspective in a picture. He begins by outlining a rectangle 'as an open window through which the object to be painted is seen'. He then determines the scale of a man in relation to the window (pl. 24). This man is taken to be three *braccia* high. The scaled *braccia* in turn provide the basis for a series of *braccio* divisions along the base of the picture. He next determines the point at which the centric ray strikes the picture, 'no higher than' the scaled man, and this point is joined to the divisions of his base line. The resulting lines (the orthogonals) 'demonstrate to me in what way, as if going into infinity, each transverse quantity is altered visually'.[28] That is to say, he has created a sliding scale for proportional diminutions of size into the depth of the picture. But, clearly, some system is needed to establish precisely measured *positions* in depth—which is the very problem that the *trecento* painters had failed to solve adequately.

Alberti's answer is another scaled construction, at right angles to the first, so that intersections corresponding to horizontal divisions of one *braccio* can be determined in relation to the distance between 'the eye of the spectator and the painting'.[29] These points of intersection provide the vertical locations for the regular horizontal divisions in the finished construction. His recommended way of confirming the accuracy of the resulting pavement is to draw a diagonal through the opposite corners of several foreshortened squares, a procedure which resembles the *trecento* constructional

24. Diagram of Alberti's perspective construction.

1. B—one *braccio* module (one-third of the height of a man). The base of the picture is divided into *braccia*. The height of the man at the front plane of the picture gives the level of the horizon, H.

2. The *braccio* divisions are joined to the perspective focus, V, to give the orthogonals.

3. In side elevation, lines are drawn from *braccio* divisions behind the picture plane P to the eye at E. The points of intersection on P are noted.

4. The levels of the points of intersection are marked at the side of the picture plane, and locate the horizontal divisions of the tiles. Z is the 'distance' point, though Alberti only mentions using one diagonal to check the construction.

method, though Alberti only mentions one diagonal and does not discuss its further implications.

The receding 'pavement' subsequently provides the key for the scaled distribution of all forms. If a horizontal, 'centric line' is drawn—we would call it the horizon—this will provide an indication of whether the seen objects are above or below the spectator. Buildings and more irregular objects can be transferred by means of plans to the foreshortened pavement, as can circles (pl. 25). The height of any feature can be calculated by determining the relative size of the *braccio* module at each receding plane. All is thus set fair for a precisely controlled proportional exposition of all forms in a geometrically logical space.

25. Diagrams of Alberti's method for the perspective projection of a circle on the floor plane.

The circle is drawn on a square grid. The grid is drawn in perspective. Equivalent points on the projected grid permit the construction of the circle in projection.

The greatest problem in Alberti's account is not his dodging of the physics and physiology of vision—which is understandable in his given context—but his failure to demonstrate precisely why the visual pyramid results in the practical construction of the orthogonals. He excused himself as follows: 'we have talked as much as seemed necessary about the pyramid, the triangle, the intersection. I usually explain these things to my friends with certain prolix geometrical demonstrations, which in this commentary it seemed to me better to omit for reasons of brevity.'[30] What were these demonstrations, and did they resolve this problem? He could well have demonstrated the intersections formed by the parallels perpendicular to the picture plane in the manner shown in the illustration to Appendix 1 (pl. 552B), but he provided no clue that this is what he did. Thus the disjunction between visual process and construction remains unresolved in the treatise as it stands.

Alberti's intention in describing the process of construction has often been misunderstood. He was not providing an inviolable formula for a fixed, centralised viewpoint. He did not say that the point should be central at all, and said no more than that it should not properly be higher than his modular man. He was too intelligent and too aware of pictorial practice to think that every picture could or should obey the same con-

26. Paolo Uccello, *The Selling of the Host*, *c*.1468, Urbino, Galleria Nazionale della Marche.

ditions. We should not be surprised that very few pictures resemble our basic demonstration of his system—Uccello's *Selling of the Host* (pl. 26) is exceptional in this respect—but rather recognise that an imaginative exploitation of his principles, such as that in Piero della Francesca's *Flagellation* (pl. 39) is entirely in tune with the intentions of Alberti's treatise. Alberti was, to adapt his own words, demonstrating the basic 'roots in nature', which he was then happy 'to place in the hands of artists'.[31]

One of the artists in whose hands he left them to best advantage was the great sculptor, Lorenzo Ghiberti. During the course of his career Ghiberti responded with intelligence and sensitivity to the experimental work of his contemporaries, effectively absorbing perspectival techniques together with other aspects of the new styles. I do not subscribe to the view that his career pattern was that of a late-Gothic craftsman developing more or less successfully into a Renaissance intellec-

27. Analysis of the perspective in Ghiberti's *St. John before Herod*.

tual. His work from the first exhibited a sophisticated ability to reconcile particular aspects of antique Roman art with the linear grace of the *trecento* masters, especially the Sienese whom he so admired.

In matters of perspective, however, there is no doubt that his position was that of an artist who was responding to the innovations of others, though, as we will see, he did make a distinctive contribution to the theory of the artists' science. His vision of space in his earlier relief sculpture was conditioned by the established convention of a flat background plane in front of which the forms were modelled in varying degrees of relief. When he did attempt more ambitious spatial effects, as in his relief of *St. John before Herod*, completed in 1427 for the same Siena font as Donatello's *Feast*, he turned for guidance to the *trecento* pioneers.[32] The rectangular ceiling pattern exhibits a decent series of converging orthogonals (pl. 27), but the horizontal divisions appear to be calculated according to the ratios 8 : 4 : 2 : 1, the kind of arithmetical method fairly criticised by Alberti as inaccurate. By the mid 1430s, when he had almost certainly completed the design work on his second set of Florentine Baptistery doors, he had not only seen the examples of Donatello's and Masaccio's latest works but also may have had the opportunity to read *Della Pittura* or otherwise hear Alberti's views.[33] The effects are obvious.

The most harmoniously perspectival relief from the *Porta del Paradiso* is the *Story of Jacob and Esau* (pl. 28); it may be no coincidence that immediately beneath this panel Ghiberti proudly inscribed his signature in immaculate Roman capitals. Its frame is a modified Albertian window: not only do the carefully calculated, receding structures and tiled floors press the space back through the plane, but he has also constructed a perspectival platform protruding forwards from the window to accommodate the most prominent actors in his multiple story. The whole scene breathes an air of proportional grace and visual measure. Close analysis of its structure confirms this impression.

Given the difficulties involved in the coordination of illusionistic space, created by perspectival means, and the actual depth of the relief, resulting from modelled figures and inclined planes, Ghiberti has achieved a remarkable essay in geometrical precision. The orthogonals converge with impressive consistency towards a point in the very centre of the square window (pl. 29). The viewpoint is thus higher than that recommended by Alberti, but not disconcertingly so. The horizontals are placed with considerable accuracy, and even the very compressed patterns in the distant tiles at the centre and right have been computed with some care. The height of the figures decreases in just order, with the exception of Esau climbing the hill in the right background, who has been enlarged for the sake of narrative clarity. Although the figures do not precisely obey Alberti's formula that they should be three tile-widths tall at each plane, the people in the foreground are (as observed by Krautheimer) equivalent in height to three of the units at the very front of the relief.[34] If this is deliberate, it does not correspond to Alberti's *spatial* use of the module. The architectural features, by contrast, show a more fully Alber-

28. Lorenzo Ghiberti, *Story of Jacob and Esau*, c.1435, Florence, Baptistery, East Doors.

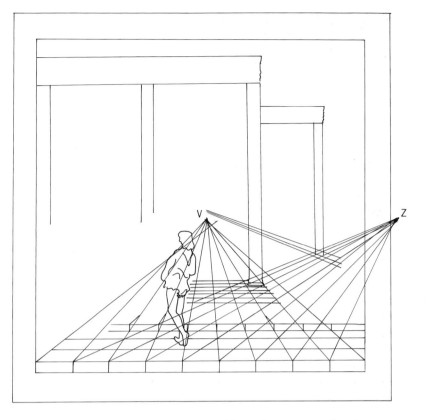

29. Analysis of the perspective of Ghiberti's *Story of Jacob and Esau*.

V—main focus of orthogonals
Z—focus of the diagonals through units two 'squares' deep and one 'square' wide

tian concern with proportional size in the relation to depth. The tile dimensions provide the key for the width of the pilaster bases. The pilasters themselves divide the space into three equal parts horizontally, and, with the main cornice, describe a subsidiary square within the main square of the frame.

If we use our diagonal method to calculate the viewing distance we will find that it was designed to equal the width (and height) of the panel. This may alternatively mean that he adopted Donatello's expedient of using the diagonals through the opposite corners of tiling units two 'squares' deep since the lateral points then fall within the frame of the actual panel. Even so, I do not think this means that Ghiberti intended his tiles to be read as half-squares—it may simply have been a matter of constructional expediency. If he had read *Della Pittura*—and the whole concept of the space and narrative suggests that he had—he would have been able to understand the concept of the viewer's distance from the plane in a way which Donatello probably could not at the time of his Siena relief.

The *Jacob and Esau* richly justifies Ghiberti's subsequent claim to a high level of artistic rationality: 'in order always to understand first principles, I have striven to investigate in what manner nature functions in itself, and how I may be able to apprise nature, how the incorporeal images [*spetie*] of objects come to the eye, and how the visual power operates, and

how the visual sensations arise, and by what means the theory of the arts of sculpture and painting may be formulated'.[35] He became a fervent advocate of the learned status of the visual arts, at least as practised by a true artist: 'sculpture and painting comprise a science, adorned with many disciplines and various branches of learning; it is the greatest invention of all of them; it is made with a certain level of meditation, during which it is composed according to rational considerations'.[36] In this he had been strongly affected by the tone of the *Ten Books of Architecture* written by the Roman author Vitruvius, whose 'rediscovered' text was avidly studied in the Renaissance as the only surviving artistic treatise from antiquity.[37] Ghiberti specifically followed Vitruvius in devising a list of the liberal arts which graced painting and sculpture and with which the artist should be acquainted: grammar, to be able to write effectively about the principles of art; geometry, for the purposes of rational harmonies in design; philosophy, for the natures of things; medicine, for the nature of man; astrology, for the geometrical harmonies of the planets; perspective as the visual science of space; history, for the composition of stories; anatomy, for the understanding of human structure, motion and proportions; theory of design, for obvious reasons; and arithmetic for the calculations necessary for the practice of his profession.[38]

If they had come from Alberti, these claims would not have been altogether surprising. Coming as they do from someone trained as an artist, they testify strikingly to the new self-image of the artist, an image for which the rational science of perspective was so obviously significant. These ideals were recorded late in Ghiberti's career in his *Commentaries*, but by the time he was designing the *Porta del Paradiso* he was

already beginning to move within the circles of humanist-connoisseurs of antique art and to cherish the classical texts they collected. These involvements provide the humanist background to the *Commentaries*, above all to the ingeniously compiled account of ancient art with which they open. Subsequent sections contain the history of his *trecento* predecessors, his laudatory autobiography, and, of most immediate concern to us, a compilation of texts from the mediaeval science of vision.

The third and final section of the *Commentaries* consists of an anthology of translations from just the right authorities to study for the most advanced optical ideas then available.[39] These authorities were: Alhazen, the Islamic natural philosopher whose career bridged the tenth and eleventh centuries; the British thirteenth-century Franciscans Roger Bacon and John Pecham; their Polish contemporary, Witelo; and to a lesser degree the Arabian authorities on anatomy and medicine, Averroes and Avicenna. I have already alluded at a number of points to the tradition of mediaeval *perspectiva* represented by Alhazen and his followers. It is now necessary that we look at their ideas in rather more detail, and try to define how this tradition stands in relation to the invention and development of the artists' science.

Alhazen's science was founded upon a union between the certainty of mathematics and the direct experience of natural phenomena.[40] Light, propagating itself in geometrical configurations—by direct transmission, by reflection and by refraction—is received into the eye, an organ which is conceived as a complex mechanism of refractory spheres specifically adapted to its superior function. The methods and details of this science were absorbed by the Christian West into a theological context in which light came to be regarded as an intimate manifestation of God's rational presence in natural design. For Roger Bacon the experience and analysis of optical phenomena led man towards one kind of understanding of divine power.[41] The quotation from John Pecham via Leonardo which opens Part I of this book conveys precisely the mediaeval philosophers' rapturous sense of the spiritual delights to be gained from optical studies.[42]

They described light as being transmitted throughout the air by means of an infinite number of radiant pyramids. On entering the eye, the visual pyramid as a whole or in its many parts did not actually reach its vertex, since it was refracted in such a way as to form an upright image of finite dimensions. However, the geometry of visual judgement was based on the *apparent* vertex of the pyramid and its *apparent* angle in relation to its base and length. The authorities were all in agreement that the perception of size and distance could not be accomplished by the geometry of sight alone, but required some scale of reference. Bacon typically argued that size is understood 'by comparison and immediate reference to some definite measure accessible to the memory, like the size of the man measuring, . . . and all these things are determined by the visual axis passing over the objects'.[43] We have already heard echoes of these ideas in Alberti.

During the thirteenth century optics became perhaps the most impressive branch of mediaeval science, and was part of the curriculum in the universities. Manuscripts of the Latin translation of Alhazen's 'Perspectiva' were quite widely available, as were versions of Bacon's *Opus Majus*. The third of Ghiberti's main sources, Pecham's *Perspectiva communis*, was an abridgement of his predecessors' works—albeit one of some length and complexity—suitable for teaching. This last source, at least, is likely to have become familiar to Alberti during his period of studies in natural philosophy.

Given the existence of this accomplished science, which undoubtedly contained within itself all the tools necessary to construct a perspective painting, why have I so obviously hesitated to introduce it in detail before this? The answer is that unless we read the mediaeval texts with a large measure of hindsight, there is nothing which will guide us steadily towards painters' perspective, and it is not easy to pick out even the few helpful signposts which do exist. Rather, the sheer complexity of the refractory systems within the eye, the complex discussions of the perception of size and distance, and the comprehensive discussions of illusions, might well lead us to conclude that a simple formula for pictorial representation was neither feasible nor desirable. Indeed, as we will see, a close study of mediaeval optics later led Leonardo at least part of the way towards this conclusion. These non-pictorial or even anti-pictorial properties provide the reason why I prefer to characterise specialist optical science as having at most a tangential and supporting role in the invention of perspective. Our passing glimpses of Alberti's optical knowledge provide no encouragement for us to believe otherwise; he says more than once that the advanced natural philosophy of sight has no essential bearing on his system.

Ghiberti's achievement in making his anthology—and it was not an inconsiderable achievement—was to go a long way towards bringing the mediaeval science and the artists' system into harmony. He skilfully cut, spliced and reordered material from his sources to give a coherent picture of the visual process as it was then best interpreted. His reordering conveys the impression that he well understood what he was reading. Translations from quite widely spaced sections of the same text are effectively juxtaposed in a number of places, as are the texts by different authors. For good measure, he has followed the main sections in his anthology with a quotation from Vitruvius concerning perspectival scene-painting in antiquity, which proved to Ghiberti at least—if not to the satisfaction of many modern scholars—that he was following the precedents of the revered ancients, both as an artist and an author.[44]

If the translations from the mediaeval texts are Ghiberti's own, they show a remarkable ability to grapple with the technical vocabulary; if they were made for him, the ambition and achievement in editing them is little less notable. He has directly confronted the question of the physical, opthalmological and perceptual bases for perspective, which Alberti had neatly side-stepped and which continue to exercise students of perception today.

Ghiberti's third *Commentary* may be interpreted as taking up the optical implications of Alberti's outline. The third of the major perspective theorists of this era, Piero della Francesca, can by contrast be regarded as taking up its geometrical im-

plications, particularly in its Euclidean aspects. Not that Piero regarded the structure of the eye as irrelevant; rather, like Alberti, he was concerned to analyse the geometrical properties and consequences of the visual pyramid, taking its very existence for granted.

Chronologically, Piero takes us well outside the period of Alberti and Ghiberti—his *De Prospectiva pingendi* was written by *c*.1474—but the spatial ideals of his art were formed in Florence during the 1430s and his treatise may be regarded as a logical extension of the Albertian geometry of vision. At the beginning of his treatise he provided a succinct outline of the necessary conditions: 'first is sight, that is to say the eye; second is the form of the thing seen; third is the distance from the eye to the thing seen; fourth are the lines which leave the boundaries of the object and come to the eye; fifth is the intersection, which comes between the eye and the thing seen, and on which it is intended to record the object'.[45]

He did profess some knowledge of the first of these factors. He noted that 'the eye is round, and from the intersection of the two nerves that cross arises the power of vision at the centre of the crystalline humor'—echoing mediaeval opinion.[46] He also argued, on the grounds that only the front quarter of the sphere of the eye is exposed, that the visual angle in a perspective construction should be restricted to less than 90°. He demonstrated that at an angle of 90° or more a square will inevitably be projected on to the picture plane in such a way that it will appear to be deeper than wide (pl. 30)—although his proof as it stands fails to acknowledge that there are circumstances in which squares seen at an angle of less than 90° will be subject to a similar distortion.[47] However, these references to the physical basis of vision are exceptional, and elsewhere in his book he was almost exclusively concerned with the pure geometry of light.

To understand Piero's activities as a perspectivist, we should remember that he was a man deeply conversant with pure and applied mathematics, capable of writing treatises to match in

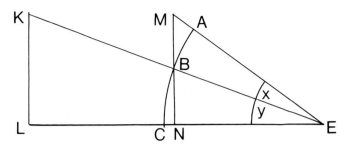

31. Euclid's demonstration of the diminution of objects placed at different distances.

Although object KL will appear smaller than MN viewed from E, the diminution is not directly proportional to their angles, i.e. EN:EL does not equal BC:AC (nor y:y + x).

quality anything produced in the Italy of his day. His book on practical mathematics, the *Trattato del abaco*, written perhaps as early as 1450, preceded his *Libellus de quinque corporibus regularibus* ('Book on the Five Regular Solids') by as much as thirty years.[48] It would, therefore, by easy to characterise his career as moving from pictorial practice to mathematics and eventually to abstract mathematical speculation. However, the *Trattato* does not altogether bear this out. Its central concerns are calculation and measurement, as in other such treatises which served to provide useful skills for a mercantile society, but Piero does not concentrate on practical estimation—wine barrels and such like. Instead, he emphasises the principles of measurement as applied to plane and solid geometrical figures. It was these specifically geometrical sections which were considered as worthy of incorporation into Luca Pacioli's compendium of mathematics in 1494.[49]

His treatise on the five 'Platonic' polyhedra is uncompromisingly a work of pure mathematics, though in his ambition to reconcile the geometry of Euclid with arithmetical procedures we may see a natural continuity with the more practical calculations in his abacus book. As if to underline the essential relationship between the branches of pure and practical mathematics, he requested the Duke of Urbino to place his *Libellus* on the shelves of that magnificent library next to his book *On the Perspective of Painting*.[50] The flavour of all this is clear: the deductive perfections of mathematics provide an active, *a priori* model for our understanding of experience, rather than arising simply from an empirical study of the sensory world. This formulation should not be taken to mean that Piero was blind to sensual delight—far from it—but that the framework of explanation was predetermined and absolute.

His introduction to his perspectival procedures is accordingly through the principles of Euclid, in an even more explicit manner than we found in Alberti. Euclid's writings are specifically cited at regular intervals, and Piero's introductory statements concerning the roles of visual angles read like a paraphrase of Euclid's *Optics*, with which he was obviously acquainted in a manuscript version. Euclid emphasised visual angles, which led to his asserting that 'lines of equal length and parallel, if placed at unequal distances from the eye, are not seen in proportion to their different distances' (pl. 31).[51] This has not infrequently been taken to indicate an incompatibility

30. Demonstration of the need to restrict the viewing angle to less than 90°, according to Piero della Francesca.

E—eye AB—row of square tiles
DP—picture plane AEB—90°

The point at which CE intersects DP will be outside DF. The side CD will appear to be longer in projection than DF.

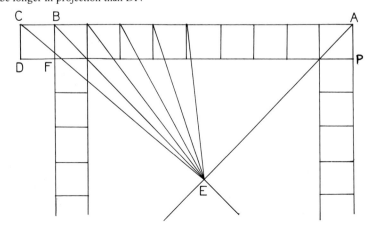

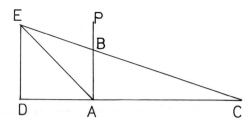

32. Proportional system of diminution as demonstrated by Piero della Francesca.

E—eye PA—picture plane
C—object behind picture plane DC : AC = ED : BA

between his optics and Renaissance pictorial perspective. However, as Piero certainly was able to realise, Euclid did not deny that there was some kind of relationship between apparent size and distance. Indeed, Euclid wrote that 'there are places where the eye may be located and the same thing appears sometimes half the size, sometimes the whole size, sometimes quarter size, and in general in the given proportion'.[52] He was simply saying that double the distance does not mean half the angle.

What Piero set out to accomplish was to investigate the nature of the proportional relationships left undefined by Euclid. That he was able to perform this task was a result of his concentrating on the *intersection* of the visual pyramid in terms of projected size, rather than analysing the actual angles subtended at the eye by the objects. His investigations took the form not only of geometrical demonstrations but also of the calculations of arithmetical ratios—allying Euclid and arithmetic just as he was to do in his *Libellus*. The foundations of his analysis were the laws of proportional triangles, in the Alberti manner, but he took their consequences much further than Alberti had been willing or able to do.

The proportional laws he established were concerned with the way in which the apparent size of an object at the intersection responds to its distances from the eye and the intersection. Most specifically he studied the ratios of each successive projection formed by objects of equal size situated at regular distances. At its simplest his formula provides (referring to pl. 32) the ratios DC : AC = ED : BA. Converting this to figures as Piero did, we may say that an eye situated three *braccia* above the ground plane and ten *braccia* from the intersection, regarding a line extending twenty *braccia* behind the intersection, will

33. Successive ratios of intersection as demonstrated by Piero della Francesca.

The eye, O, is four units from the picture plane, AB. CD, EF, GH are equal lines at one unit intervals. The intersection produced by CD : AB = 4 : 5 The intersection produced by EF : the intersection produced by CD = 5 : 6. The intersection produced by GH : the intersection produced by EF = 6 : 7.

34. Perspective projection of a square by Piero della Francesca's method.

E—viewer ABCD—square
EH—horizon (not so labelled by Piero)
V—focus of orthogonals from A and B
BE and CE are drawn, and points B' and C' noted. C'B' is transferred (at the level of B') to give C"B".

35. Perspective projection of a given point by the method described by Piero della Francesca.

ABCD is foreshortened as ABC'D'. P is the point on ABCD. Draw AC and AC'. A horizontal is drawn from P to intersect AC at E. Verticals PF and GE are drawn. F and G are joined to V. AC and GV intersect at E'. Where a horizontal through E' intersects VF, will be the desired point in projection, P'.

see that line diminished to two *braccia* at the intersection.[53] A more elaborate demonstration of successive intersections illustrates the law that 'the [length of the] second line to the first line [on the intersection] is always proportional to the [ratios of the distances from the] eye to the first line and from the second to the eye'.[54] This is more easily understood in the practical demonstration with accompanying calculations (pl. 33). Thus an eye situated four *braccia* from the intersection AB, regarding lines of one *braccio* length at CD, EF and CH, will see them at the intersection according to the ratios AB : CD = 105 : 84, CD : EF = 84 : 70, and EF : GH = 70 : 60, or to reduce these to simpler numbers (which Piero did not record), 5 : 4, 6 : 5 and 7 : 6. We can well imagine Piero's delight at discovering such consonances. Well might he regret that 'many painters dismiss perspective, because they do not understand the power of lines and angles and how they are obtained'.[55]

When we turn to his constructional procedures, we find two main methods, both related integrally to the proportionality of lines on the intersection. The first method (pl. 34) results in a foreshortened square using what may be described as a 'condensed Albertian' system, in which the stages are neatly combined in one geometrical diagram. One great advantage of Piero's demonstration is that by showing the intersection in

36. Foreshortening of a geometrical pattern from Piero della Francesca's *De Prospectiva pingendi*, Parma, Biblioteca Palatina, MS 1576, fig. 29.

37. Perspective projection of an octagonal structure such as a well-head from Piero della Francesca's *De Prospectiva pingendi*.

38. Perspectival construction of a vaulted bay from Piero's *De Prospectiva pingendi*, fig. 43.

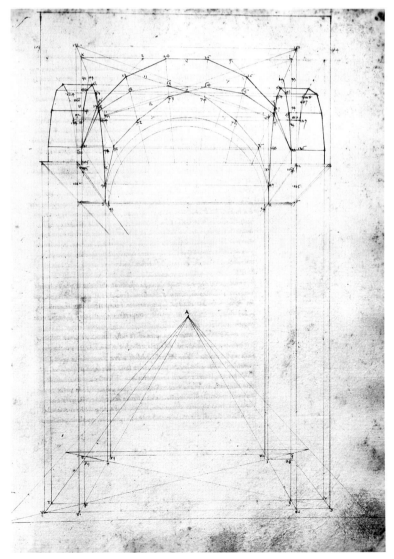

plan as well as elevation, he is able to avoid Alberti's failure to demonstrate the rationale of the orthogonal pattern. According to his proportional formula, if the distance from the eye to the plane and from the plane to the object both equal one *braccio* and the object is one *braccio* wide, the intersection will be equivalent to one half *braccio*.

This basic, foreshortened plane can be used to plot the location of any point on the original plane. If we take, for example, a corner of a square (pl. 35) we can locate its lateral position by projecting the orthogonal on which it lies, and determine its horizontal location by reference to coordinates which cross at one of the diagonals of the plane. With the necessary patience and with the aid of numbers, which help to identify each point as it is traced through its transformation, complex patterns can be properly foreshortened (pl. 36). A solid form, such as an octagonal well can then be erected on this base (pl. 37) using a vertical scale to judge the relative height of the corners at each receding plane. One of the forms he erected on a square base was a vaulted structure (pl. 38) not dissimilar to that in Masaccio's *Trinty* and resembling in its basic constructional method the type we envisaged Masaccio as having used.

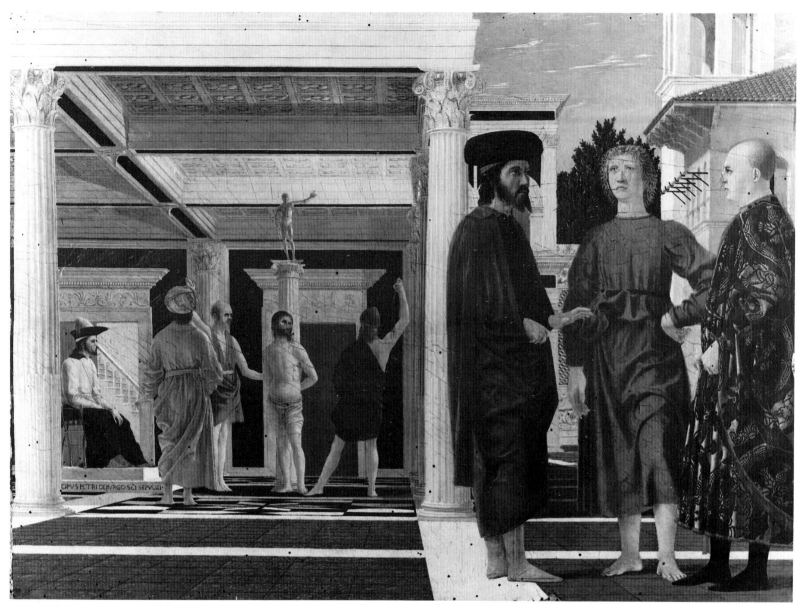

39. Piero della Francesca, *Flagellation of Christ*, *c.*1460, Urbino, Galleria Nazionale della Marche.

The point-by-point method looks more complicated than it is in practice, but there is no denying that the procedure is long-winded and makes demands upon the operator's patience. Can we really expect even Piero, who seems to have been fabled for his slow production of paintings, to have gone through such a procedure in making actual works of art?

The evidence of his paintings suggests that he did exercise a quite extraordinary degree of meticulous, time-consuming, geometrical care over the perspectival projection of architectural forms when appropriate to the subject, as it was most spectacularly in his *Flagellation* (pl. 39). No picture could exude a more pronounced air of geometric control and no painting was ever more scrupulously planned. The tile pattern on the floor inside the praetorium of Pilate's palace looks almost random in its tightly compressed foreshortening, but proves on analysis to be designed with great coherence and subtlety. Christ stands on a simple green circle, inscribed within the

basic square unit of the design. The units in front and behind this are composed according to a sophisticated formula in which the diagonals of the smaller squares provide the side lengths of the corner squares and the cross axes of the central star (pl. 40).[56] This complex design can most readily be devised in a given square using auxillary octagons (and circles) of the kind already seen in his demonstrations (pl. 41). It is difficult to know when to stop drawing out the geometrical implications of such patterns. It is probably enough to know that the implications are legion, and that they comprised much of the attraction of such forms for Piero and the Renaissance geometers.

The principle underlying the design of the black-and-white tiles is based upon the length of the diagonal in Pythagoras's theorem as the square root of the sum of the squares of the two opposite sides; that is to say on incommensurable ratios, such as $\sqrt{2}$, which cannot be perfectly expressed in rational num-

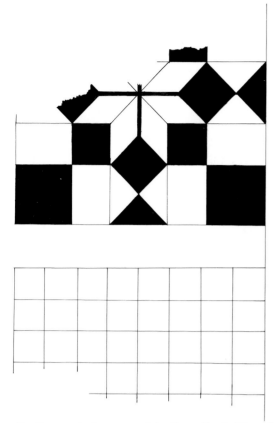

41. Geometrical construction of the patterned floor tiles in Piero della Francesca's *Flagellation*.

A circle is constructed within the square ABCD. The diagonals AC and BD are used to construct an octagon within the circle. Draw AG and AE, intersecting the octagon at X and Y. A horizontal through X and vertical through Y meet at F. AF is the diagonal of one of the corner squares of the pattern.

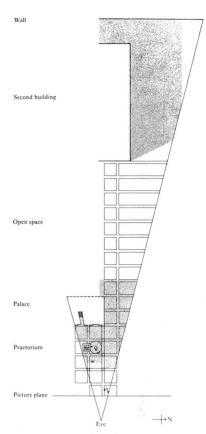

40. Geometrical pattern of the floor tiles in Piero della Francesca's *Flagellation*.

42. Ground plan of Piero della Francesca's *Flagellation* (as reconstructed by M.A. Lavin).

bers. The tile pattern outside the praetorium is by contrast based upon a simple arithmetical division into eight parts, expressible in terms of exact linear measures. There appears to be no obvious correlation between the patterns, no matching divisions other than the centre lines. Is this deliberate, and does it symbolise the spiritual difference between the praetorium, sanctified by Christ's suffering, and the more mundanely regular world outside? For someone as subtle as Piero, this is not impossible. Even without this symbolic reading, it is obvious that he has deliberately exploited the relatively simple and more complex tiling patterns in the context of his remarkable interplay between the apparently subsidiary space allocated to the main event and the exterior space dominated by the three foreground figures. The relations between the spaces have been calculated with the greatest precision, the outer space extending remarkably far into the depth of the *piazza* (pl. 42).

Once we realise that Piero's thoughts have turned to the relationships between the sides and diagonals of squares, other aspects of the design begin to fall into place. The panel is one *braccio* high (58.4 cm., allowing for unevenness in the edges of the painted surface), but the horizontal dimensions and other internal measurements seem to bear no simple relationships either to the height or to each other. However, the width of the panel is closely equivalent to the diagonal of a square produced by the height of the painting (pl. 43).[57] This is quite easily constructed using compasses centred on A. Expressed in terms of *braccia* the width is therefore $\sqrt{2}$. The side of the resulting square, which coincides with the edge of the 'palace', also provides the location at the foot of the picture for the white band which marks the edge of the praetorium. The side length of the square then provides the diagonal for a smaller square, which gives the location of the vanishing point and horizon. Repeat the process, and the equivalent point, which is located half way up the panel (i.e. at half a *braccio*), stands precisely at the crown of Christ's head. The location of the front of the praetorium is situated at a level half way between the horizon (VK) and the base of the picture. Its width at this plane (IH) is equal to half its width if projected to the front plane, and, therefore, IH = $\frac{1}{2}$GE. This kind of ratio is precisely what we have seen Piero investigating in his treatise (pls. 32–3).

Within this framework, I believe that a series of interlocking decisions needed to be taken on a practical, or 'visual' basis. Piero decided, for example, that he wished to give at least a glimpse of each of the columns at the side of the praetorium. This provided a rough point of location for the left edge of the white band at the front of the picture. The actual width of this band then appears to have been calculated more precisely so that it is equal to the diagonal of each of the smaller tiles (sixty-four of which comprise each of the reddish squares). It would be at this stage that the complex foreshortening of the floor of the praetorium would be accomplished in a separate construction and transferred to the evolving design.

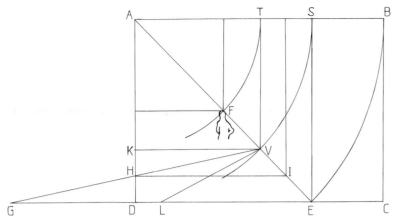

43. Geometrical construction of Piero della Francesca's *Flagellation*.

With compasses centred on A and given the square ASED:
with radius AE draw AB; with radius AS draw AV; draw VT; with radius AT draw
AF.

V—Vanishing point F—top of Christ's head
IH marks the front of the praetorium IH = GL = LE

The supreme rationality with which Piero controls his design also lets us read one important element in meaning of the picture. The natural light proceeds through the picture with persistent rationality casting gentle shadows on the pavement from left to right with a slight inwards inclination. But all the forms within the praetorium, even the brass studs of the door, are illuminated in a pronounced manner from the right by a lateral and relatively lower source. Its location can be defined quite precisely—such is Piero's command of planar geometry—as lying within the colonnade at an angle corresponding to the direction of Christ's raised glance (pl. 44)[58]. Only Christ is aware of the super-natural radiance which illumines his passion. How does this rational demonstration of an ineffable presence relate to the meaning of the picture as a whole?

It is not my intention in this context to debate the many alternative identifications of the three foreground figures, but in as far as perspective and content were as interwoven for Piero as they had been for Masaccio we must obviously try to arrive at some idea of their significance. Whoever they are—and I am reluctantly inclined not to recognise them as portraits of particular persons—they are displayed in such a way that the prime meaning of the picture must concern the significance of Christ's suffering for *them*. The frame was said to have carried an inscription, *'convenerunt in unum'*—'they conspired together'.[59] They may well thus stand as representatives of the groups who combined to reject Christ, and, by extension, as representative of similar factions in later generations. The positioning of the richly attired 'merchant' in front of a fine town house, the bearded 'potentate' against a grand palace and the barefoot young 'peasant' against the one glimpse of nature, may not be accidental.

This sense of the sharp conjunction of near and distant forms, working against space rather than with it, is one of the most striking effects in Piero's paintings, and reflects lessons well learnt during his early association with Domenico Vene-

ziano, whom we will be encountering in his own right in the next section. In one later work, the *Altarpiece of Federigo da Montefeltro* (Brera, Milan), Piero describes a chapel interior of considerable depth with utter logic, but it is condensed by visual effect to a space of *apparently* shallow dimensions in which the foreground forms 'fit into' the background shapes.[60] In the *Flagellation*, the artful ambiguity is less developed, but there is no question that Piero is sharply aware of surface interplays such as those between the sharply silhouetted light and dark forms inside and outside the praetorium. I think it is true in general to say that the greatest perspectivists—we may think of Masaccio, Piero, Leonardo, and Saenredam as among such—have not only exhibited complete mastery of the construction of space, but also have shown a heightened awareness of the shapes of forms when projected on to the *flat* surface of the painting. The mastery and awareness are entirely complementary.

Architectural forms are obviously amenable to geometrical treatment, but what about the more intractable 'irregular bodies', such as those of man and his clothing? In the *Flagellation* there is evidence of at least one of these forms having been subjected to a precise system of advance planning. A series of dots outlining the interwoven strips of the turban of the figure next to Pilate reveals that a tiny, pricked cartoon has been used in its construction.[61] This observation indicates that it had previously been the subject of separate study. We may suspect the dark hat to have been similarly constructed in advance. *De Prospectiva pingendi* contains the means for studying such forms perspectively. The method is that of projection by 'transformation' using plans and elevations of the object. One example on which Piero spends a good deal of time is that of a *mazzocchio* or *torcullo* (pls. 45–6), a faceted structure used to

44. Demonstration of the internal source of illumination in Piero della Francesca's *Flagellation*.

The dotted lines represent the angles of the light from the secondary source into the vault and on to Christ's body. The star indicates the vertical location of the light source, marginally in front of a horizontal line drawn through the base of Christ's column.

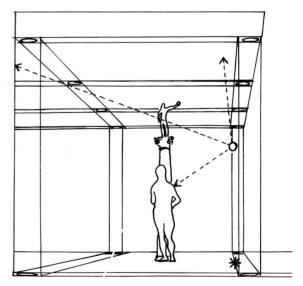

45. Projection of a *mazzocchio* in plan on to a picture plane as demonstrated by Piero della Francesca.

E—eye P, P—picture plane

M is projected to M¹ etc.

Note: this corresponds to the procedure in pl. 552 B

give voluminous shape to fashionable head-gear. The hat worn by the 'potentate' is different in shape, but the principle is similar. The technique involved—namely the careful plotting of points of intersection from plan and elevation so as to provide coordinates for the location of each point—is not too difficult, though the number of lines involved and the proliferation of points, each identified by corresponding numbers, demands a good deal of systematic patience.

Even more complex forms such as a human head can be

46. Perspective projection of a *mazzocchio* from Piero della Francesca's *De Prospectiva pingendi*.

47. Projection of the profiles of successive horizonal sections ot a numan head on to a picture plane from Piero della Francesca's *De Prospectiva pingendi*.

48. Projection of marked points on a human head in lateral elevation (not tilted) on to a picture plane from Piero della Francesca's *De Prospectiva pingendi*.

49. Perspective projection of a tilted human head from Piero della Francesca's *De Prospectiva pingendi*.

50. Piero della Francesca, *Resurrection of Christ*, c.1465, Borgo San Sepolchro, Palazzo Communale.

handled in the same way by the selection and labelling of nodal points for the transformation (pls. 47–9). The nodal points used by Piero run at horizontal intervals across the front and side elevations of the head, and along radial coordinates for the views above and below. The resulting stereometric 'cage' can be tilted at will in one or more planes in relation to the intersection to give the desired effect. Again, the procedure is more long-winded than inherently difficult, though it is a distinct advantage to possess a developed sense of the relationship between the planes of the object, the intersection and the viewing position.

It is difficult to be certain looking at Piero's paintings, if this technique was regularly used in the depiction of foreshortened heads, or whether his theoretical experiments taught him to achieve good effects 'freehand'. There are occasions, however, when the control is so apparent that the use of calculation is strongly implied. The heads of the sleeping soldiers in the *Resurrection* (pl. 50) are a case in point. They are all conspicuously tilted in at least one plane. The head in front of the staff of Christ's banner, in particular, looks like an overt exercise in anatomical stereometry. A tendency to generalise form into semi-geometrical units is inherent in Piero's procedure, and

such forms as the hemispherical Adam's apple and lidded eyes clearly show the signs of his perspectival attention. This virtuosity is not insulated from meaning. The tilted heads, each isolated psychologically from the spectator and each other, stand as a perfect foil for the riveting head of Christ, which is notably frontal and unforeshortened, as is the sarcophagus on which he places his foot.

All this magnificent effort of formal definition is precisely complemented by a control of light which is at once scientific and sensual. In the *Resurrection* lucid modelling is the order of the day and the light serves chiefly to enhance the stereometry. In other paintings the light is no less systematic, but it also plays more openly upon a diverse range of optical effects. The *Flagellation* itself contains some such effects. We have already noted the gleaming door studs. Into the same category fall the glinting highlights on the golden statue, on (and within) the crystal ball held in the statue's hand, and on the lavish gold brocade of the rich 'merchant'. Other paintings by Piero contain delightful descriptions of highlights on pearls, the gleam of armour, the mirrored surfaces of calm water and the visible passage of sunlight from a window across the dense, dusty atmosphere of a room (this latter in the *Senigallia Madonna* in

34

Urbino). Not the least remarkable of these effects is the way in which the bottom of the shallow river is visible in the foreground of the *Baptism* (London, National Gallery), where the visual angle is relatively steep, whereas further into the picture Piero has reasoned that the more acute angle results in reflection rather than transparency.[62] If Piero knew the mediaeval texts on vision, as we may fairly suppose he did, he would appreciate that they spend much time discussing reflection and refraction in terms no less systematic and geometrical than those in which they discussed perception of size. In his attention to reflection and refraction, as in every aspect of his painting, Piero exhibits an extraordinary form of ascetic rapture in the rationality of beauty. The expression of sensual pleasure through ice-cold logic provides the dominant visual effect of his art.

EXPERIMENTATION AND THE WORKSHOP TRADITION

In looking at the ideas of Alberti, Ghiberti and Piero della Francesca, we have studied the main body of written evidence relating to the development of perspective as a scientific technique between its invention and the time of Leonardo da Vinci. During the span of about fifty years from the date of Masaccio's *Trinity* we can see many artists in an increasingly wide range of Italian towns taking up perspectival design in interesting, individual and sometimes innovatory ways. We need, therefore, to retrace some of our chronological steps. It is clearly beyond the scope of this chapter to write a history of pictorial space in the fifteenth century. Many of the most subtle and individual masters of pictorial space will not be discussed, since they did not obviously add significantly to the scientific or technical means of perspective in itself. Thus, sadly, there will be no Masolino, no Fra Angelico, no Filippo Lippi, no Botticelli, no Giovanni Bellini. . . . Instead, I shall concenrate on a few artists whose works show deliberate attempts to forge new solutions in perspectival optics, either within or outside the orthodox framework. I do not see any of these artists as bringing new sciences to bear on perspective—the parameters in this respect seem to have been established by the artists and writers already discussed—but rather as tackling some of the potentialities, problems and puzzles which are inherent in the orthodox sysem once it is intelligently applied in practice, either to the painting of pictures or to the perception of the natural world.

Of the series of major paintings completed in Florence in the years immediately following Alberti's treatise, probably the most remarkable was made by a non-Florentine, Domenico Veneziano. His *St. Lucy Altarpiece* (pl. 51) not only contains a virtuoso display of advanced perspective but also exploits a marvellously cunning series of visual conjunctions which compress elements at different depths into an interlocked composition. The floor pattern is based on a series of hexagons, or, to reduce it to its simplest units, a grid of equilateral triangles (pl. 52).[63] This configuration does not arise naturally from the

51. Domenico Veneziano, *St. Lucy Altarpiece*, *c.*1444, Florence, Uffizi, with montage (but omitting the framing elements) of the predella panels (1 and 2, Washington, National Gallery; 3 and 4, Cambridge, Fitzwilliam Museum, 5, Berlin, Staatliche Museen).

52. Tile Pattern in Domenico Veneziano's *St. Lucy Altarpiece*.

53. Analysis of the perspective construction of Domenico Veneziano's *St. Lucy Altarpiece*.

V—focus of orthogonals of floor
D¹, D²—focus of 60° diagonals of the floor pattern
Z—point of convergence of 45° side of loggia with the horizon
VZ—viewing distance

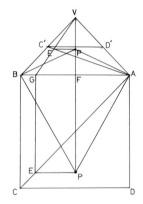

54. Method for the perspectival projection of an equilateral triangle.

Labelled to correspond to pl. 35. P is here a vertex of the equilateral triangle ABP.

55. Hypothetical ground plan of Domenico Veneziano's *St. Lucy Altarpiece*.

E—observer P—picture plane
M—position of Madonna under loggia EG—viewing distance
AB—width of picture

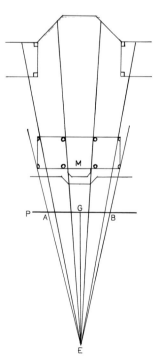

standard pattern of squares. The correct determination of the lateral points of convergence (pl. 53) requires a special technique, since they are not true distance points but correspond to lines which subtend angles of 60° to the front plane. There are a number of ways of determining the angles of the foreshortened triangles. One of the most convenient would be to adapt a technique recorded by Piero (pl. 54) and already illustrated (pl. 35).

Behind the tiled floor lies a three-bay loggia over a raised platform, followed by an open space and a concave structure which we are clearly invited to read as consisting of five sides of an octagon. The lateral sides of the 'octagon' converge to the central vanishing point, and the diagonal elements (corresponding to angles of 45°) to the true distance points. The viewing distance for the painting can be calculated as equal to twice its width.[64] Making certain assumptions about the regularity and relative sizes of the architectual elements, it is possible to produce a feasible ground plan for the structures (pl. 55). However, in this instance (unlike the *Trinity* and the *Flagellation*) a geometrical plan does not appear to be a virtual *necessity* in the design of the picture. The elements at the rear of the loggia could well have been produced by a combination of 'judgement by eye' with orthogonal lines which relate the octagon to the nearer structures and to the frame.

For all its spatial coherence, however, the visual effect of the *Altarpiece* is deeply ambiguous. The tops of the foremost arches adhere visually to the surface, while their bases are located well into the space. The shell niche appears to 'frame' the Madonna and Child, but is actually situated a considerable distance behind her. Similar space-surface interplays have already been observed in Piero's paintings, but these almost certainly post-date Domenico's *Altarpiece*. Another striking similarity between the two painters is their use of precisely angled light. In the central *predella* of the *Altarpiece*—the *Annunciation* in the Fitzwilliam Museum, Cambridge—the angle of a prominent light-to-shadow boundary is carefully incised in the gesso priming.[65] Given the documented association between Domenico and Piero in 1439, it is tempting to see them as developing solutions in concert, devising new ways of foreshortening geometrical patterns, asserting a controlled rationality for light and working out new aesthetic solutions for the relationship between illusionistic depth and pictorial composition. There is no way of proving such an interaction between the two men, and even if it did occur in something like the suggested form it in no way lessens the innovative position of Domenico's masterpiece.

The *St. Lucy Altarpiece* subtly realises some of the potentialities of canonical perspective. Other artists were more specifically concerned with the problems and conundrums posed by the Brunelleschian and Albertian systems. No one was more sharply alert to such conundrums than Paolo Uccello, and no two of his pictures seem to rely upon quite the same technique. There are also tantalising glimpses in early descriptions of lost works of an even wider variety of effects than we can now see. The *Selling of the Host* (pl. 26) is one of the rare examples in his *oeuvre* of an Albertian scheme, though we shall see that even this construction has certain idiosyncracies.

Broadly speaking, I think we can characterise his variations on perspective as attempting to extend the fixed formula of the Albertian system by manipulating the relative orientations of viewpoint and objects, as investigating the means to subjugate increasingly diverse objects to the control of spatial geometry, and as manipulating the established workshop devices for new effects. Illustrating these themes from a necessarily limited selection of paintings is not easy.[66] Perhaps it will be best to begin with the painting for which the clearest constructional framework survives, the *Nativity* originally in S. Martino alla Scala, Florence (pl. 56), though the painting itself has been battered to the point of illegibility.

Underneath the final layer of plaster is a geometrical underdrawing. This takes the form of a complex bifocal interlace (pl. 57) of the kind implicit in Lorenzetti paintings and Donatello's Siena relief. In itself, this is not very remarkable, but its use in the final painting is utterly novel. The lateral points are not auxillary to a central construction, but provide points of convergence for two separate systems of orthogonals. On the left is a tiled pavement of vast dimensions on which the 'shepherds in the fields' incongruously sit, while a massive open stable or barn recedes sharply to the right behind the 'Nativity' itself (pl. 58). The rightwards recession is the more dominant and the barn partly straddles the tiles on the left, but the space for the subsidiary narrative does retain its spatial autonomy. Whatever means he may have used to deal with the awkward collision of the two systems are unfortunately obscured by a severely damaged section of the fresco.

It has been claimed that this dual perspective design is a response to the problems of bifocal vision, as discussed in medieval optics.[67] But it is difficult to see how two such widely separated points of convergence correspond to two-eyed vision. Perhaps it could be an attempt to deal with the consequences of the rotation of the axis of vision, given a wide pictorial field and close viewing position. In other words, the eye looks to the left along one tunnel of orthogonals and right along the other. This explanation is superficially tempting, but will only work if we assume that Uccello did not understand the optics of projection (which is, of course, always a possibility). If the relationship between the picture plane and the object remains constant, the rotation of the eye at the same central point will not affect the projection, and rows of tiles parallel to the plane will still exhibit a central vanishing-point system (pl. 59). If the tiles are positioned diagonally to the plane, two lateral recessions will indeed be apparent, but the tiles should then abut the base of the picture diagonally— which they do not—unless the picture plane is reorientated—

56. Paolo Uccello, *Nativity*, *c*.1450, Florence, Soprintendenza alle Gallerie (formerly S. Martino alla Scala).

57. Diagram of the geometrical underdrawing for Uccello's *Nativity*.

V—central focus Z^1, Z^2—lateral 'vanishing points'

58. Analysis of the perspective of Uccello's *Nativity*.

Note: the fragmentary state of the fresco prevents certainty in a number of crucial areas.

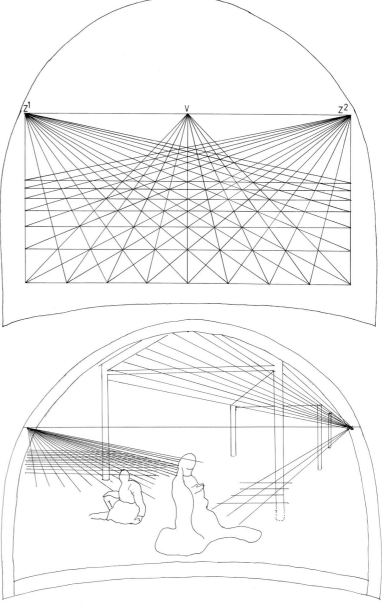

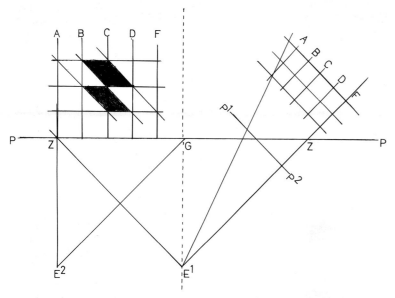

59. (left) Analysis of a rotating eye given a fixed picture plane and tiled floor.

If the eye E[1] looks at the tile pattern ABCDF through the picture plane, P, the vanishing point for ABCDF will lie on the picture plane at G. If the tile pattern is comprised of diagonal elements (shaded), the vanishing point will be at point Z on the picture plane for an observer at E[1]. For an observer at E[2], the vanishing point of ABCDF will lie at Z.

60. (right) Lateral recession produced by the diagonal orientation of a tiled floor.

If the eye at E[1] looks at the diagonally orientated pattern ABCDF through the picture plane, P, the vanishing point will be at Z, but the pattern will still appear to be diagonally disposed unless the picture plane is orientated to P[1]P[2].

which it is not (pl. 60). The only arrangement which will give Uccello's configuration from a central viewpoint would be a series of rhombuses, which is surely not how Uccello intended us to read his pavement.

This leaves one legitimate alternative, namely to view the fresco from two separate positions, each perpendicular to the lateral margins of the lunette. We are thus drawn to the left to watch the shepherds, and to the right to witness the event in the Bethlehem stable. Since the fresco is no longer in its original setting it is difficult to know if this manipulation of viewpoint was a response to the situation in which it was to be viewed, either on its own or in conjunction with other frescoes. Those elements which have survived in the set of narratives by Uccello in the Chiostro Verde of Sta. Maria Novella, one of which we will be analysing shortly, suggests that he did consciously explore different systems of spatial design in double and multiple narrative compositions in response to the spectator's changing position in the cloister. A closely related manipulation of space in a narrative series occurs on a quite different scale in the *Profanation of the Host* panels, the first of which we have already encountered (pl. 26). In this instance, we are dealing with a row of six small scenes which were intended to run along the base of an altarpiece, and we are therefore less concerned with the physical motion of the spectator than with the control of the progress of the eye as the stories are read in succession.

This opening scene, in which the woman pawns the holy wafer with a Jewish money-lender, is set in what appears to be a canonical box of Albertian space. To some extent it is, but the incisions in the gesso priming of the panel suggest that Uccello has used an abbreviated technique. Having established the orthogonals of floor, ceiling and walls, converging to a point at the centre of the panel, and determined the relative size of the end wall, he has simply drawn one diagonal from the far right corner of the floor to the angle of the incomplete tile at the extreme bottom left (pl. 61). Horizontal divisions have then been produced from the intersections. Since the control of a compressed pattern of this kind is difficult with one diagonal, it is not surprising to find that the foreshortening of the squares is less than perfect at various points. Once he had established the space of the first scene by these economical and tolerably effective means, he then manipulated the space in the adjoining panel (pl. 62) in a much more ambitious way which recalls the *Nativity*.

The incised underdrawing in this instance suggests that he began with another centralised scheme (pl. 63), but successively pulled the perspective focus to the right until it is coincident with the edge of the baluster separating it from the third scene. This results in a plunging system of space in which the scene is viewed from a standpoint outside the house. We stand, by implication, alongside the soldiers who are battering down the door to arrest the Jew and his family, who have sacrilegiously attempted to fry the host on their fire. Taken together, as they are clearly meant to be, the two scenes resemble the fresco of the *Nativity* in that Uccello deliberately pulls the viewer hither and thither to achieve spaces which are as responsive to narrative function as they are stimulating visually.

Other paintings show a no less ambitious response to a different but related problem: the effect of different orientations of more or less complex forms in relation to the picture plane. The famous fresco of the *Flood* in Sta. Maria Novella (pl. 64) shows his ambitions at their most pronounced. Again, the scene looks canonical but is not. The vanishing points of

61. Analysis of the perspective construction of Uccello's *Selling of the Host*.

DE—inscribed diagonal

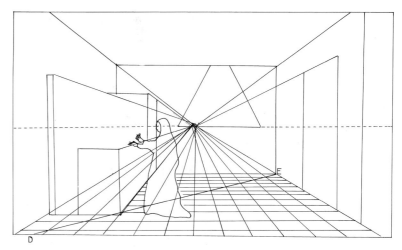

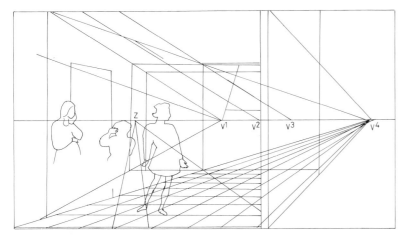

62. Paolo Uccello, *The Jew's Attempt to Destroy the Host*, *c*.1468, Urbino, Galleria Nazionale delle Marche.

63. Analysis of the perspective construction of Uccello's *The Jew's Attempt to Destroy the Host*.

V^1, V^2, V^3—alternative ideas for the vanishing point as indicated by inscribed lines
V—vanishing point as in the final version
Z—point of convergence of diagonals through the tiled floor

64. Paolo Uccello, *Flood and Recession of the Flood*, *c*.1445, Florence, Sta. Maria Novella (formerly in the Chiostro Verde).

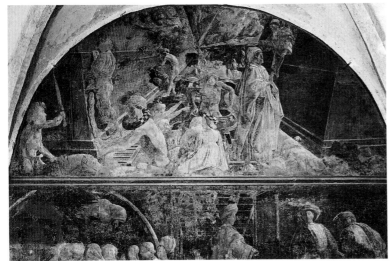

the twice-represented Noah's ark (during and after the Deluge) quite definitely cross rather than coincide, and the front edges of the arks are slightly but discernibly inclined in relation to the front edge of the lunette. This slight visual disjunction, in which the arks have deliberately been rotated away from a perfectly regular orientation, again seems to be a response to the disjunction in time between the two parts of the narrative.[68] Within the corridor of space squeezed by the arks are a series of virtuoso effects of foreshortening—a foreshortened barrel top, a fallen ladder, stiff corpses, strongly patterned *mazzocchii* and so on. The whole exercise exudes an air of manic desperation as Uccello has attempted to weave the diverse motifs into some kind of coherence.

We have already seen Piero della Francesca's fully developed, mathematical system for treating such problems, but Uccello's fresco must predate Piero's treatise by at least a

quarter of the century. Debating chronological precedence—whatever the value of such an exercise—is not easy given the chronological problems in defining the shapes of both artists' careers. Particularly troublesome is the loss of vital works for which the dates are known. However, I think it is fair to see Uccello as having laid down the basic problems and as doing enough to show that they should be soluble, without having fully reached Piero's point of mathematical resolution. Uccello's painted *mazzocchii*, of which he was so fond, are executed with considerable ingenuity and effectiveness, but appear to be less than wholly secure in every aspect of their construction. I suspect that his versions were foreshortened using points of convergence on a central axis, rather than by the full procedure of plane projection used by Piero.[69] Uccello's strikingly foreshortened figures also seem to stop short of complete consistency in the Piero manner, in that the relative size of nearer features (generally the feet of men who have fallen) is insufficiently large.

An anecdote recorded by Vasari in which Donatello chided Uccello for devoting his time to perspectival conundrums—abandoning the 'certain for the uncertain'—suggests that the ambitious yet unsatiated and unresolved nature of Uccello's quest was well recognised from an early date.[70] Donatello's reported attitude corresponds well to his own exploitation of perspective during the years following his role in its invention—or perhaps in his later works it is better not to speak of perspective as such, but of the manipulation of rhythms of assertive form and dynamic void. There is hardly a relief which does not deserve sustained analysis for the way in which space is charged with meaning, but few of his manipulations appear to be conceived with Uccello's kind of optical problems in mind.[71]

We left Donatello in the mid-1420s, following the crucial contribution he made to the implementation of perspective devices in his relief of the *Feast of Herod*. In contrast to the tragically short-lived Masaccio, Donatello still had forty years or so of remarkable creativity ahead of him, and it is obviously important that we attempt to gain some idea of what happened to perspective in his hands. A review of his numerous later reliefs shows that linear perspective became a groundbass on which he performed moving improvisations, often at urgent and sometimes at frantic tempos, in which the geometrical rule is never the dominating consideration. There is no question that he had achieved a total mastery of the canonical system by the 1430s—a marble relief of the *Feast of Herod* in Lille shows this clearly—but his restless search for communicative effects took precedence over optical formula.[72]

This is not to say that he neglected to give deep consideration to the operation of the eye in the world. The example I have chosen to analyse, the *Assumption of St. John* (pl. 65), shows a remarkable blend of perspectival awareness, perceptual experimentation and expressive force. Situated high in a spandrel of the dome of Brunelleschi's Old Sacristy in S. Lorenzo, this roundel exploits a startlingly low viewpoint. We are in effect gazing up at the complex cluster of buildings from a point well below the edge of the platform over which one of the foreground figures attempts to peer. Our viewpoint

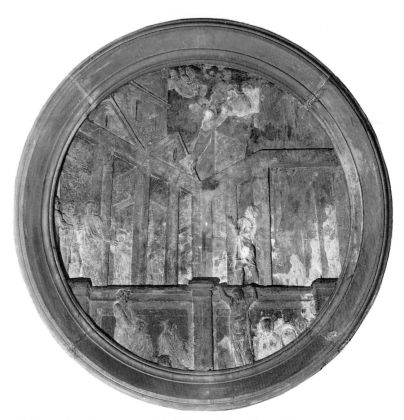

65. Donatello, *Assumption of St. John the Evangelist*, c.1430.

appears to be near the bases of the two flights of inclined steps on which the other foreground figures are by implication standing. The uprights of the architecture above the platform are canted inwards towards the central axis more or less steeply, to give a powerful sense of the way in which tall buildings in a narrow space seem to crowd in over our heads. A complicated network of diagonal elements describes a series of interpenetrating compartments of oblique space. Almost none of this in conducted according to specific rules. Only the sharply receding arcade and row of upper pilasters on the right converge to anything resembling a vanishing point. The ensemble is the result of extraordinary levels of perception and intuition, placed in the ultimate service of the significance of the event—St. John the Evangelist's ascent from our lower would into the embrace of Christ.

Another anecdote associated with Donatello—one recorded nearer his own lifetime—nicely conveys his sense that the artist's intuitive judgement should ultimately reign supreme. Pomponius Gauricus, a humanist from Padua where Donatello had worked for some ten years, wrote a treatise on the art of sculpture that was published in 1504.[73] He narrated a 'well known' story about a distinguished young visitor who wished 'to catch a glimpse of Donatello's abacus'; that is to say he hoped to see the device with which Donatello controlled the mathematics of his works. The sculptor explained that 'I have no other calculator than that which I always carry without fail amongst my belongings. Now if you wish to see it demonstrated, young man, bring me paper and pen'. Donatello simply proceeded to draw 'figures nude and clothed'.[74]

This was a way of saying to his puzzled visitor that his abacus was in his brain—or, as Michelangelo later insisted, that the true artist must possess 'compasses in his eyes', rather than relying upon mechanical calculation. This formula does not mean, for Gauricus any less than for his hero or for Michelangelo, that unaided and licentious judgement were the order of the day, but that the science of art should be so assimilated by the artist that it could be put to use in whatever manner was appropriate in each instance.

Although Gauricus was writing rather later than the main events with which we are concerned in this chapter, he does provide a good insight into the humanist atmosphere of Padua, and it will be appropriate at this point to look at his instructions on the construction of space. These instructions are not altogether easy to follow, since they are expressed in a terse Latin which struggles with its descriptive role.[75] His procedure appears to go as follows: a foreground line is bisected by a perpendicular, and marked off at regular intervals (pl. 66); a distance point is selected, at least as far from the vertical as it is high, and joined to the divisions on the base; the resulting intersections on the median line provide the horizontal divisions, which in turn provide intersections for the orthogonals. This procedure is a curious mélange of the Albertian method, using an intersecting plane (the central vertical), and the 'workshop' method which depends on the diagonal point(s).

He subsequently also provided a pseudo-Albertian method for the foreshortening of a given shape. A square with diagonals is inscribed in a circle and foreshortened within a similar circle, using the circumference to locate the vanishing point and the diameter to define the top of the tile (pl. 67). To show the side of the tile, Gauricus (as far as his instructions can be understood at all) suggested using the circumference of the second circle to define its thickness. This has a certain geometrical charm, but like his larger construction has an inbuilt inflexibility even greater than in Alberti's system. However, his formulae should not be regarded as prescriptions for artists but rather as demonstrations of the mathematical base of perspective directed at the learned audience for whom he wrote.

Gauricus's *De Scultura* provides just one example of the widespread diffusion of perspective to the regions of Italy north of Florence. Some of the most avid disciples and *afficionados* of perspectival techniques were to be found in the northern cities, not least in Padua itself. As early as the 1440s Michele Savonarola, a leading Paduan humanist in the generations preceding Gauricus, had acclaimed the new science of artist's perspective and praised its practitioners.[76] And it was in Padua that Andrea Mantegna learnt the basis for the perspectival skills which were to inspire successive generations of decorative painters with the ambition to paint 'that which is not' and to delude the spectator 'that it is'. In as far as the means used by Mantegna were in principle already established, neither he nor his followers will be major focuses of our attention in this chapter, but in that he realised new applications for the techniques we certainly should not ignore him altogether.

His formative experiences in Padua not only included the works and presence of Donatello but also his admiring study

66. Reconstruction of Pomponius Gauricus's perspective construction.

Compasses are used to draw the vertical CD as perpendicular to the horizontal, AB. E is the eye point. E is joined to A, F, G, H etc. Where AE, FE, GE, HE etc. intersect CD, the horizontals are drawn. Lines HX, IY etc. are drawn through the intersection of the horizontals and diagonals, to give the orthogonals

67. Reconstruction of Gauricus's method for the perspective projection of a tile.

Square ABCD is foreshortened as A'B'C'D' with vanishing point, V. CDFG = FGB'A' = the thickness of the edge of the tile.

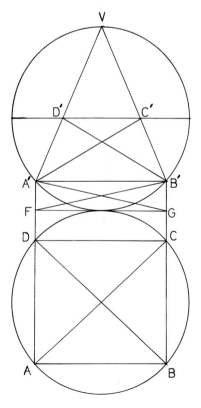

of a room of 'giants' painted by Uccello but now sadly lost.[77] How far Uccello's secular schemes of decoration provided a close precedent for Mantegna is difficult to tell. Uccello's potentially important decoration of a vault in perspective for the Peruzzi in Florence has also disappeared. But we may well imagine that in this area as in others, Paolo had taken a significant lead. Another imponderable factor in Mantegna's education is the training he received from the widely-berated Francesco Squarcione. By the 1460s Squarcione had gained some reputation as a perspectivist, but he may have developed skills in this field in response to the work of his own pupils and other young artists in Padua rather than possessing ad-

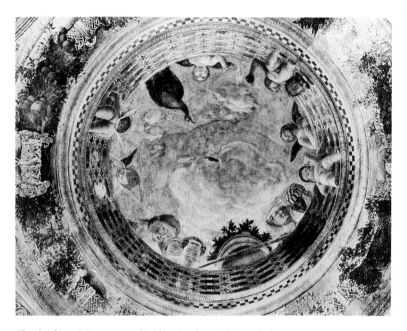

68. Andrea Mantegna, Oculus in the ceiling of the Camera degli Sposi, 1465–74, Mantua, Palazzo Ducale.

vanced knowledge at the time of Mantegna's youth. One of Mantegna's early associates, Niccolò Pizzolo, had acted as an assistant to Donatello. And Mantegna married the daughter of Jacopo Bellini, one of whose perspective designs will be illustrated shortly.

Opportunities to acquire the basic techniques were, therefore, relatively abundant. What is remarkable is the use to which Mantegna put them. He realised, more clearly than any painter since Masaccio, the illusionistic potential of perspective in a specific architectural context. This quality is seen most obviously in his Camera degli Sposi in the Ducal Palace at Mantua, on which he seems to have worked for a number of years preceding 1474.[78] For the first time in a surviving scheme, perspective is used in a fully illusionistic manner to dissolve the plane of a vaulted ceiling just as Masaccio had dissolved the plane of a wall. The extraordinarily effective architectural illusion of an open oculus (pl. 68) is entertainingly adorned with a virtuoso display of foreshortened figures. That the linked-ring motif of the oculus wall is composed from

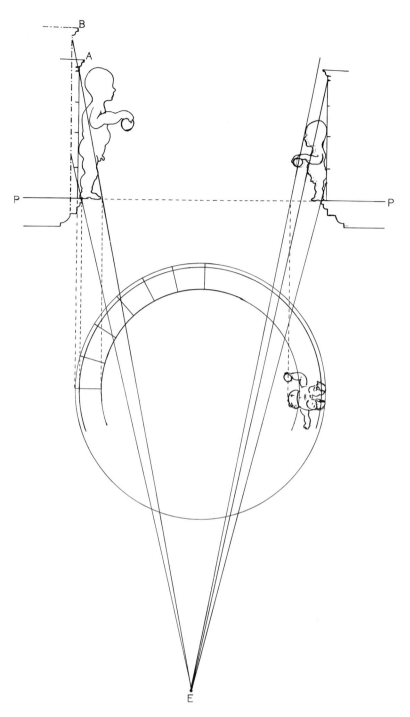

69. Alternative elevations of the oculus in Mantegna's Camera degli Sposi.

P—plane of the ceiling E—observer

On left: (i) cornice at position A, with putto's head up to cornice level; (ii) cornice at position B, with an oculus 5 units high and set further back from the rim.

On right: demonstration of the size of a putto to achieve the relationship between the putto's head in projection and the oculus.

Note: none of the alternatives are consistent with all aspects of the appearance of the painting.

regular circles is confirmed by the same motif on the wall paintings below. This permits a hypothetical reconstruction of its elevation (pl. 69).

The reconstruction, however, raises some problems. If we assume that the oculus is four units tall, the small ledge on which the putti precariously stand will necessarily be too narrow in relation to their implied height, if it is not to obscure more of the lowest tier of rings. It is certainly possible to suppose that the oculus is set further back and that it is more than four units high—the lower tiers being totally hidden by the lip of the oculus—but this is not how we are invited to read the oculus, and it would imply even taller putti than the present infants of Herculean potential. A further vertical extension at the oculus wall would also exaggerate the already over-large scale of the ladies' heads. It appears likely that there was a measure of improvisation in the development of the design which effectively involved his accommodating the putti on the extremely narrow ledge by reducing their feet below the size they should be if the perspective rules had been dogmatically observed.

Another difficulty concerns the determination of the viewing distance. The elaborate, fictive mouldings prevent any clear definition of the effective picture-plane of the ceiling. If we assume a plane which starts at the bottom of the projecting ledge, the implied viewing position falls at a depth more-or-less consistent with the head of an 'average' spectator standing at the centre of the room. However, precise calculation is not possible, and Mantegna may have discovered what every illusionistic decorator should know; namely that a certain amount of sly ambiguity helps enormously in achieving the impression of precision.

The foreshortening of the figures is almost certainly too good to have been left to chance. Mantegna may have used any one or more of a variety of techniques: a full-blown process of plane projection in the Piero manner; a rather simpler version later illustrated by Leonardo (pl. 84); a perspective grid or 'machine' of the kind to be considered later in Chapter IV; or the study of sculptural models.[79] Whatever method was used, Mantegna does not follow through the full implications of the extreme foreshortening of his figures and tends in the Camera, as in the *Dead Christ* in the Brera, to play down the relative increase in size of the nearest forms, just as Uccello had done. This propensity is understandable if he wished the figures' heads to retain some measure of prominence. Whether it is calculated or instinctive is unclear from the surviving evidence.

Mantegna's example certainly provided an important lead for a group of enthusiastic perspectivists in the North Italian courts, but we should be careful not to overrate his role. A number of artists appear to have developed in parallel. The techniques of his father-in-law, Jacopo Bellini, seem to be substantially independent of Mantegna's approach. Jacopo's great drawing books—they are too grand to be called sketchbooks—contain elaborate *fantasie* on perspectival themes (pl. 70), in which plunging orthogonals are liable to play a disruptive role, stretching the forms in depth until they assume improbable proportions.[80] There are clear signs that he is not in total control of the horizontal scaling in depth—the attenuated body of the Virgin bears witness to his difficulties—and his regular use of wide viewing angles occasions just the kind of

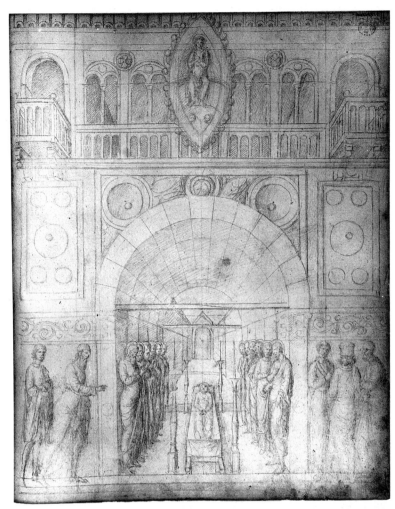

70. Jacopo Bellini, *Death of the Virgin*, c.1450, London, British Museum, fol. 67r.

eccentrically shaped squares which Piero had been keen to avoid. However, his ambitions are pronounced, and it is not altogether surprising to find that he was the dedicatee of a lost treatise on perspective by Giovanni da Fontana, a Venetian speculator on the secrets of the universe, magician and engineer.[81]

Vincenzo Foppa in Milan may also be largely independent of Mantegna, though his surviving paintings only go a limited way to justifying his high reputation as a perspectivist.[82] Successive generations of perspectivists maintained his tradition in Milan, including Donato Bramante in the years before he emerged as the greatest architect of his generation, and not least the underrated Bartolomeo Suardi (Bramantino) who exploited perspectival devices in devotional subjects with great imagination.[83]

Mantegna's direct example is more obviously central for those perspectivists who turned their hand to illusionist schemes of decoration, particularly the painting of vaults and domes. Most brilliant of these were Melozzo da Forlì and his pupil, Marco Palmezzano.[84] The destruction of Melozzo's vault decoration in SS. Apostoli in Rome has, to judge from the surviving fragments and related drawings, robbed us of

71. Devices relating to the Liberal Arts, including an astrolabe, armillary sphere and mazzocchio (detail of *intarsia* decoration), *c.*1476, Urbino, Palazzo Ducale, Studiolo of Federigo da Montefeltro, South Side.

the century's supreme example of illusionistic painting in a religious context. Palmezzano's own paintings testify to a fascination with geometrical forms rendered in perspective, rather in the manner which had become *de rigueur* in the practice of *intarsia* design. Piero della Francesca's close associations with virtuoso designers of these inlaid wood decorations, particularly Lorenzo and Cristoforo da Lendinara, helped to establish a genre of perspectival motifs which increasingly assumed the character of abstract exercises in three dimensional geometry (pl. 71).[85] Carpaccio, in Venice, was another of the painters who picked up such motifs in a highly adept manner.[86] As far as can be judged from their extant works, and in the absence of written accounts, none of these technicians of perspective—however accomplished and imaginative they might have been—contributed significantly to the theory or geometrical procedures of perspective design, which are our present concern. The next crucial phase in this respect was not inappropriately to be taken in Milan by an artist fully conversant with the most advanced Florentine practice and theory, Leonardo da Vinci.

LEONARDO DA VINCI

In the context of a synoptic review of the kind attempted in this book, Leonardo characteristically presents us with a pro-

digious problem. There is virtually no aspect of perspective he did not address, and most aspects were approached not just once but on many occasions and in different ways. Furthermore, since he regarded all the physical sciences and arts as integral components in a great continuum of causes and effects, it is difficult to say that his studies of dynamics, for example, should be excluded as irrelevant to his theories of vision. However, the attempt to summarise and select must be made—even if we share and sympathise with Leonardo's own problems in this respect—and I think it will be wise to signal how we can best organise our approach.

The main topics tackled by Leonardo can be summarised as follows:

(a) techniques of artists' perspective in theory and practice;
(b) the geometry of visual rays and intersection as related to questions of size, distance, etc. considering all the variables of the relative positions of the viewer, plane and object;
(c) devices and instruments connected with the study of vision and artists' perspective (which will be dealt with mainly in Chapter IV);
(d) the study of optics through the properties of the eye;
(e) the investigation of curiosities of vision and representation, such as anamorphic images;
(f) the problems arising from apparent contradictions between the various factors and approaches.

I think the best way to tackle these issues is chronologically, since Leonardo began from a standpoint similar to that of Alberti and Piero. He then moved progressively, though certainly not smoothly, towards a position in which a series of optical complications left him far from the painters' home ground, that is to say, far from the territory we have been occupying for the most part in this chapter.

Leonardo clearly benefited from a solid training in the basic techniques of artist's perspective. The reliefs and paintings emanating from the studio of his master, Andrea del Verrocchio, exhibit a sound grasp of what by now was an established tool in any self-respecting artist's equipment in Florence.[87] Leonardo's own earliest known narrative painting (pl. 72) was designed in conformity with what a young artist would be expected to know about the construction of pictorial space. The tile pattern on the right of the *Annunciation* is diagonally orientated, which gives a clear signal as to the method used, that is to say the lateral point sysem (pl. 73). It is worth remembering that both Donatello and Ghiberti appear to have used this method, and that Leonardo's master was one of the sculptors who stood in direct line of artistic descent from these great men. Lines incised in the gesso priming in the now familiar manner testify to the care Leonardo has taken. For example, the square top of the pedestal of the Virgin's lectern has been subdivided so as to aid the construction of the inscribed circle and to establish the central axis of the supporting baluster.

It is, therefore, no suprise to find that his earliest written definitions of perspective give voice to established theory:

perspective is a rational demonstration by which experience

confirms that the images of all things are transmitted to the eye by pyramidal lines. Those bodies of equal size will make greater or lesser angles in their pyramids according to the different distances between the one and the other. By a pyramid of lines I mean those which depart from the superficial edges of bodies and converge over a distance to be drawn together in a single point. A point is said to be that which cannot be divided into any parts, and such a point, located in the eye, receives all the points of the pyramids'.[88]

There are a number of drawings in his earliest manuscripts which accordingly resemble the basic demonstrations in Piero's treatise and are consistent with Alberti's text (pl. 74). On two occasions he set himself the task which has occupied us at various points, namely the reversing of Alberti's procedure in order to reconstruct the eye point for an already foreshortened plane. Given the measurement of the plane at the front of the picture, he showed how to establish the measured distance of any point placed on the foreshortened plane (pl. 75).

Like Piero he tackled the question of the proportional ratios of diminution at the intersection. He conducted an incredibly persistent study of the variables of distance from eye to object and the relative distance and orientation of the intersecting plane. A typical analysis states that 'if you place the intersection one *braccio* from the eye (pl. 76), the first object, being four *braccia* from your eye, will diminish by three-quarters of its height on the intersection; and if it is eight *braccia* from the eye by seven-eighths and if it is sixteen *braccia* away it will diminish by fifteen-sixteenths and so on by degrees. As the space doubles, so the diminution will double.'[89] The crucial law that emerged from his analysis was that if the distance from the eye to the plane remains constant, the apparent size of

72. Leonardo da Vinci, *Annunciation*, c.1472–3, Florence, Uffizi.

73. Analysis of the perspective of Leonardo's *Annunciation*.

V—central perspective focus, or vanishing point
Z—point of convergence of diagonally disposed tiles
W—'wild' line

74. Basic perspective construction as demonstrated by Leonardo da Vinci (based on MS A 41r).

E—observer
V—point of covergence for orthogonals from A, F, G, etc.

E is joined to A, F, G etc. Where AE, FE, GE etc. intersect PB, horizontals are drawn. The diagonal BD is the 'proof' of the resulting projection.

75. Leonardo's method for the establishing of the measured distance of any given point on a foreshortened plane (based on CA 251 va).

A: point P stands on a foreshortened square.
B: AD and GH are extended to V; DH is extended to cut the vertical from G at C; AC is extended to meet the horizontal through VT at E.
C: E is joined to A, B, F etc. Where AE, BE, FE intersect TE, horizontals are drawn to give the construction of a grid as in fig. D.
D: point P can be located by reference to the grid

76. Successive proportional diminution as demonstrated by Leonardo (based on MS A 8v).

E—observer AB—picture plane

CD, at 4 *braccia* from the eye 'will diminish by three quarters of its height'. FG, at 8 *braccia* from the eye 'will diminish by seven-eights'.

77. Optical system of the eye according to Leonardo *c.*1483 (based on CA 85v).

The ray passing along the central axis, AC, will be strongest.

78. Visual pyramids emanating from a round object from Leonardo's MS BN2038 6v (Paris, Institute de France).

the object on the plane is inversely proportional to the distance of the eye to the object. Such systems of proportional diminution convinced Leonardo that he was dealing with a form of visual harmonics in which the perspectivist forms his 'intervals' in the way 'the musician does with his notes'.[90]

There are also early signs of his interest in the optical principles underlying the geometrical procedures. In what may be his earliest surviving note on perspective, he outlined a rudimentary eye which was specifically designed to function in accordance with the Albertian pyramid (pl. 77). He referred to the 'crystalline humour', to the 'pupil', to the transmission of images either to the *senso comune* or to the 'intellect', and emphasised the special directness and power of the central ray. These concepts indicate some contact with sources beyond those strictly required for painter's perspective, though the way in which he used the technical terms does not indicate at

this stage any detailed mastery of the mediaeval optical science from which they were ultimately derived.

A little later we find him providing an entirely adequate account in the Pecham manner of the infinity of visual pyramids diffused throughout the air:

> every opaque body fills the surrounding air with an infinite number of its images, which by means of infinite pyramids infuse the representation of this body all in all and in every part. . . During their concourse, although they intersect and intermingle, they are never united one with the other, and so with diminishing concourse they proceed through the surrounding air, dispersing and extending themselves (pl. 78).[91]

In a closely related image he speaks of the radiance of light from a body as comparable to 'a stone flung into water' which 'becomes the centre and source for many circles'.[92] This means that the apexes of pyramids of comparable 'strength' (i.e. of the same angle) will occupy the circumference of the same circle and that the 'weakening' of the pyramids will take place in a graded manner across successively wider circles.

This pyramidal system was related by Leonardo to the fundamental law which governed the diminution of all the powers of nature. The same pyramidal law governed the diminution of sound over a given distance, the gradual draining of impetus from a moving body, and any other effects which were subject to proportional diminution over time and distance. Gravity, by contrast, he described as operating with a reversed pyramid, bestowing extra velocity pyramidally rather than losing it.

The height of his involvement with the analysis of the painter's pyramid came in the 1490s, during the phase of his artistic development which culminated in the *Last Supper* (pl. 79). This painting, with its assertive recession and the system of harmonic correspondences on its surface, appears on first sight to be an uncomplicated expression of the rationality of the painters' science in the context of natural law. And, I believe, this aura of logicality is just what Leonardo hoped we would assume to be in operation. However, closer analysis reveals a series of ambiguities and artifices which save the appearance of optical legitimacy while acknowledging the inbuilt problems and contradictions of perspectival illusion in a given situation.

It should be said at the outset that the condition of the painting makes precise analysis a perilous business. It is not possible to determine what happens at the lateral edges of the painting, where it adjoins the lateral walls, and the location of the lower margin is uncertain. The latest campaign of restoration has begun to clarify some features, such as the form of the coffers, but also confirms that crucial aspects of the construction are irredeemably lost. The second point to be made at the start of our analysis is that Leonardo's construction is designed not to declare itself in an overt and unambiguous manner. However, I think we can gain some idea of Leonardo's likely procedures, bearing in mind the techniques available to him.

The coffered ceiling, like the tiled floor of Piero's *Flagellation* or the vault of Masaccio's *Trinity*, provides the obvious key to the description of the space, but it is visually isolated from the upper and lateral boundaries between the real refectory and the painted room. The ceiling does not join the picture plane at the bottom of the painted cornice, DC (pl. 80) but presumably passes behind the screen of lunettes to a level at which it abuts the wall plane.

Precisely to what level the coffered ceiling should be extended is not explicit. If its lateral edges are extended to meet the lateral margins of the painted surface at J and K—giving a continuity between the walls of the real and painted rooms—the ceiling stops at an awkward level in relation to the lunettes and near the middle of a coffer. If, alternatively, the ceiling is extended to the height of the central lunette the lateral edges of the painted room, FG and HI, will be wider than the actual refectory. In this second scheme, thirteen coffers will be accommodated, allowing for a strip at the top to accommodate the depth of the painted screen. Neither solution is entirely comfortable. The tidiest solution would be to assume that the ceiling is six coffers wide and twelve coffers deep, but this can only be reconciled with the first alternative if we suppose that the remainder of the 'last' coffer is taken up by the depth of the painted screen plus an additional band of moulding.

In either case, the reconstruction of the painted space is further complicated by the question of the shape of the coffers. If the coffers are square—as we tend to assume—the room would be at least twice as deep as it is wide. This would incongruously mean that the tapestries become progressively wider to a considerable degree in the deeper parts of the room.

If we approach the question of coffer shape from a different direction, a different result is suggested. If we draw diagonals through the coffers in the by now familiar manner, we will find that diagonals through pairs of coffers in depth will focus on lateral ('distance') points at Z^1 and Z^2 close to the margins of the fresco. These points would, in the traditional manner, provide a convenient means for carrying out the construction on the actual wall surface. This device of diagonals through two coffers—analogous to the systems suggested for Donatello's *Feast of Herod* (pl. 16) and Ghiberti's *Jacob* relief (pl. 29) —would imply that each coffer was intended to be half as deep as it is broad. This would in turn correspond to a 90° viewing angle, a viewing distance equivalent to half the width of the wall, and a painted room that is either square or slightly over square.

There is no certain method of choosing between the alternatives. Two recent computer reconstructions of the painted space have favoured different alternatives, confirming that different solutions can achieve a fair measure of internal consistency without necessarily being susceptible to precise proof.[93]

The problems presented by the *Last Supper* so analysed might lead us to wonder whether we are asking a question which the painting was not designed to answer. I suspect that the perspective was designed by Leonardo specifically as a *pictorial* effect within the composition as a whole in its particular setting. His notebooks indicate his growing awareness of the vulnerability of orthodox perspective, particularly on a large scale and with relatively close viewing distances. His decision to isolate the coffers in a spatial 'island' and his unwill-

47

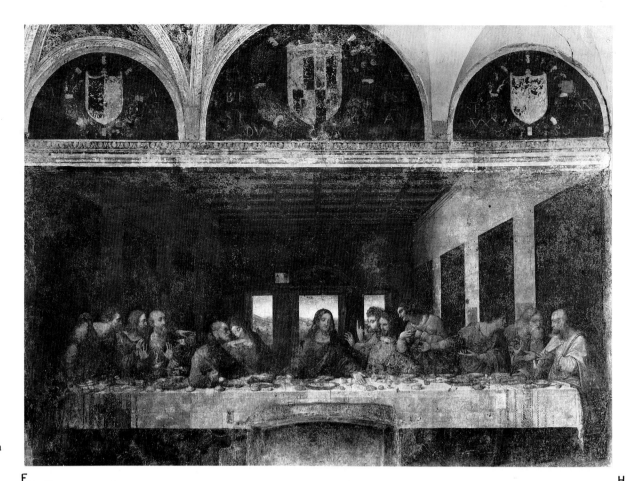

79. Leonardo da Vinci, *Last Supper*, *c.*1497, Milan, Sta. Maria delle Grazie, Refectory.

80. Analysis of the perspective of Leonardo's *Last Supper*

ABCD—the room as visible in the painting.
AB, CD, are divided into 12 equal units.
BC, DA, are divided into 6 equal units.
JK—height of painted room if it is as wide as the real room
FH—height of the painted room if it is as high as the central lunette
FG, HI—width of the painted room if the ceiling height is FH.
FGIH—notional dimensions of the room, wider than the refectory and equal in height to the upper border of the central lunette.
MN—notional rear lower corners of room
V—vanishing point
Z^1Z^2—focus of diagonals through units two coffers deep. Each of the coffers on the right is marked by a dot.

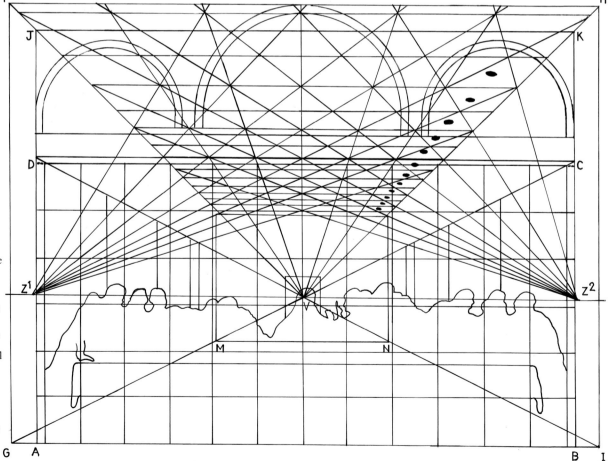

48

ingness to spell out too specific a relationship between the real and painted architecture may indicate his desire to minimise the vulnerability of his illusion when viewed from different viewpoints. In other words, Leonardo has used perspective for pictorial suggestion rather than absolute definition. The perspective is, therefore, just one of a series of compositional devices. Another device is the 6 × 12 grid of squares, which seems to provide the surface location for a number of the major elements, including the rear of the ceiling itself.

Within his slippery set-up, Leonardo has given free reign to other ambiguities, most notably the impossibly crowded overlapping of the figures behind the table—where could they all sit?—and the undefined relationships between the seats at either end of the table and the side walls. The sum total of the ambiguities is of a quite different order than that used by Piero and Domenico Veneziano. Their pictorial spaces are predominantly logical and at the same time play upon surface conjunctions. Leonardo's space looks logical but actively resists unequivocal translation into an actual space.

The factors which led him to subvert the rationality of painter's perspective resided both within the system itself and in its relationship to physiological optics. Let us look first at the internal factors.

Working on such a scale in a particular building, he clearly became acutely conscious of the problem of viewpoint. Theoretically, the painting should be viewed from one ideal position. By placing the viewpoint at the level of the heads within the painting, which obviously makes good sense in telling the narrative, he has already conceded that the spectator will not be viewing his illusion from the ideal position, since this position is located at more than twice the height of an average person. As the spectator—and, we may imagine, Leonardo himself—moves around the refectory, so the picture plane itself distorts perspectively, with a corresponding effect on the foreshortened objects in relation to the real space. He has done his ambiguous best to preserve the illusion, but even he must admit ultimate defeat.

There is clear evidence in his notebooks at this time that he was beginning to undertake an analysis of such problems, and that his analysis led him to distinguish between two main types of perspective; 'artificial perspective' (*prospettiva accidentale*) 'which is made by art' and consists of the painter's projection of forms on to a plane which is itself liable to foreshortening; and 'natural perspective' which concerns the perception of the relative sizes of actual objects in nature.[94] The difference revolves around the Euclidian question of visual angles. The problem, stated briefly, runs as follows. If the eye looks at a series of objects of equal size distributed at equal intervals along a plane perpendicular to our axis of vision (pl. 81), the visual angles under which the objects and intervals are seen will progressively diminish at points towards the extremities. Thus the more remote objects will be seen as smaller.

Diagrams relating to this problem appear in his drawings during the 1490s, and perhaps earlier. In these he takes a 'curved plane' (not a 'curved wall' as sometimes translated) as defining when the forms are equidistant from the eye in 'natural perspective' and, therefore, when they will appear the same

81. The problem of wide angle vision as explored by Leonardo.

E—observer
CD—plane along which a row of equally spaced columns 1, 2, 3 etc., are located
The columns project on to the picture plane AB at 1', 2', 3' etc., but the visual angles subtended by the intervals between 1, 2 and 3 are progressively smaller towards the extremities of CD, and the intervals are therefore seen as smaller.
A curved picture plane HI would permit the drawing of intervals corresponding to the visual angles subtended by 1, 2, 3 etc. Alternatively a series of objects equally spaced on the curved plane FG would be seen under equal visual angles.
Intersections on the plane AB in artificial perspective only work in harmony with the visual angles of natural perspective when viewed precisely from E.

size.[95] I think we should be clear at this point that Leonardo is not openly advocating that the painter should adopt the practice of curvilinear perspective, nor is he demonstrating that the painter's construction is necessarily invalid. He is saying that when the painter's representation of forms on a flat plane (AB in pl. 81) is viewed from anywhere other than the perfect point—ideally 'through a hole'—it will fail to act in a manner consistent with natural perspective. The problems become particularly severe for forms seen at the extremities of wide angles.[96] When he suggests, much later in his career, how the painter might represent the lateral diminution of a wide object he proposes not a curvilinear recession but one in which two lateral points of rectilinear convergence result in a 'hexagonal figure' (pl. 82).

By this later stage he has organised his thoughts systematically and defined the various kinds of perspective. Two of these, 'natural' and 'artificial', we have already encountered. The third is 'compound perspective', which relies upon a combination of foreshortening on the plane and the foreshortening of the plane itself. In paintings such as the *Last Supper* this compound effect is nothing but a nuisance, and from extreme angles 'all the depicted objects will look monstrous'.[97] But the artist can also exploit compound perspective to his own advantage, through what we now call anamorphic images. In this composite system, the projection on the picture plane is

82. Lateral recession of a wall in front of the observer as demonstrated by Leonardo (based on MS E).

AB—part of the wall perpendicularly in front of the observer that is seen as closest
CD—vanishing points of extreme lateral ends of the wall

83. Anamorphic drawing of a human eye as invented by Leonardo (based on CA 35va).

To be viewed from the right at a shallow angle. The vertical divisions at the top mark out the reversed perspective of the image

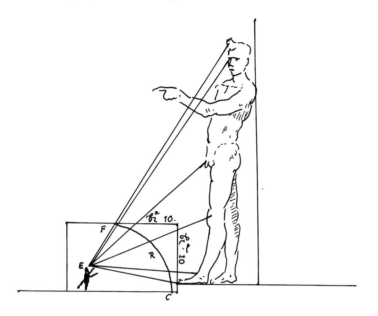

84. Perspective projection of a standing figure on to a curved vault (based on Codex Urbinas, 139r).

FRC—curved vault E—observer

Key points from the figure are projected on the vault by joining them to E and noting their intersections on the curved plane.

85. Optical system of the eye according to Leonardo, *c*.1507–8 (based on MS D 10v).

P—aperture of pupil, through which rays cross
H—crystalline humour, refracting rays through a second crossing
O—optic nerve receiving configuration of rays at rear of eye

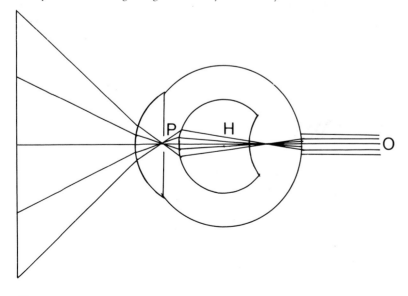

systematically distorted so that it will look bizarre or even illegible from head on (pl. 83), but will assume proper proportions when viewed at an angle which foreshortens the picture plane itself to the appropriate degree. Leonardo appears to have been the earliest promoter of this visual trick, though, as we will see in Chapter IV, Piero della Francesca was aware of its principles. Towards the end of his career Leonardo made a pictorial demonstration of anamorphosis for Francis I in the form of a painting of a dragon fighting a lion.[98]

Anamorphosis remained more in the nature of a visual game than a method which could be widely used in normal circumstances. It shared the chief disadvantage of one-point perspective, namely its reliance upon a single viewing position, and actually worked less well than orthodox perspective from less than perfect viewpoints.

A related technique which Leonardo was also considering did prove to have a more serious, regular application. This technique provided a way of projecting an object on to more than one plane or on to curved planes in such a manner that the distinctions between the planes or their surface configurations appear to dissolve. He explains how 'to make a figure which declares itself to be forty *braccia* high in a space of twenty *braccia*' (pl. 84), by projecting the figure on to two planes at right angles, such as a wall and ceiling, or on to the curving plane of a vault.[99] The accompanying diagram only indicates half the necessary procedure but the principle is clear enough and is in essence the first record of a technique which was to be followed by generations of illusionistic decorators from the mid-sixteenth century onwards.

This technique, like all the others, would be vulnerable to changes of viewpoint. The best Leonardo could do was to minimise and disguise the most directly vulnerable elements, as in the *Last Supper*, or advise the painter to ensure that each picture works reasonsbly well from a distant viewpoint, since changes in the viewer's position will then have relatively little effect on the shape of the picture plane.[100] However, even if these expediencies are adopted, he acknowledged that there remain a series of factors which further erode the 'naturalness' of the painter's system. I will give just three examples. The painter cannot cope with binocular vision. The representation of transparent or nebulous forms, such as water and smoke, lies outside the system of linear perspective. Colour and tone will affect our subjective appreciation of size and distance.[101] The more Leonardo studied the visual world, the more such problems of perception asserted themselves.

All these problems may be seen as qualifications or limitations to be acknowledged in the theory and practice of painters' perspective. But there was an even more fundamental difficulty, which arose from the physiology of vision as then understood. The prevailing view of the eye in the sources available to Leonardo was that it consisted of a complex series of spheres and part-spheres which were designed to refract the incoming light rays in such a way as to produce an upright *simulacrum* of the seen object at the seat of the visual power.[102] This system was at variance with the pyramids of Alberti, Piero and early Leonardo, which actually converged to a point. Leonardo, as we have noticed, even characterised the

point as specifically mathematical, i.e. having no dimension.

During the 1490s he gained a closer acquaintance with standard optical texts—he quoted at length from Pecham's 'hymn' in praise of optics, an excerpt from which appears at the head of Part I of this book—and he began to realise the contradiction.[103] By 1507–8 when he came to compile his short manuscript treatise 'On the Eye', he was able to state confidently that 'it is true that every part of the pupil possesses the visual power, and that this power is not reduced to a point as the perspectivists wish'.[104] The Albertian pyramid is not, therefore, a physical reality. Indeed, Leonardo's pattern of rays in the eye involves a complex double inversion (pl. 85)–one occasioned by the camera obscura effect of the pupil and the other required to reinvert the image.

This revision in itself would not be too problematical for the painter, since we have seen that the mediaeval theories envisaged the refracted pyramid measuring visual angles as if the rays converged to an *imagined* or notional vertex. The real difficulties arose from the fact that rays from the same parts of the object would reach different parts of the visual power and vice versa. The geometrical simplicity of the canonical pyramid was disrupted. According to the pyramidal theory, near forms occluded remoter objects in an absolutely straightforward manner. However, according to his later theory, no edge will ever be seen absolutely (pl. 86), and no object near the eye will occlude distant objects in a totally clear-cut manner. This theory also seemed to explain why a very small object close to the eye appears to be translucent, and why we are able to see relatively well through an open-weave cloth held near the eye.

This optical system is logical enough as a consequence of the supposed anatomy of the eye, and bore some relationship to Leonardo's revered 'experience'. However, he was some way from anticipating Kepler's idea of an inverted 'picture' which is focussed on the retina, and no amount of juggling with quotations from Leonardo's notebooks will prove otherwise. Given the logical consequences of his opthalmology he was honest enough to admit that they caused more problems than they solved for the perspectivist. He did not throw the pyramid overboard altogether, and recognised that it retained its sphere of valid if limited operation as *prospettiva accidentale*, though it had lost its centrality and infallibility. His own later paintings contain no overt displays of linear perspective, even in the compromised manner of the *Last Supper*. Although the subjects of these later paintings do not particularly lend themselves to architectural perspective, it is significant that they are characterised by optical qualities of a very different kind— softly veiled distances, fluid transitions of form, blurred contours and horizons that refuse to be simply horizontal.

When we look at his later drawings we see correspondingly fluid visions of form in motion and of mobile viewpoints. He developed a remarkable sense of the continuity of forms in space—a vision which was nourished by the traditional concept of 'continuous quantity', which served to differentiate geometry from the discontinuous terms of arithmetic—and he devised systems of illustration in which forms are depicted as rotating in front of our eyes (pl. 87). In a complementary manner, he also depicted figures themselves in local movement, as

86. The blurred-edge phenomenon as demonstrated by Leonardo (based on MS D 10v).

The receptive surface of the eye, CD, will see the edge, E, of an object at a range of positions against the background, AB.

87. Leonardo da Vinci, *Studies of a Human Shoulder and Arm*, c.1510, Windsor, Royal Library, 19008v.

88. Leonardo da Vinci, *Studies of a Man Wielding a Hammer*, *c.*1510, Windsor, Royal Library, 19149v (detail).

occupying a series of continuous positions in space, in what may fairly be described as a cinematographic sequence (pl. 88).

In important respects, Leonardo stands at the climax of the development we have been describing in this chapter. It was he who most completely realised and investigated the multi-faceted nature of Brunelleschi's invention. And, like his greatest predecessors, he did not so much add science to art, or even art to science, as show how the 'science of art' possessed a creative unity of its own special kind in relation to both form and content. In another sense, however, he will have done this chapter no good at all. All his predecessors had, to their own satisfaction, at least, isolated what they considered to be the salient factors in the analysis and construction of space. This concentration of ways and means had been accomplished by emphasising the mathematics of the intersection largely at the expense of the physiology of vision. Ghiberti's anthology was exceptional in this respect, but he created parallel rather than integrated forms of perspectival science. Leonardo's sheer comprehensiveness and persistence laid bare the series of tensions and contradictions which were implicit from the first in the painter's new technique. He thus marks both the climax of the first part of our story and also the point at which it ceases to have a consistent story-line. For all the diversity of earlier approaches, there was nonetheless some shared sense of the nature of the problem which was being tackled. Leonardo showed that the artists had been barely aware of true extent and nature of the Pandora's box of intriguing problems they had opened.

Linear perspective from Dürer to Galileo

No artistic technique ever enjoyed a more triumphal progress than that of perspective in the years following 1500. By the beginning of the next century no Western European artist could hope to be measured on an international scale without a sound grasp of the basic technique. In subsequent years it was even to invade apparently incompatible artistic traditions in non-European countries, often with rather unhappy results for the integrity of the indigenous art. The countries with which we are presently concerned are those within the Western tradition. Although the mathematical technique was uncomfortably absorbed into the existing styles of some of these countries at first, there was no 'major' country in which perspective was not a more or less naturalised citizen by about 1650. The sheer breadth of this diffusion, and the regional varieties it engendered, will work against a unified, consistent picture emerging during the course of this chapter. However, I hope to indicate that there are certain patterns to be discerned in those countries in the forefront of the quest for what we may call 'scientific illusion' in art.

Related to the diffusion of perspective science in European art is the question of its impact on other disciplines. Perspective provided the basis for an illustrative tool which left no branch of applied science untouched. It is not my intention here to address the whole question of the role of visual analysis in the empirical thought of the Scientific Revolution—though it is a question which still needs to be fully tackled by someone—but in as far as the uses made of perspective outside the field of art refract back into the story of science *within art*, we must obviously be alert to what was happening to perspective in science itself. I think it will become clear that I am sceptical of some of the extreme claims that artists' perspective in some way 'anticipated', 'stimulated' or even 'precipitated' what are normally described as the new visions of infinite or indefinite space formulated by Kepler, Desargues and Descartes at the heart of the Scientific Revolution, but I would not deny that the painters' science is locked into the intellectual and philosophical developments in a complex and creative manner.

The opening sections of this chapter will be concerned with the remarkable impact of perspective on a few important theorists in Germany and France in the sixteenth century, that is to say in the two countries most consistently and keenly concerned with the humanist culture of Italy in a wide variety of its manifestations. The supreme example of Albrecht Dürer, the first Northern artist to take up perspective in a whole-hearted manner, will show that we will not simply be witnessing a passive acceptance of Italian ideas. The way in which perspective became creatively transmogrified as it travelled Europe is partly a consequence of the possibilities it offered to artists of high intellect and individuality, but also reflects the position of perspective as a new citizen in an adopted country—naturalised to a degree, but still speaking with a foreign accent, for the first generation at least. Like any adopted citizen, it has a unique relationship to the country in which it has grown to maturity—its modes and manners will have developed in complex symbiosis with its formative environment, giving it a special kind of natural integration. In its new country, a certain strangeness tends to persist.

When it arrived in the late Gothic North the practical and intellectual facets of perspective were enthusiastically embraced by increasing numbers of resident artists. In common with converts of all kinds, the new devotees tended to show signs of an obsessive concern with a credo which seemed to promise privileged access to artistic excellence. For an artist like Raphael, who was growing to maturity in the Italy of 1500, perspective was an established fact of artistic life. For an artist like Dürer, trained in Germany to make angular woodcuts in a late Gothic tradition, it came as more of a 'revelation'. For some of Dürer's contemporaries and followers—and even to some degree for Dürer himself—perspective seems to have been regarded as a form of magic, a kind of visual alchemy which transformed the base materials of art into visionary experience.

ALBRECHT DÜRER AND THE GERMAN PERSPECTIVISTS

When Dürer made his woodcut of the *Presentation of Christ in the Temple* in 1504 (pl. 89), he was a mature artist who had assimilated many of the motifs and at least some of the principles of the Italian Renaissance style. His first visit to Italy, probably ten years earlier, did not so much provide him with

89. Albrecht Dürer, *Presentation of Christ in the Temple*, Woodcut, *c.*1505, London, British Museum.

❡ formez deſſus traiz principaux/
Puet on baſſes ⁊ chapiteaux.

90. 'Corrected' version of the architectural setting in Dürer's *Presentation of Christ in the Temple*, from Jean Pélerin's *De Artificiali perspectiva*, Toul, 1509.

an overwhelming change in direction as with vital first-hand experience of the kind of art which had already begun to attract him, and which he was increasingly to utilize on his own terms during his subsequent career. The *Presentation* shows his awareness of how perspectival devices can be utilised powerfully in a narrative context—in this instance to convey a sense of the solemn and imposing dignity of the ancient temple. Since about 1496 he had been using the controlled convergence of orthogonals to a definite point and we will not be surprised to find that this rule has been observed in the *Presentation*.[1]

However, more detailed analysis shows that Dürer's mathematical control of perspective recession was still some way from complete. If we attempt to plot the verifying diagonals through the 'square' apertures of the vault, we will find that they are not aligned consistently and that they fail to converge to any noticeable extent. The apertures cannot therefore be

read as squares or even as consistently-sized rectangles. This inconsistency was recognized as early as 1509 when Jean Pélerin, whom we will encounter in the next section of this chapter, published a more or less 'corrected' version of the setting (pl. 90).[2] We may argue that Dürer's design works more effectively in practice than Pélerin's tidied-up version—as indeed it does—and that to look for mathematical accuracy is mere pedantry. This argument, however, would not have been acceptable to the Italian perspectivists, who believed that geometrical consistency was absolutely essential to the proportional harmonics of spatial design, nor seemingly would it have appealed to Dürer himself, who was becoming increasingly concerned with the principles and intellectual status of his art. It was in this spirit that Dürer, during his second visit to Italy, wrote from Venice to Pirkheimer in Nuremberg on 13 October 1506: 'I shall be finished here in ten more days; then I shall ride to Bologna where someone is willing to teach

me the secrets of perspective. I intend to stay there for about eight days and then return to Venice. . . Here I am a gentleman, at home a parasite.'[3] The coda concerning his social position obliquely reflects how in Dürer's mind perspective was associated with the establishing of painting in Italy as an art which deserved intellectual respect.

We may imagine that Dürer would not have travelled that distance nor planned to stay for some days if all he intended to learn were some further tricks of the painters' technique. On the basis of the apparent results of his visit, we can make a hypothetical reconstruction of the kind of instructor he encountered. The results seem to have been less radical in terms of his practice of art than in the re-orientation of his intellectual interests. After his second visit to Italy we witness the great flowering of his geometrical studies, both with respect to the Euclidean connotations of linear perspective and as an intellectual discipline in its own right. His studies of perspective do not seem to have embraced physiological optics and I think it is unlikely that his instructor was a natural philosopher in the Alhazen succession. Rather, all the signs are that he gained direct access to Piero della Francesca's variety of visual geometry and acquired some knowledge of certain aspects of Leonardo's work. Piero's influence seems to have been central. A translated excerpt from Piero's *De Prospectiva pingendi* appears in Dürer's notebooks, and the techniques of perspectival transformation which we will be examining shortly are close to those of his great Italian predecessor.[4] His instructor was, therefore, likely to have been a mathematician or a mathematically-minded artist in the Piero orbit. The picture we are building up fits no-one better than Luca Pacioli.

Pacioli's earlier career had provided all the necessary background.[5] A major mathematical author on his own account, he had been the house guest of Alberti in Rome, had been strongly influenced by Piero—incorporating some of Piero's works in his own publications—and had been closely associated with Leonardo in Milan and Florence from 1496. Leonardo had devised the illustrations of geometrical solids for Pacioli's *De Divina proportione*.[6] Although Pacioli was primarily based in Florence between 1500 and 1508, his career was characterized by constant mobility, and his associations with Bologna were strong during the first decade of the century. He was *lector ad mathematicam* at Bologna in 1501–2 and had been appointed Superior to the Franciscans in the Romagna. Dürer may have been encouraged to seek him out as a result of contact with Galeazzo San Severino, who had been one of the mathematician's patrons and who stayed in Nuremberg with Dürer's closest confidant, Pirkheimer, on the fall of the Milanese regime in 1499.[7] On the other hand we might expect Dürer to have mentioned Pacioli by name when reporting his intentions to Pirkheimer. If it was not Pacioli he was to see, it was someone close to Pacioli in outlook.

Whoever Dürer met in Bologna, he returned with his mathematical ambitions well fired; the following year he purchased Bartolomeo Zamberti's translation of Euclid's *Elements* from the Greek, a step which effectively initiated his period of sustained research into classical geometry.[8] We are not concerned here with a detailed examination of Dürer's

mathematical exploits in themselves, but since his analysis of perspective is set within a mathematical treatise we must obviously understand the relevant context. The treatise, *Underweysung der Messung . . . (Instruction in Measurement with Compass and Ruler in Lines, Planes and Solid Bodies)*, was published by Dürer himself in Nuremberg in 1525, and represented the fruits of mathematical endeavours which can be dated back to at least 1508.[9] As a treatise on geometry in the German vernacular—which is in itself remarkable, though not unique—it was aimed at all those professions whose skills are (or should be) underpinned by techniques of precise mensuration. In particular it was directed at the young German artists who 'have grown up in ignorance, like unpruned trees. Although some of them have achieved a skilful hand through continual practice, their works are made intuitively and solely according to their own taste'.[10]

The *Underweysung der Messung* is divided into four books, following a broadly Euclidean progression. The first is concerned with lines, most especially plane curves and varieties of spirals. It is in this section that Dürer makes what is perhaps his most substantial contribution to mathematics, namely his analysis of conic sections. Taking up the classical challenge of Apollonius's treatise on conics, he provides a practical way of obtaining the sections of cones by what later became known as orthographic projection (pl. 91). The technique may not unreasonably be regarded as a form of perspectival transformation of a circle using an inclined 'picture plane' similar to that shown by Piero in foreshortening heads from different angles (pls. 47–9). Dürer's technique is theoretically sound but is difficult to operate near the vertices, since the intervals become extremely compressed. The actual shape of the section he obtains in plate 91 is egg-like rather than truly elliptical. He himself refers to the ellipse as the 'egg-line'—a term characteristic of his geometrical vocabulary. His language reflects both the lack of an established terminology in the vernacular and his own sense of the concrete quality of geometrical forms in relation to the natural world.

The second book of the *Underweysung der Messung* deals with the morphology of regular polygons, not only in the abstract terms of Euclid but also as applicable to decorative uses in tile patterns and so on. The third treats a variety of problems: the properties of certain solid bodies, such as pyramids, cylinders and architectural columns; the design of sundials and astronomical instruments; and the geometrical construction of letters, largely in the Piero-Pacioli manner. The final book is concerned with the properties of polyhedra. With a characteristic sense of the concretely operational aspects of geometry, he illustrates a technique (also known to Leonardo) for displaying the regular and semi-regular solids in flattened forms (pl. 92) so that they can be readily constructed from flat templates. This final book culminates in his analysis of geometrical perspective.

His demonstrations of perspective follow his descriptions of three solutions to the 'Delian problem', which involves the doubling in volume of a given cube. The solutions concern proportional transformations of the kind which had earlier exercised Leonardo. It is not illogical to find him progressing

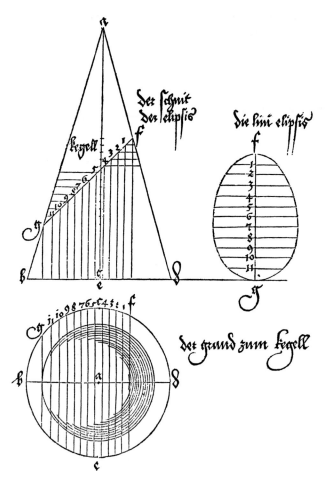

91. Method for determining oblique section of a cone, from Albrecht Dürer's *Underweysung der Messung*, Nuremberg, 1525.

an almost irresistable tendency to shade them into three-dimensional existence. One particularly nice result was thought worthy of being dated (pl. 96).[13]

This same sense of the reality of geometry in the physical world pervades his geometrical analysis of perspectival building-blocks in the human figure. The later sections of his *Vier Bucher von menschlicher Proportion* (*Four Books on Human Proportion*), which seems to have been complete by 1523 but was only published posthumously in 1528, are devoted to the stereometry of the body as it moves in space.[14] His starting-point is again similar to that of Piero (pl. 97), or perhaps in this instance even closer to Leonardo. In this relatively early scheme, the basic technique of planar transformation of a human head appears to have suggested its subsequent description in transparent sections as a kind of stereometric cage. This was later developed by Dürer into a technique in which three-dimensional portions of the human body are inscribed within geometrical solids, rather like joints of meat frozen in blocks of ice. These basic blocks can be utilised to describe the jointed motions of the human figure and can be tilted in different planes as required (pl. 98). A whole figure can be geometrically transformed in terms of the basic block (pl. 99), although the outstretched arm viewed end-on in the left-hand figure has become almost impenetrably complex. At other times, as if aware of the dangers of mechanical rigidity in his cubic hominoids, he twists the profiles of units themselves to give a more organic flow to the compound forms (pl. 100).

We should note, however, that the techniques of orthographic transformation used by Dürer with respect to the human figure should not be regarded as consistent with one-point

92. Template for the construction of a dodecahedron from Albrecht Dürer's *Underweysung der Messung*.

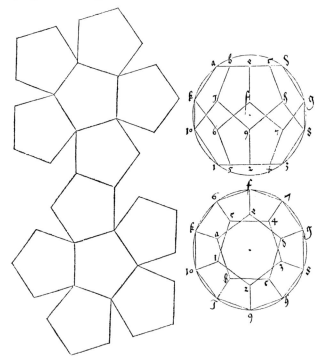

from this proportional problem, with passing references to proportionally increased weight in cannon balls of different size, to the proportional technique of perspective diminution. The 1538 Latin edition of his treatise includes a triangular diagram of proportional lines (pl. 93) entirely in keeping with Piero's principles.[11] This diagram can, Dürer informs us, 'be utilized in many ways', as in judging the angular inclination of walls towards the tops of bastions or in transforming a normally proportioned human figure towards either extreme, short-and-fat or tall-and-thin.[12]

His principal and wholly precise technique for perspective uses intersections on a plane from plan and elevation (pl. 94) and corresponds in principle to that described by Piero. The geometrical form illustrated by Dürer—a cube standing on a square ground plane—is simpler than Piero's *mazzocchio*, but gains comparable complexity with the inclusion of an adjacent source of light, which causes the cube to cast a geometrical shadow. Since vision can only take place by means of light, Dürer has reasoned that light and shade are integral to any demonstration of perspective. His inclusion of shaded planes also reflects his feeling for geometry as the visual science of actual objects. Like Leonardo, when he was experimenting with linear diagrams of geometrical figures (pl. 95) he showed

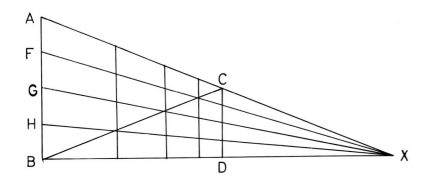

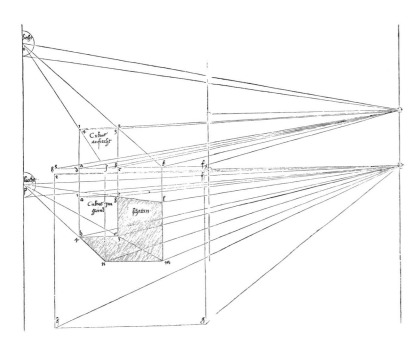

93. Proportional diagram, based on Albrecht Dürer's *Underweysung der Messung*, Nuremberg, 1538.

AB and CD are perpendicular to BD
AC and BD are extended to X
AB is divided into equal parts, and the points, F, G and H joined to X
BC is drawn
Perpendiculars are drawn through the intersections of FX, GH and HX with BC
The perpendiculars are in a proportional series

94. Perspectival projection using plan and elevation of a cube with accompanying shadow from Albrecht Dürer's *Underweysung der Messung*.

95. Albrecht Dürer, *Flat geometrical pattern*, London, British Library, MS Sloane 5229, 143r.

96. Albrecht Dürer, *Geometrical Designs*, 1524, London, British Library, MS Sloane 5229, fol. 142r.

perspective. The diminution of dimensions occurs along only one coordinate at a time. When he tilts a head away from the spectator (pl. 101) the distances between chin and forehead are duly foreshortened, but the relative widths of the features are unaffected. If we imagine a cube foreshortened according to this method (pl. 102), the problems can be readily seen. Piero della Francesca had also illustrated this technique of parallel transformation, but his full-scale foreshortening of a head (pls. 47–9) relied upon the tracing of intersections in a fully perspectival manner. We have seen that Dürer was aware of the

97. Albrecht Dürer, *Stereometric diagrams and planar transformation of the human head*, Dresden, Sächsische Landesbibliothek, MS R 147, 91v.

98. Perspectival studies of a segment of the human body from Albrecht Dürer's *Vier Bucher von menschlicher Proportion*, Nuremberg, 1528.

99. Planar transformation of a geometricised human figure from Albrecht Dürer's *Vier Bucher*

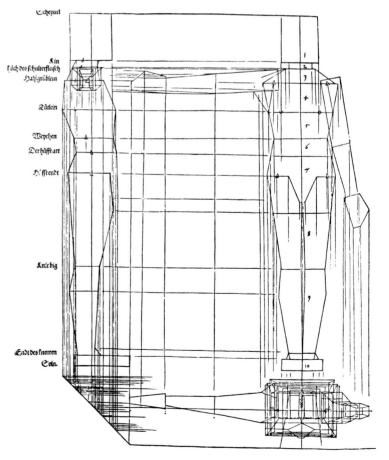

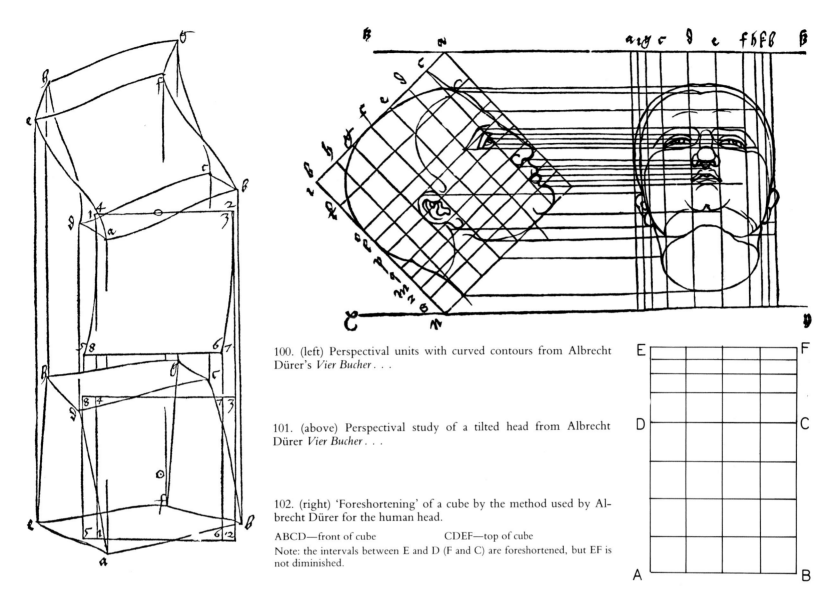

100. (left) Perspectival units with curved contours from Albrecht Dürer's *Vier Bucher . . .*

101. (above) Perspectival study of a tilted head from Albrecht Dürer *Vier Bucher . . .*

102. (right) 'Foreshortening' of a cube by the method used by Albrecht Dürer for the human head.

ABCD—front of cube CDEF—top of cube
Note: the intervals between E and D (F and C) are foreshortened, but EF is not diminished.

intersection technique, but he did not illustrate its application to forms other than his shaded cube. Whether or not he was himself aware that parallel transformation did not conform to the rules of one-point perspective, it was all too easy for subsequent artists and theorists to miss the point—including, as we shall see, Daniele Barbaro and Jean Cousin.

Armed with his techniques of perspective by intersection and stereometric analysis, Dürer was potentially equipped to compose geometrical visions of space and form to match any we have seen in Italy. However, he recognized that these techniques—for all their intellectual attraction and inherent beauty—were of limited practicality in the normal business of painting or engraving. He therefore devised what he called his 'shorter way'. This method consisted of an abbreviated technique for the foreshortening of a square 'tile' as the ground plan on which forms could be erected. The idea is simple enough, and corresponds in essence to the Albertian method. The converging sides of the square are drawn to an eye-point (the vanishing-point) in a standard way (pl. 103). The second stage involves the tracing of the visual ray from the far side of

the square through the picture plane (a/a–b/b) to the eye of a viewer placed at any desired distance. The point of intersection of the ray and the plane locates the rear horizontal (eh). So far so good. But, unexpectedly, Dürer has made an error in his diagram. Since the picture plane is stationed away from the edge of the square, he should also have plotted the intersection from f to the observer.

The diagonal (ge) of his somewhat improperly foreshortened square is subsequently used to locate the base of his desired cube, and its proportional height is duly plotted (pl. 104). This demonstration of the complete construction, including the shadow, further compounds the problems by confusing the diagonal of the square with the line to the observer's eye. Since the picture plane is close to the edge of the square, the consequences of his two errors will be marginal, but they could become serious if the picture plane were to be set further away. This imprecision stands in sharp contrast to the perfection of his fuller technique.

When we look at the implementation of Dürer's perspective theories in his own practice we find that he generally seems

59

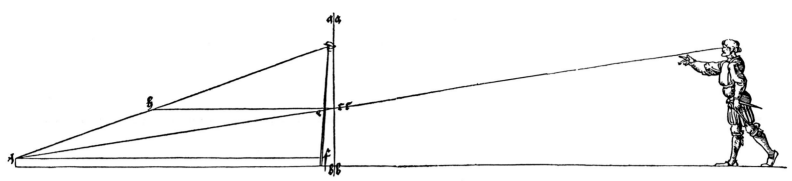

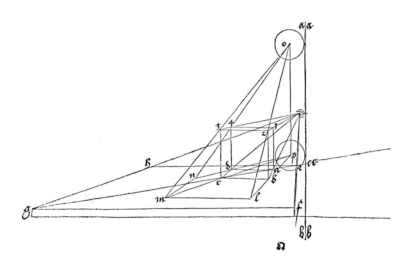

103. The 'shorter way' of constructing a tile in perspective from Albrecht Dürer's *Underweysung der Messung*.

a/a, b/b—picture plane near eh—rear side of tile
fg—side of tile
Note: the side of the tile, f, should also be projected on to the picture plane.

104. Perspectival projection of a cube on a foreshortened tile from Albrecht Dürer's *Underweysung der Messung*.

The diagonal g—cc now becomes the diagonal of the tile efgh.

abcd—base of cube 1234—top of cube
O—light source dnmlbc—cast shadow
P—point on ground plan vertically below the light source

105. Albrecht Dürer, *St. Jerome in His Study* (engraving), 1514, London, British Museum.

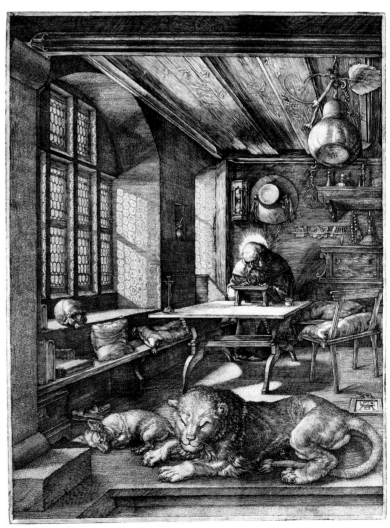

to have utilized the technique of constructing forms on pre-foreshortened planes, as in his 'shorter way'. The work which can most obviously sustain a full-scale analysis is his brilliant *St. Jerome* engraving of 1514 (pl. 105). This is his supreme demonstration of the engraver's *ars* in union with the perspectivist's *scientia*. Using a radically off-centre viewpoint, he has openly delighted in extremes of transformation and plunging space, providing a strenuous course of perspectival gymnastics for the observer's eye. Amongst his predecessors, probably only Uccello had exploited a comparable sense of the strange dynamics of perspectival geometry. The specific objects within the space which are most obviously projected according to geometrical principles are the table and obliquely positioned bench.[15] These could have been constructed in a number of ways, but his own ground-plan method based on squares is surely the most relevant.

The viewing distance, E to Z^1 or to Z^2, is very short (pl. 106). Using diagonals to either of these points it is possible to determine a working ground plan for the table and seat (pl. 107), in which diagonals and parallels on a basic pattern of foreshortened squares provide guides for the placing of the objects in a manner comparable to that illustrated in his treatise (pl. 104). The placing of the legs relative to the lines does not seem to be mathematically perfect, but I think we can be reasonably confident that this is the basic method at work here. This would mean that the lines of sight and diagonals of the squares have been compounded as in his definitive demonstration of the 'shorter way'. The use of intersections at the

vertical through the eyepoint (V), or at the edge of the engraving, does not seem to yield such consistent results.

Given the presence of directional light as an integral component in his perspective demonstrations, we will not be surprised to notice that the forms are thrown into relief by rigorously directional light. Here, however, the source is more complex, since parallel rays of light from the sun enter through two elaborately glazed windows. This prevents the simple formula of his treatise demonstrations being applied in a direct manner, but it does look as if the apex of the bright parabola under the left side of the table has been specifically calculated to lie directly at the centre of the square plan.

106. Analysis of the perspective of Dürer's *St. Jerome*.

V—vanishing point
Z¹, Z²—lateral points of convergence for diagonals
Note: VZ¹ or VZ² is the viewing distance.

107. Suggested ground plan for the table, bench and inscribed tablet in Dürer's *St. Jerome*.

A,B,C,D—location of feet of table EFGH—location of feet of bench

All this is as geometrical as anything we have seen in Italian art. Why then does it look so different? Partly it is an obvious matter of the descriptive, particularizing quality of the light, a quality that betrays his deep indebtedness to the Northern tradition of Van Eyck and his followers. But the difference also resides in the construction of the space itself. Dürer has applied perspectival techniques to the setting and to specific forms, but these pictorial elements have been invented independently of any geometrical base for the total design. In Piero's paintings the geometrical vision pervades every part of the conception from the very beginning. Dürer's perspectival motifs are not interwoven with a coordinated system of geometrical harmonics throughout the design. The ground plans for the table and seat do not appear to be elements in a system of geometric modules throughout the floor plan as a whole, and the othogonals of all the various planes seem to plunge in their own wilfully independent way to their common vanishing-point. This picturesque variety does not make Dürer's system inferior—indeed it helps give it dynamic freedom—but it does tend to make the individual motifs in perspective seem more obtrusive and, at the wider angles, even overtly peculiar.

Dürer has detained us for some time—indeed longer than any other artist we will encounter in this chapter—not only because of his intrinsic importance as the last major painter to be counted as a significant geometer, but also because his response helps alert us to the characteristically different visual qualities of perspective in Northern art. His direct influence on Northern theory and practice was enormous, particularly within the vigorous tradition of the graphic arts in Germany itself. This is not to say, however, that his example made everything easy for his German successors, or that his ideas were

108. Perspective demonstration of architecture including a spiral staircase form Hieronymus Rodler's *Eyn schön nütlitz büchlin underweisung . . .*, Simmern, 1531.

109. Truncated dodecahedron in skeletal form as designed· by Leonardo da Vinci for Luca Pacioli's *De Divina proportione*, Florence, 1509.

always fully understood. The two books which stood most immediately in his succession—Hieronymus Rodler's book on measurement and Erhard Schön's treatise on proportion—exhibited a simplified understanding of Dürer's theories and none of his complex subtlety in practice.[16] Rodler's system is dominated by converging orthogonals, with little sense of measured control over scaled distances into the space, and he was simply unable to handle more complex forms, such as a spiral staircase (pl. 108). Schön had studied Dürer's treatment of the human figure with some care, but his results graphically illustrate the dangers of mechanical oversimplification of which Dürer himself had been well aware.

The most intellectually productive aspect of Dürer's immediate succession was in Nuremberg, his own city. Perhaps the 'golden age' of Nuremberg was less radiant than its early propagandists would have us believe; and perhaps the city fathers were more ready to boast of the city's cultural virtues than actually to support its intellectuals munificently; but there is no denying that Nuremberg was the centre for one of the most remarkable phases in Renaissance culture.[17] It was a major centre for publishing, particularly in the fields of geography, astronomy, applied mathematics and music. It could boast metalworkers, armourers and other craftsmen of high skill, to equal any in Europe. Nowhere were the sciences of practical mathematics and the new humanist learning more productively united. In the visual arts, its metalworkers stood supreme as a group, not only in the production of superbly decorative objects for the European aristocracy but also in the fabrication of scientific instruments, particularly the geometrical devices used in astronomy. Dürer himself came from a background in metalwork, his father's profession, and the majority of the geometrical perspectivists who were to follow him practised metalwork and/or instrument-making.

The Nuremberg perspectivists specialised in the portrayal of geometrical bodies, particularly the Platonic solids and their derivatives. The impulse for this came not only from Dürer but also from the printed edition of Pacioli's *De Divina proportione* (1509). The illustrations Leonardo provided for Pacioli's treatise portrayed the geometrical bodies both in their solid form and in a skeletal manner (pl. 109) in such a way as to display their complete configuration in space. These forms, together with the *mazzocchio* and armillary sphere (pl. 71), had made an early appearance in Italian *intarsia* design—probably under the inspiration of Piero della Francesca—and became recognised set-pieces for decorative woodwork in secular and ecclesiastical contexts. Pacioli seems to have been the moving spirit behind the actual construction of the regular bodies and their derivatives in three-dimensional form in a variety of materials, including wood and crystal.[18] A series of Nuremberg authors adopted these motifs in their printed books. Augustin Hirschvogel's *Geometria* appeared in 1543, Lorenz Stoer's *Perspectiva* in 1567, Wenzel Jamnitzer's *Perspectiva corporum regularium* in 1568, Hans Lencker's *Perspectiva* in 1571—all of which contained elaborate variations on the regular and semi-regular solids—and in 1567 Hans Lencker published his charming *Perspectiva literaria*, a kind of A, B, C of perspective in which three-dimensional letters are displayed from every

conceivable angle.[19] The supreme example visually and intellectually is Jamnitzer's book on the regular solids, the *Perspectiva*, which will for our purposes stand as representative of the Nuremberg publications.

Jamnitzer was the outstanding goldsmith of his generation, serving a succession of Holy Roman emperors, an instrument-maker of consummate skill, and a Nuremberg citizen of considerable status. His *Perspectiva* even drew an honorarium of forty florins from the money-conscious city council.[20] His book, perhaps the most beautiful of its kind, devotes each of its first five sections to a series of almost musical variations on the five Platonic solids (pl. 110). He also orchestrates them in complex compositions in which a variety of bodies are clustered together like table ornaments (pl. 111). There is, of course, an element of sheer visual delight in these geometrical 'toys', together with an obvious pride in the virtuoso skill behind their design. But there is also a substantial philosophical background to their conception. Each of Jamnitzer's five units is identified with one of the elements in the Neo-Platonic cosmos derived from the *Timaeus*: earth is represented by the cube (hexahedron), water by the icosahedron, air by the octahedron, fire by the pyramid (tetrahedron), and the cosmos by the dodecahedron. This scheme had been enthusiastically embraced by Pacioli, was taken seriously (though ultimately rejected) by Leonardo, and was promoted at just this time in Italy by Daniele Barbaro.[21] A knowledge of the five Platonic

112. Nicolaus Neufchatel, *Portrait of Johannes Neudorfer and his Son*, 1561, Munich, Alte Pinakothek.

110–11. From Wenzel Jamnitzer's *Perspectiva corporum regularium*, Nuremberg, 1568, engraved by Jost Amman: (above) Variations on the hexahedron and (below) Arrangement of geometrical bodies in perspective.

distant points, suggests that he may well have used an instrumental method. As we will see in a later chapter, he was portrayed using a suitable device (pl. 333), and his own experience as a scientific instrument-maker would have provided him with the means to manufacture one specifically for his purposes. This hypothesis is supported by the fact that those of his geometrical drawings which have survived show no signs of constructional lines of the kind necessitated by the Piero-Dürer and other methods.[25] Regardless of what method was used, his results in this specialised field are not rivalled by anything produced in either Italy or France.

THE 'THIRD POINT': COUSIN AND FRENCH PERSPECTIVE

The context in which perspective was taken up in France shared some similarities with that in Germany—the links with

114. Perspectival rendering of Notre Dame, Paris, from Jean Pélerin's *De Artificiali perspectiva*, Toul, 1509.

113. Cosmological system illustrating planetary orbits, from Johannes Kepler's *Mysterium cosmographicum*, Tubingen, 1596.

solids was essential for anyone who claimed competence in cosmology. Thus it was that the great Nuremberg writing-master, Johannes Neudörfer, was shown in his portrait by Nicolaus Neufchatel initiating his son into the secrets of a hollow dodecahedron (pl. 112).[22] If we should doubt the seriously scientific aspect to the study of the ancient geometrical forms at this time, we only need look at Kepler's scheme for planetary orbits, which is founded upon the interrelationship of such bodies successively inscribed one inside the other and displayed like a virtuoso example of the goldsmith's art (pl. 113). It is not surprising to find that Kepler himself planned to have the model constructed in metal.[23]

Jamnitzer's book illustrates his geometrical *fantasie* in compelling perspective, but does not show *how* to draw them. As he tells the readers, 'all superfluity will be avoided and—in contrast to the old-fashioned way of teaching—no line or point will be drawn needlessly'.[24] Hence there are no construction lines. A number of techniques for drawing such forms were available by this time, including the projective systems of Piero and Dürer, but the unusually shallow perspective of Jamnitzer's solids, in which the parallels converge to decidedly

the precise sciences of measuring are similarly apparent—but the mainstream of the French development was rather different. In general it exhibited a less abstract, 'cosmological' nature and was more closely associated with the representation of realistic architectural space. The first significant French theorist, Jean Pélerin, participated in architectural design, and practising architects were prominent amongst the later theorists.

The book on perspective published in 1505 by Jean Pélerin, the Canon of Toul who wrote under the name 'Viator' ('voyager'), is one of those unheralded conceptions whose origins are difficult to explain. His *De Artificiali perspectiva* is not only the first book on artists' perspective North of the Alps but it is also the first anywhere to be illustrated with applied examples of perspective in action. Although Pélerin is known to have acted as a consultant-designer in architectural matters, he was not a professional artist but a high-ranking ecclesiastic of some

administrative reputation, who had more than once been in royal service.[26] He was also a scholar. He translated the book of Job from Hebrew and wrote a work, since lost, on Ptolemy. None of this, not even his likely knowledge of Ptolemaic systems of projection, prepares us for the content of his treatise.

His text is almost entirely devoid of the kind of scholarly philosophical excursions we might expect, while the illustrations are abundant in remarkably observed and skilfully drawn examples of different forms of perspectival representation. His subjects include real and imaginary exteriors and interiors of buildings, with and without figures, as well as landscapes, in a way which seems to foreshadow Dutch art of the next century. His methods of presentation exploit frontal arrangements of the familiar type, and the kind of oblique settings which had rather dropped out of the perspectivists' repertoire (pls. 114–15).

115. Perspectival rendering of the interior of the Palais de Justice, Rouen, from Jean Pélerin's *De Artificiali perspectiva*.

116. Perspectival rendering of a domestic interior from Jean Pélerin's *De Artificiali perspectiva*.

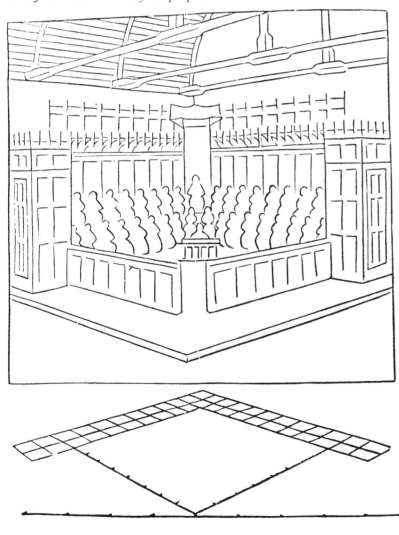

117. Method for the perspectival projection of a square using the '*tiers points*', from Jean Pélerin's *De Artificiali perspectiva*.

The basis of his construction is a three-point system, with a 'principal point' which corresponds to the central vanishing-point in the standard construction, and two '*tiers points*' at either side, which are recognisable as the distance points of the workshop method (pl. 117). These *tiers points* he rather confusingly attributes to the turning of the 'diameter' (central axis) of the visual pyramid. Differently oriented forms will result in a series of pyramids with their apexes along the horizon (or 'pyramidal') line. He recognizes that the 'third points' need to be moved further apart as the spectator's distance increases, but he is not generally concerned with the concept of viewing distance in relation to the object and the picture plane in the manner of advanced Italian theory. His brief introductory text does show an interest in the processes of vision. He suggests that the production of the apex of the visual pyramid in the eye may be compared to the focusing effect of a 'burning (concave) mirror'. And it is possible that the circle in which he inscribes his foreshortened square is a reminiscence of a Pecham-style diagram of the radiant pyramids. But the dominant purpose served by his book is to provide a series of demonstrations of his particular formula at work in the depiction of various forms. The 'artificial' in the title of his treatise is a clear signal that he is not dealing in detail with the science of vision as such.

Given its attractive and accessible illustrations it is not surprising that his book was popular. It was rather crudely pirated as part of Gregor Reisch's *Margarita philosophica* in 1508, and Viator produced his own second edition in 1509.[27] It was this second edition which included the 'corrected' version of Dürer's *Presentation* (pl. 90). Dürer for his part paid close attention to Viator's illustrations, and the *St. Jerome* (pl. 105) works Dürer's own variation on the kind of domestic interior first presented in accurate perspective in *De Artificali perspectiva* (pl. 116).

The architectural associations which characterized the introduction and development of perspective in France were reinforced by the influence of Serlio's Italian books on architecture, which proved so popular in France.[28] Serlio was not a perspectivist of notable mathematical competence by Italian standards. His first method (pl. 118) is quite simply erroneous, while his second (pl. 119), which is obviously the distance point method, wrongly gives the viewing distance as GF. It is a wonder that his perspectival drawings of actual buildings work as well as they do. His most famous and ac-

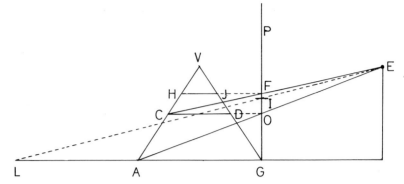

118. Perspective construction by Sebastiano Serlio based on *Il Primo libro d'architettura*, Paris, 1545.

AOE is used correctly to determine the horizontal level of CD. CFE is used incorrectly to determine the horizontal level of HJ. LE provides the correct level, at I.

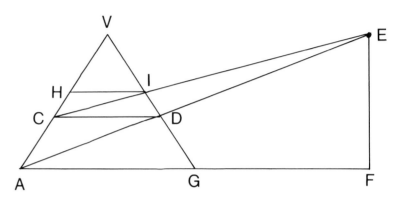

119. Alternative perspective construction by Sebastiano Serlio (based on *Il Primo libro d'architettura*, Paris, 1545.

The diagonal from A to E is used to determine the horizontal level of CD, and CE determines the level of HI.
Serlio incorrectly gives the viewing distance as GF rather than VE

120. Perspectival representation of a 'tragic scene' for the stage from Sebastiano Serlio's *Il Primo libro d'architettura* (based on Baldassare Peruzzi?).

complished perspectival representation, the *Tragic Scene* (pl. 120), is likely to have owed more to the Raphaelesque draughtsmanship of Baldassare Peruzzi than to his own skills.[29] Subsequent architectural draughtsmen in France such as Philibert de l'Orme and Jacques Androuet du Cerceau, the latter of whom wrote a substantial book on perspective, appear to have concentrated on the effective use of the distance point construction in the Viator manner rather than becoming entangled in the intersection method which Serlio so mangled.[30]

The major theorist of perspective in sixteenth-century France, Jean Cousin, can fairly be credited with perfecting the *'tiers points'* technique. In his hands it became a reliable, comprehensive and substantially accurate method for tackling the construction of space and the foreshortening of solid bodies. He explained his method in the *Livre de perspective*, which was published in Paris in 1560.[31] He begins his book with some basic instructions on the use of the *'tiers points'*, with the principal point disposed both centrally and laterally (pls. 121–2), and shows how to create a basic box of modular space

123. Perspectival projection of a box of space from Cousin's *Livre de perspective*, using the 'principal point' and 'tiers points' (top) and its relationship to the method by intersection (bottom).

124. Perspectival rendering of geometrical forms from Cousin's *Livre de perspective*.

121. Method for the perspectival projection of a tiled floor using the 'tiers points', from Jean Cousin's *Livre de perspective*, Paris, 1560.

122. Method for the perspectival projection of a tiled floor when viewed from a lateral point from Cousin's *Livre de perspective*.

(pl. 123). He also establishes a method of constructing a foreshortened ground plan on which solid bodies can be built in an accurately geometrical manner, achieving complex results by basically simple means (pl. 124). Although the *'tiers points'* technique still tends to be tied to uncomfortably wide visual angles and conveys little sense of the spectator's distance from a transparent picture plane, he does manage to adapt it to the foreshortening of a body of virtually any plan. He realises that sets of parallel lines which are neither at right angles nor at 45° to the picture plane converge to their own 'accidental' points.[32] He is able also to use the 45° diagonals of his basic system to transfer any given point on a plan to his foreshortened plane (pl. 125), providing a technique which became widely used in subsequent treatises. All this exudes an air of complete spatial control and no little geometrical competence. He was a painter of great reputation in his day—the 'French Michelangelo' as he was called—but visible evidence of his pictorial skills is frustratingly scanty. The paintings

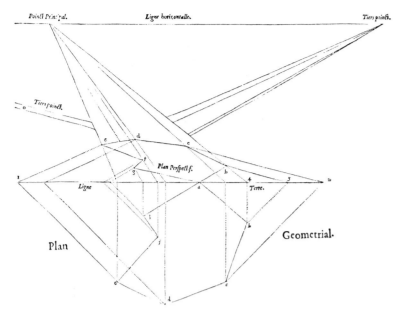

125. Method for the perspectival projection of given points on a geometrical figure from Cousin's *Livre de perspective*.

Point d is projected perpendicularly on to the 'ground line' of the picture plane. This point of projection is joined to the 'principal [vanishing] point'. Point d is also projected at 45° on to the 'ground line' of the picture plane. This point of projection is joined to the '*tiers* [distance] *point*'. The intersection of the lines gives d in projection. Points a b c e j g are similarly projected to give the figure in projection.

attributed to him show little sign of the intellectual stature of the author of the treatise.[33]

The ingenious title-page of his book (pl. 126) announces that 'in this present plate we demonstrate the five regular geometric bodies (which are deduced and elucidated point-by-point at the end of this volume) together with certain human figures foreshortened with this art: we hope, with God's help, to explain this more fully in the second volume'. This second volume, *La Vraye science de la portraicture*, was published eleven years later.[34] The foreshortening of the human figure in part and in whole is accomplished by a full-scale technique of transformation (pl. 127). The results are convincing enough on first acquaintance, but are subject to the same geometrical qualification as applies to Dürer's use of parallel transformation, namely that the transverse quantities are not diminished perspectively. This inadvertently has the effect of minimizing the more extreme consequences when a recumbent figure is foreshortened from a close viewpoint. His ambitions in this particular field of perspective may have much to do with the notable Italian painters imported to France to decorate Francis I's great palace of Fontainebleau. Both Rosso Fiorentino and Francesco Primaticcio were proficient perspectivists—Rosso as a result of direct contact with the Raphael circle in Rome after 1520, and Primaticcio from his work with Giulio Romano in Mantua. Vignola also worked at Fontainebleau for a short period and was credited by Egnatio Danti with perspectival designs for Primaticcio.[35] To appreciate the techniques which Rosso, Primaticcio and Vignola were able to import we must retrace our steps somewhat, and return to Italy.

126. Title Page from Jean Cousin's *Livre de perspective*, Paris, 1560.

127. Perspectival transformation of the human figure from Cousin's *La Vraye science de la portraicture*, Paris, 1571.

ITALY: ILLUSION AND MATHEMATICS

The ability of Italian artists after 1500 to exploit perspective for a brilliant variety of illusionistic effects stands in odd disproportion to the amount of writing on the subject—at least until the second half of the century. No Italian book on perspective was published in printed form until Lodovico Domenichi's Italian translation of Alberti's *De Pictura* in 1547, though the Latin version had already appeared in the North in a Basel edition of 1540.[36] There were a few manuscript treatises, as we have seen, but accessibility to these was inevitably limited. Even if we permit Lomazzo in his patriotic enthusiasm to add his Milanese predecessors to the list of theorists—Foppa, Zenale, Butinone and Bramantino—we may still doubt whether they were authors of publishable treatises.[37] It is surprising to realise that the first specialised treatise on perspective by a professional artist did not appear in print in Italy until Vignola's *Le Due regole* in 1583.

The explanation must lie in the fact that perspective was for the Italians an established part of their technique rather than an exciting new device in need of explanation, as it was in the North. When Italian publications did become more numerous in the second half of the century, they may be seen in part as a response to extreme varieties of illusionism in interior decoration, but I believe they were more directly occasioned by the adoption of the painters' science by mathematicians involved in the burgeoning study of three-dimensional geometry.

Before 1550 the story of perspective in sixteenth-century Italy is not concerned with new aspects of the science of perspective but with new methods of implementation. Virtually all the new methods were either taken up or invented in the studio of one artist, Raphael Santi. Near the beginning of the first chapter Raphael was characterised as a superb driver of the vehicle of perspective rather than 'an innovative scientific engineer'. Now we actually come to look at Raphael I think that the metaphor needs to be refined. Perhaps we should characterise him as a consummate mechanic, tuning the vehicle to achieve new levels of performance, though that is, perhaps, pushing the metaphor too far. I think it does remain true to say, however, that Raphael does not seem to have contributed to the optical and geometrical bases of painters' perspective, whereas he undoubtedly showed how its potential could be developed in an almost bewildering variety of ways. We will also see his contribution to instrumental techniques in Chapter IV.

By the age of twenty-one Raphael had achieved an impressive mastery of the orthodox description of architectural forms in space. The sixteen-sided temple in the background of his *Marriage of the Virgin* (pl. 128) is a perspective construction worthy of an artist born in Urbino, whose rulers had provided Piero della Francesca with important patronage. We may suspect that Raphael has used a multiple vanishing point system to plot the receding sides of his temple rather than Piero's fully-fledged method of projection, but the result has a sense of mathematical harmony worthy of his great precedessor. Urbino also seems to have been the major centre for a genre of fifteenth century painting we have not looked at—the perspec-

128. Raphael, *Marriage of the Virgin*, 1504, Milan, Brera.

tival representation of ideal townscapes.[38] The setting invented in 1504 by 'Raphael Urbinas'—as he signed himself on the temple—has much in common with the idealising aspirations of the genre to which Piero contributed much in spirit if not in actual practice.

Raphael's subsequent exploitation of perspective in almost every variety of architectural illusionism may also have had its ultimate roots in Urbino, where the *intarsia studiolo* (pl. 71) was a supreme feat of illusionistic decoration and where Melozzo da Forlì's works were well known. Contacts between the courts of Urbino and Mantua would also have helped foster Raphael's interest in Mantegna. Raphael in Rome can be seen as building upon Mantegnesque foundations in a number of important respects. His practice between 1510 and 1520 extended to an astonishing range of effects—painted illusions of architecture, ornaments, figures and sky, in the manner of Mantegna and beyond, together with infinitely subtle interplays between varieties of illusion within the illusion as a

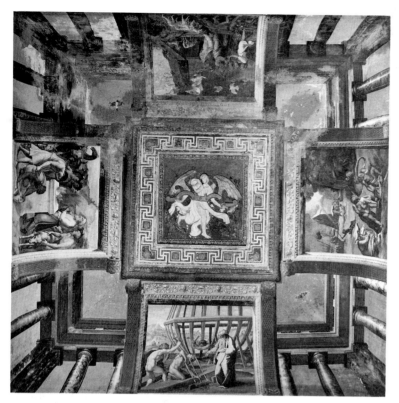

129. Raphael, Third Bay of the *Loggie* of Leo X *(The Stories of Noah)*, 1518–19, Rome, Vatican.

schemes which subjects all four walls of a room to a totally illusionistic system, played a particularly important role, not least for his influence on Serlio and Vignola.[40] Raphael's leading assistant, Giulio Romano, exploited and extended Raphael's techniques in his Mantuan interiors and it was a close knowledge of these that his collaborator Primaticcio took with him to France.[41] Giulio also provided an important stimulus for the Venetian decorators. Veronese is demonstrably indebted to him, and the Rosa brothers became the leading Venetian specialists in architectural illusion using Giulio's techniques. The story of sixteenth century illusionism is worth a book in itself, and clearly cannot be told in detail here.[42] However, we may gain some idea of what happened by tracing one important motif through some of its transformations. The motif I have chosen will also conveniently lead us into the theoretical writing of the second half of the century. The motif is the illusionistic framing of a ceiling 'aperture' in the manner pioneered in the *Loggie*.

Giulio Romano worked a nice variation on this theme in his designs for the choir of Verona cathedral which were executed in fresco by Francesco Torbido in 1534.[43] One of his inventions shows three flying angels bearing the Virgin's crown of stars in an open space surrounded by a balustrade (pl. 130). The viewpoint has been moved, appropriately for its viewing position, to a location just beyond the lateral margin which is

whole. These involved imitation reliefs, mosaics, tapestries and 'painted paintings' in various permutations.[39] He did not require new optical systems for this, but rather a uniquely heightened awareness of the potentialities of illusion and an incredible ingenuity in the implementation of perspectival devices.

At least one of his new schemes seems to have required a new mode of operation. In four of the cramped and awkwardly-shaped vaults of the *Loggie* of the Vatican, which he decorated with narratives from the Old Testament, he succeeded in suggesting the vertical extension of each bay to a square opening, well above the actual apex of the vaults (pl. 129). Across the openings, following the actual contours of the vaults, he placed his 'painted paintings' in decorative frames, with centre-pieces in low sculptural relief. The perspectival projection of the architectural forms in the corners of the tapering vaults is extremely tricky—much more so than a photograph would suggest—but unfortunately we have no direct evidence as to what technique Raphael has used. Later illusionists tackled this problem in a variety of ways. As we come to look at the various methods in later sections of this study we may be able to gain a better idea of the problem he faced and make an intelligent guess as to the technique he may have used.

The immediate circle and members of the studio of Raphael in Rome can be seen as largely responsible for the spread of the new forms of illusionistic decoration throughout Italy and ultimately throughout Europe. Baldassare Peruzzi, whose Sala delle Prospettive in the Villa Farnesina is the first of the

130. Francesco Torbido (to a design by Giulio Romano), *Angels with the Crown of Stars*, 1534, Verona, Cathedral Choir.

131. Giulio Romano's model and mirror method for the perspectival projection of illusionistic architecture for a ceiling, as described by Cristoforo Sorte.

A model of an open loggia is constructed. It is placed over a squared mirror. The eye is stationed at the required point, and the reflection is transcribed square-by-square on to a squared drawing.

nearest to the body of the cathedral. Fortunately we do have some direct evidence of Giulio's techniques, since they are discussed in a treatise written by Cristoforo Sorte, one of his pupils. Sorte tells us that he painted an illusionistic ceiling (now lost) in the ducal palace at Mantua according to Giulio's instructions.[44] This exploited the perspectival projection of the twisted, 'Solomonic' columns which seem to have become a special set-piece of the illusionist's art. Giulio, according to Sorte, used two methods. One relied upon geometrical projection, presumably using the measured intersection of rays in the manner outlined by Leonardo (pl. 84). The other involved an ingenious device, which perhaps belongs more with the next chapter, but warrants description here. A model of the structures to be painted was built above a squared mirror and viewed from an appropriate distance and angle (pl. 131). The results were then transcribed line-by-line onto a similarly squared drawing. A further procedure would still be required to transfer the squared drawing to the ceiling in the case of curved or irregularly shaped vaults, but the basic effect would have been neatly established. Perhaps Raphael used such an intermediate construction in his *Loggie* vaults.

Sorte indicates that Giulio's techniques were adopted by the brothers Cristoforo and Stefano Rosa in Venice. Their largest work, the decoration of the flat wooden ceiling of S. Maria dell'Orto is lost, but their skills are effectively seen in the architectural illusion which frames Titian's *Wisdom* in the Library of S. Marco (pl. 132).[45] Comparable motifs of illusionistic columns, including the 'Solomonic' type, and balustrades were adopted by Paolo Veronese in his 1560s decoration of the Villa at Maser for the Barbaro family.[46] At the same time in Bologna a group of artists in the circle of Vignola became enthusiastic specialists in this kind of architectural system for extending the apparent height of ceilings. Schemes in this vein were executed by Vignola himself, by Ottaviano Mascherino, Pellegrino Tibaldi and Tommaso Laureti.[47] A lost scheme by Laureti was accorded the unique honour of illustration in Egnatio Danti's edition of Vignola's *Le Due regole* (pl. 133). The technique, now in a fully developed form, was imported back into Rome by Mascherino in the illusionistic architecture in the ceiling for the Sala Bologna in the Vatican, which

132. Cristoforo and Stefano Rosa, Illusionistic setting for Titian's Wisdom, 1560, Venice, Libreria di S. Marco.

133. Tommaso Laureti, Design for a portion of an illusionistic ceiling from J. Barozzi da Vignola's *Le Due regole*, ed. E. Danti, Rome, 1583.

134. Ottaviano Mascherino and Giovanni Antonio Vanosino, Astrological ceiling showing the velarium of the heavens, 1575, Vatican, Sala Bologna.

135. Ottaviano Mascherino and Lorenzo Sabbatini, *Astrological Ceiling*, detail of the astronomers.

he painted in 1575 (pls. 134–5).[48] Mascherino, according to Danti, made use of wooden models, perhaps in conjunction with a mirror in the Giulio manner. He appears to have been one of the first specialised painters of illusionistic architecture —and was a considerable architect in his own right. In this instance he looked to other artists, to supply the non-architectural elements: Lorenzo Sabbatini for the main figures and Giovanni Antonio Vanosino for the astrological motifs. We will be returning to their ceiling later in this section.

The foreshortening of figures for such purposes had become a specialised task in its own right, and a number of competing techniques had been developed. There were the subject of vigorous disagreements amongst the partisans of each method. In the mind of at least one of the protagonists, Giovanni Paolo Lomazzo of Milan, the dispute reached ethical proportions. Lomazzo outlined three different approaches, using a classification which he credited to his Milanese predecessor, Bramantino.[49] The first type used the systematic 'reason' of optics; the second relied on 'practice' alone; while the third was an intermediate way sharing some features of the other two.

The artists who resorted only to 'practice' relied upon the innate and acquired expertise of the painter to create the neces-

72

136. Luca Cambiaso, Study for *The Return of Ulysses*, c.1565, Princeton, University Art Museum.

sary effects by freehand drawing. Small sculptural models in wax or clay might be used to guide the artist's depiction of a particular pose from unusual angles. We may suspect that Correggio worked in this way, and there is evidence to indicate that Tintoretto used models. Vasari also suggests that Michelangelo used this method on occasions.[50] At least two theorists, Bernardino Campi (who gained a reputation as a painter of foreshortening) and Giovanni Battista Armenini (who practised for a time as a painter) openly approved the use of *modellini*.[51] For Lomazzo such empirical methods would lead the artist to commit gross errors against the logic of optics.

The proper method in Lomazzo's eyes relied upon the full panoply of perspective projection, plotting the intersection of visual lines on the picture or wall plane. He particularly admired the technique of *quadratura* in figure drawing; that is to say the use of geometrical building-blocks in the Dürer manner to set up figures in space. The invention of *quadratura* was attributed by Lomazzo to Foppa and Bramante in Milan—although there is little surviving evidence to support his typically chauvinistic claims—while among modern artists Luca Cambiaso of Genoa received particular praise for his constructivist approach to the human figure.[52] Cambiaso's *quadratura* studies range from highly abstracted exercises for individual figures to complete narratives composed from schematised participants in self-consciously stereometric poses (pl. 136).

Standing between the extremes was the intermediate method which used a grid or veil for the analysis of foreshortening. Campi and Armenini had both recommended the use of a grid for the study and recording of *modellini*.[53] Lomazzo acknowledges that the grid has some value but does not consider that it ultimately offers a precise enough technique for proper foreshortening, not least because a small change in the artist's viewpoint would disturb the relationship between the figures and the grid. Ever the purist in optical matters, he insists that the rigorous procedures of geometrical projection and *quadratura* are essential for complete visual truth. He makes it clear that obedience to these procedures possesses an ethical *virtù* in itself.

How heated such debates could become is shown by a dispute which erupted in Milan in 1569. The bone of contention was a perspectival relief of the *Annunciation* to be sited in an elevated position on a tympanum in the cathedral. The new architect to the cathedral, Pellegrino Tibaldi, whom we have previously mentioned as one of the Bolognese illusionistic painters, proposed modifying the perspective of the relief designed by his predecessor. His proposal was bitterly attacked by a native Milanese architect, Martino Bassi, who accused Tibaldi's scheme of optical falsity, since it presupposed two horizons.[54] Bassi himself prepared two alternatives, one with a central vanishing point within the relief itself, and the other a fully illusionistic scheme to be viewed from below (pl. 137). To support his case, Bassi canvassed the opinions of four experts, Palladio, Vignola, Vasari and Bertani (a Mantuan authority on Vitruvius). Not surprisingly none of them approved of Tibaldi's solution—as unsympathetically pre-

137. Martino Bassi's scheme for a relief of *The Annunciation* to be viewed from below, from *Dispareri in materia d'architettura*, Brescia, 1572.

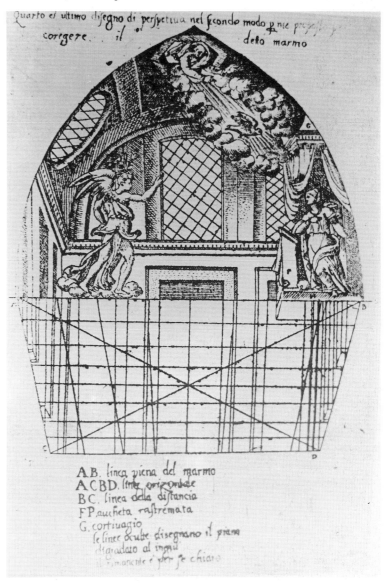

sented by Bassi—but neither were they unanimous about which of Bassi's alternatives was preferable. Vasari, quoting Michelangelo's dictum that the artist must have 'compasses in his eyes' rather than relying upon pedantic measurement, admired the 'caprice' of Bassi's illusionistic scheme, but considered that it sacrificed too many other artistic qualities. Vignola was true to his early principles as an illusionist decorator and favoured the full-scale illusion on the grounds that the artist should 'observe the true rule of perspective; that is to say placing the horizon at your level'. Even if complete agreement proved impossible, Bassi felt that he had been vindicated in his criticisms of Tibaldi's perspectival violations. He accordingly published his diatribe in 1572, supporting his arguments with references to such authorities as Euclid (especially), Witelo, Serlio and Barbaro. He also included his correspondence with the great and good.

A similarly ethical stance on the proper observance of perspectival rules was expressed during this period by the author of the Codex Huygens, whose identity has recently been confirmed as Carlo Urbino of Crema, a little-known painter from a North Italian background not dissimilar to Lomazzo's.[55] During the course of his analyses, Carlo Urbino makes an ingenious distinction between illusionistic foreshortenings shown 'with boundaries' and 'without boundaries'.[56] The method 'with boundaries' related the foreshortened figures directly to other spatial elements (normally architectural) in such a way as to tie them to the actual architecture of the setting (see pl. 142 below); while the method 'without boundaries' used the more ambiguous effect of free-floating figures and avoided any exact spatial reference to other forms (pl. 138). The former method was more demanding of perspectival expertise and therefore more admirable for the purists. As Lomazzo said, 'the location of figures comprises in my judgement all the substance and foundation of art'.[57]

The Codex Huygens is one of the more curious documents to have come out of the mid-sixteenth-century academic environment in North Italy. It is more in the nature of a studio notebook than a fully resolved treatise, and is not complete in the form in which it has survived. We should, therefore, be careful how we interpret the author's ideas. The drawings and analyses which Carlo Urbino has provided, particularly those concerned with proportions, motions and light and shade, stand in direct line of descent from Leonardo's Trattato, and one section of drawings appears to have been based directly on a series of lost folios from Leonardo's notebooks. The section which seems to relate least directly to Leonardo—that devoted to the foreshortening of the human figure from various angles—is the one which is of most interest to us in the present context.

Carlo Urbino does not appear to have been of a particularly learned frame of mind, but he had acquired enough knowledge of Euclid's Optics to be keenly concerned with the 'force of angles'.[58] His basic reasoning has already been encountered when we were looking at Leonardo's discussion of visual angles. If the eye looks at a line (AB in pl. 139), the bottom point (B) will appear further away since the arc AP represents points equidistant from the eye. He accordingly recom-

mends the avoidance of close viewpoints from which a figure would seem to be bent away from the spectator (pl. 140). At more distance viewpoints the curved base of the visual cone and the vertical plane of the object will more nearly coincide, minimising the problem.

When looking at objects above and below the spectator (pl. 141) a close position should also be avoided since the visual angle under which the objects are seen would at a certain point actually begin to diminish as the eye moves closer. The painter should select an optimum distance which would be adequate to minimise the problems but not so far away as to make the objects remote and indistinct. In practice this would mean that an illusionistic painter who wished to create the effect of a giant sitting above the spectator (pl. 142) should not select too sharp an angle: point 3 is thus to be preferred to point 1. However, for all the author's claims to geometrical precision, this demonstration as it stands is not wholly adequate. Firstly there is the problem we noted when discussing Dürer's technique of transformation; namely, that there is no perspectival diminution in the relative widths of the parts of the

138. Perspectival projection of a human figure 'without boundaries' by Carlo Urbino, from the Codex Huygens, Pierpont Morgan Library, New York, fol. 116r.

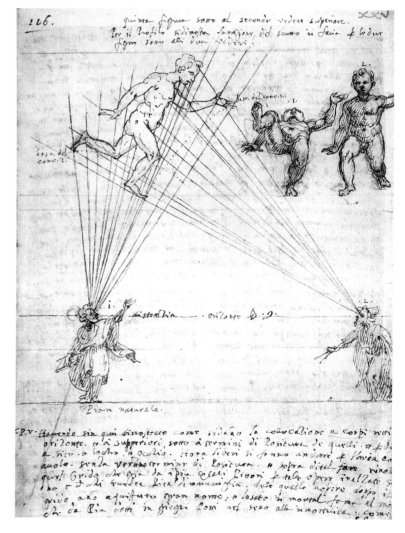

74

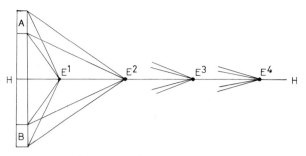

139. Demonstration of diminution and visual angles by Carlo Urbino (based on the *Codex Huygens*, fol. 98r).

E—observer AB—picture plane
1,2,3,—equal distances behind picture plane, on which equal verticals are erected
V—vanishing point

1,2 and 3 are joined to E. V is joined to B. The points of intersection provide the location for the verticals in projection to points C, D and F. The curved plane AP provides an accurate indication of the apparent sizes of the intervals between the verticals according to the visual angles they subtend.

140. Optically distorted human figure viewed from a short distance by Carlo Urbino, from the *Codex Huygens*, fol. 101r.

From the close viewpoint the figure will seem to be bent backwards as on left of the upper diagram. The more distant viewpoint in the lower diagram will result in less distortion.

141. Demonstration of diminution and visual angles for forms above and below the spectator by Carlo Urbino (based on the *Codex Huygens*, fol. 97r).

H/H—horizon E^1, E^2, E^3, E^4—alternative viewpoints
A,B—objects above and below the spectator

From the very close viewpoint at E^1, each object will subtend a smaller angle than from E^2, and will therefore appear smaller though nearer. The forms will appear successively smaller from E^3, E^4 etc.

142. Perspective rendering of a giant on a ceiling by Carlo Urbino, from the *Codex Huygens*, fol. 114r.

For the spectator at position 1 the curved base of the visual cone is labelled 1, and the effect will be as in the foreshortened figure 1.
For the spectator at position 3, the curved based of the visual cone is labelled 3, and the effect will be as in the foreshortened figure 3.

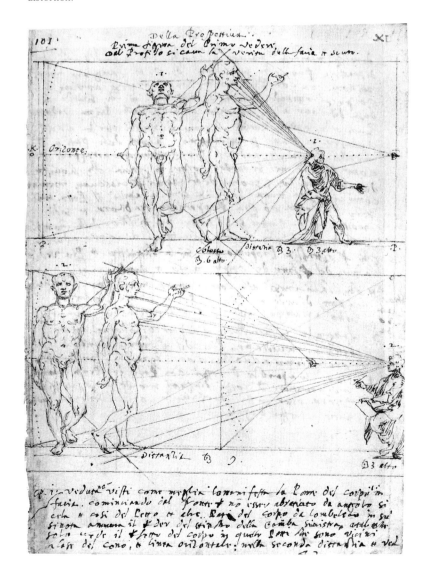

figure at greater depth. Secondly, there is no demonstration of the horizontal transcription of readings directly from his curved intersection to the final drawing. And thirdly, he does not show how he has coped with the intrusion of the figure's foot through the planes of intersection. The results are effective enough, but he does not fully live up either to his own claims or to the requirements of Lomazzo.

It is difficult to know whether Carlo Urbino is developing his own ideas or simply compiling a series of received opinions. Either way, the Codex does provide important evidence of the kind of discussions occasioned by the increasingly popular practice of illusionistic wall- and ceiling-decoration in the second half of the century. The seated figure is comparable to those by Sabbatini on Mascherino's Roman ceiling (pl. 135). Indeed, the motif of the leg kicked out above the viewer's head became something of a cliché in the illusionists' art. The Codex and Mascherino's ceiling also help to remind us that such painting was seen as having an intellectual significance beyond its obvious function as visual trickery on a grand scale. Mascherino and Laureti had been called to Rome by the Bolognese Pope, Gregory XIII, who not only brought with him a taste for the illusionistic ceilings of his home city but also a complementary interest in the geometrical sciences of astronomy, cartography and horology.[59] The Pope also imported the notable mathematician-cosmographer, Egnatio Danti, whom we will encounter shortly as a key theorist of perspective.[60] The subject-matter and formal properties of the painting in the Sala Bologna underline the intellectual associations. The figures represent astronomers, who contemplate the constellations on a *velarium* which is held taut by seated *putti*. Above and behind the astronomers are geometrical pergolas in perspectival configurations which are strongly reminiscent of the divisions of the globe as illustrated by Dürer and Barbaro. One of the walls below is decorated with the magnificent painted map or 'aerial view' of Bologna from which the room takes its name.

These associations make the point that in minds of Gregory XIII and Danti, and probably also of Mascherino himself, the science of perspective was deeply interwoven with techniques of cartographic projection, astronomical measurement and related procedures of terrestrial and cosmological geometry. These branches of practical mathematics, to which we will return in more detail, provide important elements in the background for the two major books on perspective published during this period, Daniele Barbaro's *La Pratica della perspettiva* and Egnatio Danti's own edition of Vignola's *Le Due regole*.

The other major element in the intellectual context for geometrical perspective in the second half of the century was the great flowering of Euclidian scholarship, which was accompanied by a greatly enriched knowledge of works by Archimedes and Ptolemy. The success of the humanist mathematicians in uncovering, clarifying, translating and providing commentaries on the major texts of the ancient authors should not be seen as peripheral to the scientific revolution. The mastery of the Greek and Latin texts was an essential stage in the attempt to 'surpass the ancients', and the extensive publishing of new and better-understood texts by the classical mathe-

maticians played an integral role in the founding of the 'new sciences'. Nowhere was this more apparent than in three-dimensional geometry. All the major theorists of geometrical perspective in Italy after 1550 were engaged in the search for the 'true' Euclid, in order to understand *and amplify* his exact science. Barbaro was involved largely as a patron, aiding the 1537 editions of Euclid's *Elements* and *Optics* by Giovanni Zamberto, to whom he in his turn credited his own knowledge of the mathematics of perspective.[61] The other theorists whom we are to encounter, Commandino, Danti and Benedetti, were themselves authors of commentaries on Euclidian science, to which they added highly developed interests in the practical mathematics of Archimedes and Ptolemy. Studies of Ptolemaic projection were central to the concerns of Commandino and Danti, as we will see, and became thoroughly enmeshed with the artists' science. Barbaro was the least professionally scientific of these authors, but he was no less conscious of the intellectual nexus within which perspective was situated. He was moved to include in his treatise sections on horology and the Ptolemaic projection of the celestial sphere into the planisphere: 'because it [the planisphere] appears to me to be founded on perspective, it seems reasonable to devote a part of my work to the practice of such a beautiful invention'.[62]

Daniele Barbaro, Patriarch-elect of Aquilea and Venetian patrician, was a considerable figure in aristocratic humanism and a notable patron. The villa on the Venetian mainland at Maser which he and his brother Marcantonio commissioned from Palladio remains one of the most delightful achievements of Renaissance architecture. Its interior received a series of brilliantly inventive, illusionistic frescoes by Veronese, which rival Giulio Romano's in spatial ingenuity while far surpassing in airy radiance of colour anything Giulio could achieve.[63] Daniele's passion for architecture is vividly apparent in his Italian and Latin editions of the *Ten Books* of Vitruvius, published with extensive commentaries in 1556 and 1567. His visual tastes, as we might expect, were thoroughly classicising and founded upon notions of proportional harmonies of form in time and space. He was less urgently concerned with the physical aspects of the phenomena than with their more abstract essences. Thus we find him expressing his delight in the pure forms of the regular solids, 'which for Plato signified the elements of the world and heaven itself, and by the secret intelligence of their forms we ascend to the highest speculations concerning the nature of things'.[64]

Within a few pages of the start of his book we have already been given references to Euclid, Ptolemy and Apollonius's writings on conic sections. He recognised that there were two aspects of optics: geometrical, from which the subject derives its 'reason'; and physical, concerning the nature of vision. However, like Alberti and Piero, he makes scant reference to the physical processes involved. Geometrical 'reason' is much more to his taste. Piero was in fact one of his major sources, in spite of his uncharacteristically mean comment that Piero's treatise was written for 'idiots'.[65] Like Piero, he leads into the subject via Euclidean geometry, giving simple definitions of angles and proportional divisions. His first technique of con-

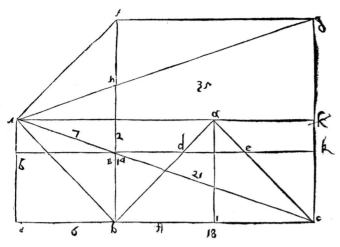

struction, which rapidly follows, can be readily recognised as deriving from the earlier treatise (pl. 143). On the foundation of the logically foreshortened plane he is able to erect a series of geometrical solids (pl. 144), which he also displays as flattened templates in the Dürer manner. He demonstrates relatively few of the constructional lines involved in the perspectival illustration of the bodies, but he does show the basic principles clearly enough. His second method, as we might expect from someone who has studied Piero and Dürer so closely, uses the full-scale technique of intersections on a plane from objects drawn in plan and elevation. The end product is a series of variations on the familiar *mazzocchio* theme (pl. 145). His most complex variations are less prolix and 'bizarre' than those of Jamnitzer, but the same kind of aesthetic and intellectual factors are at work.

Barbaro's section on 'scenography', devoted to the achiev-

143. Method for the perspectival projection of a square from Daniele Barbaro's *La Pratica della perspettiva*, Venice, 1569.

A square, bcdf, is foreshortened from viewpoint A as bced. The method is essentially the same as Piero della Francesca's in pl. 34 but with the addition of numbers, indicating diminution in the ratio of 3:1.

144. Perspectival projection of a truncated dodecahedron from Daniele Barbaro's *La Pratica della perspettiva*.

145. Perspectival projection of a stellated *mazzocchio* from Barbaro's *La Pratica della perspettiva*.

146. Projection of a celestial sphere from Barbaro's *La Pratica della perspettiva*.

ing of architectural illusions, is rather disappointing and clearly reflects his own lack of involvement with artistic practice. The most complex scenes he illustrates are the stage sets taken from Serlio (pl. 120). He is clearly much more at ease when he is describing his techniques for the projection of a celestial sphere (pl. 146) and the optical geometry of a sundial. The continuity of the latter with the artist's science of shadow projection, which he illustrates in Dürer's form, hardly needs to be emphasised. Dürer also provides the source for his parallel transformation of the human head, which he seems to assume is fully perspectival, and also for a rather inelegant illustration of a perspective machine.

Barbaro's efforts are dedicated to the construction of works of art and other artefacts which mirror the geometrical structures behind natural forms—as comprehended by the proportional procedures of sight. His use of the camera obscura, which will be discussed in Chapter IV, is not so much devoted to the literal recording of natural appearance as to the demonstration of 'the proportional diminution of objects' so

as 'to help us in every way to formulate the precepts of art'.[66] Also deeply symptomatic of this taste for geometrical rule is his unpublished manuscript treatise, *La Practica della prospettiva*, which centres upon the constructive geometry of the regular bodies in a more comprehensive manner than had been possible in the third section of his printed book.[67]

Rather oddly, for a patron of art, he shows little direct evidence of contact with artistic practice, not even with that of Veronese whose techniques he had every opportunity to observe. He simply seems to dismiss contemporary artists' understanding of perspective when he states that they 'are content with a simple procedure (*semplice pratica*)' which misses the true divinity of geometry.[68] A strong and surprising contrast is provided by Egnatio Danti, a professional mathematician whom we might expect to be rather remote from practical concerns, but who shows himself to be fully conversant with important aspects of contemporary practice. It would be all too easy to characterise Danti's commentary on the 'Two Rules' of Vignola as the grafting of complex mathematics onto the practical roots of an artist's procedure, but to do so would be to underrate the sophisticated strength of both men's work and to distort the character of a book which is far more original and searching than Barbaro's pleasing compendium.

Danti seems to me to be a figure of considerable stature, who is so relatively little known that it is worth giving some details of his careeer to make sense of his activities in the world of art.[69] His Perugian family was richly endowed with artists of intellectual ambition. His brother Vincenzo followed a distinguished career as a sculptor and planned a major treatise of fifteen books, of which only the first is now known.[70] His father and grandfather were both goldsmith-architects who were involved in literary activity. His grandfather's Italian translation of Sacrobosco's *Sphere* was later published by Egnatio.[71] His aunt Teodora is recorded as having written a work on Euclid's *Elements* and a treatise on art. Of this family output only a disappointing fraction survives. Egnatio, however, was an active publisher, and has to his credit nine printed books, including original compositions, editions with important commentaries and influential translations.

He first came into prominence in the early 1560s under the patronage of Cosimo I in Florence, where he was employed to design showpiece maps and a great terrestrial globe for the Grand Duke's room of cosmological wonders. Danti's considerable skills also provided Cosimo with the means by which to take up Leo X's ambitious plan to reform the Julian calendar, which was by that time eleven days out of step with the spring equinox and the vernal solstice. Danti embarked on the construction of a splendid quadrant on the façade of S. Maria Novella and a gnomon for tracing the path of the sun on the floor of the church.[72] This scheme was cut short by the death of his patron in 1574 and his own departure for Bologna a little over a year later. He stayed in Bologna for only three years, but that city was to play a crucial role in his career. While there, he created a further gnomon in S. Petronio and was able to make substantially accurate observations of the spring equinox, which he duly published.[73] He also published his *Le Scienze mathematiche ridotte in tavole*, a cleverly com-

78

pressed compendium of mathematical learning which contains a tabular summary of his brother's fifteen books, and his *Anemographia*, a treatise on a classically-inspired mechanism for the gauging of wind.[74] And, most importantly from our present point of view, he struck up apparently fruitful relationships with the resident school of illusionist decorators, most notably Laureti and Mascherino, who were to precede him to Rome. His contacts in Bologna also led to his acquaintance with the son of Vignola, who encouraged the mathematician to publish his late father's perspective treatise.

When Danti himself moved to Rome in 1580 as Papal astronomer at the request of Gregory XIII, he was well equipped for the role he was to play in the Bolognese 'mafia' which had gathered around the Pope. In addition to his proven abilities as a mathematician-astronomer, he had already shown his expertise in visual science in the commentary he provided when he translated Euclid's *Optics* into Italian in 1573.[75] He rapidly became involved in a series of projects which exploited his range of talents. He was commissioned to design a splendid series of maps of Italy and the Papal dominions in the Galleria delle Carte Geografiche, which had been constructed by Mascherino. The project which perhaps best exemplifies his activities is the Torre dei Venti, containing a suite of rooms of relatively modest dimensions with open loggias commanding fine views over the Belvedere courtyard and beyond. The tower was built by Mascherino before Danti's arrival, but it was from the first conceived as being dedicated to the reform of the calendar which Gregory had taken over from Cosimo and for which the Pope was establishing an impressive team of astronomers.[76] Naturally this space came to fall within the purview of Danti, and he exercised a shaping role over its decoration, devising a rich series of theological and secular motifs which relate to studies of the heavens, earth, seasons and winds. The key room is the Sala della Meridiana, on the floor of which is the meridian line—accurate to 1°10′—established by Danti in connection with the revising of the calendar. On the ceiling (pl. 147) is a wind rose and the dial of his anemoscope, surrounded by airborne figures personifying the winds and illusionistic architecture painted by Cristoforo Roncalli (Pomarancio), perhaps with the assistance of collaborators. Following wide consultations, the reformed calendar was instituted by Gregory in 1582 and still bears the Pope's name. Although Danti himself was not to be the actual author of the final scheme, he was very much at the heart of the successful endeavour.

This relatively lengthy diversion will I hope have helped illuminate the background to the commentary on Vignola's perspective rules which Danti published in 1583, three years before his own death. Vignola, who had died ten years before the publication of the commentary was famous in his own right. Having begun his career in Bologna as a painter, he developed into a productive and influential architect of secular and ecclesiastical buildings. His main Roman church, Il Gesù, established a model which was to be followed more widely than any other during the next century. All his work was characterised by compositional clarity and rigorous control of visual effects, qualities which are fully apparent in his own

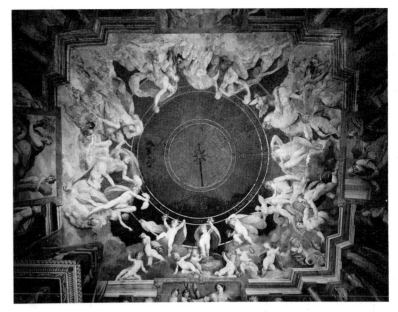

147. *Wind rose with allegories of the winds and seasons, c.1581, Vatican, Torre dei Venti, Sala della Meridiana.*

publication of the *Five Orders*.[77] His sections of *Le Due regole* show him not only to be in full control of the constructional procedures but also to have a more than elementary grasp of its underlying mathematics. Danti's respect for Vignola's text is obvious, and he faithfully retained the basic order and shape of the original treatise.

Danti's commentary considerably exceeds in length the basic text, and explores the implications of Vignola's theories in a wide-ranging manner. His comments embrace the opthalmological, optical and mathematical aspects of perspective. As we might expect from a former commentator on Euclid's *Optics*, he pays particular attention to the Euclidean connotations of the basic propositions with which Vignola opens his treatise. But it would be wrong to suggest that Danti's contributions were all concerned with the more theoretical aspects of the painter's science. He contributed on his own account perceptive observations on practical procedures, perspective machines and the contemporary practice of named masters. In all this he appears to have been scrupulous in acknowledging his sources, and he makes it quite clear to the reader which sections belong to Vignola's text and which are his own commentary. It is possible to make a similar separation of the illustrative material. The more elaborate and 'pictorial' engravings by Cherubino Alberti seem to have been based directly on the architect's drawings, while the less refined, woodcut illustrations appear to have been conceived by Danti himself.[78]

A good example of how Danti proceeded is provided by his discussion of the structure and functioning of the eye. Vignola's simple proposition that 'the centre of the eye is the centre of the crystalline humour' provides an opportunity for Danti to inform the reader of the latest ideas on the subject. Referring to a now lost section of his brother's treatise, he notes that the Spanish anatomist, Valverde, had shown (following Realdo Colombo) that the crystalline humour was lens-shaped and

148. Anatomy of the human eye according to Egnatio Danti, from Vignola's *Le Due regole*, Rome, 1583.

D/D—pupil P/P—'crystalline humour'
Q—'aqueous humour' Z—optic nerve

149. Demonstration of the visual field in relation to viewing distance and angle by Egnatio Danti (based on Vignola's *Le Due regole*).

ABCD—picture V—vanishing point
E—observer

From E the visual field represented by the Circle R¹ will encompass the whole picture. From too close a point, it will not encompass the picture, as in R².

150. Demonstration of the basis for perspective construction by Vignola, showing the Five '*termini*', from *Le Due regole*.

CAE—picture plane
F—object of known dimensions to be foreshortened (a cube)
1) CF—viewing distance (also AB)
2) BF—viewing height (also AC)
3) AD—distance of object behind the plane
4) ghID—dimensions of the object
5) AE—lateral distance of object from the central axis

151. Demonstration of the principles of perspective of parallel lines with a vanishing point at I by Egnatio Danti from Vignola's *Le Due regole*.

K—observer EFCD—picture plane
AD and BC project to DG and CH respectively.

152. Tommaso Laureti's device for the demonstration of perspective as illustrated by Egnatio Danti in Vignola's *Le Due regole*.

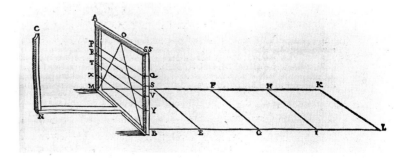

was located near the front of the eye (pl. 148), in contrast to the traditional view of Vesalius. He deals at length and effectively with the question as to whether light comes into the eye or is emitted from the eye in the form of 'seeing rays', as many in the succession of Euclid believed.[79] The problem of binocular vision is also addressed, since it provides obvious problems for the artist's system. Arguing traditionally that the two images come together at the junction of the optic nerves and are effectively seen as one, he is able to minimise the problem if not to eliminate it altogether. He is also able to circumscribe the problem of the mobile eye, by stating that the painter shows what is visible only in a single opening of a fixed eye. This formula, he argues on anatomical grounds, limits the proper visual angle for a painting to two-thirds of a right angle.[80] Later in his commentary he amplifies this with a careful discussion of the proper viewing distance, which must be of adequate length to take in all the picture in a single glance. When the vanishing point is located at the edge of the picture or beyond, the painter must be particularly careful, since a longer than normal distance will be required (pl. 149). To ascertain the truth of such assertions, Danti emphasises that it is necessary to 'examine the eye minutely'.[81]

The central purpose of the original treatise and of the commentary remains the analysis of the 'two rules', showing the essential consistency between them. These rules correspond to the two methods with which we are now well familiar: the full-scale technique of intersections on a picture plane; and the distance point (or *tiers points*) construction. Vignola indicates that his purpose is to clear up the confusion caused by the partisans of each method, who have claimed that one method alone is correct.[82] By subjecting both methods to close analysis and parallel demonstrations, Vignola is able to show that both are accurate and useful in their own particular ways.

The intersection system is the first to be analysed. Vignola establishes his definitions with notable clarity, in particular what he calls the five *termini*. These are (referring to pl. 150): the distance of the plane from the spectator (AB); the height of the viewpoint and axis of sight (FC); the horizontal location of the seen object on the ground plane relative to this axis and picture plane (AE); the distance of the object behind the picture plane (AD); and the dimensions of the object itself (F). This basic situation is subject to careful analysis by Vignola and Danti, and illustrated in a variety of diagrams ranging from flat geometry to three dimensional 'pictures'.

One of Danti's diagrams is particularly significant (pl. 151). It relates closely to a perspective machine which he attributed to Laureti (pl. 152) and was to become one of the key demonstrations for subsequent mathematicians of perspective, including Guidobaldo del Monte, Simon Stevin and François d'Aguilon. This diagram and its derivatives provide perhaps the most graphic means of illustrating the convergence of parallels to a point.

Vignola's subsequent demonstration of the distance-point method is accomplished in such a way as to show how it corresponds to the intersection technique (pl. 153). He is also able to show how it can be applied to the depiction of a cube (pl. 154), using the diagonals in relation to four 'distance points'.

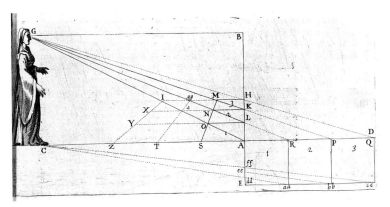

153. Demonstration of the correspondence between the intersection and distance-point methods by Vignola from *Le Due regole*.

The construction to the right of BAE corresponds to the intersection method. The construction to the left of BAE corresponds to the distance point method.

During the course of his accompanying comments Danti accurately shows the errors of Serlio, noting in passing that his father was on the best of terms with Baldassare Peruzzi, whose ideas Serlio attempted to follow and who was one of the instructors of Vignola.[83] Like Cousin, whose treatise Danti listed in his introductory review, Vignola is able to adapt dis-

154. Perspectival projection of a cube from Vignola's *Le Due regole*.

A—'vanishing point' of sides of cube
B, C, D, E—'distance points' for the diagonals through the sides of the cube

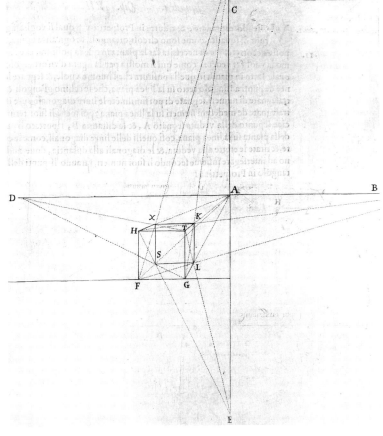

tance point method to the projection of any given point or points on a plane (pl. 155), and therefore by extension to a plan of any given shape. Vignola had invented a neat technique for accomplishing this projection with two rulers, one pivoted at the distance point and the other at the vanishing point (pl. 156). This obviates the need to draw all the constructional lines on the surface of the design, which 'would make much confusion'—a sentiment with which the reader will no doubt sympathise.[84]

Danti's own contributions to the practical aspects of the instruction include discussions of the kind of visual tricks which were increasingly popular, including anamorphic paintings and the fragmentation of an image into facets which can be optically reassembled with the aid of a mirror. We will be looking at these kinds of devices in Chapter IV, in addition to the perspective machines illustrated by both authors, including one which was intended to solve the problem of curvilinear perspective.[85] He also makes telling references to works by actual artists, including Vignola himself, Peruzzi, Laureti (whose Palazzo Vizzani ceiling he illustrates; pl. 133), and Giovanni Alberti, brother of the Cherubino who provided engravings for the book. The Alberti brothers were members of the younger generation of illusionistic decorators who were to carry the techniques of Danti and the Bolognese circle into the next century.[86] One artist whom he seems to have regarded particularly warmly was Mascherino, whose Sala Bologna ceiling (pls. 134–5) he much enjoyed—though he noted in passing that the nice conceit of illustrating the constellations on an oval velarium did not correspond mathematically to the projection of the heavens on a flat plane.[87]

Danti also included a sensible and informative section on the perspectival decoration of vaults, an achievement he greatly

155. Projection of the vertices of an octagon, from Vignola's *Le Due regole*.

lower diagram—points 8, 1, 6, 5 etc are projected both vertically and at 45° on to the plane EF

upper diagram—the projected points are joined respectively to the 'vanishing point' at A and the lateral distance point. The intersection of the lines gives the required locations of the vertices.

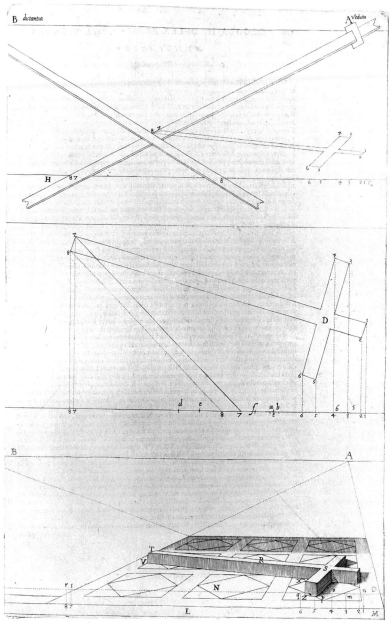

156. Device for drawing a given form in perspective projection by Vignola, from *Le Due regole*.

The procedure is as in pl. 155 with one ruler pivotted on the 'vanishing point' at A and the other on the 'distance point' at B.

admired, since 'this is absolutely the most difficult operation that can be undertaken by the perspectivist'.[88] He explains how the basic technique by intersection can be used to achieve the necessary projection on a curved surface (pl. 157), but recognises that the problems created by vaults of varied and even irregular shape made it difficult to advocate one universal method. He recommended that plumb lines and horizontals be used to check the constructions, if necessary by attaching a full-scale cartoon to the vault to see if the scheme is working properly.

Considered as a whole, *Le Due regole* was the most intelligent, useful and thoroughly informative book on perspective

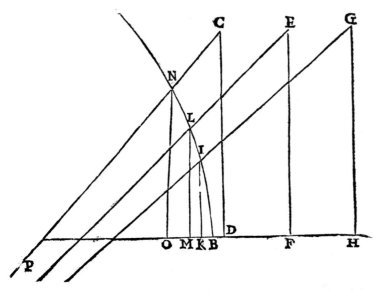

157. Perspectival projection of architectural elements on to a curved vault by Egnatio Danti in Vignola's *Le Due regole*.

The lines of the verticals CD, EF and GH as seen from point P (off the page) are projected on to the curved vault at N, L and I respectively.

construction to have appeared by that date, and it can well sustain comparison with any later books which attempt a balance of practical procedures and mathematical analysis. If the practising artist wanted a succinct outline of the basic construction, he could quickly gain this by concentrating on the illustrations of the two rules. If a mathematician wanted to follow up the implications of the artist's science, Danti would lead him informatively through the various issues.

Certainly none of the increasingly numerous treatises which emanated from the circles of the newly formed art academies in the last quarter of the century approach its clarity and completeness of exposition. These treatises are often less concerned with technical questions of perspective design than with the rhetorical promotion of the visual arts in social, literary, philosophical and theological contexts. Some of these reflect the less attractive side of humanist writing—windy, repetitive, sophistic, inflated with classical citations and bursting with self-importance. It would be wrong to suggest, however, that perspective was rejected during this period, and one artist in particular addressed the relationship of painting to visual science in a sustained, intense and partly novel manner. This artist was Giovanni Paolo Lomazzo, whom we have already briefly met as the stern moralist of illusionistic foreshortening.

Failing eyesight had cut short Lomazzo's promising career as a painter at the age of thirty-three, but this did nothing to hinder the theoretical activities which he undertook on an intellectual scale unmatched by any artist since Leonardo. His philosophy of art is contained in two closely related treatises, the *Trattato dell'arte della pittura, scoltura et architettura* and the *Idea del tempio della pittura*, published in Milan in 1584 and 1590 respectively.[89] A broader examination of the great edifice of knowledge which he attempted to construct around painting will be made when we look at his theories of colour in Chapter V. For the moment we should note that perspective was one of

what he designated as the seven 'principal parts' of painting, and was the most highly-ranked of its five 'theories'.

His insistence upon the proper mathematical procedures in foreshortening the human figure has already given us some idea of the flavour of his writing on perspective. The discipline of geometry for Lomazzo was deeply embedded in the metaphysical and cosmological structures he saw as ultimately responsible for all natural effects, and we will not be surprised to find him espousing the Platonic system of the elements. The proportions of man, to which he devotes elaborate attention, exhibit microcosmic reflections of these cosmic patterns.[90] Although the centre of his theory involves a high degree of cosmological abstraction, he is insistent that the access to true wisdom is via the eye, and does not involve the bypassing of the 'erring' senses, as some of the mystical philosophers had suggested.[91] The judgement of the eye and the intellect acted in complete concert for Lomazzo.

The only way for the artist to achieve results which would satisfy the rigour of educated judgement would be through a strict mastery of the science of art. Michelangelo's insistence on the necessity of the artist using 'the compasses in the eye' rather than resorting to mathematical procedures gave Lomazzo some trouble.[92] Like so many of his contemporaries, he assigned a god-like status to Michelangelo, and was clearly uncomfortable with an attitude which seemed to conflict with his methods. His answer—and it is not entirely satisfactory— is to say that Michelangelo's judgement was so deeply schooled in the rules that they had become integral parts of his creative nature.

It is in keeping with the mystical tenor of Lomazzo's philosophy that he was attracted by the ancient extramission theory of vision which stated that the eye operated by the emission of rays from the eye: 'the rays of sight are those which, departing from the eye, come to adopt all the particulars of the object. . . returning to the eye by the direct path whence they departed'.[93] These 'seeing rays' mingle with the external light, conveying its characteristics to the eye. The source for his discussion of the rival theories of vision was Egnatio Danti's commentary on Euclid's *Optics*, but Lomazzo's standpoint was quite different from Danti's. Lomazzo was heavily predisposed to accept the power of vision as the active, incorporeal, 'spiritual' agent of visual judgement, rather than adopting a system in which the eye merely acts as an optical receptor for rays generated by external agents.

Lomazzo was an inveterate namer, orderer and classifier, in a late scholastic manner, and this is nowhere more obvious than in his treatment of perspective. He begins with a three-part division into *ottica* (sight), *sciagrafia* (shadows) and *specularia* (reflections).[94] Sight is then subdivided into *fisiologia* (the physical processes of sight) and *grammica* (the optical rules of vision). *Fisiologia* in turn consists of three parts: direct, reflected and refracted vision. *Grammica*, with which he is most directly concerned, has two main branches: *viste reali* (the rules governing vision in nature) and *viste mentite* (the rules governing illusory depiction in art). In considering the vision of real things, he explains that there are three main viewpoints: from below the seen objects (which he calls *anoptica*), on a level

158. Diagram of Lomazzo's definitions of six kinds of viewpoint for illusionistic painting, based on his *Trattato*. . . , Milan, 1584.

E—observer
1—directly above the observer on a ceiling
2—diagonally above the observer on a ceiling
3—diagonally above the observer on an angled vault
4—above the observer on a wall
5—on a level with the observer on a wall
6—below the observer on a wall
7—below the observer on the ground

eclectic, combining elements from Alberti, Piero (probably via Barbaro) and Dürer, with some additional complexities of his own devising. He enters the discussion through an outline of human proportions, as an elaboration of the module which provided Alberti's starting point. He then unexpectedly turns for his founding demonstration to a perspective machine of the Dürer type, using his own system of numbered coordinates to affect the transfer of readings on the intersecting plane to the surface of the drawing. The advantage for Lomazzo of beginning with a perspective machine is that it provides a concrete demonstration of the path of the rays in a tangible and 'experimental' manner rather than relying upon an arbitrary recipe of a more abstractly geometrical kind. This is his 'way of demonstrating natural proportions according to the vision of the eye'. This is followed by his account of a geometrical construction of an Alberti-Piero-Barbaro kind, in which the role of the intersecting plane is strongly emphasised as the key to the recording of proportional relationships.

He subsequently uses this base to address a range of different problems, including the illusionistic painting of vaults, in which he himself had earlier achieved some success using geometrical methods of foreshortening. His drawings show that he exploited the box-like schematisation (*quadratura*) of the human figure with which we are familiar (pl. 159).[97] He also gives methods for the construction of regular bodies and architectural features in the Barbaro manner, for the treatment of low relief, for the painting of stage scenery, for the portrayal of a colossus and for anamorphic images of the kind invented by Leonardo.

His purely verbal account of perspective, written by a blind or virtually blind artist, is in many ways a heroic effort, but I think it is fair to doubt if the detailed instructions would have been read by anyone with much enthusiasm. A non-painter, I suspect, would soon drop out, while an artist requiring a course of ready instruction would benefit far more by consulting the illustrated texts of Barbaro and Danti.

There was also a growing sense, by the time Lomazzo's books were published, that this measure of technical elaboration was missing the true point of artistic endeavour. This issue did not just concern the problem that the mathematics had become tiresomely complex for many painters but it also involved the more fundamental matter of the relationship between the artist's inventive power and the obedient following of absolute rule. Michelangelo's reliance upon the 'compasses in the eye' and his scathing remarks about Dürer's exhaustive efforts to codify proportions fitted ill with the mathematical procedures of Barbaro, Danti and Lomazzo.[98] No artist or theorist seems to have gone so far as to deny that linear perspective was a necessary tool for the painter, but some influential voices were being raised to the effect that perspective was not the 'foundation' of art as it had been for some earlier theorists.

The most eloquent spokesman for this point of view was Federigo Zuccaro. The basis of art for Zuccaro certainly was not the doctrinaire science of nature, but what he called *disegno interno*—an inventive capacity of the mind which operated parallel to and in concert with the divine system of nature in

with them (*ottica*) and from above (*catoptica*). The names he assigns to these three viewpoints have been taken as characteristic examples of Lomazzo's ability of transpose earlier ideas—in this case from mediaeval optics—into inappropriate frames of reference. However, his terms are drawn either directly from Pomponius Gauricus or via an encyclopaedic compilation of ancient and modern learning by Ludovico Ricchieri (Rhodoginus).[95] When he comes to the main subject of his discourse, the illusory effects of art, his three varieties of viewpoint have been increased to six, which I have for convenience illustrated in the accompanying diagram (pl. 158). It cannot be denied that all this categorisation is rather ponderous and taxes the modern reader's patience, but it is an essential part of Lomazzo's attempt to provide painting with an intellectual structure to bear comparison with that of any academic discipline.

His detailed instructions on the achieving of perspectival effects are contained in the part of his *Trattato* dedicated to 'practice'.[96] It is in this section that the lack of illustrations is most keenly felt. Reading his instructions is rather like listening to someone trying to describe a spiral staircase without the aid of illustrations or gestures. I confess that I am personally far from certain as to what he means at various points, but the general character of his techniques is reasonably clear. His approach, typically for the theorist of the period, is elaborately

159. Giovanni Paolo Lomazzo, Schematic figure-study of a prophet for the vault of S. Marco, Milan, 1570, Princeton, University Art Museum.

order to give visible form to the concepts originating from the artist's cerebral faculties. The 'ideas' of the artist were viewed by Zuccaro within a complex system of sense, fantasy, imagination and rational speculation which owed more to Thomas Aquinas and mediaeval faculty psychology than to the Neoplatonism often adduced as the source for his theory. The 'ideas' were communicated through illusion, in that art 'is the mirror of holy nature, a true portrait of all the *concetti* that may be imagined by force of light and shade on a plane covered with colours. The plane shows every sort of form and relief without the substance of a body—a work not susceptible to the sense of touch, a practice more divine than human'.[99]

Earlier theories, even at their most idealising and abstractly geometrical, all had recourse to the mathematical 'roots in nature'—to use Alberti's phrase. Zuccaro's artistic 'roots' lay incontrovertibly elsewhere:

> I say strongly, and I know I say the truth, that the art of painting does not derive its principles from the mathematical sciences and has no need of recourse to them to learn the rules and means for its practice; for art is not the daughter of mathematics but of nature and design. . . If you wish to attempt to investigate all things and to understand them by means of theory and mathematics, working in conformity with them, this would be intolerably prolix and would represent a waste of time with no prospect of fruitful results.[100]

The painter's powers of conception must not be 'fettered by mechanical dependence on artificial rules'—a criticism he aims directly at Dürer and Leonardo. A few lines later Zuccaro appropriately quotes his brother Taddeo's paraphrase of Michelangelo's famous dictum about the 'compasses in the eye'.[101] Lomazzo had earlier gone a long way, particularly in his later treatise, towards embracing the 'idea' as the central concept in artistic invention, but Zuccaro's overt devaluation of the mathematical foundations would have been unacceptable to Lomazzo.

This is not to say that Zuccaro rejected perspective and geometrical proportions as valid means of communicating natural effects to the external and internal senses, but rather that he saw the source and ultimate end of art as residing in the inner stimulation of divine ideas, which stood over and above the pedantry of calculation. His own practice as a painter actually reflects a notable grasp of perspectival construction, and he was well capable of devising illusionistic schemes to rival those of his Bolognese predecessors.[102] But for Zuccaro such sensory illusions were, in theory at least, to be regarded as the visual vehicles of the 'forms' which had arisen as sparks of divine inspiration within the creative intellect.

An additional factor which weighed against the conception of art as a mathematical science of natural appearance, and most definitely against virtuoso perspective effects, was the implementation of Counter-Reformation requirements in ecclesiastical commissions. The demands of the Catholic reformers brought a renewed insistence on theological ends over and above the artistic means. The artist's primary function was to manifest divine form and meaning in a direct manner without overt demonstrations of self-conscious artistry such as foreshortenings and illusionistic tricks.

In the next chapter we will underline the strong sense of continuity in Italian perspective theory, but this tended to be temporarily obscured by precepts which placed the main emphasis elsewhere. The criticism of the traditional perspective science which arose in some of the leading circles in Italy coincided with the drawing away of certain aspects of perspective science itself from the practice of art. Even in the writings of Danti, who did maintain fruitful contact with pictorial practice, we may sense that the mathematical ramifications of perspective were being extended beyond the needs and even the understanding of most practitioners. Three of Danti's fellow mathematicians moved even further in this direction. With the treatises of Commandino, Benedetti and Guidobaldo del

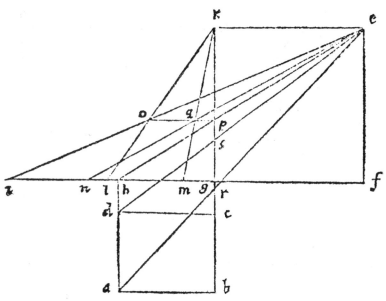

160. Federigo Commandino's first method of perspectival projection of a square, from *Ptolomaei planisphaerium*, Venice, 1558.

e—eye abcd—square to be foreshortened
f—location of viewer on ground plane

a, b, c and d are transferred to i, l, m and n respectively; i, n and h are joined to e; l and m are joined to k; pqo is drawn parallel to if; oqml is the projected square.

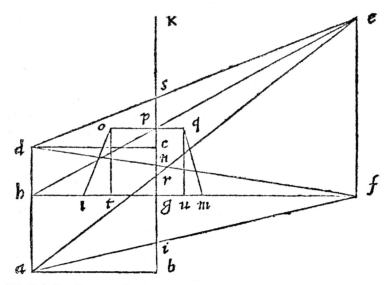

161. Federigo Commandino's second method, from *Ptolomaei planisphaerium*.

C and b are transferred to m and l respectively; h is joined to e; a and d are joined to f; i and n are transferred to u and t; verticals are raised from u and t to meet the horizontal through p; oqml is the projected square.

Monte we see the birth of projective geometry as a discipline in its own right, related to but increasingly separate from the painters' science in its means and ends.

We have already seen the way in which Barbaro and Danti had brought perspective into the orbit of Ptolemaic projection. A far more complete integration had been accomplished by Federigo Commandino as early as 1558 in the commentary he provided for his editions of Ptolemy's and Jordanus's treatises on the *Planisphere*.[103] The planisphere, in its form as an astrolabe, was the most popular astronomical instrument of the

Middle Ages and Renaissance. Its construction involved the projection of the orbs of a celestial sphere on to a plane (pl. 146), using the south celestial pole as the centre of projection. Recognising that the principles involved were related to 'scenographic' (illusionistic) perspective, Commandino resolved the problems posed in Ptolemy's text by reference to the geometry of perspective projection on to a plane from a given viewpoint. His two basic constructions (pls. 160–1) clearly bear some relation to the painters' methods, but translate them into uncompromisingly geometrical terms.[104] Indeed, his assumed audience was that of mathematician-astronomers rather than artists or general readers. His projective techniques rely upon the transfer of the salient dimensions of the figure to be projected on to the base lines of his constructions (fi in pl. 160 and fh in pl. 161), in a manner which can be readily correlated with Cousin's procedure (pl. 125). This means that the resemblance of his first method to the Albertian construction is less close than might at first seem the case. His second method shares some important features with the Piero technique of perspective by intersections, but Commandino's actual presentation is markedly different and less obviously 'pictorial' in intention.

On this base he tackles a number of problems, including the tilting of the plane on which the original figure is situated, and the projection of regular polygons inscribed in circles (pl. 162). This latter problem is obviously related to the requirements of astronomical projection, and is closely associated with the general problem of conic sections which he was to take up in his commentary on Apollonius's *Conics*.[105] The close interweaving of these perspectival and astronomical aspects of three-dimensional geometry can be seen in his edition of and commentary on Ptolemy's *Analemma*, published in 1563 as a natural companion to his *Planisphere*.[106] The *Analemma* uses orthographic projection—parallel projection on to a perpendicular plane—to determine the position of the sun at any given moment and thus to provide the basis for the geometrical construction of sundials. In the *Analemma* we find Commandino making reference to Dürer's work on conics, and providing a series of three-dimensional diagrams drawn with considerable perspectival skill to illustrate such questions as the elliptical configuration of an inclined circle in orthographic projection (pl. 163).[107]

Commandino's treatise on the *Planisphere* provides the first signs of what was to become a characteristic feature of perspective science in the hands of professional mathematicians in the late Renaissance. This feature is the concern with the underlying principles, geometrical proofs and the general case rather than with the more descriptive application of perspectival methods to the portrayal of diverse forms on planes. This tends to give their texts succinctness and a level of abstraction which would have been forbidding to non-mathematicians. Barbaro described Commandino's techniques as 'obscure and difficult' for the non-specialist.[108] Nowhere is this tendency more in evidence than in the terse, condensed and unyieldingly mathematical treatise on perspective which occupied twenty-two pages of Giovanni Battista Benedetti's *Diversarum speculationum mathematicarum et philosophicarum liber* (*Book of Various*

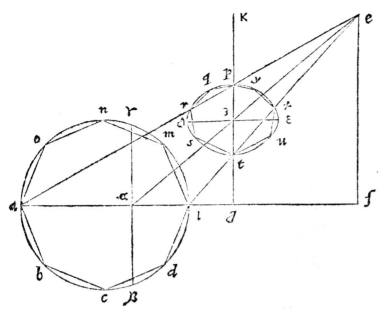

162. Perspectival projection of an inscribed octagon from Commandino's *Ptolomaei planisphaerium.*

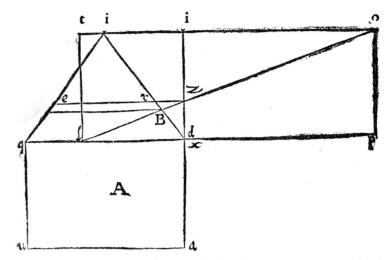

164. Perspective projection of a rectangle from Giovanni Battista Benedetti's *Diversarum speculationum mathematicarum. . .*, Turin, 1585.

The point Z, marking the intersection of the ray to the eye (o) from l on the picture plane (id) gives the correct location for the rear edge of the rectangle. Point B gives a false position.

163. Elliptical projection of a circle inclined to a plane from Commandino's *Claudii Ptolomaei liber de analemmate*, Rome, 1563.

Mathematical and Physical Speculations), published in 1585.[109] Benedetti was a mathematician-physicist of considerable intellectual power who conducted innovatory investigations in a number of fields, including the science of falling bodies and the geometrical-cum-physical definition of musical harmonies.[110] His innovations do not generally seem to have made the impact their quality warranted—perhaps his lengthy residence at the court of Savoy removed him from the mainstream of scientific debate—and his treatise on perspective is important for its intrinsic merits rather than for any widespread influence.

Benedetti begins by noting, in his characteristically austere manner, that the topic of perspective has given rise to more disputes than agreements. He pointed to the uncertainty as to whether the proper projection of the rectangle A (pl. 164) should be accomplished using the intersections at B or at Z, which we can recognise as belonging to the distance-point and intersection methods respectively. He may well have been aware of the muddle Serlio had perpetrated in his second book on architecture, since a later part of his treatise is specifically addressed to an architect, Jacobo Soldato, who was employed at the court of Savoy.[111] His knowledge of the distance-point construction could also have come from the *Livre* of Jean Cousin, one of whose techniques fell under Benedetti's analytically critical eye later in the treatise.[112]

Benedetti's solution is to produce a skeletal, three-dimensional diagram (pl. 165) which shows incontrovertibly that point I from a centre of projection at O projects to Z on a vertical plane above qd. This illustration gives a fine sense of the structures involved in the geometrical projection, but does not depend upon any discussion of the physical processes involved in vision. Nor does it make any concession to a painter's needs; it is orientated vertically and does not define the intersecting plane as a rectilinear surface (i.e. as a 'picture plane')

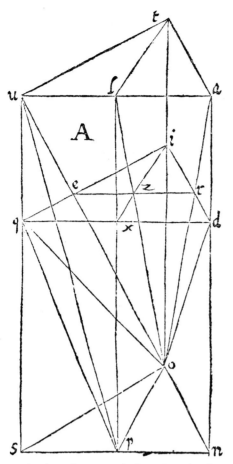

165. Perspective projection of a rectangle from Benedetti's *Diversarum speculationum mathematicarum. . .*

uadnsqu—ground plane uadq—rectangle
P—station point of the 'observer' o—'observer's' eye
l projects to z, u to e and a to r.

167. Perspective projection of a given point from Benedetti's *Diversarum speculationum mathematicarum. . .*

erdq—the rectangle K in perspective b—the given point
i—'vanishing point'

Draw ubf and qbg; qn = ug; join ni to cross er at c; join qc and fe; t = the point b, as projected.

166. Perspective projection of a rectangle on to a skewed picture plane from Benedetti's *Diversarum speculationum mathematicarium. . .*

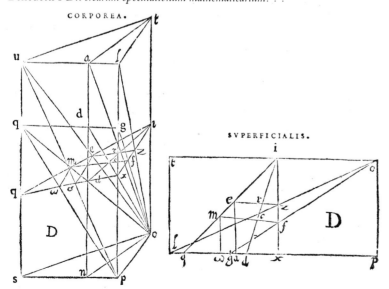

independently of the triangular configuration required by the construction itself.

In a similar way, his subsequent analysis of a rectangle projected on to a skewed plane (pl. 166), and his rotation of the object and subject planes into each other are innovatory in geometrical terms, but reverse the painter's normal priority of maintaining the regular orientation of the picture plane both to the axis of vision and to the ground plane. Somewhat closer to traditional concerns are his methods for the transfer of any given point on a plane to its foreshortened equivalent. One of these proposes a splendidly succinct technique using two diagonals which intersect at the equivalent point on both planes (pl. 167). In Chapter IV we will see that his own perspective device is comparably economical in its geometrical and technical means.

The setting of Benedetti's exposition of perspective in his *Diversarum Speculationum. . .* confirms the intellectual context into which perspective was being drawn. The other treatises and letters published in his book deal with such matters as the arithmetical analysis of geometrical figures, mechanics, Eucli-

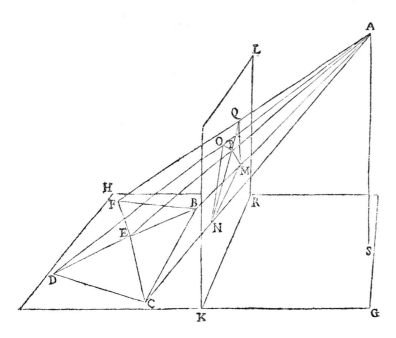

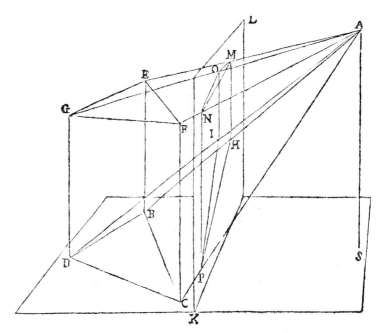

168. Perspective projection of a geometrical figure from Guidobaldo del Monte's *Perspectivae libri sex*, Pesaro, 1600.

FBCDE—figure to be projected
A—observer's eye
QMNO—figure in projection

S—station point of observer
KL—picture plane

169. Perspective projection of a solid body from Guidobaldo's *Perspectivae. . . .*

GEF CDB: solid body
OMN PIH: solid body in projection

dian geometry, music, optics (making some cogent remarks on the path of rays in the eye), ballistics, the construction of a pentagon in the Dürer manner, and relationships between the five regular solids. We may also note with interest that one section consists of a letter to his patron about the Gregorian reform of the calendar.[113] In 1578 the Duke of Savoy had obviously been one of the early recipients of Gregory XIII's proposals and had asked his mathematician to confirm that the new system was worthy of support. Not surprisingly, Benedetti was the author of a notable treatise on dialling.[114]

A number of Benedetti's perspectival innovations foreshadow the techniques of Guidobaldo del Monte, who in 1600 published what may be regarded as the culminating book in the phase of mathematical perspective with which we have been concerned in the latter part of this chapter. However, there is little evidence of Benedetti's direct influence, and Guidobaldo can be recognised as standing in a more direct line of descent from Commandino, with whom he studied, and Danti, whose writings he undoubtedly consulted.

Guidobaldo, like his master and colleague, Commandino, came from a prominent family with independent means. Benedetti was also financially independent and seems to have been 'attached' to the court rather than employed in a salaried post. That the backgrounds and status of these gentleman-mathematicians should have been so different from that of most artists is of no small consequence. It not only meant that they were in a position to acquire a good grounding in the classically-based sciences which were to provide the intellectual context for perspectival geometry, it also meant that their lives could be more readily devoted to an intellectual understanding of mathematical and cosmological matters as ends in

themselves. By contrast, the priority of most painters was to gain mastery of such professional procedures as might allow them to advance in their profession, and only very exceptionally to move beyond it.

Guidobaldo did play a practical role as Inspector General of the fortifications and cities of Tuscany from 1588, but the greater part of his career was spent in the circle of the Urbino intellectuals, pursuing scientific scholarship and furthering the aspirations of like-minded investigators, such as Galileo.[115] The publication of his *magnum opus* on perspective in 1600 stands near the end of a long career which had seen distinguished contributions to the physical and mathematical sciences. Much of his reputation rested on his *Liber mechanicorum* of 1577, which played a major role in promoting a proper understanding of Archimedes.[116] Particularly relevant to his later writings on perspective was his own treatise on a universal astrolabe which was published in 1579.[117]

His *Perspectivae libri sex* provided a definitive and often original analysis of the mathematics of perspectival projection, in a far more extended way than either Commandino or Benedetti had aimed to do. From our present point of view his most significant contribution comes in the first of his six books. His two opening demonstrations plunge the reader immediately into the heart of the matter, providing complex but lucid demonstrations of a flat figure and a three-dimensional object in perspectival projection (pls. 168–9). These demonstrations bear some resemblance to those of Benedetti, but appear to be more directly extrapolated from the Danti-Vignola diagrams, not least with respect to Guidobaldo's retention of the rectangular picture plane. This plane he terms the 'section', while the surface which provides the planar base for the projected

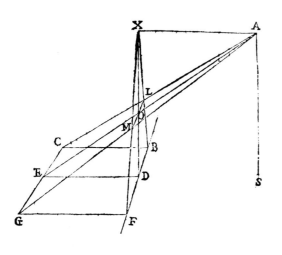

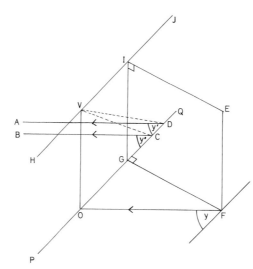

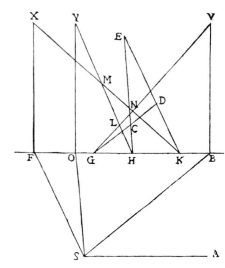

170. Demonstration of the *Punctum concursus* in the projection of parallel lines perpendicular to the picture plane from Guidobaldo's *Perspectivae. . .*

G, E and C are projected to M, O and L respectively; FM, DO and BL are drawn and extended to meet in X, the 'punctum concursus'.

171. Demonstration of the *punctum concursus* for parallel lines at any orientation to the picture plane, based on Guidobaldo's *Perspectivae. . .*

EF—observer
HJ—horizon on picture plane
PQ—base line of picture plane
AD and BC subtend angle y on PP

Draw FO parallel to AD and BC; erect the vertical OV; V is the 'punctum concursus' for BC and DE.

172. Perspective projection of a triangle, from Guidobaldo's *Perspectivae. . .*

SA—viewing height
CDE—triangle
FB—base line of picture plane

SF, SO and SB are drawn parallel to DE, CE and CD respectively; FX, OY and BV are drawn as perpendiculars equal to SA; ED, EC, DC are extended to K, H and G respectively; X is joined to K, Y to H and V to G; LMN is the triangle in projection.

figure and the spectator is called the 'subject plane'. Commandino had referred to the picture plane as the '*tabula*', preferring this to the vernacular '*parete*' (wall) which was used in many earlier treatises.[118] Guidobaldo's convenient terms will be adopted in the following account.

Having shown us the end in view, Guidobaldo proceeds to provide a series of systematic definitions and theorems, dealing with such standard questions as the projection of lines perpendicular and parallel to the base of the section. His fundamental contribution is to define the vanishing point (*punctum concursus*) for any given set of parallels (pl. 170). He shows that if a line is drawn through the eye parallel to the given line(s), the point at which the line through the eye meets the section (pl. 171) provides the vanishing point(s) for the given line(s). Since the subject plane contains an infinite number of lines of different orientation, the section will potentially contain an infinite number of 'points of convergence' along the horizon line. Differently oriented subject planes will result in an infinite series of points across the whole section.

One of the consequences of Guidobaldo's discovery is that he is able to use parallels in the subject plane to project any given point, line or figure. This can be accomplished either in a three-dimensional demonstration or in a flat construction (pl. 172). In the latter case, the section and the subject plane have effectively been folded into each other. The viewing height is represented graphically as SA; and S is stationed at a desired distance from the junction (FB) of the section and the subject plane. The figure to be projected is the triangle DCE. Lines from S are drawn parallel to the sides of the triangle to meet the base at F, O and B. Verticals equal to SA are erected at F, O and B. The sides of the triangle itself are produced to meet

FB at G, H and K, and these points are joined to the tops of the verticals FX, OY and BV. The triangle described by the resulting lines will be given the desired projection. Implict in this construction, as we will see in the next chapter, is one of the basic theorems of projective geometry, known as Desargues's theorem.

In his fourth book Guidobaldo shows how this basic technique can be adapted for the elliptical projection of a circle (pl. 173). We may notice that if the constructional parallels are at 45° to the section, the result will be recognisable as our old friend, the distance-point construction. Guidobaldo also shows exhaustively other methods for the projection of a given point, both when they are located in the subject plane and when they are above it. This permits the projection of any solid body whose shape can be geometrically described. He also analyses the effects of tilting the plane on which the object is located, a problem tackled by Commandino, and shows how to determine the centre of projection (the 'viewpoint') given the original and projected figures but not the distance or height of SA. A section of Book III deals with the important question of projection on to curved surfaces. This question naturally intersects with the problem of conic sections, as does his discussion of shadow projection in Book V. Looking at his diagram of the shadow cast by a sphere when illuminated by a point source of light (pl. 174), it is easy to see why questions of astronomical projection, sundials, conics and perspective had become entangled. There had long been an idea that Ptolemy's projective techniques were related to cast shadows, and in the next century we will find Rubens providing a graphic illustration of the principles involved.[119]

Guidobaldo's book rightly came to be regarded as the main

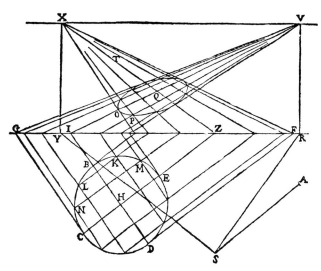

173. Perspective projection of a circle on an inclined plane, from Guidobaldo's *Perspectivae*. . . .

174. Projection of the shadow of a sphere from a point source of light, from Guidobaldo's *Perspectivae*. . . .

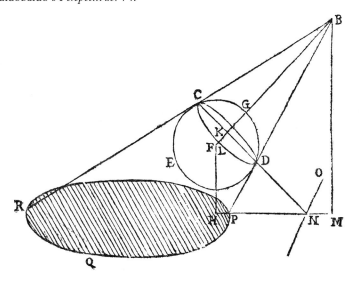

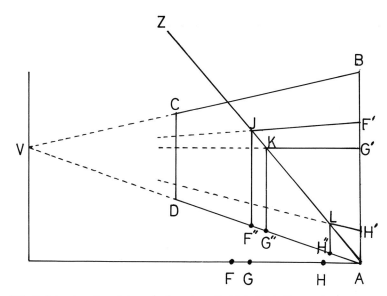

175. Points at various intervals, based on Guidobaldo's *Perspectivae*. . . .

V—vanishing point for plane ABCD
F, G, H—points on a horizontal at known intervals

The intervals are transferred to AB as F', G' etc.; F', G' etc are joined to V; F'V, G'V, H'V intersect the diagonal AZ at J, K, L. Drop verticals from J, K on to DA at F", G" etc., to obtain the required intervals.
Note: if AZ is extended to meet the vertical through V at Z^2, the viewing distance equals VZ^2.

176. Perspectival projection of an arcade from Guidobaldo's *Perspectivae*. . . .

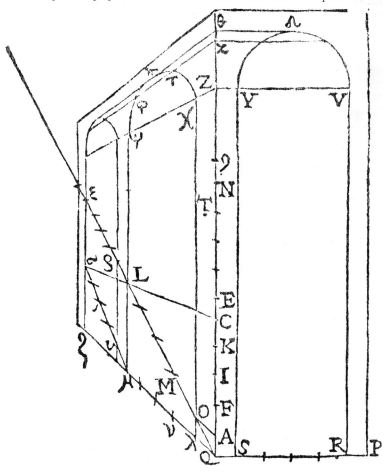

source of reference for anyone seriously interested in the underlying geometry of perspectival projection. But this is not to say that he made life at all easy for the painter who wished to approach his text. His only substantial treatment of a representational technique occurred in his final book, in which he analysed the scenographic perspective of stage design. The particular problem here was to create the illusion of deep space on slanting planes of limited length, a problem related to Guidobaldo's interests in inclined sections. This form of scenography, which will feature later in this study, was in effect a highly specialised form of relief sculpture and did not provide direct guidance for the painter interested in the more orthodox problems. The only illustration and analysis of a genuinely pictorial technique comes in Book IV, when he explains how the diagonal of a foreshortened square (pl. 175) can be used to plot the locations of intervals along a given orthogonal (pl. 176). If Guidobaldo's book had fallen into the hands of Zuc-

177. Ground plan for a fortification based on a decagon, from Galasso Alghisi's *Delle Fortificationi*, Venice, 1570.

caro, as well it might, we could well understand the painter thinking that the mathematical base of Guidobaldo's perspective science was remote from his own concerns as an inventive artist.

It is at this point of increasing remoteness from the needs of artists that perspective played its most important role in relation to the mainstream of scientific thought. It assumed this role as a result of being drawn into the closely-knit context of those sciences which relied on three-dimensional geometry for their principles of operation. There has been a tendency to project this sixteenth century nexus of intellectual connections back into the era of the very founding of perspective, and, indeed, to regard this context as a causal factor behind Brunelleschi's invention. It cannot be denied that the potential associations were there from the first, and it is tempting to read profound implications into the fact that Toscanelli constructed a gnomon in 1475 within the space vaulted by Brunelleschi's dome.[120] It would be foolish to deny that Brunelleschi and Toscanelli would have been alert to the compatibility of their respective interests, but the hard evidence from the fifteenth century does not provide grounds for suggesting that perspectival techniques in art did more than move in approximate parallel to astronomical and geographical knowledge. The evidence of the period with which we are now concerned indicates that it was only when the painters' technique had been thoroughly absorbed into a different function context and placed on a different methodological base that the interplay between perspective and its sister sciences could be direct and reciprocal.

As redefined by Commandino, Benedetti and Guidobaldo, perspective was well placed to participate in the incredibly complex pattern of scientific developments generally called the

Scientific Revolution. Mathematics stood at the heart of these developments, not only with respect to the invention of new techniques within mathematics itself but also in the provision of new tools with which to analyse physical procedures in almost every field of applied science and in many of the traditional 'crafts'. The 'art' of fortification provides a good example of what was happening. During the second half of the sixteenth century, the designing of defensive structures had become a mathematician's paradise. The calculation of the angular inclinations of bastions, both to resist artillery and to provide the most favourable lines of fire, had come to rest on complex geometrical principles. The overall design of fortifications, which involved questions of the length of walls relative to enclosed areas, had come to be based on the properties of polygonal figures (pl. 177). In its most extreme form, this resulted in a 'paper architecture' which belonged more in the theorists' books than to actual situations. When we find one author typically claiming that 'this Profession is governed solely by points, lines, intervals, measures and such-like', we can well understand the acerbic complaint of a practising soldier that 'this craft is not to be learned in Bologna or Perugia or Padua but in action'.[121]

The study of ballistics, which had literally been given fresh impetus by the new forms of artillery, was also thoroughly mathematicised. The crucial move came with Niccolò Tartaglia's *La Nova scientia* in 1537.[122] His attitude is perfectly summarised by the frontispiece (pl. 178), in which Euclid opens the door to the atrium in which the mathematical sciences are gathered, while Plato guards the inner sanctum and displays his forbidding motto, 'Let no one who is destitute of geometry enter here'. As the translator of Euclid, Tartaglia obviously felt qualified to meet Plato's requirements.[123]

The mathematicised sciences of fortification and ballistics were intimately interwoven with the other geometrical sciences during this period. A significant number of the major perspective theorists and mathematicians were involved with the art of war in one form or another. Benedetti, who had apparently studied with Tartaglia, wrote on ballistics, while Guidobaldo was employed to inspect the fortifications of Tuscany. Ricci and Galileo were also involved in such activities, and a group of major perspectivists we will encounter in the first half of the next chapter—Stevin, Marolois, Dubreuil and Desargues—were all engaged to a greater or lesser degree on military design. These concerns were also integrally linked to the instrument-maker's art. In Chapter V we will see the close associations between instruments of military surveying and ballistics, practical calculating devices and perspective machines. These associations involve much the same cast of characters.

The career of the little-known Ostilio Ricci precisely reflects these trends. Active as a mathematician in Florence from 1580, he was employed as a military consultant, and may have previously been a student of Tartaglia.[124] He is known to have provided mathematical guidance not only for Galileo but also for Lodovico Cigoli, the leading painter from Florence and a close friend of Galileo. One of the texts from which Ricci taught appears to have been Alberti's *Ludi matematici*, which

178. The realm of the mathematical sciences, from Niccolò Tartaglia's *La Nova scentia*, 1550.

di S. Luca, he also made provision for mathematical instruction, though it was to be just one part of the total spectrum in the intellectual training necessary if the artist was to bring the 'idea' into effect. This was the period of burgeoning academies, particularly in the literary and scientific fields. Involvement with the academies provides vital components in the careers of both Galileo and Cigoli.

Galileo's encounter with Ricci in about 1584 was crucial in diverting the young man's studies away from medicine and towards the mathematical sciences, particularly those concerned with measuring and weighing.[128] His early involvement with such questions also led to his contacts with Guidobaldo from 1588 onwards. Guidobaldo did much to further Galileo's career, and in 1594 Galileo visited the renowned mathematician-physicist to see, amongst other things, the as yet unpublished text of Guidobaldo's great treatise on perspective.[129] It seems to have been substantially due to Guidobaldo's influence that Galileo was appointed to the chair of mathematics at Padua in 1592.

In 1610, the year in which Galileo returned to Florence, we can witness the fruitful convergence of his astronomical interests and his early experiences of visual science. The astronomical questions with which he was urgently involved at that time centred precisely upon 'seeing and knowing', and had been occasioned by the newly invented telescope. Cigoli and his artistic circle were to become intimately involved in these questions. The first major component in the debate was Galileo's *Sidereus nuncius* ('Starry Messenger'), published in 1610, in which he provided brilliant illustrations of the irregular patterns of light and shade on the moon (pl. 179). The configurations he observed, and most particularly the way the lights and shadows changed their disposition as the moon moves through its phases, convinced the astronomer that the moon possesses a surface even more irregular than that of the earth. This opinion, which was seen as deeply subversive by

179. The surface of the moon from Galileo Galilei's *Siderus nuncius*, Venice, 1610.

contained a series of problems in practical mathematics such as measurement and surveying.[125] He is credited on his own behalf with the design of a surveying device called an *archimetro*. Particularly interesting from our point of view is his election to the Accademia del Disegno in 1593.

The Florentine Academy of Design had been founded on the initiative of Giorgio Vasari in 1563.[126] From the beginning it was envisaged that this first of all formal academies of art should provide instruction in Euclidean and other mathematics—though this was no doubt the subject of lively controversy, as it was later to be in France. We know the names of some of the mathematicians involved. Piero Antonio Cataldi, who wrote a treatise on Dürer's pentagon, was involved in 1569, and in 1595 Antonio Santucci was enlisted. Santucci was a brilliant artificer of such instruments as quadrants and celestial spheres, and developed into a mathematician-astronomer in his own right.[127] When Federigo Zuccaro in 1593 founded the Roman sister organisation, the Accademia

180. Lodovico Cigoli, *The Virgin of the Immaculate Conception*, 1610–12, Rome, Sta. Maria Maggiore, Capella Paolina.

some Aristotelian cosmologists, was founded on his understanding of the behaviour of shadow with respect to different angles of illumination on non-planar and curved surfaces.[130] Arriving at a correct conclusion, for Galileo, was not simply a matter of looking; it also necessarily involved a framework of explanation which aspired to geometrical certitude.

The visual acumen of the moon illustrations so pleased his

181–6. Motion of the sunspots, from Galileo's *Istoria e demonstrazioni intorno alle macchie solari e loro accidenti*, Rome, 1613.

Note the cluster marked M as it passes round the sphere and diminishes perspectivally.

friend, Cigoli, that the fresco of the *Virgin of the Immaculate Conception* which he was painting during 1610–12 in Sta. Maria Maggiore, Rome, shows Mary standing on a rough-surfaced Galilean moon rather than the conventionally smooth crescent (pl. 180).[131] Cigoli does not appear to have followed Galileo's detailed description of the craters and 'seas' all that closely, and may have turned to his own new telescope for guidance—but the Galilean principles are clear enough.[132]

Cigoli became more actively involved in Galileo's next major project of telescopic observation, the description of the newly discovered sunspots. For three years a stream of correspondence passed between Cigoli in Rome and Galileo in Tuscany. Twenty-nine of the painter's letters survive, compared to only two of Galileo's, but the nature of their exchanges is fully apparent.[133] Cigoli helped to keep Galileo abreast not only of news of mutual friends, but also of the activities of the Roman philosophers and astronomers such as Clavius who were reacting, sometimes in a hostile manner, to Galileo's discoveries. The issue of the sunspots was initiated by the publication of letters by an astronomer who referred to himself (appropriately for dealing with such a visual matter) as '*Apelles latens post tabulam*'.[134] '*Apelles*', as it later transpired, was the Jesuit astronomer, Christopher Scheiner. Galileo's own interpretations conflicted with those of '*Apelles*'. The controversy can be followed in Cigoli's letters.

During 1611 Cigoli informs the astronomer about objections by Clavius amongst others to Galileo's mountainous moon.[135] He also writes on more than one occasion that his fellow painter, Passignano (Domenico Cresti), was busy observing sunspots. Passignano decided that the spots follow a spiral path, but was gently reminded by Galileo that the relative orientation of the sun as it crosses the heavens needs to be taken into account.[136] By 23 March 1612 Cigoli had set up as an observer on his own account: 'I do not believe I have told you that I have a telescope, and it is sufficiently good to enable me to see the clock of St. Peter's and its hand from Sta. Maria Maggiore, but not the numbers of the hours as distinctly as I saw it with yours.'[137] He confirms that he can see the 'stars' of Jupiter, newly and sensationally discovered by Galileo, but

had not made any sense of Saturn and Venus. Most importantly Cigoli writes that he 'has made these twenty-six observations' of the sunspots, which look like 'faults in a [glass] carafe' and move progressively to the surface before extinguishing themselves. Cigoli hesitantly entertains the idea that they 'are stars which interpose themselves between us and the sun'. This was indeed the interpretation that Scheiner and the more traditionally-minded astronomers favoured, in order to avoid the idea that the sun was subject to any blemishes or imperfections which might indicate its corruptibility. The means by which Galileo refuted their arguments relied upon his understanding of *prospettiva*.

Galileo's own graphic recording of the sunspots had been accomplished by the projection of telescopic images on to a sheet of paper 'four or five *palmi*' from the end of the instrument—a method devised by his pupil Benedetto dei Castelli.[138] A circle was drawn on the paper and the telescopic image was fitted to this circle. This procedure ensured that the plane of the paper would not be inclined in such a way as to give a falsely elliptical image. The resulting images of the spots could be 'drawn without a hair's breadth of error in a very elegant manner'.[139] By July 1612 Cigoli and his circle were also using this method.[140] The really important step was the way in which Galileo analysed the results they obtained. He noted three visual properties of the spots as they traverse the sun: they become thinner at the periphery of the sun; they appear to travel greater distances near the centre of the sun; they seem to move further apart from each other as they near the centre, and vice versa. If we look at the cluster of spots marked M on the drawn illustrations of his observations from 23 to 28 June (pls. 181–6) we can see these aspects clearly. Galileo set out to explain these '*in virtù di Perspettiva*', as he put it.[141]

What was happening, he argued, was that the spots were progressing on the surface of the sun in such a way that they became foreshortened to his sight as they moved towards the edge of the sphere. The spots near the edges are seen '*in scorcio*' (in foreshortening) while those near the centre are seen '*in faccia*' (flat on). These are precisely the terms he uses when dis-

187. Perspectival analysis of the appearance of the sunspots on the surface of the sun, from Galileo's *Macchie solari*. . . .

As a spot occupies the intervals PL, LD, DB etc., it will appear diminished in size according to RS, SO, OC etc., and does not appear beyond A.

cussing anamorphic images in one of his two surviving letters to Cigoli.[142] A diagram (pl. 187) makes his perspectival point clear. Since the sun is very distant, the rays may be considered as effectively parallel, and the projection will therefore be orthographic in nature. As a unit of given width (M in the diagram) moves through points P, L, D and B on the circumference of the sun, so the angle it subtends to the eye will become greater and its apparent width less, according to the ratios of the intersections on the plane through M. If, as his opponents claimed, the spots were in orbits clear of the sun, passing through points T, H, Q, G and E, the ratios of diminution would be different and the spots would not diminish to virtually nothing at point A. These arguments combine his famed commonsense with the geometry of projection on to curved surfaces. The knowledge of Guidobaldo's *Perspectivae libri sex*

188. Lodovico Cigoli, *The Virgin of the Immaculate Conception* viewed from the entrance to the chapel.

dome, so that the figures around its rim appear distorted. This contrasts with the confident display of illusionistic foreshortening in the putti around the oculus and the central figure of God the Father, who are shown '*in scorcio*'. The lateral figures are quite deliberately shown more '*in faccia*' and only assume full coherence when viewed from lateral positions. Most importantly, the Virgin achieves her full impact when viewed laterally from the position at which we enter the chapel from the nave of the church (pl. 188). This device of more than one viewpoint, which violates the principles of Lomazzo and the doctrinaire illusionists, presents the essential features of the Virgin more comprehensibly than would have been possible in sharp foreshortening. This serves the needs of lucid exposition at the expense of the simple and consistent deception of the eye. The roles of subject matter, pictorial description and the spectator are far more knowingly complex than in illusionistic schemes in the Bolognese tradition, which relied on a fixed relationship between a stationary spectator, the sensory experience of perspectival configurations and their perception in the mind.

Although I do not think we should push the parallel too far, Galileo similarly rejected the one-to-one relationship between seeing and knowing advocated by some Aristotelians in Rome. In answer to the claim that perception properly applied can alone define whether comets generate their own light, he admits 'I do not posses such a perfect faculty of discrimination. I am more like the monkey who firmly believed that he saw another monkey in the mirror . . . and discovered his error only after running behind the glass several times . . . I should like to know the visual differences by which he [his adversary] so readily distinguishes the real from the spurious.'[144] This vital act of discrimination, for Galileo, was to be accomplished by the tools of rational analysis, above all by those of a mathematical nature. Ideally, the rational explanation should be demonstrable experimentally, as when he recommends placing dots of bitumen on a hot iron ball to test one theory about the nature of sunspots.[145] All this stands in sharp contrast to the claims of one of his adversaries who asserted that 'anyone who thinks he can prove natural properties with mathematical arguments is simply demented'.[146]

Cigoli for his part possessed a comparably sophisticated understanding of theoretical issues in his own profession. Coming from a background of minor nobility, he received a good education and achieved some reputation as a poet and lutenist.[147] He was elected to both the major literary academies in Florence, the Accademia Fiorentina and the Accademia della Crusca. Not surprisingly, he was active as a theorist in his own right, but of his writings only his treatise on 'Prospettiva pratica', which is coupled with a demonstration of the 'Five Orders of Architecture', seems to have survived. It has never been published, following his sudden death in 1613, although it matches in visual and geometrical sophistication anything produced by a practising artist during the Renaissance and Baroque periods.[148] An inscription on a drawing in the Uffizi by one of his pupils, Sigismondo Coccapani, suggests that he continued to work on the treatise with Coccapani's assistance during the final years of his life in Rome.[149]

which he gained when he was given a pre-publication preview in 1594 could well have predisposed Galileo to this particular mode of analysis.

The painting on which Cigoli was then engaged, his fresco of the *Virgin* inside the dome of the Pauline Chapel of Sta. Maria Maggiore (pl. 180), proved no less controversial in its own way than Galileo's publication of his sunspot analyses in his *Istorie e dimostrazione* in 1613. In a sense, the arguments centred on the same point, namely the faculty of seeing. Cigoli's treatment of space and foreshortening, which owed much to his admiration for Correggio, was very different from that of the traditional illusionists in Rome, one of whom, Cherubino Alberti, was a losing competitor for the commission.[143] His battle, like Galileo's, seems to have been fought over the question of the relationship between direct seeing and knowing interpretation. Viewed from a point vertically below the centre of the dome, it appears as if something is amiss with Cigoli's system of foreshortening. He appears to have made inadequate compensation for the curvature of the

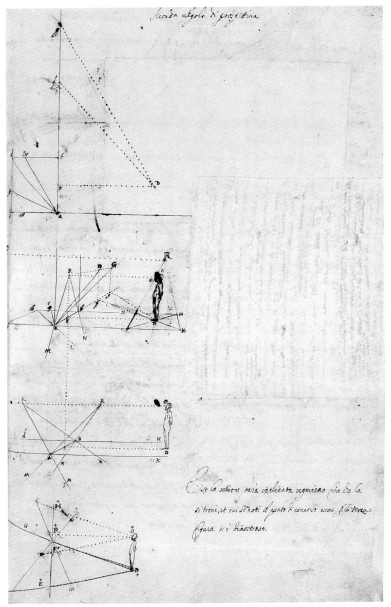

189. Demonstration of the vanishing point of given lines on perpendicular and inclined picture planes from Lodovico Cigoli's 'Prospettiva pratica' fol. 41r.

upper diagram—the vanishing points of lines ad and ax are found by drawing Df parallel to ad, and Dg parallel to ax
second diagram—procedure as in pl. 171

Cigoli's text and diagrams show him to have been very well informed about earlier theoretical writings, not only major published sources such as Dürer, Barbaro, Danti and Guidobaldo, but also the unpublished 'Trattato' of Leonardo. In the preface to his 'first rule of perspective', he closely paraphrases Leonardo to the effect that 'a painter without perspective will be like a helmsman on the sea without a rudder or compass'.[150] This first rule, preceded in his treatise by effective expositions of the functioning of the eye and some basic geometrical procedures, concerns the familiar method of projection by intersections, demonstrated with the standard range of geometrical

and other solid bodies, including the popular lute.[151] His second rule corresponds broadly to that in the Vignola-Danti book, but it is cast in the more up-to-date form of Guidobaldo's method for the construction of the *punctum concursus* for a line at any given angle to the picture plane. Cigoli's diagram (pl. 189) shows that he well understood the geometry of Guidobaldo's procedure, and, as we will see in Chapter IV, he was able to devise a novel kind of perspective machine on this basis.

The 'Prospettiva pratica' ranges knowingly over all the main topics in Renaissance perspective, and in two particular areas, scenography and perspective machines, shows a considerable degree of originality. Cigoli's machines, as will later become clear, provided his 'third rule', and one device was to be repeated with minor amendments as late as the nineteenth century. Not surprisingly, he paid close attention to the perspectival projection of forms on to curved vaults and domes (pl. 190), providing methods that bear obvious affinities to Galileo's perspectival demonstrations of sunspots on the spherical surface of the moon.

Cigoli's high level of mathematical expertise does not lead him, however, to adopt a doctrinaire attitude to its application in practice. He recognises that there are many situations in practice, as when portraying complex views in nature or the human body, in which point-by-point projection will result in 'wearisome labour' and to be totally impractical. Once young artists have a secure grounding in the rules, they will be able to design with good judgement, knowing when it is appropriate to depart from the rules of absolute verisimilitude, taking a degree 'of modest licence so that we may be able to proceed effectively' in a given situation.[151] We have already noted that

190. Projection of architectural forms on to a curved vault from Lodovico Cigoli's 'Prospettiva pratica', fol. 38r.

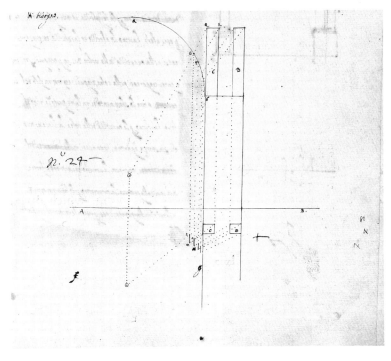

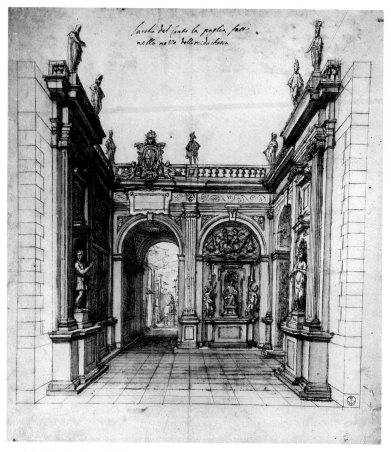

191. Lodovico Cigoli, *Perspectival design for a triumphal arch at the Canto alla Paglia*, 1608, Florence, Uffizi, Gabinetto Disegni e Stampe (N. 1797 Orn.).

he took such 'licence' in his Sta. Maria dome. Alternatively, he could produce designs of canonical orthodoxy when he needed to fulfill the functions of precise illusionism. A good example is his design for a commemorative arch to adorn the narrow entrance to the Canto alla Paglia in 1608 for the entry into Florence of Maria Maddalena of Austria, the wife of Prince Cosimo (pl. 191).[152] In the majority of his paintings Cigoli exploited this knowledge in a supportive, even reticent manner, secure in his grasp of spatial structure but never using it in a rigidly doctrinaire fashion or parading perspectival virtuosity for its own sake.

Just as Cigoli supported Galileo's observations on the moon and sunspots, so Galileo lent assistance to the artist on questions of theory. On 26 June 1612, apparently responding to a request from Cigoli, Galileo provided the painter with a *para-gone* of the arts of painting and sculpture. Cigoli had obviously been drawn into one of those popular but increasingly tiresome debates on the priority of the various arts. Galileo's arguments in favour of painting drew heavily upon the high levels of skill involved in creating the illusion of three-dimensional forms in light and colour: 'the most artful imitation will be that which represents relief on its opposite, that is to say on a plane'.[153] With a characteristic interest in 'the real and the spurious' he suggests that if a sculpture was to be painted progressively more darkly in the more strongly illuminated areas it would appear perfectly flat—effectively achieving the reverse of what he had observed on the moon through his telescope.

Galileo's tastes in the arts for lucidity over ambiguous complexity is well attested in his not infrequent use of artistic similes in his writings. Allegorical poetry, which he thoroughly dislikes, is compared to the obscure, concealed illusions of anomorphic images, while his Aristotelian opponents, who constantly resort to collages of arguments from Aristotle, are compared to 'certain capricious painters who occasionally constrain themselves, for sport, to represent a human face or something else by throwing together sometimes some agricultural implements, at others some fruits or perhaps the flowers of this or that season [i.e. painters of the Arcimboldo type (pl. 498)] . . . If anyone were to pursue all his studies in such a school of painting and should conclude in general that every other manner of representation was blameworthy and imperfect, it is certain that Cigoli and other illustrious painters would laugh him to scorn.'[154] Cigoli's own eschewing of the complex double-takes of the virtuoso illusionists is evident in his Sta. Maria Maggiore dome, where his desire for descriptive lucidity in the portrayal of the Virgin has taken precedence over the elaborate application of perspectival tricks for their own sake. This is not because Cigoli was ill-informed about the laws of perspective at the highest level—as his treatise and drawings make clear—but because he has tempered simple 'seeing' with interpretative 'knowing' on behalf of the spectator and the subject.

The remarkable interaction between Cigoli in Rome and Galileo in Tuscany is perhaps the least forecastable of the ways in which advanced art and innovatory science of a mathematical nature have been able to nourish each other. A fitting culmination of this episode was provided on 18 October 1613 when Galileo was elected a member of the Florentine Accademia del Disegno.[155] Appropriately enough he was already proud to be a member of Federigo Cesi's exclusive scientific academy in Rome which went by the name of the Accademia dei Lincei—the 'Academy of the Lynx-eyed'.[156]

CHAPTER III

Linear perspective from Rubens to Turner

The absorption of geometrical perspective into mathematical science, with the concomitant emphasis on the general case and underlying theorems, worked against the provision of ready formulas for achieving pictorial effects. The drawing apart of geometrical and pictorial perspective was partly a consequence of the greater technical difficulty of the geometry—though I do not think its difficulty should be exaggerated—but it was more profoundly based on a difference in intention. This difference meant that the relationship between pictorial practice and perspectival theory would necessarily be different from that during the Piero della Francesca era. Even for an artist concerned with perspectival demonstration, the relationship would now be closer to that between an engineering technology and a pure science. We have already seen one manifestation of the changed relationship between visual science and painting in the interchange between Galileo and Cigoli, but this does not provide a model for other such relationships. Indeed, I believe one factor which will emerge from this chapter is that there is no single or even predominant model after 1600. Particular aspects of Dutch and French art will on occasion move close to the earlier direct correspondence between perspectival theory and pictorial practice, but such episodes do not provide the norm, In Italy perspectival techniques in art reached a peak of illusionistic complexity in theory and practice, but were based on an underlying science little more complex than that of the *quattrocento*. For many intelligent and even overtly intellectual painters, perspective became a kind of five-finger exercise—an essential grounding for technique but one which should be so much a natural part of an artist's skill and judgement that it is not an apparent part of the finished performance. Henceforth, overt demonstrations of perspectival learning were only to be occasioned by special circumstances or by the special proclivities of the artists and patrons involved.

It is to acknowledge this new situation that I have chosen to begin this chapter with two major artists of high intelligence who experienced close contact with optical learning at an advanced level, who possessed a profound sense of the intellectual foundations of their art, and yet whose paintings are almost devoid of conscious displays of constructional geometry. The two artists are Peter Paul Rubens and Diego Velázquez.

I should perhaps say at the outset that 'Rubens and optical science' is not the non-subject it might appear to be, given the popular image of the great Flemish master. However, there is no denying that it is a topic which faces grave problems of evidence. The notebooks and more formal manuscripts which contained his theoretical precepts have almost entirely vanished. His famous 'pocket book' exists only in a few scattered sheets and some records by later hands, including Van Dyck's.[1] The discourse on colours to be discussed in a later chapter is no longer traceable. And a book which contained 'observations on optics, symmetry, proportions, anatomy, architecture, and investigations of efficient causes and motions drawn from the descriptions of the poets and the demonstrations of the painters'—which was known to G.B. Bellori and Roger de Piles—has likewise vanished.[2] His voluminous correspondence provides only hints of this side of Rubens—mainly references in letters to Nicolas-Claude Fabri de Peiresc, the Parisian collector and intellectual. These concern such matters as a perpetual motion machine devised by the painter and various Archimedean questions of weight and motion.[3] Few of Rubens's extant drawings betray his activities in scientific or theoretical fields. One of the rare exceptions is a surviving excerpt from his pocket book, which analyses the structure of the Farnese Hercules according to cubes in the *quadratura* manner (pl. 193). He argues that the cube is inherent in the construction of massively robust male figures, while the circle pertains more properly to female anatomy. The triangle corresponds to robust thoraxes or in a more attentuated form to the extremities of the body.[4] This is hardly the evidence, however, on which to erect a scientific theory of art for Rubens. We may in any case believe that such design criteria were implicit rather than actual when he came to portray the contrast between masculine strength and female beauty (pl. 192).

There is, fortunately, a more solidly documented episode which allows us better to judge Rubens's stance. This was his involvement with François d'Aguilon (Aguilonius) in the production of a substantial book on optical science. Aguilonius was Rector of the Jesuit Maison Professe at Antwerp, and Rubens had become a member of the Grand Sodality of the Annunciation at the Maison.[5] The text of Aguilonius's trea-

192. Peter Paul Rubens, Samson and Delilah, *c.*1610, London, National Gallery.

scattered by Juno across the tails of her attendant peacocks.[7] According to Macrobius, who is quoted by Aguilonius, Argus's eyes signify the starry sky which is extinguished by the radiant sun (Mercury) at each dawn.[8] In the next chapter we will see a related painting of this story by Rubens from this period (colour plate III).

The title page on its own would suggest no more than an illustrator's job well and professionally done. However, the vignettes which Rubens provided for the individual title pages of each of the six books (pl. 195) show such a complex and knowing relationship to the text as to leave no doubt that Rubens's intellectual involvement was considerable. The vignettes range from compositions which exhibit clever if

193. Geometrical analysis of the figure of *Hercules* by Peter Paul Rubens, London, Courtauld Institute, Princes Gate Collection, MS Johnson, no. 427v.

tise, the *Opticorum libri sex*, was approved by the censor in 1611 and was published in 1613 with seven illustrations by Rubens skilfully engraved by Theodore Galle.[6] The treatise represents an intelligent, highly lucid and fundamentally conservative synthesis of various threads in classical, mediaeval and Renaissance science. It is not without its subtle observations, original touches and—as we will see—a nice sense of experimental procedures, but Aguilonius's intellectual stance is circumscribed by the defined parameters of traditional optics rather than venturing into the more revolutionary territories of Kepler, Galileo and Descartes.

Rubens's main title page (pl. 194) provides a series of ingenious references to the alliance of vision and reason. There are some obvious details—the disembodied eye shining forth, the visual pyramid on Juno's knee, the celestial sphere and the optical-geometrical instruments—together with some less obvious, mythological references. Mercury with the many-eyed head of Argus, for example, refers to a visual allegory. Mercury, acting on Juno's orders, had lulled Argus's watchful eyes to sleep before decapitating him. The 'hundred' eyes were

194. Peter Paul Rubens, Title page from F. Aguilonius's, *Opticorum libri sex*, Antwerp, 1613, engraved by Theodore Galle.

195. Peter Paul Rubens, Six vignettes from F. Aguilonius's, *Opticorum libri sex*, engraved by Theodore Galle.

general relationships to the book in question to those which make quite specific references to the arguments in the text. I will list them in an order which corresponds roughly to increasing specificity to the text:

Book I, 'On the Organ, Object and Nature of Sight', illustrates the dissection of the conveniently large eye of a cyclops, in keeping with Aguilonius's insistence on accurate knowledge of the eye's structure. He demonstrated his awareness of advanced anatomical investigation of the eye, but his view of its physiology remained essentially traditional and made no reference to Kepler's concept of a 'picture' on the retina.

Book II, 'On the Visual Ray and the Horopter', displays a range of surveying instruments in action, including a staff used for the optical measurement of the Colossus of Rhodes. These complement Aguilonius's discussion of Euclidian angles as the foundation of visual judgement.

Book VI, 'On Projection' shows a rough-and-ready means of projecting a celestial sphere onto a plane surface. Aguilonius acknowledged Commandino's works on orthograpic and stereographic projection and looked towards Guidobaldo for the related science of cast shadows (pl. 196).[9]

Book IV, 'On Misleading Appearances', which deals with the apparently transformed shapes of objects viewed from different angles etc., is illustrated by reference to the parallax phenomenon. The illustration shows how an object is seen in two different places relative to the background when viewed by each eye in succession. Parallax was also a key concept in the astronomical measurement of distances.

Book III, 'On the Cognition of Common Objects', represents a 'humorous experiment' described in the text, in which the author points out how difficult it is to reach out with certainty to touch a small object using one eye alone.[10]

Book V, 'On Light and Shadow', is the most interesting experimentally, and depicts one of two set-ups devised by Aguilonius to show that the relationship between the strengths of light sources and their diminution over distance does not simply stand in inverse ratio.[11] If a light twice the strength is placed at twice the distance from the receptive surface, it will still exceed in brightness the original light at the original distance. The result of this experiment goes against common expectation and, I suspect, would have perturbed Leonardo who believed that the uniformly pyramidal law applied in all such cases of the diminution of the powers of nature. The law at work here, as we now know, is the inverse square law, which is so widely used in astronomical calculations of distances.

What relation does all this bear to art in general and to Rubens's painting in particular? In the next chapter we will attempt to answer this question with respect to colour, which is the last of Aguilonius's four parts of painting—contour, light, shade and colour.[12] The author does treat scenographic (artistic) perspective effectively and succinctly in Book VI. He

196. Projection of the shadows of a pyramid and sphere from point sources of light, from Franciscus Aguilonius's *Opticorum libri sex*, Antwerp, 1613.

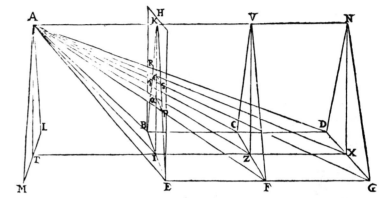

197. Demonstration of the *punctum concursus* for parallel lines perpendicular to the picture plane from Aguilonius's *Opticorum*. . . .

TA—observer H—picture plane

Points on the parallel lines BCD and EFG are joined to A. The '*punctum concursus*' is at K.

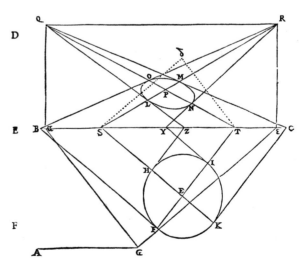

198. Perspective projection of a circle using the points of convergence for lines at a given angle, from Aguilonius's *Opticorum*. . . .

The basic procedure as in Guidobaldo, pl. 173.

provides a clear outline of the basic points in Guidobaldo's treatise, including neatly designed diagrams of the convergence of parallel lines perpendicular to the picture plane and the construction of a circle in projection using the theorem of the *punctum concursus* (pls. 197–8). Such diagrams are fine for

199. Peter Paul Rubens, *The Gonzaga Adoring the Trinity*, central fragments of a dismembered altarpiece, 1604–5, Mantua, Palazzo Ducale.

demonstrating the geometrical principles at work, but do not readily serve the needs of pictorial construction.

There can be no doubt that Rubens was intellectually equipped to understand the text and he was too intelligent to have dismissed Aguilonius's visual science as irrelevant. But neither was he concerned to use such knowledge or techniques in a direct or mechanical manner in his paintings. Relatively early in his career when he was in the service of the Gonzaga at Mantua, he had been faced with the challenge of a large-scale composition in an architectural setting to be viewed from a low viewpoint. The result was his painting of 1604–5 for the Church of Sta. Trinità showing the Gonzaga family adoring the Trinity (pl. 199), now sadly mutilated as a series of dispersed and incomplete fragments.[13] What survives of the central part of the scene shows that he did not fail to take up the illusionistic challenge of Giulio Romano's example in Mantua, and more specifically the challenge of Cristoforo Sorte's lost scheme which used Solomonic columns. However, his architectural setting for all its apparent rationality is more in the nature of 'painter's architecture' than a precisely projected geometrical illusion of a logical structure in the central Italian manner. He took his lead in this from Titian and from Veronese's normal procedure as a decorator (though not as in the Villa Barbaro) in which perspectival suggestion is used to evoke an artistically flexible space of a predominantly non-geometrical kind. A functioning understanding of perspective provides the artist with the means to bend it suggestively to particular ends. This remained Rubens's position with respect to linear perspective throughout his career.

However, it is worth remembering that the measurement of distance comprises only a small portion of Aguilonius's visual science, just as in the works of Alhazen and Witelo. There

is much else in Aguilonius's book that could have inspired Rubens in his study of light and colour. His vignette for Book V displays his sensitivity to Aguilonius's treatment of light and shade. It is not unreasonable to look for some reflection of this in Rubens's paintings. For example, the *Samson and Delilah* (pl. 192), which dates from this period, contains a deliberately contrived set of complex light effects emanating from four independent sources: two braziers, one candle and one taper. This is more complex in ambition and effect than the earlier *tenebroso* pictures he had painted in the fashionable vein, and makes great play with the varied effects of different intensities of light on various colours and textures—ranging from matt absorption to gleaming reflection and from stony depth to luminous refraction (in the glass carafes). One observation is particularly in keeping with the tenor of Aguilonius's treatise. The old maid who holds the candle above the central incident of the cutting of Samson's hair cups her other hand behind the candle in such a way as to enable her to see *past* the candle to the covert operation itself. If the glare fell directly into her eye it would obscure the view behind it—an 'experiment' we can all perform with a light bulb. The maid's gesture is thus more subtly 'optical' than the simple shading gesture which had appeared in Rubens's earlier paintings in a stock manner.[14] As we will see in the next chapter, he also made a related observation on the simultaneous contrast of light and shade which is directly based on Aguilonius.

I do not wish to imply that Rubens was in these respects a visual scientist in the manner of some of his Renaissance predecessors, but that his literacy in such matters informed his practice in a deeply integrated and yet non-dogmatic manner. He had, I should like to propose, reached the position which Lomazzo implicitly attributed to Michelangelo—the state in which his basic learning and controlled scrutiny of natural effects was so much a natural part of his creative equipment that he could act with secure judgement in transcending the rigid prescriptions of a particular theory.

To some degree Velázquez appears to have stood in an analogous position, though the model of his particular relationship between optical learning and pictorial practice was rather different. In the popular and scholarly images of Velázquez, science is unlikely to enter into consideration at all. Yet we have more impressive evidence of his access to the exact sciences than for any other painter of the seventeenth century. On his death in 1660, inventories were drawn up of the contents of the suite of rooms he occupied in the Alcázar Palace in Madrid. These contained a library of 154 volumes.[15] His holdings were relatively thin in fiction, poetry and religion, but remarkably rich in the books which we have already encountered in the first chapters. Looking down the inventory in order we find (with their inventory numbers): Luca Pacioli's *Summa d'aritmetica*. . . (2); Aguilonius's book (8); Dürer's treatise on proportion (11); Witelo on optics (13); Serlio on architecture (16); Benedetti's treatise on the gnomon (17); Zuccaro's *Idea*. . . (30); Cousin's treatise on perspective (35); a Spanish translation of Euclid's books on optics and catoptrics (49); Daniele Barbaro on perspective (50); Tartaglia's *Works* in Italian (56); Euclid's *Catoptrics*, in Italian (78); Guidobaldo

on mechanics (82); the *Perspectiva* of Euclid, i.e. the *Optics* in Latin (91); Alberti's *Della Pittura*, in Italian (or Latin?) (96); Egnatio Danti's treatise on the astrolabe and planisphere (107); a *Pratica della perspectiva*, possibly Vignola's, whose *Five Orders* is next on the list (119 and 120); Tartaglia's translation of Euclid's *Elements* (132); Dürer's treatise on measurement in Latin translation (141); and Leonardo da Vinci on painting, presumably the 1651 *editio princeps* from France (145).[16] If we add to this list of already familiar works further writings in the same and related fields, including Céspedes's *Libros de instrumentos nuevos de geometria* (*Book of New Instruments of Geometry*) (81), we have an astonishingly full bibliography of advanced learning in pure and applied geometry, perspective and those exact sciences which use projective techniques.[17] Amongst his other appurtenances he also possessed 'a little bronze instrument for producing lines' (595), two compasses and 'a thick round glass placed in a box' (174, probably a camera obscura). And no less than ten mirrors![18] These instruments will resurface in Chapter IV.

All this conveys an impression of a man fascinated with visual science and its instrumental corollaries. It confirms the account given by Palomino, his eighteenth-century biographer:

> he investigated the proportions of the human body in Albrecht Dürer; anatomy in Andreas Vesalius; physiognomy in Giovanni Battista della Porta; perspective in Daniele Barbaro; geometry in Euclid; arithmetic in Moya; architecture in Vitruvius and Vignola and other writers from whom with the diligence of a bee he skilfully selected for his own use and for the benefit of posterity what was most advantageous and perfect.

All the authors mentioned by Palomino are represented at least once in the inventory.[19]

His obvious interest in the geometrical sciences does not of course mean that he necessarily has to manifest geometry in his paintings, any more than he would have to paint bees if he was an expert bee-keeper. But it does suggest strongly that his art was not made in geometrical ignorance or incapacity. We can also infer that he was keenly interested in the Italian variety of perspectival illusionism. On his second visit to Italy in 1648 he acted on King's behalf as recruiting agent for artists to decorate the buildings Philip was erecting and renovating. In Bologna he met the then leading practitioners of that Bolognese speciality—illusionistic ceiling design—who were the partners Michele Angelo Colonna and Agostino Mitelli.[20] Some ten years later they were to travel to Spain to work under Velázquez's direction on the decoration of the Salón Grande and other apartments in the Alcázar. Palomino conveys the effect of the lost frescoes:

> Mitelli painted all the walls, uniting the real and imitation architecture with such perspective, art and felicity that it deceived the eye and made it necessary to touch it to make sure it was really only painted. By Colonna's hand were all the trompe l'oeil images—figures in high relief, scenes in bronze bas-relief. . . and a little black boy going down a staircase looking like a real one—and the real little window

200. Michele Angelo Colonna and Agostino Mitelli, Painted design for a ceiling decoration in the Buen Retiro Palace, c.1658, Madrid, Prado.

> introduced into the body of the painted architecture. . . . Those who looked at this vista, doubting whether it was simulated—as indeed it was not—were also in doubt as to whether it was real.[21]

We will encounter the redoubtable partnership of Colonna and Mitelli later in this chapter. For the moment we can gain a visual idea of the spirit of their lost works from a painted *modello* for the ceiling of a loggia in Philip's Buen Retiro Palace (pl. 200).[22]

Since Velázquez was responsible for the Italian partners' presence in Spain and was supervising their works, we may fairly believe that he appreciated their particular skills. To judge on a superficial level, it is remarkable how little this taste is apparent in his own paintings, which contain few perspectival passages of overtly geometrical construction and almost nothing of the fictive illusionism of his Italian charges. I think it would be wrong, however, to read his art as a jaundiced rejection of Italian visual science or as indicating a lack of concern with the nature of illusion in relation to the processes of sight. I should like to entertain the possibility that his eschewing of assertive perspective reflected, as in late Leonardo, a heightened awareness of other optical factors—elusive light, veiling shadow, fleeting motion, ambiguous translucency, detached highlights and so on. Colonna and Mitelli were producing a variety of mechanical illusions. Could Velázquez produce a truly natural illusion by capturing more of the vagaries of sight itself? This, I should like to suggest, became the goal central to the visual quality of his art. In this sense, *Las Meninas* (pl. 201), which may justly be regarded as his pictorial testament, stands as a knowing challenge to the scientific naturalism which had preceded it, above all in Italy.

No painting, not even Masaccio's *Trinity*, ever posed a more complex interpretative challenge than *Las Meninas*, not

201. Diego Velàzquez, *Las Meninas*, 1656, Madrid, Prado.

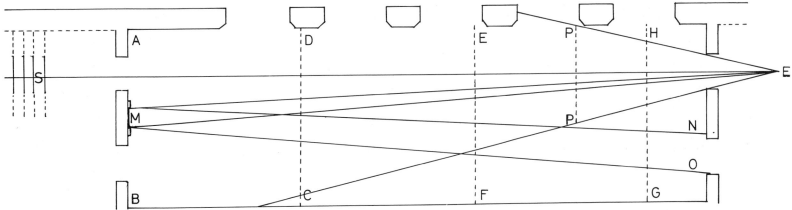

202. Ground plan of the room in the Alcázar Palace represented in Veláz-quez's *Las Meninas*.

E—viewer
S—stairs on which the man stands

M—mirror

ABCD, CDEF, EFGH—square units equivalent to the width of the room
PP—required position of picture plane, if the picture had been designed in a precisely scaled manner.
NO—width of the area reflected in the mirror

least because it does not fit tidily within any of the recognised genres. It is a group portrait but not simply a group portrait, since there is by implication something going on. It is a narrative picture in that it breathes the air of an 'event' in which something has happened and is about to happen, but it does not tell a known story. Painted in 1656 towards the end of Velázquez's great career—great in artistic achievement and social success—it was clearly conceived as a unique statement of his art, as a declaration of his supreme gifts as a magician of painterly illusion and as a subtle master of courtly allusion.[23]

The setting of the 'action' is quite specific—this is not the

least original of its aspects—and can be identified as a long room in the Alcázar adjacent to the painter's own suite of rooms (pl. 202).[24] It was part of the palace which he had personally remodelled. It was therefore a room he knew intimately as a physical structure and which was readily visible to him whenever he wished. Accordingly we will not be surprised to find that those of the shadowy paintings which can be identified on the walls in his painting can be precisely correlated with items in the relevant inventories.[25] Velázquez himself, palette and brushes in hand, stands some distance from a very large canvas. At the centre, accompanied by a retinue of re-

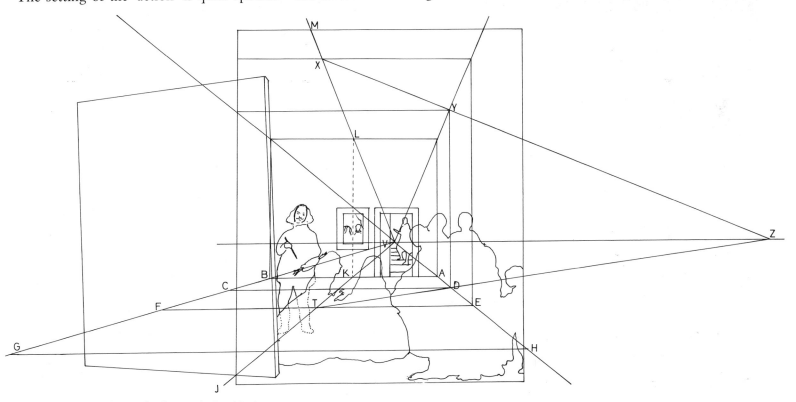

203. Perspectival analysis of Velázquez's *Las Meninas*.

V—'vanishing point'
ABCD, CDEF, EFGH—square units equivalent to the width of the room (as in pl. 202)

JKLM—central axis of room
XY, TD—diagonals through units twice as deep as wide
VZ—half the viewing distance

tainers, is the precociously poised Infanta Margarita, daughter of Philip IV and Queen Mariana, whose reflections are elusively but unquestionably visible in the mirror at the centre of the rear wall. A flight of stairs is visible through the open door and across a relatively short vestibule. The man on the stairs holds open a further door. The glances of no less than six of the figures are directed through the picture plane and into our space. The strong implication of all this is that the subject of their attention is the Royal presence itself, and that the King and Queen are shortly to progress through the room to the short staircase at the far end. The corollary is that the painting on which Velázquez is engaged depicts the Royal couple. Are these implications supported by a more precisely spatial analysis of the setting?

The perspectival clues are less blatant than they might be in an Italian Renaissance painting, but they are definite enough. The vanishing point lies close to the central point of the door opening (pl. 203). The visual axis thus runs asymmetrically down the room along a line between two of the doors. The painter's own position in the picture can be determined as straddling the central axis of the room. Given the viewing axis, the centrally-placed mirror cannot but reflect a relatively narrow vista which lies almost exclusively to the left of the central axis. The line of vision from the mirror would almost certainly have been intercepted by the large canvas. The painting would, therefore, represent a double portrait of the King and Queen. This interpretation corresponds to that of Palomino and is confirmed by the pictorial device of a red curtain visible in the mirror reflection. Velázquez would not have required advanced optical planning to achieve this effect, but simply his first-hand knowledge of what was visible in the room from a certain standpoint and what was (or would be) reflected in that mirror. However, if he has followed optical logic, it seems that the depicted figures must have been somewhat larger than life size, in that the viewing distance is doubled by the mirror reflection.

Given the clues within the painting and our knowledge of the setting, we can legitimately ask if Velásquez has precisely recreated the view according to optical principles. Let us for the moment suppose that he has used perspectival geometry, and see where this will take us.[26]

We can determine units corresponding to squares in the ground plan using the width of the end wall as the side length. These show that the picture plan is stationed somewhat more than three-and-one-quarter units from the rear wall (at IJ in pl. 203) and must therefore be nearly if not precisely coincident with the plane of the opposite wall of the room. However, this would not be consistent with the scales of the uprights canvas (which can be judged to be about three meters high and *Las Meninas* itself, which is over three meters tall. To produce the proper scaling, the picture plane would need to be located at PP in pl. 202.[27] I interpret this discrepancy to mean that there was probably not a directly geometrical relationship between the setting and the perspective of the painting. The setting and the painting would therefore stand in a different relationship from that in the standard construction.

In the light of this, I should like to suggest a design procedure as follows. Velázquez took his basic view of the room as framed by the upright edges of the door from point E. This would mean that the plane of the door aperture acted as the Albertian 'window', a concept with which he would have been well familiar from the treatises by Alberti and his successors. This view was directly recorded 'by eye', either in a rough sketch or less probably in the underdrawing on the canvas itself. It was organised in the picture itself using a standard construction of orthogonals converging on the vanishing point, but without a precise scaling of all the architectural forms in depth in the Piero manner. The figures would have then been added 'by eye' to create the desired impression.

If this is anywhere near the truth, it would mean a procedure very different from the perspectival calculations of Colonna and Mitelli. Given Velázquez's access to perspective science, this would represent a conscious choice. According to this interpretation he would be openly challenging the perceptual limitations of the Italians' geometrical mechanics. They had painted 'a little black boy going down a staircase looking like a real one' using the traditional techniques of the illusionist decorators. By contrast, Velázquez's man on the staircase is conjured up through complex interplays of tone, colour, definition and scale. The bright patch of wall silhouetting the distant man—which optically draws the wall towards the spectator—and the more ghostly *sfumato* of the reflection in the mirror are to my mind quite deliberately juxtaposed. This is just one instance of Velázquez's desire, manifested throughout the painting, to give a wider sense of the subtle processes of vision and how they can be magically evoked or paralleled in the medium of paint than was possible with the drier mechanisms of linear perspective and geometrical shadow projection. No painting was ever more concerned with 'looking'—on the part of the painter, the figures in the painting and the spectator. Velázquez's art is a special kind of window on the world—or a perceptual mirror of nature—or perhaps even more literally in this instance his personal door to the subtle delights of natural vision and painted illusion.

Velázquez and Rubens indicate in their respective ways that artists of high intelligence who were urgently concerned at this time with questions of visual representation could set their understanding of perspective into a broader context of seeing and representation. In as far as many of the optical effects to which they turned fall into the subjective category—that is to say, they were based on their appearance to the viewer rather than theoretical constructs—we will not be surprised that their visual solutions differ in detail. Similar questions of seeing and representation in relation to the science of art are posed even more directly by the art of many of their contemporaries in Holland, who were regularly involved in the business of precise architectural and topographical description in a way which Rubens and Velázquez were not.

OPTICAL GEOMETRY IN DUTCH ART OF THE SEVENTEENTH CENTURY

The flowering of easel painting in the seven United Provinces—the territories in the Northern Netherlands which had

204. Albrecht Altdorfer, *Study of a Ruined Church*, c.1520, Berlin, Staatliche Museen, Kupferstichkabinett.

been effectively freed from Spanish domination in 1609—is nowhere more remarkably seen than in the burst of perspectival painting which occurred from about 1630 onwards. This was directly linked to a striking group of illustrated texts. The character of Dutch perspectival art, above all the painting of townscapes, church and domestic interiors, was locked into contemporary thought and society in a way which is not so coherently apparent in most of the other episodes in the story we are telling. Perhaps only fifteenth-century Florence and sixteenth-century Nuremberg are in any way comparable in the earlier periods. Amongst the contemporary and successive episodes, only French art and theory of this same period offers anything like as responsive a picture—but without the internal coherence which characterises Dutch art, thought, technology and society.

To understand the nature of Dutch painting at this time it is necessary to take account of the powerful tradition of Northern and most specifically Netherlandish naturalism from the fifteenth century. As characterised by its leading figure, Jan van Eyck, this tradition had developed a high level of effectiveness in the empirical rendering of space, in concert with the kind of particularising light we noted in Dürer's art. Some idea of what could be accomplished when this tradition was allied with Italian techniques has already been provided by Dürer himself. There are comparable hints of this potential in the work of other major painters. Albrecht Altdorfer, probably shortly before 1520, made a very remarkable study of a partially ruined Gothic church (pl. 204), using a lateral-point system similar to that of Viator to achieve an effect of angled

space which virtually seems to belong two centuries later.[28] However, when perspectival techniques were taken up in a wholesale manner by Netherlandish artists in the sixteenth century it was as part of the whole baggage of the Italianate style. In the hands of painters like Mabuse and van Orley, perspective was not so much married with the native tradition as imposed upon it, as an elaborate and virtuoso part of the *all'antica* vision to which so many Northerners were converted at that time.

To some extent the dominant Dutch pespectivist of the latter part of the century, Hans (or Jan) Vredeman de Vries, is a representative figure of the Italianate phase of Northern art, but he also genuinely leads us into the era in which Dutch artists were to achieve their individual contributions to the systematic portrayal of space. Hans Vredeman was a painter, graphic artist and architectural designer who pursued a peripatetic career around Europe, comparable to that of many mobile artists during this period, and worked for a while at the illustrious court of Rudolf II in Prague.[29] His major significance was as an indefatigable producer of books of engraved designs portraying architecture, ornamental motifs, fountains, gardens and most notably perspective. These designs emerged in a steady stream from 1560 to 1604. His drawings and his *Scenographiae sive perspectivae* of 1560 show that he had acquired a competent grasp of the rudiments of spatial construction during the late 1550s and was already capable of exploiting perspectival effects with an unusually lively imagination.[30] His finest book, his two-part *Perspective* which was published in 1604–5, stands at the climax of his long career as a practising artist and educative designer.[31]

In more than one sense, Vredeman is the first natural heir to

205. Orbital diagram of the visual field, from Hans Vredeman de Vries's *Perspective*, The Hague and Leiden, 1604–5.

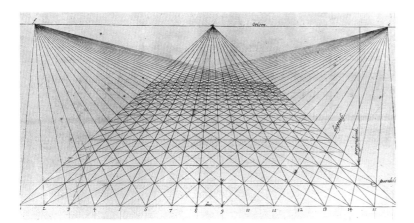

206. Basic perspective construction using two 'distance points' from Vredeman de Vries's *Perspective*.

f, c—distance points

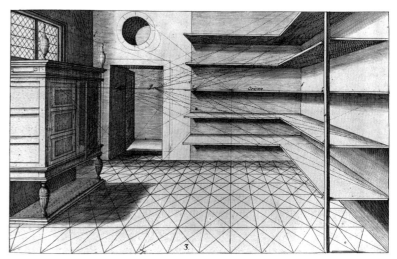

207–9. Perspectival projections from Vredeman de Vries's *Perspective*:
(above) Interior. r, g, f—alternative 'vanishing points'
(below) A tiered loggia.
(bottom) Geometrical bodies.

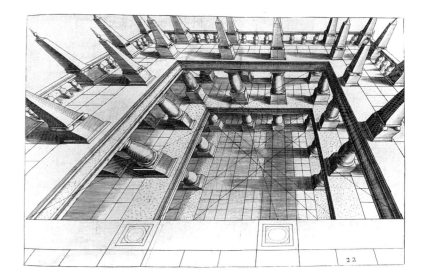

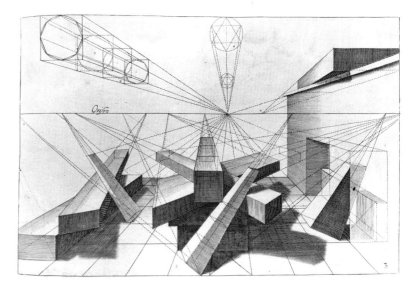

Viator. Like his predecessor, he provides can unfailingly inventive series of demonstrations of perspective in action, with brief commentaries and little overt display of constructional geometry. In his first diagram (pl. 205) he may be directly taking up one of Viator's themes, in that he illustrates the motion of the axis of sight as the eye rotates. The result in his case is an orbital diagram of successive pyramids with curved horizontals rather than Viator's straight horizon. Vredeman's second diagram shows the arrangement which corresponds to a static viewpoint (pl. 206), and this familiar scheme provides the basis for his subsequent constructions. Although he cites Dürer as the greatest master of precise perspective, his actual constructions seem to owe more to Viator, Serlio, Cousin or one of the other *tiers points* specialists.

The more than seventy demonstrations in the two parts of his *Perspective* provide a fertile series of variations on architectural themes. There are at least some signs of strain as his geometrical techniques prove inadequate for some of the more complex problems he has set himself, particularly those involving regular curves. Relatively orthodox designs based on canonical boxes of space (pl. 207) are followed by some eye-catching variants (pl. 208) in which architectural forms are portrayed at odd angles from such close viewpoints that the effects are those of anamorphic images which assume undistorted appearance only when viewed from a particular position. Occasionally his geometrical shortcomings are apparent, as in the third plate of the second part (pl. 209), in which some of the forms are clearly characterised as truncated pyramids parallel to the picture plane and yet still neatly converge at the horizon level as if subject to parallel diminution. Not suprisingly some of the designs relate directly to his own pictorial practice. He is known to have devised lost schemes of illusionistic decoration.[32] His vault perspectives (pl. 210) pay clear homage to the Italian tradition in this respect. Of his few surviving paintings, the majority exploit complex fantasies on Italianate themes of the kind he illustrates in a number of the plates (pl. 211).[33] Perhaps most significantly for the future, he also applied perspectival techniques to the portrayal of con-

vincing Gothic structures (pl. 212). During the 1590s he made a number of paintings of the interiors of actual mediaeval churches.[34] In this aspect of his practice he had apparently been preceded by Hendrick van Steenwyck the Elder, who had painted a perspective of the interior of Aachen cathedral as early as 1573.[35]

During the later part of the sixteenth and earlier part of the seventeenth centuries, architectural painting in the Vredeman de Vries manner, ranging from entertaining fantasies (with or without narrative subjects) to more sober portrayals of actual or credible monuents, continued as a conspicuous sub-genre in Netherlandish art. The full range would often be embraced by individual artists, for example the van Steenwycks, the Neefs and Bartolomeus van Bassen.[36] Vredeman's direct influence on this practice appears to have been considerable. His influence on the theoretical literature was equally significant. His immediate heir was Hendrik Hondius, a pupil who became a print-maker, publisher, expert on fortifications and author. In addition to publishing successive editions of Samuel Marolois's writings on perspective and related subjects, for which he utilised illustrations by Vredeman and himself, he wrote a popular treatise on his own account, his *Institutio artis perspecti-*

210–12. Perspectival projections from Vredeman de Vries's *Perspective*:
(above) An open loggia for an illusionistic ceiling.
(below) View of an Italianate palace courtyard with figures.
(bottom) View of the interior of a Gothic church.

213. Perspective projection of an interior with objects, from Hendrik Hondius's *Institutio artis perspectivae*, The Hague, 1622.

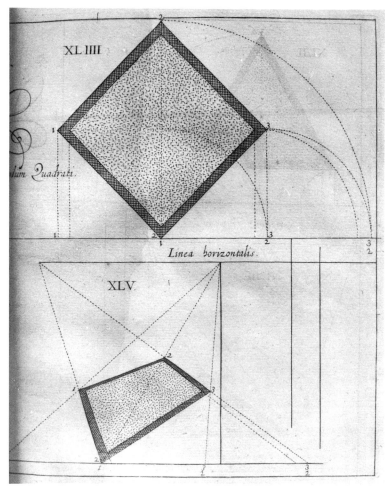

214. Perspective projection of a square using the distance point, from Samuel Marolois's *Opera mathematica*, Amsterdam, 1628.

Procedure essentially as in pl. 155.

215. Perspective projection of a loggia, from Marolois's *Opera mathematica*.

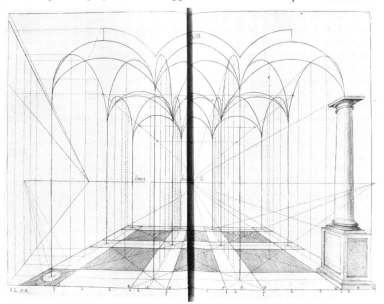

vae (issued in French as *Instruction en la science de perspective*). His book provides a series of neatly conceived demonstrations of perspective in its abstract and applied forms (pl. 213) and gives an original if brief analysis of the upwards convergence of tall verticals to a '*contre-poinct*' when viewed with a plane tilted slightly towards the spectator.[37]

Marolois, a mathematician and fortification designer (in the manner with which we are familiar), provided the standard treatment of mathematical perspective for Dutch painters and served in large measure to make the Italian mathematicians' projective techniques accessible to artists of intellectual inclination. The numerous editions of his work suggest that there was no lack of interest in his methods. His treatise on perspective first appeared in his *Opera mathematica ou oeuvres mathematiques traictons de geometrie, perspective, architecture, et fortification* in 1614.[38] Not surprisingly, in the setting of a compendium of mathematical sciences, his approach to the subject is thoroughly geometrical in nature. He insists that the artist should not naively represent 'what the eye receives' but should found his representation on the principles of projection onto a plane surface which intersects the lines of light. In answer to the claim that the painter should follow the natural phenomena of vision with respect to lateral and upwards recessions, he argues that the resulting images will violate 'natural reason'. The geometry of projection (*scenographia*) will produce a demonstrably accurate record of optical fact on the surface of the picture, and this itself will be subject to the rules of natural vision (*optica*).[39]

As we might expect he is much concerned with the perspective of geometrical bodies in the Italian manner and he provides basic instructions which are akin to those of Danti-Vignola (pls. 214–15). He also follows Vignola in providing some reasonably accessible demonstrations of projection in three dimensions and paying a good deal of attention to neatly conceived 'machines' for the obtaining of proper projections (as will be seen in Chapter IV). The mathematical yet practical tenor of his treatise is consistent with the publications by other Dutch theorists, most notably Salomon de Caus, whose *La Perspective, avec la raison des ombres miroirs* was published in London in 1612, and Simon Stevin, whom we will meet when we look at Saenredam's church interiors.[40]

Most studies of Dutch art have paid little attention to the relationship between such geometrical theories and pictorial practice. There has been a general sense that the naturalism of Dutch art is largely indepenent of geometrical theorising.[41] More specific beliefs have been expressed to the effect that such 'Italianate' mathematics are radically incompatible with the naturally descriptive vision of Dutch art. It is true that we should not automatically regard the mathematical theorists as representing the typical face of Dutch art—it could simply be the case that the mathematically-minded theorists were inclined to put their thoughts down on paper, while the 'empiricists' were not. However, all the indications are that the books served a very real need and were hugely successful. Marolois's treatise re-appeared in 1616, 1628, 1629, 1630, 1638, 1639, 1644, 1651 and 1662, adorned with illustrations by Hondius and incorporating plates from Vredeman de Vries.[42] The

mathematical aspects were re-edited by Albert Girard, a mathematician-engineer of some significance, who was also the editor of texts by Stevin.[43] Hondius's own compendium sold sufficiently well to warrant a number of editions in a short space of time.[44] All this, to my mind, is symptomatic of an avid interest in perspective in the United Provinces, an interest which fully expressed itself in pictorial form–not in pictures which imitate the Italian mode but in representations which find a new way of expressing the geometry of perspective within the framework of the direct scrutiny of nature. The way in which Dutch artists from about 1630 succeed in integrating perspective with the direct portrayal of real structures may be seen as the realisation of one of the potentialities of Brunelleschi's original invention, a potentiality which had remained largely dormant.

The diverse levels and wide range of approaches to 'natural mathematics' in Dutch art make it difficult to know where best to begin. Perhaps it would be wise to begin where the detailed evidence is strongest. This, happily, is also where the art is at its most compelling. I am referring to the architectural paintings of Pieter Saenredam. Even without close analysis and without any knowledge of their creator's background, his paintings speak a language of consummately measured control in every respect. When we choose to undertake close analysis of particular paintings and investigate his known interests we will find that this impression is amply confirmed.

We are fortunate in knowing the contents of his library immediately after his death.[45] His collection consisted of over three hundred books—an outstanding total at this time for anyone in any walk of life. Amongst these is a coherent group of texts on pure and applied geometry and related arts. He owned three Euclids, including the first Dutch translation (1606), Dürer's treatises on proportion and measurement, and a Dutch edition of the *Mathematical Works* of Frans van Schooten, one of the teachers of the great Christian Huygens.[46] Perhaps the most interesting set of texts from our point of view are the treatises by Simon Stevin. He possessed Stevin's works on land-metering, architecture, and the military sciences—engineering, logistics and manoeuvres.[47] Stevin is an interesting and important figure, who will require closer attention in our efforts to understand Saenredam in particular and Dutch perspective art in general.

Stevin was a mathematician-engineer whose researches in pure science were deeply informed by his practical activities in the service of Prince Maurice of Nassau, the leader of the United Provinces.[48] He was involved in geometry, algebra, arithmetic (pioneering a system of decimals), dynamics and statics, almost all branches of engineering and the theory of music. Not altogether unexpectedly, he published a treatise on perspective in 1605.[49] His approach to perspective belongs in the Commandino-Benedetti-Guidobaldo tradition, and his main demonstrations are uncompromisingly geometrical in nature (pls. 216–17). He also took up the essentially non-pictorial problem of the rotation of the picture plane into the ground plane, formulating one of the basic theorems of homology.[50] However, he does show some of Marolois's sensitivity to the needs of practitioners. His treatise was occa-

216. Demonstration of the 'vanishing point' for parallel lines, from Simon Stevin's *De Deursichtighe*, Lieden, 1605.

FE—observer AC—base of picture plane
AB and CE—parallel lines projected to AM and CN
K—'vanishing point'

217. Perspective projection of rectangle and a parallelogram, from Stevin's *Der Deursichtighe*.

The basic procedure as in Guidobaldo, pl. 172.

113

218. Pieter Saenredam, *Study of the Interior of St. Bavo's Looking West*, 1635, Haarlem, Municipal Archives.

219. Pieter Saenredam, *Lower Left Portion of the Construction Drawing for the Interior of St. Bavo's*, 1635, Haarlem Municipal Archives.

sioned by the desire of Prince Maurice to understand the principles of pictorial representation—'wishing to design exactly the perspective of any given figure with knowledge of causes and mathematical proof'.[51] Stevin accordingly provides 'abridgements' of his geometrical techniques for artists—albeit rather abstract abridgements—and illustrates a Dürer-like perspective machine.[52]

Stevin's work as a whole is deeply characteristic of Dutch activities—scientific and practical—at this time. The close allegiance he forged between abstract mathematics and technical practice, drawing the pure sciences away from their metaphysical base and uniting them with concrete procedures, is altogether typical of Dutch science.[53] Stevin and his fellow mathematicians were concerned with an astonishing range of applied skills and technologies—fortifications, guns, ships, canals, navigation, windmills, cranes, modes of transport, timepieces, surveying, accounting, banking and, certainly not least, the optical instruments such as the telescope and micro-

scope that were being exploited to revolutionise the visual data of science. No less characteristic was the self-conscious 'Dutchness' of the total enterprise. Stevin wrote fervently about the intellectual power and practicality of the Dutch language, which thus became a vital tool in the triumph of the moderns over the revered ancients.[54] All this activity was taking place in consciously new kind of society in which the properties of order were seen from both within and without as manifestations of the Dutch genius for functional rationality.

With respect to the geometrical particulars, the technical precision and the generality of outlook, Saenredam's art is a high manifestation of these Dutch ideals. He is the first artist who turns exclusively to the unwavering scrutiny of Dutch buildings. Each on-the-spot drawing is typically inscribed in an obsessive manner with particulars of when and where it was made and often with details of when it was translated into a painting, which sometimes did not occur until years later.[55]

220. Pieter Saenredam, *Lower Right Portion of the Construction Drawing for the Interior of St. Bavo's*, 1635, New York, Ian Woodner Family Collection.

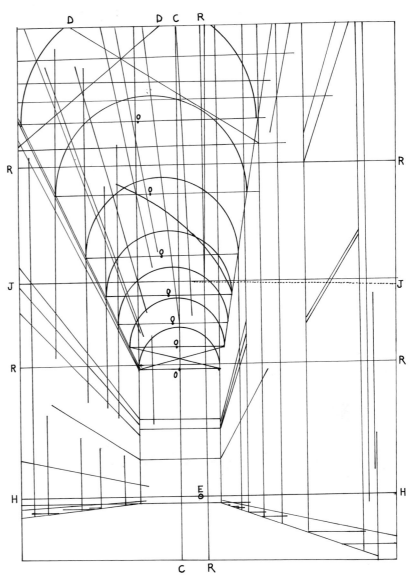

221. Transcription of the more readily visible lines in the graphite underdrawing in the construction drawing for Saenredam's *Interior of St. Bavo's* (pl. 220).

E—'eye point' (or vanishing point)
CC—vertical line through centre of end wall
DD—diagonals for the construction of the vault
RR—squaring lines in reddish ink

HH—horizon

JJ—join in the pieces of paper

Thus the illustrated drawing of the 'Great Church' of St. Bavo's Haarlem, looking through the crossing to the West end (pl. 218), is inscribed 'On 25 August year 1635, Pieter Saenredam' on the capital of the rightmost pier.[56] It is as if Saenredam's presence has become part of the fabric of the building. In the more highly-finished construction drawing which grew out of this study (pls. 219–20), he wrote on the base of the leftmost pier, in the manner of a graffito: 'finished drawing this on the 15 December 1635. And is a view in the great church of Haarlem the painting finished on 27 February 1648. The panel on which this construction (*ordonnantij*) was painted is five feet and two inches wide and 6 feet and 3 inches high. After *kermer* or *kennemer* footmeasurement'. In the resulting painting (pl. 222) the inscription is set amongst other graffiti on the same pier base: 'This is the Cathedral great church of Haarlem, in Holland. Pieter Saenredam, finished painting this, the 27 February 1648'. We know that this obsession with precision was reflected in his taking precise measurements of at least

some of the buildings he was to portray. Some of his drawings record actual dimensions and others bear a linear scale along the base of the perspective construction.[57]

When we look at this particular construction drawing in detail we find ample evidence of the level of precise planning involved. A complex armature of drawn lines (pl. 221) underlies the architectural forms modelled in pen and wash.[58] He has not only noted his 'eye point' as he calls it—i.e. the vanishing point—but he has also recorded the position of the one distance point which lies within the construction itself. This is marked by a crossed circle on the base of the leftmost pier and its distance from the central axis, '30' Dutch feet, duly noted. This point would have provided one means for controlling the scale of all forms into the depth of the painting (pl. 223). The relative dimensions of breadth and height in the end wall are so

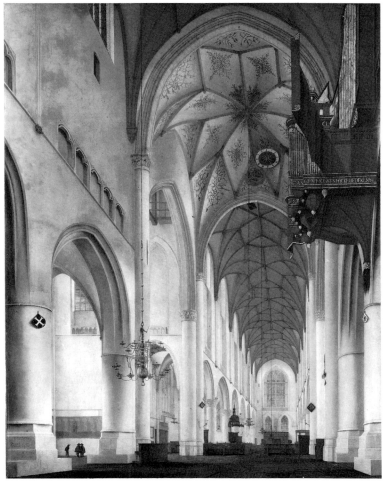

222. Pieter Saenredam, *Interior of St. Bavo's Looking West*, 1648, Edinburgh, National Galleries of Scotland.

223. Demonstration of the use of the 'distance point'.

V—'eye point' (or vanishing point)
Z—'distance point'
CV—orthogonal marking the axis of a colonnade
AB—scale along the base of the picture
ZF—diagonal intersecting CV at a depth of 4 units
G—a vertical of 8 units erected on CV at a depth of four units

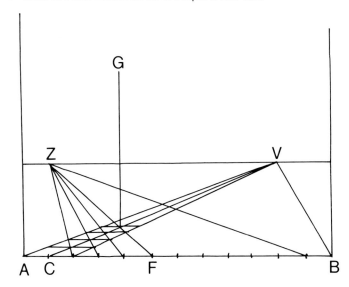

accurate as to suggest that this has served as a stable point of proportional reference.[59]

All this effort of constructional precision does not result in a painting which is drily mechanical. This is partly a result of his marvellously subtle use of light, as he traces the nuances of diffused radiance throughout the space, but it is also a consequence of a particular kind of visual magic which is built into the linear structure of the picture itself. His fascination with the geometrical transformation of shapes when projected onto a plane surface—a fascination which was nourished by his knowledge of three-dimensional geometry—clearly influences his choice of viewpoint and visual angle. The subsequent exercise of projectional geometry remains continually responsive during the design procedures to his dual sense of the subjective effect of the seen object and the physical properties of the drawings and paintings on flat surfaces in particular media. It can be shown that he has perceptibly stretched the vault over the nave and the crossing to create the desired effect of verticality.[60] This is accomplished in the context of the peculiarly tensile equilibrium of the linear design on the surface of the panel. If any part of the cobweb of tense visual threads were to be severed, we feel that the whole delicate armature would shatter into discrete filaments.

The particular procedure adopted for this design is not precisely the same as that for his other paintings. His design process was continually responsive to the special needs of each individual case.[61] Indeed, the visual and technical range within the apparently limiting confines of his chosen genre is astonishing. What this painting does share with all his mature works is the *level* of precise planning and degree of perspectival acumen which went into its construction. It also shares one inviolate technical feature, namely his steadfast allegiance to the parallel alignment of the picture plane with one of the predominant planes of his subject—in this instance the plane running parallel to the end wall, the lateral walls of the transepts and the transverse faces of the pier bases. This dogged planarity is an expression of his desire to retain a clear sense of the projection of forms in terms of their *transformed shape* on a plane surface, in a manner analogous to the geometrical demonstration of Stevin.[62]

Other Dutch artists in the direct or indirect succession of Saenredam adopted a variety of solutions which departed to a greater or lesser degree from his sense of plane projection. The most perspectively adventurous solutions were those developed by Delft artists in 1750 and shortly thereafter, above all by Gerard Houckgeest and Emanuel de Witte.[63] Almost simultaneously these two artists turned to the depiction of real church interiors, usually with angular viewpoints which create a quite different sense of Gothic space from that of Saenredam. Houckgeest's *Interior of the New Church at Delft* of 1651 (pl. 224), showing the tomb of William the Silent—a subject whose popularity is explained by its status as a focus for Dutch patriotic feeling—gives an idea of their approach at its most virtuosic. The extraordinarily wide angle of view, which can be calculated as close to 120°, picks up three converging systems in the diagonally-orientated tiles, two corresponding to the sides of tiles and one passing along the diagonal axis (pls.

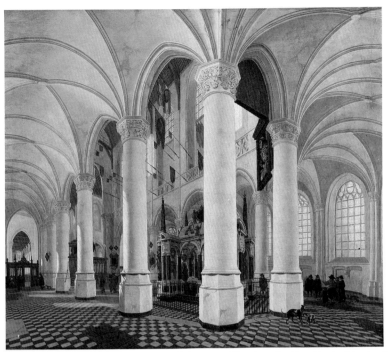

224. Gerard Houckgeest, *Interior of the New Church at Delft with the Tomb of William the Silent*, 1651, The Hague, Mauritshuis.

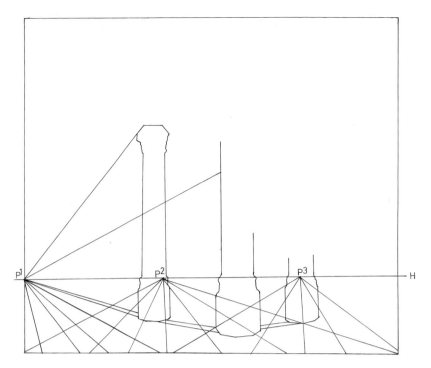

225. Perspective analysis of Gerard Houckgeest's *Interior of the New Church at Delft*.

P^1—point of convergence of orthogonals of floor tiles looking down the aisle
P^2—point of convergence of diagonals of the floor tiles
P^3—point of convergence of the orthogonals looking across the choir
H—horizon

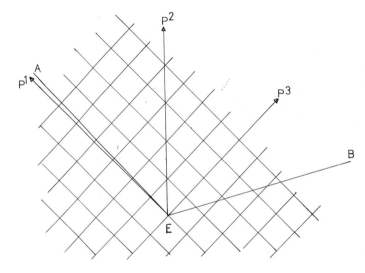

226. Demonstration of the viewing angles in Houckgeest's *Interior of the New Church at Delft*.

E—observer AB—visual angle
P^1, P^2, P^3 as in pl. 225

227. Perspectival representation of architectural forms under an angle in excess of 90°, from Vredeman de Vries's *Perspective*.

225–6). The basis for this type of construction was very probably the wide-angle illustrations of forms in Vredeman de Vries's *Perspective* (pl. 227), though Houckgeest has used the system for quite different visual effects. He has brilliantly suggested the almost bewildering variety of spatial configurations with a Gothic church, particularly in a formally complex area like the ambulatory. Narrow slivers of upright space, sharply angled vistas, fractured occlusions of remoter objects and dynamic rhythms of clustered lines create a new species of optical variety without losing the sense of an organic whole. Probably only Altdorfer (pl. 204) had earlier approached this effect. In other paintings by Houckgeest and de Witte similarly unconventional vistas are complemented by a special attention to irregular patches of light and shade which contribute yet more optical complexity to paintings in which the artists seem

228. Pieter de Hooch, *The Bedroom*, c.1660, Washington, National Gallery of Art, Widener Collection.

tive in foreground to establish the pace of the recession.[66] This even applies to exterior pavements composed from rougher tiles or bricks of varied sizes. Equally characteristically, the constructional geometry is endowed with a kind of homely irregularity—perhaps we should call it a sense of humanity—through the use of differently orientated patterns in the secondary spaces, and not uncommonly by the portrayal of tiles of different size and shape from those in the foreground. To this is added the optical variety of broken patches of illumination, both direct and reflected, together with the sheen of polished floors, which not infrequently masks the linear patterns as the light glances from surfaces at a low angle in the deeper portions of the space.[67] Perspective is thus exploited with a control which would win the respect of an Alberti, but it is subtly subverted by other ocular effects in a way which would have unsettled an Italian's sense of geometrical integrity.

These techniques provided the Dutch artists with the means to create illusionistic decorations on their own terms. As with Vredeman de Vries's work in this field, disproportionately small numbers of such illusions, painted in and for specific domestic settings, have survived. One exception is the compelling illusion of three successive rooms painted by Hoogstraten on his visit to Britain in 1662. His 'perspective', as it was called, was located at an early date at the end of one of the cross-axes in the country house of Dyrham Park in Gloucestershire (pl. 229).[68] That such illusionistic decorations were thought to be capable of sustaining comparison with the devices of the Italian illusionists is indicated by Hoogstraten himself, who follows his admiring reference to Giulio Romano's frescoes at Mantua with an account of Fabritius's optical art and his own perspective boxes.[69] His surviving perspective box (pls. 408–9) will be discussed in the next chapter, but the reader might like to refer forward to the illustrations for additional confirmation of the kind of visual challenge Hoogstraten was capable of mounting.

Hoogstraten's own treatise on painting, his *Inleyding tot de Hooge Schoole der Schilderkonst* (perhaps best translated as 'Introduction to the High School of Painting') is in many ways a curious concoction and rests uneasily with much of his own pictorial practice. It is organised in nine books, each dedicated to one of the Muses, and is predominantly larded with generous helpings of derivative humanist learning which serve to emphasise the high intellectual and social status of painting. He provides no technical exposition of perspective, simply referring the reader to Dürer, Vredeman de Vries, Marolois, Guidobaldo and Desargues.[70] His general remarks on optics do not suggest an attitude very different from that of Marolois or even Stevin, and he professes an open admiration for Alberti's treatise.

The art of painting is a science for representing all the ideas or notions which the whole of visible nature is able to produce and for deceiving the eye with drawing and colour. . . . I say that a painter whose work it is to fool the sense of sight also must have so much understanding of the nature of things that he thoroughly understands the means by which the eyes are deceived.[71]

deliberately to be stretching irregularity as far as it will go before it collapses into spatial incoherence.[64]

The painting of domestic interiors, which occupied a no less prominent part of the careers of other Dutch artists, also yields a rich crop of perspectival effects, though none with the overtly mathematicising quality of Saenredam. Often it was simply a case of the basic construction of a tiled floor and the converging orthogonals of wall and ceiling being used in a routine way with greater or lesser care to provide the desired space for the subject. Within the *oeuvres* of some painters, Jan Steen for example, it is possible to find both careful schemes of precise perspective and casual constructions which indicate little concern with accuracy.[65] Others, such as Pieter de Hooch, Jan Vermeer and Samuel van Hoogstraten, exhibit a consistently high level of care for exact construction. Of these painters, Vermeer presents the most striking visual and intellectual challenge. However, I think it is impossible to discuss the optical qualities of his art without a fuller understanding of instrumental systems for the imitation of nature. I am, therefore, postponing an analysis of his paintings until the next chapter. I am adopting the same procedure for Carel Fabritius. This is one instance—I hope the only conspicuous instance—in which my chosen division of the material creates real difficulties, but the many other advantages seem to outweigh this one major dislocation. That this should occur with Dutch art may itself eventually say something about the visual qualities of that art.

For the moment Pieter de Hooch will serve to exemplify Dutch painting of domestic interiors at the highest level (pl. 228). Whenever he wished to describe one of his typically enticing series of intimate glimpses through a succession of domestic spaces, he almost invariably used canonical perspec-

229. Samuel van Hoogstraten, *Perspective Illusion*, 1662, Gloucestershire, Dyrham Park, the National Trust.

Like Aguilonius and his great Swedish contemporary, Schefferus, he is well aware that scenographic perspective is only a very limited case within the whole science of optical phenomena, but this does not lead him to suggest a fundamental revision to the available means at the painter's disposal.[72] Where he does show an individual flavour is in his wholehearted placing of illusion in the service of natural representation. His attention to light effects, which he discusses before he makes his brief comments on perspective, is consistent with this emphasis, and had been foreshadowed to some extent by Salomon de Caus's lively demonstrations of cast shadows in domestic interiors.[73]

The actual optical ideas in all the Dutch treatises were deeply conservative. Hoogstraten, like Marolois, still advocated an extramission theory of sight, and there is not the slightest glimpse of the new ideas on the mechanism of the eye pioneered by Kepler and extended by Descartes. Kepler's concept that 'vision is brought about by a picture of the thing seen being formed on the concave surface of the retina'—that 'the retina is painted with the coloured rays of visible things'—seems to offer a tempting parallel to the optical veracity of Dutch art.[74] Unfortunately, there is no evidence that such an identification was made. Indeed Kepler's theory on its own terms—set within his mathematical investigation of astronomical optics and placed in the service of his elaborately Platonising cosmology—offered the artist nothing new that he could immediately use.[75] Indeed, certain features of his theory, such as the 180° viewing angle, would simply have caused unwanted problems in an area which was already complicated enough.

The optical-perspectival features of Dutch art represent a complex alliance of traditionally Aristotelian optics, geometrical theory, standard workshop techniques and Eyckian naturalism with the empirical and applied tenor of Dutch thought at this time. The ingredients and proportions in this compound naturally differed for different artists, but there seems to be nothing in theory or in practice which cannot be encompassed by this interpretative model. There is much to be done in illustrating and refining this model—and we will ourselves be approaching it from a different angle in a later chapter—but I do not at present see any reason to look beyond it.

THE FRENCH PERSPECTIVE WARS

The matching span of fifty years or so in France from 1630, which saw the foundation of the most potent of all the early academies of art, may not unreasonably be considered as the golden age of the perspective treatise. It was certainly the prime period for vicious battles over questions of perspectival ethics. The disputes reached levels of personal bitterness which make the Bassi-Tibaldi altercation seem quite restrained. The story of these years, both as a human tale of factional rivalries within the artistic profession, and as an account of colliding aesthetic values, is not the first or last episode we are encountering in this study which is worth a book in itself. The sheer quantity of primary sources is formidable.

A list of the authors of the most significant treatises devoted specifically or substantially to perspective will give some idea of this abundance (the dates of the first editions of their main work or works are given in brackets): Vaulezard [1630], Desargues [1636], Niceron [1638 and 1646], Dubreuil [1642, 1647 and 1649], Aleaume and Mignon [1643] Bosse [1648, 1653, 1665, and 1667], Gaultier [1648], Le Bicheur [1660], Bourgoing [1661], Huret [1670], and Le Clerc [1682].[76] To this list need to be added the names of authors like Félibien who discussed perspective at greater or lesser length in more general books, of mathematicians who analysed pictorial perspective in their writings, and of foreign theorists like Marolois whose works were available in French. Not surprisingly, these treatises brought with them a great proliferation of constructional techniques. It is in the nature of perspective, for geometrical reasons that will become apparent when we look at Desargues, that the same result can be achieved in any number of geometrical ways. Many of the theorists in our list devised their own systems of varying degrees of ingenuity, practicability, complexity and obscurity. Not a few of them use geometrical devices which are remote—particularly from a painter's standpoint—from the optical realities of the original concept of seeing objects through the picture plane. The reader may be relieved to know that I do not intend to work laboriously through all the new variations.

The way I have chosen to approach this huge body of evidence is through the writings of Girard Desargues. I am doing this both because he was the greatest prespectivist and projective geometer of his generation, and because the arguments which raged around his system provide a good insight into the key issues with respect to art and science. Desargues was a civil and military engineer, an architect specialising in staircase design and above all a geometer of extraordinary spatial vision.[77] His intellectual ambition was expressed in two closely-related aspirations: the building of a geometry of position (i.e. non-metrical) based on projective techniques; and the provision of all-embracing methods of geometrical operation for practioners in various fields. He intended theory and practice to be integrated just as they had been for Stevin:

> I freely declare that I never had a taste for study and research in either physics or geometry except in so far as they could serve the fundamental purpose of arriving at a form of knowledge of proximate causes, . . . having observed that a large part of the practice of the arts is founded on geometry as the basis of certainty, amongst others the art of cutting of stone in architecture. . . that of sundials, . . . that of perspective. . . .[78]

He emerged as a publishing theorist in 1636, with an essay on the reading and writing of music which he contributed to Mersenne's *Harmonie universelle*, and with his own *Exemple de l'une des manières universelles . . . touchant la pratique de la perspective . . . (Example of One of the Manières Universelles of S^r G.D.L. concerning the practice of Perspective without Employing Any Tiers Point, of Distance or of Any Other Kind which Falls Outside the Area of the Work).*[79] In the twelve-page pamphlet with its one compound illustration (pl. 230), he aimed to pro-

vide a technique which would subsume all previous methods and provide a completely self-sufficient procedure embracing all possible cases encountered by the practitioner. To accomplish this he devised a double construction within the field of the picture using precise scales and projective geometry to achieve a more detailed degree of spatial calculation than was possible using the standard checker-board floor. A detailed outline of his procedure is provided in the caption to the plate.

The basis of his construction is the creation of two geometric scales. The 'scale of measures' uses orthogonal lines drawn from G to a series of scaled divisions at the base of the picture plane to provide the measures for horizontal dimensions into the depth of the ground plane in a more-or-less standard manner. The 'scale of distances' uses a separate scale of *petits pieds* corresponding to the viewing distance and is produced along the base of the picture from A to C. The intersections of the diagonals FC and AG mark a point 24 units or *pieds* into the space. If further diagonals are drawn from F to divisions on the scale AC, they intersect the diagonal AG at points which give the locations of corresponding depths in the space. Thus the line from F to point '17' marks a position 17 units from the front plane and therefore provides the horizontal coordinate for the near corner of the structure he is projecting. The vertical location of this corner on the horizontal is achieved by transferring the measurement of 1½ units (rm on the plan) from the 'scale of measures' on the right of the construction to give the scaled distance of M from R. The whole technique is neatly ingenious, but the use of two scales along the base of the picture plane and the way in which the viewing distance is manipulated without moving point F would have proved rather disconcerting for painters familiar with the uniformly-scaled method.

Desargues's next significant publication was his *Brouillon project . . . (Rough Draft of an Attempt to Deal with the Outcome of a Meeting of a Cone with a Plane)*, fifty copies of which were issued in 1639.[80] Besides dealing with such technical questions as points in involution (an example of which we will encounter below) and the perspectival properties of quadrangles inscribed in conic sections, this treatise also contains fundamental statements of a new kind of geometry which had been independently set in motion by Kepler.[81] According to the new principles, straight lines are to be considered as equivalent to curves of infinite radius meeting at infinity. The technical and conceptual innovations which crystallised during his studies of conics seem to have refracted back into his studies of linear perspective and led to the formulation of one of the theorems which bears his name. This states that: if two triangles are produced such that lines connecting pairs of corresponding vertices meet in a point, then the points of intersections of pairs of corresponding sides lie on a straight line; and conversely (pl. 231).

He has brought together a number of concepts in classical geometry—Euclid's Porism and theorems by Pappus and Menelaus—in a new synthesis to provide a theorem of such a fundamental kind in the field of projective geometry that it has on occasion been granted axiomatic status.[82] Its basic proof is normally achieved in three dimensions, and if we envisage it in

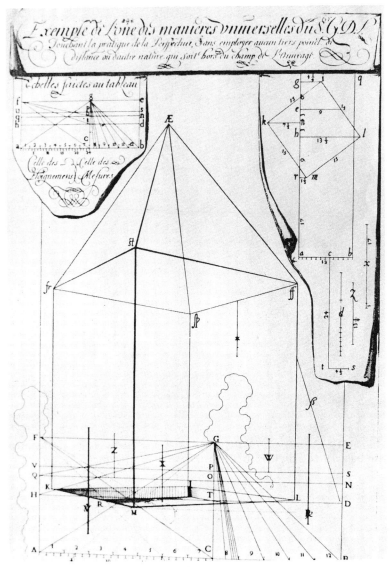

the familiar guise of a picture plane onto which a triangle is projected (pl. 232) we will be more readily able to grasp its essential features in terms of the perspectival techniques which had culminated in Guidobaldo's book. The theorem may have been published in the supplementary *Livret de perspective* which he issued in 1643, and it certainly appeared in Bosse's exposition of Desargues's *Manière universelle* in 1648.[83]

The rich implications of his theorem have been explored by geometers in the nineteenth and twentieth centuries. From our present standpoint it might be interesting to examine two of its relationships with the 'workshop' procedures we have seen so many artists operating. If we take three or more lines (a 'flat pencil' in geometrical terms) diverging from a single point and cutting two non-parallel lines and we draw diagonals between opposite points, the crossings of the diagonals will lie on a straight line. The points are described as in 'involution': i.e. the ratios between them (and other properties of their relative positions) remain constant in projection.[84] The corresponding

230. Metrical perspective projection of a building on a square plan, from Girard Desargues's *Example de l'une des maniéres universelles . . . touchant la pratique de la perspective*, Paris 1636.

Inset drawing upper right: scale plan of object, picture plane, and viewpoint.

Main drawing: (1) Base line AB is divided into 12 feet corresponding to ab in inset drawing upper right. (2) FE = horizon, on which G marks the axis of sight. (3) Diagonals AG and FC give horizontal HD. Inset drawing upper left: (4) Draw ft, giving horizontal qn where ft intersects ag. (5) Draw fo, giving horizontal us, and so on . . . Main drawing: (6) AC is divided into 24 feet corresponding to tc (viewing distance) in inset drawing upper right. (7) HD (see 3 above) is 24 feet behind picture plane. (8) QN is 48 feet behind picture plane, and so on (9) BG and orthogonals to right of GC are drawn. (10) Each intersection of orthogonals on HD, QN, etc. = scale of 1 foot. Thus HD contains 24 scale feet, QN 36 scale feet, etc. To find the position of m. (11) A distance equivalent to ra (upper right inset) is measured on the scale AC, i.e. at point 17. (12) Point 17 is joined to E, and the point at which it intersects AG provides the horizontal R on which M is to be located. (13) A distance equivalent to rm (upper right inset) is measured on the horizontal R using the scale of orthogonals to right of GC. (14) The scaled distance is measured from the intersection of AG and R to give the location of M. (15) All other points on the plan can be produced by procedures equivalent to 11–14 above.

The verticals, V, Z, W, R¹, represent the height of standing figures. The height of the verticals of the house are calculated according to the corresponding horizontal scale.

231. Desargues's theorem

ABC and DFG—triangles

When lines joining the vertices B and D, A and F, C and G converge to a single point, E, the extensions of the opposite sides of the triangles meet on a common line, IJ, and vice versa.

232. Desargues's theorem as a three-dimensional diagram.

E—eye
ABC is seen as DEF

IJ—base of picture plane (P)

233. Desargues's theorem when two of opposite sides of the triangles are parallel (i.e. meeting at infinity).

ABC and DFG—triangles
(labelled to correspond to pls. 231 and 232)

CB is parallel to GD

234. Desargues's theorem when the lines through the vertices are parallel (i.e. meeting at infinity).

ABC and FG—triangles
DB is parallel to FA and GC, meeting at point E at infinity (labelled to correspond to pls. 231 and 232)

pairs of triangular figures made by the diagonals and the two non-parallel lines will obey Desargues's theorem. Let us now consider two particular cases of this construction: one in which a pair of corresponding sides of two triangles are parallel, i.e. meeting at infinity (pl. 233); and one in which the lines through the vertices are parallel (pl. 234). The identity of both these with elements in our familiar distance-point or *tiers points* construction will be readily apparent. The generality of Desargues's theorem is thus expressed in the particular cases of the triangular sections of our standard tiles in their regular foreshortening.

Within the world of mathematics, Desargues's innovations were largely smothered by the very different techniques of algebraic analysis introduced by Descartes, which rapidly proved their power both in their own field and with respect to the new techniques of calculus.[85] Although Desargues's techniques survived more actively than the standard histories suggest—not only in the work of an immediate disciple, Blaise Pascal, and a later follower, Philippe de la Hire, but also in the literature on stereotomy and perspective—it is true to say that the mathematical implications of his projective techniques were not to be properly realised until their 'rediscovery' by Poncelet and Chasles in the nineteenth century.[86] His perspectival techniques could well have suffered a similar fate in the world of art. Most painters would have been little concerned with his general theorem, and his *Manière universelle* might seem to represent little more than an eccentric byway from the main path of the artists' perspective. However, the actual story is very different. Through his own efforts as a polemicist and with the conspicuous assistance of Abraham Bosse in the Academy, his *Manière* became the centre of a noisily prominent controversy.

Desargues's work on conics had been the subject of a limited polemic in 1640.[87] Two years later the perspective wars began in earnest on a larger scale. The immediate cause was the publication of *Perspective practique*. . . by a 'Jesuit of Paris' (actually Jean Dubreuil).[88] This was a substantial, effective and not overly technical introduction for artists, which imprudently contained a bowdlerised version of Desargues's *Manière*. The mathematician's response was immediate. He issued two posters (or hand bills) accusing the anonymous author of 'incredible error' and 'enormous mistakes and falsehoods'.[89] Dubreul's answer. in a pamphlet entitled '*Diverses méthodes universelles*. . . , was to accuse Desargues of having plagiarised the ideas of Vaulezard and Aleaume (which does not seem to have been the case).[90] The Jesuit's publishers also issued a collected edition of anti-Desargues pamphlets under the ironic title, *Avis charitables sur les diverses oeuvres et feuilles volantes du Sieur Girard Desargues* (Charitable Opinions of the Various Works and Leaflets of Sieur Girard Desargues of Lyons).[91] Desargues replied with pamphlets devoted to *Six Errors on Pages 87, 118, 124, 128, 132 and 134 in the Book Entitled the 'Perspective Practique'*. . . and a *Response to the Sources and Means of Opposition*. . . .[92] Such terms as 'imbecility' and 'mediocrity' were used with undisguised venom by both parties.

In the next year, 1643, Bosse brought out the first of the publications in which he expounded Desargues's views. These

235. Perspective scales from Abraham Bosse's *Manière universelle de M. Desargues pour pratiquer la perspective*, Paris, 1648.

236. Demonstration of the picture plane as a window from Bosse's *Manière universelle*.

237. Scaled box of interior space from Bosse's *Manière universelle*.

238. Scaled modules for human figures, from Bosse's *Manière universelle*.

239. Perspective projection of a grid design on to a flat ceiling, from Bosse's *Moyen universelle de pratiquer la perspective sur les tableaux ou surfaces irrégulières*.

consisted of treatises devoted to *manières universelles* for the cutting of stones in architecture according to the principles of projective geometry and the making of sundials, etc.[93] These attracted new assaults, this time from an expert in stonecutting, Curabelle, who devoted three pamphlets to the criticism of Desargues's works and of the 'pitiable feebleness' with which the mathematician had reacted.[94] At this distance in time it is perhaps difficult to understand the vehemence, but we should remember that these disagreements were not simply keen disputes over geometrical solutions or theoretical issues; they related directly to the cherished practices of professional groups who were as protective then as such bodies are today.

Initial victory, somewhat surprisingly, seems to have lain with Desargues and Bosse, the 'new' men. This success is perhaps explained by the desire of the founders of the *Acadèmie Royale* to establish their intellectual independence from the older professional bodies such as the guilds.[95] In 1648, shortly after the Academy's foundation, Bosse was invited to provide instruction in perspective. As an engraver by profession he was not eligible for formal election to the Academy, but he was made an Honorary Member in 1651 in recognition of his contribution as a teacher.[96] The publications issued by Bosse during and after his years at the Academy give a clear idea of his courses.[97] He provided direct instruction in Desargues's *Manière*, which was extended to embrace different ways of creating the two scales (pl. 235), the means of relating the underlying geometry to the notion of a picture plane as a 'window' (pl. 236), demonstrations of how a complete box of space can be created (pl. 237), and the scaling of human figures in the space (pl. 238). His expanded publication of the *Manière* in 1648 was followed in 1653 by his *Moyen universelle*, which

240. Abraham Bosse, Study of architectural perspective with light and shade, from *Traité des manières de dessiner les ordres de l'architecture*, Paris, 1664.

his own man, Jacques Le Bicheur, into the Academy as an authority on perspective, and to use Leonardo's newly published *Treatise on Painting* to undermine Bosse's doctrinaire insistence on geometrical devices. It was helpful in this respect that the particular selection of Leonardo's writings in the manuscript compilations of the *Trattato* which were used for the 1651 edition included little in the way of detailed instructions for perspectival construction.[100] Matters came to a head in 1660 when Le Bicheur published his *Traitè de perspective*, prominently dedicated to Le Brun.[101] Bosse issued a pamphlet of vigorous criticism against the 'derivations, disfigurements and falsifications' in the new treatise and petitioned for its examination by the Academy.[102] By this time, the Le Brun faction was

241. Perspective study of geometrical bodies with shadows from Bosse's *Traité des pratiques géométrales et perspectives*, Paris, 1665.

paid particular attention to the illusionistic projection of perspective onto ceilings and vaults of various configurations (pl. 239).[98] Bosse's own engravings, executed with a scrupulous graphic technique characteristic of his whole approach, generally set genre subjects of a moralising or anecdotal kind in meticulous boxes of space.[99] On occasion he found scope for particular tours-de-force of perspectival recession in his subject engravings and book illustrations (pl. 240).

Signs of opposition from within the Academy, above all from Charles Le Brun, began to appear as early as 1651 but were at first containable. Bosse was able to rely upon substantial support, not least from Laurent de la Hire, whose son Philippe has already been mentioned as one of Desargues's few successors in the seventeenth century. By 1657, however, serious trouble was brewing. Le Brun had begun to insinuate

242. Demonstration of foreshortened objects in a perspectival interior, from Jean Dubreuil's *Perspective practique. . .* , Paris, 1642.

der', while the second provides systematic instruction in the rendering of objects in space (pl. 241). Towards the end he specifically addresses the activities of 'the new Reformer' (Le Bicheur or Le Brun?) who is leading the youth of the Academy astray by pretending that they can dispense with Bosse's precise techniques in favour of judgement by eye.[107]

These disputes were not just concerned with which techniques were to be preferred. They more profoundly involved the relationships between theoretical prescription, visual judgement, practical procedures, and artistic ends. Dubreuil would have agreed with Bosse that failure to master the rules was not to be commended: 'however excellent a painter may be, he must follow all these rules or end up appealing only to the ignorant'.[108] But Dubreuil's rules are only to be pursued as far as is useful to the practising artist (pl. 242), and he accordingly accommodates himself 'to the capacity of Learners; not perplexing them with many Demonstrations'.[109] In a later publication, this practical attitude has been softened even further: 'neither I nor my like have enough patience to bind ourselves to these rules' in every respect when wishing to achieve the desired effects.[110]

The challenge mounted by Le Bicheur, and in a more substantial way by Grégoire Huret in 1670, was potentially more corrosive than Dubreuil's pragmatism and loss of patience.[111] Huret's *Optique de portraicture et peinture* is an uneven work, exhibiting demonstrations of some geometrical ingenuity alongside passages which unsettle the reader's faith in his capacities. The latter part of his treatise is devoted to an anti-Bosse polemic in the intemperate tone which characterised earlier contributions to the debate. Although he goes to some length to illustrate the geometrical procedures, he clearly regards them as serving the end of pedagogical completeness rather than providing techniques which would be of universal application in the making of a picture which recreates natural effects. In practice, the formulae of geometrical perspective hold sway only in a limited sphere of operation, namely when the artist wishes to create an illusion of space by portraying architectural forms disposed in a regular manner. For irregular bodies and for those disposed irregularly it is necessary 'to multiply the visual angles, and . . . distribute various points of convergence along the horizon line of the picture' as if the visual axis is rotating—a view which recalls Viator's account from over a century-and-a-half earlier.[112] In portraying the bodies of man and animals Huret grants 'the liberty to the painter to draw them without any perspectival distortion on the picture plane, just as the eyes see them in life'.[113] This is a plea for a flexible response to 'natural vision' and 'judgement by eye' in portraying complex forms and scenes, and represents a probably unwitting articulation of the standpoint we have previously inferred in the cases of Rubens and Velázquez. Not surprisingly he criticized Cousin, Barbaro, Marolois and Desargues for taking mathematical perspective beyond its visual limits.[114]

The pragmatism of Dubreuil and the more overt challenge of Huret bring us face to face with the central issue for painters, namely what all this theorising has to do with the practice of art. It would be easy to dismiss the perspectivists' polemics as storms in a theoretical teacup, but we should remember that

ready to exercise its increasing muscle, and matters went badly for Bosse. . . 'One member of the Academy questioned the credentials of the said M. Bosse. The latter became highly agitated and withdrew, whereupon the assembly postponed its deliberations until another day.'[103] The unhappy result was the expulsion of Bosse in 1661, 'removing all rights and privileges accorded to him, forbidding him further entrance to the Academy, refusing to accept or read any more of his leaflets'.[104] The following year an order was obtained 'on pain of prison' to stop Bosse from spreading his 'libels' about the Academy.[105]

A less resoluté character might have been tempted to give up in disgust, but Bosse continued publishing. His *Traité des practiques géométrales et perspectives. . .* (*Treatise of Practical Geometry and Perspective as Taught at the Royal Academy of Painting and Sculpture*), issued in 1665, is a succinct and uncompromising synthesis of his teachings.[106] The first part concentrates on the geometry of the 'sphere, circle, cone and cylin-

243. Nicolas Poussin, *Holy Family on the Steps*, *c.*1646, National Gallery, Washington.

244. Analysis of the perspective in Poussin's *Holy Family on the Steps*.

practising artists—amongst whom we must of course number Bosse himself—played active roles both as theorists and as members of the newly-founded Academy, which took upon itself direct responsibility for the intellectual well-being of the profession. The greatest French painter of the era, Nicolas Poussin, certainly did not participate in any direct sense, not least because his career was largely based in Rome. However, his art had established itself as the supreme exemplar for his French contemporaries, and we will not be surprised to find that participants in the debates were keen to adduce him in their support. Le Brun saw himself as the guardian of Poussiniste standards, and must have been rather disconcerted to find the great master being quoted back at him by Bosse. Since Le Brun was using the newly-available *Trattato* of Leonardo as a stick with which to beat the engraver, it was in Bosse's interests to diminish the worth and even to question the authen-

ticity of the published compilation. His most potent weapon in this respect was a letter from Poussin, whose services had earlier been enlisted to provide illustrations for the *Trattato*. Bosse quoted Poussin to the effect that anything of value in the Leonardo treatise could be written on a single side of paper in large letters.[115] Although Bosse's own testimony is the only evidence we have for this opinion, he did publish it during Poussin's lifetime and it is unlikely to have been entirely fabricated.

Poussin's surviving statements about his own principles are themselves compressed to the point of terseness, when compared to the rhetorical inflation which seemed the norm in much art theory. As they stand they do much to encourage the absolutist stance of Bosse on questions of visual truth. 'Good judgement', Poussin informed his patron Paul Fréart de Chantelou, 'is very difficult unless one knows that theory and practice are united together in great art. We must not judge by our sense alone but by reason.'[116] Bellori records Poussin as saying that 'painting is nothing but an idea of incorporeal things, even if it is displayed in bodies, and represents only the order and the mode and the species of things'—which paraphrases the Neoplatonic philosopher Marsilio Ficino, who had been similarly quoted by Dürer and Lomazzo.[117] Even more overtly geometrical is a letter of 1641–2 in which he states that there are two procedures for viewing objects:

> one is by simple seeing, and the other ponders them attentively. Simple seeing is nothing other than the natural reception in the eye of the form and resemblance of the seen object. But to see an object with deliberation . . . we search with a particular procedure for a way to understand that same object properly. Therefore we may say that simple 'aspect' is a natural operation, while that which I call 'prospect' is a function of reason and depends on three things—knowledge of the eye, of the visual ray and of the distance from the eye to the object.[118]

This formulation has been shown to be drawn directly from the introductory section of Daniele Barbaro's *La Pratica della perspettiva*, with the Italian's *perspettiva* translated as 'prospect'.[119]

The Italian flavour of these ideas is not surprising given Poussin's declared allegiance to the great Renaissance masters. The strength of his contacts with the Leonardo tradition—notwithstanding his later reservations about the *Trattato*—have recently become clearer with the rediscovery of four manuscripts by Matteo Zaccolini, at least one of which was specifically copied for Poussin by his brother-in-law, Jean Dughet.[120] Zaccolini was a minor painter and architectural designer with a line in illusionism, whose writings as a theorist exhibit a lively understanding of the visual science of art in the Leonardo succession, as we will see in the next section and in Chapter VI. The manuscript on light and shade copied for Poussin exercised a direct impact on his treatment of shadows cast by multiple light sources, above all in the *Eucharist* from the series of 'Sacraments' commissioned by Cassiano del Pozzo, who was librarian to the Barberini and played a major role in the preservation and transmission of the Zaccolini

manuscripts.[121] When we also find Poussin summarising the Alhazen-Witelo views on the conditions necessary for sight, we have further evidence of the essential compatibility of his attitudes with Renaissance predecessors such as Ghiberti, Piero and Leonardo: 'nothing is visible without light; nothing is visible without a transparent medium; nothing is visible without colour; nothing is visible without distance; nothing is visible without a mechanism'.[122]

When we look to his actual paintings, the impression that we may be dealing with a 'Baroque Piero della Francesca' appears at first sight to be amply reinforced. The *Holy Family on the Steps* (pl. 243) has recently been assessed in just these terms:

> the picture is as perfect and as cool as a proposition from Euclid. Our eyes perceive the perspective and other geometrical relationships in the constructed space. . . . Still, he seems to have purposely telescoped recessional features such as the steps, in order to accentuate the foreground composition and keep our awareness of the picture plane. . . . The result is a densely rich interplay between the surface of the painted canvas and the fictive space.[123]

This could have been written about Domenico Veneziano or Piero—and how it would have pleased Bosse! But if we subject Poussin's picture to the kind of analysis the Renaissance paintings sustained, we will find that the perspective has been constructed with decidedly non-Euclidean approximations (pl. 244). The whole 'air' of solid geometry, which is as apparent in the preparatory drawings as in the painting, is based upon visual effect rather than precisely mathematical calculation. He has, to adopt his own terminology, used his mastery of 'aspect' to convey the impression of 'prospect'.

There were other occasions on which he certainly went to greater lengths to obey the basic rules. The lower section of the *Ecstasy of St. Paul* (colour plate V), which we will be studying in connection with Poussin's use of colour in Chapter V, exhibits a fair measure of constructive rationale (pl. 245). The motif of the sword, book and niche is conceived with a care for light, shade, volume and space which is entirely in keeping with the teachings of Zaccolini (pl. 257 below). A nicely characteristic touch is the slight but perceptible curve of the sword blade under its own weight. Other of his later paintings, most notably the *Death of Sapphira* (pl. 246), place narrative subjects

245. Analysis of the perspective in Poussin's *Ecstasy of St. Paul*.

246. Nicolas Poussin, *Death of Sapphira*, Paris, c.1654, Louvre.

cannot tell how far he went in adopting the mathematician's techniques.[129] His other paintings exhibit a good level of perspectival competence, but hardly show him as a Desarguian. Laurent de la Hire may be firmly associated with the Bosse camp. He was one of those who supported Bosse at the Academy, and his own works, particularly his drawings, exhibit a studied care for spatial structure whenever architectural or other regular features were to be parts of a composition. His *Allegory of Geometry* (pl. 247), painted in 1649 as part of a set which includes the beautiful *Music* in the Metropolitan Museum, stands as an appropriate monument to the timeless principles of geometrical clarity.[130] A fusillade of paint brushes beside the globe stresses that painting properly belongs in this intellectual realm. Laurent's son, Philippe, whom we have already characterised as one of Desargues's few immediate successors as a geometrician, was responsible for the only surviving transcription of Desargues's work on conics. As a professor at the French Royal Academy of Architecture from 1687, Philippe actively sustained the Desarguian tradition in at least one field of artistic endeavour.[131]

The painter whose works declare the most direct implementation of the Desargues-Bosse methods is Eustache Le Sueur. The evidence of his drawings shows clearly that he used a form of Bosse's perspective scales. His study for the *Presentation in the Temple* (pl. 248) contains two crossed diagonals, one of which is divided into a 'scale of distances', and a scaled vertical with numbered divisions. The elaborately coordinated space in the drawing is used in an understated manner in the actual painting, but the fact of its underlying presence would have been all-important for a theorist of Bosse's persuasion.[132] When the occasion demanded, Le Sueur transposed his Desarguian geometry more openly into the finished picture. The major project he undertook during his relatively short career was a series of paintings in 1645–8 for the Chartreuse of Paris. In addition to a set of stories of St. Bruno, effectively narrated in succinct spaces, he painted a set

in spatial settings which are as deep and elaborate as anything we have seen since Piero's *Flagellation*.[124] The major lines of the construction appear to have been carefully laid in, and the lighting of the distant buildings enhances their 'Euclidian air'. Even here, however, we are not dealing with an absolute system. The disposition of the pavement pattern and steps appears to be contrived more for visual effect than to underline the logic of the construction, and many of the apparently perspectival details of the buildings, such as rows of capitals and window pediments, have been added freehand.

As a witness in our debate, therefore, Poussin provides ambiguous testimony. If, as Bosse and Roland Fréart de Chambray wished to believe, Poussin supported the absolutist line, the master's statements and the 'look' of his paintings did much to encourage them. Chambray, the brother of Poussin's most faithful French patron, Paul Fréart, was the French translator of Euclid's *Optics*, and author of the *Idée de la perfection de la peinture*, in which he propounded the basic features of perspective as a series of axioms.[125] This approach reflected his conviction that art relied on 'the perfect intelligence of the Principles, primarily Perspective and Geometry, without which painting cannot subsist'.[126] Poussin reacted with what we may sense to be guarded warmth in 1665 when he acknowledged the treatise which Chambray had sent for his approbation.[127] On the other hand, if Le Brun, Le Bicheur and Huret wished to claim Poussin as a supporter of their less dogmatically scientific orientations, the actual practice of perspective in the master's art would do much to sustain their criticisms of Bosse's unwavering adherence to geometrical rule. Perhaps Félibien, Poussin's perceptive biographer, strikes the right balance in his undogmatic assessment of the interaction of theory and practice in the master's work.[128]

We do know that Desargues and Bosse received support from a number of painters at the Academy. One account indicates that Philippe de Champaigne had availed himself of Desargues's advice as early as 1628, when he was painting a vault in L'Eglise de Carmel, but since the painting is lost we

247. Laurent de la Hire, *Allegory of Geometry*, 1649, Ohio, Toledo Museum of Art.

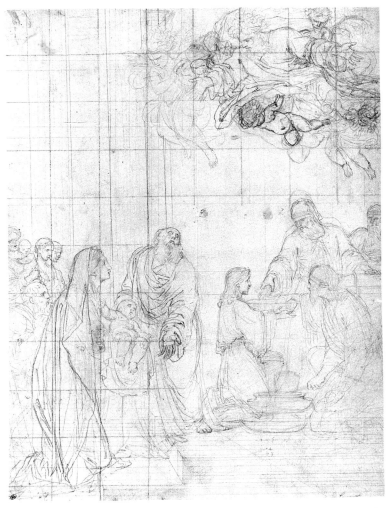

248. Eustache le Sueur, Study for the *Presentation in the Temple*, c.1652, Paris, Louvre, Cabinet des Dessins, 9191.

of illusionistic canvases for the corners of a cloister, including the compellingly perspectival *Dedication of a Carthusian Church* (pl. 249).[133] No Dutch artist could have been more meticulous in controlling the spatial effects in a church interior. Le Sueur also had the advantage which few of the Dutch artists possessed, namely that the classical forms of his architecture openly aid and abet the lucid geometry of space. Particularly nice is the asymmetric curve described by the cornice of the apse as seen from the off-centre viewing position.

The vigorous theoretical disputes and their fertile engagement with practice occurred at a period in France of great intellectual vigour. Father Marin Mersenne of the Order of Minims was very much at the centre of this activity in Paris, spinning his elaborate web of correspondence across those European centres which were in the forefront of new ideas in science and philosophy.[134] His Academia Parisiensis provided from 1635 a testing-ground for new ideas, including those of Desargues and most especially of René Descartes. Although the greater part of Descartes's working career was spent in the Netherlands, Mersenne helped ensure that he retained a powerful personal presence in French intellectual life. This intellectual context inevitably raises the question of the potential relationship between the artistic battles over spatial representation and the new concepts of space in Cartesian and other modern science.

If we look for direct links between the painters, perspectivists, scientists and philosophers, they are not hard to find. Desargues's involvement with Mersenne is amply documented, as are his friendly contacts with Descartes.[135] Of the professional painters, Poussin's intellectual associations are best documented. During his period in Paris, after 1640, he associated with a group of men sympathetically disposed to the mathematicising of science, most notably Pierre Gassendi, a keen Copernican and supporter of Galileo.[136] Amongst the perspective theorists, Jean-François Niceron, whose theories were first published in 1646, showed the most up-to-date awareness of the ideas of Galileo, Kepler and Descartes, as befitted a fellow member of Mersenne's order.[137] The French version of Niceron's *Thaumaturgus opticus* (*La Perspective curieuse*) was coupled in a 1663 edition with Mersenne's book on optics and catoptrics.[138]

However, we should hesitate before we begin to weld this into a unified and seductive whole, seeing the art of painting as an integral and fully coherent part of a French intellectual movement. The geometrical approaches of Desargues and Descartes—the one projective and the other algebraic—were founded on utterly divergent techniques, as they recognised themselves. Even their views on space were different. Desargues posited the meeting of parallel lines at infinity as a geometrical 'reality', without exploring its philosophical connotations, while Descartes on philosophical grounds would only go as far as to accept the 'indefiniteness of extension'.[139] Gassendi, Poussin's friend, disagreed violently with Descartes on fundamental issues of philosophy. Niceron was associated not with the artists of the Royal Academy, but with Simon Vouet, who was at the centre of the Paris Guild's rival foundation, the Academy of St. Luke.[140] The more we look into the individual cases, the more factional fragmentation becomes apparent on a variety of social, intellectual and artistic grounds.

249. Eustache le Sueur, *Dedication of a Carthusian Church*, 1645–8, Paris, Louvre.

250. The optical system of the eye, from Descartes's *Discours de la méthode plus la dioptrique, les météores et la géométrie'*, Leiden, 1637.

251. The camera obscura as an analogy for the human eye and demonstrations of the picture plane, from Jean François Niceron's *Thaumaturgus opticus*, Paris, 1646.

Historians are by nature synthesisers, looking for patterns, sensing underlying themes, even searching for some kind of unity beneath the apparent chaos of appearance. Uncomfortable as it may be, I think we should say clearly when we fail to find a clear pattern. It would be tempting to weave an attractive tapestry from the artist's perspective, projective geometry, the physical sciences and philosophy, showing the major French protagonists marching heroically along the same strenuous road towards the new visions of space. The historical evidence relating directly to the science of art does not seem to me to support such a vision—at least as far as painting is concerned. This is not to deny that aspects of the new thought did impinge creatively upon art. The annexing by Le Brun of Cartesian ideas on the passions to the portrayal of feeling in history painting is well proven.[141] And the perspective 'tricks' of Niceron, which we will encounter in a later chap-

ter, are open to interpretation in a more-or-less Cartesian framework.[142] But the actual theory of *pictorial* space, as expounded by Desargues no less than other theorists, remained obstinately apart from the new ideas in their most philosophically radical guise.

Poussin will again provide a good touchstone. The writings which provided him with the most directly amenable sources for his ideas were entirely traditional—Daniele Barbaro for perspective, Alhazen and Witelo for optics, Lomazzo, Dürer and Ficino for beauty, and Zarlino (who was by this time a dated musical theorist) for the idea of the 'modes', which we will outline when we later look at Poussin's use of colour.[143] This traditionalism is, I believe, an indication that the artistic debate in seventeenth-century France about the relationships between nature, art, order and mathematics used frames of reference which had been laid down before 1600, particularly

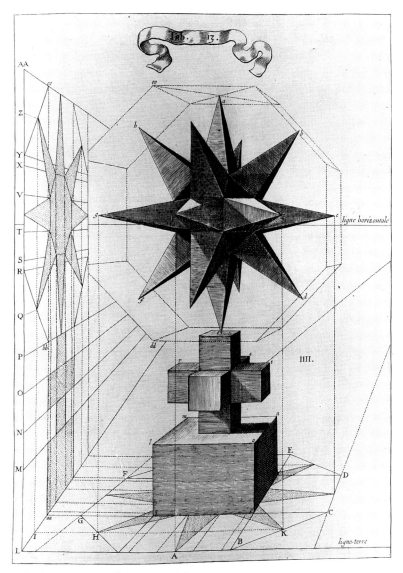

252. Composition of geometrical bodies in perspective with cast shadows, from Niceron's *Thaumaturgus opticus*.

valid. Indeed, Descartes's subtle definitions of the relationships between optics, opthalmology and intellectual perception in his *Discours de la méthode* were devoted to the examination of questions essentially different from those of the geometrical or pictorial perspectivist.[144] It was understandably difficult for traditional perspectivists to see any immediate consequences of Descartes's ideas for the techniques with which they were concerned. Descartes's emphases upon the deceptiveness of visual appearance and the relativity of the perception of size and distance were undoubtedly relevant to picture-makers, particularly those concerned with the kind of illusionistic 'devices' we will be studying in Chapter IV. However, as far as the art theorists were concerned, Alhazen and Witelo had already made similar points in an entirely adequate manner.

We will not be surprised, therefore, to find that Niceron's perspectival optics are founded on traditional principles, and that he continued to rely upon constructional techniques similar to those of Marolois and Desargues. These techniques are devoted to such standard problems as the exposition of geometrical bodies in space (pl. 252). The second part of his work, which is primarily devoted to anamorphic images (and will be discussed later) is more novel, but nowhere does he adopt an intellectual stance towards visual geometry which could not be accommodated by Barbaro, Danti or Marolois.

These two case studies do, I think, point to a broader truth—that the most advanced thought of the Scientific Revolution was moving to philosophical and technical positions in the mathematical and physical sciences which took them increasingly beyond the range of ready applicability to the needs of art. Once the raw material, techniques and mechanisms of the new sciences and artists' perspective moved on to different footings, the dialogue between science and art would need to change its premises—if it was to survive at all at a high level of intellectual significance in both fields. This is a topic to which we will necessarily return.

ITALY c.1600–c.1770: TRADITIONALISM AND NEWTONIANISM

The position of geometrical perspective in Italy after 1600 continued to reflect the long-standing integration of perspective with the rudiments of art. This situation holds good well into the later part of the eighteenth century and is marked by a particularly Italian sense of continuity, which is actively reinforced by regular cycles of revivalism as new generations of artists returned for fresh inspiration to the great High Renaissance masters. This continuity predisposed Italian theorists towards a conservative stance on the necessity for the academic fundamentals such as perspective and anatomy in their standard forms. However, as we shall see, the traditionalist stance did prove surprisingly compatible with ideas from the new sciences in the particular form in which they were absorbed into the mainstream of Italian thought.

Standard histories of Italian painting in the later part of the sixteenth and earlier part of the seventeenth centuries naturally

in Italy. Poussin's ideas on the geometrical scrutiny of nature, according to the rules of 'prospect', would in a general sense have been sympathetic to French Cartesians and Galileans—and vice versa—but this affinity does not necessarily bear witness to a great unity of purpose at the heart of a shared revolution at this particular time.

In the world of art theory, Niceron, the most 'scientifically advanced' author after Desargues, will provide a similar picture. He was fully aware of Kepler's and Descartes's new concepts of lens focusing an inverted image of the surface of the retina (pl. 250), and he illustrated a camera obscura to demonstrate the basic mechanism (pl. 251). However, there is no suggestion that Cartesian optics should provide the basis for a new system of pictorial representation, and the revised conception of the eye is simply used to show that the existing formulas for the perspectival ratios of size and distance are

tend to emphasise the new concepts as they come along—the strictures of the Counter-Reformation, the idealising stance of Zuccaro, the so-called eclecticism of the Carracci, the assertive naturalism of Caravaggio and the new baroque complexities of Pietro da Cortona. But beneath all these eye-catching developments, there was a good deal of traditionalism in the main body of artistic theory and practice, particularly in the academies. In Rome, within Zuccaro's academy, Tommaso Laureti and the Alberti brothers helped to sustain the tradition of perspectival orthodoxy into the seventeenth century. Perspective practice in the Piero della Francesca succession continued to be expressed with impeccable rectitude by Romano Alberti, in the context of his writings about the Roman Academy, and Lorenzo Sirigatti, whose *La Practica di prospettiva* in 1596 provided lucid and attractive demonstrations of the intersection method for geometrical bodies in a way which would not have been out of place in the two preceding centuries.[145]

The Carracci family, who provided the focus for much of the thinking about art in Bologna and Rome in the early seventeenth century, cannot really be claimed as strong partisans of the science of art. However, their successive academies certainly would not have ignored the desirability of perspective studies for the young artist. Ludovico Carracci's *Annunciation*, painted in the mid-1580s, shows that he could turn his hand to an overt demonstration of geometrical space when the subject required the depiction of a regular interior.[146] Against this, it must be admitted that the central work in Annibale's career, the painted ceiling of the Gallery in the Farnese Palace, rejects more of the perspectival-illusionist tradition than it accepts. And this rejection is made all the sharper by the previous engagement of Cherubino and probably also Giovanni Alberti on the project.[147] But Annibale had himself seriously

253. Transcription of the freehand perspectival study in Annibale Carracci's drawing for *Domine quo vadis*, c.1600–1, Vienna, Albertina.

considered 'Bolognese-style' schemes, including one idea for foreshortened Solomonic columns in the familiar fashion.[148] It is also worth noting that a number of his drawings, including a study for the ceiling of the Cerasi Chapel, contain freehand variations on systems of pictorial scaling (pl. 253).[149] There is no reason to think that Annibale was openly hostile to orthodox perspective as such, but he was not prepared to be constricted by its requirements in particular decorative schemes.

Annibale's major follower, Domenichino, seems to have been more closely concerned with the scientific basis of art, and was instructed in perspective by one of the least known yet most original theorists of his period, Matteo Zaccolini.[150] The setting for Zaccolini's writings, which will be assessed shortly, and Domenichino's practice is what may reasonably be called a Leonardo revival in both Rome and Florence at this time. Manuscript abridgements of Leonardo's 'Treatise on Painting' had continued to circulate in academic circles during the sixteenth century, but it was in the early seventeenth that Leonardo's particularly insistent message of taking Nature as the only 'mistress' began to seem especially relevant.[151] Annibale regretted that he had not read the '*Trattato*' earlier in his career, and in his orbit Guido Reni is known to have possessed a copy. Another version was acquired by Vincenzo Viviani, Galileo's most notable pupil, who was the incumbent Professor of Mathematics when the Chair was officially transferred from the Studio Fiorentino to the Accademia del Disegno in 1639.[152] At the centre of this revival in artistic principles which were generally Leonardesque in tone and not infrequently inspired directly by Leonardo, was the redoubtable figure of Cassiano del Pozzo.

Under the wing of the powerful Barberini family from the 1620s, Cassiano established himself as one of the chief arbiters of taste in Italy, particularly with respect to the classical heritage. Well-informed on scientific questions, he was a friendly supporter of Galileo, and was elected to the Accademia dei Lincei on his own account in 1622.[153] His remarkable patronage of Poussin would alone single him out for special mention in the history of art, and we may take Poussin's cerebral style as corresponding very closely to Cassiano's own tastes. In 1635 Cassiano himself copied out a version of Leonardo's 'Trattato' with a view to publication, and Poussin was involved in providing some suitable illustrations. Cassiano was the driving force behind the first major attempt to grapple with Leonardo's written legacy in the scientific as well as the artistic field. The eventual outcome was less extensive than he hoped, but his efforts did lead to the French *editio princeps* of 1651, which we have already seen contributing to the debates in Paris.[154]

Cassiano was actively involved in the preservation and dissemination of Zaccolini's treatises and he provided an appreciative account of their contents:

Matteo Zaccolini of Cesena was endowed by Nature with such a marvellous disposition for painting, particularly for perspectives, that, in spite of his not having undertaken systematic instruction and not having the opportunity to learn the Latin language, . . . he was able on account of his

254. Demonstration of the convergence of parallel lines on inclined planes, based on Matteo Zaccolini's 'Prospettiva lineale'.

Parallels from A, B, C and D, and from M, N and X on the inclined plane MB share the 'vanishing point' V.

255. Demonstration of the convergence of two sets of parallels in the same plane, based on Zaccolini's 'Prospettiva lineale'.

The parallels BA, DC, GF, HI perpendicular to the picture plane, share the 'vanishing point' V¹.
The parallels BJ, DK, GA, IL, share the 'vanishing point' V².

vigorous mental aptitude to participate in discussions in the house of Signor Cavaliere Scipione Chiaramonti. . . . He began to collect some rules pertaining to the practice of perspective.[155]

Cassiano then lists Zaccolini's sources as Euclid, Witelo, Aristotle, Pecham, Kepler, and most especially Leonardo, and gives a brief description of the four treatises. These are entitled: 'Prospettiva.lineale'; 'Della Descrittione dell'ombre prodotte de' corpi opachi rettilinei'; 'De' Colori'; and 'Prospettiva del colore'.[156] All are highly finished manuscripts with detailed illustrations and were virtually ready for publication. The letter dedicating the treatise on the 'Perspective of Col-

ours' to Scipione Chiaramonte of Cesena, the noble astronomer and man of letters who was his patron, is dated 1622. Zaccolini, who was a lay brother of the Regular Clerics of the Theatine Order, is now virtually unknown as a practising artist, and few of the illusionistic schemes admired by his contemporaries have survived.[157] However, his treatises do much to justify the high regard in which he was held and show a considerable intelligence at work.

Although Zaccolini is interested in the structure and functioning of the eye, his ideas in this area of optics are unremarkable and incompletely resolved. Rather, his main concerns and abilities lie in the field of geometrical optics and colour theory. His deficient Latin does not appear to have been a serious obstacle to his acquiring a reasonably wide-ranging knowledge of geometrical theory, and he may have been assisted by Chiaramonte in the understanding of otherwise inaccessible texts. We know, for example, that he consulted Guidobaldo's *Perspectivae libri sex*, since it is acknowledged as the source of his methods for drawing ellipses.[158] We can also confirm the essential accuracy of Cassiano's list of sources, although Kepler cannot be seen as a significant influence on any aspect of Zaccolini's optics.

Notwithstanding the expected echoes of Leonardo and other theorists, the content of his treatises has a far higher quotient of originality than is usual in theoretical writings by artists. This originality consists of utilising ideas from his sources in imaginative ways, relating them effectively to his own observations of nature, and devising ingenious diagrams for his demonstrations.

Two of the demonstrations from his treatise on 'Linear Perspective' will give an idea of his approach. The first (pl. 254) shows that parallel lines in two inclined planes will converge to the same vanishing point. The second (pl. 255) shows that two sets of parallels in the same plane will converge to two different points on the horizon. These relate to well-established procedures, but the particular form of the demon-

256. Demonstration of the effects of refraction on the appearance of human legs in water from Zaccolini's 'Prospettiva lineale'.

The toes at points A and Q will be seen at points B and P for an observer at R, looking through the surface of the water MD.

257. Study of cast shadows from Matteo Zaccolini's 'Della Descrittione dell'ombre', c.1617–22, Florence, Biblioteca Laurenziana, MS. Ashurnham, 1212, IV, fol. 13v.

cifically for him.[160] He almost certainly owned a copy of the treatise on shadows, which contains the most visually compelling of the illustrations, including complex demonstrations of shadows on different planes cast by geometrical bodies under the illumination of single and multiple sources (pl. 257).[161]

An even more direct reflection of Cassiano's tastes is provided by the writings and prints of Pietro Testa, who was drawn into Cassiano's Roman ambience, with results which do not seem to have been altogether beneficial for Testa's creative health.[162] Testa never organised his thoughts into publishable form, but his surviving notebook in Düsseldorf does present a clear picture of his commitment to rational imitation:

> Painting is a habit that has its foundations in scientific and contingent reasoning; the one has to do with *mores*, decorum and emotions, while the other is concerned with shadows and lights and reflections, with the way forms diminish virtually to a point, how colours diminish in intensity through the weakness of light or from distancing, how colour harmonies are made according to the rules of music and other similar things. Painting remains, so to speak, a cadaver, like a body that has no soul, without these sciences, and, in sum, practice needs to be united with theory.[163]

I do not think that Leonardo, Zaccolini or Cassiano would have dissented from this formulation.

Testa's own science of art is relatively unremarkable if reasonably proficient. His main perspective source appears to have been Barbaro, although he did look to Commandino's translation of Euclid's *Elements* for a list of those subjects which stand with perspective as disciplines founded on applied geometry.[164] His most considerable achievement as a theorising artist was his elaborate print, *Il Liceo della pittura* ('the High School of Painting' [pl. 258]).[165] In an ensemble deliberately reminiscent of Raphael's *School of Athens*, the left side of the composition is peopled by those who represent the abstract joys of mathematics (including the inevitable Euclid, stooping to measure with his compasses), while the right side is dedicated to the application of 'public well-being'. The figures to the right include Aristotle, who stands in the foreground holding one of his books of applied wisdom. The figures below the platform on the extreme left and right graphically make the point that 'practice needs to be united with theory'. Theory, for all her naked perfection and intellectual measure, is found to be incapable of acting, while practice, accompanied by his imitative monkey, gropes blindly without the guidance of higher reason. In the proper pursuance of painting, Testa is declaring, theory and practice are liberated from their bondage to work in fruitful union.

strations may have been invented by Zaccolini himself in his typically agile manner. Later in this treatise he displays sufficient knowledge of conic sections to consider questions as 'how to determine the position in which the eye is located so that the given hyperbola will appear to be a portion of a circle'.[159] He is also the first art theorist since Leonardo to give serious sustained attention to the effects of reflection and refraction (pl. 256).

To some extent Zaccolini's unpublished manuscripts, which we will encounter at great length in our later studies of colour, represent eccentric byways in the story we are telling, but we would be wrong to think that they played no role in the mainstream of theory and practice. Not only did Domenichino admit his indebtedness to Zaccolini on questions of perspective, but Poussin also paid close attention to the manuscripts, to the extent that one or more of the treatises was copied spe-

In terms of printed treatises during this period, a comparable stance is adopted by Pietro Accolti, in his *Lo Inganno de gl'occhi, prospettiva pratica* ('The deception of the eye. . .'). Published in Florence in 1625, Accolti's treatise expresses the orthodox standpoint of the Florentine Academy in the Cigoli-Galileo succession. His acknowledged sources—Witelo, Leonardo, Barbaro, Danti-Vignola, Guidobaldo, Aguilonius, etc.—give a clear idea of what kind of book to expect. This is

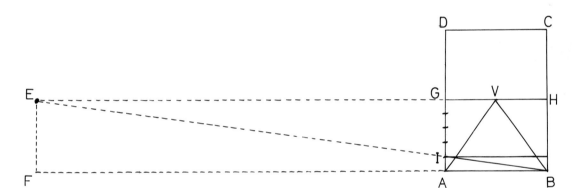

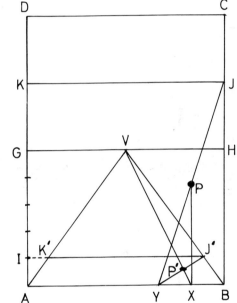

259. Proportional method of determining perspective diminution based on Pietro Accolti's *Lo Inganno de gl'occhi*, Florence, 1625.

ABCD—picture plane GH—horizon
V—vanishing point
The viewing distance is 4 × the width of the picture.
AG is divided into 5 parts. The first division, I (at a ratio of 1:4 along AG) gives the location for a horizontal at a depth behind the picture plane equivalent to AB.
The construction in dotted lines shows that this is equivalent to the Alberti-Piero methods.
E—observer at 4 units from the intersection AD
B—is seen at I

260. Method for the perspectival projection of a given point on a foreshortened plane, based on Accolti's *Lo Inganno de gl'occhi*.

Begin with the construction as above.
ABJK is a square plan on which point P is located.
ABJ¹K¹ is the foreshortened square. Draw JP and extend to Y; draw YJ¹; drop a perpendicular from P to X; draw XV.
The intersection of J¹Y and XV give the location of P in projection at P¹.

not to say that he is uncritical of earlier authors. He criticises both Barbaro and Guidobaldo for describing shadows cast only by point sources and not by the sun, whose rays are virtually parallel, as Aguilonius had emphasised.[166] He counsels the painter not to lose colour in the shadows, which tends to happen with the Leonardo method of shading.[167] He makes a knowing reference to the glimmer of reflected light on the shaded side of the moon, a phenomenon explained by Leonardo and more recently by Galileo.[168] And he provides a neat, self-contained method for constructing perspective within the picture field for any viewing distance—a problem which we have seen the French theorists tackling in their own ways.

His constructional method relies on the proportional sectioning of the side of the picture between the base and horizon (pl. 259). The location of any point on the original plan can then be determined in relation to the foreshortened square using diagonal and orthogonal coordinates in a way which seems to be his own variation on the standard constructions (pl. 260).

261. Michele Angelo Colonna and Agostino Mitelli, *Illusionistic wall decoration*, 1646–7, Sassuolo, Palazzo d'Este.

262. Analysis of the perspective in A.M. Colonna's and A. Mitelli's scheme for an illusionistic ceiling (pl. 200).

The results are perhaps rather forbiddingly abstract, but Accolti makes it clear that he does not expect the painter to perform this construction each time in making a picture. By writing his treatise he hopes 'so to open the eyes of contemplators and to inculcate the mind and intellect, that having drunk in these demonstrations and grounded ourselves in these maxims, we will not fear to express freely with the brush those things which I have shown pedagogically through geometry and by means of mathematical demonstrations'.[169] Accolti is in fact much concerned with the reception of his ideas by the students of the Florentine Academy, and the last section of his treatise is devoted to pedagogical advice which is drawn very substantially from the relevant sections of Leonardo's as yet unpublished '*Trattato*'.[170]

When we look at the paintings of the major masters of the 'rational style' during this period, such as Domenichino, Reni and Poussin, we can see the extent to which they followed the spirit of the law, as advocated by Accolti and Testa, without being constrained to follow its letter to the minutest degree. When we turn to the more unsung masters of baroque perspective painting, who were able to meet the continuing taste amongst private and ecclesiastical patrons for elaborate illusionism of the Bolognese variety, we find a pattern of even stronger continuity in optical art between the Renaissance and baroque periods in Italy. New generations of Bolognese artists were prominent in satisfying the continuing demand. The first major successor to the Laureti generation of perspectivists was Girolamo Curti (il Dentone), who incorporated baroque architectural motifs into schemes which obstinately retained the single-point arrangement in which he had been schooled, rather than adopting the looser systems of Annibale Carracci and Pietro da Cortona.[171] It was left to his successors, Angelo Michele Colonna and Agostino Mitelli to effect an accommodation of the Bolognese tradition with the new Roman ideas. Their notably potent partnership generally stands on the fringes of the standard histories of baroque art, but this implied estimate of their marginal importance is belied by their contemporary reputation. Their services were sought in such important centres as Florence itself, where they worked extensively in the Palazzo Pitti, and we have already encountered them serving the King of Spain.[172]

Their partnership was formed in the mid-1630s and continued until Mitelli's death in Spain in 1660. The division of labour seems roughly to have been that Mitelli undertook the technical aspects of the geometrical illusion, while Colonna contributed the *trompe-l'oeil* effects and the figures, but we know that Colonna was an inventive perspectivist on his own account and this division of labour may not have been altogether tidy. The basis on which they constructed their illusions remained the single vanishing-point system, and when they were presented with a surface which could be coherently subjected to a unified presentation they related all the forms to a specific viewing point. A splendid example can be seen in the great hall of the Palazzo d'Este at Sassuolo (pl. 261), the end wall of which provides an elaborate interplay of rectlinear and curvilinear elements with sculpted and 'flesh-and-blood' figures, in a way which corresponds closely to the described

263. Demonstration of a 'softened' system of perspective for illusionistic ceiling decorations, from Gioseffe Viola Zanini's *Della Architettura*, Padua, 1629.

geometrical method for illusionistic 'softening by the manipulation of the focal point' (pl. 263), an invention he plausibly attributes to the Rosa brothers in Venice, though the loss of their major works makes this impossible to verify.[175] The Colonna-Mitelli approach did not seem to be tied to a fixed formula such as Zanini's, but represented their own flexible combination of the Bolognese geometrical techniques with Annibale Carracci's predominantly non-perspectival illusion of sculptural and pictorial elements in the Farnese ceiling.

An art such as theirs, which places a primacy on the spectator's unashamed delight in decoration, abundance and illusion, has met with relatively little favour in this century. It would be absurd to claim that their work embodies the profound range of human values to be discovered in the work of a Velázquez or the high intellectual merit of a Piero della Francesca, but equally it would be wrong to underrate the artistic skill and inventiveness involved. We would also be mistaken in thinking that such illusion is necessarily inimical to the conveying of meaning and emotion, though these are not factors which loom large in their particular practice. Others of the baroque illusionists were more involved in taking these expressive factors more fully into account. This is true above all of the greatest of the ecclesiastical perspectivists, Andrea Pozzo, whose frescoes at the Church of S. Ignazio in Rome represent the culmination of developments in religious illusionism which stretch back to Melozzo da Forlì and even to Masaccio in the fifteenth century.

Not only was Pozzo's practice spectacular enough on its own account, but he also published two splendidly illustrated and deservedly popular volumes on his techniques and designs. His *Perspectiva pictorum et architectorum* was published in two parts in 1693 and 1700, with parallel Latin and Italian texts.[176] It was subsequently translated into German, English, French and Dutch. The first volume, which matches alternating pages of plates and text, builds up in a systematic way from his basic demonstration of a distance-point method (pl.

effects in the lost Spanish frescoes. When they were faced with longer or wider pictorial fields in which unified effects tend to become strained, as in the ceiling and long wall of the hall, they adopted more varied systems, in which the foreshortening of the elements is softened, and curved elements are used to work against a definite reading of the illusionistic space. These techniques can be seen in action in the highly-finished oil sketch they made for one of their Spanish ceilings (pl. 200).[173] The ends of the rectangular field have been adorned with rhythmic curves which create a sense of plasticity without a single perspective focus, while the more overtly perspectival motifs which form the centre-pieces on the longer sides are not foreshortened to a central vanishing point but to two lateral points of a more distant kind (pl. 262). The result is an illusion which works by sleight of hand rather than absolute definition.

A 'softened' system for long ceilings similar to that developed by Colonna and Mitelli had first been advocated in print by Gioseffe Viola Zanini in 1629.[174] Zanini gives a

264. Demonstration of the 'distance point' method, from Andrea Pozzo's *Perspectiva pictorum et architectorum*, Rome, 1693.

O—'vanishing point' E, E—'distance points'

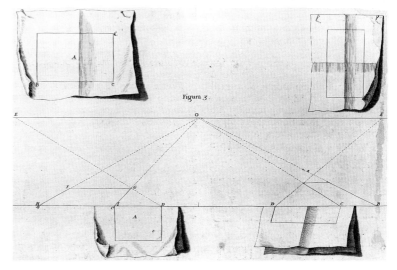

265. Perspective representation of elements of the Doric Order, from Pozzo's *Perspectiva*.

266. Use of the 'distance point' method to foreshorten architectural elements for an illusionistic decoration, from Pozzo's *Perspectiva*.

The dotted line from G goes to the distance point (as in pl. 264). The solid line CD goes to the 'vanishing point'.

264) to the construction of more complex architectural forms (pl. 265) and eventually to the depiction of complete settings. His demonstrations of 'horizontal perspective' in ceilings (pl. 266), with which he is naturally concerned, retain clear indications of how the basically simple method can be applied to the foreshortening of complex forms.

As an example of what can be achieved he illustrated the illusionistic dome (pl. 267) which he painted in 1685 for S. Ignazio, the third of the great Roman churches of the Jesuit Order in which he was a lay brother.[177] In the years between 1685 and 1694 he was virtually to remodel the interior of S. Ignazio in paint. The dome, cunningly viewed from an off-centre position as we approach it down the nave, is painted on a flat canvas stretched across the aperture of the circular drum.

It serves not only as a piece of sheer visual bravado but also as a quick, light, cost-effective alternative to an actual structure. He amusingly records the kind of controversy his *tour de force* stimulated: 'Some architects disliked my setting advancing columns upon corbels, as being a thing not practised in solid structures; but a certain painter, a friend of mine, removed all their scruples by answering for me, that if at any time the corbels should be so much surcharged with the weight of the columns, as to engender their fall, he was ready to repair the damage at his own cost.'[178]

Three years later, amidst intensive debate, he undertook the much more radical and permanent step of painting the whole of the nave ceiling (pl. 268). The system of architectural perspective he used was deeply uncompromising, and restorted to none of the softened or ambiguous effects that Colonna and Mitelli would have favoured for such an enormous space. The whole of the architectural framework, which dramatically extends the height of the nave towards a radiant heaven, is subordinated to a single-point system. The perfect viewing position in the church is denoted by a disk in the floor. The method Pozzo used to achieve this precision was not essentially new, but he did describe it with notable clarity (pl. 269), and applied it with remarkable control. His perspectival design was first drawn to scale on a sheet of paper, which was divided into squares. A matching grid of strings was suspended across the nave at cornice level. A further string was then used to take 'sightings' through the suspended grid from the viewing posi-

267. Andrea Pozzo, Illusionistic dome, 1685, Rome, S. Ignazio.

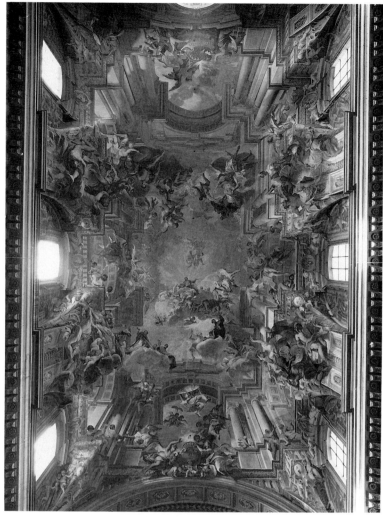

268. Andrea Pozzo, *The Transmission of the Divine Spirit*, 1688–94, Rome, S. Ignazio, illusionistic decoration of the nave vault.

269. Demonstration of the use of a grid to project an illusionistic design on to a curved vault, from Pozzo's *Perspectiva*.

O—observer
BLA, EF—grid which is projected on to the curved vault from position O

tion, O, in such a way that the grid was projected onto the curved surface of the vault. The design was then transposed line-by-line from the squares of the drawing to the curved equivalents on the ceiling.

In answer to the inevitable charge that his one-point system is overly rigid and unresponsive to the needs of differently-placed spectators, he marshalls a series of arguments: he claims that all 'the greatest masters' have observed the single-point rule (though he does not go into details); he argues that 'the painter is not obliged to make it appear real when seen from every part, but from one determinate point only'; he criticises multi-point systems, in that they do not look entirely correct from anywhere; and, most interestingly, he asserts that the distorted appearance of the work seen from the wrong position is 'so far from being a fault, that I look on it as an excellency in the work'.[179] The whole point of the illusion, in Pozzo's eyes, is that the distorted chaos of shapes is able miraculously to coalesce into a coherent revelation when viewed from the proper position. I think that 'miraculously' is the operative word in this case. In his preface, Pozzo firmly announced that he intended 'with a resolution to draw all the lines thereof to that true POINT, the Glory of GOD'. In the case of the nave, that 'POINT' is actually the Son of God who, in Pozzo's own words, 'sends forth a ray of light into the heart of Ignatius, which is then transmitted by him to the most distant regions of the four parts of the world'.[180] The whole system of optical dynamics, as it surges to its central focus, serves the radiant core of the vision, and it is from this core that the rays of spiritual energy radiate to the peoples of the world through Jesuit missionaries.

Such placing of illusion in the service of both astonishment and communication breathes a strong air of the theatre, and Pozzo himself is happy to refer to other of his ecclesiastical illusions specifically as 'theatres'.[181] The second volume of his treatise, which deals predominantly with the intersection method, also illustrates a series of examples of Pozzo's skills in ecclesiastical and secular action. In particular he provides detailed instructions about the perspective of stage scenery, using angled flats (pls. 270 and 271). This strong presence of the theatre in Pozzo's theory and practice serves to remind us that one of the greatest reservoirs of perspectival expertise during the seventeenth century was to be found amongst those artists who practised illusionistic stage design.[182] Although this is not the place to undertake a full-scale analysis of scenographic techniques, I think it will be useful to summarise briefly the main developments, since the scene painters' techniques begin to feed back into the art of easel and mural painting, as we will have increasing cause to see.

The simplest form of illusionistic stage design is a perspectival backdrop, and this is what Pellegrino da Udine seems to have used in his innovative design in Ferrara in 1508. The main need, however, was for settings which combined the real but necessarily shallow depth of the stage with an illusion of extended space. From the second decade of the sixteenth century, pioneers such as Baldassare Peruzzi (perhaps himself inspired by Leonardo) had devised various systems of 'accelerated' perspective which operated with a series of lateral ele-

270. Plan of scheme for an illusionistic stage setting, from Pozzo's *Perspectiva*.

272. Various plans for illusionistic stage settings in the manners of (A) Baldassare Peruzzi (based on Serlio), (B) Vincenzo Scamozzi, (C) Egnatio Danti, (D) Jean Dubreuil, (E) Inigo Jones and (F) Andrea Pozzo.

ments variously orientated to the audience (pls. 272 and 120).[183] The type advocated by Pozzo, with angled flats, had the advantage that it permitted laterally placed members of the audience the least chance to see between the elements of scenery, but this system was also the most demanding perspectivally, since the designer needed to compensate for the optical distortion caused by a series of oblique, overlapping planes. The problem is not unlike that faced by a sculptor working in low relief, who has to coordinate the actual and fictive recessions. It is also closely related to the illusionistic effects practised by Bernini and Borromini in actual buildings when they wished to convey the impression of greater depth than the site permitted.[184]

The interplay between scenographic perspective and pictorial techniques became particularly intense towards the end of the century. Indeed I think it is true to say that the last major phase of Italian perspective painting, from Pozzo to Canaletto, cannot be understood without taking the scenographic dimension into account. At the heart of this interaction was the widely influential work of the Bibiena dynasty of scenographic designers, at least eight of whom have definable careers of some substance.

Ferdinando Galli da Bibiena, who was responsible for

271. Scheme for illusionistic stage decoration from Pozzo's *Perspectiva*.

upper left: elevation of the 'building' with flats on the right
lower left: plan of the 'building' with angled flats on the right
upper right: effect from the auditorium
lower right: five lateral flats viewed separately

founding the dynasty, owed his training to the Bolognese school of illusionists, and later returned to the city to lend his own skills to the continuance of that tradition.[185] One of his early instructors, Giulio Troili, was the author of a text book on perspective, *Paradossi per pratticare la prospettiva senza saperla* (1672), a treatise which has a certain charm, though, as its title suggests—'perspecⁱve without understanding it'—not one which demands or reflects a high degree of perspectival erudition.[186] Troili's activities as an author may well have been in Bibiena's mind when he sat down to prepare his own *Architettura civile, preparata su la geometria e ridotta alle prospettive*, which was published in Parma in 1711.[187] The scope of his book, as it progresses through basic geometry to the design of architectural elements and the construction of perspective views, is standard enough, and the basic techniques he effectively illustrates (pl. 273) do not introduce any essentially new principles. Its importance lies in its exposition of the scenographic technique for which the Bibiena became famed across Europe, the *scena per angolo* (pl. 274). The aim of this form of design was the setting of buildings at sharp angles to the audience so that diagonal vistas were opened up. These effects were remarkably created by perspective illusion on a series of flats which were more naturally adapted to the standard forms of illusion. The advantage of the new technique was twofold: it lent itself to the creation of dramatic effects of monumental architecture with varied recessions; and it was rather less vulnerable to distortion from different points in the auditorium. The use of diagonally disposed forms was not, of course, a new idea as such—Brunelleschi's Palazzo de' Signori demonstration, for example, relied on such an arrangement—and earlier scenographers had used diagonal elements; but Ferdinando was the first to exploit the *scena per angolo* in a dominant and compelling manner.

During the latter part of his career in Bologna, Ferdinando became increasingly involved with the Accademia Clementina, and his *Discrezione ai giovani studenti nel disegno dell'architettura civile* in 1731 was designed to provide a pedagogic introduction to his techniques for the young Bolognese artists.[188] In these activities he worked closely with Giampietro Zanotti, the painter-author who was the founder and secretary of the Academy, and its subsequent historian.[189] It is an indication of the continuity of the intellectual context in this Italian academic environment that Giampietro's son, Eustachio Zanotti, should develop into a Newtonian scientist and astronomer of note, who wrote his own treatise on perspective, the *Trattato teorico-pratico di prospettiva* (1766).[190] The nexus within which perspective is situated in Bologna in the middle of the eighteenth century is thus little different in kind from that which obtained in the days of Egnatio Danti. Eustachio Zanotti's treatise, as would be expected from a scientist of his quality, provides an analytical treatment of the mathematics of perspective at a highly professional level but he makes no real concession to the latest ideas about the visual process as such. He is aware that the science of geometrical perspective cannot be regarded as a precise matching of visual experience, and he recommends the avoidance of doctrinaire effects of foreshortening in large-scale schemes to be viewed from various

273. Perspective projection of a twisted column for an illusionistic ceiling design, from Ferdinando Galli da Bibbiena's *Architettura civile*, Bologna, 1711.

274. Scheme for an illusionistic stage setting 'all'angolo', from Bibiena's *Architettura civile*.

275. Giovanni Battista Tiepolo, *The Banquet of Cleopatra*, 1744, Melbourne, National Gallery of Victoria.

angles, but his ultimate recommendation is that the painter can best evoke reality by following the established rules with care and consistency.[191] His own tastes lean towards principles of order and proportional beauty in the classic sense, and he is naturally biased against the freer and more capricious effects practised by some of the later baroque decorators.

Zanotti's conservative, classicising taste is utterly characteristic of a group of scientist-connoisseurs in Italy during the middle years of the eighteenth century in North Italy. Foremost among these, as a European man of letters, as an arbiter of taste and as a patron on his own account, was Count Francesco Algarotti.[192] A great traveller and an energetic correspondent, Algarotti was part of an active circle of intellectuals, patrons and artists who shared similar scientific and aesthetic interests. This circle included the Zanottis; his older colleague Antonio Conti, who pioneered the appreciation of Newton in Italy; Padre Carlo Lodoli, who adopted a radical, rationalist

stance in aesthetic matters; and Consul Joseph Smith, the notable promoter of Canaletto, who can hardly be regarded as a man of science yet professed a marked enthusiasm for Newton.[193] Typical of this atmosphere was Algarotti's *Newtonianismo per le dame* ('Newtonianism for the Ladies'!) published in 1737 and translated shortly thereafter into English and French.[194]

In this lively popularisation of Newton's views on light, we find, as is typical in Algarotti's writings, Raphael rubbing shoulders with Racine, and Newton being paired with Palladio. The general message is that there is a classic canon of order and beauty which is revealed by the greatest art and science, no less by Newton than by the classic painters, sculptors, architects, writers and musicians who had preceded him. Algarotti's Galilean and Newtonian taste for underlying order and logic emerges increasingly clearly in a series of writings which are devoted in whole or in part to the practice of the

visual arts. In addition to the treatise he devoted specifically to painting, which contains a systematic statement of academic orthodoxy, he wrote on architecture, swept broadly across a panorama of the arts, and published a series of letters, a number of which deal specifically with painting, past and present.[195] A typical formulation, from his *Pensieri diversi*, is that 'those who have studied geometry, and other matters equally, make more orderly and conclusive discourses than those who have never been grounded in Euclid'.[196]

Although he resided in his native city, Venice, for relatively short periods of his working life, his impact on the Venetian art world was considerable. The spending power he exercised after 1743 as the agent for Augustus III, Elector of Saxony, no doubt helped him to establish a position as someone with whom to reckon, but he does seem to have been genuinely liked and respected on his own account, not only by fellow patrons and intellectuals but also by the artists, who often had a reputation for being awkward. The major painter with whom he first struck up a productive relationship was the current star of Venetian art, Giovanni Battista Tiepolo. The particular version of the late baroque practised by Tiepolo—a kind of air-filled Rococo—might seem hard to reconcile with what I have said about Algarotti's taste for classical order. However, his appreciation of Tiepolo not only indicates the undogmatic way in which his taste manifested itself in practice, but it also more profoundly reflects the way in which Tiepolo could be read very differently from the manner in which he is generally approached today. For Algarotti, Tiepolo was the true heir of Veronese, the classic master of Venetian space and light in its most high-keyed form.

One of the paintings that Algarotti commissioned for Augustus, the *Banquet of Cleopara* (pl. 275) will help illustrate the qualities he admired in Tiepolo.[197] He himself had acquired the *modello* for the painting, and wrote enthusiastically about the way in which the painter had increased the quotient of classical learning and richness of antique effect in the final version: 'it exhibits the erudition of Raphael or of Poussin'. The whole setting is notably Palladian in feel, and the perspective—as Algarotti did not fail to notice—is more openly paraded for the spectator's admiration than in the earlier scheme. What Algarotti did not notice or record, is that the perspective has been contrived for visual effect rather than for strict spatial logic. Compared to the *modello*, Tiepolo had doubled the number of horizontal intervals, which means that we are no longer dealing with square tiles of clearly determinate plan. If the present tiles are square, the chair and drapery of Mark Anthony would have to span an improbable distance.

In Tiepolo's relationship with the illusionistic decorators who assisted on many of his decorative schemes—the chief of whom was Girolamo Mengozzi-Colonna—the same use of perspective for effect rather than for strict logic is apparent.[198] This certainly did not offend Algarotti, who believed that 'inspiration (*ingegno*) is no less necessary than doctrine; we should bring together equally the vivacity of *fantasia* and the certainty of judgement'.[199] The equilibrium between imagination and rationality mirrors the 'magnificent example of the fabric of

276. Mauro Tesi, *The Temple of Zeus* from *Raccolta di disegni originali di Mauro Tesi estratti da diverse collezioni*, Bologna, 1787.

the universe' in which the tangential forces of the planets' motions and the centripetal forces of gravity act in such a fine balance that 'all the system is in equilibrium around the common centre of gravity'.[200] This is typical of Algarotti's version of the science of art; it is less a question of specific prescriptions from science which the painter must rigidly follow, but rather a shared community of philosophical and aesthetic principles which the scientists and artists must mutually respect in their response to the visible world and its underlying order.

Increasingly during the course of his own patronage of artists we find Algarotti adopting a formative role. Nowhere is this more apparent than in the career of his Bolognese protégé, Mauro Tesi. Algarotti was convinced, as were Giampietro and Eustachio Zanotti, that recent Bolognese illusionistic painting had betrayed the great tradition by resorting to proliferations of swags, cartouches, Rococo panels and such like— all of which offended against architectural logic and perspectival lucidity. He even saw the seeds of this decay in the work of the classic masters, Curti, Colonna and Mitelli, who sometimes fell into the easy trap of sumptuous illogicalities.[201] He clearly saw the young Tesi as leading the reform of Bolognese

illusionism under his promotion. He did everything he could to promote Tesi, by word and by deed, and the young man followed a successful if relatively short career as a painter of perspectives and architectural designer. He is virtually unknown today, and his works await proper study. A suite of designs published after his death give a fair idea of his style, and show clear reflections of his study of Bibiena and Piranesi as well as of the older masters such as Serlio and Vignola.[202] The illustrated design (pl. 276), which is closely related to one of the paintings commissioned by Algarotti, will give some idea of the qualities of perspectival conviction and archaelogical imagination for which both patron and artist were striving—with some degree of success and with a fair measure of originality.

We can also see the actively shaping characteristics of his patronage at work in his relationship with Canaletto, much of whose art seems to have been rather too literal and nonclassical for his taste. On 28 September 1749 Algarotti enthusiastically wrote to Prospero Pesci, the Bolognese painter of architecture and landscape, that he had invented a new genre in which the painter was required to take an existing view and to enrich it with approved buildings.[203] This was, of course, related to the architectural *capriccio*, in which different buildings or elements from different buildings are artificially brought together in a compound scene. This type of picture as practised most notably in Rome by Pannini—one of whose paintings of the Pantheon was owned by Algarotti—was enjoying a considerable vogue at this time. However, Algarotti's invention was subtly different from the standard *capriccio* in that an actual, given location provided the fixed base for the improvisation. 'In this way', he tells Pesci, 'it is possible to arrive at a union of nature and art.'[204] The painting he describes as effecting this union was the view he commissioned from Canaletto of the Grand Canal at the Rialto in Venice (pl. 277).[205] The bridge has been flanked by two of Palladio's

278. Antonio Canaletto, *The Campo di SS. Giovanni e Paolo*, c.1735–8, Collection of her Majesty The Queen.

masterpieces from Vicenza and is itself based on Palladio's unexecuted scheme for a new bridge at the Rialto. The delightful compound of mathematics (Palladio's proportional designs and Canaletto's perspective), reality and imagination maintains the kind of aesthetic equilibrium between order and invention which stands at the heart of Algarotti's attitudes in art and science.

The growing bands of *vedutisti* (view painters) at this time, above all in Venice, where Canaletto was the dominant figure, represent what may be regarded as the last major phase of the perspective tradition in Italian painting. The *veduta* may not unreasonably be regarded as a fusion of the Northern genre of perspective townscapes—one of the leading early practitioners was Gaspar van Wittel (Vanvitelli) who brought his Dutch training to bear on the Italian scene—with the native Italian tradition of perspectival architecture, particularly in scenographic design.[206] Canaletto's father, Bernardo, practised as a scene painter, and father and son worked together on the sets for an opera by Scarlatti in Rome in 1720.[207] Although Canaletto's paintings avoid the dramatic implications of the *scena per angolo*, as adopted by Piranesi from the Bibiena and Juvarra, the way he presents architecture and space in many of his paintings is deeply imbued with the principles of scenic design. The squares of Venice—the Piazza San Marco and its lesser urban *campi* (pl. 278)—become stage sets in which everyone may play a role, however small and fleeting.[208]

Canaletto's paintings and drawings bear witness to the enormous effort of constructional precision which went into the geometrical control of foreshortened and unforeshortened elements.[209] The compass, the divider and the ruler were essential tools for him. His greatest paintings achieve an extraordinary control over the viewer's eye. Look, for example, at the way he draws our gaze towards the narrow, main exit from the Campo si SS. Giovanni et Paolo. He does this by means of the perspective and the diagonal light, while at the same time our orientation to the diagonal path which leads to the front of the church creates a secondary or 'accidental' *punctum concursus* of no little importance. These effects are clearly

277. Antonio Canaletto, *The Rialto, Venice, Embellished with Palladian Bridge and Palaces*, c.1749, Parma, Galleria.

279. Antonio Canaletto, *The Thames from the Terrace of Somerset House Looking Towards the City (i.e. East)*, *c.*1750, New Haven, Yale Center for British Art.

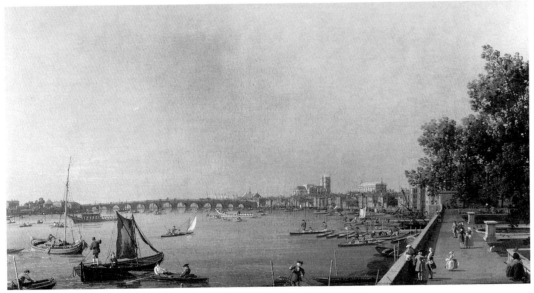

280. Antonio Canaletto, *The Thames from the Terrace of Somerset House Looking Towards Westminster (i.e. West)*, *c.*1750, New Haven, Yale Center for British Art.

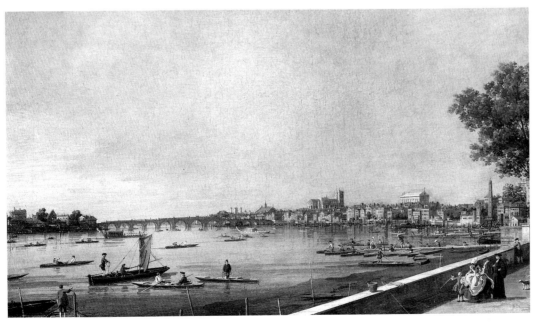

281. Antonio Canaletto, *The Thames from the Terrace of Somerset House Looking Towards Westminster (i.e. West)*, *c.*1750, New Haven, Yale Center for British Art.

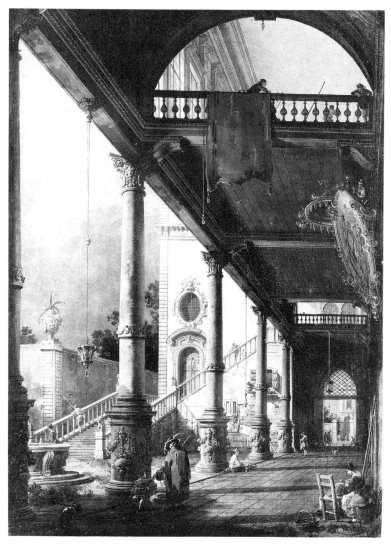

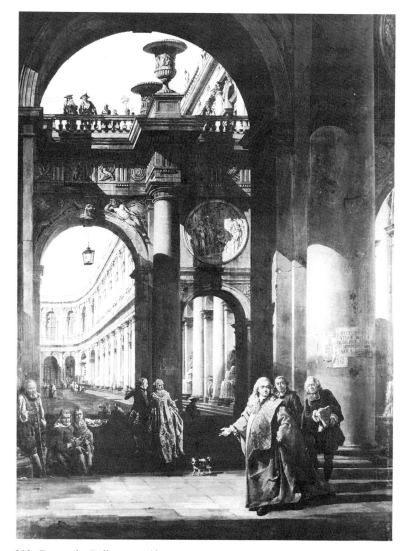

282. Antonio Canaletto, *Architectural Capriccio with Loggia and Palace*, 1765, Venice, Accademia.

283. Bernardo Bellotto, *Self-Portrait in an Architectural Setting*, c.1765, Warsaw, National Museum.

based on a rigorous scrutiny of the actual scenes—something we will discuss further when we look at his possible use of instrumental techniques—but they are also based on a knowing measure of optical contrivance. This contrivance, like that of Saenredam, relies upon a complex compound of the physical characteristics of the actual scene, the geometry of perspective construction and an instinct as to what will achieve the desired effects in the actual picture. Not infrequently different paintings of the same set of buildings use slightly different relative orientations for the individual elements, as well as altering the viewpoint or angle.

The splendid sets of views looking in either direction up and down the Thames from the terrace of Somerset House show his artful contrivance at work (pls. 279–81).[210] It is well known that he has multiplied the number of the spires of the city churches—perhaps he found, as many photographers have cause to know, that a distant effect which is striking on the spot looks unimpressive when reduced by perspective rule within the smaller compass of a representation, and he decided

that the effect of the towers needed amplification in the actual painting. But the contrivance goes further than such additive procedures. In the different painted and drawn versions he has manipulated the geometry of the terrace with respect to viewing height and angle, sometimes in a pronounced manner. Some of the foreground forms do respond to some extent to the changed viewpoint, but there is no consistent revision of the relationship between foreground and background features either with respect to parallax or their orientation to the picture plane. It is just possible that Canaletto based this bending of visual rule on a conscious awareness of the new kinds of optical-perceptual theories which we will encounter most prominently in France, but I think it is more likely that it is based on the traditional perspectivist's manipulation of rule for pictorial effect in given circumstances.

Given the prominence of the *vedutisti* in eighteenth-century Venice, it is not surprising to find that perspective played an increasing role in the Venetian Academy, which was founded in 1650.[211] Antonio Visentini, a perspectival illusionist who

146

284. Illusionistic stage design from Pozzo's *Perspectiva*.

collaborated with Tiepolo and made prints after Canaletto—and painted *vedute* in his own right—became President of the Academy in 1761 and held the chair of 'architectural perspective'. In 1767 a new Professor was appointed, Giovanni Francesco Costa, who wrote a treatise on the *Elementi di prospettiva*.[212] Between 1772 and 1778 Visentini returned to his old post. And in 1790, the son of Tiepolo's favourite architectural painter, Mengozzi-Colonna, was appointed to teach perspective. Canaletto, perhaps rather belatedly, was elected to the Academy in 1763, and two years later presented his reception-piece (pl. 282).[213] In this academic context, it is significant that the presented painting is one of his imaginative *capriccios*, showing his powers in 'uniting art and nature' in the Algarotti manner, rather than one of his more realistic *vedute*. In any event, it is one of the most overtly 'scenographic' of all Canaletto's paintings and one of his most dogmatically perspectival, with its strong diagonal accents.

The way in which mere 'view painters' felt constrained to inflate the intellectual pretensions of their art in an academic context can be seen most spectacularly in the career of Bernardo Bellotto, Canaletto's nephew and most considerable pupil.[214] The central feature of Bellotto's practice was the painting of splendidly effective *vedute*, particularly in Dresden, where he spent some of the most productive years of his career. However, when he wished to present his own image to the world, he did so in a grandly theatrical manner (pl. 283).[215] The context which makes sense of this extraordinary picture is the founding of the Dresden Academy of Fine Arts in 1764, and Bellotto's appointment as tutor in perspective. Bellotto himself parades in the foreground as a Venetian grandee. Behind him opens a vista into an invented courtyard of most splendid kind, rendered in striking perspective, and displaying brilliant effects of cast shadows. One source of visual inspiration for the architecture appears to have been a theatrical design by Pozzo (pl. 284), a source which reflects the kind of perspective tradition in which Bellotto wished himself to be viewed. If we should remain in any doubt about the intellec-

tual claims he is making, the handbill pasted on the column at the right quotes the famous dictum from Horace's *Ars Poetica*: '*pictoribus atque poetis quidlibet audendi semper fuit potestas*' ('painters and poets always have an equal right in daring').[216]

There is a group of drawings by Bellotto for such imaginary architecture which supports his claims to be taken seriously as an intellectual artist. They consist of grand architectural structures fully worked out in plan and elevation, which are projected element-by-element onto the flat plane of the perspective rendering (pls. 285–6). As Pozzo had done on occasion, Bellotto has placed the intersecting plane within the depicted structure, and some forms are thus projected 'backwards' onto the plane.[217] This procedure has the practical advantage that it avoids some of the compression of lines if a single plane is

285. Bernardo Bellotto, *Architectural Study of Imaginary Architecture with Curved Arcades and Church*, c.1765, Warsaw, National Museum, Rys. Pol. 2070.

286. Bernardo Bellotto, *Plan of Curved Arcades and Church, with Projective Lines*, c.1765, Warsaw, National Museum, Rys. Pol. 2071 r.

placed near the apex of the visual pyramid in the normal manner. This variation, however, does not reduce the fundamental affinity of his approach to the long-winded procedures of perspective by intersection first described by Piero della Francesca three centuries previously. Nothing could better illustrate the continuity of geometrical optics in Italian painting. But, sadly, Bellotto's generation also represents the last great flowering of the perspectival tradition in the country which had given it birth.

BRITAIN, BELATEDLY

Any perceptive and well-informed continental observer of the visual arts in Britain in the first half of the eighteenth century—even a confirmed Anglophile like Algarotti—could not help but notice the imbalance between Britain's contributions on an international scale to the sciences and her minor place in the international spectrum of the fine arts. Architecture was the only major exception to this rule. Algarotti was ready to couple the name of Inigo Jones with that of the great Palladio. Jones's stage sets had provided the only really distinguished episode in perspectival design by a native artist before 1700.[218] It is symptomatic that the British translation of Pozzo's treatise was dedicated to the architectural triumvirate, Wren, Hawksmoor and Vanbrugh.[219] By Algarotti's time, however, there were signs that the artistic, intellectual and social foundations were being laid for new achievements in the arts of painting and sculpture. The new climate is nicely captured in Algaroti's dedication of his *An Essay on Painting* to 'the Society Instituted in London for Painting, Arts, Manufactures, Commerce':

> the English nation claims the superiority. . . in the world of Science. . . Painting indeed has but recently engaged the attention of the English so far as to inspire them with a design of contending with the Italians, for those honours of which the latter have long boasted an exclusive possession. The design is nevertheless becoming formidable, in being promoted by a society. . . , instituted by free people, and composed of the choicest public spirits of their age and country, who, while they generously encourage the best artists, excite emulation in others, by exhibiting the works of all to public view, therein appealing, even for their own judgement, to that of a learned, ingenious and subtle nation.[220]

Algarotti thus precisely acknowledges the two factors behind the great surge in perspectival theory and practice in eighteenth-century Britain: the high level accomplishment in the exact sciences; and the birth of the art institutions and academies. There is no doubt that the mathematicians were in the lead. Two considerable treatises on perspective were published during the second decade by Ditton and Taylor, well in advance of any perspectival painting of comparable sophistication, and almost fifty years before the specifically artistic treatise of Joshua Kirby. However, once perspectival mathematics was absorbed into the context of the new academies,

it took vigorous hold and resulted in a series of notable publications by Kirby, Fournier, Highmore, Malton, Edwards and a succession of less prominent authors. In terms of artistic practice, this surge was reflected in the impressive rise of topographical draughtsmanship and in the work of one painter of real genius, J.M.W. Turner.

Alongside these geometrical and pictorial stands of perspective, there also ran the sophisticated British discussions of perception in the wake of John Locke. These came to result in sustained questioning of the relationship between seeing and knowing—between sensations, senses and intellect—in a way that possessed clear implications for the visual premises on which perspective painting was founded. I am leaving aside this theme for the moment—it will appear in its own right in Chapter V—since even those British theorists who did acknowledge the problems in the eighteenth century allowed the edifice of perspectival illusion to stand largely unscathed when they presented the 'rules' to artists.

In British perspective theory, the name of Brook Taylor has achieved a position of dominance not rivalled by that of one writer in any other country. His enormous reputation has tended to obscure the fact that he was not the first author of an accomplished book on perspective in England. That honour falls to his fellow Newtonian, Humphry Ditton, who in 1712 published his *A Treatise of Perspective, Demonstrative and Practical*.[221] Ditton does not now enjoy the reputation of being one of Newton's foremost disciples, but the great man regarded him sufficiently highly to support his appointment as Master of the New Mathematical School in Christ's Hospital. His book is devoted to 'projection' rather than 'appearance', making the same kind of distinction as Barbaro and other authors had earlier laid down.[222] His exposition is accordingly geometrical in nature, setting up the basic propositions in a neatly-conceived series of three-dimensional and flat diagrams reminiscent of Guidobaldo and Stevin (pls. 287—8). By international standards, Ditton is not an innovator, but the composition of his treatise is an act of some note in the British context.

Within three years of its publication, Ditton's work had been overshadowed by that of Brook Taylor. The reason is not so much that Taylor's treatise was a dramatic improvement on his predecessor's, but that his greater intellectual distinction lent it a special lustre. He is said to have been an accomplished amateur painter in his own right and was one of the co-authors with Newton of an unpublished treatise on music.[223] Amongst his purely scientific works, his *Methodus incrementorum directa et inversa* won the respect of the international mathematical community.[224] The first edition of his *Linear Perspective*, published in 1715, is little more than a geometrical booklet—forty-two pages long—and although the second edition of 1719, *The New Principles of Linear Perspective*, is provided with additional demonstrations of a 'more ornamental' kind, (pl. 289), it remains a highly condensed and mathematical work.[225] This terseness results from his desire to illustrate only the general principles rather than the variety of their applications. Thus, for example, he makes 'no difference between the Plane of the Horizon, and any other plane what-

287. Demonstrations of the principles of perspective projection on to the picture plane, from Humphry Ditton's *A Treatise on Perspective*, London, 1712.

288. Demonstrations of the perspective projection of a triangle from Ditton's *A Treatise on Perspective*.

Procedure as in Guidobaldo del Monte, pl. 172.

289. Perspective composition of geometrical bodies and architectural elements, from Brook Taylor's *New Principles of Linear Perspective*, 2nd edn., London, 1719.

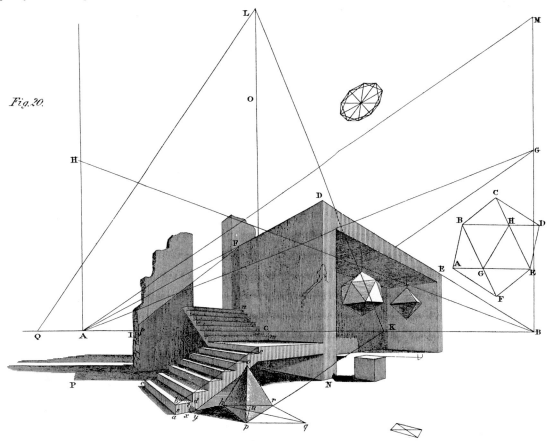

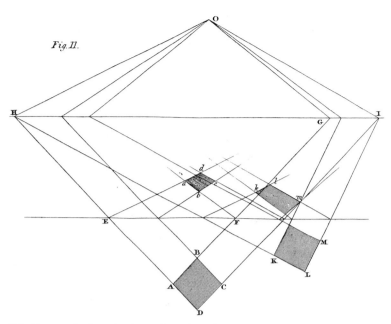

Fig. II.

290. Perspectival projection of a series of points to give the projection of a given form from Taylor's *New Principles*, 1719.

E.g. to project corner A of the square ABCD, for an observer at O: extend DA to E and H; extend AB to F and G; join H and G to O; draw a line from E parallel to OH; draw a line from F parallel to OG. Where the lines intersect is A, in projection.

291. Principles of perspective projection by the 'measure point' method for scaled divisions on a line given orientation.

E—observer
EG—viewing distance from base of picture plane AB
DJ—given line in projection, extended to 'vanishing point' V

Drop the perpendicular from V to B and join B to E (all projected lines which meet at 'vanishing point' V will be parallel on the ground plan to EB). With compasses centred on B, draw EA; erect a perpendicular from A to M (M is the vanishing point for all lines parallel on the ground plan to EA, and is termed the 'measure point'). To divide DJ at scaled intervals equivalent to O, P, Q as measured along the base of the picture plane: join O, P and Q to the 'measure point' M; where OM, PM and QM intersect DJ will be the required divisions O', P' and Q'.
Note: The angle BAE = BEA. RO, SP and TQ are parallel to AE. Thus BRO = BEA = BOR = BAE etc. DOM and DO' O etc. are equivalent to the angles BRO, BOR etc. in projection. Thus DO'O is an isosceles triangle in projection.

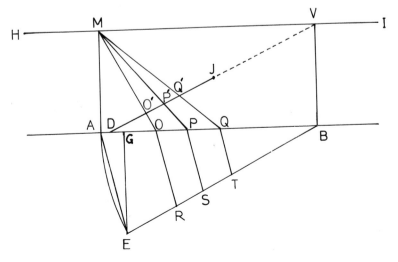

soever; for since planes, as planes, are alike in Geometry, it must be proper to consider them as so, leaving the artist himself to apply them to particular Cases'.[226]

Taylor acknowledges that his geometrical procedures belong to the 'executive' rather than the 'inventive' ('poetic') aspect of art, but warns the painter that if he finds it necessary to bend the geometrical rules in particular circumstances, his original invention must be at fault, not the rules.

Ditton and Taylor both provide succinct accounts of various ways of projecting points, lines, planes (pl. 290) and bodies in a series of geometrical demonstrations. Taylor, more importantly, also gives a new method which was to become a particular characteristic of British perspective technique, namely the use of what was later called 'measure (or 'measuring') points' (pl. 291). These points, produced by striking off a distance on the horizon from the vanishing point of any given line equal to the distance of that point to the eye, permit the division of the projected line into lengths of any required size, as measured along the base of the intersection or picture plane. The geometrical basis of the measure points can be quite simply demonstrated, although Taylor himself does not deign to do so. The British mathematician does not appear to have been the inventor of the technique—it makes a brief appearance in Ozanam's *La Perspective théorique et pratique* in 1700—but the subsequent expansions and commentaries on his treatise were responsible for establishing it as a uniquely economical way of controlling the precise dimensions of the division of any projected line, whatever its angle.[227] As such, it proved notably useful to achitectural draughtsmen, particularly those concerned with the precise rendering in perspective of projected buildings for the client's approval. We will see that Turner was acquainted with the technique of measure points.

Taylor also deals with the 'inverse problem', that is to say the determination of the original properties of a set-up known only in projection. This concern is more mathematical than practical, and is typical of the theoretical tone of his work. Cast in the form of a geometrical treatise, with axioms, lemmas, theorems etc., his book would have been forbidding for contemporary artists. It is not surprising to find John Bernouilli condeming it as abstruse and unintelligible for painters.[228] What is remarkable is that such a 'difficult' book should have become the foundation for artistic perspective in Britain for two centuries. This success was probably not so much a result of the book being widely read in itself—though it did run to five editions—but rather due to the dozens of books by followers which aspired to translate the principles of Brook Taylor into a practice intelligible to artists. Such a translation was more or less openly invited by Taylor himself. In the century following its first appearance, there were at least eight publications which declared in their titles that they intended to present 'easy' or 'practical' versions of Taylor's revered method.[229] To this list must be added the many treatises which were openly or covertly dependent on Taylor's principles.

Taylor's book also played an important role in the continuing strand of projective geometry which runs from Desargues to Poncelet in the nineteenth century. The most substantial

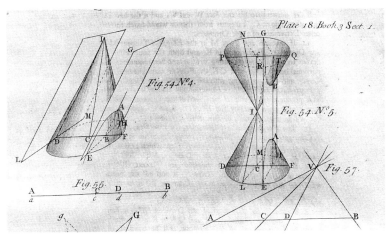

292. Studies of conic sections, from John Hamilton's *Stereography or a Compleat Body of Perspective*, London, 1738.

293. Studies of the planes of intersection of curved forms, from Hamilton's *Stereography*.

294. Demonstration of perspective projection of an interior and inclined cube from Hamilton's *Stereography*.

mathematical adoption and amplification of his ideas occurred in John Hamilton's *Stereography or a Compleat Body of Perspective* in 1738.[230] This is a mammoth book of 400 pages which elaborates a wide range of mathematical procedures. He points out that the painter should be concerned to cultivate the knowing 'art of seeing' rather than relying upon the superficial 'sense of seeing', and he therefore emphasises that even the most practised hand and eye can 'do nothing perfectly well' without the guidance of stereography.[231] However, for the most part Hamilton deals with mathematical issues which move considerably beyond the painter's ken. The statement in his preface that 'Stereography . . . appears to have a much

295. William Hogarth, *Perspectival Absurdities*, from J. Kirby's, *Dr. Brook Taylor's Method of Perspective Made Easy in both Theory and Practice*, Ipswich, 1754.

nearer affinity to Conic Sections than has hitherto been observed' gives a good indication of what is to follow (pl. 292). The writers whom he most admires are the mathematicians Brook Taylor and Philippe de la Hire, the latter of whom we will meet again in Chapter V. His discussions of the conditions under which the image of a circle appears as an ellipse, a parabola and a hyperbola, and his description of the transformation of one conic section into another, declare his allegiance to the Guidobaldo-Desargues-La Hire sucession. An accurate flavour of his approach is provided by his skilful treatment of projection onto two or more inclined planes and his studies of the planes of intersection of curved bodies (pl. 293). Such mathematical concerns in the works of Taylor and Hamilton lead discernibly towards the projective geometry of Lambert in Germany and the descriptive geometry of Monge in France.

Hamilton's concessions to painter's practice (pl. 294) do little to alleviate the daunting character of his book. Turner was acquainted with it and may have grappled with its complexities in his own rugged manner, but most artists would have naturally turned to the other kind of treatise in the Taylor sucession, namely those aimed at artists within the new institutional frameworks of the academies. Of the half-a-dozen

authors who wrote works in this category, Joshua Kirby and Thomas Malton provided the most respected and widely used sources of instruction and illustration.

With Joshua Kirby, British perspective reaches full maturity. A topographical artist of decent if not outstanding talent, he was well connected with many of the leading painters of his day, including his fellow East Anglian, Thomas Gainsborough, and the founding genius of the British school, William Hogarth, whose ingenious satire on absurdities occasioned by ignorance of perspective provided the frontispiece for Kirby's treatise in 1754 (pl. 295).[232] Hogarth was the dedicatee of the first part of Kirby's *Dr. Brook Taylor's Method of Perspective Made easy both in Theory and Practice*, while the second part is dedicated to the 'Academy of Painting, Sculpture and Architecture in London', that is to say the St. Martin's Lane Academy, which had developed out of Hogarth's promotional activities.[233] Kirby taught perspective at the Academy, and, as the first professional teacher of the subject in

296. Demonstration of vanishing points in flat and inclined planes, from John Joshua Kirby's *Dr. Brook Taylor's Method of Perspective Made Easy*, Ipswich, 1754.

297. Demonstration of the folding of the viewing plane and subject plane into the picture plane, from Kirby's *Dr. Brook Taylor's Method.*

299. Perspective projection of hollow figures from Kirby's *The Practice of Perspective.*

298. Demonstration of the 'measure point' method, based on Kirby's *The Practice of Perspective, being the Second Part of Dr. Brook Taylor's Method of Perspective Made Easy,* Ipswich, 1755.

Britain, provided the future George III with instruction in the rudiments of the art.

His treatises show a natural talent for geometry, and it is clear that he learnt a good deal from Hamilton as well as Taylor, although he confesses that Hamilton's work can be comprehended by 'very few of those Persons who are Students in the Arts and Design'.[234] He provides a useful anthology of the latest British opinions on optical questions, including the mechanism of the eye. His primary source was Robert Smith's *A Compleat System of Optics* (1738), a book of considerable importance which we will have cause to quote in Chapter V. He also showed himself to be alert to the latest debates on problems of perception, and, as a result, steered a middle course between absolute obedience to rule and reliance upon 'our common Judgement and Estimation of the Appearance of objects from Custom and Experience'.[235] In spite of these introductory qualifications, the instructions which comprise the bulk of his three treatises are founded securely on the mathematics of projection. He makes a thoroughly good job of easing the reader into a consideration of Taylor's ideas in

theory and in practice, providing lucid analyses and illustrations of such Taylorian questions as vanishing points in inclined planes (pl. 296). Those diagrams in which he shows the consequences of folding the planes into one another (pl. 297) certainly help the reader to interpret the flat geometry of his other demonstrations. He also provides important elaborations of the measure point method, showing it can be applied to the construction of various forms (pl. 298). Many of the problems are of an uncompromisingly geometrical nature, including his projection of a hollow box standing on one corner (pl. 299), and his studies of cast shadows in niches (pl. 300) which were published in his *The Perspective of Architecture* (1761).[236] However, he always keeps an eye on the implications for pictorial practice, providing some nice exemplars

302. Joshua Kirby, *Castle* and Thomas Gainsborough, *Landscape*, from *Dr. Brook Taylor's Method.*

300. Geometrical demonstration of the shadows in niches from Kirby's *The Perspective of Architecture*, London, 1761.

301. Studies of shadows and perspective from Kirby's *The Perspective of Architecture*, Ipswich, 1761.

(pl. 301), and illustrating topographical works of art by Gainsborough and himself (pl. 302).

When the academic movement in England reached its climax with the establishment of the Royal Academy in 1768, it is not surprising that the founders followed European precedent by making specific provision for the teaching of perspective.[237] The first Professor of Perspective was Samuel Wale, who had provided a charming vignette for the first chapter of Kirby's 1761 treatise (pl. 303).[238] Wale had been a vigorous advocate of the need for an official Academy, publishing *An Essay on Design including proposals for the erecting of a Public Academy* in 1749. As early as the 1740s, he had acquired a good working knowledge of perspective design, as is shown by the roundel in the manner of Canaletto which he painted in 1748 for the Foundling Hospital and by his architectural illustrations (pl. 304).[239]

The first really substantial treatise on perspective produced within the environment of the new Academy was Thomas

303. Samuel Wale, *Putti Engaged in the Study of Geometry and Perspective* from J. Kirby's, *The Perspective of Architecture*, London, 1761.

Malton's *A Compleat Treatise on Perspective in Theory and Practice on the True Principles of Brook Taylor* (1779), the subscription list of which reads like a 'Who's Who' of British art.[240] In some ways, Malton's writings are curious in tone. He was undoubtedly widely read in the subject, and possessed a real measure of geometrical understanding, providing ingenious demonstrations with folding flaps and strings, but he treats opinions which run counter to his devotion to the rules of perspective with a form of dismissive bluster which works against the kind of balanced discussion promoted by Kirby.[241] However, as a handbook to perspectival geometry, his trea-

305. Study of vanishing plains in roofs etc., from Thomas Malton's *A Compleat Treatise on Perspective . . .*, London, 1779.

304. Samuel Wale, *St. Stephen Walbrook by Sir Christopher Wren*, engraved by J. Miller, 1746.

306. Perspectival study of a staircase, from Malton's *A Compleat Treatise.*

308. Carriages and mechanical devices, from Malton's *A Compleat Treatise.*

307. *St. Paul's, Covent Garden*, from Malton's *A Compleat Treatise.*

tise fulfills its function more than adequately, and he provides some startlingly brilliant illustrations of lines, planes and bodies in space, as applied to the depiction of actual objects (pl. 305). His own measured skill as an architectural draughtsman stands him in good stead when he comes to provide examples of the portrayal of complex spaces (pl. 306) and of the depiction of actual buildings with the fall of shadows properly calculated (pl. 307). He also provides clear demonstrations of the value of perspectival draughtsmanship to those working in the fields of applied design and engineering (pl. 308), contexts which were to provide the setting for an increasing number of handbooks on systems of technical illustration.

All this body of theorising certainly had an effect on the practice of art at the Academy, above all on the genre of topographical illustration, and most particularly on the portrayal of townscapes and historical buildings in the wake of Canaletto. The levels of skill achieved by English draughtsmen can be vividly illustrated by the *Studies for a Bridge of Magnificence at Somerset House* (pl. 309), a project illustrated at the Academy in 1781 by the Professor of Architecture, Thomas Sandby, whose brother, Paul, was also a leading illustrator of

309. Thomas Sandby, *Studies for a Bridge of Magnificence at Somerset House*, 1781, showing the vista across the centre of the bridge, at right angles to its main axis, Windsor, Royal Library.

architectural views.[242] Thomas's grasp of shadow projection on curved surfaces is illustrated by the windmill in his fine panorama of the *Military Camp at Cox Heath* in 1778 (pl. 310).

Such artists provided the environment in which the precociously talented Turner grew to maturity as a topographical watercolourist. We know that Turner later consulted a wide range of perspective books, in preparation for his lectures at the Royal Academy.[243] His first direct encounter with a practitioner of the science of art was probably during his early tuition by Thomas Malton the Younger, whose brother, James, joined the family tradition by composing *The Young Painter's Maulstick, being a Practical Treatise on Perspective containing the Rules and Principles for the Delineation of Planes* (1800). James claimed to be uniting the rules of Vignola and Sirigatti 'with the theoretic principles of the celebrated Dr. Brook Taylor'.[244] The close attention he pays to the earlier Italian sources, Sirigatti in particular, helps confirm how amenable the geometricising tastes of the Renaissance theorists proved to be in the context of late eighteenth-century Britain. Although Thomas is reputed to have despaired of teaching perspective to Turner, there is no reason to doubt that the young painter's perspectival interests were well fired by his contacts at an early stage of his career.

The post of Professor of Perspective did not prove to be an easy one to fill. Edward Edwards, a friend of the Sandbys, was employed to teach pespective in succession to Wale, and published his own version of Taylor's principles, but he could not become the Professor since he was not a full Academician.[245] By the early nineteenth century, no instruction had been provided for more than a dozen years. In 1806 the Council of the Academy decided that it was time to re-establish instruction on a proper basis. Given the dearth of willing and suitably qualified candidates, Turner himself put his name forward with a show of reluctance, and he was duly elected as Professor of Perspective in 1807.[246]

His statutory obligation as Professor was to deliver six annual lectures. He appears to have worked hard in preparing his lectures, feeling a real sense of responsibility to his beloved Academy, but felt it necessary to make a series of postponements. He finally began his first course on Monday 7 January 1811. During the next seventeen years he gave a further twelve series of lectures. Turner was not a systematic thinker, nor, by most accounts, a lucid lecturer. His erratic pronunciation,

310. Thomas Sandby, *Military Camp at Cox Heath*, 1778, Windsor, Royal Library.

311. The perspective method of 'Vredeman Friese 1619', according to J.M.W. Turner.

312. The perspective by 'The Jesuit Method', according to Turner.

V—'Vanishing Point' Z—'Distance Point'

313. The perspective method of Brook Taylor according to Turner (labelled to correspond to Turner's annotations).

Vertical and Perpendicular Planes

Point of Sight Centre of the Picture and vanishing Lines

Centre Point

lines original to produce the figure

Original Points for the picture

Original line for measures of figures

Ground & Base Line

Station Point Place of the Spectator

158

mumbling delivery and fragmented arguments rapidly discouraged many members of his audience, and the later lectures seem to have become something of a charade, with only one or two people—including Turner's faithful father—bothering to attend on a regular basis. He was criticised for departing from his brief by his inclusion of a wide range of visual topics, including colour, which stood outside the field of perspective proper.[247] However, he did try to establish an orderly syllabus of the expected kind, as his surviving notes testify:

1. INTRODUCTION—its main origin, use and how connected with Anatomy, Painting, Architecture and Sculpture. Elements of Parallel, Angular, Aerial perspective. I shall show how an original subject appears on the plane of the picture with geometrical definitions necessary to be known and practiced.
2. VISION—Subdivision of the elements and terms of perspective necessary to be understood. Parallel perspective, the cube by the Old Masters.
3. ANGULAR PERSPECTIVE—Circles, colour.
4. AERIAL PERSPECTIVE—Light, shade and colour.
5. REFLEXIES—Reflections and colour. Shadow of the sun and moon, and artificial lights and reflection from still water or mirror.
6. BUILDINGS—Introduction of Architecture and Landscape. Application of rules of Perspective to the different parts of architecture, the examples here produced show their necessity to Painters as well as Architects.[248]

The range of topics he discussed under these headings are essentially the same as those found in the standard treatises, albeit with some eccentricities in terminology. Like many of his predecessors, he attempted to provide some basic instruction in the fundamentals of pure geometry through a discussion of Euclid's *Elements*.[249] It may be worth noting that Malton himself had published a popularising book of mathematics, *The Royal Road to Geometry* in 1774. Turner also reviewed and provided illustrations of famous earlier methods. Some of these, such as the techniques he credits to 'Peter John a Priest' in 1505 (i.e. Jean Pélerin!) and 'Vredeman Friese 1619' (pl. 311), were known second hand, mainly through the historical review provided by Kirby, while others were consulted in the original.[250] His pithy comments, such as that on the 'Jesuit Method' by Dubreuil or Lamy—'like Vredeman's but we have not the number of moves on his drafts table' (pl. 312)—show a lively appreciation of the characters of the works, though he did not in every instance make full sense of all the technical procedures.[251] The up-to-date methods recommended by Turner are drawn from the Brook Taylor succession (pl. 313), particularly Kirby and Malton.

Turner achieved a considerable if not infallible understanding of the techniques and endeavoured to provide working definitions of the necessary terms e.g. 'the *Vanishing Plane* is a supposed plane, passing from the Eye Parallel of the original one'.[252] A report of one of the 1815 series suggests that not all the members of his audience missed the point of his basic definitions:

Mr. Turner thought it necessary to explain some of the principal elementary terms, such as the original plane or ground plan, that on which the spectator is to stand; the original line, that is the intersection of the original plane with the picture; the point of sight which in parallel perspective ought to be the centre of the picture, and the station point and the vanishing lines.[253]

One of the most attractive features of his lectures, and one which did much to repay those patient enough to sit through them, were the drawings which he used to demonstrate his points. In keeping with the treatises of Kirby and Malton, these included elaborate demonstrations of the perspective rendering of actual buildings (pl. 314). The illustrated example shows the use of a measure point in the Malton manner to plot the dimensions (recorded on the horizontal lines) on to the oblique planes of the building, according to the rules of 'angular perspective', upon which he placed special emphasis.

Turner also attempted, in his unsystematic yet original way, to deal with the optical complications which worked against the integrity of geometrical perspective. He certainly discussed at some length the vexed question of the apparent bending and convergence of the horizontal and vertical edges of large buildings when viewed under a wide angle, though he apparently stopped short of devising and implementing a fully-fledged alternative to the orthodox system.[254] He was also worried by a number of the other problems with the orthodox method, such as the distortion of square and circular forms at the lateral edges of a wide-angle view and the way in which laterally placed columns apparently subtend a wider angle than more central columns located along the same line parallel to the picture surface.

In addition to such conundrums of geometrical perspective, he devoted a fair amount of time to the beguilingly complex effects of reflection and refraction, devising innovatory demonstrations with water-filled spheres which he represented

315. J.M.W. Turner, *Studies of Reflection and Refraction in Glass Spheres containing Water, c.1815*, London, British Museum, Turner Bequest, CXCV 117C.

in huge watercolours (pl. 315). The effects of colour naturally attracted his attention—more so than was strictly justified for perspectival purposes—as we shall see in Chapter VII.

The general thrust of Turner's analyses is to acknowledge the importance of geometrical understanding while insisting that the painter's eye should remain supreme when the implementation of geometry alone results in forms that look 'wrong'. His willingness to override the rules of perspective is entirely consistent with his general attitude to 'rule' and 'science'. He had no patience whatsoever with 'restrictive rule', but he was fascinated by the way in which science revealed the awesome powers of nature. Light, for Turner, was a dynamic force, and its scientific study enhanced rather than diminished its emotional potency. The exciting juxtapositions of scale occasioned by long perspective vistas, and the plunging force of strongly-characterised spaces were powerful weapons in his visual armoury. A fine example is provided by the pair of paintings looking in either direction along the terrace at Mortlake on the Thames (pls. 316–17)[255]. Making obvious reference to Canaletto's views from Somerset House (pls. 279–81), he has combined a particularly rhythmic use of perspective with his own special vibrancy of light and shade which both amplifies and competes with the linear effects. There is more than a hint of the curving of the horizontal lines under the wide-angle views—an effect which becomes pronounced when the same kind of orbital description is accomplished within a single painting (pl. 318).[256] The radiating spokes of the perspective scheme in this latter picture—to which we will return—are defined by the cast shadows and by the stream of excited dogs who rush out to greet their master with a respect for perspectival regularity worthy of Uccello's orthogonal animals.

More often than not, we may feel that Turner uses perspective to suggest the infinite vastness of space, rather than its enclosed, Euclidian, box-like quality. The awesome sense of the sublime infinity of space had been evoked regularly by the early Romantic poets who did so much to nourish his imagination. A passage from Akenside quoted in his lectures

314. J.M.W. Turner, *Perspective Demonstration of Pulteney Bridge, Bath, c.1815*, London, British Museum, Turner Bequest CXCV 113.

316. J.M.W. Turner, *Mortlake Terrace, Early Summer's Morning*, 1827, New York, Frick Collection.

317. J.M.W. Turner, *Mortlake Terrace, Summer's Evening*, c.1827, Washington, National Gallery.

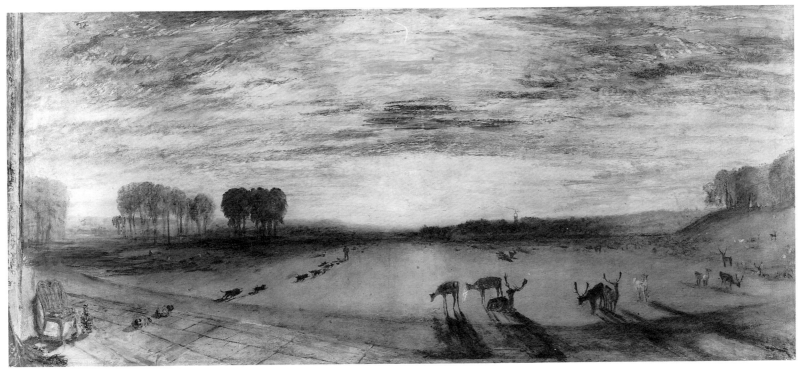

318. J.M.W. Turner, *Petworth Park, Tillington Church in the Distance*, c.1828, London, Tate Gallery.

gives a perfect flavour of the way the Romantics exulted in the Newtonian vastness of space:

> The various forms which this full world presents
> Like rivals to his choice, what human breast
> E'er doubts, before the transient and minute,
> To prize the vast, the stable, the sublime.[257]

Or, as Turner said in his own words when discussing Euclidian geometry: 'each point, one line, is out of the many in the Building of Nature, a building too collossal for the intellectual capacity, its height to measure or its depth to fathom—the Universe and Infinitude'.[258] All this is much in the spirit of Milton: 'Beyond is all abyss, Eternity whose end no eye can reach.'[259]

Turner was certainly much in tune with those aspects of British Romanticism that regarded Newtonian science as a source of rapture rather than as a demystification of the powers of nature. One of the more improbable expressions of this sentiment occurred in the *British Manufacturer's Companion and Callico Printer's Assistant* by C. O'Brien:

> for, while philosophy on one hand, bursting through all the elementary barriers of nature, pursues her to her inmost recesses and analyses those objects, whose minuteness confounds the imagination, and which are only perceptible by their effects; on the other hand; it not only adds new orbs to our solar system, but darts into the immeasurable expanse and scrutinises objects that as equally confound by their magnitude, and the spaces they possess; in short, it can be said, it exposes immensity itself, gages the very Empyreum, and exhibits its construction!!![260]

When we look at Turner's most perspectively assertive compositions, such as *Juliet and her Nurse* (pl. 319), we may feel that the perspective does not so much enclose a defined space as suggest that it is an expansive fragment of infinitude.[261] It is, as Gowing has written, one of Turner's 'visions of the world as an endless continuum' which is 'appropriately peopled with an almost indeterminate human clay, barely separated into individuals'.[262]

319. J.M.W. Turner, *Juliet and her Nurse*, 1836, Argentina, Collection of Sra. Amalia Lacroze Fortabat.

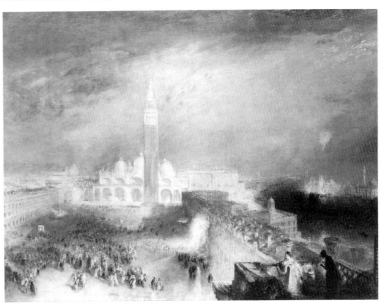

320. John Martin, *Belshazzar's Feast*, 1820, New Haven, Yale Center for British Art.

It is at this stage in the history of art that the new visions of infinite space formulated in the Scientific Revolution and the perspectival formula of parallel lines meeting at infinity move into expressive union in the context of painting. Much as we might like it not to be so, the visions of space in science and art are some two hundred years out of step.

The vision of infinite space conjured into optical reality by the exploitation of perspective on scales of implied vastness is even more literally expressed at this time in the cacophonous narratives of John Martin (pl. 320).[263] Given his scientific contacts and his propensity for scientific speculation on his own account, Martin provides a kind of caricature of one aspect of Turner's genius. His unambiguous spatial message was certainly not missed by contemporary observers, such as Bulwer-

Lytton: 'vastness is his sphere, yet he has not lost or circumfused his genius in its space; he has and wielded and measured it at will; he has translated its character into narrow limits; he has compassed the infinite itself with mathematical precision'.[264]

So spectacular was Martin's use of perspective that it won praise in one of the specialist perspectival treatises. A.W. Hakewill, in his introduction in 1836 to an English treatise based on Thenot's French handbook, believed that the painter had raised perspective to the supremely expressive power previously reserved for the figurative expression of passion in history paintings:

> Throughout his extraordinary performances, the magic of linear and aerial perspective is substituted for that great level of our sympathies, the portrayal of passion and sentiment... The mysterious and electrifying suggestions of boundless space and countless multitudes which their wonder-working elements shadow forth, captivate the fancy, by entangling it in a maze of unearthly conceptions —the result chiefly of a copious and intelligent display of the resources of perspective, and without the aid of any of the higher attributes of art.[265]

This kind of painting is at once perspectival and antirational. It uses the inherent dynamism of perspective to suggest that there are cosmic and mental factors which lie infinitely far beyond the circumscribed techniques of orthodox perspective. The stage-like boxes of tangible space which had been the perspectivists' goal for centuries have effectively lost their containing walls, floor and roof. The paintings of Turner and Martin are at once the climax of the story we have been telling and potent manifestations of intellectual and aesthetic factors that weakened the foundations of the neat edifice constructed by generations of perspectivists. These factors are to be discussed in Chapter V.

Part II: Machine and Mind

'There are some who look at the things produced by nature through glass, or other surfaces or transparent veils. They trace outlines on the surface of the transparent medium . . . But such an invention is to be condemned in those who do not know how to portray things without it, nor how to reason about nature with their minds . . . They are always poor and mean in every invention and in the composition of narratives, which is the final aim of this science.'

(Leonardo da Vinci)

Introduction to Part II

The major participants in the story told in Part I, whatever their apparent diversities in theory and practice, shared for the most part one important underlying assumption, namely that the science of geometrical optics corresponded in a real way to the central facts of the visual process. The corollary of this often unstated assumption was that geometrical procedures provided an appropriate means for the representation of three-dimensional objects on a flat surface in such a way that the projection presented essentially the same visual arrangement to the eye as that presented by the original objects. In retrospect, it may seem remarkable that a detailed consideration of the eye itself should have figured so little in these concerns. Leonardo was exceptional in the way in which he allowed his ideas about the structure and functioning of the eye to disturb the central assumptions about linear perspective. Even Kepler's revised concept of the eye as a form of camera obscura—in which an inverted image is focused on the retina—left the main assumptions largely unchallenged. His new eye had been conceived entirely within the context of geometrical optics, and the basic ideas of visual angle and the proportionality of image to object remained intact. Those theorists who did discuss the workings of the new eye were readily able to make it operate in harmony with the pre-established facts of perspective.

If the eye figures little, the mind features even less. The perceptual mechanisms which resulted in the translation of sensory stimuli into visual knowledge barely entered the perspectivists' picture at all. The dominant framework in the earlier periods was the Aristotelian theory of faculty psychology, in which the ventricles of the brain were regarded as the chambers in which mental processes were performed. However sophisticated the theories had become in assigning relative functions to the inner and outer senses, they shared the common conviction of the Aristotelian tradition that knowledge of the world was acquired by an extractive process, in which visual impressions were subjected to mental procedures designed to 'invent the truth' about natural phenomena. This is not to deny that mediaeval students of perception had developed a sharp awareness of the unreliable aspects of the senses—delusions, illusions, ambiguities etc.—but these could in themselves be rationally analysed within the predominantly mathe-

matical model of vision. When Galileo and Descartes, at the heart of the Scientific Revolution, emphasised the dangers of formulating explanations directly and naively on the basis of sensory effects, they did so to reinforce the conviction that analysis should be undertaken in a precisely mathematical manner. This conviction could only help reinforce the belief of intellectual artists like Poussin in the essential validity of geometrical perspective in capturing the truth of 'prospect' rather than the superficial ambiguities of 'aspect'.

We have seen, in passing, at least some signs of challenges to the validity of geometrical optics. These challenges came from two main directions. One argument was concerned with the natural 'judgement of the eye', and drew attention to the flexibility of the visual process, particularly with respect to the mobile eye and two eyes operating in conjunction. This concern had arisen most conspicuously in France in the seventeenth century, when the opponents of Bosse argued that mathematical procedures must be tempered by an awareness of how the eye actually 'sees' complex forms in nature. As yet, however, this awareness did not crystallise into a coherent visual theory. The other challenge came from what we might call the aesthetic direction, that is to say from the belief that there were fundamental features in art, such as imagination and transcendent talent, that could not be circumscribed by rules. This belief was not articulated into a full-scale aesthetic theory until the Romantic period, but it had appeared in various guises throughout the periods with which we are concerned. The quotation from Leonardo at the head of Part II reflects a not uncommon distrust for mechanical and slavish imitation. This distrust seems to have been as old as the theory of imitation itself.

To these challenges the eighteenth century added a far more radical questioning. That century saw the beginnings of a fundamental reappraisal of perception as a whole—how we 'see', how we unscramble sensory impressions, how we understand, how the senses relate to each other, and so on. I have dropped hints of such matters during our examination of British theory, but felt that we could for the moment leave them aside, since they were largely smothered by the enthusiasm within the academies for the geometrical certainties of the perspectival tradition in general and for the Newtonian abso-

lutes of Brook Taylor in particular. I have, as readers may have noticed, not adopted the same procedure with respect to French eighteenth-century painting, which has so far been omitted. In this instance, my judgement is that the balance in France had shifted away from a belief in the centrality of orthodox perspective and towards other concerns. One of the functions of Chapter V will be to see how far these other concerns were of an optical or perceptual nature.

The two chapters in Part II should throw the optical, aesthetic and perceptual issues into higher relief. The first will concentrate on 'mindless' images in their most extreme form—the images made by devices which mechanically record and represent certain features of the visual world, culminating in the photographic camera. Yet we will also see how devices could enter the realm of 'natural magic' in a way which seems to transcend their mechanical base. The second chapter is concerned with the divergence between the new ideas in perception (and by extension in aesthetics) and the technical developments in perspective, including those which lead in the direction of projective and descriptive geometry in their more modern forms. In some ways these two chapters are odd bedfellows. They certainly cover different chronological ranges: the chapter on devices returns to the fifteenth century again as the starting point; while the other, is based in the eighteenth and nineteenth centuries. However, I hope that the issues they raise—optics, the eye, perception, representation, imitation, and 'Art' will intersect in a telling manner.

Machines and marvels

The ambition to invent a machine or device for the 'perfect' imitation of nature appears to have been virtually limited to Renaissance and post-Renaissance Western art—until the universal craze for photography.[1] This uniqueness amongst all the varied traditions of world art underlines the exceptional aesthetic base of the era with which we are dealing. I do not think it is coincidental that this was also the period in which the technologies of scientific and utilitarian devices came to occupy a central place in European man's striving for intellectual and material progress. Indeed, the whole notion of progress in this phase of Western thought is deeply shared by science, technology and naturalistic art. The great new inventions of the Renaissance, most conspicuously the printing of books with movable type and the ever more potent firearms, provided the most directly measurable claims that the revered 'ancients' were being surpassed—that discernible progress was being achieved. Within the field of pure science, devices such as the telescope and microscope were being exploited to take understanding of the universe into realms of expanse and minuteness inaccessible to the scientists of classical antiquity. The new sciences, which had broken out of the regimen of repeated commentaries on the Aristotelian corpus, and the new forms of art, which were striving purposefully towards a complete command of natural appearance, were part of this general pattern.

In this context, it is easy to see how perspective machines, camera obscuras and suchlike could simultaneously serve as entertaining diversions from the mainstream of perspective science and as genuine sources of intellectual excitement. This chapter is concerned with mechanical and optical devices for the imitation of nature and with those related devices which use optical 'tricks' to create startlingly real visual effects, such as anamorphic and stereoscopic images. I should perhaps say at the outset that I am not planning to extend this theme into a full-scale examination of all the various forms of 'optical entertainment', which proliferated so extensively in the late eighteenth and nineteenth centuries, nor do I plan to write yet another potted history of early photography. Rather, in the later periods in particular, I will be selecting those episodes in which a new optical idea or type of optical effect is used to replicate our visual experience of nature. I should also say that

I will not be attempting to give a comprehensive review of all the many and often derivative perspective machines in successive treatises, nor will I be enumerating the many incidents in which artists may have used or did use a camera obscura or camera lucida. I shall be concentrating on those aspects of the story which best seem to illuminate the shape of the historical developments and raise the contingent issues of scientifically controlled imitation and artistic freedom most sharply.

Broadly speaking, this chapter will be organised around three themes, corresponding to the three main types of device: perspective machines as instruments for the recording of linear effects according to projective principles; optical devices involving lenses etc. for the formation of reduced images of the world in a full array of light, shade and colour; and 'magic' devices which use optical principles to ambush the spectator's perception. Finally I will suggest how the invention of photography fits into this aspect of our story.

PERSPECTIVE MACHINES

Embarking on our historical study of the mechanical means of perspectival representation, we are immediately faced with the same problem which beset us at the opening of Chapter I, namely that we know enough about Brunelleschi's activities to realise how crucial they were, but not enough to say certainly what he achieved or the means he exploited. I have already suggested that his knowledge of mediaeval surveying techniques provides the most ready source for the technical skills required for his perspectival projections of the Baptistery and Palazzo dei Signori. This knowledge is not the only plausible source, but in as far as it relates to what is known of his education and to his own particular style of applied ingenuity, it seems to me to be the least arbitrary of the choices. The continued intersection of geometrical perspective and its related machines with the mathematics of mensuration is so strong that we would be well advised to say a few words about the standard skills of estimation and surveying which were available to the better educated artisans and to the merchant classes.

The skills which most immediately concern us are those of geometrical mensuration, which might be described as 'ap-

plied Euclid'. The most ready sources of instruction for use privately and within schools were the abacus books, which provided step-by-step procedures for the calculation of distances, heights, areas and volumes. Young students would be instructed in the basic procedures and then set to work on a series of specimen problems of the peculiarly 'academic' kind which has not essentially changed over the centuries. A typical problem, taken from Paolo Dagomari's widely used 'Trattato d'aritmetica' was 'how many times will Città di Castello go into Florence'.[2] A suitable text-book for specifically geometrical techniques was Leonardo Fibonacci's 'Practica geometriae', which was available in vernacular translation in the fifteenth century—and we have already noticed that Piero compiled his *Trattato del abaco* in this tradition.

The basic techniques of surveying lengths, breadths and height were based on simple concepts of triangulation. Their ultimate foundation lay in Euclid's trigonometry, but the abacus books required no more than the simple skills of addition, subtraction, division and multiplication in the context of similar triangles. In the case of two similar triangles for which two side lengths of one triangle and one side length of the other triangle are known, the unknown length of the corresponding side in the second triangle can be calculated. In its simplest form, using a measuring rod to calculate the height of a tower (pl. 321), we can use the formula $FH = AG \times HE/GE$. This procedure bears a clear relationship to the proportionality of triangles and of forms at the intersection (in this case, AGL) at the centre of Alberti's system.

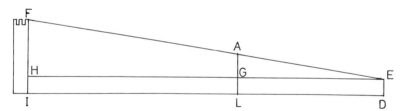

321. The measuring rod used to survey the height of a tower.

IF—tower AL—measuring rod ED—observer
HF—height of the tower in excess of the height of the rod

GE—distance of the eye from the rod $FH = AG \times \dfrac{HE}{GE}$

AG—the measurement of DE on the scale of the rod

Other techniques made use of small mirrors, either placed on the ground or hung on vertical measuring rods. The aim in each case was the same: to establish similar triangles, one small and one large, optically, so the proportional calculation of an unknown dimension could be completed. A testimony to the continuity and utility of these methods is that they are described in essentially their mediaeval form in Cosimo Bartoli's late-sixteenth-century text-book, *Del Modo di misurare*.[3] Bartoli was also the first editor of Alberti's *Della pittura* in the context of this *Opuscoli morali di L.B. Alberti* in 1568.

An involvement with the basic techniques and instruments of mensuration is perhaps the most widespread of the common factors amongst the most prominent of the early perspectivists. Brunelleschi was directly involved in the surveying of

ancient architecture, while Piero della Francesca and Leonardo both wrote about measuring techniques. Two other prominent theorists in the *quattrocento*, Francesco di Giorgio and Filarete, confirm that anyone involved in architecture would be expected to master the basic methods. Looking at the written sources as they run from the fifteenth to the sixteenth centuries, there is a clear impression that the methods become increasingly refined in the mathematical sense—in keeping with the great growth in the understanding of astronomical techniques of measurement and projection—and that instruments of increasing complexity are devised.

Alberti reflects both the basic and sophisticated forms of mensuration. His 'Ludi mathematici' is typical of a certain type of fifteenth century treatise in which a range of applied mathematical techniques were exploited for utility and delight.[4] Many of these involved no more than the simplest procedures. There were, however, mediaeval instruments of considerable elaboration and precision, most notably quadrants and astrolabes, which could be used for terrestrial mensuration, although this was not their prime function. The 'shadow square' of a quadrant or astrolabe, consisting of straight scales at right angles to each other (pl. 322) could be used as a much more precise substitute for measuring rods, wooden squares and such like. Alberti himself used such an instrument, mounted in a horizontal plane, for the measurement of the angular disposition of landmarks in his *Descriptio urbis Romae*.[5] I believe that it makes a good deal of sense to see Brunelleschi's earlier techniques as emerging from this kind of context, rather than presupposing his direct adaptation of the rarefied science of medieval optics. Many of the perspective machines in subsequent years are certainly closely related in their invention and operation to the instruments of terrestrial and astronomical mensuration.

322. An astrolabe used for surveying a building, from Cosimo Bartoli, *Del Modo di misurare*, Venice, 1589.

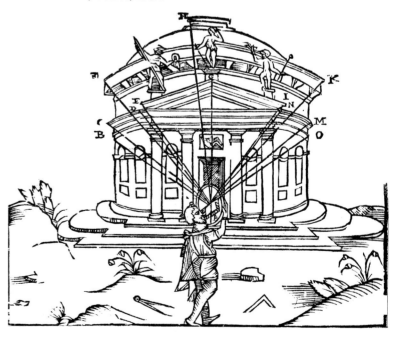

Alberti's own perspective device as recorded in *De Pictura* introduces us to the most simple and ubiquitous of the procedures, namely the direct transcription of the linear disposition of objects as they appear to the eye on the intersecting plane. He describes 'a veil loosely woven of fine thread, dyed whatever colour you please, divided up by thicker threads into as many parallel square areas as you like, and stretched on a frame'.[6] This device, 'whose usage I was the first to discover . . . is called the intersection among my friends'. Viewing the objects through this translucent network from a fixed station point, the artist would be able to transcribe the arrangement of forms onto a drawing surface which has been divided into similar squares. This technique is seen by Alberti as specifically applicable to 'circumscription', one of the three branches of painting (with 'composition' and 'reception of light and shade').

However, even at this very earliest point in the mechanical imitation of nature, there are clear signs of the repeated criticism which such devices were to provoke, namely that they are 'mindless'—intellectually and aesthetically. Alberti, for his part, 'will not listen to those who say it is no good for a painter to get into the habit of using these things, because, although they offer him the greatest help in painting, they render the artist unable to do anything without them'.[7] In achieving the goal of an exact representation of the components of an object and of the corresponding patterns of light and shade, the veil will permit the artist to capture appearance in an unrivalled manner. The resulting forms, 'circumscribed' according to nature, will provide the building blocks for the artist's 'composition'. The impression is that Alberti did not actually expect the veil to be used directly in the final work, which is not surprising when we remember that 'history' painting remained his supreme goal for the inventive artist. Alberti's defensive position over the use of the veil echoes and re-echoes throughout the history of such devices, and is especially characteristic of the nineteenth-century literature defending photography from the charge of mechanical artlessness. Our introductory quotation has shown Leonardo adopting the critical stance which had already faced Alberti.

In Leonardo's own practice of perspective science, the links with techniques of mensuration which we have hypothesised for Brunelleschi and seen more concretely with Alberti, are readily apparent. He undoubtedly possessed a keen interest in the form and function of astrolabes and quadrants, and he also recorded—for the first time in a specifically artistic context—a cross-shaped measuring staff which he calls the '*bacolo* of Euclid' (pl. 323). This is the instrument, according to Bartoli, that the Latins called a *baculo*. It is also closely related to the so-called 'Jacob's staff' of Levi ben Gerson, and is used to establish the similar triangles with which we are familiar.[8] Its advantage is that the sides of the two or more triangles are firmly embodied within the instrument, which can be calibrated for easy measurement. The use of this instrument was to be perfected in the sixteenth century as the *radio astronomico* by the great geographer, astronomer and theorist of measuring, Gemma Frisius (pl. 324), who commends it for terrestrial as well as astronomical measurement:

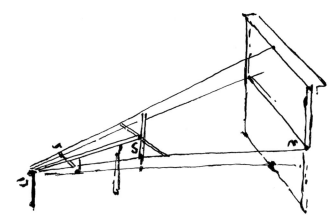

323. The 'bacolo of Euclid' measuring a plane, as drawn by Leonardo da Vinci, based on Codice Atlantico 148vb.

I shall, however, not discuss how some painter, standing high above a place beneath him, might delineate by optical principles either an entire fort or a sacred building or even a town (should he wish to) with the aid of our *radius*. For this is something which any clever person can easily deduce both from what has been related earlier and what is being said. And yet I cannot pass over in silence the very great ease and advantage of our instrument which some architect or painter might attain if . . . he wished to depict the entire face of a building opposite him graphically in a picture and in accordance with the symmetry of the parts.[9]

Although no account from his own hand survives, Leonardo certainly used an astrolabe or a closely related instrument in taking measurements for his maps, of which the *City of Imola*

324. The *radio astronomico* used to measure the width of a façade from Gemma's Frisius's *De Radio astronomico. . . .*, Antwerp, 1545.

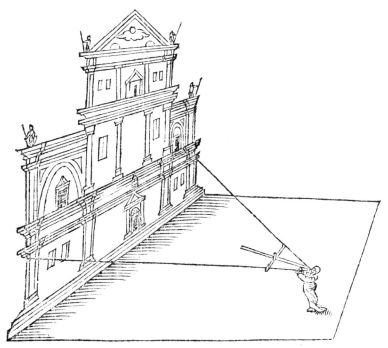

325. Leonardo da Vinci, *Map of Imola*, *c*.1504, Royal Library, Windsor, 12284.

326. A compound '*bussola*' for taking horizontal and vertical bearings, from Bartoli, *Del Modo di misurare*.

is the supreme surviving example (pl. 325). From a central vantage point, he had taken angular measurements, correlating these with the compass directions of a wind-rose and with the linear measurements of streets and buildings which had apparently been paced out by himself and his assistants. It seems likely that his way of working was essentially the same as that described by Raphael in his letter to Leo X, in which he commends his survey of ancient Rome to the Pope.[10] Raphael provides a detailed account of a circular instrument, at the centre of which is a compass. Around the peripheral scale, divided into degrees and marked with the names of the winds, move arms which carry two sight-vanes. A similar device, a *bussola*, is illustrated later in the century by Scamozzi and in a compound form by Bartoli (pl. 326). Using a network of vantage points, a complete system of triangulation can be achieved. The instrument can also be used to record measured ground plans and elevations of existing buildings. Raphael stresses that such drawings will provide accurate information of a kind which is not available from a drawing executed according to the painter's customary system of diminishing perspective. In keeping with the theme of progress which I emphasised at the beginning, he also expresses the opinion that 'the manner of measuring with the magnetic compass . . . is an invention of the moderns'.[11]

The evidence of Leonardo's own involvement with the design of perspective aids for artists is rather fragmentary, but we do at least possess one explicit drawing of a complete set-up (pl. 327), showing a draughtsman at work with an armillary sphere. A note from about 1490, entitled 'A method of showing a site accurately' explains the procedure.[12] The draughtsman's 'eye is to be placed at a distance from the glass of $\frac{2}{3}$ *braccio* [i.e. a little under 40 cms], and the head is fixed by an instrument in such a way that the head may not be moved at all. Then one eye is covered or closed.' The image of the object is next traced on the glass with a brush or red chalk. The resulting design is itself subsequently traced for transfer to the proper drawing paper. 'If you wish, it can be painted, using aerial perspective in a proper manner.'

The same text continues with an instruction on 'How to learn to copy poses well'. This technique consists of a large-scale adaptation of Alberti's veil. 'A net which is squared with threads' is stretched over a frame $3\frac{1}{2}$ *braccia* high and 2 *braccia* wide. It is placed 1 *braccio* from the nude model and seven *braccia* from the draughtsman (pl. 328). 'Then place a pellet of wax on that part of the network which will serve as the sight.' The line of the artist's vision as it passes beyond the sight should strike the neck of the model. The outlines of the forms as viewed through the grid are then duplicated on a drawing which has been prepared with a corresponding network of smaller squares. The purpose of this method is not so much to act as a comprehensive means of imitating nature as to be a teaching aid for the painter who wishes to study the relative positions of shoulders, hips, etc. in a variety of poses. This limited, pedagogic use of the device reflects his insistence that the artist should so acquire an understanding of the rules of nature as to be able to produce them at will in imaginative compositions. It is this conviction that lies behind his dismissal

of 'those who do not know how to portray things without it [the glass], nor how to reason about nature with their minds'.

We would certainly not, therefore, expect to find signs of the direct use of such aids in his paintings or drawings for works of art, but there is one category of drawing in which we may infer their use. When studying the perspective of a complex body, such as an armillary sphere or one of the Archimedean semi-regular solids, and attempting to draw it with precision, the use of a perspective glass would undoubtedly have saved a great deal of labour in projective geometry (pl. 327). Just such a degree of precision was required when he came to illustrate Luca Pacioli's *De Divina proportione* (pl. 109). A close technical study of the illustrations in the finer of the two manuscripts and of the related drawings suggested that Leonardo did not resort to the full panoply of geometrical projection, but used a technique in which the key junctions of each complex form were established for direct transfer to the manuscript page. In view of the frequency with which armillary spheres and geometrical objects appear in earlier intarsia designs (pl. 71), we may surmise that Leonardo was not the first to use artificial aids to shortcut the otherwise daunting task of perspectival projection in such instances. It may be that glasses and veils had already established their particular usefulness in this specialised and limited sphere of operation.

It was probably Leonardo's reservations about the value of perspective machines in a broader context that prevented him from giving sustained attention to the perfection of such devices and their extension into wider realms of utility. It remained for Dürer, who seems to have been aware of Leonardo's net and glass, to investigate their potentialities in a sustained manner. Perhaps Dürer's technical background in metalwork and Nuremberg's expertise in the construction of instruments disposed him more favourably towards instrumental techniques of imitation. The four illustrations in the first and second editions of his *Underweysung der Messung* represent what in today's language of technology would be called 'the state of the art' in perspective machines.[13] Two woodcuts illustrate the Leonardesque net and glass in action. The net (pl. 329), as Leonardo recommended, is placed close to the figure, although the positioning of the reclining model indicates that Dürer is more interested in sharp foreshortening than in the rhythms of poses. The extreme exaggeration of foreshortening which would result from such a set-up suggests that the woodcut is intended in general terms to illustrate the forms of the net, eyepiece and squared drawing surface rather than providing a precise method of operation to be imitated by the student. The glass (pl. 330), mounted on a specially designed stand, carries a greater air of conviction, not least in his description of mechanical accessories such as the horizontal screw for adjusting the alignment of the eyepiece. When this device is used to outline a portrait in the manner shown by Dürer, the size of the head on the intersecting plane will be no more than about 8 cm high, which may seem impractically small, but it does correspond quite closely to the sizes of heads in his engraved portraits.

The other two devices are more novel and open the way for later machines which use strings and rods to replicate optical

327. Leonardo da Vinci, *Draughtsman using a Transparent Plane to Draw an Armillary Sphere*, *c*.1510, Milan, Biblioteca Ambrosiana, Codice Atlantico 1ra (new 5).

328. Leonardo's net for copying poses, based on his description in MS BN 2038, 24r.

AB = 3 *braccia*	AD = CB = 3½ *braccia*
FG = 7 *braccia*	GM = 1 *braccio*

329. A draughtsman using a net to draw a nude figure in foreshortening, woodcut from Dürer's *Underweysung der Messung*, 2nd edn., Nuremberg, 1538.

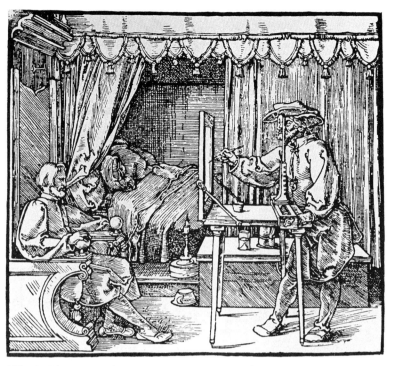

330. Artist using a glass to take a portrait, woodcut from Dürer's *Underweysung*, 1st edn., Nuremberg, 1525.

geometry. Piero had earlier envisaged using threads in place of the drawn lines of his diagrams, but these threads were simply intended to map out the flat geometry of his demonstrations and were not components in a fully-fledged perspective machine. The system illustrated by Dürer in the first edition (pl. 331) is devoted to one of the classic set-pieces of the perspectivist's art, the foreshortening of a lute. The eye-point is denoted by the pulley on the right-hand wall. The string or 'ray' passes from this 'eye' to the tip of a pointer, which is

331. Two draughtsmen plotting points for the drawing of a lute in foreshortening, from Dürer's *Underweysung*, 1525.

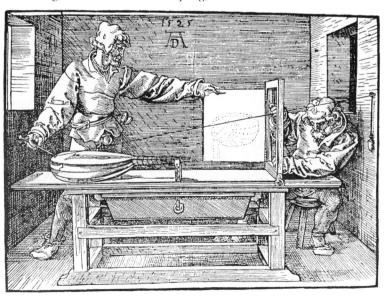

moved successively to key points on the lute. The precise positions at which the 'rays' pass through the intersecting plane are recorded by two crossed strings. For each successive position, a hinged board is swung across the frame, and the point of intersection marked by a spot on its surface. An adequate number of judiciously placed points will enable the foreshortened lute to be drawn. This method is undeniably cumbersome and long-winded, but it does serve to illustrate the principle of the intersection and light rays with graphic clarity. I suspect that it was conceived less as a practical aid in making works of art than for the purposes of demonstration. It could well have been used to make the kind of mechanical and generally unattributable drawings of solid bodies which still survive in some drawing collections (pl. 364).

The other stringed mechanism, which appeared in the second edition (pl. 332) was not Dürer's own personal invention. However, it does serve to show his sharp awareness of the greatest shortcoming of the conventional machines. The problem arises from the inevitable limiting of the distance between the eye and the intersection to the relatively short span of the draughtsman's arm as he reaches towards the glass. It is true that the use of a net would avoid this difficulty, but nets

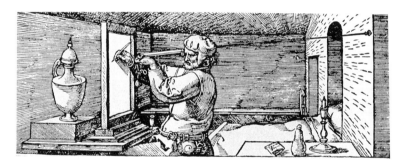

332. Draughtsman using Jacob de Keyser's perspective device, from Dürer's *Underweysung*, 1538.

and veils were relatively imprecise systems, in that direct transcriptions were not drawn on the actual intersections. The solution, which Dürer credits to Jacob de Keyser, is to use a string and gunnery-style sight to extend the 'eye-point' as far as may be desired. One of Dürer's manuscript notes in the British Museum explains its advantages:

> It is easy [with the conventional device] to trace a flat object placed close to the eye on a glass pane as it will not be subject to distortion. If, however, you wish to draw a lute or various other objects close to the observer by sighting their points, this will readily result in distortion. If, for example, you wish to draw a lute with its finger board pointed towards the observer, its body will be out of proportion . . . If the thing I wish to draw is placed far from my eye, I would have to hold the glass on which it is to be traced close to my eye so that I could reach it with my hand. In that case the object I am to draw will appear very small on the glass pane. If I placed the glass closer to the object that I wish to draw,

in order to make it appear larger, I would be unable to reach the glass . . . For this reason it is necessary to use another method that saves much trouble and permits any object to be drawn on the glass plane regardless of size . . . For this purpose Jacob Keyser invented the following: he takes a long, thin silk string, as long as required, and attached one end to point of sight o. It is for him as useful as if his right eye were in its place . . . To this string he now attaches an instrument that has a pointed, vertical element in front and a peephole in the back.[14]

Dürer then proceeds to give details of the construction of the sight, with its relative dimensions, and to describe how the peephole is adjusted—much like the sight of gun—to give the proper angle of view relative to the string. The illustration, the written description and the detailed preparatory drawings leave no doubt that this was a real instrument which Dürer tested with success. However, we are still left with the impression that its main use was in the set-piece and pedagogical demonstrations of the solid bodies which were favoured by the perspectivists and that it was not intended for universal application.

It is not a matter of chance that one of the most direct descendents of the Keyser-Dürer machine is shown in Jost Amman's engraved portrait of Wenzel Jamnitzer, who is using it to study geometrical forms (pl. 333). We have already noted that Jamnitzer's illustrations of geometrical solids (pls. 110–11) are portrayed as if seen from a relatively distant viewpoint, and we may reasonably suspect that he used an artificial eyepoint of the illustrated kind. Such a device would enable him to lay down the perspective frameworks for his illustrations, even if it is unlikely that all the variant bodies were actually manufactured in their full complexity and studied individually in this manner. Jamnitzer is known to have been a superb maker of astronomical instruments. He thus possessed the skill and, we may infer, the intellectual inclination to manufacture

333. Jost Amman, *Portrait of Jamnitzer in his Studio with a Perspective Machine*, engraving, *c*.1565, London, British Museum.

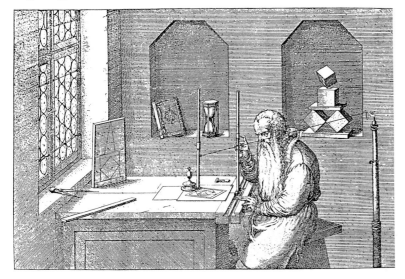

and exploit a perspective machine with a high degree of precision. A further engraving by (or attributed to) Amman shows the same technique applied to the representation of a townscape from a high vantage point.[15] This nicely brings the perspective machine back into the realms of surveying and map-making. Bird's-eye views of towns long retained their popularity, either in conjunction with, or as alternatives to, flat maps.

Dürer's machines, superbly illustrated and internationally accessible in the Latin editions of his treatise on measurement, provided the standard source of reference for generations of later theorists. Daniele Barbaro is typical in the way in which he adopts the Dürer lute machine with no modification and illustrates it in a graceless woodcut.[16] A more creative exploitation of a machine that appears to combine various elements from the Dürer devices occurs in Lomazzo's *Trattato*, in which the physical demonstration of mechanical perspective is used as a 'concrete' way of introducing the more abstract procedures of constructional geometry.[17] By the middle years of the century a number of Italian perspectivists had shown an interest in inventing devices which went beyond the conventional veil, glass and the other instruments described by Dürer. The intellectual background to the Italian developments was, not surprisingly, that in which a variety of optical interests were intermingled—illusionism, terrestrial measurement, astronomy, horology and mathematical instruments—the context we have already noted in Chapter II. The leading Italian theorist with respect to instrumental techniques as for optical theory was Egnatio Danti, who provided what seems to have been a comprehensive review of the most interesting devices invented by his Italian contemporaries.[18]

One of the instrumental techniques is not, strictly speaking, a perspective machine, but rather a drawing device which, as we have seen, was invented by Vignola (pl. 156) and obviated the need for the multiple construction lines on the surface of a drawing. A ruler is pivoted at the vanishing point and another at one of the distance points. These are then aligned successively on pairs of points which have been projected perpendicularly and at 45° from the ground plan to the base of the intersection in the manner already described (pl. 155). The points at which the rulers cross provide the key locations for the drawing of the object in its projected form. A not dissimilar use of two pivoted rulers is illustrated by Benedetti (pl. 334), and serves to achieve the projection of a given point (b). A ruler laid from the vanishing point at i to the perpendicular projection of the point at c provides the orthogonal on which the projected point is to be located. The other ruler from the viewing distance, D, is laid to point m such that bc = mx, and the point at which this second ruler intersects ix at f provides the horizontal location for the required point at K. Such draughting machines provide a welcome degree of constructional economy, but they depend upon geometrical theory rather than the direct copying of nature, and cannot therefore be truly regarded as mechanical means of imitation.

The other Vignola machine illustrated in Danti's treatise is a splendid, large-scale affair which is depicted in convincing mechanical detail (pl. 335). The chief operative turns a shaft

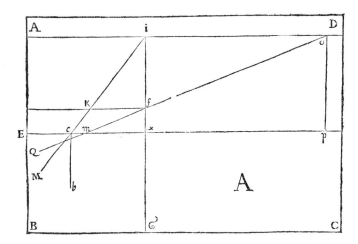

334. Pivoted rulers used to project a given point in perspective, from Giovanni Battista Benedetti's *Diversarum speculationum mathematicarum*, Turin, 1585.

b—point on the plane EC
Mi—ruler pivoted at i
ci—gives the orthogonal to the vanishing point at i
xm = bc
Draw a horizontal through f; K is the required projection of point b.

b—is projected to c
Qo—ruler pivoted at o

Qmo intersects ig at f

around which is a rope running over two pulley wheels. The rope moves the vertical shaft laterally across the horizontal scale. A sight slides up and down the vertical scale, and is viewed through a fixed eyehole. The sight can thus be effectively moved to any point across the plane described by the vertical and horizontal co-ordinates of the instrument. The regular scales marked on the vertical and horizontal members accordingly provide a notional grid or veil of lines across the plane. The key points in a viewed object can thus be readily transcribed on to a drawing which has already been divided into equivalent squares on a smaller scale. The practicability of using a second operative to transcribe the design, presumably from the spoken instructions of his companion, may be doubted, but the principle of the device as a kind of mechanised veil is clear enough.

The other three devices described by Danti are each carefully credited by him to different inventors. What we may call the cross-strut device (pl. 336) is attributed to Girolamo da Perugia, Abbot of Lerino. His idea of describing the points of intersection across the picture plane by crossed rulers may well have been suggested by the crossed strings of Dürer's lute method. Girolamo's device has the advantages of compactness and convenience of operation over Dürer's, but it suffers from the limitation that the viewing distance is necessarily short. The second of the machines, credited to Tommaso Laureti, has already been illustrated in plate 152 and faces the same disadvantage, in that it relies upon a simple, rigid, construction to establish the relationship between viewpoint and the intersecting plane. Where Laureti's machine is important is that it is used to demonstrate the geometrical principle of the convergence of parallel lines and the diminished intervals between equally spaced horizontals. It is clearly not adapted to the transcription of nature—indeed, the viewpoint, C, and the top

335. Perspective Machine, from Jacopo Barozzi da Vignola's *Le Due regole della prospettiva pratica*, ed. E. Danti, Rome, 1583.

336. Girolamo da Perugia's perspective device, based upon Vignola's *Le Due regole*.

337. Baldassare Lanci's device for the perspectival projection of a view on the inside of a cylinder, from Vignola's *Le Due regole*.

TE—sight vane
DF—pivoted sleeve for the drawing 'needle'

338. Baldassare Lanci, 'Universal instrument' for surveying and perspective, 1557, Florence, Museo di Storia della Scienza.

339. Baldassare Lanci, 'Universal instrument', detail of surveying activities.

of the frame, AS, are at the same horizontal level—but is designed so as to assert the underlying rationale of perspective. As such it may well have provided the direct source for a more abstract proof which became one of the standard geometrical demonstrations from the time of Guidobaldo (pl. 170).

The third of the machines is the most remarkable of all, not least because it postulates an alternative to the canonical system of one-point perspective. It is devoted to the production of a panoramic image on a drawing surface which is arranged in the form of a half cylinder (pl. 337).[19] The authorship of this machine is not in doubt. Not only does Danti attribute it to Baldassare Lanci of Urbino, but the central feature of the device can be recognised as part of the 'universal instrument' which survives today in the Museo di Storia della Scienza in Florence (pl. 338).[20] An inscription not only records that the instrument was made by Baldassare Lanci in 1557 but also sings the praises of its multifarious uses in all kinds of practical measurement and its relevance to the making of paintings. To understand how it functions, we should realise that it has two modes of operation.

As a geographical surveying instrument its two arms with sight vanes and the surface calibrations of the disk are used in a standard manner to establish the lesser of the two similar triangles required by the standard techniques of land mensuration. When functioning in this mode, in a horizontal, vertical or inclined plane—as illustrated in fine *intaglio* work on the uncalibrated area of the disk (pl. 339)—the central shaft with its pivoted arms could be unscrewed and removed. It would, therefore, look much like a closely related instrument in the

340. Baldassare Lanci (?), Surveying device for the measuring of angles, Florence, Museo di Storia della Scienza.

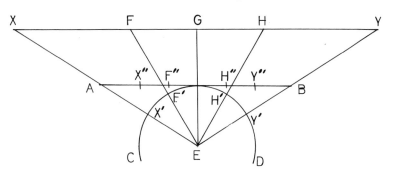

341. Geometrical analysis of Lanci's curved system for drawing, based on Vignola's *Le Due regole*.

E—observer
XY—line divided by equally spaced points
AB—flat picture plane
CD—curved picture plane
X projects to X′ on CD, F to F′ etc. If CD is 'unrolled' to lie along AB, X′ will move to X″ etc.

342. A panelled wall portrayed by Lanci's curved system as in pl. 341.

XY—wall
X″Y″—wall as projected when CD is 'unrolled' to lie along AB

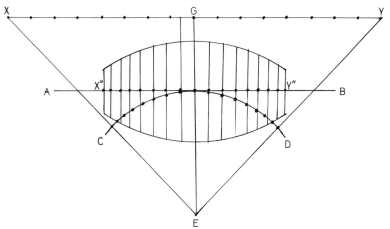

same museum which may be attributed with some confidence to Lanci (pl. 340). In this case, the crossed arms are aligned on the extremities of the objects and the subtended angle can be read at the point where the left vertex of the base of the triangle touches the scale around the circumference.

As a drawing machine, the disk of the 'universal instrument' would be orientated horizontally, and the central apparatus screwed in place. A hemi-cylindrical drawing surface would be attached around one half of its rim, using the holes provided as anchor points. The draughtsman looks down the sight arm (ET on Danti's rudimentary diagram) and pivots it to look at successive points in the surrounding scene. A hinged arm, F, through the axis of which runs a moveable pin, replicates the motion of the upper arm. Key points of the subject are recorded on the surface (LHIK) by pressing the pin through the arm to make a series of prick marks. On the completion of the procedure the draughtsman may either join up the prick marks on that same piece of paper or transfer them to a separate surface by pouncing charcoal dust through the perforations. The result would be an image designed according to the curvilinear principle of visual angles rather than one which conforms to the canonical technique of intersection on a flat plane.

If the image is viewed in its curved form, corresponding to the original disposition of the drawing surface, it will give a panoramic effect which is not essentially in conflict with the optics of the standard method, but when it is unrolled and viewed flat it will produce very different results. As Danti explains, the intervals between equally spaced objects across a plane perpendicular to the axis of the viewer's sight will appear to diminish towards the outer ends, in contrast to the normal intersection method, in which such intervals remain constant (pl. 341). The effect, for example, of a wide wall divided by uprights depicted according to Lanci's method would be to show the top and bottom of the wall curving progressively together at the extremities, with decreased intervals between the uprights (pl. 342). Danti makes it quite clear that he by no means approves of this result, since it does not accurately 'represent the section of the visual pyramid', unless it is arranged specifically as a curved section.[21] This is a bone of contention to which we will return.

We know that Lanci himself, when he came to create a large-scale illusion, resorted to more standard techniques. His chief employment was as Grand Duke Cosimo's engineer, specialising in military architecture, but, appropriately enough for a pupil of Girolamo Genga, he also gained a reputation as a perspectival designer. The most spectacular surviving product of his work in this field is the beautiful stage design he produced in 1569 for Giovanni Battista Cini's comedy, *La Vedova* (pl. 343).[22] This sizeable drawing displays a number of familiar buildings—the Loggia de'Lanzi, the Palazzo Vecchio, part of the Uffizi and the towering upper portions of the Cathedral—in a rather drastic realignment of Florentine topography. The constructional lines on the drawing show that he has adopted what had rapidly become the classic technique in Italian stage design—using angled flats in conjunction with accelerated perspective to create the effect of a single, cen-

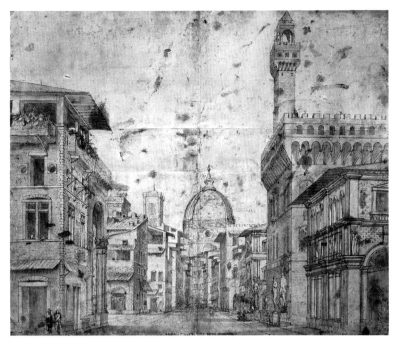

343. Baldassare Lanci, *Florentine Scene Design for 'La Vedova'*, 1569, Florence, Uffizi, Gabinetto di Disegni e Stampe.

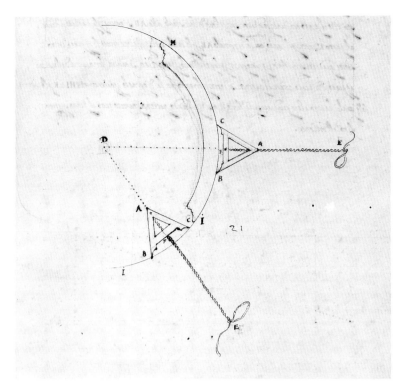

344. Device for drawing converging lines from Lodovico Cigoli's 'Prospettiva pratica', *c*.1610–13, Florence, Uffizi, Gabinetto di Disegni e Stampe.

345. Device for determining the vanishing point of a given line from Cigoli's 'Prospettiva pratica'.

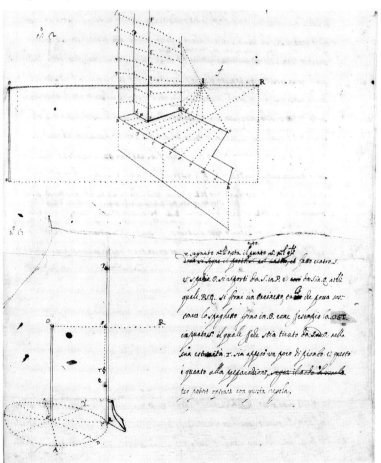

tral vanishing point. This orthodox practice leaves some doubt about the status of Lanci's curvilinear technique. He may have intended his machine to demonstrate a specific variety of spatial representation that was potentially 'truer' than normal perspective, but he clearly was not so committed to its universal validity that it could replace the standard technique whenever a functioning illusion was required.

Danti's decided fascination with perspective machines is entirely understandable given the conjunction of his mathematical concerns with his engagement in the making of astrolabes and related instruments. A similar conjunction of interests occurred in the Ricci-Galileo-Cigoli orbit, and we will not be surprised to find that Cigoli's 'Prospettiva pratica' contains a brilliantly inventive section on perspective machines.[23] Of the five devices he describes, four appear to be original, while the other is an adaptation of the Dürer-Keyser instrument.

Two of the devices appear in one of the theoretical rather than 'instrumental' sections of his treatise, presumably because they are concerned with the geometrical draughting processes rather than the imitation of existing objects. The first instrument (pl. 344) is an ingenious device for drawing pairs or sets of lines which converge on the same point even when that point is inaccessible in the particular circumstances under which a draughtsman may be working. The second (pl. 345) is designed to provide the artist with more comprehensive assistance in discovering the point to which any set parallels should converge. It differs from Vignola's and Benedetti's draughting instruments in that it is free-standing in the manner of a surveying instrument, and, even more notably, is devoted to the plotting of the *punctum concursus* for any given line according to the most advanced ideas of Guidobaldo. At the centre of a disk stands a vertical rod, from the top of which runs a cord

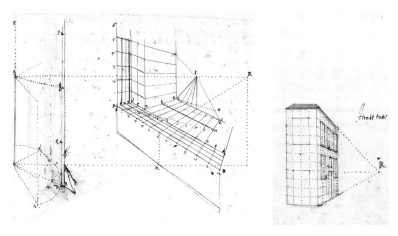

346. The vanishing point device used for a stage set, from Cigoli's 'Prospettiva pratica'.

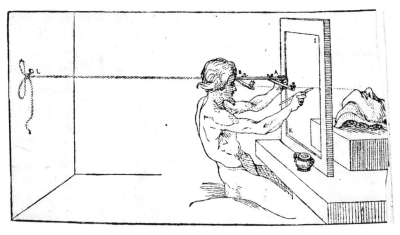

347. Sighting device for perspectival projection, from Cigoli's 'Prospettiva pratica'.

348. Cross-staff device for perspectival projection, from Cigoli's 'Prospettiva pratica'.

to a second upright. The base of this second vertical element can be moved around the circumference, which is graduated in degrees, and can therefore be located in such a way that the cord will be parallel to a given line at any angle behind the picture plane. The artist places the device in front of the picture plane at the required distance and takes sightings along the cord onto the plane to give the points of convergence for a line or lines at any given angle in the subject. Cigoli himself gives an example of its employment in scene design, using it to determine the *punctum concursus* of the 45° diagonal through the tiles of the accelerated perspective of the pavement (pl. 346).

The other three devices are described in the section of his treatise devoted to the 'third' rule, which is cast in terms of advice to 'a young painter who delights in perspective'. When the young painter is faced with 'a view of roads with various features of palaces, landscapes and other compositions of different subjects situated at various inclinations' or with a form as complex as the human body, he may be tempted to think that the geometrical rules are inapplicable and decide to rely upon judgement 'by eye'.[24] However, such a decision would be contrary to the 'nobility of art'. Perspective machines provide a solution to this dilemma. Cigoli draws the reader's attention to various earlier devices—those illustrated by Dürer, the veils of Alberti and Leonardo, and the instruments discussed by Danti, including 'the concave half-cylinder' of Lanci. In line with the established methods, he describes the operation of a device which is a modification of the Dürer-Keyser machine, using a sight which reflects his knowledge of gunnery (pl. 347). He also illustrates a cross-staff device (pl. 348) as his own variant on the methods of direct transcription. A bead on a string which runs around the upright of a staff is sighted on successive points of the subject. The motion of the lower end of the staff, as the draftsman moves it up and down and across, guides the tracing of the outlines of the subject on the picture plane.

Cigoli expresses dissatisfaction with the traditional methods: the veils are too imprecise, and those which use strings to replicate light rays suffer from the problem that the strings sag under their own weight. His ultimate aim, therefore, was to invent a machine which would not only be flexible and practical but would also possess a high level of instrumental precision, in keeping with the standards set by the new sciences of his friend, Galileo. The result of his efforts was an automated device of considerable ingenuity, which continued to provide the basis for the most advanced machines as late as the mid-nineteenth century. His account of its construction and operation, which occupies thirteen pages in his treatise, provides comprehensive guidance for anyone who wishes to manufacture it—including full-size drawings of its components—and to use it for diverse purposes.

The machine consists of two upright elements on a horizontal frame which is screwed on to a base-board (pl. 349). One upright is articulated in such a way that the height and lateral position of the eyehole at the top can be adjusted as required, while the other traverses a horizontal bar which marks the base of the intersection. A chord with a sighting bead and counterweight runs over a pulley at the top of the second upright,

around a further pulley at its base and along a horizontal arm to the handle of a drawing instrument.

A woodcut illustration (pl. 350), used both on the title page of the treatise and in the text, shows the draughtsman operating the machine. He uses his left hand to pull the chords which move the vertical member back and forth across the intersecting plane, while he moves the drawing instrument in his right hand in such a way as to move the bead up and down the shaft. The position of the bead as sighted through the eyehole can thus be moved continuously over the object while the draughtsman's hand traces the resulting configuration on a drawing surface which is pinned to the base board. No doubt some practice would be required to co-ordinate the motions of the two hands, and we may suspect that it would have been difficult to trace complex outlines entirely smoothly, but this machine is the first which has a genuine claim to provide an automated drawing system. It uses only one operation to make a direct transcription on the drawing surface of the object as it appears at the intersection.

With its ingenious automation, Cigoli's perspectograph outstrips two of its near-contemporary rivals, the quadrant-like device presented to Rudolf II in Prague in 1604 by Jost Bürgi, and the machine illustrated in 1605 by Lucas Brunn, which worked from ground plans and elevations.[25] We may also note in passing that Cigoli had devised his own simple device for the correlation of ground plans and elevations of geometrical bodies with their perspectival projection.[26]

Cigoli also explains that his 'perspectograph' (as it may fair-

349. Components of the automatic perspective machine, from Cigoli's 'Prospettiva pratica'.

350. Draughtsman operating the perspective machine, from Cigoli's 'Prospettiva pratica'.

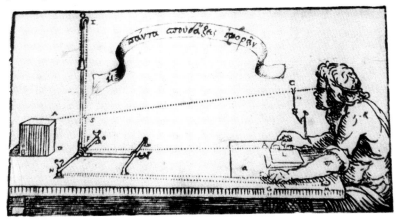

351. Perspective machine used to project forms on to a wall and curved vault, from Cigoli's 'Prospettiva pratica'.

ly be called) is highly adaptable. If the upright members are tilted towards or away from the spectator, the projection of forms on to tilted planes can be accomplished, as would be useful in illusionistic decoration and most especially in anamorphic design. It can also be used in 'reverse', that is to say working from a perspective drawing to its projection on any given plane. In this mode (pl. 351), the draughtsman moves his hand over the drawing and instructs an assistant on the plotting of key points of the form on the picture plane.

Although Cigoli's treatise was not published, knowledge of his perspectograph certainly entered circulation. There are various ways in which this could have happened, in addition to direct knowledge of the manuscript or its copy. One possibility is that the illustrations of the perspectograph, which were amongst those executed in woodcut in anticipation of publication, could have circulated inside and outside Italy. But probably the most important source of knowledge came from the existence of an actual machine or machines. We have clear evidence that a perspectograph constructed according to Cigoli's design was known and admired in France in the seventeenth century. The second book of Niceron's *Thaumaturgus Opticus*, which contains a rich compendium of perspectival curiosities, illustrates an '*instrumentum universale*' (pl. 352), then in the *cabinet* of Ludovic Hesselin, counsellor to the French King.[27] This instrument can readily be recognised as a Cigoli perspectograph.

The variations apparent in the instrument illustrated by Niceron concern questions of detail rather than basic operation: the horizontal arm which runs perpendicularly from the base of the intersection does not terminate in the maker's initials LC but is joined to the horizontal rod at the 'foot' of the spectator; the counterweight and handle of the drawing instrument have amusingly assumed the decorative forms of little *putti*; and the whole machine is mounted on what appears to be a specially designed draughting table, with hinged sections which allow it to fold up and drawers for the storing of the

352. Cigoli's perspective machine as illustrated in J.F. Niceron's *Thaumaturgus opticus*, Paris, 1646.

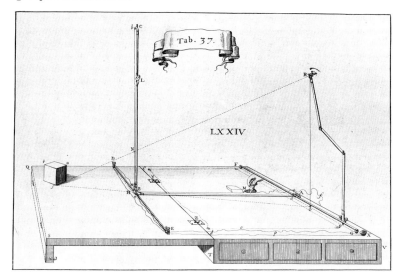

components of the perspectograph (and other paraphernalia) when it is dismantled. The popularity of Niceron's treatise on its first publication in 1646 would alone have ensued that Cigoli's invention remained available to successive generations of perspectivists.

The inventor of the major rival to Cigoli's design was, appropriately enough, one of the most prominent astronomer-mathematicians in the group opposed to the revolutionary consequences that Galileo was drawing from his astronomical observations, namely Christopher Scheiner, the 'Apelles' of the sunspot controversy. It would be wrong, in the light of this controversy, to brand Scheiner as an incompetent conservative. He was a major student of optics and an observational astronomer of real skill, who certainly possessed inventive powers on his own account, as was fully apparent in his devising of the pantograph. In the introduction to his *Pantographice seu ars delineandi* of 1631 he tells the story behind the invention of his drawing machine.[28] In 1603 at Dillingen, a certain Master Gregorius, 'an excellent painter' boasted to Scheiner of his drawing device, but irritatingly refused to divulge its secrets. Tantalisingly, Gregorius said that 'he did not believe that such a thing could even be imagined; in fact that it was not so much a human as a divine invention, which he thought had been brought and disclosed to him by no human efforts but rather by some celestial genius'. All he would tell the astronomer was that it relied upon the use of compasses with a fixed centre. Intrigued by the possibilities, Scheiner set to work on his own account, and after a period of intense effort produced a device of great ingenuity and widespread utility—for copying or enlarging or reducing designs, for representing objects in perspective and for the production of anamorphic designs. The secretive Gregorius was astonished to find his machine surpassed.

The central idea behind Scheiner's pantograph is the use of a parallelogram of levers for the proportional enlargement and diminution of a flat image. As such it provides the basis for the pantograph still available today (pl. 353). Mounted vertically it could also serve as a perspective machine. The frontispiece of his treatise (pl. 354) shows it being used in this manner, and a further illustration (pl. 355), demonstrates its use with a special drawing board in which a window has been cut. The pantograph is less mechanically elegant than Cigoli's perspectograph, but it possesses the operational advantage that the relative size of the image as transcribed by the draftsman's hand can be adjusted at will without altering the distance between the viewer's eye and the intersection.

The pantograph, as a device for making enlarged or reduced copies, became a standard instrument, and was therefore far more widely known than Cigoli's more specialised machine. Its function as a perspective machine remained secondary, but it does seem to have provided the inspiration for a number of related devices. One variant (pl. 356), which uses the upper arm of a parallelogram to sight the object, is described in 1645 by Mario Bettino (Bettinus) and credited to P. Griemberger.[29] A mechanically refined descendant 'for drawing Out-lines of an Object in Perspective' was devised by no less a figure than Sir Christopher Wren (pl. 357) and published in the *Philo-*

353. Modern pantograph, collection of the author's daughter.

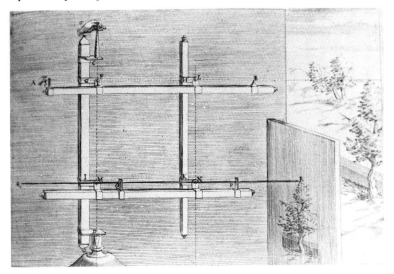

355. Pantograph set up as a perspective machine, from Christopher Scheiner's *Pantographice. . .*, Rome, 1631.

354. Uses of the pantograph, frontispiece from Christopher Scheiner's *Pantographice seu ars delineandi*, Rome, 1631.

356. Griemberger's perspective machine as illustrated in Mario Bettino's *Apiariorum philosophiae mathematicae*, Bologna, 1645.

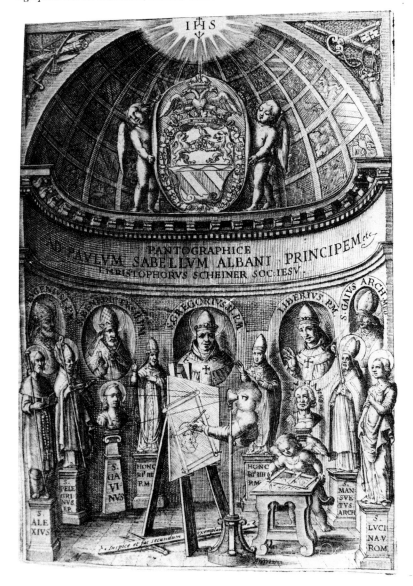

357. Christopher Wren's perspective machine, from *Philosophical Transactions of the Royal Society*, 1669.

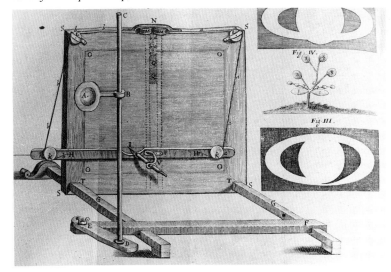

358. The geometrical spider, from Mario Bettino's *Apiariorum philosophiae mathematicae*, Bologna, 1645.

359. Components of a 'universal' drawing device, from Samuel Marolois's *La Perspective contenant la théorie. . .*, Amsterdam, 1629.

360. Marolois's machine used as a device for draughting geometrical bodies in perspective, from *La Perspective*.

sophical Transactions of the Royal Society in 1669.[30] Wren's perspectograph relies on a parallelogram in a manner reminiscent of Scheiner's invention, but its system of pulleys and counterweight would have ensured a much smoother and more balanced operation in tracing the outlines of a complex form than a vertically mounted pantograph. A variant on the Scheiner-Wren system was worked in the eighteenth century by James Watt, while George Adams the Younger experimented with alternatives to Cigoli's perspectograph.[31]

The inventions of Cigoli and Scheiner in the first part of the seventeenth century effectively established the main types of automated perspective devices, and all subsequent machines known to me can be more or less directly related to their precedents. We have, therefore, reached a suitable point to take stock and to review the position of such devices in the broader picture of art and science. The intellectual basis for the machines is reasonably clear and has been mentioned at a number of points. A marriage of geometry, optics and precise instrumentation was a prominent feature of the Scientific Rev-

olution. A Renaissance pioneer such as Dürer gave a foretaste of the alliance of abstract science and practical skills that was to play such an important role in the 'new sciences'. Bettinus's *Apiariorum philosophiae mathematicae* (1645), which we have already noted for its illustration of a perspectival pantograph, perfectly captures the flavour of this endeavour. Nature is seen as a garden of mathematical delights including such designs as hexagonal honeycombs and geometrical spiders' webs (pl. 358). The task of the human intellect is to draw the geometrical nectar from the flowers of nature and to use the resulting principles to nourish the artifice of mechanical design.

Mechanical instruments were not simply regarded as utilitarian objects, or even as utilitarian objects which could be the subject of rich ornamentation (pls. 338–9), but as sources of

361. Marolois's machine used for copying plans on a reduced scale, from *La Perspective*.

362. Marolois's machine used for perspective projection of a solid body from above and below, from *La Perspective*.

363. Hendrik Hondius, Surveyors in a landscape, from *La Perspective*.

real intellectual pride. This pride is certainly apparent in the writings of Scheiner, and the whole of Wren's career as a scientist and architect bears witness to his faith in the inherent worth of mathematics as applied to technical design. It is typical that the same volume of the *Philosophical Transactions* that published his perspectograph should also contain 'Wren's Engine, designed for grinding Hyperbolical glasses'.[32] Even the less obviously serious machines, such as the popular courtly automata which operated by water or weights or clockwork, provided evidence of the technical prowess of modern man and his ability to surpass the ancients.[33] This picture holds good in Holland no less than in Italy and Britain. Salomon de Caus, a prominent theorist of perspective, was renowned as an inventor of mechanical contrivances, utilitarian and entertain-

ing.[34] It is not surprising that an adaptable drawing machine (pl. 359), holds a prominent place in Marolois's treatise, where it is shown performing three main functions: as a flat geometrical draughting device rather in the manner of Danti and Benedetti (pl. 360); as a form of pantograph for copying plans on a reduced scale (pl. 361); and as a fully-fledged perspective machine (pl. 362).[35] Marolois's concern with such a machine is integral to his interests in applied mathematics, such as the procedures of surveying which are illustrated in a Hondius engraving in the later editions of his book (pl. 363). Perspective machines, for Marolois and his contemporaries, form part of a general picture of intellectual delight in mechanical contrivances and scientific instruments.

When we look at the place of perspective machines in pictorial practice, their role is less clear. Evidence of their actual use is virtually non-existent. The impression we gain from the treatises is that they were certainly valued as concrete demonstrations of the optical base of the painter's art. A few setpiece, machine-made drawings do survive (pl. 364), either undertaken as graphic exercises or intended for use in intarsia and related decorations. The machines also served as intellectual toys suitable for a royal *wunderkammer* or *cabinet* of curiosities. The machine described by Niceron thrived in such a context, and Scheiner indicated that the Duke of Bavaria experimented keenly with his device.[36] But if we ask the obvious question as to whether the perspectographs were used by professional artists in the actual making of works, paintings, reliefs or scene designs, the answer must be almost entirely negative—or, at best, inconclusive. In the context of a practising studio a perspective machine might be an attractive teaching device and serve as an auxiliary aid in solving some specific problems of perspective, but I should be surprised to find that it ever provided the dominant basis for a painting,

treatises, of one or more of the simpler devices, such as the glass or veil. Dubreuil (pl. 365) and Kirby (pl. 366) provide suitably unremarkable seventeenth- and eighteenth-century examples of variants on existing patterns.

The one form of what may loosely be called a perspective machine that continued to flourish prominently in the later treatises was a device in which folding elements in the illustrations themselves could be set up for the purposes of three-dimensional demonstration. Perhaps the earliest was one of the introductory demonstrations in the French treatise by Le Bicheur (pl. 367), in which a folding flap represents the picture plane and thin threads trace the light rays in a configuration which bears a loose resemblance to Laureti's sixteenth-century device (pl. 152). In some of the eighteenth- and nineteenth-century books these folding plates accompanied by threads, thin cords or wires became increasingly elaborate and were used to help the reader to translate the complex tangle of lines

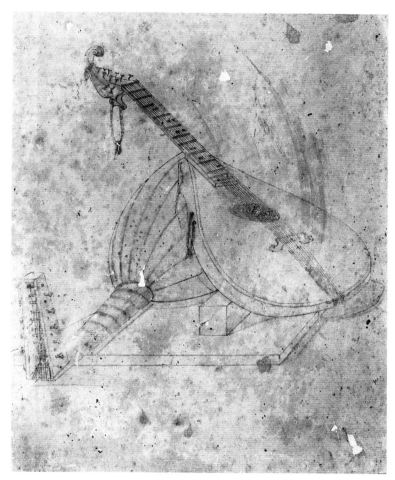

364. Perspectival drawing of two lutes, Italian, sixteenth century (?), drawn using a perspective machine, Princeton, Art Museum.

even when we look specifically at those artists whose aim was the close imitation of nature. One reason why perspectographs appear not to have been used by artists who were sympathetic to the use of optical aids in the naturalistic representation of nature, such as the Venetian *vedutisti*, was that the camera obscura began to perform this function with greater efficiency and directness at the very time when the perspectograph was achieving its highest degree of mechanical refinement. This is not to say that perspectographs lost their interest for theoretically-minded artists and patrons, but they appear to have become largely redundant or obsolete as aids in the actual making of pictures in the face of the far more dramatic effects of verisimilitude produced by the camera obscura.

The history of the linear perspective machine after about 1630 is therefore of far less significance to our story of the science of art than in the preceding periods. This particular section of the present chapter is thus heavily weighted towards the earlier developments. Perspectographs continued to be made and described during the period 1650–1750, but their intellectual role was greatly diminished compared to the prominent place they occupied in the writings of Dürer, Danti, Cigoli and Marolois. Most later theorists confined themselves to giving a brief account, often at the very end of their

365. Drawing frames, from Jacques Dubreuil's *Perspective practique*, Paris, 1642.

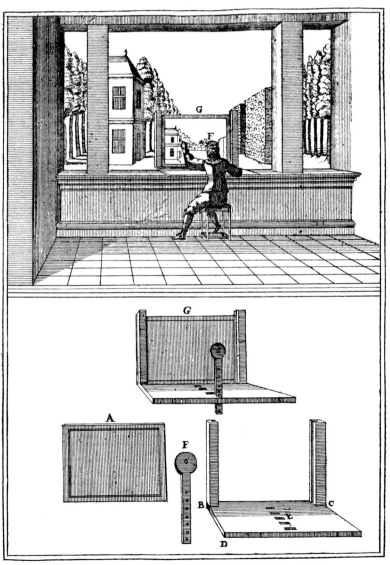

366. Drawing devices and studies of cast shadows from John Joshua Kirby's *The Practice of Perspective*, Ipswich, 1755.

A camera obscura, grid, and cross-staff.

367. Perspective diagrams with folding flaps and string, from J. le Bicheur's *Traité de perspective. . .*, Paris, 1660 (?).

368. John Wood, Perspective demonstration using glass and metal flaps, from *Six Lectures on the Principle and Practice of Perspective*, 2 vols., London, 1804.

in the flat diagrams into somewhat more comprehensible demonstrations in which the various planes regain their true physical orientation.[37]

A few treatises even went so far as to issue perspective 'kits'. The second volume of John Wood's *Six Lectures on the Principles and Practice of Perspective* 1804), bound to look like a normal book, opens up to reveal not a sequence of pages but a series of glass and metal flaps hinged on the inside covers of the volume in such a way as to make a relatively elaborate machine (pl. 368).[38] Thin metal rods, slipped into a long pocket, can be used to represent the rays. To guide the reader, the perspectival projections of the geometrical lines on the base and 'side walls' have been traced on the glass intersection. This kind of device, even in such a substantial form, was obviously a demonstration piece for the teaching of basic principles and certainly was not intended to serve as a tool for the imitation of nature. These bookish devices thus represent a continuation

of what had always been the most obvious function of many linear perspective machines.

After about 1750, however, there was a minor renaissance of interest in linear perspective machines for the direct representation of natural form. There were, I think, three main factors which lay behind this revival. One was the burgeoning popular fascination with the marvels of science in general and with the magic of optical devices in particular. The late eighteenth and early nineteenth centuries saw the birth and growth of optical entertainments as a precocious form of mass medium. It was the age in which the magic lantern came into its own. It was the period of phantasmagorias and similarly astounding manifestations of optical magic. We will encounter these entertainments—which stand on the fringes of our present study—again in later sections of this chapter. The second factor was the rise in demand for relatively cheap and rapid portraiture by increasing numbers of the middle classes. The third was the increasing prominence of the leisured amateur for whom the genteel cultivation of the arts and sciences was both socially desirable and intellectually diverting on its own account. In Britain most especially there was a growing band of amateur artists, particularly ladies, who practised the gentle art of topographical representation in watercolours. Generally speaking, camera lucidas and camera obscuras served as the main means of satisfying the requirements of imitation and entertainment, but perspective machines were not entirely neglected.

A typical example is provided by the 'Perspective Tripod' which was advertised in various of Charles Hayter's treatises on perspective and colour:

> S. and J. FULLER, desirous to bring so useful an instrument into general use amongst Artists and Amateurs, have availed themselves of Mr. HAYTER's mechanical aid to construct the PERSPECTIVE TRIPOD *conveniently* portable, and so simple, as to be clearly understood on the slightest inspection; for no more skill is requisite to using it than would be necessary to the tracing of a print or drawing by the transparent aid of a window... The most *perfect knowledge* and utmost application to all the rules of perspective, could not produce a more scientific *general* outline.[39]

The advertiser notes 'how many Ladies and Gentlemen ...enjoy the pleasure of taking views from Naure', but he does wisely add a caution to the effect that 'the student must proceed to finish the drawing with the same mind and talent that he must have had recourse to, *on a view taken by the eye*'. As we will have cause to see later, none of the mechanical aids could ultimately overcome lack of artistic skill and visual judgement on the part of the operator. For good measure, the advertisement informs the aspiring artist that Hayter will give lessons at the rates of five shillings 'at his Residence...or a moderate distance from home for 10s. 6d.'

Comparable variations on traditional themes are illustrated in such compendia as Rees's *Cyclopaedia* (pl. 371) and Smith's *The Mechanic*. One device in particular allowed artists to respond to the way in which the widening social market for portraiture had led to demand out-stripping quality of supply.

Any machine which could aid modestly-skilled hands in the quick and relatively inexpensive production of functioning likenesses obviously stood an excellent chance of success. The invention that went some way to fulfilling this purpose was the physionotrace. It was invented in 1786 by Gilles-Louis Chrétien, who had begun his career as a musician but turned with modest success to the practice of portrait engraving. A convenient, fast and reasonably infallible way of catching a likeness held obvious attractions for him. The machine he developed (pl. 369) stands in recognisable line of descent from the Scheiner's pantograph.[40] The draughtsman moves a sight, which resembles that of a surveying device, across the contours of the subject as viewed through the upper part of the frame, and a stylus traces the corresponding lines on a sheet of paper. The image could be reproduced according to pantographic principles to any required size.

The standard application of the physionotrace was the production of profile portraits (pl. 370). Not only did this format appeal to a Neoclassical age by virtue of its 'Roman' connotations but it also corresponded to Lavater's popular theory of the scientific reading of character from profiles. Lavater him-

369. Drawing of Gilles-Louis Chrétien's Physionotrace, Paris, Bibliothèque Nationale.

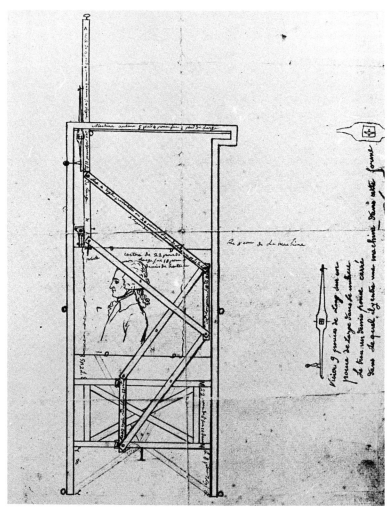

370. C.B.J.F. de Saint-Mémin, *Portrait of Thomas Jefferson*, physionotrace etching, 1805, Washington, National Portrait Gallery.

self recommended the use of cast shadows to record the nose, forehead, chin and other tell-tale signs of the human profile. Goethe is known to have followed this advice, and the popular cut-out silhouettes were not infrequently made this way.[41] The name of Chrétien's instrument clearly plays on these pseudo-scientific associations, since it implicitly promises the tracing of human features so as to permit the physiognomic truths to emerge. In the era before photography, the physionotrace facilitated the production of successful and modestly attractive likenesses in Europe, and most especially in America, where C.B.J.F. de Saint-Mémin used it in his portraits of revolutionary leaders. Like any successful device, it was inevitably imitated and pirated, each practitioner claiming the inherent independence and superiority of his own method. The competing studios of the physionotrace portraitists strikingly prefigure the commercial studios of the daguerreotypists.

One advantage the designers of the new perspective machines possessed over the old was access to the developing technologies of the period, which enabled the production of instruments of increasing optical refinement. One such was the 'Optigraph' (pl. 371) invented in the late eighteenth century by the great Yorkshire instrument-maker and optician, Jesse Ramsden, and developed by his pupil, Thomas Jones.[42] A telescopic sight is moved over the subject whilst an extendable arm traces the image. The length of the arm determines the relative size of the resulting drawing.

Perhaps the best example of how the delights and precision of scientific instruments in the later eras could breathe new life into old ideas is provided by the new generation of perspectographs which appeared in the first half of the nineteenth century. The most prominent of these was the machine patented in 1825 by Sir Francis Ronalds, who is chiefly remembered as the inventor of the electric telegraph. In his *Mechanical Perspective or, Description and Uses of an Instrument for Sketching from Nature* he gives a comprehensive account of a linear perspective machine which stands in obvious direct line of descent from Cigoli's device (pl. 372).[43] This confirms our initial impression of the quality of Cigoli's original invention. The principle of the two machines is the same. The motion of the bead of the sight across 'the *imaginary picture plane*' is coordinated with the path of the drawing instrument across the horizontal drawing surface. The important change—in addition to the obvious mechanical refinement of the moving parts of Ronalds's machine—is that movement of the handle of the drawing instrument controls the motion of the bead along both the horizontal and vertical coordinates. It will be recalled that the lateral traverse of the upright across the picture plane

371. Ramsden's 'Optigraph' (bottom left), delineators by Peacock and Edgeworth, and Wollaston's camera lucida from A. Rees, *The Cyclopaedia*, 39 vols., London, 1829–30, vol. XI.

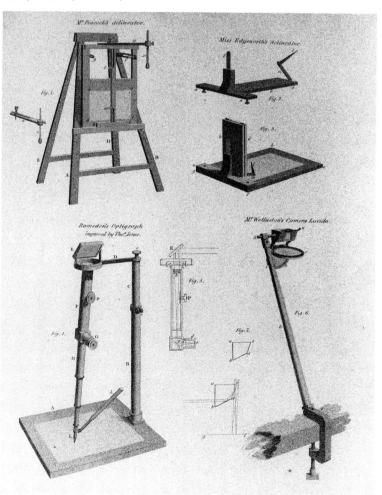

in the Cigoli device was controlled by an independent system of cords and pulleys.

The French counterpart to Ronalds's perspectograph was the *diagraphe* of Charles Gavard of Paris, which was itself awarded a British patent in 1831. Gavard also invented a machine for drawing panoramas. Full-scale and 'pocket' versions of the *diagraphe* were produced, and one highly developed example was exhibited by Adrien Gavard at the Great Exhibition of 1851.[44] The Gavard machine illustrated here (pl. 373) gives a good idea of the quality of engineering which went into the nineteenth-century devices. The provision of the second upright with a further counterweight helped bring the whole system into an equilibrium that facilitated the smooth and apparently effortless motion of the drawing instrument over the paper. The eye-piece, lying separately in the foreground of the illustration, is provided with a clamp by which it may be secured to a table or drawing board.

Ronalds's book on his perspectograph shows that the aesthetic issues posed by such devices were much the same as they had always been. The limitations of mechanical imitation are frankly acknowledged: the requirements of 'picturesque' beauty stand in conflict with the unadjusted imitation of reality; one of the most important aspects of high art is imaginative 'composition'; and the availability of machines could encourage a belief that the artist need not bother to learn the basic theory of perspective.[45] Above all, slavish reliance on machines would be detrimental to 'the proper use and cultivation of that most beautiful and convenient camera-obscura and perspectograph, the human eye, which, *when* well trained,

373. Adrien Gavard, Perspective machine or Diagraphe, Edinburgh, National Museum of Scotland.

372. Sir Francis Ronalds's perspective device, from *Mechanical Perspective*, 2nd edn., London, 1838.

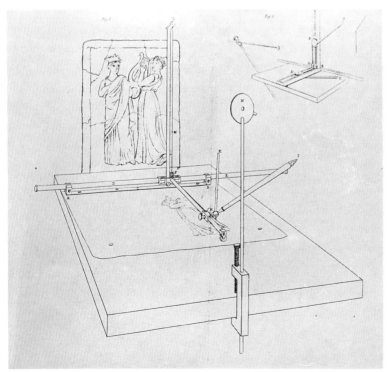

never has been, and never will be, rivalled, upon the whole by mortal machinery'. These issues of natural vision, artistic invention and mechanical imitation were those which were about to explode on an unprecedented scale with the announcements of the invention of photography in 1839, a year after the publication of the second edition of Ronalds's treatise.

CAMERAS ETC.

Linear perspective machines, for all their intellectual charm and mechanical ingenuity, do not seem to have brought any major transformations in artistic practice at any point in their history, and they eventually underwent progressive extinction. By contrast, the lens-based systems, which resulted in the formation of reduced, two-dimensional images of objects and scenes in their full optical array of light and colour, laid the visual foundations for the photographic techniques which were to revolutionise our means of representation. The premier instrument in this story is the camera obscura, although at various moments in artistic practice it came under concerted challenge from other devices, most notably the camera lucida.

My approach in this section of our present study will be to highlight a few selected aspects of the history of camera obscuras in as far as they relate to the intellectual profile of the relationship between art and optical science. I will not be attempting to provide anything resembling a comprehensive history of the devices in themselves, of their use by artists over the centuries in various countries, or of the invention of photography. Rather, I will begin by outlining briefly such major steps in the invention and perfecting of cameras as are necessary to understand the nature of the devices with which we are dealing, before concentrating on how attitudes to cameras relate to the interplay of optics, imitation and artistic creation. With this end in view, I will be looking in some detail at three particularly revealing and significant episodes in the story. These concern Vermeer in the context of seventeenth-century Dutch naturalism, Canaletto and the Italian *vedutisti*, and the British topographical tradition in the eighteenth and early nineteenth centuries. This last tradition will also serve to introduce us to Wollaston's camera lucida and Varley's graphic telescope.

The camera obscura is founded on the principle that rays of light from an object or scene will pass through a small aperture in such a way as to cross and re-emerge on the other side in a divergent configuration. If the divergent pattern is intercepted by a flat screen, a reversed and inverted image will be formed. For this image to become adequately visible, it is necessary that the screen be placed in a chamber in which the light levels are considerably lower than those around the object—hence the name camera obscura, or 'dark chamber'.

The basic phenomenon of light through apertures first received sustained attention from Alhazen and his followers in the Middle Ages.[46] They were interested not for purposes of artistic representation but what the phenomenon told them about the behaviour of light. Studying the transmission of light from separate candles through a small aperture, they concluded that one of the fundamental properties of light rays was that they could cross without mingling. Leonardo shared their fascination, and wrote in rapturous praise of the miraculous 'point' through which the rays could pass without losing their integrity: 'O marvellous necessity. . . O mighty process. Here the figures, here the colours, here all the images of the parts of the universe are reduced to a point. . . Forms already lost, can be regenerated and reconstituted' in the image formed behind the pin-hole aperture.[47] He also applied the principle of small apertures to his study of the eye, arguing that the rays must cross in the pupil. However, he clung to sufficient of the mediaeval ideas about the anatomy and physiology of the eye to prevent this adoption of the camera obscura as a precise model for the functioning of the eye as later opticians were to do.

The crucial step in the camera's development as a functioning instrument was the placing of a convex lens in or near the aperture. The earliest, albeit somewhat unclear reference to a lens may be found in Girolamo Cardano's *De Subtilitate* in 1550, but the first lucid account is provided by Daniele Barbaro in his *La Pratica della perspettiva*.[48] Barbaro places a convex lens—as 'used by old men in their spectacles'—in an

aperture in a window shutter. A sheet of paper is then moved to and fro until a focused image is formed. By covering the outer parts of the lens, leaving 'a little of its circumference at the centre', an even stronger effect can be achieved. The essential aspects of focus and aperture are thus clearly acknowledged by Barbaro.

The subsequent technical history of the camera obscura consists of a series of refinements directed to two ends: the improvement of optical performance; and the invention of different types of instrument for specific purposes. Probably the most urgent technical need was for the re-inversion of the upside-down image. Two main methods were developed. The most commonly exploited technique was the use of an angled mirror to reflect the rays after they have passed through the lens. Danti, G.B. della Porta, and Benedetti show that this solution using a concave mirror, was known in the sixteenth century. The alternative use of a further lens to re-invert the image appears in the early seventeenth century with Kepler and Scheiner. Kepler also seems to have been responsible for the invention of a tent-type camera, with a revolving reflector and lens at its apex, which could be conveniently dismantled for transporting from one site to another (pl. 374). Its practical applications in topographical surveys—civil, military and artistic—were readily apparent. An important further development was the invention of small-scale, portable instruments in box form, equipped with lenses in sliding tubes and built-in screens. The best early selection of these was illus-

374. Charles-Louis Chevalier, Tent-type camera obscura, a nineteenth-century development of the type invented by Kepler, London, Science Museum.

trated by Johannes Zahn in 1685 (pl. 375).[49] About the same time Robert Hooke invented a convenient and effective camera in two versions, one of which used a slightly concave, movable screen to achieve a precise focus.[50]

The major later improvements concerned the design of lenses. The scioptic ball, invented by Schwenter in 1636, in which a combination of lenses could be rotated in a socket, proved to be of use in allowing a fixed camera to take in wide-angle views, but was largely redundant in the portable versions favoured by artists.[51] The most important developments involved the optics of lenses themselves, which in various combinations were able to provide increasingly distortion-free and achromatic images. Perhaps the most advanced instru-

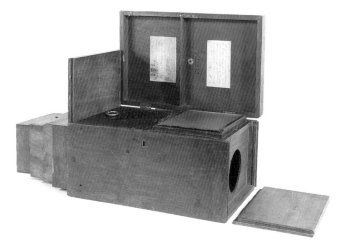

376. William Storer, The 'Royal Delineator', 1778, London, Science Museum.

ment in the eighteenth century was William Storer's 'Royal Delineator' (pl. 376), which used two rectangular lenses with an additional plano-convex lens below the ground glass screen, to improve marginal definition.[52] It proved itself to be capable of producing sharp images under a wide variety of lighting conditions, 'being used without the assistance of sun in the day-time, and also by candle light, for the drawing of the human face, inside rooms of buildings, also perspectives, landscapes, foliage and fibres of trees and flowers'. Such luxury devices were relatively expensive and tended to be produced in limited numbers—Storer manufactured only fifty copies of the first version of his Delineator—but reasonably effective instruments could be produced more cheaply and could even be home-made. There was no essential difference in optical concept between the box-type camera obscuras available to professional and amateur artists during the early nineteenth century and the cameras used by Niépce, Daguerre and Fox Talbot in the invention of photography.

The existence of the technology to produce effective images at least as early as the middle of the sixteenth century did not of course ensure that it would be used by artists—or dictate how it would be used when it was. Its use was entirely dependent on attitudes—aesthetic attitudes towards the precise imitation of nature and, as I hope to suggest, the complementary attitudes of scientists to the value of optical devices for the direct analysis of nature.

We have already noticed that the mediaeval philosophers looked towards the phenomenon for the elucidation of physical principles. In a not dissimilar manner Barbaro looked to his more developed camera image as a means of demonstrating the principles of proportional diminution in such a way as to 'help us to define the precepts of art'.[53] The image instructs the artist in 'perspective and shading and colouring'. Although he certainly would not have regarded its literal and unselective imitation as providing a recipe for a worthy painting, he was sensible to the special delights of the image—'clouds, the rippling of water, birds flying . . .'—as we might expect from someone who obviously had a taste for visual 'magic'. Gener-

375. Camera Obscuras, from Johannes Zahn's *Oculus artificialis teledioptricus*, Würzburg, 1685.

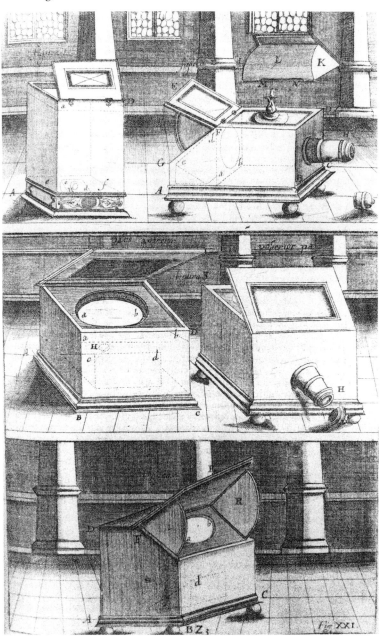

ally speaking, the camera obscura flourished best in late sixteenth century Italy in the context of natural magic, as a means of exploiting natural phenomena to astonish and entertain the spectator, rather than as a direct crib for painters. The most renowned of all the sixteenth-century accounts of the camera, in Giovanni Battista della Porta's *Magiae naturalis* (1558 and 1589), occurs in just such a setting.[54] His great compendium contains a rich blend of science, arcane secrets and overt mysticism, in which the wonders of nature reflect the awesome mysteries of creation. The camera obscura can thus serve him as an analytical model for the optics of the human eye, as a guide for painters and as a way of producing visions to delude the spectator. By projecting scenes of battles, strange animals

377. The formation of images in nature, including the camera obscura from Athanasius Kircher's *Ars magna Lucis et umbrae*, Rome, 1649.

378. Christopher Scheiner's '*machina helioscopica*' for projecting an image of the sun, from *Rosa Ursina*, Bracciano, 1630.

or diabolical apparitions into a darkened room, a skilled operator would be able to evoke feelings of wonder and terror in his innocent audience. The camera appears in a similar context of natural magic in mid-seventeenth-century Rome in Kircher's *Ars magna lucis et umbrae* (pl. 377), where it is discussed and illustrated alongside such natural and artificial curiosities as images in stones and landscapes in which human features can be discerned.[55] It is not surprising that the magic of the camera came to be exploited by showmen and religious charlatans in the service of a more-or-less dubious range of causes. It would be wrong, however, to make a rigid separation of such ingenious deceits from either mathematical science or devout religion. Optics, mystery and divine awe naturally co-existed as major strands of mediaeval, Renaissance and baroque thought in a manner which is difficult to understand from a modern perspective.

In addition to providing a physical model for the eye, which in the hands of Kepler was to develop into a proper understanding of the retina as a 'screen' for the inverted visual image, the camera also served an important scientific function in astronomical observation. It was particularly useful in studying the sun, which was too bright to observe safely by direct means. We have already seen that Galileo used a telescope as a compound lens for the projection of the sun within a darkened chamber when he was recording the motions of the sunspots. His great rival, Christopher Scheiner (the 'Apelles' of the initial controversy) devised a *machina helioscopica* (pl. 378) accord-

ing to the same principles for his own minutely detailed observations of sunspots.[56] Scheiner's concern to understand the implications of such devices led him to make a telling series of comparisons between the human eye (*natura*) and the camera obscura (*arte*) when coupled with various combinations of lenses (*natura cum arte*) to produce upright and inverted images (pl. 379). It was entirely in keeping with the tenor of Jesuit thought at this time that the frontispiece of his treatise on the eye (1619) should show the camera being exploited for varieties of natural magic (pl. 380).

Much the same ingredients can be observed in accounts of the camera obscura in Britain and Holland at this time. The extraordinary Cornelius Drebbel, a Dutch scientist-engineer-magician who spent important years of his career in London, took characteristic pleasure in the magical image of the camera. He demonstrated its delights to the more scientifically sober Constantijn Huygens, who wrote home enthusiastically about its properties in 1622: 'It is impossible to express its beauty in words. The art of painting is dead, for this is life itself, or something higher, if we could find a word for it.'[57] Huygens's warning about the imminent death of painting, which so strikingly foreshadows some of the reactions to photography in the nineteenth century, becomes understandable in a context in which art could be viewed as a direct and empirical form of representation, rather than as a systematically perfected recreation of nature in the Italian manner. No art theorist in Holland went quite so far as Huygens. Hoogstraten is typical in that he sees the camera as providing optical gui-

379. The production of images by lenses in cameras and by the human eye with and without lenses, from Scheiner's *Rosa Ursina*.

380. Allegorical frontispiece from Christopher Scheiner's *Oculus hoc est fundamentum opticum*, Innsbruck, 1619.

dance rather than serving as the ultimate tool in a process of imitation: 'I am sure that these reflections in the dark can give no small light to the vision of young artists; since besides gaining knowledge of nature, one sees the main or general qualities that should belong to a truly natural painting.'[58] This attitude is not all that far removed from Barbaro's, but the goal of 'truly natural painting' does accurately reflect the ultimately different balance between nature, vision and rule in the generality of Dutch painting. The Dutch willingness to regard the painter's craft as founded upon empirical procedures, which could be directly aided by the visual effects of an optical device, is perfectly in keeping with one of the main thrusts of Dutch seventeenth-century science, in which a reverence for mathematical certainty was allied to the direct and impartial

scrutiny of natural effects with the aid of the most precise optical and mechanical instruments. It is in such a context that the close use of a camera obscura by painters could become conceptually possible and could be regarded as relatively free from the stigmas of mindlessness or even of 'cheating'.

When we look at the actual paintings of this era and ask whether the camera obscura has been used in their creation, we generally encounter insuperable problems in framing an unequivocal answer. Direct written evidence, in the form of contemporary accounts of named painters actually using the camera obscura, is almost entirely lacking. The visual evidence of the paintings themselves tends to be inconclusive. The superb effects of spatial and atmospheric naturalism in Dutch painting exhibit a condensed precision which is worthy of the best camera obscura images, but these effects can be credibly and independently explained by the developing techniques of naturalistic painting in Holland without any necessary resort of optical aids. It is possible that the camera did no more than confirm the ambitions and stylistic tendencies which were already deeply established in Dutch art. However, the camera image does typically exhibit certain visual characteristics which are not apparent, or less apparent, in nature. I think it is possible to demonstrate that one artist in particular, Jan Vermeer, did respond to these characteristics in his paintings, enhancing them in such a way as to transform them into significant stylistic features in his highly individualistic art.

Frustratingly little is known of Vermeer, either directly or via the circles in which he moved. The most attractive straw at which we can clutch is posthumous. The great microscopist, Anthony van Leeuwenhoek acted as an executor of the painter's will in 1667.[59] However, the only substantial evidence of his intellectual life is provided by the paintings themselves.

His paintings surely testify to an intense interest in light, shade, colour, space and modes of representation. His varied depiction of maps, mirrors and paintings on the walls of his painted interiors breathes a sustained concern with ways of reflecting reality. His obvious delight in patterns of varied types—tiled floors, oriental carpets, heraldic stained glass, inlaid wood and needlework—bespeaks a conscious scrutiny of how patterned surfaces react under the influence of light and shade. His studied evocation of different textures—translucent glass, varnished maps, gleaming brass studs, polished wood, varieties of rough and lustrous cloths, and utensils made of materials ranging from shining metal to matt earthenware—indicates an active interest in the qualities of reflection and refraction. His exquisitely refined grading of simple and compound shadows in response to different kinds of direct and diffuse illumination is obviously the result of many hours of purposeful looking. It is easy to imagine that such an artist would have been attracted to the optical charms of the camera obscura.

A camera obscura image of reasonable quality does possess a special visual 'feel'. It produces condensed enhancement of tone and colour, providing subtle intensification without harshness or glare. Nuances of light and shade which seem too diffuse or slight to register in the original scene are somehow clarified, and tonal effects gain a new degree of coherence. The

shapes of forms, miniaturised in such a way that they seem to be condensed to their very essence, acquire a crystalline clarity. Striking juxtapositions of scale at different planes, of which we remain largely unconscious in the actual scene, become compellingly apparent. We are now so familiar with contrasts of scale in photographs (pl. 381) that they have lost much of their original element of surprise. Mutual enhancement at the boundaries of areas of contrasting tone and colour—known as 'simultaneous contrast'—is registered with particular strength in the camera obscura. The different focuses required for different planes, particularly those close to the spectator, become clearly apparent. Gleaming highlights

381. Members of the Scottish football squad (Dawson, Strachan, McLeish, Provan and Brazil) at Largs, from *The Glasgow Herald*, 15 May 1980.

382. Circles of confusion in the unfocused foreground of a photograph of fruit on a silver stand.

383. Jan Vermeer, *Soldier and a Laughing Girl*, c.1660, New York, Frick Collection.

exhibit a propensity to 'jump' from their surfaces, particularly in foreground planes when the focus is on more distant objects. This effect can be replicated photographically (pl. 382). Small highlights tend to coalesce and expand as circular globules of light, technically known as circles of confusion.

All these effects can be paralleled in Vermeer's paintings more completely than in the work of any other artist.[60] Two specifically 'optical' effects are of particular note in our present context. In the relatively early *Soldier and a Laughing Girl* (pl. 383), the consolidated massing and tonal 'wholeness' of the large foreground figure acquires added intensity from enhanced edge contrasts. The uncompromisingly dark silhouette of the solider's arm gains a special vibrancy from the perceptible lightening of the already luminous wall at the very margin of the tonal boundary. The other particularly notable 'optical' effect is apparent in paintings from the middle and later stages of his career. It consists of the scattering of circles of confusion across highlit forms. In his later works, such as the *Lacemaker* (pl. 384) the coalesced highlights on the relatively unfocused foreground objects are described by calligraphic points and squiggles of impasted paint. It should be said that this painted effect does not replicate what can be seen in a camera obscura in a literal sense, since Vermeer scatters globules of light across relatively matt surfaces which would not exhibit circles of confusion in a camera. In his later works the luminous dabs are exploited as a form of painterly shorthand which is at once optical in origin and artificially contrived in application.

The evidence of comparisons between Vermeer's paintings and camera obscura images is highly suggestive rather than fully conclusive. Is it possible to go beyond the drawing of such parallels to produce more decisive arguments and, perhaps, even to provide a model of his working procedures? Recent investigations undertaken by Philip Steadman indicate that we may be reaching a point at which the arguments can move on to firmer ground.[61]

A group of ten paintings are set in what is recognisably the same or a closely similar room. The only significant difference is the infilling of the diagonal tile pattern on the floor. Six of these paintings, including the *Music Lesson* (pl. 385), show sufficient of the room to permit its architectural features and the location of the furniture and figures to be reconstructed with a fair degree of precision. We can readily confirm that Vermeer has used techniques (whether geometrical or optical) to create entirely credible spaces according to the canonical rules of linear perspective. He has used the rules to exploit remarkable effects of scale, but the underlying optics do not depart significantly from perspectival orthodoxy. A beguilingly detailed model has been made by Steadman (pls. 386–7) which is capable of replicating the painter's compositions in a compelling fashion. Not the least striking aspect of the correspondences between the painting and model are the compound shadows cast by the inclined mirror and back of the virginals.

The reconstruction of the room permits Vermeer's viewing positions to be deduced for the six paintings (pl. 388). Stead-

384. Jan Vermeer, *The Lacemaker*, c.1665, Paris, Louvre.

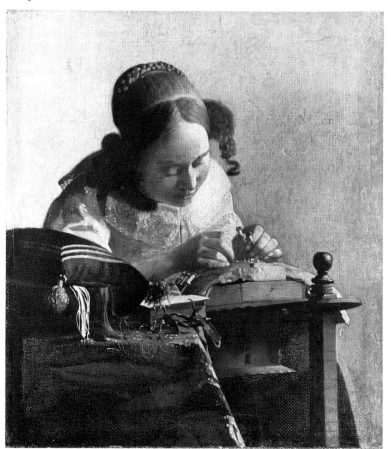

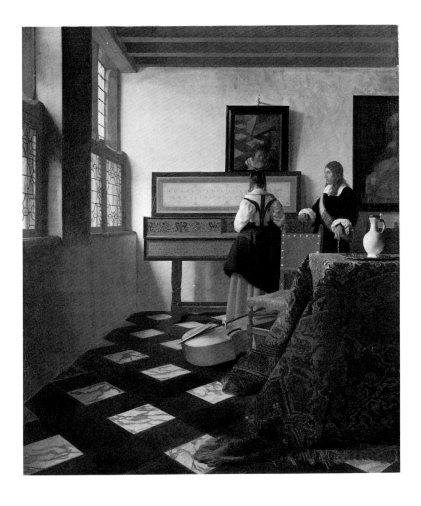

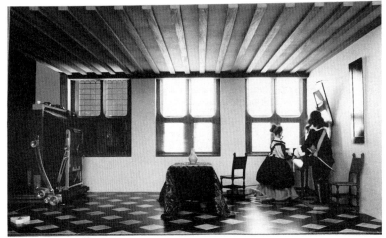

387. P. Steadman, Model of the Music Lesson, photographed from the side.

385. (left) Jan Vermeer, *The Music Lesson*, c.1670, London, Buckingham Palace, Collection of Her Majesty the Queen.

386. (below left) P. Steadman, *Model of the Music Lesson*, photographed as from Vermeer's viewpoint.

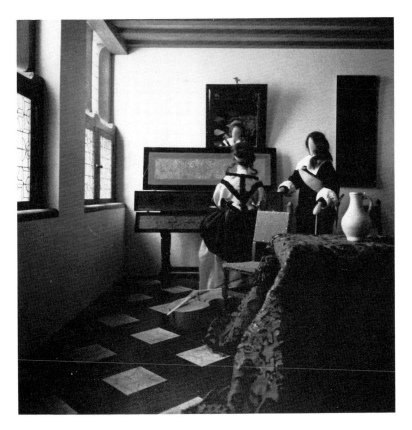

388. Ground plan of Vermeer's room as shown in the *Music Lesson* and other paintings, drawn by Philip Steadman.

The 'viewing points' for the pictures are shown as 1, 2, 3, 4, 5, 6, and the visual angles are extended through these points and towards the rear wall until the bases of the secondary triangles equal the widths of the pictures.
1 *Woman and Two men*, Brunswick, Herzog Anton Ulrich Museum.
2 *The Glass of Wine*, Berlin-Dahlem, Gemäldegalerie.
3 *Lady Writing a Letter*, Blessington, Sir Alfred Beit Collection.
4 *Lady Standing at a Virginal*, London, National Gallery.
5 *The Music Lesson*, Collection of Her Majesty The Queen.
6 *The Concert*, Boston, Isabella Stewart Gardner Museum.

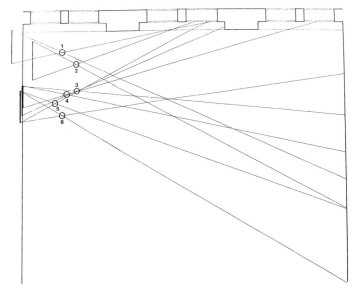

man has observed that if the visual pyramids are projected through the viewing positions, as if through the aperture of a camera obscura, and continued as far as the rear wall of the room, the bases of the secondary pyramids correspond very closely in four instances to the dimensions of the actual paintings. This correspondence seems too close to be the result of coincidence. It suggests, very strongly, that the four paintings were planned using the end of the room, suitably sectioned off and darkened, as the location for a paper screen. A convex lens, especially if shuttered down, would serve to clarify the image. The model confirms that suitable light levels can readily be obtained for a good image. The position of the hypothetical screen for the other two paintings proved respectively to be a small distance into the room and a small distance outside, perhaps through a door.

On this basis, it is possible to imagine a working procedure. The artist, much like a photographer, composes his picture by adjusting the locations of his subjects, the strength of light and the position of his device to achieve the desired effects. The basic outlines of the forms in their spatial array are then recorded on the screen. These outlines can be transferred to the painting surface, re-inverted and re-reversed, by one of the standard methods such as pricking. The painter next takes down his camera construction and sets up his stool and easel,

389. Camera Óbscura, inscribed 'A. Canal', Venice, Correr Museum.

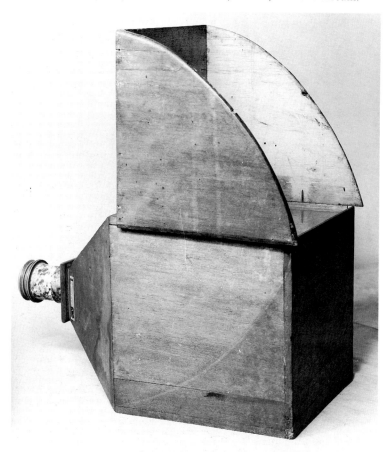

the legs of which can be seen in the mirror in the *Music Lesson*. He is then able to depict the details of colour, light and shade in his inimitable manner. This hypothetical procedure, it should be emphasised, is not such as to produce a 'mindless' or mechanical image, but necessitates a controlled series of aesthetic choices at every stage. That is why his paintings, like great photographs, can be regarded as utilising optical 'mechanics' for highly individualistic effects.

If Vermeer did use the camera obscura, as increasingly seems likely, was he exceptional amongst Dutch artists? No other painter's products yield so readily to optical analysis and in their cases the judgements remain more hypothetical and subjective. Huygens indicated that Torrentius, one of the earlier still-life painters, exploited the camera obscura, and later masters of this genre may well have followed his lead. Of the landscape-townscape painters, the most likely candidate is Jan van der Heyden, whose paintings share many of the tonal, colouristic and spatial qualities of camera images, and who, as we will see later in this chapter, was concerned with optical devices. However, for a really substantial body of evidence for topographical painters using camera obscuras we have to wait until the eighteenth century.

Art historians have generally been reluctant to study the implications of this evidence, feeling, no doubt, that it is not quite proper for their favoured artists to resort to what has become regarded as a form of cheating. There are two main objections to this modern prejudice: firstly that skill in constructing and using optical devices was highly valued in the periods with which we are dealing; and secondly that the use of a camera in no way prescribes the artistic choices to be made at each stage of the conception and making of a painting. If we are able to set aside the prejudice, we will be better placed to approach the question of the camera as an artistic tool in eighteenth-century Venice and Britain.

The position of Canaletto amongst the Italian *vedutisti* is comparable to that of Vermeer amongst the Dutch painters. Not only is Canaletto the supreme master of his chosen genre, but he is also the artist whose works pose the question of the use of optical aids most clearly. Compared to Vermeer, however, we are relatively well-informed about his practice and his intellectual ambience, and we do have direct evidence of his involvement with the camera.

Algarotti, whose writings provide such a good key to Canaletto's balance between nature and artifice, provides a fine and enthusiastic account of the camera image, which is worth quoting at some length.

As this artificial eye, usually called a Camera Optica or Obscura, gives no admittance to any rays of light, but those coming from the thing whose representation is wanted, there results from them a picture of inexpressible force and brightness; and as nothing is more delightful to behold, so nothing can be more useful to study, than such a picture. For, not to speak of the justness of the contours, the exactness of the perspective and of the chiaroscuro, which exceeds conception; the colours are of a vivacity and richness that nothing can excell; the parts which stand out most, and

390. Antonio Canaletto, *Campo di SS. Giovanni e Paolo*, c.1735, Venice, Galleria dell'Accademia, Quaderno fol. 50v–51r.

are most exposed to the light, appear surprisingly loose and resplendent; and this looseness and resplendency declines gradually as the parts themselves sink in, or retire from the light. The shades are strong without harshness, and the contours precise without being sharp. Wherever any reflected light falls, there appears, in consequence of it, an infinite variety of tints, which, without this contrivance, it would be impossible to discern. Yet there prevails such a harmony amongst all the colours of the piece, that scarce any one of them can be said to clash with another.[62]

He then proceeds to point out the excellence of the image in demonstrating diminution and aerial perspective. The only artist he specifically names as a user of the camera is 'Spagnoletto' (G.M. Crespi), whose painterly bravura and freely energetic compositions seem to make little obvious reference to camera images, with the possible exception of his portraits.

Other contemporary authors do specifically associate Canaletto with the camera. Antonio Maria Zanetti, a perceptive and well-informed observer, wrote that

il Canal taught the correct way of using the *camera ottica*; and how to understand the errors that occur in the picture when the artist follows too closely the lines of the perspective, and even more the aerial perspective, as it often appears in the camera itself, and does not know how to modify them where scientific accuracy offends against common sense. Those learned in this art will understand what I mean.[63]

The errors to which Zanetti refers are probably the optical distortions inherent in the available cameras—the perspectival and colouristic aberrations of the lenses, the problems of depth of field in relation to focus, and the eccentric diminutions caused when the camera is tilted. Zanetti's valuable testimony to Canaletto's involvement with the camera appears to be confirmed by the inscription 'A. Canal' on a surviving camera obscura in the Correr Museum, Venice (pl. 389), though the status of the inscription has been questioned.

Amongst Canaletto's many drawings there is a category of design which is best explained by supposing that it is based on a camera image. One sketchbook contains sets of two to four drawings which join up to produce a continuous vista.[64] The illustrated example (pl. 390) shows two of the four sketches which make up a view of the Campo di SS. Giovanni e Paolo, equivalent to that in one of his paintings (pl. 278). As we will see when we look at British painters, such a serial compilation of a wide-angle view from successive 'shots' corresponds to one of the characteristic ways of using optical aids. I think it is virtually certain that these and similar drawings by Canaletto were transcribed from a camera image, either directly—if he used a tent-type camera (pl. 391)—or by one of the many methods of transfer. The line possesses an unusual quality; it traces the perspectival outlines in a summary, free-hand manner with virtually no auxiliary construction lines. Between such drawings and the final paintings, there remained a considerable effort of perspectival, tonal and colouristic organisation, in the manner already noted in Chapter III. It may be that the coherent massing of tone in his paintings, enlivened by little luminous globules of impasted paint, retains signs of the camera image which the artist studied at the beginning of the process.

It is reasonable to suppose that the *vedutisti* in his orbit and in his following, particularly Bellotto, also took advantage of the camera.[65] The strongest indications that this occurred are apparent not in the works of his fellow Italians but in the topographical paintings by those British draftsmen who stand in his succession.

British attitudes to the camera reflect the inherent tensions between the established practice of the majority of painters, who were much occupied by portraiture and latterly by landscape, and the emergent academic theory of 'high' art. On one hand, the camera could be greeted with an enthusiasm to

391. View of the canal beside the Chiesa della Mira showing two men with a tent-type camera obscura, from Giovanni Francesco Costa's *Delizie del Fiume Brento*, 1750–6, London, British Museum.

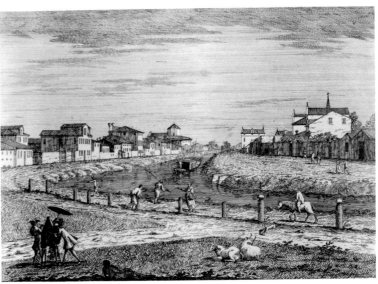

392. Book-type camera obscura owned by Sir Joshua Reynolds, London, Science Museum.

for the Delineator, and we know that Reynolds possessed a camera obscura of his own, in the not uncommon form of a hooded box which folds down to resemble an outsize book (pl. 392). However, the idealising aesthetic which he preached as President of the Royal Academy certainly did not embrace the literal imitation of a camera image as the basis for a painting of high merit. Indeed, the Dutch masters were implicitly criticised in his comparison of their paintings to camera images.[67] For a busy portraitist like Reynolds, with an organised studio, the camera could serve a valuable function, but it would have been regarded as a subsidiary tool rather than as a precise guide for the making of a painting.

The most prominent use in Britain for the camera obscura and its later rivals—the camera lucida and the graphic telescope—was in the representation of scenery and buildings. The Sandby brothers, Thomas and Paul, provide appropriate and accomplished illustrations of its use. Both were employed in the Drawing Office of the Tower of London, and performed what may be described as the role of official topographer.[68] Thomas, for instance, was attached to the Duke of Cumberland's army, making splendid panoramic representations of fortifications and encampments in Scotland and England (pl. 310), which were mounted on long canvas strips with silk ties for storage in rolled form.[69] Thomas is known to have possessed a large camera obscura, and one of his non-military panoramas (pl. 393) is specifically inscribed to the effect that it was 'drawn in a camera'.[70] It is composed from four overlapping sheets, the second of which has been cut to follow the contours of one of the towers and its adjacent chimneys. To take in the wide sweep of the castle and river, Thomas has turned his camera through four different positions. His distant viewpoint has minimised the problem of the changing perspective which would arise from the changing orientation of the camera. As a friend of the astronomer, Sir William Herschel, and as a geometrical perspectivist of some accomplishment (pl. 309), he was well placed to use the camera with real understanding of its optical properties.

His brother, Paul, provides a nice illustration of how the working tool of the professional topographer can also serve as a charming diversion for the cultivated amateur. His watercolour of *Rosslyn Castle* (pl. 394) depicts a graciously attired sketching party, which probably includes the Duchess of Buccleuch and Lady Douglas using an instrument similar to Stor-

match that of Huygens. Horace Walpole praised Storer's Royal Delineator with little short of rapture, declaring that it 'charms me more than Harlequin did at ten years old, and will bring paradise before your eyes. . . it will perform more wonders than electricity, and yet is so simple as to be contained in a trunk, that you may carry on your lap in your chaise. . . In short it is terrible to be three score when it is just invented.'[66] On the other hand, there is the ambiguous reaction of Joshua Reynolds. Walpole and Storer both reported his admiration

393. Thomas Sandby, *Windsor Castle from the Gossels*, 1770, Windsor, Royal Library.

394. Paul Sandby, *Rosslyn Castle* with a lady using a camera obscura, *c*.1775, New Haven, Yale Center for British Art.

er's Delineator. The flourishing market for cameras—and the impetus to provide ever-improved versions—appears to have depended substantially upon the rising numbers of cultivated amateurs with enough knowledge, leisure and money to enjoy experimenting with the new artistic-cum-scientific toys.

The problem remained, however, that the camera image was traditionally stigmatised as mechanical and inartistic. Its effect might be astonishingly natural but it would not meet the highest requirements of either 'ideal' or 'picturesque beauty'— to use the terms which played such a central role in aesthetic controversies around 1800. A simpler device, the so-called Claude Glass, seems to have met the demands for picturesque beauty in the eyes of many artists. In its most common form it consists of a mildly convex glass, either with a black backing or self-tinted, and was commonly mounted in a velvet-lined carrying case (pl. 395).[71] Its effect was to convey a relatively wide-angled view on to a small-scale surface. The slight curvilinear distortion is more than offset by the sense of a coherent gathering together of the disparate elements of the scene. Its tonal effect is to reduce glare at the top end of the scale, as in a large expanse of luminous sky, and thus to allow the subtlety of the middle tones to emerge, as, for example, in a bank of clouds. The darker tones acquire unity, without totally suppressing the detail. It was these harmonising effects that were, after about 1850, to earn the glass the name of the great landscape artist, Claude Lorrain.

The glass does not appear to have any direct associations with Claude himself, but it was certainly known to his Northern contemporaries in Rome. A number of authors refer more generally to the advantage of a convex mirror as a means of encompassing a wide prospect within a small field. Gerard de Lairesse in 1707 states that it is

very convenient for drawing all Sorts of large Works in narrow Places or Streets... 'Tis also useful to Landskip-

painters in their Country Views: They may take whole Tracts of Land, with Towns and Villages, Waters, Woods, Hills, and Sea, from East to West, without moving either Head or Eyes. 'Tis likewise proper for those who are ignorant of *Perspective*.[72]

The landscape glass or 'mirror' really came into its own in the eighteenth century. It became available in a number of shapes—rectangular, with or without champfered corners, oval and circular—and could alternatively be backed with silver for use in dull conditions. Tinted transparent glasses were also available, and permitted the modulation of colours and tones in any desired manner. Pierre Henri Valenciennes, an important landscapist and theorist in France, considered that 'the mirror represents Nature with more force, purity and finish than the camera obscura, because the reflection in it is simple and the objects are painted there instantaneously'.[73]

Other serious artists paid attention to its properties. One of Gainsborough's drawings shows a circular 'mirror' in use.[74] It came to be regarded as a kind of instant 'artist's eye', favoured by ladies and gentlemen of sensibility for its ability to transpose an admired view into the optical semblance of a venerated masterpiece in the Claudian style. The most complete testimony of its use occurs in Thomas Gray's account of his tour of the Lake District in 1775. The splendid views 'gave much employment to the mirror'. At Kirkstall Abbey, for example, it encapsulated 'the gloom of those ancient cells, the shade and verdure of the landscape, the glittering and murmur of the stream, the lofty towers and long perspectives of the church'.[75] It is clear that such employment for the 'mirror' is less in the service of optical precision than for its ability to transpose reality into a more melodious key. As such it was well placed to escape the censure of mechanical artlessness levelled against most optical aids.

395. 'Claude Glass', Edinburgh, National Museums of Scotland.

396. Camera lucida with eye-piece, lenses and equipment box, London, Science Museum.

397. Upper portion of a camera lucida, from Cornelius Varley's *A Treatise on Optical Drawing Instruments*, London, 1845.

Drawing Instruments.

PLATE VI.

Fig. 37.

After 1800 the armoury of optical devices available to the landscapist increased considerably beyond the Claude Glass and the camera obscura. The most prominent of the new instruments was the camera lucida (pls. 371, 396 and 397) invented by the important optician, physicist, chemist and physiologist, William Hyde Wollaston.[76] Patented in December 1806, it inspired numerous variants and rivals. Its central feature is a prism with two reflecting surfaces at 135°, that conveys an image of the scene at right angles to the observer's eye placed above it. The observer carefully positions his pupil, with the aid of a small viewing aperture, in such a way as to perceive the image and at the same time, to see past the edge of the prism to the drawing surface below. The draughtsman can thus contrive to watch the point of his pencil tracing the outlines of the reflected image. In its basic form, the camera lucida is not a particularly easy instrument to use and requires a certain amount of experimentation and practice before mastery is achieved. It also requires two auxiliary lenses, hinged in such a way that one could be swung below the prism and the other in front, to cope with various problems of focus. These difficulties were far outweighed by the advantages: not only was it conveniently portable, but it also operated in virtually any lighting conditions. Not surprisingly, numerous attempts were made to obviate the problems of such a useful device, and it was the progenitor of plentiful offspring, British and foreign, including the Laussedat Camera Lucida, the Abbe Camera Lucida, Nachet's Drawing Prism, Amici's Camera Lucida, Abraham's Improved Sketching Instrument, and Alexander's Graphic Mirror (pl. 398).[77] The last of these was an instrument which relied on partial reflection, so that the image and the 'point of the pencil can clearly be seen at the same time' without the tricky manoeuvering of the eyehole to see into and past the prism. However, it did require a hinged glass 'shade' to control the brightness of the incident light if the vividness of the reflection was not to obscure the drawing surface.

The camera lucida and its close variants proved their worth in a number of specialist capacities, including technical drawing, the copying of images for publication (particularly for encyclopaedias), and the drawing of images in microscopes. It also worked well in the right hands—and in the right eyes—for the portrayal of landscapes. Sir John Herschel, the son of Thomas Sandby's friend and a major scientist who was to become deeply involved in the invention of photography, achieved splendid results over a number of years with his camera lucida (pl. 399).[78] His experience in using optical devices no doubt helped, as did his obvious manual dexterity and artistic skill. His drawings often contain detailed technical measurements of coordinates relating to the width of field, axes and angles of view, as well as more descriptive notes of colour. That the use of a camera lucida did not guarantee a successful representation is shown amply by W.H. Fox Talbot's confessedly miserable efforts (pl. 400). Had Talbot possessed his friend's skill, or that of his wife, Constance, he might not have felt the need to fix the image by chemical means and thus to invent photography.

A graphic illustration that the use of the camera lucida did not guarantee a life-like image is provided by an unusually

398. Alexander's Graphic Mirror, London, Science Museum.

399. Sir John Herschel, *Camera Lucida Drawing of Tintern Abbey Looking East*, 1829, Pasadena, Graham Nash Collection.

400. William Henry Fox Talbot, *Camera Lucida Drawing of the Terrace at the Villa Medici*, 1833, London, Science Museum.

401. Basil Hall, *Camera Lucida Sketch of Sir Walter Scott*, 1830, Edinburgh, National Portrait Gallery.

well-documented incident in which Captain Basil Hall, amateur scientist and artist, used his own camera drawings to aid his younger brother, James, who was an aspiring portraitist.[79] In 1830 the great author, Sir Walter Scott, allowed Basil Hall to make some sketches in Scotland for a full-length portrait which his London-based brother hoped would make his reputation. The sketch of Scott standing (pl. 401), used directly as the basis for the painting which James completed in 1838, shows the laboured and broken lines which can all too easily result from the camera lucida as the draftsman strives to retain dual attention on the refracted image and the point of the pencil. In the transforming of such an image into an effective painting, the artist still requires a full range of pictorial skills. For all his enthusiasm for the truthfulness of the camera image, Basil Hall was right to recognise that such a drawing is 'very limited' as a guide for the painter.

The most effective alternative to the camera lucida was the Graphic Telescope patented on 5 April 1811 by Cornelius Varley. We have already noted that telescopes had been used for astronomical projection soon after their invention. Scheiner had also experimented with a lens-based instrument, somewhat like an artificial eye, to project an image of a landscape,

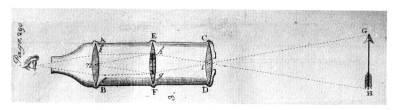

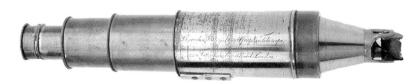

402. Benjamin Martin's 'optical instrument' for drawing and viewing, from *A New and Compendious System of Optics*, London, 1740.

EF—glass micrometer marked with lines for measuring

403. Cornelius Varley, Graphic Telescope, London, Science Museum.

but such telescopic systems do not appear to have entered general currency as devices for artists.[80] A distant ancestor of Varley's Telescope was Benjamin Martin's Graphical Perspective Instrument (pl. 402), designed in the mid-eighteenth century 'for measuring the Angle of Vision, or estimating the apparent Magnitude of Bodies; also for viewing Perspective Prints, Pictures etc.'.[81] In the middle of the 'telescope' was a glass micrometer on which were engraved lines, at forty to the inch, which enabled the viewer to measure the angle subtended by the object. If the micrometer gauge was drawn as a squared grid, it could be used for copying in the traditional manner of a veil. A more recent ancestor was Ramsden's Optigraph (pl. 371).[82] None of these, however, possessed the complexity and adaptability of Varley's invention.

Varley's Graphic Telescope (pls. 403–5) was the most optically sophisticated and ingenious of all the drawing aids. Although he and his more famous brother, William, are mainly known as accomplished painters in watercolour, they possessed a wide range of intellectual interests and activities.[83] Cornelius had been trained in his uncle's instrument-making and lens-grinding business. His book, *A Treatise on Optical Drawing Instruments*, published in 1845, shows a highly professional understanding of the optical properties of lenses, as does the design of the telescope itself.[84] The light enters his telescope through a circular aperture (s) and is reflected horizontally through a series of four lenses before it arrives at the eyepiece (v) where it is reflected perpendicularly into the viewer's eye. The viewer is enabled to look simultaneously at the image and the paper, and to focus the telescope so that the image seems to lie in the plane of the drawing surface. The adjustable focus gives the instrument a flexibility which permits the production of large or small images of the same subject, depending upon the distance of the instrument from the drawing surface. By using 'charcoal at the end of a long reed stick', drawings on an enormous scale can be made.

Not only does Varley claim that the Graphic Telescope is 'one of the best helps to a teacher of perspective that has been brought forward', but also that it provides a highly effective aid in the representation of nature in art.[85] Varley himself used it in his landscapes and for a series of delicately precise portraits, such as that of the great watercolourist, John Sell Cotman, (pl. 406). Cotman himself was obviously greatly taken by the device. In 1817 he arrived in Rouen 'for the purpose of taking an accurate view of Notre Dame'.[86] He had with him 'a very large and newly-invented Camera Lucida by Varley' which had been given to him by Sir Henry Engerfield, his

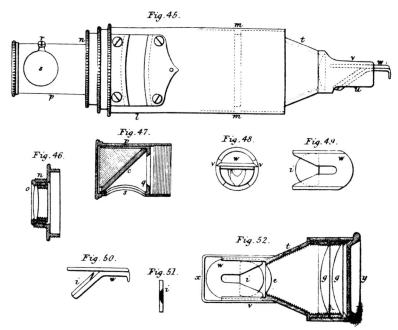

404. Cornelius Varley's Graphic Telescope, from his *Optical Drawing Instruments*.

405. Varley's Graphic Telescope in use, from his *Optical Drawing Instruments*.

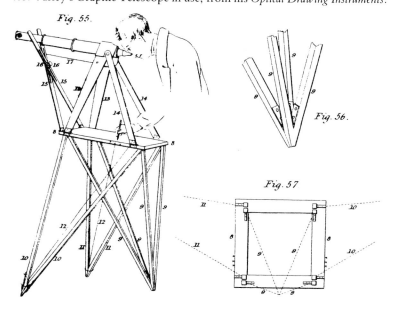

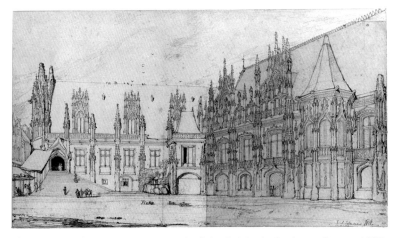

407. John Sell Cotman, *Courtyard of the Palais de Justice at Rouen*, 1817, Christies, 21 November 1978.

406. Cornelius Varley, *Portrait of Cotman*, c.1811, Sheffield, Graves Art Gallery.

patron. However, Cotman did not find it easy to use and achieved only a 'wretched performance'. A year later, on his return to Normandy, he had mastered it sufficiently to instruct the daughter of Mrs. Turner to produce drawings 'with all the lines in the right places and memoranda on the margins of all needful to be known towards making finished drawings'. Cotman's own drawing of the *Courtyard of the Palais de Justice at Rouen* (pl. 407), compiled from three separate sheets in the manner of Canaletto's and Sandby's composite views, testifies to the high degree of precision facilitated by the optical refinement of Varley's device. This drawing, like others made on his visits to the area, was etched for publication in Dawson Turner's *Architectural Antiquities of Normandy* in 1822.[87]

The impression gained during our highly selective review of optical devices in the topographical tradition is that artists took them up most keenly in particular functional contexts, most especially when they were expected to produce precise, documentary records of the appearance of a scene or buildings. The growing demand for albums of views of picturesque places

and antiquarian sites, both at home and abroad, provided just such a context—as in the case of Cotman's views of Normandy. Optical devices also served the cause of small-scale, inexpensive portraiture with considerable effectiveness. The existence of demands such as these, which could be met by mechanical systems of imitation, does much to explain the enormously rapid success of photography. It is altogether appropriate that Varley, near the end of his long life, should have greeted the photograph as 'the most glorious associate the arts have ever had'.[88]

ARTIFICIAL MAGIC

The aim and achievement of cameras was to produce a picture from nature herself, exploiting the natural magic of her optical phenomena to form remarkable images. The second category of optical magic was that termed 'artificial', that is to say, based on the inventor's ability to contrive painted, drawn or printed illusions that achieve astonishing effects when viewed under specific circumstances. Strictly speaking, all perspective illusions, even the most orthodox, could be considered as varieties of artificial magic, but almost all the theorists regarded orthodox perspective as corresponding in a more-or-less straightforward way to the central facts of the visual process and therefore as 'normal' rather than bizarrely magical. The earliest types of perspectival images which fall into the category of artificial magic, as normally defined, were of two main kinds: viewing boxes that created their own visual world when seen in the prescribed manner; and images designed in such a way that they only assumed coherent form when viewed from exceptional angles or with the use of special aids. Later types of artificial magic aspired to create effects which could transcend the limitations of the standard forms of pictorial illusion. I am thinking of images such as panoramas, which attempt to evoke a natural scene as it 'wraps around' the spectator, the systems of binocular illusions known as stereoscopes, and those devices which even finally succeeded in creating moving pictures.

A comprehensive exploration of all the many varieties of artificial magic would take us too far into the extensive realm of optical entertainments—magic lanterns, popular peepshows, phantasmagorias, dioramas and so on. My intention here, as in the preceding sections, is to look at those aspects of this huge topic—the history of which remains to be written—that relate most tellingly to our central theme of the science of art.

The earliest and most obvious of the magic devices was the showbox or peepshow. Its essential ingredients seem to have been established as early as the fifteenth century, by none other than Alberti. An anonymous biography of Alberti, perhaps an autobiography, describes two of his 'miracles' of painting:

> He . . . created effects that had previously been unknown and were considered incredible by viewers. The pictures, which were contained in a small closed box, were seen through a tiny aperture. There you were able to see very high mountains and broad landscapes around a wide bay of the sea, and, furthermore, regions removed very distantly from sight, so remote as not to be seen clearly by the viewer. He called these things 'demonstrations'. . . . He called one of them 'daytime' and the other 'night time'.[89]

A number of important questions are left unanswered by this account. Were the paintings illuminated from in front or behind? Were they on translucent surfaces? Were they in one plane or were they executed in layers? Whatever doubts remain, I think it is reasonably clear that we are dealing with a showbox which uses a peephole and not with a camera obscura.

The main thrust of subsequent illusionism in Italy was, as we have seen, on a larger scale than Alberti's box and located in specific architectural contexts. Some of the most all-embracing schemes, such as Peruzzi's Sala delle Prospettive, Veronese's decorations at Maser, and the Colonna-Mitelli interiors may almost be considered as perspective boxes on a grand scale. Although there were also artists in Holland who practised illusions on an architectural scale, including Vredeman de Vries, Fabritus and Hoogstraten (pl. 229), the small-scale perspective box is perhaps more characteristic of the Dutch vision. It certainly is better represented by surviving examples than large-scale Dutch work. The domestic scale of the *perspectifkas*, compared to the architectural grandeur of the Italian palace decorations, does give the spectator a different emotional relationship to the illusion, but once our eye is pressed to the viewing hole, the physical confines of the box are somehow transcended, and we stand psychologically within the painted houses no less securely than we stand physically within Palazzo del Tè or Villa Barbaro. It is entirely understandable that Hoogstraten should proudly equate the miracle of the perspective box with Giulio Romano's large-scale illusions.[90]

Hoogstraten is the author of the most brilliant of all the surviving boxes. Since its particular magic consistently eludes the eye of the photographic camera, I will provide a brief description of how it is set up.[91] The box consists of a wooden cabinet (58 × 88 × 60.5 cms.), one lateral wall of which permitted the

entry of light. The exterior sides of the box are decorated with allegorical paintings in praise of the painter's art. The top displays a less than wholly convincing anamorphosis of Venus in bed, accompanied by Cupid, setting up the theme of love, which is more covertly apparent in the interior. Two high, lateral eye holes in the two end walls permit controlled views into the interior (pl. 408). Three of the interior walls and the ceiling are painted with perspectival scenes which not only create coherent space on the end panels, which are at right angles to the viewing axis, but also on the oblique planes of the longer side wall and ceiling. Along the open edge of the box, Hoogstraten has added some further trickery. The top of a chairback is painted along the upper edge of the frame at the base of the aperture. The near edge of the chairback is denoted by a chiselled gouge in the frame, and real chair studs have been hammered along the top edge. Beyond the chairback, in the floor near the open aperture, is a groove which almost certainly provided the location for a vertical strip painted as a curtain to prevent illicit views of the opposite eye-hole. With consummate skill Hoogstraten has created an enticing series of primary and secondary spaces, each with its own carefully characterised aura. He even succeeds in suggesting the light-filled space which surrounds the house. The hazy outlines of a man peeping at the lady through a window (pl. 409) humanises the relationship between interior and exterior spaces.

Some forms at the junction of two wall planes, such as the dog, broom and mirror, optically contradict the obliquity of the planes, one to the other, while one of the chairs thrusts towards us against no less than three separate planes on which it is painted at the corner of the box. Conspicuous *pentimenti*, particularly in the portrayal of the chair which occupies three planes, suggest that he worked out the geometrical projection separately on each panel and subsequently made adjustments 'by eye' when he could judge how the effects were actually working when viewed through the peepholes. The degree of control in the projection of forms can fairly stand beside

408. Samuel van Hoogstraten, *Perspective Box*, montage of photographs of the floor, walls and ceiling, *c*.1756, London, National Gallery.

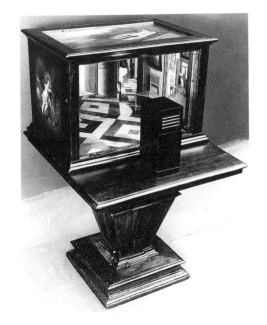

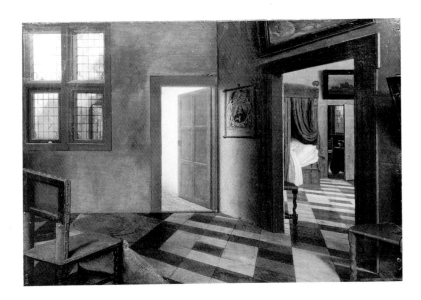

409. Samuel van Hoogstraten, *Perspective Box*, detail showing the seated lady.

Marolois's abstract demonstration of the projection of a circle on two inclined planes (pl. 410).

Less elaborate but no less revealing is an attempt by Jan van der Heyden to set up one of his easel paintings as a kind of peepshow. When his *View of the Dam in Amsterdam* of 1667 (pl. 411) was bought for the Medici Grand Duke, the agent wrote explaining that the painting should be viewed 'from its [proper] point, by means of an instrument of iron which is attached to the frame'.[92] This instrument probably resembled the eyepiece of a perspective machine. Any perspective painting should, in theory at least, be seen from its ideal point, but Jan was particularly concerned in this instance since he had followed the dictates of perspective so precisely as to depict the cupola of the City Hall on the base of a deformed ellipse.

Viewed from the wrong position the cupola tends to look distorted, as in some of Vredeman's more extreme demonstrations (pl. 208), whereas it appears optically correct from the proper viewing position. In another version of the same scene

411. Jan van der Heyden, *The Dam in Amsterdam*, 1667, Florence, Uffizi.

410. Shadows from a round object cast on inclined planes, from Samuel Marolois's *La Perspective. . .*, 1629.

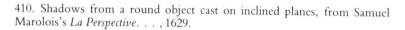

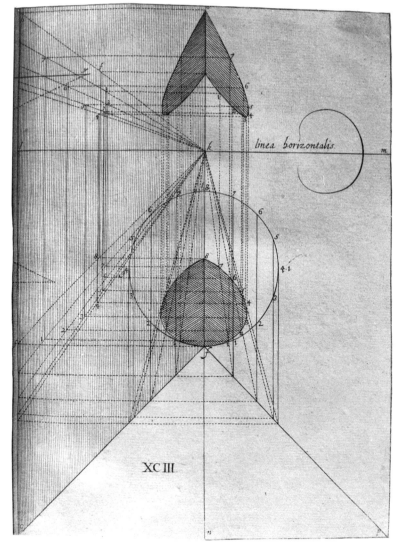

he portrayed the cupola as a symmetrical ellipse and hemisphere, a description which is less optically 'correct' but which allows the painting to be viewed more comfortably from a variety of positions.[93] The question as to whether spheres and related forms should be projected asymmetrically towards the edges of wide-angle pictures was becoming a considerable bone of contention in the theoretical literature. In France, for example, Huret argued with characteristic acidity that the ovoid spheres and elastically deformed heads required by projective principles merely showed how extreme allegiance to mathematical rules of the Bosse type resulted in absurdities which violated the experiences of natural vision.[94] Van der Heyden seems in effect to be saying that both systems have their own kind of validity.

The activities of Jan and his brother Nicolaes van der Heyden give some clue as to the intellectual and technical background to his optical variations on a single view. Jan was trained as a glass engraver and painter, and was involved with the running of a mirror shop. The brothers collaborated in the design of a new kind of fire hose in 1672, which became the subject of a book by Jan in 1690.[95] Jan was also appointed to be director of street lighting in 1670. This mix of perspectival optics, visual devices, and creative engineering—all under the general embrace of practical mathematics—is typical of the environment we sketched when we were considering Stevin earlier in the century.

The Dutch perspective peepshows represent the intellectual highpoint of the perspective box, and henceforth its history belongs more to the story of popular visual diversions than to the interplay of mainstream arts and sciences. One related de-

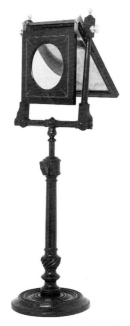

412. Zograscope or 'Optical Diagonal Machine', London, Science Museum.

413. Pierre Edouard Frère, Zograscope in use to view perspective prints, 1857 (?), New York, Brooklyn Museum.

vice does, however, warrant mention in our present context, namely the Zograscope or 'optical diagonal machine' (pls. 412–13).[96] This consisted of a large convex lens and plane mirror mounted in such a way as to give a magnified view of a two-dimensional image, most typically a specially-designed print of a perspectival subject. Invented in France probably in the early eighteenth century, it retained its popularity into the next, and spawned a number of variants, such as the graphoscope. An elaborate variation, with three viewing lenses arranged in an arc, is described by Valenciennes in his treatise on perspective.[97] The painted images in his 'Optique' were displayed in a black-sided cabinet and could be changed by pulling a string. Tinted glass slides could be interposed singly or in combinations to produce varied and even mobile effects of atmosphere and light. The vividness could be enhanced by lights placed behind the images and shining through special apertures or through transparent areas to represent the sun or moon. If the images themselves were designed with powerful spatial effects, comparable (he says) to those used by Poussin, and due allowance was made to counteract the curvature produced by the convex lenses, the Optique would create 'a pleasing and fascinating spectacle for all the viewers, worthy of the attention of Artists and Physicians'. The effects probably shared much with the more theatrical of French eighteenth-century landscape paintings, particularly those of Joseph Vernet.

That such devices were indeed considered as 'worthy of the attention' of serious artists is shown by Gainsborough's *Show Box* (pl. 414) with its beautifully painted transparencies.[98] Having collaborated with Philippe de Loutherbourg on the extraordinary *Eidophusikon* (1781), an automated miniature

414. Thomas Gainsborough's Show Box, *c.*1781–2, London, Victoria and Albert Museum.

415. Thomas Gainsborough, *Moonlight Scenery*, painted on glass for viewing in his Show Box, London, Victoria and Albert Museum.

theatre replete with special effects, Gainsborough was inspired to contrive a less glamorous device of his own.[99] The box is equipped with a moveable eyepiece containing a lens, and a sliding carriage for the changing of the transparencies. Rear illumination is provided by a series of lamps diffused by a silk screen. The light radiates through the glass on which the images are painted, to produce striking effects of chiaroscuro, particularly in those scenes that exploit strong tonal contrasts (pl. 415). Gainsborough's box was perhaps the last truly distinguished work in direct line of descent from Alberti's peepshow. The static and relatively sober effects of such boxes were rapidly being outstripped by a range of new technologies capable of creating sensational results on a larger scale, such as Philipstal's phantasmagoria and the dioramas which established the early reputation of the French inventor of photography, Daguerre.

The perspective box in its most advanced form had involved illusions on inclined planes. The side walls of Hoogstraten's box may be said to depend on a form of anamorphosis, and this provides the second of our categories of artificial magic. The difference, however, between the peepshow and an anamorphic image is that the viewer of the box is required to approach the illusion from the point at which it works, whereas an anamorphosis deliberately presents a scrambled image from the anticipated viewpoint, and often leaves the viewer to find the secret of its optical trickery by searching out its wildly improbable viewing position.

The idea of anamorphosis appears to have arisen as a byproduct of the investigation of oblique images and wide-angle views by Piero della Francesca and Leonardo da Vinci. At the very end of his treatise Piero considers the special case of how to paint an illusion of a 'solid body that is to appear in relief'

on a plane surface which is above or below the spectator and is viewed obliquely.[100] The examples he illustrates are those of a ball, a hanging ring, and a 'drinking goblet on a stem which is to appear elevated' above the plane of a table (pl. 416). The construction is achieved by the projection of the relevant rays of the visual pyramid past the contours of the object and on to the plane behind it, much as if an adjacent source of light is casting a shadow. When the oddly dislocated outlines are viewed obliquely from the point of projection, they convey the effect of the goblet standing out from the plane surface of the table.

We have already noted in Chapter I that Leonardo's awareness of the difficulties caused by wide-angle perspective had led him to experiment with elongated designs which turned the problems to his advantage (pl. 83). Although his major demonstrations of anamorphosis, most notably those made in France, have disappeared, we may believe with some confidence that it was his example that inspired the sudden wave of anamorphic designs in Northern Europe.[101] It was in the North, most especially in the work of Erhard Schön, that one of the major potentials of these picture-puzzles began to be realised—not simply as curiosities, but as symbolic compositions which could embody concealed meanings of a political, religious or erotic nature. Schön may have been the first to give the frontal, distorted image a coherence of its own by the transformation of the otherwise incomprehensible outlines into the contours of a landscape peopled by tiny figures (pl. 417).

The classic early example of anamorphosis exploited at the highest level of seriousness for symbolic purposes occurs in Hans Holbein's *The Ambassadors* of 1533 (pl. 418). The two Frenchmen, Jean de Denteville and Georges de Selve, stand in front of a table loaded with the paraphernalia of various aspects of human learning which relate to practical mathematics. The instruments are of a type (and are portrayed with

416. Perspectival projection of a goblet laterally on to a plane from Piero della Francesca's *De Prospectiva pingendi*.

417. Erhard Schön, *Anamorphic Print of Four Portraits* (Charles V, Ferdinand I, Pope Paul III and Francis I).

a perspectival precision) which stands in line of descent from the *intarsie* of the Urbino *studiolo* (pl. 71). Smeared diagonally across the perspectival floor is an anamorphic skull which only assumes full coherence when viewed from a particular position to the right of the picture at the level of the ambassador's heads, at about one picture's width from the edge of the painting, and at a short distance from the plane of the picture surface. We may imagine that one of the axes along which the viewer would have approached the picture in its original setting was through a door abutting on the end of the wall on which the picture was hung.[102]

What is the purpose of the semi-concealed skull? It almost certainly relates to the other partly-concealed symbol, the sculpted crucifix half-hidden by the curtain in the upper right corner. If the skull serves to remind us of the ultimate triumph of death over all human pursuits—even those as intellectually beguiling as astronomy, horology, cartography and music—the silver crucifix represents our only legitimate chance of salvation in the next life. As we have so often seen

418. Hans Holbein, *The Ambassadors*, 1533, London, National Gallery.

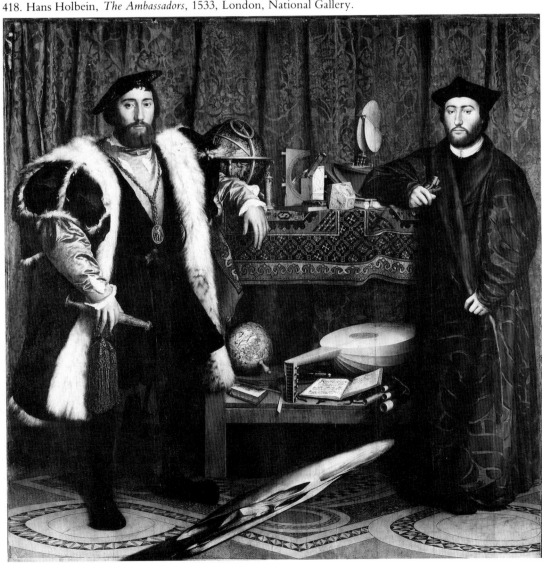

419. Technique for the anamorphic distortion of faces from Niceron's *Thaumaturgus opticus*.

420. Design for a conical anamorphosis, from Niceron's *Thaumaturgus opticus*.

with the greatest masters, an optical device has assumed a deeply pondered meaning.

During the course of the sixteenth century, anamorphic images continued to appear erratically in the North and South, in paintings, prints and theoretical treatises, though their authors do not always exhibit an adequate grasp of the optical principles involved. The classic phase of anamorphosis, during which it came to relate vitally to a series of scientific and theological concerns, occurred in France and Rome in the 1630s and 1640s. The theorist at the centre of the Paris-Rome developments was Jean-François Niceron, whom we have already characterised as a geometrical theorist of some note in the Mersenne circle. The second part of his *Thaumaturgus Opticus* (1646) is dedicated to a comprehensive treatment of anamorphic images and related varieties of 'artificial magic', to use his own term.[103] He provides lucid accounts of how to project anamorphic images using a perspectivally distorted grid (pl. 419), of the kind that had probably underlaid the most optical of the earlier images, such as those by Schön and Holbein. He also gives mathematical instructions for the design of other forms of anamorphosis: on surfaces which are pyramidal or conical (pl. 420); and curvilinear images which are designed to be viewed in cylindrical or conical mirrors. The curvilinear types became particularly popular as optical toys during succeeding centuries (pl. 421).

There is obviously an element of sheer entertainment in such images. The Château d'Esonnes of Ludovic Hesselin, owner of a Cigoli perspectograph (pl. 352), was a treasure house of illusions and curiosities, designed to astonish even a sophisticated observer like Queen Christina of Sweden, who was treated to such visions as burning cities and vast caverns.[104] But there were also serious sides to these visions—theologically and scientifically. Just as Pozzo was concerned to place extreme illusionism in the service of reverence, so Nicer-

421. Anamorphic image of a peasant carrying buckets, eighteenth century, to be viewed in a cylindrical mirror, Florence, Museo di Storia della Scienza.

on and a fellow member of his order, Emmanuel Maignan, saw the possibilities of anamorphosis within a religious context. The crucial episode in the interaction between the two Minim fathers occured during the second of Niceron's two residences at the convent of Sta. Trinità de' Monti in 1635 and 1642. On this latter occasion he painted a huge (lost) anamorphosis, *St. John the Evangelist writing the Apocalypse*, along one of the side walls of 104-foot gallery on an upper floor in the convent, while Maignan painted a companion piece, *St. Francis of Paola* on the other. Both men used a form of perspective machine to achieve their anamorphic projections. Niceron noted, entirely correctly, that the Cigoli device in the Hesselin collection could be angled in such a way as to provide an anamorphic image, but his own choice in practice was to use a form of Dürer's 'window' (pl. 422). The notional 'window' is constructed at the point on the wall at which·the near edge of the image is to be located. Given points across the 'window' can be registered by a small moveable bead on a vertical string, the top of which traverses a horizontal bar just below the ceiling. The precise placing of a particular point in the image, or of the divisions which comprise the distorted grid, can be obtained as follows: a scaled and reversed representation of the undistorted image is swung across the window and the bead moved to coincide with the required point in he design; the image is then removed and the draftsman extends a chord from the eye-point at A, past the bead and to the wall at L, where he records its position. The marking of key points in the image is confirmed by reference to a squared grid superimposed on the original design, to which the distorted grid on the wall corresponds. Maignan's method, recorded in his own *Perspectiva horaria* (1648) differs only in that he does not exploit the underlying grid but relies on the point-by-point plotting of the contours from the 'window' to the wall.[105]

In the vigorous intellectual community of the French convent in Rome, these strange images of saints in landscapes would have been appreciated as tours-de-force of perspectival cunning, but we should also remember that they were painted in a convent and that Maignan was a teacher of theology as well as an authority on such questions as the design of sundials. We have already seen that Kircher's style of natural magic could be seen simultaneously as providing entertaining diversions and as deeply resonant of the spiritual powers which lay behind the illusive appearance of reality. Kircher regarded artificial magic—he was understandably fascinated by anamorphic images—as a means by which human science could achieve effects which parallel those of natural magic. Niceron and Maignan used the resources of geometrical artifice to ape natural magic: their images of saints were insinuated by optical means into frescoes which appeared in the guise of peculiar landscapes when viewed from the front. The saints thus manifested the hidden spiritual order of God's creation, which to the casual eye merely seems a chaos of disparate forms.

The interplay of illusion and certainty in the works of Niceron and Maignan strikes obvious chords with the interests current in the circle of their fellow Minim in Paris, Marin Mersenne, and in particular with the philosophy of Mersen-

422. Demonstration of the method used by Niceron for painting his anamorphic wall painting of *St. John the Evangelist*, from his *Thaumaturgus opticus*.

Note: the left-hand side of the upper diagram continues at the right of the lower.

ne's supreme correspondent, Descartes. Moreover, Niceron and Descartes, though they never met, are known to have exchanged books.

In Chapter II I expressed scepticism as to how far the perspective of Niceron and other French theorists, and the more perspectival paintings by contemporary French painters, could be aligned with Cartesian thought. Perhaps that scepticism is beginning to look less justified in the light of Niceron's and Maignan's anamorphic images, which seem to signal a truly Cartesian awareness of the delusory nature of sensory experience. However, once the relevance of anamorphosis to Descartes's concerns has been admitted, I am not sure we can go much further, without making Niceron say something he did not intend. Whatever the mutual admiration of the two men for each other's grasp of advanced optics, Niceron's writings give no clear indication of a philosophy which can be aligned with Descartes's sophisticated and innovatory epistemology. Niceron's treatises bespeak a quite traditional view of the essentially geometrical nature of the visual process and of the mathematical rationality of the interaction between the eye and light. Indeed, the aim of anamorphic techniques was 'to represent perfectly a given object from a certain point'.[106] The lesson to be drawn was that anamorphosis certified the rules of perspective rather than undermined them.

Illusion, as we have seen, was a pervasive feature of art in Catholic Europe during the Baroque era, but the forms, meanings and general significance of illusion were certainly not the same for its many serious and less serious devotees. If we wish to set Niceron and Maignan into general patterns of seventeenth-century thought, I think that they rest more easily with the tradition of natural and artificial magic which runs from della Porta to Kircher (and back ultimately to Albertus Magnus, Roger Bacon and Nicolas Oresme) than within the Cartesian framework with which they are obviously as-

423. Anamorphic image of the 'eye of God' from Mario Bettino's *Apiariorum...*

sociated by strong circumstantial evidence. I think it is not a matter of chance that the subsequent life of anamorphosis as a phenomenon worthy of intellectual attention during the seventeenth century lay with the Jesuit 'magi', Athanasius Kircher, Mario Bettino (pl. 423) and Gaspard Schott.[107]

Anamorphosis was not to regain the intellectual prominence it enjoyed in the seventeenth century. Not surprisingly it enjoyed renewed popularity in the late eighteenth and early nineteenth centuries, carried up on the rising tide of demand for visual diversions of all kinds. It also appealed to those aspects of the Romantic imagination that delighted in an allegiance between science and astonishment. However, the later vogue, minor as it was, does not appear to impinge vitally upon the main theme of our present study. By 1800 the professional purveyors of 'artificial magic' could offer the public much newer and grander fare than anamorphic tricks.

If there is anything that the post-1800 varieties of natural magic share it is that they endeavoured to introduce forms of illusion which lay outside the traditional limitations of pictures designed according to one-point principles. These new forms of illusion sought to replicate the perceptual effects of parallax and motion. The effects of motion involved both the turning eye and the mobile subject. The earliest of the techniques to appear was the panoramic images which evoke the 'all-round' nature of our visual world. The first documented example is the circular device of Baldassare Lanci (pl. 338), which could be used to construct a hemispherical record of a scene from a revolving viewpoint. However, it is not clear whether the re-

424. Carel Fabritus, *View in Delft*, 1652, London, National Gallery.

425. F.J. Bandholts, *Panoramic Photograph of Albia, Iowa*, 1907, Washington, Library of Congress.

sult was to be viewed in a curved configuration—necessarily enlarged to make this possible, given the smallish scale of the instrument—or to be folded out flat, in which case it would produce a variety of curvilinear perspective. There is, to my knowledge, only one surviving painting before the late eighteenth century which appears to exploit the optical principles if not the actual method of Lanci's invention. This is the *View in Delft* (pl. 424) painted by Carel Fabritius in 1652.[108] Little survives today to justify Fabritius's high reputation as a perspectivist—the loss of all his large-scale illusions in architectural settings is particularly to be regretted—but this one little picture is enough to show that he had thought carefully about the problems of wide-angle views which had so troubled some of the Italian theorists, including Leonardo and Danti. The sweeping curvature of his view is precisely of the kind that Lanci's or a closely related method would produce, and it is very comparable to the effects of photographic panoramas which work according to curvilinear principles (pl. 425). The artist's alterations to the left-hand side of the composition, revealed on technical examination, suggest that he was concerned to mitigate some of the extreme consequences of his method, but the modifications have done little to disguise its exceptional appearance.

We know nothing about the conditions under which Fabritius's view was to be seen. There is no clear evidence that it was to be displayed on a curved surface, as in a round perspective box. It is possible that it was designed for viewing in a cylindrical mirror, as a kind of vertical anamorphosis, or even through a lens—though this latter technique would distort the verticals, as would a convex mirror. On the other hand, it may have been intended to be viewed frontally in the normal manner of an easel painting, in which case it may be regarded as an overt challenge to the assumption that standard perspective

corresponds to our normal manner of seeing. I rather favour this final possibility—namely that it is an experiment in 'natural perspective'—but we know too little about Fabritius's ideas to do more than speculate along these lines.

Panoramic images of cities from high viewpoints, which had first appeared in the sixteenth century, became quite widespread in the seventeenth. Perhaps the most famous is Wenceslaus Hollar's view of London take from the tower of Southwark Cathedral.[109] The 'unrolling' of an all-round view on to the flat surface of a drawing or print necessarily involved a series of perspectival compromises, and those early panoramas known to us do not appear to exploit consistent optical systems. The camera obscura, particularly Kepler's tent-type with a mirror revolving like the turret of a windmill at the top, could have aided the taking of the necessary views, and we have already seen the way in which Canaletto, Sandby and Cotman were to use cameras to produce a serial image of a wide prospect. By the early nineteenth century it was recognized that the camera obscura had 'proved of essential use' for the 'delineators of that beautiful representation called the Panorama'.[110] By this time the panorama was at the height of its popularity as a public spectacle.

The large-scale panorama as a 'step-in' spectacle was invented by Robert Barker in Edinburgh. From the vantage point of Calton Hill in his adopted city, he used a perspective frame to take a series of continuous views which could be arranged around a semicircle or, in its more developed form, around a complete circle. He patented his idea in 1787 as '*la Nature à Coup d'Oeil*'.[111] In 1789 he exhibited the first of his panoramas in London, and in 1794 his city-scape panoramas were joined in his new premises near Leicester Square by his stirring view of the *Grand Fleet at Spithead*, a scene which elicited an admiring response from Nelson himself. The striking

426. Henry Barker, Two of eight studies for a Panoramic Painting of Paris, 1802, London, Victoria and Albert Museum.

427. Thomas Hornor's view of London from the painter's platform, from Rudolph Ackerman's *Graphic Illustrations of the Colosseum, Regent's Park*, 1829.

effects of verisimilitude depended both on the all-embracing nature of the large-scale image, which measured over 280 feet in diameter, and upon special viewing conditions. The spectators were restricted to a central platform often in semi-gloom, while the view, the edges of which were concealed as far as possible, was cunningly top-lit by concealed windows.

The panorama of London exhibited by Barker in 1792 had been drawn by his teenage son, Henry Aston Barker, from the roof of the Albion Sugar Mills in Southwark, close to Hollar's vantage point. Some idea of the skilled draftsmanship involved may be gained from Henry's 1802 studies for a panorama of Paris (pl. 426).[112] The eight drawings confirm that the Barker panoramas were composed from a series of views, very probably with the aid of a perspective frame or camera obscura, rather than designed in a continuously curving sweep in the Lanci manner. This means that their panoramic images are essentially polygonal views arranged cylindrically, with the junctions between the serial views suitably 'softened'.

We know that a related procedure was followed in the design of the most celebrated of all the panoramas of London, Thomas Hornor's view from the top of the Dome of St. Paul's. Hornor took advantage of scaffolding which had been erected around the ball on the Dome in 1821 to take a panoramic survey of the city using Varley's Graphic Telescope: 'after satisfying himself of its capabilities, having erected an observatory on the dome of St. Pauls, . . . he fitted up a Graphic Telescope, and traced his magnificent panorama'.[113] The painting was executed from Hornor's designs by E.T. Parris and assistants in the upper part of a building specially designed for the purpose by Decimus Burton, the Regent's Park Colosseum. The splendid building and its great panorama opened with

428. Geometrical ascent to the galleries in the Colosseum, from Ackerman's *Graphic Illustrations*.

much to-do in 1829. One of the commemorative prints (pl. 427) shows the view across the Colosseum from one of the painter's platforms to another suspended vertiginously on the opposite side just below the curve of the Thames. The hordes of spectators who visited the completed spectacle ascended to the high viewing galleries by a revolutionary lift (pl. 428), emerging from deliberate gloom into the radiant light of the panorama's dome, with the prospect of London and its environs spread out below and around them.

Panoramas became all the rage following Barker's demonstrations. Examples appeared as far east as Poland and as far west as America. They were popular entertainment on a considerable scale, but this should not lead us to underrate their artistic qualities. These qualities are now impossible to demonstrate adequately, given the loss of almost all the key examples, but the comments by sophisticated observers and by a number of considerable artists testifies to their merits. Perhaps the saddest loss is the *Eidometropolis* of London painted by Thomas Girtin in 1799–1801. Surviving drawings by Girtin in the British Museum give some idea of the wealth of observation and grand visual scope combined in such views.[114]

The panorama was designed to overcome one of the limita-

tions of traditional painting—that of the static eye. During the early nineteenth century the first successful attempts were also made to introduce the effect of two-eyed vision, which was necessarily eliminated in all the one-point systems. Although the properties and some of the functions of binocular vision had long been apparent—Aguilonius, for example, illustrated the phenomenon of parallax (pl. 195)—the earliest sustained attempt to simulate the phenomenon in flat designs was made in, or shortly before, 1832 by Sir Charles Wheatstone, famed chiefly as a pioneer of electrical science.[115] In the paper of 1838 in which he outlined his invention, he framed the central question: 'What would be the visual effect of simultaneously presenting to each eye, instead of the object itself, its projection on a plane surface as it appears to the eye'.[116] In other words, he was seeking a way of designing the two slightly differing perspective views of an object seen by each eye, and of projecting them so that the left and right eyes would only see the picture appropriate to that eye. The instrument he devised was his reflecting stereoscope (pl. 429). The earliest images were simple parallax representations of geometrical forms. In the words of one observer, 'the original solid figure will be reproduced in such a manner that no effort of imagination can make it appear as a representation on a plane surface. This and numerous other experiments explain the cause of the inadequacy of painting to represent the relief of objects.'[117]

The announcement of photography shortly afterwards in 1839 gave Wheatstone the idea of exploiting the principles of his stereoscope for more realistic images than his linear diagrams of simple forms: 'at my request, Mr. Talbot, the inventor, and Mr. Collen (one of the first cultivators of the art) obligingly prepared for me stereoscopic Talbotypes of full-sized statues, buildings, and even portraits of living persons'.[118] To obtain the pairs of photographs two cameras were used, their lenses separated by the appropriate distance and angled in such a way as to imitate two-eyed vision.

The two steps needed to transform this cumbersome process and its unwieldly viewer into a readily manageable system

429. Charles Wheatstone's reflecting stereoscope, with two stereoscopic photographs, London, Science Museum.

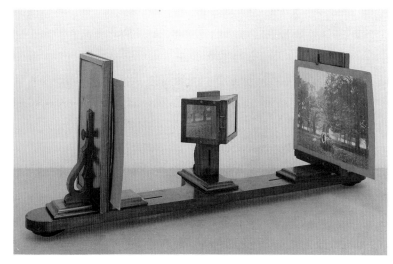

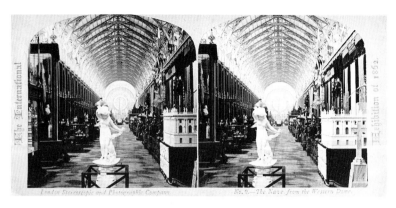

430. Stereoscopic photographs of the International Exhibition of 1862, Author's collection.

431. Lenticular stereoscope as designed by Sir David Brewster, London, Science Museum.

432. A Holmes-Bates stereoscopic viewer with photographic and geometrical images, Author's collection.

were both announced in 1849 by Sir David Brewster, the eminent Scottish authority on optics.[119] A formidable and argumentative figure, whom we will encounter as an important theorist of colour, Brewster characteristically became embroiled with the reluctant Wheatstone in a dispute about the priority of invention. Brewster attempted to promote the claims of two alternative inventors, without seriously denting Wheatstone's claim to be regarded as the originator of the stereoscope.[120] Brewster's own later refinements certainly made their own distinctive contributions. He devised a lenticular stereoscope of a compact and highly effective kind (pls. 430–1), and a stereoscopic camera in which the two lenses were set like two eyes. After an abortive effort to produce his viewer in Britain, he interested two Parisian opticians, Soleil and Dubosq in its potential. Their stereoscopic daguerrotypes with Brewster's viewer were displayed with considerable success at the Great Exhibition of 1851. Like Brewster's other popular invention, the kaleidoscope, his stereoscope was a raging success.[121] By 1856 something like half a million had been sold, and ten thousand different sets of photographic images were available. Of the later variants, that invented by the Harvard medical professor, jurist and essayist, Oliver Wendell Holmes, and improved by Joseph Bates (pl. 432) proved to be the simplest and most efficacious. The stereoscope provided endless hours of enjoyment for Victorian families within their own sitting rooms, as they were conducted on three-dimensional tours of exotic locations and sites of particular moment. We are not perhaps so far removed from the spirit of visual magic which had attracted della Porta and his immediate successors. Not for nothing did Brewster write a series of *Letters on Natural Magic*, which he addressed to that great author of historical romance, Sir Walter Scott.[122]

The most prophetic of all the new forms of pictorial illusion in the nineteenth century was the simulation of motion. The basic phenomenon behind the production of moving pictures, namely the persistence of vision, had been observed from the infancy of optical science. Leonardo's observation that a whirling firebrand appears to leave a circular trace in the eye was typical of the early observations.[123] During the first quarter of the nineteenth century the phenomenon became the subject of serious investigation. Rouget, in France, recorded that the blurred spokes of a rotating wheel appeared stationary when viewed through slits, while Faraday, in Britain, wrote a paper on 'Wheel Phenomena' in which he observed, for example, that if two superimposed cog wheels were rotated in opposite directions at the same speed the resulting impression is of a doubled set of stationary cogs.[124] The extension of such studies to the production of moving images appears to have been undertaken simultaneously by Joseph Antoine Plateau in Brussels and Simon Stampfer in Vienna.[125] Plateau had written on the underlying principles in 1829, but their realisation in a stroboscopic wheel does not seem to have been accomplished until 1833. Plateau's device (pl. 433) works as follows: a series of designs of a figure in successive positions are placed around the circumference of a disk; radial slits are cut in a concentric circle around the images; the disk is then revolved and the viewer looks through the sequence of slits from the back of

the disk at a mirror, which successively shows the figures in reflection. A flickering form of cinematographic motion is achieved. By a remarkable coincidence, Stampfer's essentially similar invention was being developed in 1832 and was patented a year later.

The instrument subsequently appeared under various names—stroboscope, phantasmascope, phenakistoscope and zoescope—and sucessfully joined the growing catalogue of optical novelties which were being marketed so widely in the nineteenth century. Variants inevitably followed. The most effective was the Zoetrope (pl. 434) invented by W.G. Horner of Bristol shortly after the Plateau-Stampfer inventions but not widely available until the 1860s. Horner's Zoetrope, or 'Wheel of Life' as it was commercially called, transformed the stroboscopic disk into a drum. The viewer peeps through a series of slits at the sequential images on the inner face of the opposite side of the drum as it revolves on its stand. This cylindrical method was further refined in 1877 by Emile Reynaud's Praxinoscope in which the images are watched via a series of mirrors mounted polygonally around the axis of the drum. The Praxinoscope relieves the viewer of the need to squint through revolving slits. The ultimate in this form of moving illusion appears to have been the Stereophantoscope, which Helmholtz described as using 'revolving stroboscopic disks . . . in the panoramic stereoscope' to create wide-angle views of moving forms in three dimensions.[126]

The reader will not need to be told that such instruments are bringing us to the threshold of cinematography. The early limitation of the stroboscopic systems to relatively simple images, such as drawings of dancing figures and springing cats, restricted the degree of reality which could be achieved. However, photographic techniques were shortly to develop to the point at which a series of instantaneous shots could be taken of an object during successive stages of its motion. Displayed stroboscopically, sequential images of humans and animals in action were found to coalesce into compelling illusions of real forms in natural motion. The story of these developments, in the hands of such pioneers as Eadweard Muybridge and Thomas Edison in America, and Jules Marey in France, belongs to the early history of cinematography and clearly lies beyond the feasible scope of our present study.[127]

PHOTOGRAPHIC POSTSCRIPT

The story of the invention of photography in France and Britain has often been told, and its broad outlines are reasonably clear, whatever details still remain to be clarified.[128] I do not intend to repeat the story here, but I think it will be useful to draw together those many threads in this chapter which lead towards the advent of photography and to see the extent to which it may be regarded as a logical (if not inevitable) outcome of the many attempts to contrive mechanical systems for the imitation of nature. Before doing so, let us remind ourselves briefly of the chronological landmarks in the development of photography itself, up to the point at which it became a working process on a commercial scale.

433. A stroboscopic disk as invented by Joseph Antoine Plateau, Author's collection.

434. Zoetrope or 'Wheel of Life' as invented by W.G. Horner, constructed by the Author.

217

435. Joseph Nicéphore Niépce, *View from his Window at Gras*, 1827(?), Austin, University of Texas, Gernsheim Collection.

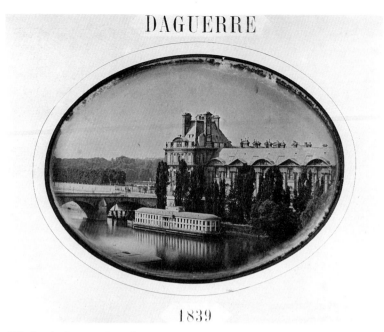

437. Louis Jacques Mandé Daguerre, *Le Louvre: Vue de Pavilion de Flore*, 1839, Paris, Conservatoire National des Arts et Métiers.

The earliest sustained efforts to fix the image in the camera obscura permanently were undertaken by Joseph Nicéphore Niépce in about 1816. He investigated various light-sensitive substances for this purpose, and by 1822 had succeeded in etching a photographic image into a copper plate which had been coated with asphaltum and exposed to light. By 1829 his work was sufficiently advanced (pl. 435) for him to enter into legal partnership with Louis Jacques Mandé Daguerre, who had begun to experiment along similar lines with light-sensitive chemicals in a camera obscura.[129] Although Niépce died in 1833, Daguerre continued to experiment intensively

436. Louis Jacques Mandé Daguerre, *Still Life with wine Flask and Casts of Sculpture*, 1837, Paris, Société Française de Photographie.

with a variety of techniques until by 1837 he had perfected a process which relied on the development of a latent image on iodised silver plates by the action of mercury vapours. The results (pl. 436) were startlingly brilliant. After an inconclusive attempt to attract commercial backing in 1837, the announcement of the invention of photography was finally stage-managed with triumphant success in Paris in 1839. A Government commission reported on the invention with unstinted praise and Daguerre received a life pension for his 'gift to the state'.[130] The Daguerreotypes of 1839 (pl. 437) confirmed the remarkable qualities of the new medium.

Preliminary notices of Daguerre's discovery reached Britain, where they stung William Henry Fox Talbot into action. Talbot had himself been endeavouring to fix the camera obscura image following his laboured attempts to draw with a camera lucida in Italy in 1833 (pl. 400).[131] Working with various processes on paper, rather than on copper plates, he achieved the first functioning negative in 1835 (pl. 438). By the time of Daguerre's announcement. Talbot's negative-to-positive process was capable of achieving quite sophisticated results, with the advantage over Daguerre's single images that the negative could be used for mutiple printings of the same picture. Before the full report on Daguerre's invention was available he had published a letter which gave *Some Account of the Art of Photogenic Drawing: or, the Process by Which Natural Objects May be Made to Delineate Themselves without the Aid of the Artist's Pencil*.[132] At this time Talbot was still experiencing problems in fixing his silver chloride images in a really permanent manner, but once Sir John Herschel, a close confidant, had demonstrated the use of sodium thiosulphate as a highly effective fixing agent, photographs of real quality and durability became increasingly possible (pl. 439).[133]

218

Latticed Window
(with the Camera Obscura)
August 1835

When first made, the squares
of glass about 200 in number
could be counted, with help
of a lens.

438. William Henry Fox Talbot, *Latticed Window* (paper negative), 1835, London, Science Museum.

439. William Henry Fox Talbot, *The Haystack*, from the *Pencil of Nature*, London, 1844.

The straightforward narrative of these events in standard histories of photography, fascinating though it is, tends to obscure rather than reveal how the motives of the leading participants depended in a very complex way upon a series of necessary conditions that had been established during the preceding years. I think it will be a fitting conclusion to this chapter if we look briefly at the most conspicuous conditions in turn. The order in which I will consider them is not chronological, but progresses roughly speaking from technical to social factors.

1. *The scientific technology of imitation*

We have already seen that the invention and perfecting of the camera obscura was intimately associated with scientific optics and geometrical perspective. The advances in optical instruments around 1800 played a conspicuous role in the upsurge of mechanical systems of imitation. The involvement of Ramsden, Ronalds and Herschel at various stages of this process underlines the connection. The associations of Niépce and Daguerre with the Chevaliers, a famous family of French instrument makers, makes the same point. Fox Talbot himself was a scientist of some note, having published papers on mathematical and optical themes. François Jean Arago, responsible for the 1839 report on the Daguerrotype, was a proficient physicist and astronomer, with whom Fox Talbot had worked in Paris in 1825. Sir David Brewster, in St. Andrews, to whom Fox Talbot communicated his results at an early stage, was a major scientist of optics and was responsible for the development in Scotland which led to that great early flowering of 'art photography' in the partnership of Robert Adamson and David Octavius Hill.[134] This list of scientific associations could be extended until it reached massive dimensions.

2. *Artistic recognition of the direct imitation of specific views*

The resistance amongst mainstream theorists to direct and literal imitation of nature was constant throughout the periods we have been studying, but by 1800 the actual practice of naturalistic art, even within the academies' exhibitions, was being consolidated particularly in Britain. Whether we are dealing with Constable's large ambition to become a truly 'natural painter' or with the humbler aims of the topographical illustrators, the supply and demand for recognisable images of real scenes had come to occupy a prominent place in the world of professional painting. Inherent in such images was the premise that a specific spectator was standing in a specific geographical location at a specific time. It is symptomatic of this specificity that at least one of the panoramas of London by the Barkers and the later panorama by Hornor prominently included foreground views of the roofs above which they were working, as did Eduard Gärtner's panoramic image of Berlin in the six magnificent canvases completed in 1834.[135] This same specificity of viewer and topographical location provides the conceptual context for the use of optical aids by Sandby, Varley and Cotman, and ultimately supplies one element in the ready-made framework for the photographic image.

3. *The rise of the amateur*

The increasing bands of amateur artists were little concerned to ape the history paintings esteemed by the academies, but rather with the making of small-scale works in convenient media as sensitive and pleasing representations of admired scenes. The presence of this market is vividly attested by the advertising literature produced by the makers of optical aids. The less and more successful forays into the field of optically-aided drawing by Fox Talbot and Herschel show that such pursuits were not limited to idle daughters of the gentry. This factor may legitimately be regarded as contributing to the aesthetic context for photography, although it was to be some time after the initial invention of photographic processes that they became conveniently accessible to the more casual amateurs. We should not forget, however, that such superb early photographers as Julia Margaret Cameron and Lady Clementina Hawarden stand as supreme exponents of this amateur tradition.[136]

4. Optical magic and popular entertainment

The photographic activities of Daguerre grew entirely naturally out of the tradition of optical entertainment which reached its peak in the nineteenth century. Daguerre had trained with Prevost, the master of a panorama in Paris, and had established his independent reputation through his hugely successful dioramas. These consisted of large painted scenes on translucent linen which could be transformed from night into day by cunning changes of lighting from both back and front. The pictorial effects of his first diorama in 1822 were extended in later versions by the introduction of real animals and other 'stage props', accompanied by sound effects.[137] When the 1829 agreement was drawn up between Niépce and Daguerre, it is easy to distinguish the voice of the gentleman 'amateur' from that of the entrepreneurial professional. Niépce, as the agreement records, had been endeavouring 'to fix the images which nature offers, without the assistance of a draughtsman' by means of 'the automatic reproduction of the image received by the camera obscura'. With a characteristic eye for the commercial opportunity, 'M. Daguerre, to whom he disclosed his invention, fully realises its value, since it is capable of great perfection, and offers to join with M. Niépce to achieve this perfection and to gain all possible advantages from this new industry.'[138]

By contrast, the whole thrust of Fox Talbot's efforts was dominated by the more scientific and philosophical aims of capturing a little bit of 'natural magic', to use his own term from the 1839 paper. He was particularly keen to emphasise the potential of photography for the recording of images in the microscope for scientific purposes. This is not to say that he was blind to its popular potential and commercial possibilities, but he shared little of Daguerre's entrepreneurial spirit. Even Sir David Brewster, whose kaleidoscope and stereoscope showed his sure touch in matters of popular optical diversions, did not immediately see the commercial implications of Fox Talbot's invention, advising his friend that it was not worth bothering to take out a patent in Scotland. Without the more 'vulgar' commercialism of Daguerre in the field of mass spectacle, the events before and after 1839 would not have moved as fast as they did.

5. The market for reproductive images

Both Niépce and Fox Talbot recognised at an early stage the way in which photographic reproduction could satisfy the increasing demand for relatively inexpensive images, whether in books such as encyclopaedias or as separate items. Niépce had shown considerable interest in the relatively new medium of lithography, and directed much of his early efforts to 'heliogravure', that is to say the photographic reproduction of engravings. Fox Talbot similarly believed that 'this invention may be employed with great facility for obtaining copies of drawings or engravings, or facsimiles of MSS'.[139] He also saw photography as satisfying the need for cheap portraiture, just as the physionotrace had been designed to do:

Another purpose for which I think my method will be found very convenient is the making of outline portraits, or *silhouettes*. These are now often traced by the hand from shadows projected by a candle. But the hand is liable to err from the true outline, and a very small deviation causes a notable diminution in the resemblance. I believe this manual process cannot be compared with the truth and fidelity with which the portrait is given by means of solar light.[140]

All these factors, already existing within the tradition of mechanical imitation, meant that photography arose as an organic part of historical progression, comprising a number of related strands. Technically, aesthetically and socially, the ground was well prepared. The undeniable fact that the consequences of photography were to swamp the previous tradition should not lead the historian to overlook its natural place within that tradition. Even Gargantua had a family tree.

It is symptomatic of photography's place in this tradition that the responses to its invention and artistic potential should essentially be the same as those we have described in connection with earlier systems of mechanical imitation. On the one hand there is delight and pride in the precision of the image; on the other there is distrust of its lack of humanity and, ultimately, dismissal for its mindless lack of 'Art'. The story of the varied reactions to photography is a vast topic in its own right. In this context I think it will be sufficient to quote just one author to show how the earlier debates find new echoes and also how complex were the issues when mechanical imitation finally became a reality. The author is John Ruskin.

During the early years of photography, Ruskin wrote from Italy in the first flush of enthusiasm that

> Daguerreotypes taken by this vivid sunlight are glorious things . . . It is a noble invention—say what they will of it—and anyone who had blundered and stammered as I have done for four days, and then sees the thing he has been trying to do so long in vain done perfectly and flawlessly in half a minute won't abuse it afterwards.[141]

About twenty years later, on sober reflection, he had come to recognise that the visual 'truth' of photographs is of a necessarily incomplete and selective kind and that their properties stood in conflict with the non-mechanical values which he had come to see as paramount in 'Art':

> their legal evidence is of great use if you know how to cross-examine them. They are popularly supposed to be 'true', and, at worst, they are so, in the sense in which an echo is true to a conversation of which it omits the most important syllables and re-duplicates the rest. But this truth of mere transcript has nothing to do with Art, popularly so called, and will never supersede it.[142]

Ruskin's subtle, complex and shifting views of the relationship of art and reality in the context of seeing and knowing brings us naturally to the question of the role of the mind with respect to optical perception. This question provides a major theme in the other chapter of this part of our study.

CHAPTER V

Seeing, knowing and creating

The story of spatial representation in eighteenth- and nineteenth-century Europe and nineteenth-century Britain centres around a major paradox. This paradox is that the theoretical aspects of optical and geometrical space became ever more widely discussed in the literature on the arts and sciences at the same time as the hold of perspectival techniques on the practice of the 'Fine Arts' was being radically loosened.

Questions of how we read depth, of the perceptual relationship between the various senses, of the technical functioning of the sensory organs, and of the relative status of the senses with respect to knowledge were amongst the central issues of the age. The volume of literature on the technical aspects of perspective and projection in pure mathematics and in such applied fields as cartography, military science, architecture, design and engineering, reached enormous proportions. There was more teaching available and there were more instructional books published for artists and technicians than ever before. Indeed, it will not be possible within the limits of this chapter to do more than touch upon a few of the interesting and characteristic items from the vast body of available material. On the other hand, allowing for the partial exceptions of Jacques-Louis David and his orbit, and some topographical artists in Germany, the theory and practice of linear perspective ceased to play a vitally creative role in the forefront of painting. This is not to say that paintings from this era would have looked the same if their creators had been ignorant of perspective but rather that the exercise of perspectival planning generally possessed little or nothing of the intellectual and aesthetic urgency that it had held for many of the artists we have studied in the earlier chapters.

I plan to organise our exploration of this paradox around three main themes. The first investigates the continuities and developments in perspectival geometry in a range of literature from advanced mathematics to technical illustration. The second looks at the optical, perceptual and philosophical issues which were raised by the juxtapositions of nature, vision, the mind and geometrical knowledge. The third is concerned with the articulation of aesthetic attitudes in their own right, as various authors attempted for the first time to define in a systematic way the specific emotional and intellectual areas of valid operation for the 'Arts' *in contrast to* the 'Sciences'.

When we learn that the characters involved are as diverse as Gaspard Monge, the French founder of descriptive geometry and technical illustration, and John Ruskin, the English aesthete who was the avowed enemy of technological 'tyrannies', we may catch an initial glimpse of the extreme contrasts which lie beneath the paradox. To watch these contrasts developing, I propose to return to France about 1700, to the point at which it is still possible to identify authors who stood centrally in the Renaissance tradition of art and science. One of the most rewarding of these figures is Philippe de la Hire, son of the painter and supporter of Bosse, Laurent de la Hire.

GEOMETRICAL CONTINUITIES

Philippe de La Hire is an almost perfect intellectual embodiment of the intersecting traditions of art and spatial geometry with which we have been concerned. Trained as a painter, in the footsteps of his father, he became a distinguished mathematician, astronomer, physicist, optician and engineer.[1] His *Nouvelle méthode en géométrie* (1673) stands in clear line of descent from the perspectivists' methods and the stone-cutting tradition, dealing as it does with conic sections in terms of geometrical projections of circles, rather than resorting to the tools of Cartesian analysis. Not surprisingly, when he encountered the generally neglected works of Desargues, he was immediately drawn to his predecessor's methods. In 1679 he was responsible for making the manuscript copy of the *Brouillon projet . . .* which served to transmit Desargues's projective techniques to later centuries. La Hire continued to attack Apollonian problems on his own account in his *Nouveau éléments des sections coniques* using Cartesian techniques, and in the book which seemed to be the last word on the subject, his *Sectiones conicae* of 1685. We may recall that Hamilton acknowledged La Hire's pre-eminence in this field. La Hire's fascination with visual geometry also found expression in a treatise on the optics of vision, which set the tone for a line of enquiry that we will follow in the next section of this chapter.[2] The practical dimensions of his interests are represented by his work as a hydraulic engineer, which included the renovation of one of Desargues's schemes, his authorship of a book on

440. Perspectival 'pantograph' for drawing plans in perspective projection from Johann Heinrich Lambert's 'Anlage zur Perspektive', 1752, Basel, Universität Bibliothek.

theoretical and practical mechanics, his Professorship at the Académie Royale d'Architecture in 1687 and his posthumously published treatise on the media of drawing and painting.[3] The only factor spoiling this picture, from our point of view, is that he does not appear to have written the treatise on linear perspective that he was eminently qualified to do.

La Hire's activities stress that the conventional story of the virtual disappearance of projective geometry between the era of Desargues and the late eighteenth century stands in consid-

441. The principles of the 'perspective protractor' as described in Lambert's *La Perspective affranchie*, Zurich, 1759.

E—observer CD—protractor

To project lines subtending angles of 40° at points P[1] and P[2]: join P[1] to points 20 and 60 on the scale AB; join P[2] to points 20 and 60 on the scale AB. (A solid whose nearest angle is 40° is constructed from P[1].)

erable need of qualification. The great Newton, for example, was certainly responsive to the value of projective procedures: 'if onto an infinite plane lit by a point source of light there should be projected the shadows of figures, the shadows of conics will always be conics, those of curves of the second kind [cubics] will always be curves of the second kind . . .' and so on.[4] The careers of the two major contributors to the geometrical theories of projection in the eighteenth century, J.H. Lambert and Gaspard Monge, also underline the persistence of the interlinked interests we noted in the earlier phases of three-dimensional geometry. Lambert was an important mathematician, astronomer and theorist of cartography, while Monge rose as a mathematician through his involvement with the military sciences of fortification and gunnery. These two great geometers provide the dominant figures in this section of our study. I plan to take Lambert first, both because he belongs to an older generation and because his research was more directly concerned with pictorial perspective.

Johann Heinrich Lambert, whom we will also encounter as a colour theorist of note, rose from humble origins through minor teaching posts in Switzerland to become a member of the Prussian Academy of Sciences in Berlin.[5] He won a European reputation as a philosopher, mathematician, astronomer, cartographer and pioneer of photometry. His concerns as a cartographer were inextricably linked to perspectival questions: 'a map should bear the same relation to countries, to hemispheres or even to the entire earth as do engineering drawings to a house, a yard, garden, field or forest. But it [the globe] has a spherical surface, and all the requirements cannot be satisfied simultaneously, and it is therefore necessary to emphasise one or several especially valuable requirements at the expense of others.'[6] He then proceeds to outline the respective merits of orthographic (parallel), stereographic (perspectival) and central projection in the making of maps. These interests related intimately in their turn to his research in the field of spherical geometry, in which he became renowned as one of the pioneers of non-Euclidian concepts. His study of such figures as triangles and rectangles on the surface of a sphere led him to consider types of geometry in which the sum

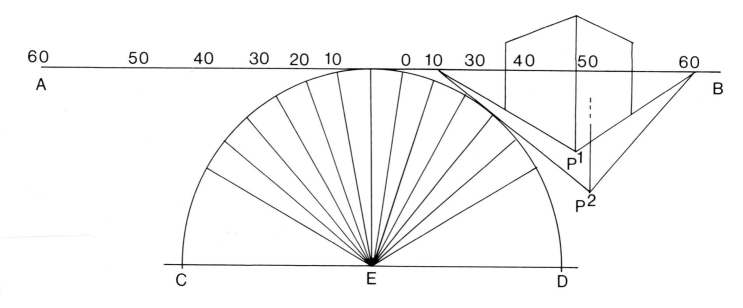

of the inscribed angles may be more or less than the Euclidian figures of two and four right angles. He also conclusively demonstrated the irrationality of the ratio (π) between the radius and circumference of a circle.

Lambert's activities as a perspective theorist occupied a prominent place in his work from a relatively early stage in his career. In 1752 he wrote a manuscript treatise, 'Anlage zur Perspektive', which was followed in 1759 by his *La Perspective affranchie* (*Free Perspective*), published simultaneously in French and German versions.[7] A second edition appeared in 1774, amplified by a historical review drawn partly from Montucla's *Histoire des mathematiques* (1758) and partly from his own continued studies of earlier writers such as Brook Taylor. One of the chief points of interest in his unpublished manuscript was his design for a perspective machine in the form of a 'distorting pantograph' which automatically transcribes a given ground plan in orthodox perspective (pl. 440).[8] A simplified device appeared in his published work. However, the dominant thrust of his *Free Perspective* was to accomplish perspectival control without recourse to ground plans and elevations. This ambition is clearly signalled by its subtitle,'*Without the Encumbrance of Geometrical Plans*'. His initial claims for the complete originality of his approach might have been tempered if he had access at that time to Brook Taylor's work, but his techniques do demonstrate a high level of independent inventiveness.

His aim was to facilitate the perspectival drafting of a line of any given length at any required angle directly on to the drawing surface without the aid of laborious projection from a preconceived ground-plan. At the heart of his technique lies his 'perspective protractor', which consists of a graduated semicircle, the centre of which is envisaged as the viewing point, with the 90° axis impinging on the central vanishing point on the picture plane (pl. 441). The protractor is used to mark a scale of angular measurements along the horizon. Each point on the scale will correspond to the vanishing point of a line at a given angle to the perpendicular axis of sight in a horizontal plane. Thus, if we wish to draw in perspective projection two lines meeting each other at an angle of 40°, the draughtsman simply joins two points 40 units apart on the horizontal scale in such a way that the apex of the angle appears in the desired position on the drawing surface.

The protractor also enables a given line at any angle to be cut to any required length. A given line (AB) on the drawing surface (pl. 442) is extended to the upper scale to give its angular measurement, that is to say, in this instance, 40° from the perpendicular axis of sight and 50° from the plane of the intersection. The first angle is halved and the corresponding point (20) is marked on the other side of the scale. The length and scaled division of the line can now be read by extending lines from point 20 to points on a uniform scale along the base of the drawing surface. This procedure is geometrically equivalent to the use of 'measure-point' in the British treatises of the Brook Taylor succession, and if the line FG were to be extended to meet ST, a proof corresponding to that in plate 291 could be undertaken. Looking at Lambert's technique in operation, as in the practice of topographical representation

442. Lambert's method for the cutting of a line at a given angle to a required scale, as described in *La Perspective affranchie*.

AB—horizon
ST—base of picture plane, divided into a scale
FG—the given line at 40° to the axis of sight meeting the horizon at C
The angle is halved and the equivalent point (20°) is marked at M to transfer 6 scaled units to FG, draw MH and MI.
Note: M is equivalent to the 'measure point'.

(pl. 443), it is easy to see how the convenient scale of angle along the horizon and scale of length along the base permit the draftsman the desired measure of 'freedom' to dispose the forms at any angle and precisely where he wishes them to be on the drawing, while at the same time conforming precisely to the rules of perspective. With the necessary care and patience, complex effects of oblique perspective can be achieved with this method.

Other sections in Lambert's *Free Perspective* and in his subsequent writings take up a rich series of perspectival themes which deserve further independent study. From our present standpoint, we will be interested to notice that he instructs the reader in the use of a proportional compass in judging the ratios of the height of an object above and below the horizon.[9] It is typical of his historically informed analyses that he should follow Bosse and others in recommending this use for the compass. He was one of the first authors after Leonardo to explore the possibility that proportional diminution in space

443. Houses and an avenue of trees in perspective, from Johann Heinrich Lambert's *La Perspective affranchie*, Zurich, 1759.

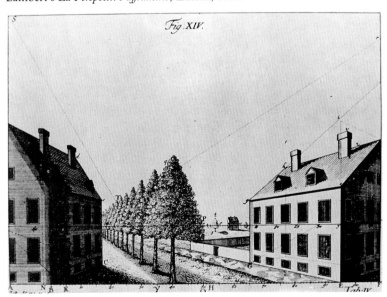

444. 'Perspectival' method for drawing a line through a given point parallel to two given parallels, based on Lambert's *La Perspective affranchie*.

L¹, L²—parallel lines P—given point
Draw BP and extend to V; draw V to any point (A) on L²; join A to D and B to C, crossing at F; join F to V; draw AP, cutting FV at G; draw BG, extending to R. PR is the required parallel.

might be regarded as equivalent to musical intervals. Another Leonardesque theme he takes up, probably from Guidobaldo, is the 'inverse problem' of perspective; that is working from a given projection towards the viewing position in relation to the object and intersection. Finally, near the end of his treatise, he shows his awareness of the power of line geometry of a perspectival kind to solve certain problems with only the aid of a straight edge (pl. 444).

Of the secondary themes in his *Free Perspective*, the one which was to hold the greatest long-term interest was his 'military or soldier's perspective'. Following the pioneer work by Christian Rieger, *Perspectiva militaris* (1756), this form of projection was increasingly favoured in eighteenth-century military circles for the representation of fortifications.[10] According to this system, the form is displayed orthographically (pl. 445); that is to say, as if seen from an infinitely extended viewpoint. The advantage of such parallel projection is that it enables the spatial disposition of the structures to be visible at a glance while at the same time permitting the measured dimensions of the forms to remain constant in one, two or three planes, since perspectival diminution is eliminated in whole or in part. The body of accurate informative potentially available from an orthographic projection of a fortification

445. Non-convergent or 'military' perspective, from Lambert's *La Perspective affranchie*.

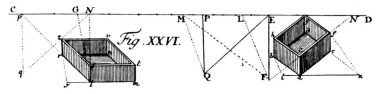

446. Perspectival projection of a pyramid by the intersection method, from Gaspard Monge's *Géométrie descriptive*.

would effectively rival that provided by separate plans, elevations and perspectival views of the same structure. It was this type of 'military' perspective that was to provide the foundation for Gaspard Monge's work in descriptive geometry.

Monge was trained as a draughtsman at the French military school at Mezières.[11] He rapidly attracted attention through his precocious abilities to see the most economical solutions to the three-dimensional problems posed by the design of fortifications in given locations so as to present the attackers with the least favourable targets while simultaneously giving the defenders the best lines of fire. His work on fortification design would have introduced him to the science of geometrical stone-cutting (stereotomy), as represented most spectacularly in the eighteenth-century by A-F. Freziér's *La Théorie et la pratique de la coupe des pierres . . . ou traité de stéréotomie* (1754), which stood as a worthy heir to the tradition initiated by Philibert Delorme.[12] The reforming zeal with which Monge approached the application of mathematics to utilitarian prob-

447. Shadow cast by a cube using a light from an infinitely distant source from Monge's *Géométrie descriptive*.

448. Projection of the shadow cast by a sphere on a cylinder by a light from an infinitely distant source from Monge's *Géométrie descriptive*.

Shown in plan (below) and elevation.

lems was given an opportunity to flourish by the French Revolution. He became Navy Minister, served on the Commission of Arts, was responsible for advising on the Napoleonic plunder of historic treasures from Italy and Egypt, and worked with lasting effect on the reform of French education in mathematics, particularly as applied to technical subjects such as engineering and mechanical drawing. He was active as a teacher and administrator in the newly established École Polytechnique and École Normale during the 1790s.

The most influential publication of his ideas was not directly supervised by Monge himself. His *Géométrie descriptive . . .* of 1799 comprises the text of his 1795 lectures at the École Normale as prepared for publication by his colleague Jean Hachette while he was absent on his official travels.[13] His projective techniques did exhibit a concern with some traditional problems, such as the perspectival drawing of a form from plan and elevation (pl. 446) and the shadows cast by bodies from adja-

cent and infinitely distant sources (pl. 447). This latter interest led, as it had for Marolois and Hamilton, to complex analyses of shadows cast on compound and curved surfaces (pl. 448). The relevance of shadow projection for the technical representation of three-dimensional structures had earlier been underlined by Dupain de Montesson's *La Science des ombres . . . avec le dessinateur au cabinet e à l'armée* published in Paris in 1750. These problems of spatial description led naturally to his own particular brand of descriptive geometry, which used the tools of geometrical graphics to 'express the position of any point in space'.

Monge advocated the cause of his descriptive geometry with a sense of missionary zeal: 'it is a means of investigating truth; it perpetually offers examples of passing from the known to the unknown; and since it is always applied to objects with the most elementary shapes, it should necessarily be introduced into the plan of national education'.[14] Its

449. Studies of curved surfaces and their intersection, from Monge's *Géométrie descriptive*.

the particular points through which it passes, but by being able to construct the generating curve through any point.[16]

The more abstract complexities of such descriptive geometry (pl. 449) clearly lie outside our present concerns, but Monge was always concerned to emphasise the practical implications of his techniques for the typical range of utilitarian sciences that we have already encountered with some frequency—fortification, cartography, stone-cutting and any form of illustration which has to deal with the abutting of straight and curved planes. He also specifically addressed himself to questions of artistic representation.

Painting, he believed—very much in line with the French academic tradition—embraced an expressive dimension, which was aimed at inducing a sense of high philosophical principles, and a formal dimension, which required scientific exactitude in execution. 'Nothing is arbitrary' with respect to these formal requirements.[17] For example, the appearance of an object depends on the tangents of the planes of the forms in relation to the eye of the spectator, the angle of the incident

450. Hatching lines in an engraving, describing the lines of curvature of forms, detail from Hendrik Goltzius's *Pygmalion and Galatea*.

intellectual-technical discipline involved learning how 'to define the position of a point in space' by reference to 'those other objects which are of known position in some distinctive part of space, the numbers of objects being as many as are required to define the point'.[15] In its simplest form—and Monge was always seeking the simplest sufficient answer in each case—this definition can be accomplished by reference to two intersecting planes on which the projection of the point is known.

From the basic principles of spatial description, he moves on to more complex cases, such as the definition of three-dimensional curves:

'It is evident that all curved surfaces may be generated by the movement of certain curved lines, and that there is not any surface whose form and position cannot be completely determined by an exact and complete definition of its mode of generation. . . . The form and position of a curved surface is not, therefore, determined by knowing the projection of

451. Stellated body in perspective with cast shadow, from P. Heinecken's, *Lucidum prospectivae speculum*, Augsburg, 1727.

light and its distance: 'for each point on the surface, the intensity of light is in direct proportion to the size of the angle of incidence of the ray on the tangent plane at that point and in inverse proportion to the distance from the luminous source'.[18]

Although he would hardly expect the painter who depicts the complex planes of the human body to make such an analysis in each case, he did believe that anyone who 'has been practised in researching lines of curvature in a large number of different surfaces which are susceptible to exact definition, will be more aware of these contours and their locations' when faced with a model.[19] A more literal application of his descriptive techniques occurs in the practice of engraving, in which the parallel lines of hatching which describe the convexity of a form 'are the projection of lines of curvature on the surface which they wish to print' (pl. 450).

There is, it must be confessed, an unrealistic tone in Monge's admonitions, and, for that matter, those of Lambert, in as far as they require the artist to master the geometrical rationale behind their procedures and to be able to see the advantages in following their demanding instructions in practice. In the specialised field of technical illustration, the advantages are considerable, and, as we will find later, the technique of orthogonal description produced superb results. In the 'Fine Arts' the advantages were less clear. Were the geometers beginning to talk only to themselves?

Those painters in the eighteenth century who were concerned to master the technicalities of perspectival representation would generally have turned to the traditional text-books or to the new books which adopted standard approaches, such as those by Paul Heinecken in Germany (pl. 451) and Jean Courtonne and Edmé-Sébastien Jeaurat in France.[20] But there is considerable evidence, in France in particular, that few painters were prepared to bother themselves much with artisitic perspective at an advanced level. Even those artists during the middle years of the century who were most concerned with the traditional academic disciplines of religious and historical painting appear to have attended to questions of perspective only to the degree necessary to achieve reasonably convincing effects of space and architectural structure. Courtonne, who wrote as an architect for architects, lamented that 'perspective . . . has all but vanished from the sacred hierarchy of the Fine Arts'.[21] It is generally true to say that perspective science continued to flourish more vigorously within the schools of architecture (with authors like Bretez and Courtonne) and military science (Jeurat) than in the world of the professional painter.

The religious paintings of Jean Restout, which speak an admiration for Eustache le Sueur, do represent an exception to this rule, as do (to varying degrees) the works of specialist painters of architectural caprices, such as Jacques de Lajoue, Michel Boyer and Hubert Robert.[22] The other group of artists who necessarily concerned themselves with perspective were those landscapists involved in topographical representation. The dominant landscape painter around the middle of the century, Claude Joseph Vernet, was able to use perspectival recession to dramatic effect in his great panoramas of Naples in 1748 and in his officially commissioned 'portraits' of the ports of France, such as those of Bordeaux (1759) and Rochefort (1763).[23] It was one of Vernet's protégés, Pierre Henri Valenciennes, who was responsible for writing the most intelligent book on perspective by a practising painter during the course of the eighteenth century in France.

Valenciennes, having studied perspective as a student, tells of a meeting with Vernet in Rome.

'I see', he said to me, 'that you have learnt perspective; but I also see that you do not *know it*. . . Don't worry', he added seeing my surprise, 'you understand enough at present for me to show it to you in a single lesson'. And this is what he proceeded to do, teaching me about the truth of the Distance Point, and explaining to me very clearly the application of this principle to painting.[24]

The function of this anecdote, in the context of Valenciennes's *Eléments de perspective pratique* (1800), is to reinforce his message that a geometrical understanding of the technical procedures of perspective needs to be seasoned by the experience of pictorial practice in representing scenes: 'almost all the Geometers, who have not studied painting and who, as a consequence, never make their theory accord with the practice necessary in copying Nature, can never be make themselves comprehensible to Artists'.[25] The major lesson to be learnt from practice, for Valenciennes, consists in acquiring the ability to imitate nature in conformity with 'the charm and sublimity of the *Beau Idéal*'.[26]

Valenciennes provides a highly competent outline of some basic geometrical procedures, showing the correspondence between the distance-point construction and the more compact use of scales in the Desargues manner (pl. 452). He also draws out some of the implications of perspectival scaling for landscape painters (pl. 453). When it comes to applying these procedures in practice, Valenciennes recommends the student

452. Scaled system of perspective projection, from Pierre Henri Valenciennes's *Eléménts de perspective pratigue*, Paris, 1800.

The lines continue at the right to the viewing point.

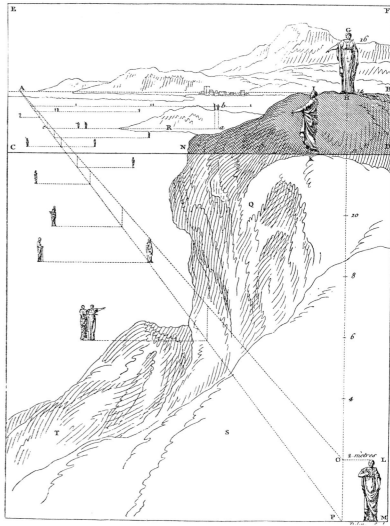

453. Perspectival scaling of figures in a landscape with a high horizon, from Valenciennes's *Eléménts de perspective pratique*.

454. Pierre Henri Valenciennes, *Buildings on the Palatine*, c.1783, London, Collection of John Gere.

455. Pierre Henri Valenciennes, *The Ancient City of Agrigentum*, 1787, Paris, Louvre.

to look at paintings by Poussin (especially the *Sacraments*), Veronese, le Sueur (the *Life of St. Bernard*), La Hire and Vernet.[27] These artists show how geometrical rules, the observation of nature and the search for the higher imaginative beauty of the 'Ideal' can be combined. Valenciennes's own paintings, rather underrated today, show how his fresh studies of views in nature (pl. 454) are informed by his understanding of spatial structures and cast shadows, while his set-piece compositions (pl. 455), which are often controlled by strongly perspectival motifs, betray the eye of an artist who has responded directly to natural effects.

None of this somewhat muted perspectival activity in eighteenth-century French painting had any obvious contact with the rigorous formulas of Monge. However, there were increasing signs during the second quarter of the century that artists were turning again to the spatial description of those very 'objects with the most elementary shapes' which provided the focus of Monge's attention. The most decisive developments in this direction became apparent in the form of a series of highly pictorial drawings by an architect, Etienne-Louis Boullée. That this development should occur within the field of architectural design is not altogether surprising, since the geometrical traditions had retained a stronger hold in the Academy of Architecture than in the Academy of fine arts.

The dominant principle in Boullée's architectural teaching and in the manuscripts which summed up his ideas in and around the 1780s was his reverence for the elemental forms of regular bodies as inherent in nature. The more regular the form, the more its divine perfection would become explicit to the eye of the beholder:

Weary of the ineloquence and sterility of irregular volumes, I proceeded to study regular volumes. What I first noted was their regularity, their symmetry and their variety; and I perceived how this constituted their body and their configuration. What is more, I realised that regularity had alone conveyed to man a clear conception of the shape of volumes, and thus he gave them descriptions which . . . resulted not only from their regularity and symmetry but also from their variety.[28]

Of all the regular bodies, the sphere was to be regarded in true Renaissance fashion as the most perfect and endlessly fascinating.

Boullée's visionary architecture combines the aesthetic perfection of elementary bodies with an awesome sense of extended volume. Nowhere are these qualities more potently expressed than in his *Cenotaph for Newton* (1784). The cenotaph consisted of a massive sphere set on a cylindrical podium. The interior of the vast hollow orb (pl. 456) was punctured with apertures through which sunlight could filter in imitation of the moon and stars. This design was Boullée's supreme attempt to 'attain the unattainable', that is to say to invoke the infinite and ineffable majesty of the Newtonian cosmos in all its sublime order. Disorientated and dwarfed, 'the onlooker finds himself as if by magic floating in the air, borne by the vaporous images into the immensity of space'.[29]

456. Section of the projected cenotaph to Newton, from Etienne-Louis Boullée's *Architecture, Essai sur l'art*, Paris, Bibliothèque Nationale, MS F 9153.

457. Etienne-Louis Boullée, *Interior of the Cathedral*, London, Royal Institute of British Architects.

458. Jacques-Louis David, *Oath of the Horatii*, 1784, Paris, Louvre.

In his designs for monumental buildings in the city he is able to evoke comparable effects of infinite space through perspectival means. His scheme for the Cathedral (pl. 457) reflects his desperate striving to make a worthy 'homage to the infinite Being'.[30] The structure 'should, if that were possible, appear to be a universe'. His design consists of temple-sized structures within a temple stretching into the remote distance and capped by floating vaults. The optical technique is similar to the effects of 'endless' repetition we noted in the paintings of John Martin. The architectural elements are multiplied so that 'the successive aspects in which they are revealed to us are removed continuously until we can no longer count them. . . The greatest magnificence and the most perfect symmetry, that is what results from the order that extends in every direction and multiplies them in our glance. . . The laws of optics and the effects of perspective give an impression of immensity.'[31] Albeit in a more intellectual and classical fashion, Boullée is creating a form of Newtonian sublime which is comparable to the visions of endless space in the paintings of Turner. A German parallel is provided by the visionary stage sets of Karl Friedrich Schinkel, which use geometrical masses to articulate vast slices of infinity.[32]

Although Boullée's designs are for buildings, I think it is right to consider them within the context of a study devoted chiefly to painting, in that his 'paper architecture' has notably pictorial features, as he himself fully acknowledged: 'this type of architecture based on shadows is my own artistic discovery. . . If I am not mistaken, Artists will not refrain from following it.'[33] At the time when he was completing his most spectacular designs a group of French painters, led by Jacques-Louis David, were indeed returning to the simple grandeur of elemental forms described by the directional play of light within canonical boxes of space (pl. 458). David's

Oath of the Horatii (1784), the archetypal picture in this movement, does not exploit the vast space of Boullée's Newtonian sublime—that would have been quite inappropriate for a narrative focused on a few figures—but it does exhibit the same stripping of forms to their elemental components, in the sharpest possible contrast to the encrusted elaboration of the Rococo style.

The context within which David worked drew him increasingly towards the world of fundamentalist architects, revolutionary scientists and social engineers.[34] The austere architecture in his mature paintings seems to reflect not so much his own studies in Italy as the building style of Boullée's greatest successor as a propagandist for visionary classicism, Claude-Nicolas Ledoux, who was erecting a series of monumentally forbidding gates around the city of Paris.[35] In 1788 David painted a classicising double portrait of the major scientist and reformer, Antoine Lavoisier with his wife, who was a pupil of the painter. During the next decade he was actively embroiled in the Revolution, as one of the signatories to the King's death warrant and subsequently as the supreme master of artistic activities at the heart of the new regime. These developments brought him on a convergent course with the great Monge, whose quest for mathematical concision in the service of society is so closely in tune with David's pictorial and political aspirations at this time.[36]

David's *Oath* possesses a simple austerity of pictorial structure which looks back beyond the revered example of Poussin to the earliest ideas on the use of perspectival space in the service of narrative. The emphatic lines of the construction focus our attention on the point of harsh tension at which the three swords are held aloft by the father, while his sons swear to

459. Analysis of the perspective of Jacques-Louis David's *Oath of the Horatii*.

Note: the orthogonals converge to the vanishing point accurately; the diagonals through the large 'squares' along the central axis are not coordinated precisely with the other large and smaller 'squares'.

defend the Roman ideal to the death. As in a Renaissance picture, the scale of the figures is anchored to the tiling of the floor. Each of the men is equal in height to the corresponding horizontal length of the interval between the stone strips on the floor (pl. 459). I do not think it is coincidental that this should recall the Albertian formula. There was a renewed wave of editions of Alberti's treatise at just this time, and Masaccio's frescoes were receiving fresh attention following the restoration of the fire-damaged works in the Carmine.[37] The *Oath* represents David's supreme attempt to return to the very fundamentals of narrative painting on a perspectival stage.

This being said, however, the painting's air of Euclidian 'prospect' (to use Poussin's term) is more apparent than real. The geometrical scheme of the floor stops some way short of geometrical precision, and there are other inconsistencies, such as the extension of the pier behind the grieving women to a point apparently below the ground level as defined on the left of the painting. David did not profess a high level of technical concern with perspective. He confessed, in an often repeated statement, that 'other artists know perspective better than I do, but they do not feel it as well'. His pupil, E.J. Delécluze, records that David 'was obliged to have recourse to an outside hand', that of the architect Charles Moreau, when he needed a 'purely scientific' perspective setting for his *Oath of the Tennis Court* (1791).[38] Delécluze himself helped David in the preparations for the *Leonidas at Thermopylae* by casting a 'topographical plan' of the pass at Thermopylae into perspectival views from three alternative viewpoints.[39] David obviously recognised the value of accurate perspectival description but did not aspire to be 'an engineer or demonstrator of perspective' on his own account. I think the situation is not unlike that in Poussin's perspective constructions. The artist is careful to give the impression of rational calculation, and uses space with fine pictorial judgement, but does not follow the long-winded letter of the optical law in each instance. Other projects by David, such as his schemes for a painting of Homer in 1794, do show a greater precision of geometrical construction than the *Oath*, but their sense of solid geometry remains as a pictorial effect rather than a structural cause.[40]

There is, therefore, no case for forcing Mongean descriptive geometry and Davidian classicism into an arranged marriage. What we are witnessing is the convergence of ideas which arose from closely related bases: in David's case from his study of classic design in those Renaissance and baroque masters who practised the science of art; and in the case of Monge from the science of three-dimensional design as associated with military architecture and the stereometric cutting of masonry in complex structures. We may perhaps sense some kind of spiritual affinity between David and Monge on this basis, and they certainly both attempted to apply their ideas in the context of the new social structures, but we cannot adduce any direct sharing of actual techniques.

A number of artists in the succession of David, Girodet for example, showed a willingness to use perspective in an accurate and effective manner. The same is true of the Northern classicists and their more fundamentalist successors, the Nazarenes. But I gain the impression, looking at their drawings and paintings, that perspective had simply become a standard tool for most of the artists, and that it was not built into the creative urge of the draughtsmen as strongly as it had been for their Renaissance predecessors. There were exceptions to this general tendency. Occasionally an individual ploughed his own furrow in depicting optical space with unusual intensity. Amongst the Neoclassicists, Nicolas Abilgaard, a Danish contemporary of David, exploited a stern sense of Euclidian geometry in large-scale architectural settings.[41] The most conspicuous exception in mid-nineteenth century France was Charles Méryon, the etcher of dramatic cityscapes in which mass and shadow create powerfully modelled spaces.[42] Of the Impressionist generation, only Gustave Caillebotte used perspective in a truly creative manner.[43] In Central and Northern Europe a number of naturalists in and around the so-called 'Biedermeier' tradition used perspective in an assertive manner not paralleled in France. Eckersberg, a pupil of David, and Købke in Denmark are particularly notable in this respect, as is Eduard Gärtner in Germany, whom we have already mentioned as the author of panoramic images and whose views of Berlin demonstrate a fanatical desire for the systematic description of space and light.[44] Perhaps the most openly mathematicising of these painters was Johann Hummel, whose meticulous command of perspectival forms, cast shadows and reflections was not matched by compositional grace or control of figure drawing.[45] Such perspectival veins in nineteenth-century art warrant more attention than they customarily receive in the standard histories, a shortcoming that cannot unfortunately be rectified within the limits of the present chapter.

However, I think it is true to say that within most of the academies and schools as the century progressed, the acquiring of optical techniques seems to have become part of the grind of necessary tutelage—something that was expected of the young artist as a matter of routine, and, like all routines, something to be 'got over' rather than enjoyed. Volumes of instructional literature poured out in unprecedented numbers, particularly in the 1820s. A list of some of the author's names with the dates of the first editions of their books, will give some idea of this profusion: Lespinasse (1801), Lavit (1804), Delaizeau (1818), Phélippeaux (1819), Vallée (1821), Dupin (1822), Hachette (1822), Choquet (1823), Cloquet (1823), Brunel de Varennes (1825), Dufour (1827), Farcy (1827), Thibault (1827), Thenot (1827 and 1834), Cousinery (1828), le Breton (1828), Normand (1833), Leroy (1834), Adhémar (1836 and 1838 etc.), Jump (1841), Similien (1841), Depuis (1841), Guiot (1845), Boniface (1847), Lahure (1847), Olivier (1847), Poudra (1849), Girardon (1850), La Gournerie (1859), Sutter (1859), and Goupil, to take the list only as far as 1860.[46]

It is important to realise that not all of these books were aimed at the same market. Some, such as Adèle le Breton's *Traité de perspective simplifiée*, aimed to speak to those amateurs and aspiring professionals who wished straightforward instruction in the basic principles with attractive illustrations of perspective in acion.[47] These works comprise the largest group in the list. Others were specially concerned with

460. Perspective projection of a spiral staircase with figures and a dog, from Joseph-Alphonse Adhémar's *Cours de mathématiques. . .*, 3rd edn., Paris, 1870.

461. Study of cogs with cast shadows, from Joseph-Alphonse Adhémar's *'Cours de mathématiques. . .'*, 3rd edn., Paris, 1870.

architectural and technical illustration. Dupin's *Applications de géométrie e de mecanique à la Marine . . .* falls into this category. One prominent group of treatises stands in direct line of descent from Monge, most obviously the *Traité de géométrie descriptive* by Hachette, who had been responsible for the first edition of Monge's book.[48] Some of the later treatises also reflect the revival and development of projective geometry in the Desargues tradition, above all in the work of Jean-Victor Poncelet, whose *Traité des proprietés projective des figures* of 1822 rekindled enthusiasm for the power of pure geometrical techniques rather than Cartesian analysis.[49] The revival of Desarguian techniques was closely associated with a growing interest in the history of geometry, as witnessed by Michel Chasles's *Aperçu historique* in 1837 and Noël-Germinal Poudra's magisterial history of perspectival projection (1864), which is still unsurpassed as a mathematical review from classical antiquity to the time of its composition.[50] Jules de la Gournerie's *Traité de perspective linéaire* (1859) takes up the projective theme of the relationship between perspective and conic sections, and treats the perspectival configurations of forms in terms of homology, with suitable acknowledgements to the work of Poncelet.

A good example of an author who attempts to embrace the mathematical, pictorial and technically illustrative aspects of perspective in this period is Joseph-Alphonse Adhémar, one of the Mongean theorists. Adhémar was a prolific author on applied geometry, and his various treatises were gathered together in a set of volumes under the title *Cours de mathématiques à l'usage des architectes, ingénieurs civils etc.*[52] These included accounts of descriptive geometry, linear perspective, the theory of shadows and the applications of Mongean techniques to engineering drawing. If we look at two examples of his applied geometry we will be able to see how his grasp of descriptive techniques informs his draftsmanship. His solution to the depiction of a spiral staircase (pl. 460) in his *Perspective linéaire* bears some resemblance to the traditional solutions for this classic problem, but the way in which he describes the generation of the three-dimensional curve as a spatial motion in relation to the horizontal and vertical planes is fully in keeping with Monge's descriptive principles. His illustrations of mechanical components (pl. 461) exploit his command of spatial geometry and the science of cast shadows to produce results of great complexity and not inconsiderable beauty.

This kind of draughtsmanship flourished in the technical context of mechanical and architectural design in a way that it did not within the realm of the 'Fine Arts' in the nineteenth century. For a comparable example in architectural draughtsmanship, we may look to Giambattista Berti's splendid representation of a column base (pl. 462) in his *Delle Ombre e di chiaro-scuro* published in Mantua in 1841. Practising architects were responsible for a series of perspectival images unmatched in contemporary painting. In Britain, most notably, architects such as Soane, Cockerell, Scott and Waterhouse produced full-dress perspectival watercolours of actual, projected or imaginary buildings which set standards of spatial excitement that their built structures were hard pressed to equal.[53]

However, the desire for precision in technical illustration

462. Elevation of a column base with cast shadows, from Giambattista Berti's *Delle Ombre e de chiaro-scuro*, Mantua, 1841.

favoured an alternative to the optical 'deceptions' of pictorial perspective. The kind of parallel projection described by Lambert under the heading 'military perspective' (pl. 445) became increasingly used to convey information. The most persuasive advocate of nonconvergent perspective was a Cambridge mathematician and engineer, the Rev. William Farish. In his *Isometrical Perspective* of 1820, he explained that his system

is preferable to the common perspective on many accounts. . . It represents the straight lines, which lie on the three principal directions, all on the same scale. The right angles contained by such lines are always represented either by angles of 60 degrees or the supplement of 60 degrees. And this, though it might look like an objection, will appear to be none on the first sight of a drawing on these principles, by any person who has ever looked at a picture. For he cannot doubt that the angle represented is a right angle.[54]

Within this convention, the draughtsman can choose to retain constant scaling along one, two or three of the dimensional coordinates as may be required in each case. Alternatively, the scales along each coordinate could stand in fixed ratios to each other. Architects increasingly came to realise the advantages of this form of descriptive geometry. a good example is provided by the illustration of a farm complex in Joseph Jopling's *The Practice of Isometrical Perspective* in 1833 (pl. 463).[55] As one of the later editors of Brook Taylor, Jopling was well qualified to judge the respective merits of the pictorial and technical systems of perspective in different contexts. Such non-convergent procedures were to result in a triumph of representation in

463. Isometrical view of a farmhouse with outbuildings, from Joseph Jopling's *The Practice of Isometrical Perspective*, London, 1842.

464. Basilica of Constantine (to the scale 1:100), from Auguste Choisy's *L'Art de bâtir chez les Romains*, Paris, 1873.

Auguste Choisy's compelling illustrations of antique architecture (pl. 464).[56] His plates are unrivalled for visual excitement by any purely pictorial use of perspective in the second half of the century. Some of the reasons for the comparative loosening of the grip of geometrical perspective in the pictorial field should become clear in the succeeding sections of this chapter.

LOOKING AT SPACE

We have seen that Kepler's definitive formulation of the inverted image on the retina did not seriously unsettle the geometrical basis of perspective, since the image retained its proportionality. However, Kepler's idea did have insidious long-term consequences for the relationship between the object, light, sensation and perception. If the image is inverted, why do we 'see' it as upright? Is it a matter of acquired learning or innate mechanism? What is the connection between the 'picture' on the retina, the sensations it produces and our developed perception of the images of objects 'out there' in space? Kepler himself left these problems strictly alone, feeling that he had done his own particular job as a student of optics by taking the process as far as the retinal picture.

As Descartes was the first to state clearly, it is no good simply assuming that this picture is passed as a picture to the brain to be 'looked at', because such an assumption would merely pass the problem on to interior eyes which would in turn pose the same question as to what was doing the 'looking at'.[57] There is a necessary distinction to be made between the properties of things (including the physical phenomena of the visual process) and the nature of the mental sensations which are responsible for our perception of spatial order. Once this point is conceded, as it was in one form or another by almost all the major philosophers of perception and scientists of optics during the eighteenth century, it focuses attention on what was and still is one of the great bones of contention: do we accomplish perception as the result of innate structures in the mind or do we need to learn progressively how to 'see' the medley of physical impressions which impinge on our senses? The answering of this question by the 'nativists' on one side and the 'empiricists' on the other—if I may be permitted this over-simplification for the moment—was complicated by the increasing realisation of how variable were the sensory mechanisms themselves.

Once the eye was regarded as a camera obscura, the problem of focus (or 'accommodation') required attention. Once it was realised that all parts of the retina did not exercise an equal power of discrimination (or 'acuity'), and even that there was a 'blind spot', the concept of the retinal picture became problematical. Once it had been shown that there was not an invariant correspondence between the pictures on the retinas of each of our eyes, the complications of binocular vision needed to be more fully addressed. Even with respect to the one-eyed vision of the traditional perspectivist—a limitation acknowledged by Leonardo and Danti—there was a new level of awareness of the optical and conceptual problems in reading the slippery clues of size and space, both in themselves and in relation to touch and motion. These debates involved the most considerable philosophers of the eighteenth century, from Locke to Kant, and the major students of geometrical optics and opthalmology, including La Hire, Camper, Smith, Porterfield, Le Cat, Bouguer and Priestley. All these optical and perceptual questions were no less urgently controversial and even more complex in the nineteenth century when Helmholtz came to compile his massive *Handbook of Physiological Optics*.

The empiricists' case was articulated with considerable precision by John Locke in his *An Essay Concerning Human Understanding* (1690 and 1694).[58] For Locke it was a matter of acquired custom and accumulation of knowledge that permits us to translate the flat patches of coloured light on our retina into a three-dimensional perception of the world. The image on the retina is not therefore perspectival *per se* but only becomes so when we have correlated a set of experiences from vision and touch as we move around the world, learning to make sense of its spatial arrangement. As Robert Smith, the Cambridge philosopher, explained in *A Compleat System of Optics* (1738), a comparison of 'the memory of former perceptions by sight and the other senses' can be brought to bear instantaneously on a given scene by the judgement of an experienced observer.[59]

The 'nativist' challenge to this attitude posed the question as to how we could even begin this process of understanding if there were no pre-existing patterns in the human mind. Thomas Reid drew evidence from the famous case of the blind Cambridge mathematician, Saunderson, who was able to form concepts of the 'projection of the sphere and all the common rules of perspective', although he was deprived of the most relevant sensory experience.[60] The mathematical frame of reference must therefore be innate in Saunderson's mind. Using a complementary line of argument, Condillac in France argued that we do possess an inherent ability to *see* a sphere as a sphere. He accepts 'Locke's reasoning that the retinal image of a sphere is merely a flat circle, composed of different coloured points' but believes that our processes of visual perception act in their own right in such a way as to tell us that it is a sphere.[61] If our reading of spatial form is solely a matter of acquired knowledge, why cannot we use this knowledge to negate the compelling illusion of a bas-relief?

Whereas most optical scientists leant towards an empiricist stance, not least because it tended to support their observational approach, William Porterfield of Edinburgh, one of the finest investigators of the properties of the human eye, argued that 'the judgements we form of the Situation and Distance of visual Objects, depend not on Custom and Experience, but an original connate and immutable Law to which our Minds have been subjected from the Time they were at first united to our Bodies'.[62] This line of argument was to culminate in Kant's idea of space as an *a priori* intuition, which we will encounter later.

A number of theorists showed themselves to be alert to the implication of the philosophical issues for the rules of art. It was possible to argue that the rules of perspective, whatever their epistemological status, still provided the only effective

way for the painter to operate. Claude Nicolas Le Cat recognised that 'it is in us an Art, a Science, acquired by habit of Judgement that objects are external in our Regard and at a certain Distance'.[63] However, 'this circumstance does not at all detract from the Necessity and Advantage of the. . . Rules. It is Proof only, that the repeated use of these Rules forms in us a Faculty of drawing Consequences almost without being apprised of it.'[64] Similarly, John Wood could rehearse the Lockean arguments in the footnotes to his *Elements of Perspective* (1799) without letting them unsettle his faith in visual mathematics.[65] On the other hand, Joshua Kirby, who makes direct reference to Locke's and Smith's writings, permits the perceptual argument to soften his attitude towards the rules: 'since the Fallacies of Vision are so many and so great, and since we form our common Judgement and Estimation of the Appearance of objects from Custom and Experience and not from mathematical Reasoning, therefore it seems reasonable not to comply with strict Rules of Mathematical Perspective in some particular cases'.[66] The cases Kirby has in mind are those which result in distorted effects, as in wide-angle views of a colonnade or of a spherical object. The younger Malton also accepted the dependence of vision on experience, but drew the very different conclusion that sight should be rectified by mathematically informed judgement:

to draw as we see, with any tolerable correctness, is the result of knowledge and long attentive practice; and even then do we seldom strike the *unerring* line. According to Reid and other minute investigators of the human organ, sight is the most deceptive sense we have, and particularly requires the aid of experience and judgement.[67]

A rather similar suggestion had earlier been made by Pieter Camper.[68]

The debates to which the theorists made reference focused renewed attention on the fundamental question of the status of the sense of sight with respect to the perception of space, and served to highlight a series of problematical areas in the science of vision. Such matters were of obvious concern for the theorists of pictorial representation. Let us approach the specific problems of seeing and representing through the widely discussed issue of the relationship between sight and touch as registers of spatial truth.

The central question was whether our basic concepts of space arise from tactile (and motor) sensations or directly from the exercise of vision. The way this issue was most regularly approached was through a famous question formulated by William Molyneux, a Dublin lawyer and scientist who had been fascinated by the first edition of Locke's *Essay*. He asks us to 'suppose a man born blind, and now adult, and taught by his touch to distinguish between a cube and sphere. Suppose then the cube and the sphere placed on a table, and the blind man made to see: *quaere*, whether by his sight before he touched them, he could now distinguish and tell, which is the globe, which the cube.'[69] Molyneux answered that he could not, on the Lockean basis that the man would need to learn which visual sensations would correspond to the tactile sensations of roundness and squareness. Locke was pleased, in his

second edition, to 'agree with this thinking gentleman, whom I am proud to call my friend'.[70] In a similar vein, Bishop Berkeley, the other great radical philosopher of perception in Britain at this time, argued that a blind man who was suddenly able to see would not know by his eyes alone what was 'high or low, erect or inverted. . . For the objects he had hitherto used to apply the terms up and down, high or low, were such as only affected or were in some way perceived by his touch; but the proper objects of vision make new sets of ideas, perfectly distinct from the former.'[71]

This stance, which goes against our commonsense expectation, follows logically when the Cartesian distinction between substance and mental sensation is combined with a strictly empiricist theory of knowledge. Descartes had compared our perception of the inverted retinal image with a blind man feeling objects with a pair of crossed sticks, an analogy illustrated by Le Cat in 1740 (pl. 465). The actual orientation was irrelevant, since our understanding depends upon how the mind interprets the 'information'. And if we have to *learn* to make this interpretation, as Locke believed, the erstwhile blind man would not immediately be able to interpret what the 'crossed sticks' of the optical processes in his eyes meant with respect to his previous sensations of touch.

Not surprisingly, in a century so predisposed towards experimental evidence, scientists and philosophers began to look towards actual cases of healed blind men to answer Molyneux's question. The most informative case study—though it was not specifically aimed at this question—was made by William Cheselden, who couched the cataract of a thirteen- or fourteen-year-old boy in 1728. The account provided considerable succour for the empiricists: 'When he first

465. Studies of the eye and binocular vision, including the crossed sticks analogy, from Claude Nicolas le Cat's *A Physical Essay on the Senses*, London, 1750.

saw, he was so far from making any judgement about distances, that he thought all objects whatever touch'd his eyes (as he express'd it), as what he felt, did his skin. . . He knew not the shape of anything, nor any one thing from another, however different in shape of magnitude.'[72] It took Cheselden's patient two months before he suddenly found that he could read pictures, having previously 'consider'd them only as party-coloured planes, or surfaces diversified with paint; but even then he was no less surpriz'd, expecting the pictures would feel like the things they represent. . . and asked which was the lying sense, feeling, or seeing?'. Although it certainly was no part of Cheselden's intention to suggest that artists should attempt to make paintings which match the retinal image 'as party-coloured planes', the underlying theory of vision could be handled (or rather mishandled) in such a way as to sanction the stalking of the 'innocent eye' and the evoking of sensations by the Impressionists during the next century.

The nativists' best answer to this experimental evidence lay in challenging the exceptional circumstances surrounding the sudden acquisition of sight by more-or-less mature individuals. Above all, we should not assume that a system so long out of use would function instantaneously at its optimum level. However, even the staunchest nativist could not deny that there was in practice an element of 'learning to look' in our reading of the visual world. Even if sight did not have to learn from touch as far as space is concerned, the seeing of space was no longer regarded by any scientist of sophistication as founded upon unproblematical matches between space 'out there', the retinal image and the perception of space in our minds. In purely physical terms, the conditions for seeing space must necessarily be related to the way in which the mechanisms of the eye could provide raw data for our judgement, irrespective of whether the power of judgement was innate or acquired.

The theorist who set the tone for eighteenth-century discussions of how we use the eye to judge depth was Philippe de La Hire. In his *Traité des differens accidens de la vue* he laid down five visual conditions which contribute to our perception of depth: the apparent size of objects according to the area they occupy in 'the painting on the retina'; the apparent vividness of colour of an object; the exercise of binocular vision, particularly in the inclination of the axes of the eyes; the effects of parallax; and the relative degree of distinctness of the small details of forms.[73] Whereas theatrical illusion can exploit all five conditions, La Hire argues that painters can only rely on apparent size and apparent strength of colour, both of which, being *apparent*, are riddled with delusions. La Hire's list was widely repeated in subsequent optical texts, generally with the added condition of the active focussing of the eye, an activity La Hire surprisingly rejected on anatomical and experimental grounds. Porterfield and Camper were also prepared to add the depiction of the relative distinctness of small parts to the painter's armoury.[74] I think it will be worthwhile to make a review of these factors, not necessarily in their eighteenth-century order, to appreciate their explicit and implicit consequences for the practice of painting.

I intend to begin with those factors which have less obviously direct relevance to the effects at the painter's command. Of these the properties of binocular vision were most widely discussed. A few art theorists around 1700 did still try to resolve the problems in such a way as to suggest that they were of no consequence for the painter. Sébastien Le Clerc argued that in natural vision one eye is always dominant at any one instance, and that the painter's one-eyed vision is therefore justified.[75] Bernard Lamy, whose 1701 *Traité de perspective* was translated into English and became quite popular, also adopted this argument, adding that when our two eyes look at the plane of a painting the apex of the visual axes coincides with the surface in such a way as to eradicate the vagaries of binocular vision.[76] However, the eighteenth-century researchers showed that the problem would not go away as easily as Lamy had hoped. Le Cat was typical in believing that the 'Concurrence of the optic Axes of both Eyes is itself necessary in order to distinguish exactly the Sizes of intermediate Bodies'.[77] The converging axes thus act rather like a surveyor's triangulation device. Porterfield emphasised that 'the direction of the *Axes*. . . is sensible to us'.[78] Clearly, the painter cannot hope to emulate this condition for objects at different depths. Nor can he hope to evoke effects of parallax, whether these arise from two-eyed vision or from the relative movements of viewer and objects.

The problems of acuity (the limited retinal area of sharp vision) and accommodation (the focusing of the eye on planes at different distances) cause problems of almost equal intransigence for the painter. Porterfield describes how the eye undertakes rapid scanning motions to bring the small area of distinct vision on the retina into play across an object.[79] This motion meant that the perspectivists 'single glance' lost its validity even for a 60° view. Kepler's theory of the eye had also necessitated a focusing mechanism, since not all of a given scene could be in focus at the same time. Although La Hire denied the existence of such a mechanism, later scientists agreed that some form of accommodation must take place, even if they could not agree whether this was accomplished by the movement of the lens back and forth, by the altering of the shape of the lens or by a change in configuration of the ball of the eye, or by any permutation of these means. What should the painter do about selective focus? Should he only show one zone in his painting in sharp focus? This was precisely the solution advocated by Pieter Camper, the distinguished Dutch anatomist, who was trained as an artist and retained a life-long interest in the implications of the sciences for the practice of art.[80] We will also see that this idea was favoured by Ruskin. But it does bring considerable problems in its wake. When the viewer focuses on an object in the picture that is painted as if out of focus, will the effect not be the reverse of what is intended?

When we turn to the effects of the relative distinctness of objects over distance, the painter's skill can come more actively into play. The opticians distinguished a number of factors at work here: the difficulty of seeing small objects at a considerable distance, because they subtend too small an angle to the eye; the diminution on the force of light and colour over distance; and the progressive loss of clarity of form and colour as the light passes through the veiling atmosphere. The manner

in which optical science in the eighteenth century was analysing such factors was moving beyond the painter's concerns and understanding, since the scientists were undertaking quantitative analyses based upon elaborate instrumental measurements of the factors involved and devising mathematical formulas on the basis of their data. Bouguer, for example, investigated a wide range of phenomena similar to those that had concerned Leonardo and Aguilonius—the relative strengths of lights at different distances, reflections from various surfaces and the effects of diaphanous media—but the logarithmic laws of his photometry took his science far beyond the scope of artists.[81]

Even the underlying idea that the phenomena could be quantified did not necessarily give the painter cause for confidence in the rational powers of sight. The effects appeared ever more relative and slippery. For example, Camper and Bouguer both analysed the way in which different colours distorted our perception of distance. A distant object, an orange square for example, would appear to be situated at the same distance as a closer one painted in a more reticent colour, such as a darkish blue.[82] As we will see in the next chapter, Leonardo had already realised that cool colours receded to blueness with distance more rapidly than warm ones. La Hire also noticed what is now known as the Purkinje shift, that is to say the relatively greater receptivity of the eye to cool colours compared to warm colours at progressively lower levels of illumination.[83] Le Cat stressed that even the graded phenomenon of atmospheric veiling deals with apparent effects rather than the actual properties of size in relation to spatial location. He agreed that atmospheric perspective is a vital tool in the painter's kit: 'painting, the Mimick of Nature, in order to express the Distance of Objects in Perspective, after the diminution required by the visual Angle, covers these objects with a lay of Vapours proportional to that distance'.[84] Thus if a rat and a camel are portrayed the same size (on our retina or in a painting) their relative spatial locations are signalled by their relative degrees of distinctness. However, if we look at an object through thick atmosphere which makes it indistinct, the object will appear to be further away and we will *interpret* it as *larger*.

The other main factors in La Hire's list are those which have mainly concerned us so far in this study, namely the mathematical properties of visual angles etc. There was a general agreement amongst the scientists that there was a geometrical relationship between the configuration of light rays approaching the eye and the disposition of the image on the retina. Indeed, it is difficult to see, given the methods of analysis they used, how they could have come to a different conclusion. Le Cat, for example, goes to some pains to show that the curved shape of the retina is designed to ensure that the 'Magnitude of Images is exactly in a reciprocal Ratio to the distance of Objects. . . These are incontrovertible facts, and of Course such as both Physics and Geometry must submit to.'[85] A nativist like Porterfield makes this equation from a different angle, but the optics are essentially the same: apparent magnitude is 'proportionable to the Angle under which the object is seen', enabling 'our mind . . . to exercise its natural Geometry in judging the Magnitude of Objects'.[86]

However, as Alhazen and his followers had clearly realised, *apparent* magnitude does not allow us to read space and actual size without some frames of reference. Expressed in eighteenth-century terms, this means that the size of the patch on our retina has no spatial properties of its own. Even Smith, who places more weight than other writers upon apparent size as the key condition in La Hire's list, admits that we need to learn to interpret apparent size with the aid of the experiences of touch and to acquire an ability to form comparative judgements about the size and distance of objects on the basis of our accumulated knowledge of how visual phenomena correspond to objects in the physical world. However, even with the aid of all our accumulated experience, the reading of space from apparent size was deeply subject to delusions. To give just one example: gunners had noticed that certain kinds of broken or dead ground between the observer and the object could lead to a serious underestimation in the distance and, accordingly, in the actual size of that object.

All the weight of empirical evidence being assembled by the opticians and the perceptual arguments of the philosophers broke the simple chain of continuity between natural object, linear light, geometrical seeing, intellectual knowing, and learned representation that had explicitly or implicitly underpinned so much of the earlier theory of art. What were the consequences of this unsettling of the naive order?

I think the largest single consequence was a negative one. The rational framework of imitation in the visual arts as viewed within the world of the practising artist continued to go on its way much as it had always done, while the philosophy of perception and the study of geometrical optics entered realms of technical sophistication that were not immediately accessible to artists. As far as the big philosophical issues were concerned, we have seen that Kirby picked up the main gist of the empiricists' argument, but hardly in a very sophisticated way, and the same applies to the younger Malton's reference to Reid. Indeed, there are no signs that the main body of didactic material in their treatises had been seriously touched by the new considerations.

The philosopher's emphasis on the retinal image as a 'party-coloured' plane does seem to have seeped into nineteenth-century theory in a rather bowdlerised form, but it is difficult to demonstrate its impact upon ideas of painting before the era of Ruskin and the Impressionists. The main drift of the eighteenth-century arguments was that we did not 'see' the retinal image at all in a literal sense, since we are dealing with a series of physical impacts in the eye which evoke sensations; and the sensations, the nature of which cannot simply be identified with the objects 'out there', stand in need of interpretation.

Interesting claims have recently been made that the paintings by Henry Raeburn, the Scottish portraitist who developed short-hand brushwork of great bravura to evoke the appearance of planes of colour, can be seen as a visual 'equivalent' to the perceptual theories of Thomas Reid, whose portrait he painted near the end of the philosopher's life.[87] According to this idea, Raeburn was progressively encouraged to loosen the overtly descriptive aspects of his handling by Reid's sugges-

tion that the painter who strives to imitate nature may be regarded as attempting to capture the visual 'signs' of nature in a raw and directly available manner, before the intervention of interpretation. Such interpretation was, for Reid as for those in agreement with Molyneux, educated by our sense of touch—though Reid regarded the spatial characteristics as corresponding to innate properties of the mind. Reid's 'commonsense' perceptualism and Raeburn's painterly impressions of light and colour can be effectively juxtaposed, and the philosopher's ideas can provide a strategy for interpreting the paint handling. However, the hypothesis that Raeburn's style was actually affected, conditioned or even caused by Reid's theories, either directly or as transmitted by Dugald Stewart, does not seem to me to be capable of demonstration given the evidence available to us.

In particular, it is difficult to see how Reid's highly individual account of 'seeing and knowing' can be taken to prescribe one specific *style* of painting or manner of handling —rather than another. I can see no clear evidence that any contemporaries in the world of art, including Raeburn himself, were capable of translating Reid's sophisticated epistemology into a specific theory of action for the practising artist. The younger Malton, for example, simply uses Reid to provide up-to-date evidence of the propensity of sight for delusion, but, far from drawing the conclusion that the artist should have recourse to the retinal image, Malton asserts traditionally that the rules based on experience should be used to correct our erring senses.[88]

The same kind of problem of evidence besets us when we look at the possible impact of the conditions for spatial perception in the optical tradition of La Hire. It is very tempting to regard the qualities of visual description in some kinds of eighteenth-century painting as reflecting the reduction of the status of linear perspective to just one of five or six conditions for seeing depth. The subtle way in which Chardin evokes 'sensation' without a meticulous description of 'substance' in the Dutch manner can be used as a suggestive illustration to the perceptual-optical debates.[89] The soft-focus backgrounds and blurred peripheries of Rococo paintings, particularly in France, could imply parallels with the eighteenth-century discussions of accommodation and acuity. The loosely structured, ungeometrical compositions of Boucher in which space is more apparent than real, could be regarded as a response to Le Cat's analysis of illusory perception. I would certainly not dismiss such possibilities out of hand, any more than I can be certain that Raeburn was not a Reidian perceptualist. But there does seem to be an acute problem of demonstration for the historian, in that the extensive written evidence from within the world of art itself suggests that all the pictorial developments can more obviously be explained in other ways. Camper and Le Cat might look to painters to see how they face the visual problems. Philosophers might, as philosophers always have, use representational works of art as grist to their mills. But when we look for positive evidence as to how the ideas of the opticians and philosophers were translated into ideas about the making of specific paintings we will be disappointed. Without some credible agency for the translation of cause into

effect, I fear that we must set the cause aside until such time as new evidence can be brought to bear. I suspect that the biggest effect of the new ideas was simply to increase the compartmentalising of the various intellectual pursuits in such a way that the science of art within the world of art lost even more of its precarious unity with the most advanced sciences of mind and vision.

When making references in a study such as this to the nativist and empiricist traditions, a measure of crude over-simplification will inevitably creep in. The sophisticated and subtle stances of philosophers such as Reid and Condillac cannot be adequately captured in a few phrases. However, the process of simplification, even caricature, inherent in the foregoing analyses does correspond to some extent to the way in which the specialised ideas entered more general currency and often to how they became available within the world of art. This tendency for complex ideas to be reduced to a simple *leitmotif* is nowhere more apparent than when we study the impact of the theories of space, knowledge and perception of the philosopher who stood at the summit of the nativist tradition in the eighteenth century, Immanuel Kant.

In one sense, I will be giving Kant himself short shrift—at least as judged in relation to his stature as a philosopher. It is one of the features of the viewing of intellectual history through the science of art that it holds up what may be described as a distorting mirror to the shape of the intellectual developments as regarded within their own history. Viewed in our present mirror, the impact of Kant, in spite of his enormous impact on philosophical aesthetics, appears reduced to the exercise of certain local influences on specific tendencies coupled with some long-term implications which, for all their apparent magnitude, are difficult to define in any really tangible fashion. However, in as far as Kant formulated a radical view of mental space that set the philosophical standard for the next century (at least), we cannot pass into that century in total ignorance of his ideas. Helmholtz's description of himself as 'a faithful Kantian' is alone enough to justify their scrutiny in our present context.[90]

The central and endlessly-repeated doctrine of Kant on space is that spatial awareness should be viewed as an 'a priori intuition' and not as something that originally enters our mind as the result of investigation of pre-existing physical space in the natural world.[91] Amongst the arguments he uses is the contention that we can envisage space in the abstract without the existence of objects. He concludes that 'the representation of space cannot . . . be empirically obtained from the relations of outer appearance'.[92] This absolute interior space is characterised as a transcendentally ideal intuition—not as the result of a process of conceptualisation—and fundamentally Euclidian, although he did not exclude the possibility of non-Euclidian geometries. This idea of space can lay the foundation for sensory intuition but cannot be conceptually touched by perception of the exterior world.

He attributes our understanding of space in the natural world to a lower order process, 'the *reproductive* imagination, whose synthesis is entirely subject to empirical laws, the laws, namely, of association, and which therefore contribute noth-

ing to the explanation of the possibility of *a priori* knowledge. The reproductive synthesis falls within the domain not of transcendental philosophy, but of psychology.'[93] The acquisition of this type of understanding, based as it is upon the comparative sensations of sight and touch, takes the form with which we are familiar through empiricist theory. Although he lectured extensively on this topic, he only makes such references to it in his *Critique of Pure Reason* as to indicate why it is not subjected to sustained discussion in that context. The idea of space for which he became generally renowned was that of the pure *a priori* intuition rather than the empirically acquired space of the psychological world of perception.

Kant's central idea on space was used to account for the superior status of those mental disciplines which aspired to spatial certitude, geometry itself and mathematical mechanics. I think it is true to say—continuing our unabashed over-simplification—that nativist philosophies favoured mathematical disciplines above all others to a greater degree than empirical philosophies. An empiricist might, and often did, regard mathematical proof as the ultimate goal of all physical sciences and the foundation for the intellectual arts, but mathematics was bound up in the physical world and did not achieve reality only as pure, pre-existing ideas totally independent or even in opposition to nature. The nativist has a ready-made reason for the worship of pure geometrical forms. Boullée's elemental forms, though they are related in his case more specifically to the Newtonian aesthetics of cosmological law, could also be readily reconciled with a nativist aesthetic, as could classicising idealism more generally.

As we will see in the next section, one of the major aesthetic trends which developed in the succession of Kant did not favour classicist reserve, but influential teaching systems were developed which brought classicist design into union with nativist philosophy in general and Kantian ideas in particular. These teaching systems, at the centre of which was the practice

467. Perspectival study of an arrangement of wood blocks from Peter Schmid's *Das Naturzeichnen*, Berlin, 1828–32.

of drawing from specifically-designed geometrical solids, arose in France and Germany during the same period and shared a number of common roots. The most conspicuous of these roots was the studio of David. Alexandre Dupuis, one of the brothers who was responsible for the French system, was a direct pupil of David, while the author of the German method, Peter Schmid, came into contact with David in France between 1802 and 1806.

Schmid, after an unsettled early career characterised by deep dissatisfaction with the available training for artists, began to work along alternative lines.[94] The chief influence on his ideas was the method of the Swiss educationalist, Heinrich Pestalozzi, who regarded drawing as a fundamental way to activate the inherent propensities of our mind.[95] The student began with the most elementary units, gradually moving on to more complex syntheses in a systematic manner. Pestalozzi's elementary forms were linear in nature, and the student would be expected to train his eye and hand in drawing straight lines before progressing to curves and compound forms. By 1816 Schmid had turned to the use of direct drawing from elementary solids, a method which culminated in his four-volume treatise, *Das Naturzeichnen* published in 1828, 1829, 1830 and 1832.[96] To follow Schmid's course the student required a specifically manufactured set of wooden 'bricks' which were available in a custom-made box (pl. 466). The

466. Peter Schmid's instructional bricks for the teaching of drawing, reconstructed by Clive Ashwin.

239

468. Perspectival study of shaped forms with cast shadows, from Peter Schmid's *Das Naturzeichnen*, 4 vols., Berlin, 1828–32.

blocks would be drawn initially in various planar combinations in pure elevation, before moving on to spatial arrangements involving diagonal elements (pl. 467). The next step, in Part II of his manual, was the introduction of blocks with curved faces which can be assembled to provide some of the classic set-pieces of three-dimensional form and cast shadow, including the popular niche (pl. 468).

This resemblance to earlier demonstrations raises the question of the relationship of Schmid's methods to traditional handbooks of perspective. Although he begins differently, drawing *by eye* from synthetic bodies, the more complex

469. Perspectival study of buildings in a landscape, from Schmid's *Das Naturzeichnen*.

arrangements presuppose the orthodox theory of linear perspective, using vanishing points. When he provides instructions for the depiction of realistic scenes on an imaginary basis he resorts to techniques which use artificial perspective in a manner close to Lambert (pl. 469). This conventional side to Schmid's teaching certainly should be taken as outweighing its innovatory aspects. These aspects attracted wide admiration and inevitable imitation, to such a degree that the learning of 'natural drawing' from simple solids became a feature of many school curricula in Europe and America. At least some of the visual qualities of Frank Lloyd Wright's architecture can be attributed to the drawing blocks which he studied in his youth.[97]

The French equivalent of *Das Naturzeichnen* was Ferdinand Dupuis's *Exposé succinct du polyskématisme ou méthode concernant le dessin linéaire géométrique usuel et les differens phénoménes de la perspective*, published in 1841 and translated into English four years later. His brother Alexandre published a complementary treatise, *De l'Enseignement du dessin sous le point de vue industriel*, in 1856.[98] The brothers' methods were founded on the Pestalozzian principles of steady progression from the 'elementary alphabet of graphic science' (lines, angles etc.), through geometrical bodies in light and shade, to the complex forms of nature, such as the human head. This progression was designed to exploit the 'common faculties' of spatial awareness that we are all normally capable of developing, regardless of our artistic abilities.[99] As in Schmid's system, the student is required to study directly from physical objects, acquiring skill by 'custom of eye and hand':

the art of design is an art of imitation; the eye must be trained to see well and the hand to render exactly what the eye has seen. All the lessons must be taken from nature. In the presence of the objects themselves, the pupil can first scrutinise the real forms and then the apparent forms which bodies assume from the viewpoint of the eye which looks at them. Perspective, according to this method, thus consists of an object as experienced and is no longer a mathematical calculation.[100]

Ferdinand developed a special device, a *Polyskématiste*, for the display of his specially-manufactured lines, planes and solids. It consisted of an articulated stand that permitted the display of each object at any required angle to the spectator's line of sight. His brother's treatise lists some of the items which were available for purchase: fourteen 'models of perspective and linear design' at 20 francs with 7 francs packing; 16 model heads, ranging from schematic ovoids to fully detailed sculpture, at 48 francs and 16 francs packing, and so on. 'A collection of models for the design of flowers (packing included)' was available for 29 francs.[101] The teaching systems of Ferdinand and Alexandre Dupuis won considerable approval, receiving numerous official testimonials and being introduced at the *écoles normales* and *écoles primaires* on a widespread basis.[102] At the end of the course of instruction the student would be expected to have developed his or her faculties of spatial vision, spatial understanding and spatial draftsmanship according to a 'natural' progression that was considered to be

in keeping with the mechanisms by which we acquire perceptual knowledge.

The teaching systems of the Dupuis brothers and Schmid serve to emphasise that an understanding of the relationship between artistic ideas of spatial representation and the most advanced analyses of space, vision and perception in science and philosophy must take into account the way in which the specialised ideas filtered into the world of general knowledge. Optical-perceptual theories often arrived at the artist second or third hand, sometimes in a simplified form bordering on caricature. This process means that the direct juxtaposition of scientific ideas in their primary form and artistic notions can give a false picture. Scientific ideas of the 'eye', the 'retinal image' and 'sensations' were particularly susceptible to bowdlerised transmission. As a necessarily selective indication of the tricky relationships between the most advanced scientific ideas on vision and the notions current within the world of nineteenth-century art, I intend to look at the way in which the greatest optical scientist of the century, Hermann von Helmholtz, assessed the relevance of his theories to the practice of art, and at the way in which certain artistic notions of the 'eye' (including those of Ruskin) provided the basis for a reappraisal of representational techniques.

Helmholtz's major work, *Handbuch der physiologischen Optik* (1856–66), not only comprised the greatest experimental study of the science of vision but also contained lucid analyses of the epistemological and perceptual issues centering on the nativist-empiricist controversy.[103] The stance which emerges from his brilliant review of the eighteenth- and nineteenth-century theories is empiricist in the broadest sense, but his professed reverence for Kant indicates that the polar categories should not be applied rigidly. He was fully in accord with Kant's devotion to the principles of mathematical certainty, and agreed with many of the psychological elements in Kant's epistemology. Helmholtz accepts the 'empiricist' view that

> our knowledge of the changes of colour produced in distant objects by the haziness of the atmosphere, of perspective distortions and of shadow is undoubtedly a matter of experience. And yet in a good landscape picture we shall get the perfect visual impression of the distance and the solid form of the buildings in it, in spite of knowing that it is all depicted on canvas.[104]

Our ability to read space is not founded on a direct 'equality' between the idea in the mind and the object, but nor is it arbitrary:

> The one is a mental symbol of the other. The kind of symbol was not chosen by me arbitrarily, but was forced on me by the nature of my organ of sense and of my mind. This is what distinguishes this sign-language of our idea from the arbitrary phonetic signs and alphabetical characters that we use in speaking and writing.[105]

How far should 'the nature of the organ of sense' be taken into account in the making of a work of art? His description of how the eye works certainly might lead us to conclude that the artist should attempt to ape such effects as acuity, accommodation and retinal curvature. He observes that 'the image we receive by the eye is like a picture, minutely and elaborately finished at the centre but only roughly sketched in at the borders'.[106] However, he notes that the rapid scanning motions of the eye result in a mental image in which 'we have practically the same advantage as if we enjoyed an accurate view of the whole field of vision at once'.[107] He also shows, experimentally, that the curvature of the eye is responsible for the resolution of a certain kind of a curved pattern into a rectilinear grid when viewed from a fixed viewpoint at a close range. However, he is far from advocating curvilinear perspective on this basis, since this optical illusion does not mean that we 'see' curved lines as straight or straight lines as curved, because we do not 'see' the retinal image in a direct way:

> So far as vision is concerned, I am myself disposed to think that neither the size, form and position of the real retina, nor the distortions of the image projected on it, matter at all, so long as the image is sharply delineated all over. . . In the natural consciousness of the spectator, the retina has no real existence whatsoever. . . I do not wish to be understood as implying that when the eye is fixed, the monocular visual globe appears to have a decided form corresponding to any definite surface at all.[108]

The point is that we can only 'see' the interpretative mental symbol of the object and not the pattern of physical stimuli.

This emphasis upon the interpretative act of 'seeing' permits Helmholtz to adopt a pragmatic view of pictorial illusion based on the time-honoured concept of the picture as an intersection of the optical array: 'by a correct perspective drawing we can present to the eye of an observer, who views it from a correctly chosen point of view, the same forms of the visual image as the inspection of the objects themselves would present to the same eye when viewed from the corresponding point of view'.[109] He is fully aware of the limitations of pictorial illusion with respect to all the phenomena of natural vision, and accepts that the painter has only four very limited means of creating the illusion of depth: the use of light and cast shadows; the description of atmosphere; the relative scaling of objects of known size; and the perspectival delineation of regularly shaped forms, such as houses. All the important visual data received in the real world from binocular vision and motion are necessarily beyond the painter. However, the interpretative nature of vision allows painting to function in practice as a coherent translation of nature:

> The artist cannot transcribe Nature; he must translate her; yet this translation may give us an impression in the highest degree distinct and forcible, not merely of the objects themselves, but even of the greatly varied intensities of lights under which we view them. The altered scale is indeed in many cases advantageous, as it gets rid of everything which in the actual objects is too dazzling and too fatiguing to the eye. Thus the imitation of Nature in the picture is at the same time an enobling of the impression on the senses.[110]

The idea that the painter can evoke a remarkably wide range of *relative* effects of light within his necessarily restricted

scale of tones and colours will reappear when we look at the impact of Helmholtz's theories on Seurat in Chapter VII.

I have quoted extensively from Helmholtz because his account of the limitations and the efficacy of painting in relation to the processes of vision not only provides the most intelligent and balanced assessment of these questions in the nineteenth century but also because it acts as an important corrective to those theories of art which founded systems of representation on naive ideas of seeing the coloured image on the retina. Helmholtz provided no succour for those who believed that it was realistic to try and stalk the retinal image, and he certainly would not have founded a system of representation on an attempt to evoke 'seeing' rather than 'knowing'. I think the same would apply to most of the philosophers in the mainstream of empiricism. This explains why it is possible to characterise Impressionist art as closely related to empiricist studies of light, retinal images and sensation and yet at the same time to regard it as fundamentally inconsistent with the epistemology of sophisticated empiricists of the Helmholtz kind. I think this paradox does much to explain the failure of Ogden Rood, a dedicated Helmholtzian scientist of optics, to recognise the perceptual delights of Impressionist paintings, as we will see in the final chapter. For the Helmholtzian, the painter uses his command of the optical magic of paint to collude with the viewer's interpretative machinery—not to evoke the inarticulate impressions of stimuli in their raw state.

How tricky these questions of seeing and knowing had become in the nineteenth century can be vividly seen in the art criticism of John Ruskin, whose theory of representation centres in a subtle manner upon a tension between visual and cerebral factors. Ruskin has been popularly characterised as the leading advocate of the 'innocent eye', but his intellectual and intuitive grasp of the complexities of looking and representing prevents him from adopting any simple formulation which does away with the disciplined acquisition of knowledge. We will look at his aesthetic attitudes, particularly as related to his writings on perspective, in the next section of this chapter, but his views on focus, acuity and 'natural vision' will help at this stage to illuminate our present concerns.

It would be wrong to assume that Ruskin's naturalistic and pietistic aesthetic is inimical to mathematical discipline and geometrical optics. Within the complex, always evolving and sometimes inconsistent structure of his thought, his considerable knowledge of the precise sciences undoubtedly played a significant role.[111] We certainly cannot characterise Ruskin as a naive empiricist in matters of epistemology. In the chapter of *Modern Painters* dedicated to the proposition 'That the Truth of Nature is Not to be Discerned by the Uneducated Senses', he quotes Locke to the effect that 'whatever alterations are made in the body, if they reach not the mind; whatever impressions are made on the outward parts, if they are not taken notice of within, there is no perception'.[112] He also adopts the Lockean distinction between our understanding of 'primary' characteristics—'bulk, figure, number, situation and motion or rest of their solid parts' and 'secondary' characteristics which 'operate on our senses' in such a way as to produce effects of colour etc.[113] On this Lockean base, he regards perception as an

active, directed process, integrated with 'memory' and 'reflection'. We must *learn* to *see truly*. This act of seeing truly has a specifically spiritual dimension for Ruskin. Our ability to perceive that part of God's truth apparent in this visible world is contingent upon the moral attributes of the mind which directs that perception. Thus the 'childish' systems of visual representation apparent in works of art by the Chinese or by Red Indians reflect their lack of knowledge, and this shortcoming is a corollary of their spiritual ignorance.[114]

Ruskin is certainly not, therefore, a naive advocate of innocent seeing, but he does place far more emphasis upon the 'truths of the eye' in perception and representation than did Helmholtz. Ruskin's view of the goal for purposeful perception, placed in the service of art, is that it should be dedicated to the cultivation of true seeing in such a way that the imaginative and spiritual insights of the artist can be compellingly transmitted via the action of our visual processes. Thus his two categories of spatial 'Truth' in *Modern Painters* are both concerned with the way in which the painter needs to understand, respect and replicate the optical functions of the eye. The first of these truths is 'dependent on the focus of the eye':

> if in a painting our foreground is anything, our distance must be nothing, and *vice versa*; for if we represent our near and distant objects as giving both at once that distinct image to the eye, which we receive in nature from each when we look at them separately; and if we distinguish them from each other only by the air-tone and indistinctness dependent on positive distance, we violate one of the most essential principles of nature.[115]

He particularly commends Turner's indefinitely focused foregrounds in conjunction with more clearly focused middle-grounds. 'This, observe, is not done by slurred or soft lines (always the sign of vice in art), but by a decisive imperfection, a firm, but partial assertion of form, which the eye feels indeed to be close home to it, and yet cannot rest upon.'[116]

His attitude to the complementary property of the eye's acuity is less positive. In his earlier writings, he assumes that the painter should allow his compositions to fade into indefiniteness at the corners. In a note appended to Loudon's

470. John Ruskin, diagram of the elliptical field of vision of the human eye based on H. Repton, *Landscape Gardening and Landscape Architecture*, ed. J. Loudon, London, 1840.

ABCD—rectangular picture plane

471. Joseph Mallord William Turner, Landscape vignette to illustrate 'Theodoric', from *The Poetical Works of Thomas Campbell*, London, 1843.

1840 edition of Repton's *Landscape Gardening and Landscape Architecture*, he gives a diagramatic illustration of an elliptical field of vision (pl. 470) as a justification for indistinctness in the corners of a rectangular picture.[117] He also regards Turner's vignette illustrations, with their softened edges, as corresponding to the natural visual field (pl. 471). Some of his own illustrations follow this principle. However, by the time he came to consider the truths of space in *Modern Painters*, he believed that 'we need pay no attention' to the incapacity of the eye 'to comprehend a large portion of *lateral* space at once', because we will inevitably see only a small area of a picture at any one time, and the natural effect will thus occur automatically at each point on the picture plane.[118]

The second 'Truth of Space . . . is Dependent on the Power of the Eye', that is to say in relation to the optical diminutions which come into play as an object becomes more remote.[119] Ruskin emphasises that there is some degree of indistinctness at every distance, and that the painter should discipline himself to paint what is seen rather than what is known. Thus every brick in a middle-ground wall should not be meticulously delineated, but should be evoked by suitable skill in the medium of paint. 'Nature is never distinct and never vacant, she is always mysterious but always abundant; you always see something, but you never see all.'[120] Painterly skill in describing loss of discrimination at increasing distances allows the artist to evoke effects of infinity, not 'up to the same degree and order' as nature, but effectively enough on a lesser plane. This pictorial quality of infinity concerns both the infinitely large and the infinitely small. He describes Turner's expression of *infinity*' as 'always and everywhere, in all the parts and division

of parts. . . A single dusty roll of Turner's brush is more truly expressive of the infinity of foliage, than the niggling of a Hobbima.'[121] A scientifically informed opinion has been transformed into the poetry of great criticism.

It is characteristic of Ruskin's desire to evoke the properties of the eye in the making of a picture that he should have become embroiled in an optical controversy about the upward convergence of horizontals which broke out during the late 1830s. The problems of upward and/or lateral recession, based on an analysis of visual angles, had been a troublesome undercurrent in perspectival theory and practice from the time of Leonardo, and we have seen Carlo Urbino advocating a system in which vertical forms appear to bend away from the spectator (pls. 139–40). Hondius had explicitly experimented with a slightly tilted picture plane to capture the upward convergence of vertical parallels when seen under a wide angle. It was a problem which was clearly perceived by a few topographical draftsmen of high intelligence, like Saenredam and Turner, when they were sketching directly from such forms as tall towers from close viewpoints. In practical terms, however, artists and theorists had generally been content to accept that parallel verticals in the subject looked right when portrayed on the picture plane precisely as parallel verticals. No one before 1800 seems to have advocated and practiced a consistent system based on upwards convergence. However, in 1836 Arthur Parsey, a rather obscure miniature painter and freelance mathematician who occupied premises in the Burlington Arcade, announced a radically 'new' perspective system in which upwards convergence was to play an increasingly prominent role.[122]

Parsey, a somewhat eccentric figure, was perhaps the last professional painter who aspired to publish original discoveries in mathematics. While convalescing from an illness, he came across an entry on the hoary conundrum of squaring the circle in an old encyclopaedia. On the basis of his knowledge of Hutton's textbook in mathematics, he set vigorously to work to solve the problem—notwithstanding Lambert's demonstration of the irrationality of π, and the discouragement of those professional mathematicians to whom he spoke. In 1832 he presented his *Quadrature of the Circle Discovered* for the scrutiny of the Royal Society.[123] An air of home-made ingenuity pervades his pamphlet, and it certainly cannot be regarded as literate in the most advanced geometrical techniques of his day or even in those of the late eighteenth century. His vain if inventive efforts are symptomatic of the way in which professional geometry as applied to the most advanced problems had moved beyond the reach of even those professional painters who possessed a natural aptitude for mathematics. Nothing daunted, five years later Parsey published his *Arithmetic Illustrated by Woodcuts* as a textbook which he hoped would be seen as preferable to those in general use.[124]

His contributions to the theory and practice of painter's perspective may seem to be equally eccentric, but they did attract the respectful attention of a number of leading critics and practitioners. His ideas are expounded in two books, *Perspective Rectified* in 1836 and a heavily revised second edition in 1840, *The Science of Vision or Natural Perspective! . . . the*

New Elliptical and Conic Sections . . . and the New Optical Laws of the Camera Obscura, or Daguerreotype; also the Physiology of the Human Eye. He also aired his views widely in a series of lectures across Britain and in the correspondence columns of professional journals. The polemical basis of his theory was that all the previous theories of mathematical perspective had failed to deal with the properties of natural vision, and that orthodox paintings were founded upon abstract conceptions rather than ocular reality.

Parsey had picked up the now common distinction between seeing and knowing: 'seeing and comprehending what we see are distinct ideas; the first is a simple impression on the organs of sight, the latter is repeated impressions on the mind, till we are conscious of every attendant circumstance'.[125] He believes that the traditional science of perspective has emphasised the essentially artificial concept of the geometrical intersection at the expense of seeing: 'no section, however true in conception or abstract science, is a true or useful figure in visual science'.[126] He therefore advocates the reform of perspective in order that it can begin to speak 'the language of the eye'.[127] He accepts that painting cannot aspire to perfect verisimilitude, in that the artist depends upon the language of his media to produce visual 'symbols' or 'emblems' of natural effects, but he does require that these 'symbols' should be consistent with the workings of the eye.

The eye may be taken as standing at the centre of 'a horizontal imaginary plane': 'the visual rays of a revolving eye from a fixed position of the head make, when represented to another, a circle with an infinite number of radii'.[128] The angles between the radii are the key factors in ordering our vision: 'the proportion of angles of vision supply us with the apparent length of lines'. He therefore proposes that the correct proportional measure for an object is that represented by the chord

472. Perspective diminution by chords, based on Arthur Parsey's *Perspective Rectified*, London, 1836.

Fig. 3: the points at which lines from 1, 2 and 3 to the centre at B cut the circle provide the coordinates in the diagram Z.

473. The transfer of diminished intervals to the picture surface, based on Parsey's *Perspective Rectified*.

E—observer PG—picture plane
GH—curved arc of vision A, B, and C are joined to E
The points of intersection of AE, BE and CE with HG are transferred horizontally to PG.

474. Cube in perspective according to the standard methods (left) and 'rectified' methods (right) from Parsey's *Perspective Rectified*.

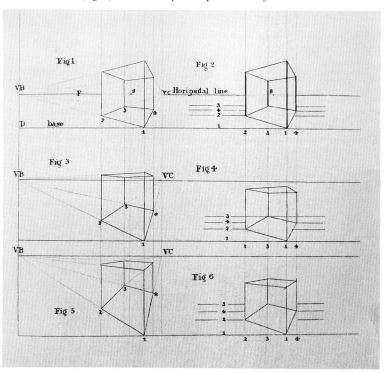

of the visual sphere passing through the base of the upright which denotes the position of the picture (pl. 472). The measurements of the chords for different objects are transferred to the picture plane (pl. 473), rather than the normal intersections on that plane. Only in the case of a picture in which a perpendicular visual axis corresponds to its precise centre can we rely on the old intersection method: 'in all other cases, the heights coming within the two outer rays from the nearest perpendicular produce a chord'.[129] When he compares geometrical bodies produced by his method with those resulting from conventional projections, the effects are not strikingly different (pl. 474), but he does insist that the greater 'truth' of

his forms is visually significant. To facilitate the production of his branch of visual truth, he also devised two instruments, a 'perspectronometer' for visual angles and a 'deflectometer' for the 'combined effects of converging and foreshortening'.[130]

By directly recording the chords produced by visual angles, Parsey intends to reduce the significance of the picture plane as the geometrical basis for the perspective construction. The picture plane simply becomes a convenient surface on which to record the results of visual angles. He considers that 'a picture is only the representation of *some space* between the eye and the objects and the position of that space is the plane of the picture'.[131] In this problematical formulation, he ignores the difficulty that when the chords are transferred to the picture plane they will no longer subtend the same angle to the eye as they did when they were recorded on the circle of vision.

475. Demonstration of the upwards convergence of verticals, from Parsey's *Perspective Rectified*.

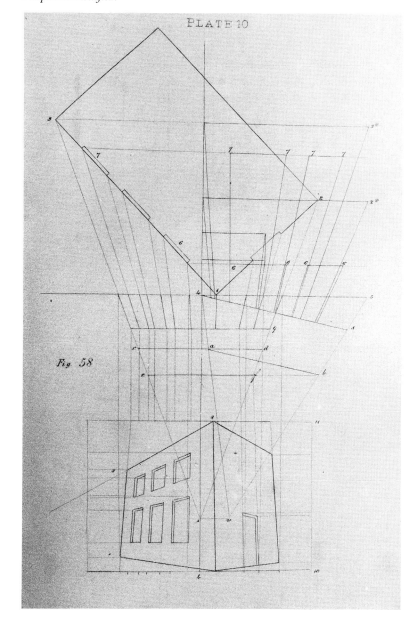

476. Perspective view of a proposed cemetery chapel (1837), from Arthur Parsey's *The Science of Vision; or Natural Perspective!*, London, 1840.

Having removed the need, in his own mind at least, for the picture plane to be rigidly defined as an intersection which stands parallel to the verticals of the subject, he is free to consider the effects of vertical recession when the eye passes upwards over elevated forms. Unless the eye is placed centrally in relation to the picture, 'the cause that shortens the length of the perpendicular in appearance lessens the breadth between a parallel at that end which is more distant from the eye'.[132] In the first edition of his treatise he did not place much emphasis upon this upwards convergence, but in response to controversial notices by Ruskin and others, he formulated his views more dogmatically and devised geometrical demonstrations to prove his point (pl. 475).[133] He also began to exhibit demonstrations of his new system. In 1837 at the Royal Academy he showed a 'Perspective View of a proposed cemetary chapel, showing the natural convergence of the perpendiculars', which he claimed to be 'the First Picture Ever Drawn with Optical Accuracy' (pl. 476).

Parsey's activities attracted a considerable degree of interest, and received favourable testimonials far from such recognised authorities as William Farish, William Etty and, as we will see, John Constable.[134] He also attracted considerable criticism, most conspicuously in the form of a sarcastic review by 'Candidus' in the *Architectural Magazine* of 1838.[135] A vigorous correspondence ensued, involving five contributions by Ruskin (writing as 'Kata Phusin'), four rejoinders from Parsey and supportive letters from William Pocock and Chappell Smith, before the editor not unreasonably announced that the correspondence was closed.[136]

Ruskin's initial arguments rely upon the necessary limitation of the visual angle in a painting to a traditional 60°, believing that upwards convergence only occurs when the eye turns above this angle. However, he is forced to give ground and admit that forms seen under an angle of 60° will show perceptible upwards convergence. He subsequently resorts to

'another reason for its non-representation', namely that the forms on the surface of the picture plane will be subject to the same kind of optical distortions as the original object: 'the eye . . . puts the perpendicular lines of the picture into perspective . . . exactly as much as it does those of nature'.[137] This assertion is supported by his observation that the perpendiculars of a building viewed through his window will always coincide with the upright edges of the frame. He is thus led to affirm that a tracing on the glass of the window 'corresponds with the image on the retina' and that the traditional idea of the intersection is optically valid. As additional evidence he cites the images which result from the use of Gavard's *diagraphe* (pl. 373).[138]

Parsey's second edition represents a concerted effort to strengthen his case, and he provides clear demonstrations of the way in which he established the 'optical accuracy' of the architectural demonstrations that he was exhibiting (pl. 475). He is delighted to note that the exciting new evidence of photographs of tall structures supports his contention of upward convergence.[139] He also attempts to revise the physiology of the human eye in a way that he believes will support his system. He argues that the crystalline lens reflects light onto the posterior surface of the iris, and that the iris is the true 'seat of vision'.[140] This untenable hypothesis would have done nothing to remove the doubts of his opponents and probably strained the sympathies of his keenest supporters.

The Parsey controversy may seem to be little more than a storm in a teacup. However, I think it is of value for the way in which it focuses analytical attention upon a long-standing tension between the absolutes of geometrical perspective and what generations of less theoretically-minded painters had felt to be the 'natural judgement' of the eye. The enthusiasm with which the elderly Constable reacted to the 'great truth and originality' of Parsey's theory is indicative of the way in which it plumbed the deep-seated intuitions of those painters who distrusted the tyranny of standard perspective but could not disprove the validity of its principles.

> The late Mr. John Constable, R.A., told me that when he was studying the art of painting in his native place, unaided by others, that he might not introduce too much foreground, and that he might sketch the view correctly, he had attached to the upper part of his easel a frame with a pane of glass in it; this frame was attached by two screw nuts to the upper corners; to the four corners he attached four strings, which he brought to his mouth in such a manner as to bring the centre of the glass perpendicular *to his eye*. On this glass, thus held and secured from shifting by fixing the screw nuts, he traced with colour the outline of the view he decided on representing. From this sketch he made his painting, and . . . his drawing must have been true'.[141]

However, Constable abandoned this simple, ocular method: 'afterwards studying in the schools of art, he followed the rules of those schools, and fell into the popular errors as he admitted and regretted'.

Although Parsey was far from advocating uninformed judgement by eye or simple tracing, his system stood in line of descent from those theories which used the Euclidian emphasis on visual angles to challenge the standard form of projection, and his ideas certainly appealed to painters like Constable who had become uneasy with the standard geometries of the painters' textbooks.

Viewed in a broad historical context, Parsey's slogan, 'natural perspective' can thus be seen as an expression of the traditional distinction between 'natural vision' and the painter's 'artificial' construction. This distinction had been recognised more or less explicitly by Leonardo and Viator, and continued to cause considerable controversy in French seventeenth-century theory as we have seen. Parsey's solution, even considered on its own terms, is open to the charge of inconsistency. If vertical lines of high towers above the axis of sight are to converge, why are the horizontal tops of wide walls to its left and right not also subjected to the same principle of convergence? A few theorists did indeed answer that all such lines should exhibit peripheral convergence, in such a way as to produce a 'bowing' of flat planes in every direction when viewed at right angles or obliquely to the axis of vision. The resulting system of bent contours is that known as curvilinear perspective.

During the mid-fifteenth century in Northern Europe, before the dominance of Italianate systems, two major artists at about the same time seem to have developed their own curvilinear systems for describing space. The first was Konrad Witz, the greatest of the early Swiss painters, who not infrequently used gently bowed lines to describe the architectural elements which enclose his figures.[142] The second was the famous French artist, Jehan Fouquet, now known chiefly as a painter of miniatures, who used even more pronounced effects of curvature to suggest the natural sweep of the eye over wide vistas and the unstable effect of towering verticals.[143] Neither artist appears to have developed the techniques according to precisely formulated rules, but their departures from orthodoxy are sufficiently striking to indicate that they must have devoted careful thought to questions of how we see and can best represent particular spatial structures. Later theorists occasionally give a glimpse of similar concerns. We have seen that Viator discussed the rotation of the visual axis, but the vertex of his rotated pyramid progressed across a straight horizon and did not result in curvilinear effects. Vredeman de Vries illustrated the orbital nature of our visual field in a remarkable manner (pl. 205), but he limited the painter's practice to the portrayal of non-curvilinear views with a static eye in the conventional way. The only unqualified assertion of the need for painters to adopt curvilinear principles before the nineteenth century occurred somewhat obscurely in William Schickhard's treatise on a meteor in 1623. Referring to a diagram in which the outlines of a square plane recede in curves to four equidistant vanishing points (pl. 477), Schickhard wrote:

> I say that all lines, even those completely straight, that are not presented as directly in front of the pupil [i.e. passing through the axis of sight, such as AN and EJ] . . . necessarily appear to be slightly curved. But no painter will believe

477. Curvilinear foreshortening of a square plane, based on Wilhelm Schickhard's *Weiterer Bericht von der Fliegenden Liecht-Kugel*, Tubingen, 1624.

ABCD square drawn in 'orbital' foreshortening.

it. Thus painters portray the flat wall of a building with straight lines, although according to the true art of perspective it is not possible to deal with it properly in this way'.[144]

He charges artists with the task of 'unravelling this enigma'. There is no evidence that contemporary painters specifically took up his challenge. In the world of science he was answered by his fellow astronomer, Kepler, who produced what has become the standard counter-argument; namely that the picture plane will be perceived according to the same principles as the plane of the wall, and that the wall represented as a rectangle in a painting will thus automatically be subject to the same laws of natural vision as the original wall.[145] The painter's overt contrivance of such an effect will therefore be redundant.

Before 1800 no theorist or practitioner of artistic perspective consistently pursued curvilinear ideals. The experiments by Lanci and Fabritius were relatively isolated. Thomas Malton went further than most writers in differentiating between perspective as the 'section of a cone or pyramid of rays' and 'the true appearance' of an object as 'the section of rays on the surface of a sphere, only'.[146] However, he dismissed the practicability of a spherical system of representation, because it would be even more vulnerable than the standard method to changes of viewpoint. It may have been from this hint in Malton that Turner experimented intermittently with curvilinear recessions on his own account (pl. 318), without, however, adopting it as his standard method.[147]

Curvilinear perspective was not championed in a thoroughgoing way by a theorist of art until the middle years of the nineteenth century, when the Liverpool artist and amateur astronomer, William Herdman, began to make topographical drawings according to curvilinear principles. His procedures were explained in 1853 in *A Treatise on the Curvilinear Perspective of Nature*, following a controversial preview of his ideas in the *Art Journal* in 1849.[148] His belief that he can portray the 'appearance of nature to the eye' is founded on the premise that 'as far as the eye is concerned, we live in the centre of an immense globe, which has reference only to that organ, having the visible horizon and the arch of space described by the radius of the eye to that horizon, for its limit'.[149] Herdman emphasises that the 'visual globe' which arises from the operation of the human eye is finite in dimension, as is every physical line in the natural world. The projective principles of geometrical perspective, in which lines meet at infinity, should not therefore be confused with the material optics of natural vision. He acknowledges that Malton had earlier entertained a similar concept of the sphericity of the visual field, but he criticises Malton for avoiding the pictorial consequence of this observation.

Before outlining his own theory, Herdman describes the conventional techniques entirely adequately, in order to point out their shortcomings. He places particular emphasis on the well-worn paradox of the colonnade, which appears to be composed of wider columns as it is seen under a progressively wider angle (pl. 478). His alternative construction relies upon a wide portion of the visual globe in which sets of circumferential lines radiate perspectivally from three 'poles' or vanishing points (pl. 479). The effects of curvature for relatively distant forms or for those seen under narrowish angles is almost im-

478. False effect of the perspective of columns according to the standard method, from William Herdman's *A Treatise on the Curvilinear Perspective of Nature*, London and Liverpool, 1853.

As the columns are seen at progressively wider angles of view, so their projection on the intersection becomes wider.

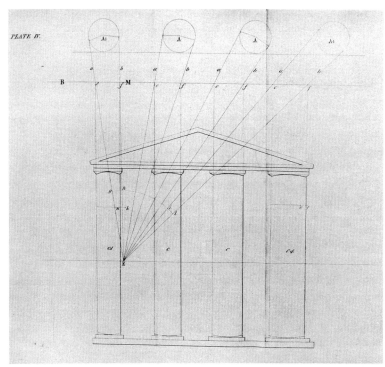

479. Buildings shown in curvilinear perspective, from Herdman's *Curvilinear Perspective*.

480. Interior of Rosslyn Chapel drawn according to the curvilinear system, from Herdman's *Curvilinear Perspective*.

perceptible. Even in a wider angle interior, such as his own study of *Rosslyn Chapel* in 1836 (pl. 480), the curvilinear effects are subtle rather than obtrusive. He believes that many artists have in fact inadvertently followed the rules of natural vision when drawing objects by eye, and he presumably applied a ruler to their free-hand sketches to prove his point.

Herdman is in obvious danger of laying himself open to a charge of inconsistency not dissimilar to the one we levelled at Parsey, in that he does not appear to apply his principles in both the horizontal and vertical planes. Herdman deals with this objection by noting that vertical lines must cut the horizon at right angles, and that on either side of the horizon they will appear 'quite straight for a considerable distance'.[150] However, 'where near views of very lofty buildings are taken', the curvilinear principles 'must certainly be practiced' in the vertical as well as the horizontal planes.

Although Herdman's ideas, like those of Parsey, stimulated a lively debate in the short term, they do not appear to have

gained a secure hold. The main reason appears to have been that buildings portrayed according to curvilinear principles actually look as if they are constructed from curved elements, and resolutely continue to look 'odd'. Advocates of curvilinear perspective could argue that this oddness only arises because we are unfortunately inured to the conventional system by existing works of art, but, even if this argument were to be accepted, the feeling of oddness undeniably persists. This problem was recognised in a sophisticated way by a theorist of far greater intellect than Herdman, Guido Hauck, who was professor of descriptive goemetry at the Royal Technical High School in Berlin. Hauck's curvilinear theory of 'subjective perspective' did exercise an important influence—not least on the ideas of the great art historian, Erwin Panofsky, partly because it was developed in the context of a considerable intellectual debate amongst students of classical architecture.[151]

Precise measurement of Greek buildings had revealed not only that the vertical contours of columns were subtly curved, as had long been recognised, but that the horizontal lines of entablatures and podia were also discernibly bent. Why should this curvature have been contrived by the designers of the buildings? The most promising form of explanation centred upon optical factors, and a group of German and English-speaking authors became embroiled in a complicated debate. F.C. Penrose, for example, believed that the rising curves of cornices were designed to counteract an optical illusion produced by the triangular pediments of classical architecture.[152] Hauck, however, rejected this form of explanation, preferring a complex argument based on subjective curvature. In his *Die subjektive Perspektive und die horizontalen Curvaturen des dorischen Styls* (*Subjective Perspective and Horizontal Curvature in the Doric Style*) in 1879, he argued that there are two forms of perspective, 'collinear' and 'conform'.[153] The first is the

481. Square columns represented according to the 'conform' system, from Guido Hauck's *Die subjektive Perspektive*, Stuttgart, 1879.

482. Perspective projection of a stool viewed obliquely, from Hauck's *Die malerische Perspektive*, Berlin, 1882.

conventional perspective of picture-making, while the second exploits curvilinear principles in a manner not dissimilar to Herdman's (pl. 481). Although the 'conform' method corresponds to the peripheral effects of natural vision, which he analyses by reference to the curvature of the eye, our mind is so conditioned to 'see' in terms of straight lines that we automatically straighten the optical curves by perceptually applying a corrective degree of opposite curvature. Thus we are accustomed to see representations that are objectively wrong as subjectively right, and those that are objectively right as subjectively wrong. Only observers less conditioned by mathematical knowledge, such as 'women and natives', will see the curves in a relatively uncontaminated manner. Thus, in looking at the curve of a Greek entablature, our corrective habit comes into play, and the wiles of the architect ensures that we are presented with the perceptual effect of a perfectly straight form.

Hauck's theories did not, however, lead him to advocate that painters should overthrow their standard systems. Indeed the way the eye surveys forms by altering its focus and orientation reflects our predisposition for perception in 'collinear' mode, in keeping with our pre-knowledge of straight lines. This belief explains why his two treatises on perspective for painters are almost wholly concerned with the explication of the 'collinear' method, using such orthodox techniques as the distance point, measure point and scales to create demonstrations of solid forms at various angles in the classic manner (pl. 482).[154] Hauck thus uses the predominance of a certain form of perceptual 'knowing' over innocent 'seeing' to validate the painter's conventional adherence to non-curvilinear systems of perspective.

The debate in which Hauck was involved is the first in which the *historic* nature of perspectival techniques becomes really significant. The arguments over Greek curves provide the first signs of what has become the dominant trend during his succeeding years and to the present day. The major writings about perspective have come to centre not so much on its current relevance for practising artists as on the intimately linked questions of its historical significance and perceptual validity. Although many of the historical accounts of perspective have adopted a predominantly descriptive tone, any historical analysis is inevitably conditioned by its author's implicit or explicit assumptions about whether perspective is an arbitrary convention—merely the conditioned vision of artists and scientists at a particular period—or a universally valid means of creating an illusion which matches in significant respects the way in which we see the world. These are topics to which I intend to return in the coda at the end of this book.

THE AESTHETIC FLAME

Alongside the optical, perceptual and epistemological doubts about the status of orthodox perspective—and intimately associated with these doubts—came the even more radically threatening advent of pure 'aesthetics', the new 'science' which aspired to define the autonomous power of artistic experience as distinct from all other human activities, science included.[155] If the essential core of 'Art' consists of a unique, incommensurable and ultimately indescribable feeling which is at once subjective and universal—as was believed by more than one influential school of thought—why should the artists waste time on the acquisition and application of knowledge from scientific and other systematic fields of endeavour?

A recurrent gloss on the exposition of rules in artistic treatises over the centuries had been that good art would not automatically follow from the application of rules on their own. During the course of the Renaissance the theory of the visual arts had progressively absorbed the ideas of *ingenium* (innate brilliance) and *furor* (inspired frenzy) from classical and Renaissance poetics. As the art theorists came increasingly to embrace Horace's famous dictum, *ut pictura poesis* (as painting, so poetry), so they came to accept that the creation of visual art at the very highest level of, say, a Michelangelo required divine inspiration, equivalent to Dante's *alta fantasia*. The genius who ascended to such a level stood above mere rules, but did not as such invalidate the concept of rational truth in the arts.

I think it is true to say that there was always something uneasy in the earlier theorists' attempts to reconcile the exercise of free imagination with the dictates of systematic imitation in the figurative arts, a problem which the arts of literature and music faced less directly. The standard resolution of the problem was a formulation which runs, with variations: rules without genius (or imagination or inspiration . . .) are nothing, and genius without rules is nothing.[156] Regardless of the side of this equation on which a particular author might place greater weight, the essential partnership of the rational and imaginative faculties of the mind in the production of a work of art was widely accepted or taken for granted. Also accepted was the goal, stated or unstated, that art should aspire to reveal the general truths of man and nature through the particulars of a work of art. The classical and mediaeval theory of the faculties (or 'inner senses') of the human mind had provided complex definitions of imagination in its various guises, but none of the existing theories adequately addressed the central questions as to what specially characterises the making or perception of a work of art as a distinct category of object. Indeed the 'distinctness' of art is not an assumption that we can take for granted before the periods with which we are now dealing.

It was during the eighteenth century, from a combination of factors internal and external to the institutional structures of art too complex to be analysed here, that the philosophical study of aesthetics began to isolate the elements distinctive to works of art. Concurrently, the parameters of science, more-or-less recognisable in their modern form, began to be established. These philosophical endeavours began to permit sustained attacks on the question, what is the relationship between art and science?

In the concluding section of this chapter, I am not intending to promise a coherent outline of the history of aesthetics as it bore upon the science during the eighteenth and nineteenth centuries—even allowing that such an outline is possible at all—but I think it will be useful to conclude our exploration of the optics of pictorial space by providing some glimpses of the complex conflagration of aesthetic notions which helped to melt the bonds previously uniting the imitative arts and optical sciences. The topics at which I intend to glance in the earlier phases of this process are the birth and consolidation of pure aesthetics, above all in Germany, and the Romantic rebellion against the rational values of academic theory, the rebellion for which Blake is a compelling spokesman. From the later phase, I have limited myself to the juxtaposition of four widely contrasting authors, Pater, Helmholtz, Ruskin and Blanc, not only to illustrate the all-too-obvious diversity in mid-nineteenth-century attitudes but also to show more surprisingly the extent to which they shared the then common assumptions about 'Art' vis-à-vis 'Science'. Of this unlikely quartet, I will be paying particular attention to Ruskin, since he was actually the author of an instructional book on perspective.

The analyses of sensation, feeling, pleasure etc. conducted by British empiricist philosophers of the eighteenth century may be considered to have initiated the specific analysis of aesthetic experience in the modern manner. The characterisation of our appreciation of beauty by Hutcheson as a kind of 'sixth sense' hints at the concept of the autonomy of artistic expression that was to be developed by the German theorists.[157] With authors like Edmund Burke, we find a growing belief that the sublime and the beautiful have unique realms of their own. Burke believed that 'beauty demands no assistance from our reasoning'.[158] In France the encyclopaedists, whose systematic classification of human endeavours did so much to establish our modern categories of knowledge, used analytic rationalism to define the roles of the non-rational faculties of the mind and their value in the arts. D'Alembert in his 'Discours Preliminaire' for the *Encyclopédie* in 1754 recognised the role of 'imagination in the geometer who creates, no less than in a poet who invents'.[159] However, 'it is true that they operate differently on their object. The first slices and analyses it, the second composes and embellishes it. It is also true that their manners of working arise from different kinds of minds; and it is for this reason that the talents of a great geometer and those of a great poet will never be found together.' This contrast between a scientist who 'slices and analyses' and an artist who 'composes and embellishes' occurs again and again in succeeding discussions of this question.

D'Alembert's fellow encyclopaedist and the founding father of art criticism, Denis Diderot, expressed a marked distrust for restrictive rule in the literary and visual arts, which should rest on a vivid confrontation between the world of nature and our personal consciousness. When looking at a tour-de-force of illusionistic perspective, we should remember that 'it is the merit not of the artist but of the rules. . . It is a matter of Euclid. . . Yet the people are entranced, ignoring the way in which such illusion is facile.'[160] Diderot, in a rather traditional manner, does not deny the value of the rules, but believes that they can never subtitute for truly artistic *sensibilité*.

The credit for the definition of 'aesthetics' as a discipline with its own distinct aims and methods may be fairly accorded to Alexander Baumgarten, in his *Meditationes philosophicas ad poema pertinentibus (Reflections on Poetry)* of 1735 and his unfinished *Aesthetica* (1750 and 1758).[161] It is not surprising, given their relative freedom from the constraints of imitation, that the poetic arts were in the lead in aesthetic formulations. Baumgarten defines aesthetics as 'the science of sensory cognition', which is to be identified neither with the study of the senses nor of the intellect. Aesthetic experience is concerned with a special type of knowledge, but the kind of 'clarity' it produces is intuitive and therefore 'confused', compared to the distinct and analytical clarity of knowledge gained by reason. The intuitive orders of art—'richness, magnitude, life, clarity, certainty and poetic truth'—are different in kind from the logical orders of scientific knowledge. In one sense, poetic truth may be regarded as intermediate between the chaos of the sense and the order of reason: 'one must pass from the darkness of unknowingness to distinct thought through the kind offices of the confused but vivid imagery of the poets'.[162] But this intermediate status should not be taken to mean that poetic truth does not have its own distinct genus of perfection, its own unalienable area of unique validity. Baumgarten is in effect saying that 'Art' is 'Art' and aesthetics can explain why.

The key development of aesthetic experience into a concept that could bear the closest philosophical scrutiny was made by Immanuel Kant in his *Observations on the Feeling of the Sublime and the Beautiful* (1764) and above all in the third of his critiques, the *Critique of Judgement* (1790).[163] Aesthetic judgement, for Kant, is akin to our innate intuitions of space and time, in that it is a determinate *a priori* principle of selective judgement. It thus resides in us and not in the object. Although it is subjective, it is universal and non-arbitrary. It is deeply satisfying but it does not respond to a natural appetite, such as hunger. As a form of pleasure it is supremely 'disinterested' and is not dependent on scales of values drawn from pure or practical (moral) reason. Art may be made purposefully, and convey an effect of purposefulness, but it has no concern with purpose in the practical sense. In this it differs from the ends of science, because the scientist seeks to anatomise the purpose or function of something in nature. Aesthetic pleasure arises as a perception or reflection of the coordination of sense and reason, producing beauty when sense and reason are brought into harmony, and generating the sublime when we become aware of magnitudes which 'surpass every standard of sense'.[164] Above all, artistic genius is not subject to the prescription of rule, though it may provide a model within which rules can be discerned. In the final analysis, the power of art is not amenable to written codification: 'by an aesthetic Idea I understand that representation of the Imagination which occasions much thought, yet without the possibility of any definite thought whatever—i.e. a *concept*—being considered adequate to occasion it; consequently it cannot be completely emulated and made intelligible by language'.[165]

This final point—that the quality of art is inexpressible in terms other than its own—became (and still is) a commonplace of attitudes towards artistic excellence. Goethe, who was by no means a systematic aesthetician, echoed this idea when he wrote that 'if imagination did not give birth to things which for ever will remain enigmatic to reason, the imagination would altogether be of small account'.[166] This non-rationality should not, however, be taken as arbitrary irrationality. Art, for Goethe, anticipates a supreme level of truth concerning the wholeness of the universe as manifested in the components of nature and in man himself. One of his leading intellectual correspondents, Friedrich Schiller, specifically characterised aesthetic experience as a privileged insight into an over-arching unity which subsumes the sensuous and rational natures of man's life: 'only the perception of the beautiful makes something whole of man, because both his natures must accord with it'.[167] This idea of the transcendent power of aesthetic experience even became, in the hands of Friedrich von Schelling, the end towards which the mechanical solutions of science must strive without ever hoping to attain:

Art and science . . . are so utterly opposed in tendency, that if science were ever to have discharged its whole task, as art has always discharged it, they would both have to coincide and merge into one. . . . Art constitutes the ideal of science, and where art is, science has yet to attain to. From this, too, it is apparent why and to what extent there is no genius in science.[168]

All this aesthetic philosophising may seem very abstract, and simply show that 'aesthetic science' has an inbuilt tendency to become disastrously divorced from the reality of making art no less than it tends to mis-represent science. There is an element of truth in these impressions, but there is no doubt that the aestheticians' assertions of the indefinable and autonomous power of art did relate to an intuition which was common amongst artists and theorists and had long stood in need of articulation. We will see one concrete example of the new attitudes in action when we look at Runge's individualistic exploitation of the science of colour in Chapter VII. It was in the world of the early Romantic artists that the ideas of the aestheticians took practical root, though the art which claimed to draw its power from the new autonomy of aesthetic experience was often far from the transcendent classical ideal which had generally been the assumed goal of the earlier aestheticians.

The most vivid testimony to the non-rational ideas of the radical artists in the new generation is given by the English poet and painter, William Blake. In one sense he is the heir to the Platonising tradition of innate idealism: 'Knowledge of Beauty is Not to be Acquired. It is Born with us.'[169] His artistic heroes include the classical giants of the High Renaissance, Raphael and Michelangelo. But the visionary stance from which he approaches these ideals radically divorces him from the academic rationalism represented in Britain by Sir Joshua Reynolds. He inscribed the title page of his copy of Reynolds's *Works* with the uncompromising indictment: 'This Man was Hired to Depress Art'.[170] His rejection of Reynolds's measured approach went hand-in-hand with his rejection of the institutionalising of the arts, a process of social engineering which transforms the artist into someone who is 'Passive and Polite & a Virtuous Ass'.[171]

Perhaps more directly than any other artist of his age, Blake mounted an unrelenting assault on the tradition of scientific rationalism and its underpinning by empiricist philosophy. The seed of decay in British thought was sown by Francis Bacon's *Essays*: 'I am astonished how such Contemptible Knavery and Folly as this Book contains can ever have been called Wisdom by Men of Sense.'[172] Bacon's pernicious doctrines were then carefully nurtured by Newton and Locke, becoming so widespread that they smothered truth. And now, with the *Discourses* of Reynolds, who openly praises 'the great Bacon', the visual arts are to be saddled with the same heretical 'Nonsense!', to use the riposte he sprinkles liberally over Bacon's own text.

Newton, in particular, becomes Blake's evil angel. The great scientist (pl. 483) is portrayed naked in a stony and lichen-infested cavern (?)—evocative of 'the Barren Waste of Locke and Newton'—and stooped over an arid conundrum of abstract geometry.[173] Recalling Plato's image of man, who can only see shadows in the dark cave of his material existence, the scientist's empirical scrutiny of nature and dry reason benefit him nothing:

The Life's dim window of the soul
Distorts the Heavens from Pole to Pole

483. William Blake, *Newton*, c.1795, London, Tate Gallery.

And leads you to believe a Lie
When you see with, not thro' the Eye.[174]

He makes the same point about sensory knowledge in his annotations to Reynolds: 'Nonsense—Every Eye Sees Differently: As the Eye, Such the Object.'[175] Even if we can rectify the erring senses, the Lockean form of knowledge we acquire is altogether trifling: 'The desires and perceptions of many untaught by anything but organs of sense, must be limited to objects of sense. If it were not for the Poetic or Prophetic Character, the Philosophic and Experimental would soon be at the ratio of all things and stand still, unable to do other than repeat the same dull round over again.'[176]

Blake's *Newton* is obsessed with 'the ratio of all things', and stares fixedly at the kind of problem in proportional geometry that had so captivated Leonardo. In answer to Reynolds's contention that colouring true to nature is 'as true as a mathematical demonstration', Blake declares, 'God forbid that Truth should be Confined to Mathematical Demonstration.'[177] One of his testy annotations to Berkeley asserts that 'God is not a Mathematical Diagram.' Blake's escape from the arid world of mathematics and the dull delusions of sense is through the imagination: 'He who does not imagine in stronger and better lineaments, and in stronger and better light than his perishing mortal eye. . .does not imagine at all. The painter of this work [he is referring to his own *The Bard from Gray*] asserts that all his imaginations appear to him infinitely more perfect and more minutely organised than anything seen by his mortal eye.'[178] The true artist 'who sees the infinite in all things, sees God. He who sees the Ratio only, sees himself only.'[179] The innate flame of divine Genius can alone permit the artist to achieve true insight. He despises 'Reynolds's opinion. . .that Genius May be Taught and that all Pretence of Inspiration is a Lie and a Deceit. . .GENIUS BEGINS WHERE RULES END'.[180]

Blake's position is an extreme one with respect to empirical knowledge and the Newtonian mathematicising of nature. We have seen that other early Romantics could be fired by the beauty of Newton's vision, and that it was still possible for a later Romantic, like Turner, to seek inspiration in science's revelation of the powers of nature. However, even Turner subscribed to opinion that the artist should never cower before the 'restrictive rule' of scientific formulas. There was a steady accretion of *avant-garde* opinion decrying the rational sobriety of academic doctrines and the suffocating nature of the institutions which promulgated them. German aestheticians early set the tone. Wilhelm Heinse, who held the extreme view that 'painting and sculpture serve first of all lust', wrote in 1777 that 'you can't learn art like sums; it's free art, not subject to any teacher'.[181] On a less philosophical level, the splenetic Benjamin Robert Haydon in his *On the Academies of Art (more particularly the Royal Academy) and their pernicious effects on the genius of Europe*, described the teaching institutions as 'royal and imperial hot-beds of the commonplace'.[182] Using a less intemperate tone of voice, the individualistic Danish classicist, Carstens, made much the same point about the academies as institutions: 'when there were no academies great artists lived and were encouraged by the powers of their time to use their genius on great works, whereas academies have caused art to deteriorate until it has become content with working at head and tail pieces in books'.[183]

In formulating their credos of creative and social autonomy, the aestheticians and artists were establishing the new orthodoxy, the modern vision of the exceptionally creative being subject to no rigid rules. The credo was expressed in its canonical form by Baudelaire:

Romanticism is precisely situated neither in choice of subjects nor in exact truth, but in a mode of feeling. They looked for it outside themselves, but it was only to be found within. For me Romanticism is the most recent, the latest expression of the beautiful. There are as many kinds of beauty as there are habitual ways of seeking happiness. . . To say the word Romanticism is to say modern art—that is, intimacy, spirituality, colour, aspiration towards the infinite, expressed by every means available to the arts'.[184]

Fully-subscribing Romanticists obviously only represent a fraction of the total art world in the mid-nineteenth century, but the central core of their belief—the autonomous power, non-rationality and ultimate unteachability of artistic creativity at the very highest level—was explicitly or tacitly accepted by *avant-garde* artists and writers on a remarkably widespread basis.

The four protagonists whom I have chosen to help us sample the unity in diversity in mid-nineteenth-century theory, bear witness to this sense of a common, underlying assumption in a way which would, I suspect, have surprised the authors themselves. On the surface, their standpoints are notably different: Pater is a most eloquent exponent of the aesthetic standpoint; Helmholtz is a sober empiricist who brings his scientific eye to bear on artistic naturalism; Ruskin erects a great Victorian edifice of words, as full of fact as it is of imagination;

and Blanc rescues what is rescuable from the academic tradition and begins to suggest how the science of art might have some kind of future after all. However, when we let them speak for themselves about the central nature of art, either in itself or with respect to science, a common thread of belief emerges.

Walter Pater formulated what is one of the classic definitions of the view of art as an irreducible entity.

Art is always striving to be independent of mere intelligence, to become a matter of pure perception, to get rid of its responsibilities to its subject or material; the ideal examples of painting and poetry being those in which the constituent elements of the composition are so wedded together, that the material or subject no longer strikes the intellect only; nor the form, the eye or ear only; but form and matter, in their union or identity, present one single effect to the 'imaginative reason', that complex faculty for which every thought and feeling is twin-born with its sensible analogue or symbol.[185]

This conviction lies behind his famous dictum, '*All art constantly aspires towards the condition of music.*'[186]

Although Pater was by no means a systematic epistemologist, he was well enough informed about such matters to formulate an odd version of perception in which visual anarchy is in danger of isolating us in enclosed chambers of pure subjectivity:

at first sight experience seems to bury us under a flood of external objects, pressing upon us with a sharp and importunate reality, calling us out of ourselves in a thousand forms of action. But when reflection begins to play upon those objects they are dissipated under its influence; the cohesive force seems suspended like some trick of magic; each object is loosed into a group of impressions—colour, odour, texture—in the mind of the observer. And if we continue to dwell in thought on this world, not of objects in the solidity with which language invests them, but of impressions, unstable, flickering, inconsistent, which burn and are extinguished without consciousness of them, it contracts still further: the whole scope of observation is dwarfed into the narrow chamber of the individual mind.'[187]

The true escape from this chamber occurs when the highest levels of imaginative thought are placed in the service of enraptured experience: 'the service of philosophy, of speculative culture, towards the human spirit is to rouse, to startle it to a life of constant and eager observation. . . To burn always with this hard, gem-like flame, to maintain this ecstasy, is success in life.'[188]

Such imaginative exaltation of the senses leaves little room for the science of art. When Pater has to confront the scientific activities of one of his idols he brings art and science together by mystifying science: 'the science of that age was all divination, clairvoyance, unsubjected to our exact modern formulas, seeking in an instant of vision to concentrate a thousand experiences. . . To him [Leonardo] philosophy was to be something giving strange swiftness and double sight, divining the sources of springs beneath the earth or expression beneath the countenance. . .'.[189] This view of Leonardo's thought contains at least as much truth as the more standard translation of Leonardo into the prophet of modern science, but it leaves little scope for the reconciliation of the science of Pater's own day with the sensory ecstasy of great art.

If Pater's view was an extreme one, at least something of its tone was shared by many of his contemporaries. A work of art, one of them wrote,

should excite and enchain our attention, arouse in us, in an easy play, a host of slumbering conceptions and their corresponding feelings, and direct them to a common object, so as to give a vivid perception of all the features of an ideal type, whose separate fragments lie scattered in our imagination and overgrown by the wild chaos of accident.[190]

Is the author of this passage a poetic aesthetician in the Pater mould, albeit one with a greater taste for the 'ideal'? The author is in fact Helmholtz, lecturing 'On the Relation of Optics to Painting'. Early in his lecture, when he states that he does not intend to deal with the 'ultimate objects and aims of art', he implicitly accepts that there is a final goal in art that cannot be identified with optical naturalism.

His companion lecture, 'On Goethe's Scientific Researches', provides the clearest definition of what he regards as the essential differences between artistic and scientific vision.

Poetry is concerned solely with the 'beautiful show' which makes it possible to contemplate the ideal; how that show is produced is a matter of indifference. Even Nature is, in the poet's eyes, but the sensible expression of the spiritual. The natural philosopher on the other hand, tries to discover the levers, the chords, the pulleys, which work behind the scenes, and shift them. Of course the sight of the machinery spoils the beautiful show'.[190]

The subjectively poetic character of Goethe's optical science stimulates a train of thought in Helmholtz that leads him to conclude that

in a perfect work of art, the idea must be present and dominate the whole, almost unknown to the poet himself, not as the result of a long intellectual process, but as inspired by a direct intuition of the inner eye, or by an outburst of excited feeling. . . An idea thus embodied in a work of art and dressed in the garb of reality, does indeed make a vivid impression by appealing directly to the senses, but loses of course that universality and that intelligibility which it would have had if presented in the form of an abstract notion.[192]

It is this 'abstract notion'—as expressed in terms of the mechanisms of causes and effects—that concerns the physical scientist. The overwhelming cultivation of Goethe's 'delicate instinct' for universal harmony, in details and wholes, gives his descriptive natural science high value, while explaining the failure of his analytical work in the more abstract field of physical science. Helmholtz would have readily recognised a mind similar to Goethe's at work in the art criticism of John

484. Studies of geometrical and natural forms from John Ruskin's *The Laws of Fésole*, London, 1879.

drawing of regular geometrical forms, such as the shield of St. George (pl. 484). This emphasis on the imitation of regular forms reflects his belief that 'a fine work of art differs from a vulgar one subtleties of line which the most perfect measurement is not alone, delicate enough to detect; but to which precision of attempted measurement directs the attention'.[194] The student progresses from the regularities of the shield to the vitalised symmetries of nature as manifested in such forms as a feather:

485. Perspectival analysis of clouds, from John Ruskin's *Modern Painters*, London, 1860.

Ruskin, though Ruskin's 'delicate instinct' did not—any more than it had in Goethe's case—prevent him from attempting to embrace the full range of human intellectual and emotional potencies in his conception of art. The artful paradox at the centre of Ruskin's aesthetics is perfectly summarised by his statement that 'real artists are absolutely submissive to law and absolutely at ease in fancy'.[193] He requires that art should draw together the poles of existence: rule and freedom; stable regularity and energetic vitality; mathematics and organism; precise description and poetic inspiration; diligence and impulse, and so on. The means by which such poles might be brought into creative harmony in the work of art are exemplified in his teaching methods. The student is expected to begin, in a rather Pestalozzian manner, with the training of the hand in the free

486. Perspectival analysis of curved configurations of clouds from Ruskin's *Modern Painters*.

every beautiful form in this world, is varied in the minutiae of the balanced sides. . . The curve which terminates the hen's feather pleases me, and ought to please *you*, better than the point of the shield, partly because it expresses such relation between the length of the filaments and the plume as may fit the feather to act best upon the air, for flight; or in unison with other such softly inlaid armour, for covering.[195]

It is this subtly vital regularity underlying nature's organic

variety that permits him, as a supreme advocate of natural vision, to analyse cloud formations according to a perspectival scheme whose basis is recognisably traditional (pl. 485). He explains that 'the absolute forms of each cloud are, indeed, not alike. . . but assuredly, when moving in groups of this kind, there are among them the same proportional inequalities of relative distance. . . the same exquisite suggestions of including curve'.[196] His illustrations of perspective in swirling groups of clouds (pl. 486) and his drawing of *Light in the West, Beauvais* (pl. 487), show how the artist's understanding of the regular principles that underscore natural appearance informs his depiction of complex phenomena.

Ruskin's recognition of regularity in nature helps explain why he was willing to write a treatise on geometrical perspective, rather against his natural instincts:

the way perspective is at present explained in treatises the difficulty is greater than the gain. For perspective is not of the slightest use, except in rudimentary work. You can draw the rounding line of a table in perspective but you cannot draw the sweep of a sea bay. . . No great painters ever trouble themselves about perspective, and very few of them know its laws; they draw everything by eye.[197]

This unpromising opinion, in his preface to *The Elements of Drawing* (1857) might lead us to expect that *The Elements of Perspective*, published two years later, will be a desultory effort. However, this is far from the case. Ruskin set himself to 'do away with the repulsive difficulties of the subject'.[198] He succeeded ingeniously in expounding 'the rules in a short mathematical form which any schoolboy may read through in a few days after he has mastered the first three and the sixth books of Euclid'.[199] Almost in spite of himself, he finds the results 'curious and interesting'.

His confident assertion that 'the size of the *object represented* in the picture. . . is fixed by an absolute mathematical law'

487. *Light in the West, Beauvais*, from Ruskin's *Modern Painters*, London, 1860.

255

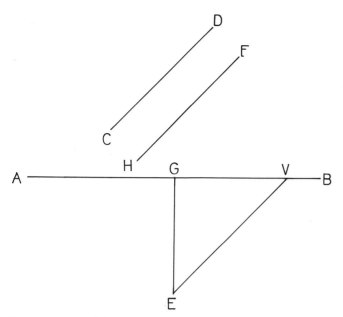

488. Demonstration of the vanishing point of given parallel lines, based on Ruskin's *Elements of Perspective*, London, 1859.

E—observer
CD, HF—parallel lines
V—vanishing point

EG—viewing distance
Draw EV parallel to CD and HF

would not have been out of place in a Renaissance treatise.[200] With accuracy and economy he explains all the basics, such as the 'vanishing point of a given horizontal line' (pl. 488), establishing the *punctum concursus* in the now classic way. He also provides more practical illustrations of a building portrayed in perspective using the 'dividing point' and 'measuring line' in the Brook Taylor manner (pl. 489). However, having done his work succinctly and well, he confesses that 'I wish this book had less tendency towards the infinite and the unreducable. It has so far exceeded the limits I hoped to give it, that I doubt not the reader will pardon an abruptness of conclusion, and be thankful, as I am myself, to get to an end on any terms.'[201] Perspective was not to be despised as a rudiment of technique, but its dry diagrams stand too far from the soul of art to excite Ruskin's sustained engagement. Those artists who mechanically exploit its geometry merely produce 'clever stage machinery'; Le Sueur's paintings are 'pure abortion and nuisance'.[202] The mathematics of art must humble itself before the spiritual vitality of nature. 'All true art is praise.'[203]

Of our strange quartet of authors, Charles Blanc alone stands in clear line of descent from the academic tradition, though not in a dogmatically *retardataire* fashion guaranteed to alienate the younger artists. His perceptive advocacy of the art of Delacroix, much in the spirit of the painter's own estimation of himself as a *pur classique*, played an important role in the establishment of Delacroix as the pivotal figure in the development of French nineteenth-century art. Blanc's ability to ally enduring virtues and innovatory initiatives is reflected in his founding in 1859 of the *Gazette des Beaux Arts*, a periodical which still flourishes today. The dominant feature in Blanc's conception of art was its ability to communicate the profound-

est values of the human soul. A supreme 'Romanticist' like Delacroix was the inheritor of the great legacy of European history painting in line of descent from Raphael and Michelangelo. Blanc's definition of painting is at once a product of the Romantic age and a statement of classic purpose: 'painting is the art of expressing all the conceptions of the soul by means of the realities of nature represented on a single surface in all their forms and colour'.[204]

The introduction to the book which most completely expresses Blanc's credo, his *Grammaire des arts du dessin* (1867) shows him to be well informed about the aesthetic issues analysed by British and German writers. Looking in admiration at the British succession—Burke, Hume, Reid, Price, Alison, Hogarth and Reynolds—and at the 'more abstract' philosophising of such German thinkers as Baumgarten, Kant, Schiller and Schelling, he laments the lack of literacy amongst his French contemporaries in the analytical techniques necessary to understand the basis of beauty.[205] They simply say that taste is so personal and subjective that *on ne peut disputer des goûts*—'it is not possible to argue about styles' —a standpoint that Baudelaire came close to adopting in the comments quoted earlier in this section. Blanc agrees that art is personal—'ART IS THE INTERPRETATION OF NATURE'—but his rather Kantian belief that 'the feeling for beauty is innate' permits him to adopt the formula that aesthetic values can be both subjective and non-arbitrary.[206] 'All the germs of beauty are in nature, but only become apparent to the spirit of the man who releases them. When nature is beautiful, the painter alone *knows* that she is beautiful, but nature knows nothing of it. . . The artist, who understands beauty, is superior to nature, who displays it.'[207]

Given his belief that the 'release' of nature's beauty by the mind of the artist is best accomplished through understanding rather than unfettered subjectivity, it is not surprising to find that he expects painters to master the principles of perspective. His own exposition of the techniques is very routine, and he

489. Perspectival projection of a building using the 'measure point' method, from Ruskin's *Elements of Perspective*.

D—'measure' or 'dividing' point

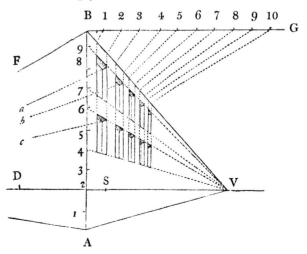

490. Expressive qualities of lines in the human face as described by Humbert de Superville, from Charles Blanc's *Grammaire des arts du dessin*, 2nd edn., Paris, 1870.

directs the reader to Valenciennes, La Gournerie, Adhémar and Sutter for more advanced instruction.[208] Even Blanc, however, seems to reflect a certain nineteenth-century tiredness amongst artists and critics with the technical tyrannies of the subject, particularly in as far as its rigid formulas may cramp the expression of human values. Perspective certainly does not correspond precisely to 'perceived' truth:

mathematical truth is not of the same nature as pictorial truth. Above all it happens continually that geometry says one thing and that our mind says another. If I see a man at five paces, his apparent size is twice the size that he appears at ten paces: science proves it, and it cannot in fact be gainsaid; nevertheless the man always appears the same size to me, and the error of my mind will be more trustworthy than the truth of geometry.[209]

This account of what is now called 'constancy scaling' in our perception of forms is based upon Voltaire's *Philosophy of Newton*.

Having given the mind sovereignty over mathematics in the seeing of space, Blanc is free to use pictorial perspective in accordance with the total 'feel' of the required scene: 'feeling should guide one and all the operations of the painter and should similarly be used to determine the height of the horizon, the choice of point of view, the choice of the point of distance and the lesser or wider opening of the visual angles'.[210] He quotes with approval David's statement that 'other painters know perspective better than me, but they do not feel it as well'.[211] His sense that 'feeling' cannot play this crucial role in the making of a photographic image leads him to conclude that photography 'imitates all and expresses nothing'.[212]

Blanc's mind-based naturalism, although hardly intended by him as a revolutionary doctrine, did contain elements that were to be deeply congenial to those amongst the younger generation of theorists and artists who were concerned to re-erect the science of art on the basis of the science of mind. Blanc had himself begun to formulate a system of expression based on psychological signs. In this attempt he was looking back to the extraordinary *Essai sur le signes inconditionels dans l'art* (1827–32) by the Dutch graphic artist and author, Humbert de Superville.[213] Humbert had developed an elaborate system of visual meanings, underpinned by Kantian metaphysics, in which colours and lines exercised inherently communicative effects on the receptive mind. Although his system showed some affinities with those of Runge and Goethe, he did not seek foundations in the precise science of optics, but rather in a form of psychical metaphysics.

The element most directly adopted by Blanc concerned the 'physiognomics' of line. Rudimentary schemata for a human face (pl. 490) provide the basis for an emotive system of linear signs, in which horizontal lines 'characteristic calmness'; lines moving leftwards in an 'expansive' configuration 'express a feeling of gaiety'; while a 'convergent' pattern of lines from the right 'corresponds to a feeling of sadness'.[214]

Humbert's ideas only fully came into their own later in the century, when younger theorists, Charles Henry in particular, brought his notions of emotive lines and colours into line with the burgeoning science of psychophysics.[215] Henry was convinced that the very subjectivity that the Romanticists had used to justify the burning of the old rule books could be analysed according to the most rigorous scientific standards. He aimed to create, using the techniques of advanced mathematics in conjunction with the new ideas of psychology, a science of aesthetic response that could account for harmony and discord in colour and form—not on the older basis of the optical properties of objects but according to the properties of the human brain. This mental variety of the science of art met with an enthusiastic response amongst those *avant-garde* thinkers and artists in the last quarter of the nineteenth century who were looking towards the marvels of science and technology to shift human consciousness and society on to a new plane. We will see echoes of these concepts at the very end of Chapter VII in connection with Seurat's paintings. The new ideas can be described with justification as a new form of the 'science of art', but it was a form that radically shifted the focus of attention from the optical science of things seen in nature to the interior of the human mind. As such the new 'science of art' belongs to a world outside the present book.

Part III: The Colour of Light

'We do not see any of the colours pure,
as they really are, but variously
intermingled with others'

(Theophrastus (?), De coloribus—*previously
attributed to Aristotle)*

Introduction to Part III

If there is anything upon which almost all the writers on colour agree, from the time of Aristotle to the present day, it is that colour as seen in nature presents a bewildering variety of kaleidoscopic variations—fleeting, fluctuating; and almost infinitely slippery whenever we try to entrap them in a regular net of scientific categories. Even our shifting perceptions and representations of space seem positively stable and consistent when compared to the elusiveness of colour vision. This elusiveness arises both from the complexity of the phenomena which our sensory mechanism translates as colour and from the flexibility, relativity and variability of the perceptual system itself as it attempts to make some stable sense of colour in a given context. The same physical phenomenon may be seen and described differently by the same person in different optical contexts, while different physical stimuli may be seen as identical under different circumstances. The lack of an agreed colour vocabulary within and across different languages reflects these problems. This is to say nothing of the common disorders of colour vision, ranging from colour blindness to relatively minor deficiencies.

The variability of our reading of colour has created infinitely tricky problems for those painters who have been concerned with the recreating of natural colour in a systematic manner. These problems have only been compounded by the 'mysteries' of colour mixing in the various media used by painters over the ages. It is no wonder that a Venetian author in the sixteenth century, a partisan of perhaps the greatest of all schools of colouristic painting, referred to the composition of colours on canvas as 'the true alchemy of painting'.[1] Paolo Pino, the author in question, was meaning to infer that colour, like alchemy, was a magical science, which manipulated the constituent materials of nature according to secret recipes in order to concoct compounds whose properties would mysteriously transcend the natures of their individual parts.

Yet for all its elusive aspects colour did prove, during the periods with which we are concerned, increasingly amenable to a system of rational analysis which promised a real measure of success in codifying the causes and effects of colour. From the time of Newton—and even in the later stages of the Aristotelian tradition—there was a conviction that the phenomena were quantifiable and controllable. There was also a progres-

sive clarification of what we may call the three 'dimensions' of colour—as approximately analagous to the three dimensions of Euclidian space. These dimensions are hue, saturation and tone. In any historical discussion of colour theory and practice, these categories provide such valuable (if simplified and conventionalised) points of reference, that we would do well to define them at the outset, so that our terminology, at least, will not be as apparently various as the effects. The term hue, as used here, refers to the nature of a colour as normally perceived in white light and named in relation to the broadly common vocabulary of colour: i.e. blue or green or red or yellow etc. By saturation (or 'intensity' or 'purity') is meant the percentage of pure hue present in any mixture. Thus a saturated red, for example, will give a powerful and intense effect compared to a red substantially diluted with grey. The tone of a colour (sometimes called its 'luminosity') concerns its relationship to a scale of value from white to black, through all the intermediate shades of grey. Thus a red can be made lighter in tone by the addition of white or darkened by black. The individual hues possess inherently different tonal values; saturated blue will, for example, be closer to black in the scale of tonal value than saturated yellow.

To these three dimensions, which were formulated with increasing clarity in scientific and artistic colour theory during the eighteenth and nineteenth centuries, the painters added a three-part system within hue arising from their own practice. The painters' discovery, first recorded in print in the seventeenth century, was that all the main varieties of hue could be mixed on the palette from only three primary or 'primitive' hues: yellow, red and blue. Simple mixtures of two primaries result in the so-called secondary or derivative colours: a mixture of yellow and red provides orange; red and blue make purple; and green arises from a mixture of blue and yellow. This system provided the foundation for the basic colour circles or wheels known to artists like Runge in Germany, Turner in Britain and Delacroix in France.

The painters' doctrine, though it was systematic in character, was not much help when it came to the formulation of an optical science of colour in painting. To some extent it would be reconciled with the Aristotelian tradition, in as much as Aristotle had not settled definitively upon a fixed number of

491. The 'additive', primaries (above) and 'subtractive' primaries (below).

R—red	P—purple	O—orange
Y—yellow	BG—blue-green	V—violet
B—blue	W—white	G—green

primary colours. But Newton, whose ideas were central to any serious discussion of colour science during the eighteenth and nineteenth centuries, was widely interpreted as having established the presence of seven prismatic colours in white light—red, orange, yellow, green, blue, indigo and violet—and we all know that three into seven does not go. Many painters, probably the great majority, would have agreed with the German painter, Anton Raphael Mengs, who wrote that 'the experience and practice of my profession' had led to conclusions 'differing much from the principles of Newton'.[2] Some artists, however, did attempt to annex Newton's prismatics to the theory of art, particularly during the nineteenth century, and the formulation of a colour theory for painting founded on the latest scientific concepts became an ambition for a number of leading artists, not least for Runge, Turner and Seurat.

A revival of interest in various three-colour theories amongst scientists around 1800 assisted to some extent in reconciling pictorial practice and scientific theory. These systems amplified, modified or, especially in the hands of Sir David Brewster, openly challenged Newtonian precepts. The schemes of Wunsch and Young, which contributed to the development of colour photography, relied upon different primaries for coloured light from those for pigments. The distinction between the two sets of primaries was ultimately explained by Helmholtz in terms of additive mixtures (for light) and subtractive mixtures (for pigments). By adding together the primaries for light—blue, green and red (or more accurately, orangish red) all the components necessary for the production of white light will be present; hence the name 'additive primaries' (pl. 491). Pigments, on the other hand, act by absorbing (or subtracting) certain bands of colour from the full spectrum. A mixture of two hues will absorb more than one, and the three primaries together, yellow, red (bluish red) and blue (greenish blue or cyan), should absorb all the colours of the incident light. Black, in theory at least, is the ultimate product of the three 'subtractive primaries'. We now know in relation to perceived colour that matters are a good deal less tidy than this account, and that a wide range of colour sensations can be contrived from the use of just two separate stimuli or 'primaries'.[3] We also know that physical colours do not possess the purity to act in perfect accord with the basic theory. However, for our historical purposes we may take the definition of the subtractive primaries and additive primaries as a working framework for analysis—even if it cannot be regarded as an adequate explanation for all the phenomena of perceived colour.

A number of artists and theorists before the mid-nineteenth century sensed or articulated an awareness that the phenomena of light and pigments were not simply interchangable. Turner, in particular showed some awareness of this distinction, albeit in a characteristically untidy and intuitive manner. It was expressed with definitive clarity in the mid-nineteenth century by Helmholtz, whose writings certainly played a part in Seurat's scientific education. However hard the earlier artist-theorists had striven, the gap between the properties of artists' pigments and actual light had remained obstinately difficult to bridge, and it was only with Seurat's marriage of Impression-

ist colour with the optical language of Ogden Rood that the goal of 'painting with light' seemed to have become attainable. But even this was to be a short-lived moment of stable union.

The two chapters which comprise this third part of our study are concerned specifically with those artists and theorists who have made the ambitious attempt to cross the chasm between colour practice in painting and the science of light. These chapters will not, therefore, trace the independent story of colour in painting from the fifteenth to the nineteenth centuries, nor will they provide an outline account of scientific colour theory during the corresponding period. Rather, they will be concerned with those points at which the two stories impinge upon one another in what I judge to be the most fertile manner—those points of contact resulting from conscious effort on the part of artists or scientists, or both acting in conjunction.

What the following account will broadly share with the history of scientific colour theory is the great divide between the pre-Newton and post-Newton periods. It should be said at the outset that the conventional picture in which the manifest truth of Newton's theory sweeps all or almost all before it in an irreversible and universal revolution cannot be sustained. It was not just in the field of art that Newton's arguments proved hard to swallow. They raised serious scientific difficulties which were concealed in popular accounts of his theories but which became disturbingly apparent to many of the most considerable later scientists in the field. However, Newton's ideas certainly needed to be addressed by any serious theorist of colour, and their publication may conveniently be taken as marking the watershed in colour science.

The first of these two chapters centres on the struggles to bring the dominant early tradition of colour science, deriving from the ideas of Aristotle and his followers, into harmony with painters' colour practice, particularly their experience of colour mixing. The first section will be devoted to the leading Renaissance attempts to outline a natural history of colour as relevant to the painter, culminating in Lomazzo's elaborate weaving of colour theory into an astrological-cum-scientific world system. The second section deals with the increasingly successful reconciliation of the painter's primaries with Aristotelian colour scales. This reconciliation first arises in the orbit of Rubens, and is developed into a reasonably successful three-colour theory in the succession of Poussin within French academic theory. The first successful maker of three-colour prints in the early eighteenth century, Le Blon, marks the climax of these developments and signals the transition to the post-Newton world.

The succeeding chapter looks at Newton's own ideas, in which aesthetic principles played a prominent role, and at the scientific theorists who developed the colour diagrams and solids that artists were ultimately to adopt. The diversity of rival colour theories in science particularly around 1800, is matched by a confusing and often unproductive diversity of artistic response. However, Runge and Turner in their very different ways were able to nourish their creative imaginations on some of the latest ideas in colour science. Finally, the French tradition in the nineteenth century, running from Chevreul and Delacroix to the great master of 'optical painting', Seurat, succeeded in bringing some order into the chaos of competing ideas. At the end of this second colour chapter, we will look briefly at the invention of colour photography, which stood in a more direct relationship to physiological colour science than even Seurat's techniques were to do.

CHAPTER VI

Colour I: the
Aristotelian legacy

Colour science during the period before Newton was domi-
nated by a tradition deriving in varying degrees of directness
from Aristotle, though this tradition did not centre upon an
altogether consistent set of principles. In colour, as in so many
aspects of his natural philosophy, the corpus of surviving
statements by Aristotle presented not one system but a num-
ber, a scattering of variable hypotheses paraded as complete
explanations in different contexts. However, one relatively
consistent aspect of the tradition—and the one which was to
separate it most sharply from Newton's ideas—was that col-
our existed as an actual property of surfaces and the surround-
ing medium, not as a sensation produced in the eye by certain
characteristics of transmitted and reflected light. This Aristote-
lian notion obviously corresponds to our subjective experience
of colour as residing in the surface of seen objects. Another
more or less consistent aspect of this tradition was that colour
was believed to result from the mixing in different ratios of the
contrasting properties of whiteness and blackness. The inher-
ently darker colours, such as blue, would contain a high ratio
of black to white, while yellow would be predominantly white
in its composition. This idea, which corresponded nicely to
the painters' awareness of the differing tonal values for various
colours (but not, of course, to their actual mixing of colours
from pigments) led to the formulation of what may be called
'colour scales'; that is to say the arrangement of colours in
graded scales according to their inherent tonal values. This Aris-
totelian tradition persisted throughout the Renaissance, and
continued to exercise a considerable hold in the seventeenth
century. It thus provides the dominant theme for this chapter.

The scattered fragments of Aristotle's views on colour and
those of his immediate circle are to be found in a number of the
authentic works, most notably in *De sensu et sensibili* ('On
sense and sensible objects') and in a treatise once attributed to
him, *De coloribus*, now more generally assigned to his follow-
er, Theophrastus. Of these, *De sensu* most readily yields a
coherent doctrine. Aristotle inclined to the view that 'there are
more colours than just white and black [the fundamental col-
ours], and that their number is due to the proportion of their
components'.[4] He distinguished seven basic colours. Between
the extremes of white and black are yellow ('a variant of
white'), red, purple ('sea purple'), green and blue. If the ratios

of white to black in the mixture are expressible in terms of
whole numbers (i.e. commensurable), such as 3:2 or 3:4, the
resulting colours will be 'most attractive', like red or purple.
Mixtures can be achieved in three ways: by laying small areas
of colour side by side; by spreading 'one colour over another
more vivid one' in the way that 'painters sometimes produce
them'; or, as in the natural colour of bodies, by the physical
mixture of substances.[5]

The same basic mechanism, the production of intermediate
colours from white and black, was also suggested in a less
organised form in *De coloribus*, with the additional identifica-
tion of colours with the physical properties of the elements: air
and water are white; fire (and the sun) provides golden yellow;
earth is 'dyed' with various colours; while black results from
elements in transition, as when burnt.[5] But, to complicate
matters, Aristotle's discussion of the rainbow in *De Meteorolo-
gica*, well known in the Middle Ages, relied upon three fun-
damental colours which 'the painter cannot manufacture' by
mixing, namely red, green and purple.[6]

The implied scale of light to dark colours, reflecting the
white-black ratios in their mixture, proved to be the most
fruitful of these ideas, and was actively promoted by a number
of Renaissance theorists. Portius's commentary on *De colori-
bus*, published in Florence in 1548, graded colours according to
the extent which they 'shine', or, as we would say, according
to their luminosity.[7] Yellow stands at the most luminous end
of the scale, while violet 'shines' less than any of the other
intermediate colours. Variations upon similar scales were
worked about the same time by Girolamo Cardano, who also
attempted to determine the precise ratios of white to black for
each colour. If a value of 100 is assigned to white and 0 to
black, the result of a 50–50 mixture is said to be red, while
yellow is 65–78% white, and blue contains 75% black.[8] Ratios
for each colour could be similarly calculated. The continuing
attraction for artists of this intimate association of hue and
tone, long after the Newtonian revolution, will be seen in the
persistence of a basically Aristotelian view in art theory as late
as the nineteenth century, most notably in the writings of
Goethe. For painters in the pre-Newtonian period, the colour
scales represented their best hope of arriving at a scientific
theory of colour in painting.

264

The only direct evidence of ancient colour practice in art available to the Renaissance theorists and painters proved to be extraordinarily unhelpful, and even the most ingenious interpreters of the classical legacy were at a loss to make much sense of it. This evidence consisted of Pliny's account of the four-colour method of Apelles, which Pliny recorded as relying upon white, yellow, red and black.[9] The absence of blue and green clearly could not be reconciled with the achieving of a full range of naturalistic colour. The only ways of reconciling Pliny's account with pictorial practice were either to assume that he was talking about a form of conventionalised colouring in which the cooler hues were deliberately omitted or to assume that he simply recorded the wrong four colours. Either way, his account of Apelles's practice was ill-suited to play a positive role in determining Renaissance theory and practice.

THE RENAISSANCE

The first tentative steps towards the recording of a colour science in painting (or at least a system for colour) were taken by Cennino Cennini, whom we have already met as an advocate of the Giottesque system for describing space. In a characteristically alert but unresolved manner Cennino has obviously picked up some hints of Aristotle's seven-colour doctrine, probably from mediaeval echoes: 'know that there are seven natural colours; or rather four which are actually mineral in character—namely black, red, yellow and green—and three natural colours which need to be developed artificially—lime white, the blues (ultramarine and azurite) and yellow'.[10] He has thus subdivided his seven colours, which differ slightly from Aristotle's, according to the manner in which they are available to the painter as pigments.

However, when Cennino comes to describe their actual application in painting, he makes no further reference to the seven-colour system, but rather concentrates upon the use of different saturations of pigment to achieve tonal modelling of form. His basic method involves the placing of equal quantities of a given pigment in three bowls, and mixing each with progressively greater quantities of white. In painting flesh, for example, these three grades of progressively lighter and unsaturated pigment are laid side-by-side over a green earth underdrawing, leaving the green showing through in the darkest sections and blending the boundaries between the areas 'like a puff of smoke'.[11] The most prominent parts of the form are then selectively emphasised using an even lighter mixture. Pure white is reserved for the strongest high-lights, and a touch of black for the deepest shadows and outlines (pl. 492). This is an essentially artificial system for describing effects of light and shade within a painting, in that the most saturated or intense colour will be visible only in the shaded areas of each form, not in those evenly lit by the strongest light. It also ties tonal modelling indissolubly to the inherent tonal values of different areas of local colour within a painting, as shown by any one of the innumerable fifteenth-century paintings executed in this manner (colour plate I). According to Cennino's system, the

492. Basic method for modelling form in light and shade, as described in Cennino Cennini's *Il Libro dell'arte*.

3, 2, 1—progressively lighter mixtures of the colour (adding white)
W—white for highlight B—black for deepest shadow
U—underpainting

shadow of a blue garment will be a deeply intense blue, while the adjacent shadow of a yellow cloth will be a radiantly saturated yellow which is relatively light in tone. Most unsettlingly, a fully lit area of blue will tend to be darker in tone than the shaded area of yellow. In the illustrated painting by Andrea Mantegna, this potentially disruptive break in tone between two adjacent colours can be seen to take its effect most obviously in the contrast between the Virgin's reddish-pink and blue garments, and in the green and yellow contrasts of Mary Magdalene's sleeves.

Within this basic system, Cennino was prepared to enliven his colours by what are called *cangianti* or *changeant* effects; that is to say when colours apparently change hue across their surfaces. A grey, for instance could be enlivened in the lights by 'using *giallorino* [yellow] for some, and white for others, as you please', while darker tones could be amplified 'with black or with violet or with dark green'.[12] Flesh tones could be similarly supplemented or 'shot' with 'foreign' hues. *Cangianti* colours were used quite extensively in the fourteenth, fifteenth and sixteenth centuries to add grace notes to a painting's colour harmonies. Taddeo Gaddi and Lorenzo Monaco in Florence were early *virtuosi* of *cangianti* colours. Mantegna was one of many fifteenth-century painters who exploited them with judicious restraint and refinement. In the London *Madonna and Saints* (colour plate I) the effect is most evident in the light purple garment swathed around St. John, which is subtly laced with green-blue shadows and shines deliciously with rosy highlights. Amongst sixteenth-century artists, these 'shot' colours were particularly favoured by Pontormo, and subsequently by Mannerists like Vasari and Francesco Salviati. Although these effects could be associated with observable phenomena—Lomazzo associated them with silk—they were chiefly exploited in painting for their inherent beauty, independently of primarily naturalistic considerations. Cennino

recommended their use selectively, as when painting 'an angel in fresco', and Lomazzo emphasised that they would be most appropriate 'for nymphs of meadows and fountains and such-like, and also for certain angels, whose garments reflect nothing other than the rainbow'.[13] Lomazzo also stressed that *cangianti* colours should not be used for the Virgin or figures deserving solemn reverence. Such a rule of decorum for 'shot' colours seems to have been in operation long before it was recorded by Lomazzo. Lorenzo Monaco, for example, re-served their flighty effects largely for secondary figures, most typically for angels. When Benozzo Gozzoli wished to suggest the sensuous effect of the dancing Salome at the *Feast of Herod*, he laced her flowing dress with *cangianti* colours.[14] Raphael seems to have associated such effects especially with Mary Magdalene. All this, however, has more to do with symbolic usage and suggestive association than the science of nature.

Given the powerful tendency which developed during the fifteenth century to search for a rational base in nature for the achieving of artistic effects, it is not surprising to find that a number of theorists wished to go beyond the visual and intel-lectual limitations of the methods recorded by Cennino. We will also not be surprised to find that Alberti, the first codifier of perspective, gave careful consideration to the principles governing the use of colour in painting. Like Cennino, though at a different level of scientific awareness, he experienced con-siderable difficulty in reconciling the *a priori* rules of traditional colour science with the actual practice of painting. He was justifiably reluctant to impose the disputed propositions of Aristotelian theory upon the practitioner:

What help is it to the painter to know how colour is made from a mixture of rare and dense, or hot and dry, and cold and wet? Yet I would not regard those philosophers un-worthy of respect who maintain that kinds of colours are seven in number. They set white and black as the two ex-tremes, and another halfway between; then on both sides, between this middle one and each extreme, they place a pair of others, with some uncertainty about their boundaries, though each pair is more like the related extreme than the other. . . I would not wish to be contradicted by those more expert then myself, who, while following the philosophers, nonetheless assert that in the nature of things there are only two colours, white and black, and all the rest arise from a mixture of these two.[15]

Alberti considers it more useful 'for painters' to identify the colours in a material fashion with the elements of nature, an idea also sanctioned by the Aristotelian tradition: fire is re-sponsible for red; air is blue or blue-grey; water is seen as green; while earth is interpreted as an 'ash-colour'. Each of these comprises a 'genus' of colour—what we would call a primary—while the 'species' are formed by the addition of white and black, which 'are not true colours' for the painters but 'modulators of colours'. In achieving naturalistic effects, this modulation of colour into species takes precedence for Alberti over the colours themselves:

A wide range and variety of colours contribute greatly to the beauty and attraction of painting, but I would prefer

learned painters to believe that the greatest art and industry are concerned with the disposition of white and black. . . Just as the incidence of light and shade makes it apparent where surfaces become convex or concave. . . so the com-bination of black and white achieves what. . . the artist must above all desire: that the things he paints should appear in maximum relief.[16]

The necessary transitions in what we would call tone should be achieved by the subtle mingling of touches of light and dark pigment 'like a gentle dew'.[17]

Alberti's emphasis upon *chiaroscuro*, as a factor which can be analysed independently and has its own special naturalistic value, recalls Pliny's identification of *tonon* as the foundation of modelling, and owes much to Masaccio's innovatory depic-tion of broadly unified areas of light and shade.[18] As a theore-tical injunction, it strikingly foreshadows an important aspect of Leonardo's tonal theory. This is not to say, however, that Alberti was insensitive to the delights of hue either in nature or art. In nature he perceptively noticed that 'reflected rays assume the colour they find on the surface from which they are reflected. We see this happen when the faces of people walking about in the meadows appear to have a greenish tinge.'[19] And in art he warmly recommends the qualities of 'grace' which result from a juxtaposition of 'sympathetic' colours. Red placed between blue and green results in the mutual enhance-ment of each colour; and he recommends a harmonious array of green, white, red and yellow garments for Diana's nymphs.[20] This 'grace', however, has no more overt connec-tion with the science of colours than had Cennino's *cangianti* effects.

The only other *quattrocento* attempt before Leonardo to lay down some basic rules for colour in painting occurs somewhat unexpectedly in the *Treatise on Architecture* by the sculptor-architect, Antonio Filarete. He informs his patron, the Duke of Milan, that there are six basic colours: white and black; and red, yellow, blue and green.[21] The latter four correspond re-spectively to fire, air, grass and flowers—an odd combination of two traditional elements with two arbitrarily selected fea-tures of the natural world. He is also concerned, as Alberti had been, to establish which colours are harmonious with each other, and he recommends looking to their distribution in nature as a guide. Yellow, red and blue—the primaries of later theory—may be used safely together, since they do not quarrel. Red is not at its best with yellow, but looks better with blue and gives the most favourable effect with green. This formulation suggests that artists had begun intuitively to develop rules-of-thumb for colour composition which were not so very remote from those established by the later theory of complementaries.

This minor success, however, cannot disguise the fact that neither Alberti nor Filarete had been able to suggest an under-lying theory which even remotely satisfied the needs of practi-tioners who would have continued to find Cennino's technical instructions far more useful than the theorists' general for-mulas. For most painters, the failure of colour science to bear productively upon their craft would have been of little con-

sequence. For Leonardo, however, no facet of painting could be properly mastered without an understanding of its foundation in natural law. No aspect of nature's infinite variety, whether the motion of water or the branching of plants, was exempt from his conviction that a pattern of classification and a system of causes must be apparent behind the diverse effects. The problem with light and colour was that the phenomena—even for Leonardo—proved to be particularly intransigent whenever he tried to effect a three-fold union between the observed effects, Aristotelian science and the painter's practice. This intransigence became more rather than less of a problem as his understanding of colour science gained in sophistication.

Some idea of the sheer complexity of classifying (let alone explaining) the effects of light and colour on natural objects can be gained from his extended scheme for a treatise on light and shade, drawn up about 1490:

> Every opaque body is surrounded and its surface enveloped in light and shade, and on this I will construct my first book. In addition to this, shadows are in themselves of varying degrees of darkness, because they arise from various amounts of subtracted light, and these I call the original shadows, because these are the first shadows which clothe the bodies, . . . and on this I will found my second book. From these original shadows arise shadowy rays which are diffused through the air and are of a quality corresponding to the original shadows from which they are derived, and hence I call them derived shadows . . . and I will make my third book about them. Again, these derived shadows in their percussion will make varied effects according to the places at which they rebound; which will form the fourth book. And because the percussion of the derived shadows is always surrounded by the percussion of luminous rays, which by reflection rebound towards the original place where the original shadow was found, they mingle and mix with it, modifying its nature somewhat; and on this I will found my fifth book. Alongside this, I will compose the sixth book, which will consider the diverse and numerous varieties of rebounds in reflected rays, which modify the original shadow with various colours, according to the place of origin of the reflected rays. Then I will make the seventh section about the various distances between the percussion of the reflected rays and the place from which they originate, and how the sensation of colour will vary.[22]

This classification is by no means complete. In particular it excludes the distinction between 'light' and 'lustre'; that is between the relatively stable effect of light on a matt surface and the mobile gleam from a shiny surface which changes its location according to the position of the observer's eye. This was a distinction with which he was keenly concerned.[23]

The complexities of reflected light and colour, the subjects of his fifth, sixth and seventh books, are the unavoidable consequences of any normal system of illumination. 'No body will ever show itself entirely in its natural colour', as he wrote, echoing the Aristotelian *De coloribus*.[24] However, the application of rebounding colour was not something which many

Florentine artists could embrace altogether comfortably, since it tended to disrupt the sculptural definition of form upon which they founded their art. It was a matter which obviously caused a divergence of opinion amongst his fellow painters: 'The theory [of reflected lights in shadows] has been put into practice by some, but there are many others who avoid it, and each side laughs at the other.'[25]

Leonardo, taking his cue from nature as always, sided with those who believed that the painter must master such effects, exploiting them with a full knowledge of the laws. These laws, dealing with the 'percussions' and 'rebounds' of light, ran precisely parallel to those of mechanics, as his vocabulary clearly implies. The most fundamental law is that the angle of reflection should equal the angle of incidence. The effects are dependent upon a variety of factors: the relative intensity of the original sources; the distances travelled; the angles of impact; the natures of the surfaces; the degrees of interference from competing sources, etc. All these 'causes' should be analysed with mathematical precision. This search for absolute formulas may sound rather chilling, but it never blinded Leonardo to the subtle and elusive beauties visible in nature and it provided the intellectual foundation for an extraordinary variety of painted effects.

The few finished paintings by Leonardo which have survived reverberate resoundingly with the percussion of light and colour. The London *Virgin of the Rocks* (colour plate II), although not perhaps wholly executed by Leonardo himself, presents these effects in a more vivid manner than his other paintings, which are either obscured by darkened varnish or significantly disfigured by the ravages of time. The forms of the figures, rocks and plants are moulded into compelling three-dimensionality by the insistent attention of direct light, while the shadows are enlivened by subtle glimmers of rebounding colour. The lower side of the Virgin's left hand, for example, receives the bouncing light from the directly lit surfaces no less surely—and according to 'mechanical' laws no less regular in nature—than the extended hand of a basket-ball player receiving a bouncing ball from the floor. The force of impact of each rebound is modulated by Leonardo with such care that it never dislodges the primary scheme of direct light and 'original shadow'. The reflections ornament but never mask the fundamental impression of relief upon which he set such store.

The potency of relief achieved by Leonardo arose from a system very different from Mantegna's traditional method. Shadow is no longer created by saturated colour, but by colour progressively veiled under a cloak of darkness. The most saturated colour accordingly occurs in the areas directly lit by the strongest light: 'the quality of colours will be ascertained by means of light and it is to be judged that where there is more light the true quality of the illuminated colour will be seen'.[26] As the different colours move progressively into shadow, so their respective hues will be less clearly differentiated, a procedure which stands in marked contrast to an unnamed 'adversary' who claimed that 'the variety of colours in shadow must be as great as that of the colours of the objects in that shadow'.[27] Leonardo's new procedure can be readily seen in

the shaded area beneath the Virgin's right arm, where the deeper colours plunge into velvety darkness, to be followed more obstinately by the light swathe of yellow drapery around her waist. This system of colour and shade—which laid the foundation for what is called tonal painting—allows each colour to declare itself with its full saturation of hue in the lit areas, but prevents any colour from disrupting the unified substratum of deep shadow from which all the forms emerge. Indeed, the power of darkness, the 'privation of light', is ultimately dominant in every sense—theoretically, aesthetically and emotionally—consuming light and colour with the appetite of an insatiable void.

Given this propensity of subordinating colour to tonal value, it is not surprising that Leonardo became greatly attracted to Aristotelian scales of colour value, apparently having gained or regained access to *De coloribus* about 1506. He never adopted the Aristotelian system in an altogether consistent manner, and he certainly never settled definitively upon a set number of 'simple' (primary) colours, but his most extended account of colour clearly owes much to the Peripatetic tradition:

> The simple colours are six, of which the first is white, although some philosophers do not accept white or black in the number of the colours, because one is the cause of the colours and the other is the absence of them. However, because the painter cannot do without them, we place them in the number of the others, and we say that, in this order, white is the first amongst the simple colours, and yellow the second, green the third of them, blue is the fourth, and red is the fifth, and black is the sixth. And white is given by light, without which no colour may be seen, yellow by earth, green by water, blue by air and red by fire, and black by darkness which stands above the element of fire, because there is no substance or dimension on which the rays are able to percuss and accordingly to illuminate it.[28]

The central colours in the scale—yellow, green, blue and red—thus correspond hierarchically to the levels of the elements as they envelope the earth with their concentric spheres (pl. 493). This neat correlation was not to endure, however, and Leonardo was soon speculating (again in keeping with the rather confusing exposition in *De coloribus*) that 'blue and green are not in themselves simple colours, because blue is composed of light and darkness, like that of air; that is the most perfect black and the most lucid white. Green is composed of a simple and compound colour, that is to say composed from blue and yellow.'[29] This origin for the blueness of the air was analogous to the way in which the 'finest black' overlaid by a glaze of 'thin and transparent white. . . . will exhibit no other colour than the most beautiful azure'.[30] Thus the blue sky in the *Virgin of the Rocks* is relatively inky above the grotto, nearest the outer void, while the misty air of the lower regions reflects a greater proportion of white light. There is no case for thinking, however, that the progressively bleached blue is actually achieved in the painting by the graded layering of white glazes over a *black* underpainting. Rather, he has used a progressively less saturated mixture of azurite and white

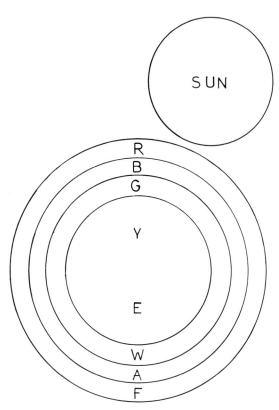

493. The colours and the elements, as described by Leonardo da Vinci, based on Codex Urbinas 75v.

E—earth	A—air	SUN sunlight = white
B—blue	W—water	F—fire
R—red	G—green	Y—yellow

over a white ground to achieve the required effect. His pigments ape the visual effect; they do not themselves act out the phenomenon.

An Aristotelian scale—though slightly different in order—also explains the different susceptibilities of colours to the phenomenon of increasing atmospheric blueness with distance. The colours nearest black in the scale will be more readily 'blued' than those nearest white, according to the sequence red-green-yellow.[31] The scale also provides the key to the light levels at which the various colours best reveal their particular beauties, the brightest colours reacting most favourably to high levels of illumination, while a deeply saturated blue will be most attractive in relatively subdued light—a perceptive observation which we now know has a basis in the physiology of vision.

At the same time as he was laying down these relatively simple foundations—comparatively late in his career—he also increasingly acknowledged the elusive complexity of actual colour effects in nature and art. His late manuscripts are full of marvellously sensitive observations of light and colour, observations which often lay outside the scope of a simple system of causes. He studied the passage of light through the leaves of trees, noting the fleeting effects of translucent yellow-green and reflected blue-green, which mingle at a distance to produce a blurred shimmer of light and colour.[32] The tonal

effects of light on bunches of leaves were comparably subtle (pl. 494). He assessed the colours of smoke and mist at different times of day, under different angles of illumination and from different viewpoints.[33] He recorded that the yellowness of firelight was apparent in two ways: by direct contrast with daylight; and from the confusion of white with yellow and blue with green.[34] He became increasingly aware of what we now call complementary colours in shadows, such as the greenish or bluish shadows which accompany reddish light, though he tended to attribute them to reflected colour.[35] He attempted to establish which colours mutually enhance each other's potency: flesh tones will look pale against a red background but reddish against yellow; red increases the 'activeness' of green, and green enhances blue; and black exaggerates the intensity of white, particularly at the very edges of adjacent areas.[36] These observations were not gathered into a coherent system by Leonardo, but they impressively foreshadow important aspects of nineteenth-century practice.

He hoped at one stage, again late in his career, that a study of the rainbow would clarify the rules for colour harmonies and mixtures:

> if you wish that the proximity of one colour should give grace to another colour. . ., apply the rule which may be deduced from the rays of the sun in the composition of the rainbow, otherwise known as the iris . . . Deal with the rainbow in the last book on painting, but first write the book on colours both from the mixture of the colours, so that you may be able to prove the production of colours in the rainbow by reference to the painter's colours.[37]

His notebooks show that he did precociously attempt to analyse the phenomenon of mixing coloured lights. In one typical experiment he showed a spherical object illuminated by blue and yellow lights which result in the white surface of the object appearing to be a 'most beautiful green'.[38] These results are, as we know, incorrect, in that yellow light (compounded from red and green additive primaries) and blue light will provide a mixture which approximates to white. We can only conclude that this and related experiments with coloured lights and shadows are 'paper demonstrations', designed to illustrate what *should* happen, according to what he regarded as firmly established principles. We know that Leonardo did perform actual experiments in the physical sciences; but it is also clear that many of his illustrations of experimental set-ups are 'thought experiments' which he considered adequate in themselves.[39]

An important factor in his late fascination with coloured lights, the rainbow, haloes and related phenomena, such as the irridescence of peacock's feathers, seems to have been his reading of Roger Bacon's *Opus majus*, in which the great thirteenth-century philosopher expressed a keen interest in the kaleidoscopic scintillation of natural effects. In keeping with this fascination, Leonardo's late paintings are full of felicitous subtleties of light and colour: variegated pebbles, semi-transparent veils, floating vapours, intangible atmospherics, translucently blended reflections of colour, the glimmer of back-reflections in the shadows, and so on. The Louvre *Virgin, Child, St. Anne and a Lamb* (pl. 495), even in its somewhat deteriorated condition, pays open homage to many such beauties.

The tension between Leonardo's scrupulous devotion to natural effects in all their infinite variety and his intellectual adherence to a rather limited and limiting set of Aristotelian causes was never really resolved. Indeed, the tension became more rather than less strained as his studies of effects and causes became more intense. Ultimately, his conviction that he must explain all the observed effects, rather than simplifying them in favour of the system, resulted in his failure to formulate a definitive system at all. What was required before Aristotelian colour theory and naturalistic art could move into a less uneasy relationship was a theorist with fewer scruples than Leonardo when it came to the manipulation of the effects for the sake of the presumed causes—someone whose allegiance to the intellectual coherence of the system was ultimately greater than his sense of the integrity of the parts. The theorist who fulfilled these conditions was Leonardo's successor as a theorist in sixteenth-century Milan, Giovanni Paolo Lomazzo. Perhaps the progressive blindness which afflicted Lomazzo from his late twenties played a role in his willingness to force at least some of the visual evidence in the required direction.

When we looked at Lomazzo's ideas on perspective, we

494. Leonardo da Vinci, *Study of light on a Tree (Robinia)*, *c*.1500, Windsor, Royal Library, 12431v.

495. Leonardo da Vinci, *Virgin, Child, St. Anne and a Lamb*, c.1508–15, Paris, Louvre.

caught a glimpse of the metaphysical base on which he erected his elaborate theories. His ideas of colour are more wholly dependent on this base, and we should at this point try to gain some impression of the system as a whole. Each aspect of artistic practice was seen by Lomazzo as one facet of the total, cosmological order of all things. His ambition in this respect resembles Leonardo's, but the general tenor of his thought was very different from his predecessor's scientific empiricism.

It is all too easy to pick holes in Lomazzo's ideas and it cannot be denied that his system, in its parts and as a whole, is not entirely resolved.[40] His occasional obscurities and inconsistencies tend to disturb the reader's confidence in his command of the ideas he has annexed. These problems are partly a consequence of the blind author's obvious difficulties in correlating his texts. And in part they are an inevitable result of his juxtaposition of ideas from a wide range of intellectual disciplines, which did not always prove to be readily compatible. We also have to make allowance for the errors perpetrated by his publisher. If all these factors are taken into account we will be better placed to appreciate the great edifice of knowledge and speculation which he designed as a temple for the worship of

painting. The occasional plastering of cracks and fudging of dimensions are procedures with which most builders of large structures are familiar.

Light and colour were of immense importance to Lomazzo in relation to the metaphysical foundations of his theory. Citing a wide range of authorities, including Dionysius, Plato, Aristotle, Witelo, Thomas Aquinas, Marsilio Ficino and Cornelius Agrippa (his main source), he drew up a theological hierarchy of illumination. Light, signifying 'the image of the divine mind', progressed successively downwards through the Holy Spirit, the angels, celestial bodies and the light of the sun as received on earth.[41] In itself 'light has no colour . . . because it proceeds from the sun, which, if it possessed colour would be corruptible, yet it manifests and reveals where the colours occur'.[42] This idea is underlined elsewhere when he states that 'colours cannot be seen without light, being nothing other, according to the philosophers, than the extreme superficies of a dense and opaque body when illuminated'.[43] Not surprisingly this Aristotelian formulation is followed by an exposition of a seven-colour theory similar to that in *De coloribus*. Between the familiar extremes of white and black, which are identified with frigidity and heat, are to be found central red (equal proportions of black and white) and the intermediate colours: 'pale' (or violet), yellow, purple and green.

This seven-part system is drawn into Lomazzo's complex vision of the correspondence of all the component parts of the universe as determined by the 'sympathies of the planets, signs and elements'.[44] This vision was inspired by the Renaissance tradition of astrological mysticism. A significant number of his ideas were derived from Agrippa's *De Occulta philosophia*; and he certainly paid careful attention to Giulio Camillo's *L'Idea del teatro*, at the heart of which was a semicircular 'theatre' of Solomonic wisdom, constructed on a seven-part base according to astrological rules.[45] Much of Lomazzo's celestial magic may seem to have nothing to do with science, as we understand it, but a system such as his suffers grave distortion if we attempt to separate his 'science' from his 'magic' in an anachronistic manner.

Governing all the properties of the natural world are the seven planets—Saturn, Jupiter, Mars, the Sun, Venus, Mercury and the Moon—acting in conjunction with the elements of earth, water, air and fire. We have already noted how the regular solids are related to this system. The seven planets, the four elements and other series of entities and properties are woven together by Lomazzo into a cosmological coat of many colours. The fabric of this coat comprised many diverse threads, including the ages of man, the four seasons, the four temperaments, representative animals, representative metals and so on. In all this he exhibits a generally impressive grasp of the sources he is using, though he occasionally drops a stitch or blurs the pattern. Where he is really original is in his attempt to bring the 'seven substantial parts of art' into this system and to assign special roles to seven named masters of Renaissance art. These seven masters are the 'governors' of the circular temple which he devises as a metaphor for the liberal art painting.

The seven parts of art consisted of the five branches of

theory—proportion, motion, colour, light and perspective—
together with the two aspects of 'practice' (or 'realisation'),
namely composition and *forma*. The last of these warrants
some explanation, since it is not simply the practical making of
forms to be included in the picture; rather it concerns the total
concept of the work as invented by the highest cerebral facul-
ties of the artist. The 'theories' and 'realisations' in the orders
listed above comprise an ascending series of structural ele-
ments in the walls and architrave of his temple (pl. 496). The
architrave is supported by caryatid statues in metal of each
of his seven governors: Michelangelo, Gaudenzio Ferrari
(Lomazzo's master in Milan), Polidoro da Caravaggio (pupil
of Raphael and noted muralist), Leonardo, Raphael, Mantegna
and Titian. Each governor is associated with the characteristics
of a particular planet: Michelangelo with Saturn; Gaudenzio
with Jupiter; Polidoro with Mars; Leonardo with the Sun;
Raphael with Venus; Mantegna with Mercury; and Titian
with the Moon. These associations deeply affect—literally
colour—the physical, temperamental and artistic characters of
each painter.[46]

The associations include a series of symbolic concordances.
The statues of the governors are each cast from an astrological-
ly appropriate metal: Michelangelo from lead; Gaudenzio
from tin; Polidoro from iron; Leonardo from gold; Raphael
from copper; Mantegna from mercury (!); and Titian from
silver. And each is signified by an animal: Michelangelo by a
dragon; Gaudenzio by an eagle; Polidoro by a horse; Leonardo
by a lion; Raphael by a man; Mantegna by a serpent; Titian by
a bull. I have attempted to summarise these and other associa-
tions in the accompanying plan (pl. 497), but the reader should
be warned that Lomazzo is not always consistent nor does he
follow through all the implications of his system. Alongside
these symbolic associations come the specific styles and modes
of operation of each governor with respect to each of the seven
parts of painting.

The planetary equations work better for some artists than
others, but it is remarkable how well Lomazzo has achieved
plausible characterisations for each painter and his products
within this astrological framework. Michelangelo, for exam-
ple, is characterised as showing a natural predeliction for mas-
sive proportions (reflected in his lead statue on the temple),
grandly sombre motions, subordinated colour, powerful
modelling, ponderously impressive foreshortenings, 'fury of
design' and grandeur of conception.[47] This effectively equates
Michelangelo's renowned *terribilità* with the characteristics of
Saturn, the profoundly melancholy God of the contemplative
mind. Raphael is rather nicely identified with the sweet char-
acter of Venus, the Goddess of love. And it is not surprising
to find a Milanese author recognising Leonardo as the true
'sun' of painting. There is obviously a danger in pushing these
procedures to their logical extreme, and Lomazzo himself
appears to have hesitated to accept all the implications of the
framework he was constructing. For example, I do not find
any justification in his text for assigning unique control over
one of the principal parts of painting to each of the seven
governors, as some commentators have done.[48] Lomazzo's
point is that the astrologically determined characteristics of

496. Elevation of the 'Temple of Painting', as described in Giovanni Paolo
Lomazzo's *Idea del tempio della pittura*, Milan, 1584.

497. Ground plan of the 'Temple of Painting', reconstructed from Lomaz-
zo's *Idea*, showing selected correspondences.

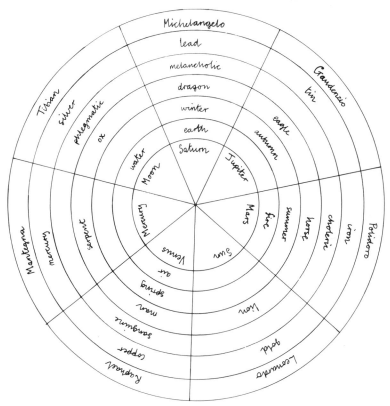

each artist are expressed in *each* of the seven parts in a manner consistent with their 'personalities'. Each painter exhibits a particular power in one area, but each also exhibits his own individual quality in every area. His system, curious though it may appear to modern eyes, represents the first coherent attempt to explain the inner causes of personal style—a question which I do not think we can ourselves claim to be much closer to understanding today.

In his *Trattato*, the earlier of his two treatises, he clearly assigns a specific colour to each of the planets: black to Saturn; blue to Jupiter; purple to Mars; red to the Sun; yellow to Venus; green to Mercury; and white to the Moon.[49] And each colour is accordingly seen as possessing certain emotional or temperamental characteristics: black is sad and melancholy; green is associated with hope and health and liveliness; purple is a triumphant, princely colour; red is ardently powerful; yellow is noble and clear; blue is glorious and dignified; and white signifies innocence and purity.[50] Elsewhere in the *Trattato* he gives a slightly different planetary identification for each colour—Jupiter and Mercury exchange their colours—but we can see what he is trying to do.[51] He is manipulating his sources, particularly Agrippa, to provide an explanation for the expressive potentialities of each colour in art. It is tempting to take the logical step of identifying each artist with the corresponding planetary colour, but Lomazzo does not appear to have taken this step, and I think we should hesitate before we do so on his behalf.

It is easy to regard all this as faintly absurd and to dismiss it as outmoded, unscientific, astrological nonsense. However, I believe that it deserves respect as a surprisingly effective system for explaining aspects of artistic character and expression, a problem which earlier humanist art criticism had not really begun to address in any sustained manner. His system of signification for colour is certainly related to the traditional symbolism of colour, as represented in the Renaissance by Dolce amongst others, but he goes much further when he seeks the structures in natural design which are causally responsible for these effects. We may take his characterisation of red as a good example: 'red among the elements represents fire and among the planets the sun, signifying ardour, greatness, victory, blood, martyrdom; if it inclines more towards the darker or obscure red of Mars it will manifest the choleric temperament; in theology it corresponds to Charity, which must be amenable to love and ardour; and among the seasons it represents summer.'[52] As an example of the use of red in pictorial practice he notes that the red complexion of the choleric is eminently suitable for the portrayal of military commanders in the heat of battle.[53]

Although the basis of his system seems far removed from the actual business of painting, the *Trattato* is full of detailed observations of light and colour which were drawn from his own experiences as a painter. He discusses a wide range of properties in pigments, the most suitable colours for shadows of coloured objects, the use of *cangianti* or 'shot' colours as seen in silk, and the diverse effects of light on surfaces of different textures and colours. In these detailed observations he moves closer to Leonardo. He also makes a series of sharply obser-

vant comments on a large number of earlier and contemporary painters, particularly his colleagues in north Italy. I do not think that his complex interplay between a schematic seven-part base and a myriad of particular observations has been properly appreciated in recent writing. A modern distaste for his astrological metaphysics certainly stands in the way of a ready appreciation of his many virtues.

Lomazzo's theories of colour, strange though they may seem to us, do not stand in eccentric isolation in the sixteenth century. Baccio Valori, as one of the spokesmen in Raffaello Borghini's Florentine dialogue, *Il Riposo* (1584), advocates a scheme based on similar principles.[54] 'Valori's'seven colours, in hierarchical order, are yellow, white, red, blue, black, green and purple, which correspond respectively to the Sun, the Moon, Mars, Jupiter, Saturn, Venus and Mercury. They further correspond to the elements, temperaments, virtues, days, months, seasons, ages of man, metals, sacraments etc. Such 'significations of the colours' are said to be relevant for 'painters and gentlemen who devise *imprese*'—though we may believe that such a complex system of symbolic associations is more appropriate to the formal art practised by the heraldic inventor of *imprese* than to the artist concerned with the imitation of nature.[55]

In Lomazzo's hierarchy of the five 'theories' of painting, colour stands in the middle. By placing proportion at the lowest level, he does not mean that it is any less essential for the proper practice of art but rather that it stands considerably lower on the scale of artistic complexity than both colour and lofty perspective, the latter of which is appropriately located at the level of the heads of the governors' statues. Colour's intermediate position is higher than it would probably have been in a Florentine artist's hierarchy but lower than it would have ranked in most Venetians' opinion. It is natural, having looked at Lomazzo's North Italian theories, to turn to contemporary Venetian authors, particularly those in Titian's immediate circle, for a colour theory which should reflect the high status the Venetian painters assigned to colour. If we do so we will be largely disappointed. It is an accurate indication of the inherent difficulties in founding a science of colour which would really work in relation to the making of paintings that the greatest school of Renaissance colourists remained substantially divorced from systematic colour theory. This is not to say that Venetian authors neglected to write about colour. At least half-a-dozen considerable treatises on colour were published in Venice during the course of the sixteenth century, including one by Titian's friend Lodovico Dolce. Rather, it is fair to say that the Venetian colour writings exist in a world of formalised symbolism, not unlike 'Valori's', that is largely and frustratingly remote from the primary concerns of Titian and contemporary painters.

Dolce's *Dialogo . . . dei colori* (1565) may be taken as typical of the Venetian tradition, closely following works by Telesio (1528) and Morati (1535) and itself influencing subsequent works by Occolti (1568) and Rinaldi (1592).[56] Dolce begins, promisingly enough from our standpoint, by outlining the basic Aristotelian propositions, including the definition that 'colour is the boundary and edge of a lit and finite body'.[57] He

acknowledged the two extremes, black and white, together with an unexceptional colour scale—violet, yellow, red, purple and green. His interest in such scales had undoubtedly been fostered by his publication in the same year of his *Libri tre delle diverse sorti delle gemme* (*Three Books on Various Kinds of Gems*), an unacknowledged translation of Camillo Leonardi's *Speculum lapidum* (1502).[58] Leonardi had stated that between white and black 'arise various colours, which are of a triple nature, namely red, green and yellow'.[59] Dolce's own intermediate colours, with his inclusion of violet and purple, is closer to the Aristotelian canon, and stands in a potentially more realistic relationship to pictorial practice.

However, when he proceeds to the main body of his own treatise, concerned with the 'natures, diversity and propriety' of the individual colours, he makes no direct reference to natural colour scales but parades a relatively standard repertoire of symbolic associations (or 'proprieties') for each colour. These associations had been repeated with minor variations in the earlier literature—white invariably denotes 'purity of heart' while red tends to be associated with ardent and fierce characteristics—and were supported by interwoven texts drawn from classical, Christian and humanist sources. While any artist cannot but be affected, consciously or subconsciously, by such associational and expressive values for colour, and no Renaissance artist could avoid the traditional constraints of colour decorum in particular religious contexts, these simple identifications of basic local colours with relatively invariable categories could hardly have been remoter from the subtle, elusive and broken effects favoured by Venetian painters. This is tacitly acknowledged by Dolce himself, when he wrote elsewhere about Titian's actual paintings—as he did with feeling and perception. Nowhere do we find him imposing the criteria of colour symbolism upon his friend's paintings, and we may infer that he was prepared to treat the metaphysical essence of colours and their use for naturalistic purposes in painting as substantially different matters.

Paolo Pino—whom we have already quoted for his statement that colour is the 'true alchemy of painting'—was the Venetian author who wrote most tellingly about Titian's use of colour. Within the constraints of humanist vocabulary, Pino showed himself sensitive to qualities of broken colour and tonal unity in Titian's paintings, qualities which were incompatible with an unequivocally symbolic use of individual colours.[60] Broken or 'corrupted' colours, as Dolce realised, do not speak the language of colour symbolism with the clarity required by the traditional system. It was Titian's abandonment of bright local colour for the subtle and sometimes sombre harmonies of tonal painting to which Cristoforo Sorte alluded when he wrote in 1580 that the painter should strive 'to satisfy with colour the taste of those with knowledge and who understand the truth, rather than to appease the taste of the vulgar hordes'.[61] Although the 'truth' of Titian's colour was self-evident to Venetian connoisseurs such as Aretino, Dolce and Pino, it never came to be analysed in terms which can remotely be called scientific or Aristotelian. The explanation is not difficult to find. It lies in the ultimate failure of the abstractions of the traditional science to cope with the complex

subtleties of coloured substances in nature and art—subtleties which the Venetian painters had increasingly expressed in a manner which positively resisted formulation. I am not suggesting that the leading Venetian masters had failed to develop intellectually coherent views of colour and tone, but rather that these found little succour in scientific colour theory.

In one respect, however, the rather abstract formalism of the colour scales proved to be a considerable advantage. This advantage was apparent in the field of what may be called colour music. The musical analogy had been suggested by Aristotle himself, and was progressively taken up during the course of the Renaissance.[62]

The musical theorist who was perhaps most concerned to draw parallels between the Pythagorean system underlying Renaissance harmonies and the visual beauty of colours was Gioseffe Zarlino, whose exposition of musical proportion made a considerable impact upon architectural harmonies in the circle of Palladio. He also, as we will have cause to see in more detail, exercised an important influence on the ideas of Poussin. Zarlino uses the Aristotelian poles of black and white as the basis for his analogy. In *Le Istitutioni harmoniche* of 1558 he writes that:

> as white and black are less agreeable than the mixed modes between them, so the principal consonances are less agreeable than the other, less perfect, consonances. Green, red, blue and others similar to them are more gratifying and correspondingly more 'pleasing' because they are more distant from the principal colours than the colours called *roanno* [brown?] and *beretino* [grey?], which are nearer to black and white respectively. . . . The reaction of the ear to the combination of sounds is analogous to the reaction of the eye to the combination of colours. Such colour combinations have a kind of harmony, in that they are composed of diverse colours.[63]

He later indicated more specifically that the black pole should be identified with high notes, and white with the low, in that white arose from a strong light and was therefore comparable to the origin of low sounds in large objects, while a dark colour was equivalent to the high sound of a small instrument.[64]

The formulation of such parallels into a more precise colour theory was accomplished by a fellow-citizen of Lomazzo's, the extraordinary Milanese painter of anthropomorphic green-grocery, hardware and animals, Giuseppe Arcimboldo (pl. 498). During his period as court artist and general maestro of visual effects for the Habsburg Emperors in Prague (1562–87), Arcimboldo 'discovered that the tones and semitones and the diatesseron and the diapente and the diapasons and all the other musical tones are consonant with the colours, and are precisely equivalent to that same art of harmonic proportions discovered by Pythagoras'.[65] Gregorio Comanini, who is the source for our knowledge of Arcimboldo's ideas, explained as best he could that the painter had formulated a series of proportional correlations between musical pitch and the compounds of white and black with each colour. 'In successively darkening white in equal degrees' Arcimboldo 'made the

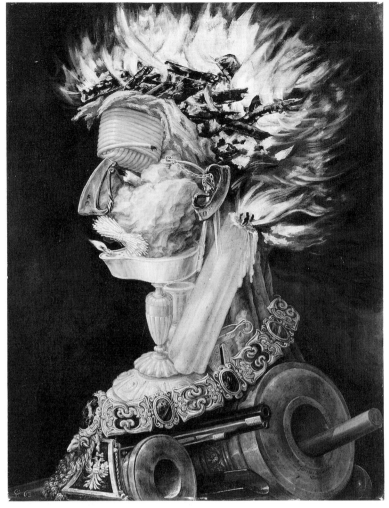

498. Giuseppe Arcimboldo, *Fire*, 1566, Vienna, Kunsthistorisches Museum.

position in art, but he was able to do this only by abstracting colour harmonies from their customary framework of empirical naturalism—and this was not a step which European painting was willing to take in a concerted manner until about three centuries later.

Arcimboldo's own paintings—most typically his free fantasies on organic themes in which fruit, vegetables and other elements from the material world are combined to assume the form of grotesque human heads—permitted him a freedom of colour combination impossible within a more naturalistic framework. Now that we have learnt to see complex intellectual themes behind his fantasies, including the microcosmic ideas which had so appealed to Leonardo, we can also begin to understand how colour music and a series of Lomazzan significations for colour could find expression in his paintings. For instance, a fiery head, composed largely with a red octave, corresponds to the martial temperament—with all the bellicose associations Mars brings in his train.[68]

It is, I think, significant that it required eccentric painting of this kind to bring existing theory and pictorial practice into close union. Arcimboldo's work, for all its brilliant ingenuity, was only marginally relevant to the mainstream of European art. Most artists were clearly not in a position to take his kind of licence with the customary appearance of nature. It is this naturalistic mainstream with which we must be primarily concerned.

RUBENS AND POUSSIN; RUBÉNISTES AND POUSSINISTES

We have seen that the most brilliant exponents of colour in the Renaissance, the Venetians, were not generally predisposed to theorise about their art, let alone formulate a science of colour. By contrast, the greatest student of Venetian colour in the Baroque age, Peter Paul Rubens, was a man of markedly intellectual tendencies, genuinely learned, widely read in Latin literature and demonstrably conscious of the potential of visual science as a foundation for his art. As we noted in Chapter III, the manuscripts in which he recorded his theories have unfortunately perished but some of what were called his 'Maxims' relating to colours can be reconstructed from echoes in writings by later authors. In addition to the lost notebooks on optical and other matters, he is known to have composed a separate essay 'on the subject of colours'

Rubens's essay was solicited by the Parisian collector and man of letters, Nicolas-Claude Fabri de Peiresc, who hoped that the painter would explain how colours 'transform themselves successively from one colour to another in a certain admirable order'.[69] In response to Peiresc's promptings, Rubens rather discouragingly replied on 16 August 1635 that

> the strong impressions which visible objects make upon our eyes seem to me to be more curious with regard to lines and contours of forms than to colours and less so for colours resembling a rainbow than if they are the proper colours of objects [i.e. the Aristotelian distinction between apparent

proportions of the diapason [the octave] rising in eight degrees of darkness from the most profound white.'[66] The individual colours of Arcimboldo's Aristotelian scale—yellow, green, blue, red and brown—were, in Comanini's far from lucid account, regarded as analogous in nature to the different pitch of human voices. This would mean that an 'octave' of colour consisted of eight tonal grades for each hue. The progressively higher notes in each colour-octave resulted from the progressive dilution of each colour with equal proportions of black. It should be stressed, however, that the unsystematic outline available to us presents real difficulties of interpretation.

Whatever doubts may remain about the precise nature of Arcimboldo's method, we can be reasonably sure that it had achieved a high degree of resolution. One of Rudolf II's musicians, Mauro Cremonese, was able to 'disclose on the harpsichord all those consonances which had been made by Arcimboldo by means of colours on a sheet of paper'.[67] The painter had thus precociously invented a form of musical notation using colour and tone. As such his 'colour music' appears to have been the most sustained and internally consistent attempt to ally Aristotelian scales with the requirements of colour com-

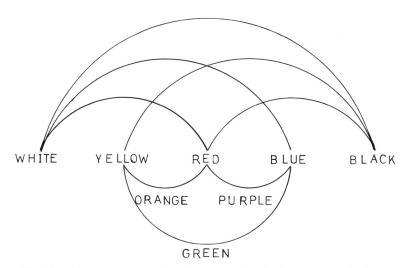

499. 'Simple' and 'composite' colours, based on F. Aguilonius's *Opticorum libri sex*, Antwerp, 1613.

500. Peter Paul Rubens, *Study of Trees and Reflections in Water at Sunset*, c.1630, London, British Museum, Gg. 2–229.

and real colours]. But I am not as versed in this subject as you think and do not consider my observations worthy of being put into writing.[70]

However, by the next February, Rubens had composed an essay which was ready for delivery. The manuscript received by Peiresc should probably be identified as the Latin treatise *De lumine et colore* known to have been owned by Van Parys in the late eighteenth century—after which it seems to have disappeared.[71]

By the time he came to write down his thoughts in an organised manner, Rubens had long since collaborated with François d'Aguilon on the illustrations for the *Opticorum libri sex*, as we have already seen. The engraved vignettes, by their black and white nature, are not well suited to illustrate colour theories, but the conspicuous peacock on the title page (pl. 194) stands as an appropriate allusion to the author's prominent discussion of colour.

Aguilonius's notions of colour are solidly Aristotelian in character. He provides what may be called the definitive version of the colour scales, based upon 'five species of simple colour with three composites'.[72] Between the inevitable poles of white and black come yellow, red and blue, which in turn form the three 'composite' colours: orange (yellow and red); purple (red and blue); and green (yellow and blue). In the published book these 'simple' and 'composite' colours are laid out in a figure (pl. 499), which resembles a proportional demonstration of musical harmonies. Although Aguilonius stresses that he is talking about 'visible qualities' rather than the painter's material colours, the compounds formed by the three intermediate primaries correspond precisely to pigment mixtures rather than coloured lights. In establishing his 'simple' and 'composite' colours Aguilonius may well have been drawing upon his friend's experience as a painter, and we can see that his system of mixtures is identical to one which became accepted as the painters' standard.

Two contemporary colour theories of a broadly comparable kind are worth noting at this point, though they both appear to stand on the fringes of the mainstream of artistic theory and practice. Both theories were published in 1609.[73] One of them occurs in a treatise on gems and minerals written by a doctor at the Court of Prague, Anselm de Boodt. His principal colours are black, white, blue, yellow, red *and* vermilion. He notes that the mixture of black and white will result 'only in an ash-colour', while the mixtures of the others will 'give birth to colours of all sorts', of which he then gives examples. The other 1609 theory was published by Louis Savot in Paris. Between the extremes of black and white, come red and blue, which 'are compounded neither of themselves nor of others, but the rest are compounded from them'. Savot characterises yellow as a variety of 'thin' red, that is as one of the 'species' rather than 'genuses' of colour. His four genuses—black, blue, red and white—he identifies as the colours that Pliny *should* have assigned to Apelles. Both these theories resemble Aguilonius's, in that they represent a tidying-up of the late mediaeval and Renaissance tradition. However, neither of them present a system as resolved as his and neither appear to stand in as fertile a relationship to pictorial concerns.

We have already seen that Rubens's vignette designs for Aguilonius exhibited a genuine understanding of the corresponding text, and it cannot be doubted that he was more than adequately equipped to understand the sections on colour. Two works of art—one drawing and one painting—appear to be so closely linked to Aguilonius's colour theories as to suggest that the philosopher's ideas found a receptive audience in the painter.

The link with the drawing, a study of trees reflected in water (pl. 500), is the more certain, since Rubens has provided an Aguilonian annotation. He notes that 'the reflection of the trees in the water is darker and more perfect in the water than in the trees themselves'.[74] There is no problem in understanding the term 'more perfect', since it is that used by Aguilonius to denote shadow which is more dense or 'penumbral'.[75] We can also turn to the philosopher for an explanation of the enhanced darkness of certain shadows. Aguilonius explained that

the closer the shadow is to an opaque body, the darker it is;

and it appears to be even darker than the object itself. . . . Since the shadow is diminished light compared to the stronger light which surrounds it (according to the 12th definition of this book), the brighter the surrounding light the more it dulls the observer's sight and the more fully it will darken the area of lesser luminosity. Thus the shadow appears darker than the object itself.[76]

The way an area of brightness appears to darken an adjacent shadow is an instance of the principle of simultaneous contrast recorded by Leonardo and later exploited extensively by Seurat.

The painting which most clearly declares its relationship to the *Opticorum libri sex* is the *Juno and Argus* in Cologne (colour plate III), almost certainly painted at the time of his work on the illustrations. Its subject matter is clearly associated with the title-page, centering as it does upon the Ovidian myth of Juno sprinkling the two hundred eyes of Argus on the peacock's tail. To underline the visual implications of the subject, Rubens had included Iris, who was not part of Ovid's story but who is an appropriate companion for the goddess of weather. He has provided her with a rainbow that carefully exhibits the red, yellow and blue 'simple' colours, interspersed with the orange, green and violet 'composites'. The whole painting sings with these colours: Juno's costume is red; Iris is draped with a blue robe; the chariot and embroideries are resplendent with golden yellow; while the flesh tones are composed from broken mixtures of 'composites', with much green apparent in Argus's lifeless body.[77]

In other paintings of this period, such as the *Annunciation* in Vienna and the *Samson and Delilah* in London (pl. 193), Rubens appears to have exploited resonant primaries and secondaries in a particularly vivid and self-aware manner.[78] In the London painting, red is granted a powerfully central role, as the crimson of Delilah's dress. This red is strikingly juxtaposed with the yellow swathe of drapery on which she sits and the blue jacket of the surreptitious barber. We may also note that his oil sketches not infrequently exploit a limited palette in which the three Aguilonian primaries play a prominent role. It is also tempting to associate his vigorous exploitation of red as an expressive force in his paintings with its central position in Aguilonius's scheme. And it seems that he regarded red—the sanguine colour of an ardent temperament—as especially associated with expansive character (of which he was one).[79]

However, I believe that it would be right to sound a note of caution. We have no direct evidence, in the form of statements by Rubens or those close to him, that he used Aguilonian science to guide his placement of colours in painting. We must obviously allow other factors, ranging from the freely intuitive to the traditionally prescriptive, to play their roles. I think we can most fairly say that Aguilonius's concepts established a framework within which Rubens could articulate his colour practice—useful intellectually and providing very real guidance as to the properties of colours, but never rigidly dictating in the final instance which colours should be used in a particular painting.

When we turn to the principles which governed Rubens's techniques of combining his chosen colours on the canvas, we can more safely posit a direct relationship with Aguilonius, since we have the surviving echoes of his 'Maxims' to set beside the scientist's text. Aguilonius proposed three kinds of colour mixture: *compositio realis*, in which materials are mixed to produce colours, as when the 'composite colour' green is made from 'a mixture of yellow and blue'; *compositio intentionalis*, in which colours are combined within a diaphonous medium, as when painting 'something beneath water'; and *compositio notionalis*, in which 'patches' of colour, so small as to 'escape the eye', converge as 'sensory impressions in the eye so that for each combination of the colours a uniform colour is received'.[80] This third category refers to what we could call optical mixture. It is an effect exploited brilliantly and extensively by Rubens, particularly for flesh tones. The body of Argus, for example, is composed from a remarkable *mélange* of pink, pale yellow, grey and green, applied in separate touches and only partially blended. There are comparable passages in the *Samson and Delilah*, most conspicuously in the brilliantly rendered carpet beneath their feet.

Such effects become one of the most prominent characteristics of his paint handling in his mature works, as the illustrated detail from the *Blessing of Peace* (colour plate IV and pl. 501) vividly demonstrates. The flesh and accessories are handled with unrivalled bravura, using opaque impastos and translucent glazes to summon up extraordinary effects of implied texture. In the highlights white and creamy-pink paint is dragged thickly across the surface of the canvas, reflecting light directly from its surface. By contrast the flesh shadows are composed from warm glazes which absorb a significantly larger proportion of the incident light while retaining a high degree of secondary radiance. Between these come partially overlaid strokes of cool grey, blended with a hint of blue-green. Where adjacent surfaces affect flesh shadows by reflection, as in the lower side of the forearm laced with gold, the received colour is swept rapidly across the glazes. Similarly in the earlier painting, Delilah's white sleeve is graced with bluish and reddish hues in the shadows. Throughout such paintings, the eye is encouraged to take an unprecedented degree of visual exercise, as it translates succulent paint into seductive illusion.

Those authors from the seventeenth and eighteenth centuries who saw themselves as heirs to Rubens's 'Maxims' consistently emphasised the employment of optical mixing in his flesh tones. Roger de Piles, writing in 1677, may be taken as typical:

Take the most beautiful colours, like a beautiful red, a beautiful yellow, a beautiful blue and beautiful green and place them separately, one beside the other. It is certain that they will conserve their clarity and form individually and all together; if you mix them, they will make nothing other than the colour of earth.[81]

These discrete patches of colour, as Henry Howard explained in 1848, 'when viewed from a sufficient distance . . . come in a blended state to the eye', where they 'acquire the tone and effect of nature, and gain in brilliance from their crudeness'.[82] Piecing together the later echoes of Rubens's 'Maxims' on col-

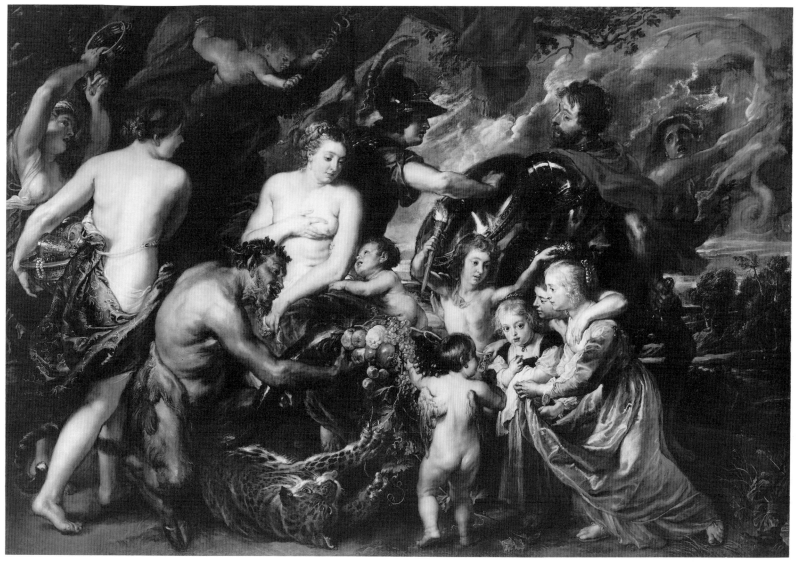

501. Peter Paul Rubens, *The Blessings of Peace*, 1630, London, National Gallery.

our mixtures, I think it is possible to attribute to him a series of Aguilonian prescriptions:

Colours should not be 'tormented'. No more than two pigments should be mixed together on the palette. Rather, colours should be applied simply, directly and separately onto the canvas, allowing mixtures to take place 'in the eye'.

Shadows should be kept translucent. Neutral glazes should be used in such a way as to permit the local and reflected colours in the shadow to blend within the 'diaphanous medium'. This ensures that colouristic vitality is not crushed to death in the shadows.

Highlights should be opaque and pure. A strong accent of opaque white should be mixed with bright colours to reflect light directly from the surface, in contrast to the translucency of the shadows.

The second of these 'maxims' is also paralleled in Aguilonius's treatise. The author was concerned to differentiate the darkly veiling shadows in a candle-lit room from the diffuse brilliance of out-door lighting: 'things in the open air should be displayed with an equal light flowing around on all sides, in as far as they prevent [full] shadow in almost every place'.[83] This principle of diffused light, which searches out colour even in shaded portions, is brilliantly realised in Rubens's landscapes by means of translucent glazes—by means of Aguilonius's *compositio intentionalis*.

It would be wrong to assert categorically that Rubens could not or would not have arrived at these principles with Aguilonius's theories. And I have suggested that the influence was not all in one direction. But it is reasonable to suppose that his contacts with Aguilonius played a valuable role in the articulation of his ideas, and enhanced the self-conscious assurance with which he exploited various properties of light and colour in his mature paintings.

277

Rubens's willingness to 'break' colours on the canvas rather than 'torment' them on the palette is the very stuff of the colourist's art. For the sharpest possible contrast, conventional wisdom suggests that we should look towards the works of his great contemporary, Nicolas Poussin. On the one hand we have the magic scintillation of elusive colour; on the other calculating compositions whose clear colours simply act as suitable accessories for rigorous design. As a corollary, we might anticipate that Poussin would profess no developed interest in colour theory, scientific or artistic. However, neither the initial polarities nor their anticipated corollary can be accepted as they stand. Poussin's paintings declare incontrovertibly that his attitude to colour was very different from that of Rubens, but this should not lead us to believe that this branch of art was of no consequence for him. His deep respect for Titian's paintings would alone suggest otherwise. And we know that he was not the kind of artist who left any part of his art to chance.

The definition of painting which Poussin outlined to Fréart de Chambray in 1665 leaves no doubt that colour is an absolutely integral part of the painter's relationship with the visible world. Painting, he considered, 'is an imitation in line and colour of all that is to be seen under the sun'.[84] When Poussin painted the self-portrait now in Berlin he appropriately displayed himself holding a volume entitled *De Lumine et colore*.[85] In the absence of any contemporary or earlier treatise of precisely this title—unless we include Rubens's essay—we can only assume that Poussin is wishing us to believe that he had composed (or intended to compose) such a treatise himself.

Beyond these general indications, however, there is a dearth of detailed statements from Poussin himself which would permit us to define his theory of colour. However, given his close relationship to academic doctrines as they developed in Italy and France during the course of the seventeenth century, we do have a number of texts which can, judiciously used, provide valuable clues as to how he regarded colour. The texts include those current in the Italian circles of Domenichino (most notably the manuscripts of Matteo Zaccolini), a later Roman treatise on optics by Athanasius Kircher, and the pronouncements of those French academicians who claimed to speak for Poussin.

The most imponderable of these factors, given the present state of our knowledge, are the attitudes to colour of the more classicising Roman artists of the early seventeenth century in the orbit of the Carracci, above all those of Domenichino. His paintings, with their light tonality and high register of colour in the shadows, speak a considered and even novel attitude to colour. When we remember that Domenichino was an accomplished musician, we may suspect that there are grounds for thinking that he would have been drawn to the ideas of colour music.[86] The problem is that relevant texts are few, and those we do possess await full publication and analysis. Accolti, whom we have met as a perspective theorist, will provide some assistance. He specifically advocated the advoidance of the kind of inky shadows which would crush colour in all but the most strongly lit areas.[87] Given Accolti's interests in Leonardo, we may suspect that in this respect at least he was rejecting the lead of his predecessor, who placed primacy on

chiaroscuro. However, we should distinguish between the impact of Leonardo's *writings* in the seventeenth century and the influence of his *practice* as transmitted mainly by North Italian followers. The lessons of his practice seemed to encourage the heavily shadowed manner, of which Caravaggio was the greatest heir in the early seventeenth century. On the other hand, the marvellously subtle colour observations of the 'Trattato' contained much to inspire even the most dedicated colourist. We may well suspect that Federigo Barrocci, the greatest colourist at the turn of the century and an important influence on Rubens, learnt a great deal from Leonardo's treatise, to which he had access through his della Rovere patrons.

The texts which probably provide our most direct access to ideas current in the Rome of the young Poussin are the treatises on colour by Zaccolini.[88] We have already seen that Poussin had been able to study Zaccolini's manuscripts through the good offices of his patron, Cassiano del Pozzo. The Italian theorist's texts 'De' Colori' and 'Prospettiva del colore' resemble his treatise on perspective in as much as they exhibit a high degree of idiosyncratic individuality, and they cannot therefore be taken unquestionably as representative of mainstream academic thinking at this time. However, given Domenichino's and Poussin's known interests in Zaccolini's ideas, we would be wrong to dismiss his writings as merely aberrant.

Zaccolini's 'De' Colori' is the most sustained, elaborate and comprehensive treatise on the natural history of colours written by any artist and, indeed, it rivals any scientific treatise written by that time. Its tenor is predominantly Aristotelian, coupled with a strong emphasis on the observation of colour in nature, but he does not confine himself exclusively to the traditional formulas of explanation. He regards the colours as

502. Colours of a flame and in the atmosphere, from Matteo Zaccolini's 'De Colori', Florence, Bibliotheca Laurenziana, Ash. 1212, I.

generated by the four elements and paired qualities of hot, dry, cold and wet—a traditional enough idea—but in his system each of the individual elements can generate a full range of colours: white, black, red, yellow, blue, green, and an infinity of mixtures.[89] On this base he reviews a wide range of questions, such as the mixing of colours, the effects on the eye of their juxtaposition, the appearances and reflections of colours on the surfaces of different coloured objects (including *cangianti* effects), and observations of colour phenomena in the natural world, including the colour-changes of the chameleon and the colours of birds' feathers. Characteristic of his combination of Aristotelian commonplace, subtle visual observation and conceptual ingenuity is the diagram in which he correlates the colours generated by fire with those visible in the sky (pl. 502).

'De Colori' is predominantly theoretical in tone, and it is left largely to the companion volume, 'Prospettiva del colore', to provide the artist with guidance on the application of colour theory to the practice of naturalistic representation. Zaccolini not unreasonably claims that such guidance has not been provided by earlier authors, and he sets out to establish colour practice on a base of unrivalled comprehensiveness, and in a spirit which is truly Leonardesque:

First we will treat how all coloured objects at various distances are made to appear as various other colours, and how all of them at remote distance will ultimately appear to be blue. And next will be given the way that one should place colours in practice of painting, according to the degrees of distance. And with this it will be demonstrated which colours participate in one another, and which go better together when placed next to each other. On the basis of such understanding, and in order to distinguish things more readily, we will give several charts for the perspectival degrading of colours, where one can see their apparent mutations according to the various degrees of distance, so that the painter in a single glance and without much mental effort, can understand the variety of diverse appearances in their particular locations, subsequently combining this with the precedence of the colours among themselves according to the difference in the various degrees of distance. And then I explain how greater and lesser sizes respond to the variety of distances. Then we pass to *cangianti* colours, also considered with respect to various distances; adding subsequently discourses on shadows, on backgrounds, on foreshortenings, and on images seen in water. And finally we devote our efforts to the explanation of drapery folds, and of the horizon with the appropriate colours for the highest parts of objects at various distances. We will also explain about pictures with shiny surfaces, so that the painter can control the use of lighting, and the shadows, and where the eye must be placed to look at the picture without being overcome by excessive light. Furthermore, in other matters, I will endeavour also to explain miscellaneous visual phenomena, so that the learned painter, practised in the peculiarities and in the observation of the variety of Nature, and drawing upon the most rigorous scrutiny of scientific considerations, will be able to imitate the surface appearance of things.[90]

The optical properties of degradation—the diminution of hue, the reduction in tonal contrast and loss of formal clarity—are attributed by Zaccolini to the smaller angles under which the images reach the eye and to the tendencies of the air-born 'species' to become exhausted, as if by the draining of their impetuses.[91] The result is that each colour loses its force (saturation). The lighter colours are dimmed and the darker colours are progressively neutralised by the intervening veils of luminous air. The tendency of colours to become bluer at increasing distance stands in direct proportion to their degree of proximity to black in his Aristotelian scale. This idea surely takes its cue from Leonardo, but Zaccolini goes much further in codifying the precise degrees of susceptibility to a degradation of each colour across four defined zones of distance, according to the scaled sequence, black-green-olive-red-flaxen-yellow-white-blue.[92]

The general tenets of the Zaccolini's theory—that saturation, tonal contrast and variety of hue would be progressively lost over distance—correspond closely the colour practice of the Carracci, Domenichino and Poussin. Where Zaccolini goes beyond the empirically established aspects of early baroque practice is in his attempt to establish a precisely reasoned system of scales, expressible in proportional diagrams to which the painter can refer for precise guidance. Although we may doubt whether any painter would have kept such charts at his elbow for direct reference during the execution of a painting, this lack of practicality would not have prevented painters of a markedly intellectual bent, such as Poussin, from welcoming his demonstration that there were systematic principles of a scientific kind underlying the effects that the painters had learnt to control by eye.

Given Zaccolini's associations with the musically-inclined Domenichino, not the least intriguing aspect of his ideas is his extended treatment of a form of colour music, which relies on a scale of nine hues: white, yellow, red, beige, purple, olive (*pallido*), green, blue and black. The way he chooses to illustrate his colour music is through the notion that colour can be used 'physiologically' during the course of a tarantella, the theraputic dance designed to cure the bite of a tarantula.[93] The idea is that appropriate notes and chords of colour will act with music in such a way as to counteract the maladies produced by the poison. The use of music alone as a cure was well enough known, and was mentioned by Zarlino amongst others, but the addition of colour to augment sound appears to be his own novel variation on the colour-music theme.[94]

Without more direct evidence it is difficult to know how closely his fellow painters were prepared to adopt his ideas on colour. His theory as a whole certainly stands somewhat apart from the mainstream writing on the visual arts and appears to have exercised no significant impact on scientific thought. It is perhaps significant that his manuscripts did not find their way into publication, though they were prepared in fair copies suitable for the printer.

Even if Poussin was not disposed to adopt their ideas wholesale, Zaccolini's writings may well have encouraged him to view colour in the context of a system of correspondencies embedded in the structure of nature and expressed in

503. The 'simple' and 'composite' colours and their correspondences from Athanasius Kircher, *Ars magna lucis et umbrae*, Rome, 1646.

the various arts. We know that Poussin was attracted to this synaesthesic manner of thinking. His famous 'Modes' were conceived in this manner, and were applicable to poetry and music (the source of the original idea) no less than to painting. Taking his key from Gioseffe Zarlino's musical theories, which we have already quoted in connection with music-colour analogies, he outlined five modes: the Dorian, which was 'firm, grave and severe' and 'full of wisdom'; the 'sharper' and more 'vehement' Phrygian; the 'mournful' Lydian; the Hypolidean, appropriate for 'divine matters' on account of its 'suavity and sweetness'; and the Ionic, of 'cheerful character' suitable for dances etc.[95]

Poussin's interests in such moral and temperamental equivalences may well have been reinforced in the later stages of his career in Rome by the writings of the great Jesuit man of letters, Athanasius Kircher, whose extensive publications included a treatise on music and a major compendium of optics, the *Ars magna lucis et umbrae* (1646). Kircher's theory of colour was at root Aristotelian and Aguilonian in type. His diagram of the colour scale (pl. 503) was clearly based upon Aguilonius, with the same principal arcs, suggesting that colour makes musical harmonies in the eye like 'the diapason in the ear'.[96] Kircher has amplified the Aguilonian scheme by introducing the mixtures of the 'median colours' with black and white, but the basic pattern is identical, relying upon the white and black poles between which come yellow, red and blue together with the three 'composites', orange, green and purple. A more significant extension to Aguilonius's ideas is provided by the series of analogies which Kircher outlined in the

table below the diagram. Unlike his predecessor, Kircher was much given to astrological mysticism of the type which Lomazzo had adopted from Cornelius Agrippa, and throughout his book Kircher weaves a complex web of cosmological concordances for visual science. The five colours are viewed within the context of elaborate equivalences, with degrees of light and shade, flavour, the elements, ages of man, levels of understanding, celestial and earthly hierarchies, and levels of being. If the implications of this scheme were followed to their logical conclusions they could have extraordinary and even objectionable results. The equation of black with the basest levels in each series meant that black races were considered by Kircher to be 'timid' and 'imbecilic'.[97]

This propensity for viewing the individual elements of the visible world in terms of collective principles became deeply ingrained in academic theory. It is not surprising to find that a number of writers who considered themselves to stand in line of descent from Poussin showed a more than passing sympathy with precise systems of meaning for colour. In general terms, almost all the academic theorists agreed that colour should signify something in relation to the narrative of the painting. The most open espousal of the tradition was by Gerard de Lairesse in his *Groot Schilderboek*, published in Amsterdam in 1707 (translated into English as *The Art of Painting* in 1738 and into French in 1787). Lairesse, 'the Dutch Poussin' as he was called, assigned 'emblematic' meanings to his three 'chief colours' and three 'mixed' colours: yellow was equated with 'lustre and glory'; red displayed 'power and love'; blue was associated with the deity; purple denoted 'authority and jurisdiction'; violet signified 'subjection'; and green stood for 'servitude'.[98] Allied to these 'emblematic significations' were broader correspondences to the ages of man, the seasons and times of day, in the by now familiar manner.[99]

This search for meaning in colour can be brought closer to Poussin himself by his leading academic heir in France, Charles Le Brun, who applied a symbolic interpretation to the colours in the master's *Ecstasy of St. Paul* (colour plate V). Addressing the Academy in June 1671, Le Brun stated that Poussin dressed the three angels in yellow for 'purity', blue for 'committed grace', flaxen green for 'abandoned grace and triumph', while Paul's red garments denoted 'ardent charity'.[100] In his earlier speech to the Academy on 5 November 1667, Le Brun had suggested that the yellow and blue garments of the Israelites in Poussin's *Fall of Manna* were chosen because they 'are the two colours which partake most of the light and air'—a less obviously symbolic interpretation, but one which does have clear physical and celestial implications.[101] This, at least, is the argument used by another speaker at the Academy in the same year, Sébastien Bourdon, in his discussion of Poussin's *Healing of the Blind Man*: 'As yellow and white partake most of light [as in the Aristotelian scale] . . . M. Poussin has put them into Christ's robe, because they are sweet colours near the carnation and are also more lively and apparent'. Together with Christ's purple cloak, these garments, 'being of a very bright and celestial colour, are perfectly suited to he who wears them, as the most worthy and principal object in all the picture'.[102]

These accounts give a clear idea that decorum of meaning in colours, their place in the Aristotelian scales and their formal roles act in total accord. The term applied to the formal role of each colour—whether it advanced or receded, whether strong or soft, whether rich or weak—was 'valeur' (value). This seemed to carry with it more than purely formal associations. It was a theorist under Le Brun's wing, Henri Testelin, who formulated the most elaborate and resolved scheme for determining the 'value' of each colour. His *Table de precepts sur la couleur*, presented to the Academy in 1679, provides a series of three 'properties' (absolute values) and three 'relations' (relative values) for each colour.[103] The 'properties' are force, luminosity and richness, corresponding in some measure to our co-ordinates of hue (referring to the inherent 'power' of each hue, judged subjectively), tone and saturation. The warmer and lighter colours such as red and yellow provide the highest points on the scale. The 'relations' indicate the ways in which adjacent colours interact. The first is by mutual enhancement when certain pairs of colours, such as red and green or yellow and blue, are placed beside each other. The second refers to the tendency of particular colours to make an adjacent colour advance or recede. And the third arises when colours create a harmony or dissonance in a manner analogous to music.

Underlying the academic theorists' sense of 'value', in matters of form and content, lay an assumption that colour should be used in a relatively clear, declamatory manner, avoiding extremes of broken elusiveness in the Titian manner and tonal veilings of the Leonardo kind. Colour should be applied in the Poussin manner, as exemplified by the *Ecstasy of St. Paul*. It is not hard to analyse this painting in Testelin's terms (pl. 504): in the centre is the richest and most forceful colour, the saturated red of Paul's cloak, which is enhanced by juxtaposed green; on the left, corresponding to the direction of the light source, is the luminous, 'advancing' yellow; on the right is the darker or 'retreating' blue; while at the summit is the light softness of pale, aetherial green, an 'aerial' or 'celestial' colour suitable for the apex of a divine group. In exploiting his effects, we could further say that Poussin has concentrated upon the three primaries (Kircher's 'median colours'), yellow, red and blue, together with the most ubiquitous of the 'composites', green. The 'tuning' of these colours in the painting is achieved in a rigorously clear-headed manner, as is the scaled degradation of colour with distance.

Kircher, following Aguilonius, had come tantalisingly close to the later system of primary and secondary colours. All that was required was the elimination of white and black as 'colours'—though this was not easy given their place in the Aristotelian order of things. This elimination was actually achieved in Poussiniste circles and perhaps even by the master himself. The crucial step seems to have been taken around the middle of the century, with science in the lead. In 1650 Marin Cureau de la Chambre, who himself devised a musical system of colour scales, proposed the three-colour theory of yellow, red and blue. Only one year later French artists could read in the newly published translation of Leonardo's *Treatise* by Roland Fréart de Chambray that 'white is not at all accounted a

504. Analysis of Poussin's *Ecstasy of St. Paul*, in Accordance with Testelin's principles.

colour, but a power (*puissance*) capable of receiving all the colours', while black is to be considered 'a simple absence' of colour.[104] Cureau de la Chambre's three-colour theory was acknowledged and espoused by one of Poussin's biographers, André Félibien, who reviewed and discarded the Aristotelian, Albertian and Lomazzan theories.[105]

All this discussion of Poussiniste theory has brought us to Poussin's doorstep, but, probably to the reader's frustration and certainly to the author's, not quite into the master's house. There are obvious dangers, as we noticed in Chapter III, in transposing the thoughts of followers into the mind of Poussin himself. A responsible historian will hesitate at this point, even though the paintings themselves do much to encourage a belief that Poussin increasingly looked to colour theory for guidance. The paintings not only declare a highly meditated use of colour in relation to formal and narrative value but also display a repeated use of the Aguilonian-Kircherian 'median' and 'composite' colours in a generally unbroken manner. This is above all true of those paintings dating from about 1637 and later. The *Holy Family on the Steps* and the *Healing of the Blind Man*, in particular, prove amenable to an analysis according to the physical and symbolic principles we have outlined.[106] We cannot, however, take paintings, even Poussin's later paintings, as written statements, and they cannot ultimately provide a final solution to problems of what Poussin himself thought. What we can say with confidence is that if he did not himself articulate views on colour akin to those of Le Brun, Testelin, Fréart de Chambray and Félibien, then his mature works provided positive encouragement for those who wished to do so. If the three-colour theory cannot be laid at his door, through his own efforts, it can certainly be seen there, firmly nailed by his friends and neighbours.

In retrospect, the recognition of the three fundamental or primary colours may appear to be of crucial importance, but at

the time it seems to have entered the literature relatively un-obtrusively, not as a radically new principle, but as a relatively unremarkable formula which corresponded in large measure to the established practices of colour mixing. Robert Boyle, writing in 1664, recorded that red, yellow and blue were the 'primitive' or 'simple' colours used by painters, in conjunction with black and white.[107] Five years later the great Swedish scholar, Schefferus, wrote in his highly intelligent book on painting that 'the simple colours are three in number: red, blue and yellow. And they are associated together with light, i.e. white, and shadow, i.e. black.'[108] The secondaries formed from mixing each simple colour with each of the others and with black and white are characterised and illustrated precisely as in Kircher's scheme.

An unequivocal acknowledgement of the three primaries was made in 1707 in Gerard de Lairesse's *The Art of Painting* (1707). Lairesse argued that 'white and black are not reckoned among the colours, but rather potentials or efficients; because others cannot have their effects without the help of them'.[109] This left him with three 'chief' or 'head' colours ('Hoofd Koleuren'), red, yellow and blue, together with three 'mixed or broken colours'. His 'mixed colours'—green, purple and violet—are not, however, quite what we might expect, since violet has been included rather than orange. It is not clear what led Lairesse to select these three 'mixed colours', unless it was that he considered it necessary for them to be situated towards the darker end of any tonal scale.

What may be regarded as the definitive formulation and artistic demonstration of the three primaries and their compounds was another twenty years or so before arriving in print, although the author responsible, Jakob Christof le Blon, claimed to have been aware of the basic theory since the early years of the century. Le Blon, a German artist who was trained in Italy published his 'invention' in London at an uncertain date during the 1720s. His brief treatise, *Il Coloritto or the Harmony of Colouring in Painting*, informed the reader that:

> Painting can represent all visible Objects, with three Colours, Yellow, Red and Blue; for all other Colours can be compos'd of these Three, which I call Primitive; for example.

> Yellow and Red } make an Orange Colour

> Red and Blue } make a Purple and Violet Colour

> Blue and Yellow } make a Green Colour

And a Mixture of those Three Original Colours makes a Black, and no other colours whatsoever.[110]

Le Blon proudly claimed that he had 'demonstrated' the truth of this conception by his 'invention of Printing Pictures and Figures with their Natural Colours'.[111] This refers to Le Blon's innovatory technique of mezzotint colour printing in which three engraved plates, each inked with one of the three 'primitive colours', were overlaid to produce a truly remarkable and precocious full colour print, akin to modern half-tone reproductions (colour plate VI).

He illustrated his treatise with six specimen plates to demonstrate the build-up of full colour effects and the consequences of using either vermilion or red earth as his basic red. Illustrated here are his second demonstration, using the overlaid impressions of yellow and blue plates, and one of the full colour prints—utilising yellow, blue and flesh-red, together with 'accidental' colours in such features as the lips and eyes. In keeping with his text, the 'reflexes' in the shadows are yellowish in colour, while 'the Turnings off, the Goings off, or the ROUNDINGS [also called the 'mezzatinta'] are made of Blew'.[112] The zonal treatment of 'the Part illuminated', the 'Turnings' and the 'Reflexes' are all strongly reminiscent of Rubens's practice.

He also endeavoured—prophetically, in the light of nineteenth-century developments—to apply his findings to 'Weaving Tapestry in the same Manner as Brocades' so as to produce 'in the loom all the Art of Painting requires'.[113] Here, however, he would have found matters more complex, since he was dealing with optical mixtures in which different principles are at work. Perhaps it was such difficulties that led him to differentiate between the 'material' colours of the painter and the 'impalpable' colours of light. A mixture of the 'impalpable' colours 'will not produce Black, but the very Contrary, White; as the Great Sir ISAAC NEWTON has demonstrated in his Opticks'.[114]

He also claimed, in conversation with Antonio Conti, that 'by following Newton's principles of the immutability, refrangibility and reflexibility of the rays of light, he had established the degrees of strength or weakness that must be given to colours in order to bring them into harmony'.[115] Frustratingly, neither Conti nor Le Blon himself provide details of how this system worked. It may have been based on the positions of colour in the 'colour wheel' invented by Newton, or it may have combined the Newtonian spectrum with the Aristotelian scales—or the claim may even have been a piece of groundless self-aggrandisement on Le Blon's part. When we look at Newton's theories in the next chapter, we will be better placed to form a judgement. Whatever doubts we may harbour about the ultimate validity of Le Blon's claims, his ambitions do mark the first attempt by an artist (though not, as we will see, the first by a theorist) to assimilate the great scientific discovery which was eventually to revolutionise colour theory.

Le Blon in his keen adoption of a Newtonian principle, is unquestionably brilliant yet historically eccentric. His own career as a print-maker followed an equally idiosyncratic course. His high hopes for the artistic and financial success of his novel process were not realised. His business ventures, supported by protective patents, all seem to have collapsed after initial success, and his claims for priority in colour printing were vigorously challenged in Paris by Jacques Gautier d'Agoty.[116] He was also unusual in that he was forming his

282

ideas outside the mainstream of the academic tradition in Europe. It was within this tradition, which was always guarded and not infrequently hostile to the charms of colour, that an articulate colour theory came to be most consistently developed.

The apparently paradoxical prominence of French academic authors in the formation of seventeenth-century colour theory is a reflection of their willingness to believe that colour, as subordinate to design, could be reduced in practice to relatively simple principles. This reduction to rule was, for those who stood in the colourist camp, no way to treat an aspect of nature which continually revealed such an infinite range of changeable beauties.

The polarities around which the colour-design controversy raged in seventeenth-century France became increasingly clear during the late 1660s and early 1670s. At first, the battle lines were relatively blurred. In an address to the Academy on 4 June 1667, Philippe de Champaigne gave a splendidly subtle exposition of form and colour in Titian's *Entombment*, in which he recognised elusive harmonies of broken colours in both lights and shades, but by the early 1670s he had declared himself as solidly Poussiniste in orientation, emphasising the rule of design above all else.[117] For the really strict Poussiniste, the 'accidents' of colour in nature, particularly the broken effects of counter-reflections, should be avoided in painting. Pierre Mignard, who took Raphael's Louvre *Holy Family* as his example of excellence, argued that reflections disastrously 'diminish the force' of three-dimensional modelling 'and make the members of a body appear too transparent'.[118] The vagaries of colour in nature were regarded as too transitory and variable to be anything other than dangerous for the painter of great subjects, who must aspire to eternal verities. Colour belonged, as Noel Coypel was to stress, to the lower, sensuous realms rather than to the higher, philosophical considerations of great art.[119]

This stigma of mere sensuality was combated with the utmost vigour by Roger de Piles, the greatest literary champion of the colourist's art during the seventeenth century. In 1668 de Piles had published his French translation of the *De Arte graphica* of Charles Alfonse du Fresnoy. Written in Latin during the 1650s, du Fresnoy's poem contained some subtle evocations of what he called the 'chromatic' delights of colour, as befitted an author who admired the great Venetians. Du Fresnoy defined colour as the essential 'complement' to draughtsmanship and as 'the soul and ultimate realisation of painting'.[120] Five years later, on his own behalf, de Piles weighed into the controversy with his *Dialogue sur le coloris*. Colour, he argued in the Aristotelian manner, 'is that which renders objects sensible to vision'.[121] Far from being basely material, accidental and practical, colour was substantial, formal and theoretical. Colour provided the key to light and shade in a painting, in such a way that *chiaroscuro* should be regarded as a function of colour, not as part of design in the academic manner. The artist must consider three factors (again Aristotelian in tenor) in painting coloured objects: the true colour of the thing itself; the colours of reflections from adjacent surfaces; and the colour of the light. Beyond this, however, de Piles did little to provide a true *theory* of colour. He unreservedly supported Rubens and the Venetians for their broken effects of elusive colour, but he could not really claim to have demonstrated his point that colour is a matter of theory rather than empirical practice.

The closest he came to an actual rule was his formulation that the compatibility or harmony of two adjacent colours could be judged on the basis of whether their actual mixture was 'sweet and agreeable'.[122] Thus blue and yellow would be harmonious, since green is 'agreeable', while blue and vermilion provide a 'disagreeable' purple. This formula is actually a good deal less subtle than Félibien's account of Le Brun's discovery of the unity of inequal colours: 'a green broken with red harmonises with a blue broken with white, because pure blue, which will be dissonant with pure green, on account of the inequal quality of light which each of these colours possess, is brought into unison (if I may avail myself of this term) by means of white and red which modify the two other colours and accord them an appropriate level of force which causes their unison'.[123] This unison thus consists of balancing the two arms of the tonal (Aristotelian) scale.

Félibien's writings serve, in fact, as a warning against taking the *Poussiniste/Rubéniste* polarities too much at face value. Félibien saw no incompatibility in admiring the harmony of Titian's 'musical' colours at the same time as emphasising that Poussin was the supreme draughtsman *and colourist* because Poussin obeyed the rule of reason in all things. The true colourist, for Félibien, was one who understood the 'proportion of light' in each colour and could exploit this knowledge in controlling the *chiaroscuro* of his painting.[124] The true colourist would also understand the meaning and decorum of colours in relation to content, as Le Brun had explained in connection with Poussin's *Ecstasy of St. Paul*.

As a translator into French of Leonardo's *Trattato*, Félibien also serves as a reminder of the continuity of seventeenth-century academic and Renaissance theory, as does Poussin himself. We have noted that Poussin provided a set of illustrations for Cassiano del Pozzo's manuscript of the *Trattato*—whatever his later criticisms—and he was undoubtedly aware of Lomazzo's writings. It may be no coincidence that the deliberately harsh rather than enhancing juxtaposition of red and green in the accuser's garments in Poussin's *Christ and the Adulteress* is precisely that recommended by Lomazzo for expressive dissonance.[125] This historical continuity is marked both by success and failure. Its greatest success was the development of the three-colour theory with its attendant compounds, which corresponded well to the practice of pigment mixing no less than to the Aristotelian systems of Aguilonius and Kircher. Other successes may also be claimed: the definition of the inherent tonal values of different colours in relation to *chiaroscuro*; the description of the different kinds of optical mixing by means of glazes and separate touches of paint; and the awareness of mutual enhancement in pairs of juxtaposed 'colours', most notably white and black, yellow and blue, and red and green. A number of theorists had also tackled the thorny problem of associational meaning and emotional significance for colours within the established systems of cosmological corre-

spondencies. The first attempts had been made to place the mathematical analogy with musical harmonies on a securer footing. The 'music' of colour was to become a major theme in its own right during the eighteenth and succeeding centuries.

The failure was a general one. Traditional colour science as a whole had not really provided a comprehensive base for the painter to understand why his pigments behaved as they did nor could it explain adequately their relationship to the effects of colour and light that he wished to imitate in nature. The new science of Newton looked more promising in these respects, but, as we shall see, this promise was long in being fulfilled.

CHAPTER VII

Colour II: Newton
and after

The key moment in the history of colour science, in the story as conventionally told, came in 1666 when Isaac Newton obtained a 'Triangular glass-Prisme, to try therewith the celebrated Phenomena of Colours'.[1] Let us, for the moment, stay with that conventional story—not least because it corresponds to the image which was bequeathed to posterity by the body of popularising literature responsible for the widespread transmission of Newton's ideas. With this prism he performed his *experimentum crucis*, in which he used a twenty-two-foot throw to separate, as he claimed, white light into its constituent elements:

1. The Sun's light consists of rays differing by indefinite degrees of refrangibility.
2. Rays which differ in refrangibility, when parted from one another do proportionally differ in the colours which they exhibit. These two propositions are matters of fact.
3. There are as many simple or homogeneal colours as degrees of refrangibility.[2]

In his experiments with prisms he had been preceded by Descartes, Hooke, Boyle, Marci and Grimaldi amongst others, and in his search for a mathematical explanation for the 'Phenomena of Colours' he was developing an idea apparent in the later stages of Aristotelian theory, particularly with respect to colour music. But these antecedents in no way lessen the magnitude of the conceptual leap which he took and which he announced to the Royal Society in June 1672.[3] Whereas all earlier theories relied upon the modification of *white light* to produce colour, he advocated the *analysis* or division of white light into constituent parts to produce colour. Sunlight was no longer regarded as a simple, homogeneous substance which could be warped or mechanically transformed in some way to make colours; it was now seen as a compound, heterogeneous mixture of rays with different properties. Certain of these rays, having been separated by the prism, could not be broken down into smaller units by further refraction or reflection, and always maintained a constant degree of refrangibility. These particular rays are correlated by Newton with particular colour effects. Those 'colorific' rays which cannot be decomposed by further optical treatment are to be regarded as the 'primary colours'. By the time he came to publish the great compendium of his ideas on colour in his *Opticks* in 1704, he had settled (or appeared to most readers to have settled) on what has become the canonical set of seven primaries: red, orange, yellow, green, blue, indigo and violet. These primary rays of different but constant refrangibility could be recombined and re-separated indefinitely, without altering their colorific characteristics. Here was a theory of colour which combined brilliant intuition with an experimental base of a more rigorous and extensive kind than had previously been accomplished.

The remaining obstacles, experimental and conceptual, in Newton's colour science were skilfully circumnavigated in his *Opticks*. Many subsequent accounts, particularly those which popularised his ideas, transmitted the basic version of the seven-colour system with no hints of the complications and difficulties. I think it will be worth our looking briefly at just four of these problems, since they help explain why it remained so difficult to reconcile the Newtonian and pictorial theories.

The first problem concerns the number of primaries. As we will see, Newton began with a five-colour system, to which he added a further two, as much for aesthetic reasons as scientific.[4] But he also realised that the continuous transitions of colours in the natural spectrum indicated an infinity of colours and therefore a continuous range of refrangible rays. The question of the infinity of colorific rays was largely concealed in the *Opticks*, but can be made to emerge on close scrutiny. The second difficulty centres on the identification of the degrees of refrangibility with colour. Since many colours, green for example, could be composed by mixing as well as existing in a simple or primary form in the spectrum, it was necessary to suppose that there were two physically different kinds of phenomena which were seen identically as green. The third involves Newton's traditional but false assumption that compound hues would be of the same nature for light as for pigments. Thus yellow and blue lights are taken to compose the intervening colour in the spectrum, namely green. The fourth is concerned with the compounding of white light. Newton steadfastly maintained that sunlight was compounded from *all* the primaries, although under strong challenge from Christiaan Huygens in Holland he was forced to concede that as few

as three primaries could make white light.[5] Huygens himself had been arguing correctly for the composition of white from two colours (e.g. blue and yellow). Newton is thus forced to argue that there are 'curious' forms of white light which work differently from sunlight. This distinct untidiness in his theory left the door open for subsequent three-colour theorists.

For the great majority of Newton's readers, even for many of his opponents, the complex structure of speculation and experiment in his *Opticks* successfully overwhelmed the problems and virtually prevented their moving to the forefront of discussion. He compellingly treated almost every conceivable aspect of colour physics, from concepts of the ultimate cause of coloured sensations to specific details of pigment mixtures. Like others before and after him, Newton was prepared to look towards sound, and to music in particular, for analogous phenomena. He speculated that light rays moved through the media in a periodic manner just as 'the Vibrations of the Air, according to their several bignesses, excite sensations of several sounds'.[6] This means, as Descartes had already insisted, that colour is a sensation in the eye, resulting from a mechanical action, not a property of the object: 'Rays, to speak properly, are not coloured. In them there is nothing else than a certain Power and Disposition to stir up a Sensation of this or that Colour' just as 'sound in a Bell or musical String, or other sounding body, is nothing but a trembling Motion'.[7]

This analogy was developed along precisely mathematical lines. Indeed, it can be argued that his desire to achieve a mathematico-musical system for colour did much to determine the development of his ideas. His *Optical Lectures*, unpublished until recently, show that he first adopted a five-colour scheme: red, yellow, green, blue and purple.[8] This scheme, however, did not satisfy him: 'in order to divide the image into parts more elegantly proportioned to one another, it is appropriate to admit to the 5 more prominent colours two others, namely, orange between red and yellow, and indigo between blue and violet. . . everything turns out proportionate to the quantity of green with a more refined symmetry. . . everything appeared just as if the parts of the image occupied by the colours were proportional to a string divided so it would cause the individual degrees of the octave to sound'.[9] Having drawn dividing lines between the seven colour bands in the spectrum of a prism (pl. 505), he contrived to recognise a series of intervals like 'chords of a Key, and of the tone, a third Minor, a fourth, a fifth, a sixth Major, a seventh

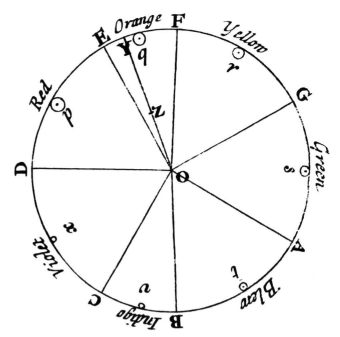

506. Colour circle, from Newton's *Opticks*.

and an eighth above that Key'.[10] He also suggested that pictorial concerns might be amenable to the same kind of analysis: 'the harmony and discord also which the more skillful painters observe in colours may perhaps be effected and explicated by various proportions and aethereall vibrations'.[11]

Not the least important of his inventions from the painters' point of view, was his demonstration that the relationship of his seven simple colours could be expressed by a colour circle in which the linear diagram of spectral intervals was joined at its distal ends (pl. 506). Each colour occupies a proportion of the circumference corresponding to its position in the musical scale. Thus red: orange: yellow: green: blue: indigo: violet = sol: la: fa: sol: la: mi: fa: sol = 1/9: 1/16: 1/10: 1/9: 1/16: 1/16: 1/9.[12] The colour wheel enables any mixed colour to be described in relation to the seven primaries and white. If, for example, Z is the 'centre of gravity' of a mixture, its colour can be judged by the radius ZY, while the length OZ gives its degree of 'intenseness' proportional to white.

Newton emphasised that he was not dealing with the quantities of the material pigments but with the 'quantities of the light reflected from them'—although he did not develop this distinction in a systematic manner.[13] He also recognised that his diagram was not mathematically infallible, although it could be considered 'accurate enough for practice'.[14] In no sense was Newton providing a colour wheel for painters but he had provided a model which needed little modification to make it serve as such. Perhaps it was this technique of determining centres of gravity for mixtures to which Le Blon was referring when he claimed to have achieved a system of 'weighting' for colour based on Newtonian principles.

Newton's exposition of general laws was supported by minutely detailed observations, some of which relate closely

505. The spectrum of seven 'primary' colours from Isaac Newton's *Opticks*, London, 1704.

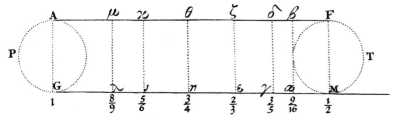

to the practice of painting. He stated that since pigments absorb even a certain amount of the type of rays they predominantly reflect, complex pigment mixtures will tend to produce a dull effect—a property already well known to artists and clearly expressed if not explained in Rubens's 'Maxims'. One part of red lead and five parts of *viride aeris* will produce a 'dull colour like that of a Mouse'.[15] If, however, the actual powders are mixed in a dry state and spread on the floor, the effect will be more vivid. He experimented with placing a mixture of powered orpiment, bright purple, *viride aeris* and blue bisc beside a sheet of shaded white paper. Viewed from twelve to eighteen feet, 'the powder appeared intensely white so as to transcend even the Paper itself in Whiteness'.[16] With characteristic brilliance he also described a different kind of optical mixture, achieved by rapidly repeated sensations of different colours which 'cannot be separately perceived' but make 'one common sensation'.[17]

Such beguiling details, however, did not make it much easier for painters to absorb the central tenets of his colour science into their theory and practice. The most substantial early appearance of Newton's ideas in the context of art theory—albeit in a treatise by a professional Newtonian scientist—is the essay that Brook Taylor appended in 1719 to the second edition of his *New Principles of Linear Perspective*. This essay took the the form of an appendix entitled, 'A New Theory for mixing of Colours taken from Sir Isaac Newton's *Opticks*'.[18] Taylor clearly differentiates between two primary characteristics of colour, namely 'hue' and 'strength of light and shadow' (i.e. tone). His primary hues or 'species' are the seven established by Newton. These exhibit varying degrees of 'perfection' or 'imperfection' in nature—qualities which more or less correspond to our 'saturation'. Taylor disposes the seven 'species' and their resulting mixtures in a Newtonian colour-wheel, progressively 'broken' with white towards the centre. In theory, this wheel should provide a perfect key for colour mixing, but he warns the reader that the impurities and peculiarities of 'the particular materials' used by the artist prevent them from behaving in perfect obedience to Newtonian law. Ultimately the mastery of these peculiarities is best left to 'practicioners in this art' who know the secrets by experience. Since he does not specifically address the potential conflict between the seven 'species' and the painter's three primaries, the most important problem remains unresolved.

This lack of clear resolution remains the case with all the subsequent accounts of Newtonian colour in the eighteenth century, ranging from those by professional scientists, like Robert Smith and Joseph Priestley, to those by the popularisers of Newton's ideas. Count Francesco Algarotti provides a good example of what was happening. He was a singularly perceptive populariser, but even he can only suggest general consequences of Newton's theory for painters, rather than formulating a detailed set of new techniques. Algarotti leaves the readers of his *Essay on Painting* in no doubt that 'every undivided ray, let it be ever so fine, is a little bundle of red, orange, yellow, green, azure, indigo, and violet, rays, which, while combined, are not to be distinguished from another, and form that kind of light called white; so that white is not a colour *per se*, as the learned da Vinci (so far, it seems, the precursor of Newton) expressly affirms, but an assemblage of colours'.[19] Although 'Titian, Correggio, and Van Dyke, have been excellent colourists, without knowing anything of these physical subtleties, that is no reason why others should neglect them'.[20] Newton's ideas of the absorption and reflection of colours from compound white light are seen as superior to the Aristotelian theory, in that they allow the painter to understand how 'colours partake of each other, according to the reflection of light from one object to another'.[21] From these mutual reflections—what Delacroix was later to call *liaisons*—'there arises, in some measure, that sublime harmony, which may be considered as the true musick of the eye'.

However, when it comes to precise prescriptions as to how the painter might become a Newtonian colourist, Algarotti provides virtually no guidance. The closest he comes to a specific instruction is in his *Lettere sopra la pittura*, in which he records that 'an idea [*fantasia*] has come to me . . . that it would be good if we could firmly establish, in the priming of paintings, the practice of working on top of a white ground, and eschewing the reddish and brown grounds which are all the rage today'.[22] He believes that the light reflected into the eye from the white priming will allow the painter to achieve a proportional balance of luminosity between translucent colours across the surface of the picture. We may suspect that Algarotti is thinking especially of the light-toned brilliance achieved by his friend, Tiepolo, and he makes specific mention of the *strepito* ('crackling') effects of Veronese, who provided Tiepolo's chief source of inspiration.[23]

Even the best efforts of Brook Taylor and Algarotti, from their different stances, left an uncomfortable gap between Newtonian science and pictorial practice. The best chance of bridging this gap lay in adapting Newton's colour wheel, and a number of writers keenly took just this option. During the course of the century the circle was given a third dimension, that of tonal gradation, to become a colour solid in direct line of descent to those in use today. The solids were founded upon two main patterns, circular and triangular. Both configurations relied directly or indirectly upon Newton's premise that colour relationships could be expressed in terms of a closed geometrical figure.

A pioneer role in developing the colour wheel was played by an extraordinary scientific polemicist, the Jesuit priest Louis Bertrand Castel. During the course of his disputatious career as a scientist, Castel become increasingly anti-Newtonian in outlook, no more so than in his *L'Optique des couleurs* (1740) and in his subsequent defence of his vulnerable position. He declared that he preferred to 'concentrate above all on the material and normal colours of painters' rather than the 'accidental colours, like the incorporeal ones of the prism and rainbow'.[24] This maintains the Aristotelian division between real and apparent colours. In considering material colours, he emulated Brook Taylor by distinguishing clearly between what we call hue and tone: 'colours may differ from each other in colour [hue] and be the same in *chiaroscuro* [tone] or be different in *chiaroscuro* and the same in colour'.[25] Of these two variables or coordinates, tone was the more fundamental,

while 'colour is only an accident'.[26] His emphasis upon the black-white scale is strongly Aristotelian in kind, and he follows the traditional pattern by placing the primaries of 'blue, red and yellow between the extremes of black and white'.[27] As he became more virulently anti-Newtonian, so he leant more heavily upon Kircher's *Ars magna* for the 'true' system as he saw it. He defended this reactionary stance by insisting that Newton's seven prismatic colours arose from the crossing and mixing of the three primary colours on their emergence from the prism (pl. 507).

Castel found support for his three-colour system in the colour prints of Le Blon, and he became characteristically embroiled in the bitter Parisian controversy between Le Blon and Gautier d'Agoty, both of whom were claiming priority in the invention of true, full-colour printing. Having appeared initially as Le Blon's champion, he eventually sided with Gautier, who was advocating an Aristotelian colour system embracing white and black, in sharp contrast to Le Blon's Newtonian ideas.[28]

Castel defined his three primaries precisely as 'celestial or

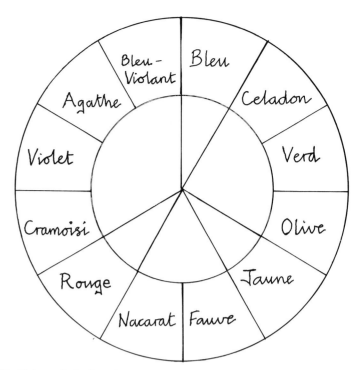

508. Colour circle, based on Castel's *L'Optique des couleurs*.

507. The production of the spectrum from three primary colours, from Louis Bertrand Castel's *L'Optique des couleurs*, Paris, 1740.

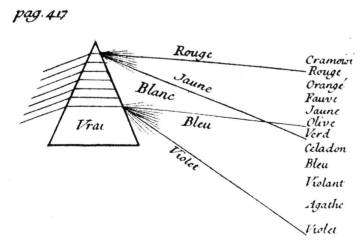

sky blue', 'the red of fire' and 'natural or earthy yellow'.[29] Between these came the three familiar secondary or mixed colours and a further series of six intermediate mixtures. These mixtures were not symmetrically disposed, however, since there were three colours between blue and yellow, two between yellow and red, and four between red and blue (pl. 508). Although further intermediate mixtures could be found, they could only be distinguished with difficulty, and he settled upon twelve as the fundamental number. A similar system of twelve divisions governed his tonal co-ordinate from black to white, commencing with 'noir, noir-noir-gris-noir . . .'![30] The two co-ordinates when combined gave Castel a set of one-hundred-and-forty-four units of colour. These provided the basis for his 'cabinet universel de couleurs et clair-obscur'.[31] This was constructed as follows: tonal series of twelve gradations for each colour were painted on boards of strips of card; each tonal unit was then cut out and pasted on a strip of cloth beside the eleven corresponding units from the other colour bands. Thus the darkest tones for each colour would be conjoined to comprise a twelve-part set, and so on up to the lightest tone. To these basic sets he added a mathematically determined series of mixtures, making a total of six hundred and fifty degrees of colour in his 'cabinet'.

Underlying Castel's system was an unswerving faith that colour and music were entirely analogous phenomena, physically and aesthetically. His interests in musical harmonies had been stimulated by his contacts with the great composer, Rameau, whose *Traité de l'harmonie* he had enthusiastically reviewed, and by his interest in Kircher's *Misurgia universalis* (1650), which introduced him to a table of precise equivalences for notes and colours.[32] Kircher's Aristotelian scale from white

288

509. Musical equivalents for colours, based on Castel's *L'Optique des couleurs*.

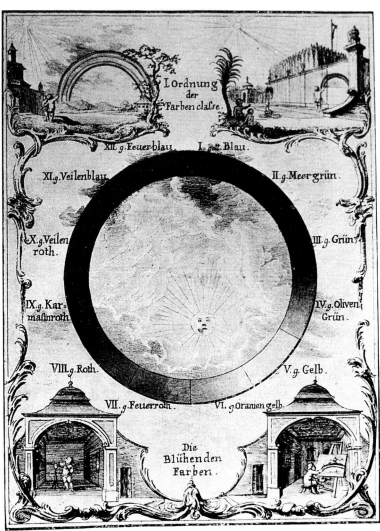

510. Colour circle from Ignaz Schiffermüller's *Versuch eines Farbensystems*, Vienna, 1772.

was being played.[35] The coordination of note and colour was prodigiously difficult, not least on account of different speeds of sound and light.

It made a successful debut before an invited company in 1754 and before an enthusiastic public audience on New Year's Day 1755. Intellectually, however, its reception was mixed. Telemann had introduced Castel's invention in Germany as early as 1739, praising it as a 'marvellous instrument',[36] but its detractors outweighed its supporters. While Diderot gave it a reasonably favourable reception, Voltaire denounced both its principles and its aesthetic basis.[37] A relatively typical reaction was provided in Britain by William Hogarth, who cited the invention of 'Pare Castle' as an extreme example of the tendency to identify colour and music: 'the knowledge of the colours bears so strong an affinity with the science of Musick that some have been induced to think that the identical principles, for the compositions of musick would equally serve for those of colours'.[38] With his tongue firmly in his cheek, Hogarth suggested that the same principle should be followed by a chef in the composition of a great banquet.[39] In the pub-

to black embraced two octaves. Castel explained that his own circle of twelve colours corresponded to one circularly-disposed octave in a chromatic scale of twelve notes, that is to say, including four semi-tones. Blue was identified as the fundamental C, yellow as E, red as G, with the other colour notes duly falling into place (pl. 509).[33]

Each of the twelve tonal bands in his cabinet thus comprised an 'octave' of colour. These twelve octaves were then further identified with the twelve-octave range on an organ. His 'cabinet' thus contained the same basic notes as an organ; it was virtually a kind of musical instrument in itself. The obvious inference was that it should be possible to construct a 'colour organ', or, as Castel himself announced in the *Mercure de France* in 1725, a 'Claveçin Oculaire'.[34] At first it was no more than an idea, and he was deterred from attempting its construction by the enormous practical difficulties. However, attacks on his concept became increasingly difficult to refute without concrete proof, and four or five years later he constructed what seems to have been a somewhat ramshackle instrument in which a keyboard activated a series of pop-up cards.

The 'Ocular Clavichord' was not to be realised in a more convincing form until 1754, when an elaborate box of 'colour-octaves' was manufactured. Its form can be judged from a description of a matching instrument made in London. The box, which was as tall as a man and contained some five hundred lamps, stood on a modified harpsichord. One side of this box consisted of sixty coloured-glass windows, each of which was elliptical in shape and about six centimetres tall. When a key of the harpsichord was depressed, light was allowed to shine through a window corresponding in colour to the note which

511. Colour triangle by Tobias Mayer, from 'Die Mayerschen Farben-dreiecke', in *Göttingische Anzeigen*, II, 1758.

G—yellow R—red B—blue
The saturated, unmixed primaries have a value of 12 at the vertices, they are progressively mixed (r^{11}/b^1; r^{10}/b^2...) with portions of the other colours.

lished text of *The Analysis of Beauty*, the musical reference was not included, presumably because he doubted its validity in both particular and general terms.

Although Castel's theory and practice of the 'claveçin oculaire' did not win general acceptance, it did excite wide interest. We have seen evidence of its reception in Germany and Britain. The German entomologist, Ignaz Schiffermüller, who reached a precocious recognition of the difference between optical and pigmentary mixtures, provided an appropriately decorative illustration of Castel's colour wheel (pl. 510). He considered that twelve diagrams should be made in all, each corresponding to one of the twelve degrees of tonal mixture.[40] The logical progression would be to place all twelve diagrams in a vertical series to make a colour solid. This step initially occured not in the context of a colour wheel, but in connection with a colour triangle in which the painters' three primaries were each placed at a corner. The colour triangle, or rather a fully pyramidal arrangement of hues and tones, appears to have originated in the 1750s with Tobias Mayer, an important astronomer, mathematician, student of physics, engineer and cartographer, who possessed some ability as a draughtsman and composed a treatise, now lost, on the art of painting.[41] In his lectures at Göttingen in 1758, not fully published during his lifetime, Mayer proposed that the transition between one primary and another could be accomplished in twelve distinguishable steps or proportional mixtures.[42] He chose twelve divisions, as had Castel, on the basis that the experience of architects and musicians had shown that divisions 'greater than twelfths... can

scarcely be perceived by the unaided senses'.[43] On this principle he compounded a basic triangle of ninety-one possible combinations for the saturated primaries (pl. 511). Each primary could also be lightened in twelve steps to pure white. Since fewer separate hues are discernible with the progressive admixture of white, each lightened triangle contains fewer intermediate combinations. The second compound triangle contains seventy-eight hues, the third sixty-six and so on, in the form of a diminishing pyramid until one (white) is reached at the apex. A similar process of darkening in twelve steps produces an opposite pyramid which tapers to pure black. The two pyramids, founded upon a common base, contain a grand total of 819 distinguishable varieties of colour.

Mayer's innovatory ideas were not published in their full form until 1775. Three years earlier they had been preceded into print by the comparable invention of J.H. Lambert, whom we have already encountered as a perspectivist of note. Lambert's book on the *Farbenpyramide* (1772) contains a brilliantly succinct review of earlier colour theories, including those of Leonardo, Le Blon, Castel, Gautier, Schiffermüller

512. Colour pyramid by Johann Heinrich Lambert, from Lambert's *Farbenpyramide*, Berlin, 1772.

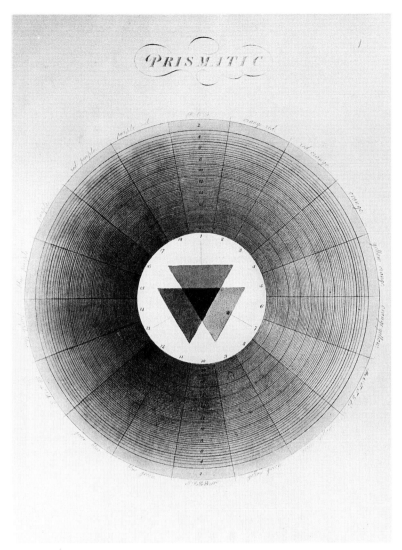

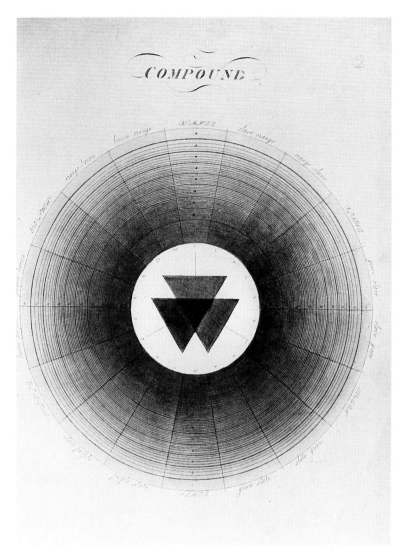

513. Colour triangle and wheel for the 'primitive' colours by Moses Harris, based on *The Natural System of Colours*, London (1766?).

514. Colour triangle and wheel for the 'mediate' colours by Moses Harris, based on *The Natural System of Colours*.

and Mayer.[44] Lambert's 'colour-pyramid' (pl. 512) relied upon a smaller number of compounds than Mayer's 819. Lambert's base was a triangle of forty-five units, ascending through triangular sections of twenty-eight, fifteen, ten, six, three, one, from the saturated primaries to white. A second pyramid descended comparably to black. Joined by their common base, Lambert's constructions formed a double pyramid, the vertical axis of which represents a tonal scale. Between them Mayer and Lambert had taken a crucial step in the systematic illustration of relationships between colour and tone.

Equally remarkable in their own way were the little-known colour wheels of Moses Harris, like Schiffermüller an authority on insects, who published his *Natural System of Colours* about 1770. At the centre of the system for the 'prismatic' colours (pl. 513), the '3 grand or principal or primitive colours are represented . . . by 3 triangular pieces of stain'd glass, the points of which lay over another . . . whereby the interposing parts become black'.[45] The wheel surrounding his primary triangles contained a more symmetrical version of the Newtonian sequence, progressing from each primary to the next by

way of five intermediate mixtures, making eighteen colours in all. Each colour was graded radially from the centre according to twenty degrees progressive lightness or 'teints'. To this first wheel, with its total of 360 'teints', he added a second (pl. 514), founded upon the 'mediates' of orange, green and purple, which provided 300 new 'teints', giving a grand total of 660 distinguishable 'teints' for the three primaries and thirty compound colours.

Harris explained that 'if a contrast is wanting to any colour or teint, look for the colour or teint in the system, and directly opposite it you will find the contrast wanted'.[46] He supported this precocious description of what we call complementary contrast with a remarkably early account of induced complementaries in after-images: 'if a pair of green spectacles are placed before the eyes, and viewed through for about 5 minutes, and then taken away, every scene and object will look a fiery red'.[47] The phenomenon of induced contrasts had earlier been recorded, as we will see, by the French naturalist, the Comte de Buffon, but this in no way diminishes Harris' originality in associating such effects with opposite 'teints' in a

291

colour wheel. It appears that Harris narrowly precedes Schiffermüller in defining this concept of opposite colours.

Although Harris persuaded Joshua Reynolds to accept the dedication of the first edition, his treatise does not seem to have attracted wide notice until its reappearance in 1811, edited by Thomas Martin and dedicated to Benjamin West.[48] The later edition excited a good deal of interest and exercised a considerable influence on Turner.

ARTISTIC REACTIONS: BRITAIN AND GERMANY

The writings of Castel, Schiffermüller, Mayer, Lambert and Harris have attracted our particular attention because they brought an important aspect of post-Newtonian colour science within the reach of painters. These writings were those of professional scientists who were not primarily involved in the practice of art. Professional artists in the eighteenth century were not so well placed to understand the mathematical and physical intricacies of Newton's arguments, and no one had satisfactorily elucidated his unresolved problem of the relationship between coloured *lights* and coloured *pigments*. The spectrum of reactions amongst artists ranged from Mengs and Barry, who dismissed Newton's ideas as largely irrelevant, to Benjamin West's wholehearted acceptance of the rule of seven primaries.

Hogarth, in whom we may see the earliest maturity of British academic discourse, belongs more with the former reaction than the latter. He was almost certainly aware of Newtonian prismatics, through the intermediary of Brook Taylor if not through Newton's own writings. However, Hogarth's own explanation of colour continued to rely upon a three-primary system accompanied by traditionally Rubensian maxims. In *The Analysis of Beauty* he described a systematic palette laid out in 'scales' of 'original colours'. These may be considered five in number:

> There are but three original colours in painting besides black and white, viz. red, yellow and blue. Green, and purple are compounded; the first of blue and yellow, the latter of red and blue; however, these compounds being so distinctly different from the original colours, we will rank them as such.[49]

The omission of orange has much in common with Lairesse, whose treatise may have been known to Hogarth.

These five colours were laid out in a vertical sequence according to how they are 'supposed to stand, red, yellow, blue, green, purple, underneath each other' (pl. 515).[50] In their saturated states—the 'prime', 'bloom' or 'virgin' tints as he called them—they provide the central (or fourth step) in seven-part tonal scales, disposed horizontally. To the left, numbers five, six and seven represent the ascent towards white, while three, two and one on the left exhibit a progressive decline towards black. The resulting palette was probably more in the nature of a demonstration-piece than the actual palette he expected artists to use, but it does successfully bring

515. Palette of colour and tonal scales, based on William Hogarth's *The Analysis of Beauty*, London, 1753.

a systematic attitude to colour and tone into the realm of artistic practice.

When he recommended techniques for applying these colours, Hogarth stood firmly in the Rubensian camp. He commended both the kinds of Aguilonian mixing used by Rubens, namely layered glazes and separate touches. In his advocacy of the latter, there is a strong echo of the 'Maxims', either directly or through de Piles: 'Rubens boldly, and in a masterly manner, kept bloom tints bright, separate and distinct, but sometimes too much so for easel painting; however his manner was admirably well calculated for great works, to be seen at a considerable distance.' He was probably thinking especially of the Whitehall ceiling. If Rubens had blended his colours 'they would have produced a dirty grey instead of flesh-tints, on account of the vast variety introduced thereby'.[51]

The essential conservatism of academic theory in the face of Newtonian optics is nowhere better illustrated than by Mengs and Barry. Mengs, the pioneer of German Neoclassical painting, firmly advocated five primaries in an 'Aristotelian' scale, white-yellow-red-blue-black, with five secondaries, orange, green, purple, grey and brown.[52] This, he realised, set him against Newton. He specifically argued that 'it is probable that light has no colour whatsoever'. Colour, he believed, arose from the *modification* of white light in the medium and by refraction. The most remarkable aspect of Mengs's otherwise traditional theory is his recommendation that each of the three 'colours', if used pure, should be set beside a mixed colour: yellow with violet; red with green; and blue with orange.[53] These are precisely what we now know as the complementary pairs, and suggest that Mengs had used a colour wheel, probably Schiffermüller's, to determine the 'opposite' colours.

James Barry, in his capacity as Professor of Painting at the Royal Academy before the turn of the century, informed his audience that he felt 'but little conviction or satisfaction in splendid theories deduced from prismatic experiment'. It was 'not evident' to the combative Barry that the coloured 'pencils did previously exist in the light'.[54] He preferred to rely upon the primaries of yellow, red and blue, citing Aristotle and Milton's poetic evocation of the rainbow in his favour. This was all very well when it came to pigment mixtures, but it led him to the untenable conclusion that white light arose from the three-primaries mixed in their 'highest degree of brightness', while black was compounded from mixing them 'in their deepest hue'.[55]

The other extreme of the spectrum of reactions to Newton in Britain is provided by Reynolds's successor as President of

the Academy, Benjamin West, who enthusiastically accepted that 'all combinations are derived from the Prismatic Colours'.[56] West believed that 'The *Order of the Colours in the Rainbow* is the arrangement in a historical picture—viz: exhibiting the warm and brilliant colours in a picture where the principal light falls and the *cool colours* in the shades; also that as an accompanying reflection, a weaker rainbow often accompanies the more powerful rainbow [i.e. the meteorological double bow], so it may be advisable to repeat the same colours in another part of the Picture to act as a *second to the superior display*'.[57] Remarkably, he considered that the greatest examples of the 'rainbow' disposition of colours were Raphael's *Tapestry Cartoons*, painted some one hundred and fifty years before Newton's *experimentum crucis*.

West was ingeniously able to harmonise the seven primaries with the traditional academic definition of formal value in relation to modelling. He envisaged a ball illuminated by bands of prismatic colours, in such a way that yellow was situated at the 'focus of illumination', followed by 'orange, red and then violet' on the 'enlightened side'. The 'shadowed side' was illuminated by green, blue and purple. 'In the same order must be placed the tints which compose the fleshy bodies of men and women, but so blended with each other as to give the softness appropriate to the luminous quality and texture of flesh.'[58] There is nothing especially novel in this conception of warm 'advancing' colours and cool 'receding' colours, either in theory or in West's own essentially academic practice, but its alliance with the Newtonian series is unusual.

West's system was illustrated in a contemporary treatise, Mary Gartside's *An Essay on Light and Shade, on Colours and on Composition in General* (1805). Gartside arranged a ball of prismatic colours 'to suit the order of them in point of illumination. . . each coming forward or retiring from the eye according to its natural brilliancy' (pl. 516).[59] The prismatic series has been broken in half, and reads inwards from red in the third ring, recommencing with green in the outer band. Each colour was assigned a width proportional to that in the spectrum: red 45°, orange 27°, yellow 48°, green 60°, blue 60°, indigo 40° and violet 80°. In this total of 360°, only 120° were occupied by the 'warm' colours, and 240° by the 'cold' colours. She did not expect the painter always to be tied to these precise proportions, but suggested that they provided a general guide. Yellow, for example, should occupy 'double the quantity' of orange in good pictures.[60] In the same year, 1805, Edward Dayes also recommended prismatic succession as the key to colour harmonies.[61] It seems that West's idea enjoyed some success.

By 1800, Newtonian prismatics had obviously become part of the general currency of academic knowledge and debate in England. George Romney, when he came to make a history painting on the theme of *Newton and the Prism*, took care to order the colours in his projected spectrum in the correct manner (pl. 517), as we might expect in an artist who so delighted in the careful tuning of clear colour notes.[62] Even the non-intellectual James Opie, one of Barry's successors as Professor of Painting, thought that it was useful for the aspiring painter to be grounded in the Newtonian primaries, red, orange, yel-

516. Benjamin West's ball of prismatic colours as described in Mary Gartside's *An Essay on Light and Shade*, London, 1805.

Y—yellow	I—indigo	O—orange
B—blue	R—red	G—green
V—violet		

517. George Romney, *Newton and the Prism*, mezzotint of the painting in the Chamberlayne-Macdonald Collection.

293

low, green, blue, purple and violet. He did, however, follow Algarotti in pointing out that such masters of colour as Titian, Rubens and Van Dyck had managed more than adequately knowing nothing about 'the divisibility of light'.[63] Other academicians had not the slightest patience with any kind of scientific colour theory. In Benjamin Haydon's eyes, Newton 'had destroyed all the poetry of the rainbow, by reducing it to its prismatic colours'.[64]

The complex and contradictory factors in this picture of colour theory in British painting reflect a more general diversity exhibited by the literary and visual arts in their attitudes to science, sentiment and naturalism. The emergent Romantic attitudes were no less various than those of the academics. One of the special features of British Romanticism, particularly in its earlier phases, was the ready incorporation by prominent authors and artists of a form of 'scientific sublime', as we noticed when discussing concepts of space. Not the least important element in this tendency was Newton's almost legendary status in Britain—a status which depended both on the scientific magnitude of his achievements and on the awesome beauty of his vision as a whole.[65] Indeed, we have seen that his mathematicising aesthetics played a formative role in his own answers to one of the central questions, namely the number of primaries.

It is an indication that we are dealing with a complex situation which resists easy generalisation that both Constable and Turner should have responded profoundly to the sciences of nature and yet have achieved such very different results. The facets of science to which Constable responded most warmly seem to have been those which dealt with the natural history of everyday phenomena. His powerful sense of reverence for the inherent divinity of natural processes did not lead him to adopt over-arching metaphysical patterns of the kind we will shortly see in the work of Runge and even to some degree in the attitudes of Turner.

Constable's devotion to the natural history of visible effects—as manifested most brilliantly in his cloud studies—did not predispose him towards the erection of great theoretical structures.[66] It is characteristic that his only documented approach to scientific colour theory was through the study of a particular natural phenomenon, the rainbow. In a small series of rough diagrams and short notes probably dating from the 1830s, Constable demonstrates a good command of the optical explanation of colours in the rainbow and the origins of the double bow in terms of refraction and internal reflection of light rays within the individual droplets of water (pl. 518).[67] His interest extended to the precise angles of refraction, noting that red cannot appear at an angle greater than 40°. When he illustrates the width of the bow, he records the Newtonian sequence of seven prismatics, and also brackets them together in three groups (pl. 519). He laconically notes '3 primaries, 7 prismatics', but he also states that 'there is no limit to the number of prismatic colours'. He has thus not only found his way to the obvious problem for the painter but also more remarkably to the heart of one of the difficulties inherent in Newton's own theory. The evidence of the notes is too slim to indicate whether he resolved the problems in his own mind. In any

518. Refraction and reflection of light within a rain droplet, as described by John Constable, based on a sheet of studies in the Tate Gallery (Estate of Lt. Col. J.M. Constable).

519. Arrangement of colours in the rainbow, as described by John Constable.

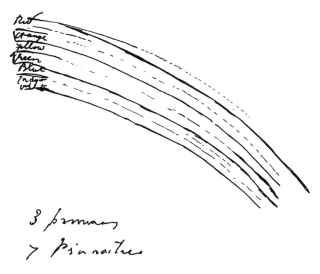

event, when he came to portray rainbows, as he did on a number of occasions, he was well enough informed about their production to know what he was painting. However, a study of his painted rainbows suggests that he was loath to shackle himself absolutely and minutely to scientific rule when this was incompatible with the desired pictorial effect.[68]

While the British artists of the generation around 1800 continued to grapple approvingly or sceptically with Newtonian optics, fresh complications had been arising in the field of colour science. These complications arose from the formulation of new kinds of three-colour theories and from the related study of what we call subjective colour response, that is to say the colour effects actually experienced in a given situation, rather than the objective study of degrees of refrangibility under experimental conditions.

The pioneer in the study of subjective colour was the great French naturalist, the Comte de Buffon (G.L. le Clerc). At the French Academy of Sciences in 1742–3, Buffon announced a remarkable series of naturalistic and experimental observations of the colours actually perceived under various special circumstances.[69] He described the startling 'accidental' colours visible in shadows at sunrise and sunset. During a red sunset the

shadows of trees on a white wall are, he observed, green in colour, while during a yellow sunrise they are 'most commonly blue, and of a blue as lovely as the beautiful azure'. He supported these observations with a no less innovatory description of what we call coloured after-images. The phenomenon occurs, for example, after looking for a time at a red square placed on a white ground. If we subsequently remove the red square, a ghostly green image will appear in its place. These effects were astutely attributed by Buffon to the overwhelming and fatiguing of the eye by the dominant effect, producing a counter-reaction.

Similar observations on coloured shadows and after-images were introduced to late-eighteenth-century Britain by Moses Harris, Joseph Priestley, Robert Waring Darwin and the American Count Rumford (Benjamin Thompson). Rumford conducted experiments with a cylindrical body illuminated simultaneously by light from a window and a candle, intercepting the two systems of shadows on white paper. He discovered that the shadow formed by the daylight was yellow, while that 'corresponding to the light of the candle. . . was the most beautiful blue it is possible to imagine'.[70] By interposing panes of different coloured glass, he was able to obtain a brilliant range of coloured shadows, including green and violet, running parallel to effects he noted in nature. He rightly concluded, in a paper to the Royal Society in 1794, that the phenomenon was subjective in type. As a corollary to his observations he suggested that the pairs of colours produced by two light sources of different quality might guide artists in 'the magic of colouring', since in the pairs of apparent colours 'one shadow may with propriety be said to be the *complement* of the other'. The complementary colours when mixed produce 'perfect whiteness', and 'one of them at least must necessarily be a compound colour'.[71]

A few years later Thomas Young explained that 'the shadow appears of a colour opposite to that of the stronger light, even when it is in reality illuminated by a fainter light of the same colour'.[72] By 'opposite' he meant the colour directly opposite on the colour circle, that is to say the complementary colour. He also clearly described induced colours, noting that a grey spot on yellow ground acquires a 'purple hue'.

The stage was clearly set for someone—an artist or scientist—to bring the complexities of post-Newtonian optics and the refinements of subjective colour observations into a convincing synthesis within the realm of art theory. On to this stage in Germany, armed with rather different scientific principles, came Philipp Otto Runge, painter, and J. W. von Goethe, author. They both saw themselves as contributing to the same grand plot—the forging of a union between scientific analysis and poetic insight, combining minute scrutiny of parts with great philosophical truths—and we know that they exchanged views on the specific subject of colour theory. In 1806 Runge expressed to Goethe his desire 'to study the peculiarities of the colours and, if it were possible, to penetrate so deeply into their qualities that it would be clear to me what they accomplish or what is effected by them or what effects them'.[73] To further his studies he asked Goethe where he might find a good account of Newton's ideas. There was, however, a con-

siderable divergence between them, not only because Runge achieved a closer alliance between theory and practice but also (and more fundamentally) because Goethe adopted an anti-Newtonian stance in a highly personal manner.

Even if we knew nothing of his written theories, Runge's most colouristically spectacular paintings, such as the allegory of *Morning* (colour plate VII), would indicate a remarkable grasp of colour. His ecstatic image of rebirth is suffused with a warm radiance of golden light which is startlingly thrown into relief by purplish-blue shadows of a remarkably translucent kind. No earlier painter had achieved comparable effects. When we find that Runge was also the designer of the first fully developed and most beautiful colour sphere or globe (colour plate VIII), we have confirmation that a radically new attitude to colour in painting had been born.

Runge's *Die Farbenkugel, oder Construction das Verhältnisses aller Mischungen der Farben zu einander, und ihrer vollstandigen Affinität* (*The Coloursphere, or the Construction of the Relationship of all Colour Mixtures to each other and their Complete Affinity; with an added Draft of an Excursus concerning the Harmony of Colour Compositions*) was published in Hamburg in 1810, the year of its author's death, accompanied by an essay on 'Colour in Nature' by Heinrik Steffens, a Danish physician and naturalist. Like a terrestrial globe, Runge's sphere is marked with degrees of 'longitude' and 'latitude'. Around the 'equator' are twelve saturated colours: the primaries (blue, yellow and red), the secondaries (green, orange and purple) and six intermediate mixtures. At the 'poles' are situated black and white. Between the poles and the equator, in a fully three-dimensional arrangement, come Runge's 'chromas', that is to say, the various compounds of 'value' (tone) and 'hue'. Pure grey lies at the very centre, as is shown in the horizontal and vertical sections. The sphere does not demonstrate all the possible grades of discernible 'chromas', which Runge numbered at 3,405, but it does provide a brilliant foundation for the understanding of relationships between colour and tones.

The twelve grades of colour, arranged in a circular pattern and combined with nine degrees of tone, clearly reflect Runge's knowledge of Castel's system, probably via Schiffermüller. Runge did not, however, share Castel's strongly anti-Newtonian sentiments. Though he realised that Newton's prismatics were not necessarily to be applied directly to artistic practice, he was concerned to reconcile his three primaries and three secondaries with Newton's seven basic colours. He accomplished this by dividing his violet into red and blue sectors, making a total of seven when the colours are arranged in a horizontal series, but only six when they are linked in a circle. Runge's system of primaries and secondaries also provided the basis for judging the harmony of colours, in pairs or in more complex sets. Like Mengs he emphasises the complementary pairs of 'contrasting harmonies', blue-orange, yellow-violet, red-green, while pairs of primary colours will produce a '*disharmonische Wirkung*' (discordant effect). The conflict between blue and red can be 'calmed' by interposing grey, 'exaggerated' by introducing yellow, 'weakened' by violet (their 'product'), and 'dissolved' by inserting their complementaries, orange and green. A spectral sequence of violet,

blue, green, yellow, orange, red and violet will, however, exhibit a 'tedious effect' in a linear series since the transitions are all achieved through intermediate steps.[74]

These colour 'chords' are no longer drawn from intuition or experience as they had been in earlier theory, but based upon the principles of complementary contrast established by eighteenth-century scientists. From scientific sources Runge also studied the related phenomenon of coloured shadows, so potently apparent in his painting of *Morning*. The purplish-blue shadows arising from the golden dawn would serve splendidly as an illustration of Buffon's original observations. Runge was also aware of optical colour mixture, both static and mobile, and preceded Chevreul by some quarter of a century in drawing particular attention to tapestry and mosaic for ocular fusion of colours. Small areas of interspersed yellow and blue in a mosaic will produce an optical green, he believed—thus continuing to perpetuate the traditional confusion between optical and pigmentary mixture.[75]

Runge's analysis of colour is very remarkable and has a genuinely scientific quality, both in terms of theory and practice. However, the resulting image of Runge as a scientific naturalist is only the tip of a profound iceberg, the main substance of which lay beneath a deep sea of mysticism. At first it is difficult to reconcile the coolly rational Runge of the *Farbenkugel* with the rapturously effusive mystic revealed in his letters to Daniel, his brother:

> When the sky above me teems with countless stars, when the wind blusters through the wide spaces, when the billows break with a roar in the far night, when the ether reddens above the forest, and the sun illumines the world; when the mist courses in the valley and I throw myself down in the grass among the glittering drops of dew, every leaf and every blade of grass teeming with life, the earth living and stirring beneath me, and when everything is tuned to one chord, then my soul cries out aloud with joy and flies into the immeasurable space around me. There is no longer any below or above, in time, no beginning, no end. I hear and feel the living breath of God, who holds and bears the world, in whom everything lives and works; here is the highest we can divine—God.[76]

The connection between this pantheistic rapture and his scientific rationalism is made through a series of ascending steps in which reverent science and scientific reverence serve progressively transcendental ends. Runge aspired to create a living science, founded upon love and directed towards the revelation of spiritual harmony within all created things. Faith was the motivating force: 'whoever has the right faith and searches the exterior world with it, that man will find science'.[77] The science of colour and tone, like all other sciences is devoted to divine ends:

> Colour is the final art, which is and always will remain a mystery. It contains the very symbol of the Trinity. Light or white is the good, and darkness is the evil; that is why men were given the revelation and colours came into the world; that is to say blue and red and yellow. Blue is the Father and red is the very link between earth and heaven.

When both disappear, then the fire appears in the night, that is yellow, or the paraclete who is sent to us—the moon too, for that matter, is yellow.[78]

He exulted in 'The One and the Three, that is, the longing, the love, and the will, that is, yellow, red and blue, the point, the line and the circle, muscles, blood and bones'.[79]

These correspondences might recall for the reader the kind of mystical analogies described by Kircher—and with good reason. It is known that Runge was greatly taken with seventeenth-century mysticism, and sought particular inspiration in the writings of Jakob Böhme. From Böhme's *Aurora oder Morgenrote in Aufgang* (1620) he adopted a divine triangle of the Trinity as the all-pervasive principle of organisation in the universe, as in the 'Trinity' of colour primaries. The overlaid triangles of the primaries and secondaries provide a hexagram which corresponds to a further series of fundamental essences or polarities (pl. 520).

Runge's intensely spiritual attitude to nature was far from isolated in Germany at this time. He had been introduced to

520. Hexagram of colours and correspondences, from Philip Otto Runge's *Hinterlassen Schriften*, 2 vols., Hamburg, 1840–1, I, p. 164.

Böhme by Ludwig Tieck, the poet, and his general stance shared much in common with that of Schiller, the Schlegel brothers, Claudius and Novalis, all of whom searched the German past for mystical truths long forgotten. Runge's *Morning* is a perfect example of the kind of symbolism to which they were attracted. The illustrated work is the smaller of two versions, the larger of which was dismembered after Runge's death, in accordance with his own wishes. It shows the arrival of dawn, 'the boundless illumination of the universe', under the aegis of the morning star, Venus, who further embodies

the potentialities of Aurora. As the light of a new day invades the earth, liberating the soul according to Böhme, new life erupts in every corner of nature: amaryllis flowers burst forth, genii release trapped infants from their cage of roots, the sun emerges warmly from behind its earthly shield, souls ascend towards the aetherial heavens, and the entranced baby is presented with rose-buds. Spiritual rapture, symbolic insight and scientific observation act in perfect concord. The translucent, white lily 'stands in the highest light', as Runge wrote in another connection, combining the yellow, red and blue radiances expressed separately in other parts of the picture.[80]

If we sense what may be called a 'symphonic' quality in Runge's *Morning*, this would be entirely in keeping with the artist's own wishes. His ultimate aim, like many of his fellow Romantics in Germany, was the *Gesammkunstwerk*, consisting of a great fusion of musical, visual and literary aesthetics into a spiritual whole. As he wrote to Goethe in 1809, 'I am thinking more and more how I could bring about the union of various arts, and that can only happen if they aid each other in their scientific knowledge, when scientific knowledge could really blossom.'[81] Within a year Runge was dead and his fragmentary *oeuvre* stands as a monument to a magnificent ambition incompletely realised.

During the year of Runge's death, also the year in which *Die Farbenkugel* appeared in print, Goethe published his own *Zur Farbenlehre* ('Doctrine of Colours').[82] Given the close contacts and obvious affinities between the two men, we might expect Goethe's work to complement Runge's. This is in some measure so, but fundamental differences prevent a real convergence of ideas. It is true that many of the technical details of Goethe's observations are shared with Runge and the late-eighteenth-century scientists. He records the phenomenon of after-images; he uses a colour wheel to define the complementary or 'opposite' colours (pl. 521); and he explores the complementary colour of shadows, using experiments almost identical to Rumford's. But these detailed observations, many of which are compellingly impressive, are placed in the service of a colour theory seriously at variance with Runge's and most contemporary ideas. Goethe was, in his own way, no less vehemently anti-Newtonian than Castel: 'A great mathematician [i.e. Newton] was possessed with an entirely false notion on the physical origin of colours; yet owing to his great authority as a geometer, the mistakes which he committed as an experimentalist long became sanctioned in the eyes of a world ever filtered in prejudices.'[83] In place of Newton's ideas, Goethe substitutes his own eccentric version of Aristotle, which, as his statement acknowledges, flies in the face of prevailing scientific theory. Some idea of how determinedly he turned back the clock can be gained by his willingness to cite Kircher as an authority on colour science.[84] This return to earlier values was not based on ignorance of colour science in its most advanced forms, and the original German edition of his book contains a remarkable review of historic and more recent theories.

Goethe insists, in a way which recalls Castel, that what really matters are 'physiological colours', that is to say, the effects of colour as actually perceived. This emphasis explains why

521. Colour wheel and diagrams of black-white contrasts by Johann Wolfgang von Goethe (based on *Zur Farbenlehre*, Berlin, 1810), from Goethe's *Theory of Colours*, London, 1840.

Part I of his treatise is devoted to such effects as after-images, simultaneous contrast and coloured shadows. In the main, his observations are impeccable and correspond in large measure to those of Buffon and his successors. It is when he turns to 'physical colours' in Part II that he both deviates from Newtonian doctrine and from the three-colour theories which were gaining adherents at this time. He did not accept Newton's differentiation or explanation of spectral colours. Instead, he argues that when a beam of light is refracted its displacement causes it to overlap the surrounding darkness at its leading

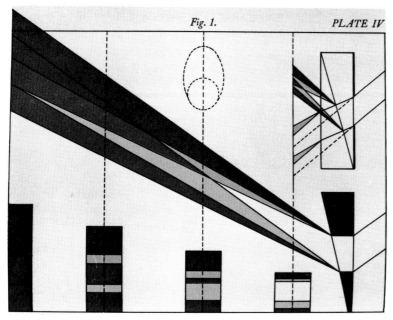

Fig. 1. *PLATE IV*

522. Production of the colours of the spectrum from the overlap of white and black (based on Goethe's *Zur Farbenlehre*) London, 1840.

edge and to be invaded by darkness at its trailing edge. These overlaid boundaries are responsible for colour: 'the colours produced by refraction may appropriately be explained by the doctrine of semi-transparent mediums'.[85] The overlap of white on black produces blue, while the diminished light on the opposite side results in yellow (pl. 522). Green comes between these two, produced by the mingling of blue and yellow in a narrow beam. Red does not appear as a primary colour at all in this scheme. It only appears in the fringes on the outer margins of blue and yellow where they begin to mingle with the surrounding darkness. Pure red is produced as a colour in its own right by a process of addition or 'augmentation', in which blue-red is combined with yellow-red from the opposite fringes. This 'augmented' red is the most potent of all colours. There are, therefore, six colours in all: two elemental colours, blue and yellow; one intermediate, green; two marginal colours, blue-red and yellow-red; and one produced by augmentation, red. The Aristotelian tenor of all this is clear enough, though in its details the arrangement is very much Goethe's own. All colours originate from variously produced compounds of lightness and darkness. This Aristotelian flavour was reinforced when he subsequently described the ways of mixing 'chemical colours'. These were two in kind, 'real intermixture' of dissolved pigments an 'apparent intermixture' of an optical kind as in mixed powders or narrow stripes.[86]

These arguments are supported by a wealth of technical evidence, which most painters would have found little less inaccessible than Newton's mathematical optics. Goethe does, however, outline in Part IV some 'general characteristics' which the painter should take into account. Although 'the natural philosopher. . . assumes only two elemental colours',

blue and yellow, 'the painter is justified in assuming that there are three primitive colour [yellow, red and blue] from which he combines all the others'.[87] In using these the painter should exploit the principles of complementary colours revealed by the experiments in Part I, and should be aware of the optical mixtures which arise when two colours 'are opposed to each other in small quantities and seen from a distance', as explained in Part III.[88] And, above all, the artist should be aware of a series of 'philosophical' associations for colour, of a not unfamiliar kind.

Goethe's correspondences centred upon two poles, positive and negative. Plus corresponds to yellow, while minus is identified with blue. A series of matched polarities are arranged under these:

Plus	Minus
Yellow	Blue
Action	Negotiation
Light	Shadow
Brightness	Darkness
Force	Weakness
Warmth	Coldness
Proximity	Distance
Repulsion	Attraction
Affinity with Acids	Affinity with Alkalis[89]

These were futher extended by 'moral associations' of colour which Goethe outlined in Part VI. Within the broad classifications of 'warm' and 'cold' colours, he assigned specific, individual effects to each colour. Pure yellow is serene, gay, softly exciting, but it is easily sullied to become 'foul'; red-yellow is 'cheerful and magnificent'; yellow-red is powerfully exciting; blue is strongly negative, manifesting 'a kind of contradiction between excitement and repose'; red-blue is disturbing; blue-red tends to convey a feeling of disquiet; pure red donotes 'gravity and dignity' in its 'deep state', while its 'attenuated tint' suggests 'grace and attractiveness'; green, as befits its intermediate position, reflects balance and equality.[90]

Like much of his colour theory, these kind of identifications depend upon tradition pre-dating the Newtonian revolution. This traditionalism tended to make his ideas relatively compatible with academic art theory. Artists were attracted by the beguiling brilliance of his observations, such as his entrancing account of the mobile rainbows of kaleidoscopic colour in bubbles.

It was in Germany, as might be expected, that the impacts of Runge and Goethe were most widespread, but no-one seems to have emulated their sustained and detailed attempts to apply a scientific theory of colours to the theory and practice of art. Of the theorists, Libertat Hundertpfund came closest to Goethe's neo-Aristotelianism, arguing that light 'upon its first entrance into Darkness. . . is absorbed by it, and its splendour diminishes—it becomes blue'.[91] As the light begins to triumph over darkness, so 'this blue becomes tinged with red', and so on—in a continuous progression towards yellow, the colour which represents the almost complete dominance of light. Also like Goethe, he proposes a series of significances for the poles of colour, ranging from negative

(blue) to positive (yellow).[92] The greatest of the younger artists in contact with Goethe, Caspar David Friedrich, inconsistently employed coloured shadows and exploited some degree of optical mixing, but the balance in his art was tipped decisively away from scientific theory. Friedrich's striking colouristic effects were contrived for visionary ends, transmuting observation into hallucination, and their use in painting was never primarily determined by optical validity.[93] The balance in the art of his most perceptive follower, Carl Gustav Carus, was inclined more to the scientific side, as might be expected from someone who was a doctor by profession. However, neither Carus's ideas nor his paintings came close to rivalling the sophistication of Goethe and Runge in matters of colour.[94] For a profoundly creative and challenging response to Goethe's science by a painter of real genius we have to look to Britain, to the art of Turner.

Turner was almost seventy by the time he made his detailed study of Goethe's *Farbenlehre* in Charles Eastlake's 1840 anotated translation, but his response was not that of an old man rigidly set in his ways. Two complex paintings of supreme quality were the remarkable result of his 'dialogue' with Goethe. His immediate reactions on reading Goethe's treatise are contained in a series of marginal notes in his copy, ranging from approbatory references to terse exclamations of disagreement. 'Poor Dame Nature' he wrote, when he felt that Goethe was doing less than justice to the ultimate source of all visual beauty.[95] He was attracted by much of what the German author was saying, particularly with respect to the integral relationship of colour and tone, but suspicious of the more rigid prescriptions and hesitant in the face of the anti-Newtonian polemics. His response was not articulated from a consistent standpoint, and could not have been, given the absence of such consistency in his own theory of colour. It is never easy to make sense of what Turner is saying, but the general thrust of his thought can be reconstructed from his scattered utterances. Understanding his reaction to earlier sources will help in achieving such a reconstruction.

Turner grew to artistic maturity within an Academy which was, as we have seen, deeply divided on the value of colour theory. The divergence of opinion typified by Barry and West persisted during the later phases of his career. Thomas Phillips, who took over from Fuseli as Professor of Painting in 1825 enthusiastically embraced the prismatic scales and commended the colour wheels of Moses Harris, as did Charles Hayter. Phillips used the phenomenon of after-images to define the complementary colours, arguing that the eye 'requires for its entire gratification the presence of the third also' when looking at the mixture of two primaries.[96] Hayter's *A New Practical Treatise on the Three Primitive Colours* (1826) is even more systematic in character, 'exemplifying the Natural and unavoidable consequences of the equilateral Union by gradual and systematical concentration on the Three Primitive Colours, according to Leonardo da Vinci's proposition' (pl. 523).[97] The aesthetic base is familiar enough: 'Painting and Music are allied, *the simple rudiments of each, when scientifically advanced*, should be *deliberately* acquired.'[98] Where Hayter shows an unusual degree of perception is in his attempt to

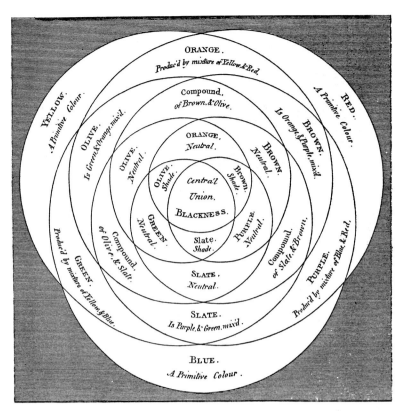

523. Diagram of colour mixtures, from Charles Hayter's *A New Practical Treatise on the Three Primitive Colours*, London, 1826.

'distinguish between the properties of such *materials* as give their *colours in substances*, suitable to the purposes of art; and the *transient effects* of LIGHT, which must not be considered as belonging to the system of *mixing colours for the purposes of painting*'.[99] Although this distinction is not analysed in a sustained manner, it does lead him to qualify the extent to which the painter's materials can ape coloured light in nature: 'all transient or prismatic effects can be imitated with the Three Primitive Colours, . . . but only in the same degree of comparison as white bears to LIGHT'.[100]

Another of Turner's contemporaries, John Burnet, while acknowledging the complementaries, believed that colour science was 'more an object of philosophy than painting, which has to produce an agreeable sensation, independent of all theoretical disquisitions'.[101] Burnet preferred to rely empirically upon what the great colourists had shown to work in practice. Turner, who was certainly acquainted with the ideas of both Hayter and Burnet, was torn between their viewpoints. He was deeply distrustful of any theory which circumscribed his creative scope by 'restrictive rule', yet he was profoundly interested in the principles of nature. He looked to science not for 'rule' but for profound insights into ways and means in the natural world. Such understanding gave special potency to the artist's powers in evoking visual effects without dictating in a rigid manner how he should proceed.

Turner certainly paid careful attention to the scientific literature on colour, past and present. He seems to have been parti-

cularly interested in those authors who worked outside a strictly Newtonian framework, though he cannot on his own account be characterised as anti-Newtonian. Two of the British scientists with whom he was in contact, George Field and Sir David Brewster, fell into this category, as did Goethe himself. Field and Brewster both warrant some attention, not only in their own right but also for their impact on Turner.

Field, a philosopher and colour maker, who played important roles in the chemical production of new colours and the promotion of artistic institutions, published a series of works on matters which interested Turner: *Chromatics* (1817), *Aesthetics* (1820), *Chromatography* (1835) and *Outline of Analogical Philosophy, Being a Primary View of the Principles, Relations and Purposes of Nature, Science and Art* (1839). Turner was listed as a subscriber to the first two volumes. Constable, incidentally, was a subscriber to Field's *Chromatography*.[102] Field did not indulge in anti-Newtonian polemics, but his system was very obviously not founded upon Newton's prismatics. His three primaries, blue, yellow and red, were viewed in the context of a tonal scale between the 'polar principles' of 'positive' white and 'negative' black:

> the principles of light and shade are co-existent and concurrent latently in the colours of pigments etc. . . . When the element or principle of black or shade predominates, it determines the colour BLUE; when that of white or light predominates it determines the colour YELLOW; and when these principles concur without predominance, they determine the medial colour RED.[103]

This Aristotelian association of colour with a tonal scale would have met with Turner's approval.

These primaries, with their three compounds, were set by Field within a cleverly-disposed colour wheel, composed from

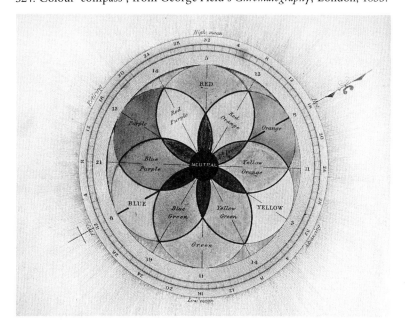

524. Colour 'compass', from George Field's *Chromatography*, London, 1835.

intersecting areas and laid out like a compass (pl. 524). The numbers in the inner ring indicated the correct proportions of two 'opposite' colours to make an equal or 'neutralising' balance, and the outer ring showed the location of three 'neutralising' colours. Red, for example, with a 'chromatic equivalent' of five, would require more than double the quantity of green to achieve a balance, since green was compounded from yellow, with a value of three, and blue, with a value of eight. The compass possessed four 'poles', corresponding to fundamental properties of colours. A bearing along or near the orange radius indicated a 'hot' colour, while blue provided the 'cold' axis. In a similar way, yellow was seen as 'advancing', while its opposite colour, purple, was 'retiring'. To these he added a series of related polarities: light-shade, activity-passivity, oxygen-phlogistic or hydrogenous substance, and positive electricity-negative electricity.[104] The polarisation of colour in the context of the powers of nature strongly recalls Goethe. Not surprisingly he also shared Goethe's belief in 'philosophical' associations for colour. Red in a man's complexion indicated anger and ardent passion; yellow showed grief and jealousy; blue denoted hate and fear. Green was the colour of spring, yellow of summer, red of autumn and blue-grey of winter. Field was also much attracted to Harington's mystic belief in the ubiquitous potencies of triads in nature.[105]

Field's more rigid formulas, such as his mathematical calculation of complementary balances, would have repelled Turner, but his association of colour with paired forces in nature possessed an obvious appeal for the artist. Turner would have particularly liked Field's conception of darkness as a 'reagent, existing in planetary or atmospheric space'.[106] Darkness may be 'negative', but it does not lack genuine force in its own right.

Brewster was one of the theorists who was advocating an alternative to the Newtonian system. His main importance for Turner was that he provided the artist with a fully scientific argument for the three primaries, and he did this from a standpoint of admiration for Newton rather than from crude anti-Newtonianism. Brewster's writings, particularly his *Optics* (1831), contained a sustained, considerable and highly influential challenge to Newton's conception of colour. He acknowledged that Newton's seven colours could be obtained from a prism, but argued that the decomposition of light by absorption disproved the laws which his predecessor had formulated. Viewing the prismatic spectrum through a piece of purplish-blue glass, Brewster noted that the orange, yellow and green bands entirely disappeared to leave blue and red at either end of the spectrum. By contrast, red and green filters in combination failed to eliminate yellow, which instead was seen to spread strongly across the areas previously occupied by orange and green. He considered that the blue glass had absorbed the yellow rays which had been responsible for compounding orange from red and green from blue.

He claimed that these and other absorption experiments had shown the decomposition of spectral orange and green into yellow, red and blue components. He proposed that Newton's spectrum was formed from three overlapping spectrums of

red, yellow and blue (pl. 525). This would mean that 'difference in colour is not therefore a test of refrangibility'.[107]

These arguments from absorption provided the basis for what Brewster called his 'Trinity' of colours. Artists ignored this 'Trinity' at their peril. Brewster, controversial and unyielding, had an alarming habit of visiting exhibitions with an apparatus of shifting glasses with which he could demonstrate the proper balance of complementary colours. He was also liable to demonstrate 'the extreme delicacy of hues by the prismatic colours in pieces of decayed glass', which he carried in his waistcoat pocket.[108] He accused painters of widespread ignorance of the true 'principles' of colouring. Turner is known to have encountered this formidable figure during his visit to Scotland in 1831. Turner exploited in his paintings some of the natural observations in Brewster's *Optics*, and he undoubtedly welcomed the Scottish scientist's proof of the primacy of red, yellow and blue for light as well as pigments.

Turner's own attempts to articulate a theory of colour occurred chiefly in connection with the lectures he gave at the Royal Academy in his capacity as Professor of Perspective from 1811. It is doubtful if he ever organised his ideas around a fully coherent theory of scientific colour, but this does not mean that scientific concepts played an insignificant role in his creative procedures. He was much given to talking of 'prismatics' in the 'constant and unalterable succession' of the rainbow and spectrum.[109] He was fully aware of Newton's seven primaries, but in the 1818 lecture he advocated a three-colour theory. In this respect Turner was doing no more than airing one of the commonplaces in art theory. What was exceptional was his attempt to distinguish separate systems for 'aerial' and 'material' colours (pl. 526). The basic disposition of his circles follows Moses Harris, with primary triangles surrounded by a circle of mixtures. However, the triangles for 'aerial' primaries are rearranged so that they do not at any point overlap in such a way as to produce black or grey, while the overlap of the 'material' primaries results in a muddy grey: 'white in the prismatic order, in the rainbow, is the union or compound of light, as is daylight', while 'the commixture of our material colours becomes the opposite, darkness'.[110] Turner was, I think, the first artist after Le Blon to spell out this fundamental difference in these entirely accurate terms. There is no question that his formulation marks a real advance over Harris and Hayter, whose various colour wheels were devoted to the compounds arising from the primaries and secondaries with no differentiation between light and pigment mixtures.

The other major departure from Harris was his rotation of Harris's diagram through a third of a revolution in order to place yellow at the top. This seemed necessary to Turner on the grounds of tonal weight. The lightest colour in the triangles, or more obviously in the surrounding wheel, would naturally tend to rise to the highest point, while the darkest, purple, would sink to the bottom. In the diagram of the aerial mixtures, yellow occupies a full half of the circumference, indicating the dominance of the lightest of all the primaries in the composition of light. In the diagram of the material colours the lowest colour now exhibits a muddy hue, though I suspect that it was originally intended to be a gloomy purple. To

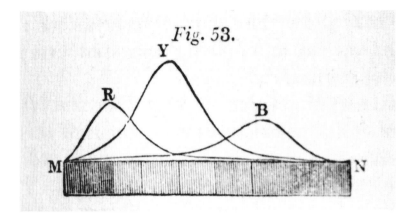

525. Production of the spectrum from three primaries, from David Brewster's *A Treatise on Optics*, London, 1831.

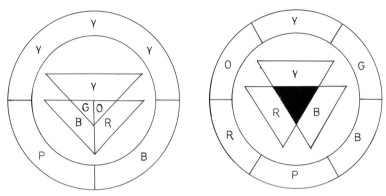

526. The 'aerial' and 'material' colours as described by Turner.

Y—yellow	R—red	O—orange
B—blue	G—green	P—purple?

527. 'Weighting' of the colours in a wheel as described by Turner.

Y—yellow	B—blue	R—red
G—green	O—orange	P—purple?

528. J.M.W. Turner, *Watteau Study by Fresnoy's Rules*, 1831, London, Tate Gallery.

emphasise the importance of this vertical 'weighting' of colours, he also devised a wheel in which chords indicate the tonal levels of each colour on either side of the yellow-purple axis (pl. 527).

The 'warm' colours in the cycle were seen by Turner as corresponding to times of day. 'Yellow morning' invades 'grey dawn', while evening is marked by the 'red departing ray'. Together, 'in ever changing combination', the yellow and red rays 'are constantly to be found by subduction or inversion of rays or their tangents [i.e. through atmospheric refraction?] These are the pure combinations [of] aerial colours', compared to 'the dense material of. . . pictorial means'.[111] He also regarded aetherial yellow as characteristic of the 'medium', red as substantial or 'material' and blue as indicative of 'distance'.[112] He was, however, sceptical of attempts to arrange colours in rigid sets of emotional or symbolic associations, and he specifically criticised Lairesse in this respect.

Turner's paintings from the 1820s onwards bear witness to his sustained attempts to make his 'dense material' assume the guise of 'aerial' prismatics. *Norham Castle* (colour plate IX) is perhaps the most brilliant of these.[113] A radiant, opalescent 'grey dawn', tinged with vibrant blue, is invaded by the harbinger of 'yellow morning'. This much is a perfect illustration of his ideas. The 'advancing' blue mass of the castle is not, however. Blue should recede into the distance in the company of warm colours. It does not. It is thrust forward by its relative substantiality in a painting devoid of opaque masses. We know that he well realised how the same colour and the same tone could act in opposite manners in different contexts. In 1831 he exhibited a painting entitled *Watteau Study by Fresnoy's Rules* (pl. 528), accompanied by a quotation from William Martin's translation of Du Fresnoy's *De Arte graphica*: 'White, when it shines with unstained lustre clear,/ May bear an object back or bring it near.' This section of the treatise continues, 'Aided by black, it to the front aspires;/ That aid withdrawn, it distantly retires;/ But black unmix'd of darkest midnight hue,/ Still calls each object nearer to the view.'[114] The painting itself is full of varied spatial relationships between white and black, light and

dark tones, some advancing and some retreating. The advancing blue in *Norham Castle* provides a comparable example of how a colour in a particular context may act in a manner contrary to its normal 'tendency'. It was all a question of relative degrees of force.

His watercolours from the 1820s, and indeed one of this same subject, *Norham Castle*, display his interest in another visual technique, namely the intermingling of small adjacent patches of colour to give optical mixture. This form of mixing, which he exploits with vivid and spectacular results, provides the watercolourist with a technique which can rival the oil painter's use of translucent glazes for optical mixture. The use of discrete patches of colour for such purposes was not of course new, but Turner's use of them on a small scale may suggest that he drew inspiration from James Sowerby's *A New Elucidation of Colours, Original, Prismatic and Material, showing their Concordance in the Three Primitives, Red, Yellow, Red and Blue*, published in 1809.[115] Sowerby, botanist, mineralogist and scientific illustrator, was, as we will see later, an interesting and original theorist of colour, and Turner may well have been attracted by his ingenious attempt to harmonise Newton's seven primaries with the three 'material' primaries of red, yellow and blue. Sowerby provided a diagram to show how narrow bands of the primaries will produce a visual effect of the intermediate colours (pl. 529). He also speculated that 'fine dots of the primaries among each other would produce binaries'.[116] Like the traditional Rubenists, Turner would have been attracted to this technique because the colours would retain their individual force rather than being sullied by mixing on the palette.

Turner's devotion to the inherent 'force' of colours, above all the 'powers' of black and white in relation to darkness and light, was enhanced by his scientific understanding that light could exercise chemical and magnetic power. Its chemical power was manifested by the oxidization of silver salts, the

529. Optical mixture in narrow bands of primaries, from James Sowerby's *A New Elucidation of Colours*, London, 1809.

1. yellow
2. red
3. blue

yellow + red = orange
yellow + blue = green
blue + red = purple

process which lay behind the invention of photography. A pioneer photographer, J.J.E. Mayall, recalled that Turner 'stayed with me for some three hours, talking about light and its curious effects on films of prepared silver'.[117] Turner was particularly keen to acquire one of Mayall's photographs of a rainbow. The two men discussed the magnetising effect exercised by colours at or near the violet end of the spectrum. Turner had learnt of this from Mrs Mary Sommerville, an astronomer friend who had published a paper 'On the magnetising power of the more refrangible solar rays'.[118] These phenomena reinforced Turner's feeling for the cosmic universality of effects, the essential affinities between sound, light, heat and dynamics. His sense of such affinities was for the most part intuitive and poetic rather than fully scientific, but he had seen enough scientific evidence to encourage him in his beliefs.

Scientific insight and poetic intuition did not live in separate compartments of Turner's mind. An earlier version of *Norham Castle* had been exhibited with a quotation from Thomson's *Seasons*: 'But yonder comes the powerful King of Day,/ Rejoicing in the East: the lessening cloud,/ The kindling azure, and the mountain's brow/ Illumin'd with fluid gold, his near approach/ Betoken glad.'[119] In the quotation associated with the watercolour version in 1798, he omitted the phrase 'Illumin'd with fluid gold', an effect which lay embarrassingly outside his command at that time. Thirty years later Thomson's 'fluid gold' is triumphantly realised, somehow transcending the 'dense material' of painter's pigments. It is not hard to envisage the chemical and magnetic power of such colours.

Turner's Goethe paintings (colour plate X) are specifically about power, the elemental power of the spiritual universe expressed by the contiguous forces of colour and tone. They are concerned with the polarities of glowering darkness and radiant light in a process of dynamic transition. The *Deluge* is announced by a dark display of fractured violence, while the new dawn is accompanied by a whirl of golden hope.

Exhibited originally in octagonal frames, they appeared at the Royal Academy in 1843 under the titles, *Shade and Darkness—the Evening of the Deluge* and *Light and Colour (Goethe's Theory)—the Morning after the Deluge—Moses writing the Book of Genesis*.[120] Each was accompanied by a quotation from Turner's own poem, *The Fallacies of Hope*:

The morn put forth his sign of woe unheeded;
But disobediance slept; the dark'ning Deluge closed around,
And the last token came: the giant framework floated,
The roused birds forsook their nightly shelters screaming
And the beasts waded to the ark [for the *Deluge*]

The ark stood firm on Ararat; th' returning sun
Exhaled the earth's humid bubbles, and emulous of light,
Reflected her lost forms, each in prismatic guise
Hope's harbinger, ephemeral as the summer fly
Which rises, flits, expands and dies [for *Morning*]

The narrative of the Deluge is clear enough; the paired animals and pitiful humans are overshadowed by the coming onslaught. The *Morning after the Deluge* contains a complex interweaving of Noah's Ark, of the Covenant, Moses writing the Book of Genesis and the Brazen Serpent (an analogue for the Crucifixion). The traditional rainbow of the covenant has been imaginatively transformed into the prismatic bubbles exhaled from the water-logged earth.

These bubbles provide a key to the painting's relationship to Goethe's theories. One of Goethe's most beguiling observations had concerned the floating kaleidoscope of prismatic colours visible in the surface of bubbles, an example of the phenomenon known to scientists as the colours of thin films and called by Goethe the 'epoptical colours'.

> All the colours of the scale are seen to pass through each other; the pure, the augmented, the combined, all distinctly pure and beautiful. . . On the highest point of the bubble we see a small circle appear, which is yellow in the centre. . . In a short time the circle enlarges and sinks downwards on all sides; in the centre yellow remains; below and on the outside it becomes red and soon blue; below this again appears a new circle of the same series of colours . . .[121]

Turner's *Morning after the Deluge* does not contain a literal illustration of these effects; that was not how he worked. But the main body of painting has assumed the form of a fragile sphere, like the water-filled spheres of glass with which he experimented on his own account (pl. 315). Its skin is adorned with elliptical swirls of ephemeral colour through which can be glimpsed the dark remains of the flooded earth. When Turner explained to Ruskin what the painting meant, his terse account was 'Red, blue and yellow'.[122] This is precisely the point of the painting. It is a hymn to the visual and emotional potency of the reflected and refracted prismatics. The warmth of yellow and red signals hope, but their very mobility suggests their transitory quality. The 'threat' of blue's inherent darkness is never far away.

The companion piece, the *Deluge*, has been seen as attempting 'to restore the equality of light and darkness as values in art and nature'.[123] I prefer to see the *Evening of the Deluge* as a dramatic exploitation of Goethe and Field's 'negative' polarities. The greens and purplish blues reside in the 'cold' sector, creating what Goethe called 'restless, susceptible, anxious impressions'.[124] They are associated with the negative power of darkness. The hollow, ruptured vortex stands in negative contrast to the implied sphericality of the *Morning*. But neither state is stable. A glow of light continues to compete with the advancing storm, just as the forces of darkness still threaten the new dawn. He has expressed Goethe's poles of power and colour in terms of his own sense of elemental flux.

No critic was more responsive to the living colour of Turner's canvases than John Ruskin. Writing about a seascape, Ruskin observed that 'in one deep reflection of this distant sea we catch a trace of the purest blue, but all the rest is palpitating with a varied and delicate gradation of harmonised tint, which indeed looks solid blue as a mass but is only so by opposition'.[125] A fine example of such induced colour is provided by the deceptive grey shadow on the hull of the *Fighting Temeraire* (London, National Gallery), which acquires a violet tinge from the 'opposition' of cream light. Turner, as Ruskin

wrote, 'had discovered that the shaded side of objects is in reality of different and often brilliant colours . . . no longer of one hue, but perpetually varied.'[126]

Ruskin was also deeply impressed by the very different kind of colour 'truth' in the paintings of the Pre-Raphaelites and their circle, above all their attempt to capture the glare of outdoor light. He saw William Holman Hunt's 1852 painting, *Our English Coasts*, retitled *Strayed Sheep*, (colour plate XI), as the key work:

> It showed us, for the first time in the history of art, the absolutely faithful balances of colour and shade by which actual sunshine might be transposed into a key in which the harmonies possible in material pigments should yet produce the same impression upon the mind which were caused by the light itself.[127]

This estimation of Hunt's importance is reinforced by Hunt's friend, F.G. Stephens, writing about the *Hireling Shepherd* which was painted in the same year:

> the painter first put into practice in a historical picture, based upon his own observations, the scientific elucidation of that peculiar effect which having been hinted at by Leonardo da Vinci in one of his wonderful world-guesses, was partly explained by Newton and fully developed by Davy and Brewster. He was probably the first figure-painter who gave the true colour to sun-shadows, made them partake of the tint of the object on which they were cast and deepened such shadows to pure blue when he found them to be so.[128]

Hunt had reached this point through a series of steps, taken by Ford Madox Brown, Millais and himself, and heralded in varying degrees by Dyce, Maclise and Mulready. The great aim was to capture the true brilliance of exterior colour in direct sunlight, in contrast to the rich, brown bituminous tone of the Rembrandtesque manner then popular at the Academy. One major source of inspiration, lauded by Ruskin, was the pre-tonal, pre-Leonardo technique of fifteenth-century Italy. The absence of deep chiaroscuro seemed to suggest the brilliant glare of sunlight, as William Dyce recorded:

> I suspect that we modern painters do not study nature enough in the open air, or in broad daylight, or we should be better able to understand how the old painters obtained truth by such apparently anomalous means. In sunlight, shadows partake largely of the local colour of objects and *still more so in shade*.[129]

What Dyce was admiring was the 'anomalous' effect of saturated colour in shadows, which resulted from the system described by Cennino Cennini, whose writings were avidly studied at this time. Brown, we know, was looking to Holbein for comparable qualities by 1845. To achieve out-door brilliance by means which were not 'anomalous', Hunt, Brown and, for a time, Millais, turned to the new ideas about colour being aired during the first half of the nineteenth century. One author, Henry Richter, seemed to foreshadow precisely Brown's (and Hunt's) declared aim of 'treating light and shade absolutely as it exists at any one moment'.[130] In 1817 Richter

had published a bizarre and lively little treatise with a big title: *Daylight. A Recent Discovery in the Art of Painting (with Hints on the Philosophy of the Fine Arts and those of the Human Mind as First dissected by Immanuel Kant)*.[131] In accordance with a somewhat simplified form of Kant's epistemology, Richter maintained that the systems we 'deduce' from our study of nature are actually 'the modes of our sensitive faculty'.[132] Armed confidently with this conviction that the painter's role is to make his works correspond directly to what he 'sees', he launched into a personal attack on the old Dutch masters. He gathered them in posthumous assembly on the occasion of the exhibition of Dutch and Flemish painting at the British Institution. He belaboured the shades of the great masters with the accusation that they had ignored the pervasive influence of 'the broad blue light of the atmosphere'.[133] Golden lights and brown shadows may be very charming, but they are simply not true. The 'light blue turban of the heavens', in which is set the 'sun as a diamond', is universally reflected from all exposed surfaces, above all these perpendicular to the axial line of the sky's semi-dome (pl. 530).[134]

It was precisely this effect—'blue shadows derived from the sky'—which Maclise admired in Hunt's *Hireling Shepherd*.[135] And it corresponds to what Hunt himself later described as the Pre-Raphaelites' aim: 'we registered prismatic hues because we found that each terrestrial feature mirrored blue sky and the tints of its neighbouring creations'.[136] Brown's *Chaucer at the Court of Edward III*, painted in 1851, displayed some striking blue reflections on top of the battlements and occasional blue touches in drapery shadows. The same kinds of effect appear in Millais's *Ferdinand lured by Ariel*, first exhibited in 1849. But neither of these adopt a systematic approach and were both retouched later by their authors, possibly to 'modernise' their colour.

Hunt seems to have been in the vanguard as far as the scien-

530. System of reflections of the sun and atmosphere, from Henry Richter's *Day-Light. A Recent Discovery in the Art of Painting*, London, 1817.

ED and EC are illuminated by less of the blue arc AB than EB; EB will therefore reflect most blue.

531. Ford Madox Brown, *Carrying the Corn*, 1854, London, Tate Gallery.

tific description of these effects was concerned, believing that 'the aid of inexhaustible science should be used to convey new messages of hope to fresh broods of men'.[137] He recalled that 'we often trenched in scientific and historic grounds, for my previous reading and cogitation had led me to love these interests'.[138] This reading may have embraced Newton and Goethe, both of whom were approvingly listed in the Pre-Raphaelite Manifesto, the latter with two stars. And Stephens may have been right in drawing attention to Davy and Brewster. Hunt was also willing to experiment on his own account. 'To test the colour of intense moonlight', for his painting of the *Triumph of the Innocents* (1876–87), 'I used a lense on a bright night and to my surprise found that the focus transmitted not a silvery tone, but that of warm sunlight.'[139]

The paintings of 1852 singled out by Ruskin and Stephens, do indeed display astonishing effects of colour, using the new pigments which Field had played an important role in developing. The fleece of the sheep in *Our English Coasts* sparkle with prismatic gleams of yellow, blue and red, with elusive glimmers of their compounds. Orangey-yellow highlights vibrate against blue shadows. The grass runs a remarkable gamut of hues, from lime green to violet. These effects are exploited with knowing precision. The fleecy prismatics recall Goethe's and other scientists' discussions of diffraction colours in thin filaments. Other aspects of the painting evince comparable attention to natural effects. The meteorological process of 'exhalation' is finely described in the mist arising from the highest cliff-top. And the eyes of the sheep glow in the shadows with subdued amber, like cats' eyes, while in light they resume their normal, predominantly dark appearance.

Hunt and Brown continued to develop natural colour in their landscapes during the 1850s. Brown enthusiastically recorded notable phenomena in his diaries. On one occasion rain had 'heightened the green remaining grass' during the harvest, 'making the hay by contrast . . . positively red or pink, under the glow of highlight here presented' (27 August 1855).[140] On

another 'the greeny greyness of the unmade hay in furrows or tufts' was accompanied by 'violet shadows . . . melting away one tint into another imperceptibly' (3 October 1854).[141] In *Carrying the Corn* (pl. 531), the painting which corresponded to the 1854 entry, two light sources of differing quality are present, the setting sun and the rising moon. The warm influence of the sun's departing rays and the 'lovely violet shadows' are set against each other with all the precision that Rumford or Goethe might obtain in one of their experiments. As Stephens observed, in connection with two of Hunt's landscapes, 'the aim, as we understand it, of the painter has been to render by means of painting two of these effects of light on the retina which, because of their extreme delicacy and marvellous difficulty, have not been attempted before'.[142]

Ruskin responded enthusiastically to the optical 'truths' of Hunt's and Brown's naturalism during the 1850s. The surface effects of their paintings corresponded closely to his own response to nature's symphonic colour:

> The noonday sun came slanting down the reeling slopes of la Riccia, and their masses of entangled and tall foliage, whose autumnal tints were mixed with wet verdure of a thousand evergreens, were penetrated with it as with rain. I cannot call it colour, it was conflagration. Purple, and crimson, and scarlet, like the entrance of God's tabernacle.

Every separate leaf was 'first a torch and then an emerald'. Even Turner, 'far from outfacing nature . . . does not, as far as mere vividness of colour goes, one half reach her'.[143]

His admiration for Turner and Pre-Raphaelite colour was distilled into the relevant section in his *Elements of Drawing*. He believed that the supreme task of the painter was to look afresh at nature with unblinking directness. A true painter 'perceives at once in sunlighted grass the precise relation between the two colours that form its light and shade. To him it does not seem light and shade, but bluish green barred with gold'.[144] If access to such visual 'truth' should prove elusive, Ruskin recommended that the painter should view each colour separately through a hole in a white card matching the seen colour with pigments painted on the card.[145] This technique ignores the subtle contextual factors in our perception of colour in nature and is likely to have resulted in a series of piecemeal effects at the expense of overall unity.

His instructions for the handling of particular areas of colour were, however, far more cogent. He stressed the 'gradation' of colour, that is to say its breaking into patches of varied tone and hue. Any area of colour, 'however small . . . shall be gradated'.[146] This may be achieved by laying one colour on top of another in a broken manner, or by painting with 'touches or crumbling dashes of rather dry colour, with other colours afterwards cunningly put into the interstices'. The effect should resemble 'atoms of colour in juxtaposition', or 'minute grains of interlaced colour'.[147] These broken touches of varied colour quite properly remind us of the techniques of Turner and the Pre-Raphaelites, in their different ways, the one freely accomplished, the other minutely calculated. They also apply remarkably well to the divisionist techniques later practised in France, above all by Seurat.

A direct link between the *Elements of Drawing* and Seurat certainly existed. Relevant sections on gradation were quoted in Ogden Rood's *Chromatics*, a book which exercised a considerable influence of Seurat.[148] This is not to say that Ruskin or Hunt would have hailed either the theory or practice of the Neo-Impressionists. Hunt considered that Impressionist painting was 'childishly drawn and modelled, ignorantly coloured and handled, materialistic and soulless'. It is almost certain that the Neo-Impressionists would have been even farther beyond his ken.[149] One of the reasons for this was the dependence of French colourists upon a very different, specifically French tradition, deriving ultimately from the *Rubénistes* of the seventeenth century.

THE FRENCH SYNTHESIS IN THEORY AND PRACTICE

The main bases for French colourism in the nineteenth century were laid down jointly by the chemist Chevreul and the painter Delacroix. However, the relationship between the two men is less clear than the sum total of their immense influence. Michel-Eugène Chevreul stands in a rather different position from any of the major theorists encountered so far in this study. He came to colour theory neither as a student of optical science nor as a practising artist. He was trained as a chemist, and in 1824 was appointed as Director of Dyeing at the Gobelins tapestry workshop. There had been earlier indications of the fruitful involvement of colour theory with the practice of weaving. Savot in France and Le Blon and William Petty in England had all advocated three-colour theories with specific reference to tapestry design.[150] In the nineteenth century, largely as a result of Chevreul's efforts, this undercurrent was to surface as a major and highly influential stream of innovatory theory and practice.

As a chemist, Chevreul was expected to supervise the preparation of dyes. What he discovered was that the major problems were less concerned with questions of chemistry than of optics. The failure of a colour to register its proper effect was often due to the influence of neighbouring hues rather than inherent deficiencies in the pigments themselves. He decided that his major task was to arrive at a scientific understanding of how such influences operated, using a 'precise and experimental method'. The result was his 'law of simultaneous contrast', published in 1839 in *De la Loi du contraste simultané des couleurs*.[151]

Chevreul's law was not primarily a product of a scientific notion of the origin of colours, although he did introduce his readers to the basic tenets of the Newtonian theory. It was founded upon a systematic observation of actual effects of juxtaposed colour in a great variety of circumstances. His observations provided the base for his famous law: 'where the eye sees at the same time two contiguous colours, they will appear as dissimilar as possible, both in their optical composition and in the height of their tone'.[152] Any given colour would influence its neighbour in the direction of that colour's complementary. He defined the complementary colour as consisting of those elements of white light absorbed by any given colour. Thus red, which absorbed a preponderance of green light, would tend to make all adjacent surfaces appear greener by contrast. Green would therefore be enhanced by juxtaposed red, as would the red itself by the action of the green.

The evidence (after-images etc.) and outlines of this theory had been known for some time, as we have seen. One precedent seems particularly relevant for Chevreul. In 1805 C.-A. Prieur had published an essay entitled 'Considerations sur les couleurs, et sur plusieurs de leurs apparences singulières' in the French chemistry periodical, *Annales de Chimie*, a source readily accessible to Chevreul. Prieur wrote that

> the painter or decorator is aware that it may not be a matter of indifference in the placing of one [colour] beside another. But when he is instructed in the law (*loi*) which governs their reactions, he will know better what must be avoided or how to arrange it to enhance the clarity (*éclat*) of the colour which he is concerned to make more forceful.[153]

Inspired perhaps by the programme which Prieur had suggested, Chevreul undertook investigations of an unprecentedly sustained kind, aimed at drawing all the earlier ideas together and building upon them. His ultimate goal was to formulate a general law, founded upon the empirical 'method *a posteriori*', and then to show its various consequences in a series of *a priori* demonstrations of the most exhaustively detailed kind.[154]

Underlying his demonstrations was a precise nomenclature for colour relationships: *tons*, for tonal value on a scale from black to white; *gamme* for the tonal scale itself; *nuances* for the modifications of one hue by the admixture of another; *couleur franches* for pure, saturated pigments; *couleurs rabattues* (or *rompus*) for colours broken with black (or grey). These qualities were graphically demonstrated in a colour wheel to which was

532. Colour wheel and raised quadrant from Michel-Eugène Chevreul's *De la Loi du contraste simultané des couleurs*, Paris, 1839.

533. Colour wheel, by Michel-Eugène Chevreul, from *De la Loi du contraste simultane des couleurs*, Paris, 1839.

attached a quadrant (pls. 532–3). The wheel shows seventy-four *nuances* of colour, marked by radial lines, and twenty degrees of tonal gradation, from white at the centre to black at the circumference. With considerable originality he placed each saturated colour at a different point on the appropriate radius according to its inherent tonal value. Pure yellow would thus be placed nearer the centre than pure blue. Saturated red he placed at point fifteen on the scale. This accommodated the tonal values of pigments more satisfactorily than previous scales and provided bands of uniform tone across the lines.

Disposed above this circular base was a hemisphere of 'broken' colours, the vertical axis of which ran from white at the centre, through shades of grey, to black at the top. This was demonstrated in the book by the hinged quadrant which represented one half of a vertical section of the hemisphere. The saturated red, at point fifteen, would be progressively darkened with optically judged proportions of 'black', until no colour remained at the central axis. Chevreul's description poses a slight problem at this point, since he should not be breaking saturated red with pure black, but with the grey corresponding to point fifteen on the tonal scale. The deepest black should be reserved for the outermost layer of the hemisphere. That his intention was not to deepen the saturated colours to the deepest black but by an unsaturated black is confirmed by the ten tonally graded wheels published in the beautiful *Atlas* accompanying his *Exposé d'un moyen de définir et de nommer les couleurs d'aprés une méthode précise et expérimentale* in 1861.[155] Unfortunately the demonstration of his hemisphere

which he made in coloured wool at the Gobelins—and which must have been an object of comparable beauty—has apparently perished.

Using the hemisphere, the designer should be able to judge the relative tonal and colouristic influences which colours would exercise upon each other. A light toned yellowish-green would tend to push adjacent colours in a darker violet-red direction. The next step, judging whether the mutual influences of colours would produce harmony, was less subject to precise definition. He could say without doubt that opposite (or complementary) colours enhanced each other, but the aesthetic appeal of other pairs or sets of colours and tones could only be judged subjectively. His incredibly detailed and elaborate analysis of harmonic combinations was based upon 'general propositions which express my own individual taste'.[156] One such 'proposition' is that 'the primaries . . . assort better together in pairs, as a harmony of contrast, than an arrangement formed of one of the primaries and a binary colour . . . which has that same primary as one of its components'. Thus, 'red and yellow accord better than red and orange'.[157]

Not the least original aspect of Chevreul's book was his definition of different kinds of conditions for 'contrast'. The simplest was when colours were placed beside each other and seen together. Contrast could also arise successively, as when turning the eye from one surface to another. Or, in its most complex form, the two types of contrast could be 'mixed' or combined. The painter or designer must strive to disentangle these effects. Above all, the 'law of simultaneous contrast' was designed to show how an artist's perception of colour may be distorted, and how these distortions could be circumvented. If a grey surface appears to be tinted violet under the influence of an adjacent yellow, the painter should be aware that it is actually grey and paint it as such. 'To imitate the model faithfully, we must copy it differently from how we see it.'[158] This doctrine of 'adjusted' imitation actually related better to academic ideas than to the attitudes of the Impressionists.

He was also fully aware of conditions in which adjacent colour areas produced mixed rather than contrasted effects. Small juxtaposed areas of colour, viewed from a distance, 'appear as a uniformly coloured surface'.[159] Like Runge he looked to mosaics and, naturally, to tapestry for examples of this phenomenon in action.

Chevreul was concerned to increase the artist's understanding of colour, but not to provide absolute formulas to say how a painting or tapestry must be composed: 'although the law of contrast affords different methods of imparting value to a colour, genius alone can indicate the mode in which this idea should be realised'.[160] The harmonies of 'contrast' and 'analogy' must be exploited with intuitive discretion, not only with respect to each other but also in relation to the type of subject portrayed. Artistic intuition remained ultimately supreme in the composing of a great work of art.

It is this intuitive element in artistic genius which makes it so hard to quantify the extent to which the remarkable colour juxtapositions used by Delacroix were related directly to his theoretical knowledge, and to what degree they were the

534. Eugène Delacroix, *Scenes from the Massacre at Chios*, 1824, Paris, Louvre.

cumulative product of his artistic practice—building perceptively upon the visual lessons he learned from earlier painters. His *Journal* and the techniques vividly apparent in his paintings leave no doubt that he articulated some highly sophisticated concepts of colour in nature and in art. Four main concepts are involved in this colourism: the controlled juxtaposition of hues and tones for particular effects; the exploitation of optical mixture; the use of coloured shadows with complex reflections; and a diminished use of earth colours in favour of a more 'prismatic' range of hues. All but the last of these were established features of *Rubéniste* practice, and there is no question that Delacroix's early and continuing study of Rubens's paintings established the basic tenets for his techniques.

The *Barque of Dante*, the painting which marked his emergence in 1822 as a significant force in French painting, already bears clear witness to colouristic lessons well learnt from Rubens's paintings in the Louvre.[161] His major painting from the next *Salon* in 1824, the *Scenes from the Massacre at Chios* (pl. 534) combines Rubensian colour mixtures with a dryer scattering of broken brushstrokes.[162] These reflected his admiration for Constable's use of sparkling dabs of impasto to convey light on natural forms—what Constable called his 'snow'. The flesh tones of the *Massacre* exhibit some remarkable features, ranging from crimson touches in the shadow

formed by the old woman's sleeve to green-grey hatching on the underside of her forearm. This kind of 'divisionism' was enthusiastically hailed by Seurat and Signac as evidence of Delacroix's systematic use of optical mixture, but there is nothing to show that Delacroix himself regarded it in this semi-scientific light at this early stage of his career. The *Journal* entries during the 1820s confirm that traditionally pictorial concerns were uppermost in his mind, rather than theoretical considerations.[163]

The crucial event in his subsequent development as a colourist appears to have been his visit to North Africa in 1832. The brilliant sketches and notes, which provided abundant fuel for the conflagrations of oriental colour during the remainder of his career, contain many beautiful observations of colour effects in nature (colour plate XII). There is unequivocal evidence that these observations were informed by a more than adequate grasp of complementary theory. At the back of one of his North African sketchbooks he drew a colour triangle (pl. 535) to which he appended the following note:

The three secondary colours are formed from the three primary. If you add to a secondary colour the primary that is opposite, you will neutralise it; that is to say you will produce its essential half-tone. Thus to add black is not to produce a half-tone; it dirties the colour whose true half-tone is to be found in the opposed colours of which we have spoken. Note the green shadows in red. The faces of the two little peasants—the one who was yellowish had violet shadows; the other who was more rosy had green shadows.[164]

By this time there was no shortage of texts which could have instructed him in theories of complementarity. And, no doubt, there was no lack of discussions amongst his fellow painters. Three French texts were particularly germane: Grégoire's *Theorie des couleurs* (1820); Bourgeois's *Manuel d'optique expérimental, à l'usage des artistes et des physiciens* (1821); and Merimée's *De la Peinture à l'huile* (1830).[165] Probably by 1833 he also became aware of Burnet's *Practical Hints on Colour in Painting*.[166] We may also recall that Chevreul's ideas became readily available in print in 1839.

535. Colour triangle by Eugène Delacroix, based on his North African Sketchbook, Chantilly Musée Condé.

308

536. Colour wheel, based on a sketch for the *Taking of Constantinople* by Delacroix, Paris, Louvre, Cabinet des Dessins.

R—red B—blue V—violet
Y—yellow O—orange G—green

The fruits of his colour studies were revealed in the great Salon pictures of the 1830s and 1840s, most influentially for the younger artists in the *Femmes d'Alger* of 1834. Although a number of nineteenth-century commentators, most notably Paul Signac, exaggerated the scientific thrust of Delacroix's colour organisation in the *Femmes d'Alger*, the striking effects of complementary contrast and red-green half-tones do confirm his understanding and conscious utilisation of advanced colour techniques.

During the planning of at least one of these Salon paintings, his thoughts turned directly to the system of complementary contrast. On a sketch for the *Taking of Constantinople*, the painting which was to be exhibited in 1841, he roughly laid out a colour wheel (pl. 536). The orientation of this wheel, with red at the top, suggests that his direct source was not Chevreul, but more probably Grégoire or Merimée, the latter of whom had illustrated a version of Harris's colour diagrams. There is also a hint that he may have been aware of Field's scheme, or one like it, in that the diagonal axes in his sketch correspond to Field's retiring/advancing and cold/hot polarities. Delacroix undoubtedly subscribed to the view that colours possessed 'temperatures'. If, as he wrote, there were circumstances under which the tonal separation between lit and shaded surfaces was relatively small, 'the cold tones of the light and the warm tones of the shadow' can be used 'to give accent to the whole. . . Veronese owes much of his admirable simplicity to it'.[167] The painting of the *Taking of Constantinople* is accordingly enlivened by a series of red-green and blue-orange contrasts, which initiate spatial vibrations throughout the picture.

The next significant step which can be clearly documented comes in 1854 in a series of notes made at Dieppe, while he was convalescing at the seaside. One of these triumphantly proclaims his belief in the three primaries, and continues with observations of violet shadows with green reflections. Even more significantly, he recorded an injunction to 'banish all earth colours', many years in advance of the Impressionists' adoption of a prismatic palette.[168] The younger painters could well have learnt of this dictum when the Dieppe notes were

published in 1865.[169] It should be recorded, however, that he does not himself seem to have been able to dispense totally with earth colours at any stage of his career, although their use is greatly diminished in his later works.

By the time he painted what for many of the younger artists were the key paintings, his murals in S. Sulpice (pl. 537 and colour plate XIII), he was exploiting incredibly complex effects of coloured light.[170] The murals are painted in a wax-encaustic medium. The clotted pigment is applied in dryish impasto, so that a series of Chardin-like pores remain across the surface, allowing the lower layers to show through. The way he built up the surface through a technique of *flochetage* was perceptively characterised by Villot in 1865: 'he interlaces the tones, breaks them up, and, making the brush behave like a shuttle, seeks to produce a tissue whose many coloured threads constantly cross and interrupt each other'.[171] The weaving simile appears to be particularly apt. An acquaintance described having seen the artist playing with skeins of wool from a basket, 'grouping them, placing one across the other,

537. Eugène Delacroix, *Expulsion of Heliodorus*, 1849–61, Paris, S. Sulpice.

separating them shade by shade, and producing extraordinary effects of colour'.[172]

The evidence of such accounts and the visual qualities of the paintings themselves suggest strongly that Delacroix's *flochet-age* drew deep inspiration from Chevreul's accounts of woven colour. Amongst Delacroix's manuscripts are notes in an unknown hand taken from a lecture delivered by the great chemist in January 1848.[173] Delacroix himself may have attended one or more such lectures, in addition to reading the published versions of Chevreul's theories. This is not so say, however, that he swallowed the theories whole. His concept of *liaison*, in particular, permitted him free play with harmonies which were theoretically illicit. *Liaison* he defined as 'that atmosphere and those reflections which make a harmonious whole of the most disparate colour'.[174]

The flesh shadows on Helidorus's leg provide a superb example of *liaison* in action. They are laced with green, adorned with fiery tongues of pure red and surrounded by contours of a violet hue. This mélange captures the complex interplay of local and induced colours with intricate reflections and counter-reflections which both amplify and compete with the dominant colour of the light. The violet edges of the flesh tones—what Le Blon called the 'turning' and the 'roundings off'—are painted in a mixture of 'cassel earth, a low-toned white and vermilion', according to Delacroix's own prescription. This hue is exploited for its efficacy in what he called 'picking up the drawing with colour', though in its present appearance it is more brown than Delacroix intended.[175]

The spatial vibrancy achieved by such means is, broadly speaking, optical in character. How far did Delacroix himself regard the means and the ends as specifically scientific? His high level of comprehension cannot be doubted and he was too intelligent not to welcome ideas which could lead to a rational understanding of the effects available to him. But his understanding did not lead—any more than it had for Rubens—to a doctrinaire adherence to a set of rigid prescriptions. The subtle relationship in his practice between visual truth, pictorial effect, communicative execution and expressive colour precluded an unbending adherence to absolute rule.

His stance was not anti-scientific. Perhaps the spirit of his attitude was not so very different from that of Turner. His position can also be compared quite closely with that of John Burnet, whose *Practical Hints on Colour in Painting* was readily available for him.[176] The colourists's art, for both men, was founded upon an alliance between systematic understanding and poetic intuition. Scientific theory had a role to play within this alliance, but it did not provide the ruling principle. The ultimate goal for Delacroix was the imaginative fusion of his literary vision with visual experience to achieve communication and delectation in the classic manner.

By the second half of the nineteenth century many of what had been advanced concepts of colour were now part of the general baggage of any reasonably well-educated artist. The proliferation of handbooks, in the fine arts and in the applied arts such as interior decoration and tapestry, ensured that there was no lack of advice for the painter who wished to inquire into the 'secrets' of colour. It was no longer necessary to con-

538. Claude Monet, *Femmes au Jardin*, 1866–7, Paris, Musée d'Orsay.

sult primary scientific sources to absorb some general knowledge of prismatics and the principles of complementary contrast. The supreme painters of 'coloured light' in the generation following Delacroix, the Impressionists, can thus at the same time be regarded as true post-Newtonian colourists, striving to evoke our subjective perception of the scintillation of light in nature, and as hostile to scientific prescriptions. This paradox does not seem to have troubled most of the Impressionists and has not been properly acknowledged in the subsequent literature.

One of the hallmarks of Impressionist colour, the brilliantly high-keyed blues and violets in outdoor shadows, had already been apparent in the work of the older generation of *plein-air* painters in France. About 1860 we find Boudin, Daubigny and Jonkind exploiting light-toned violet-blues in shadows. They in their turn had probably learned these effects from watercolourists in the British succession from Girtin, Turner and Cotman. Within the French tradition they could have derived considerable inspiration from those artists who had perfected pastel techniques, not only their immediate precursors such as Millet but also the great eighteenth-century practitioners, including Chardin. None of these precedents, however, really prepare us for the high-toned brilliance of the Impressionist palette in its mature form.

A key painting is Claude Monet's *Femmes au Jardin*, painted in 1866–7 (pl. 538).[177] He has liberally laced the white fabrics with pale violet shadows as the complementary hue to the creamy highlights. There are clear signs of green reflections—Delacroix's *liasons*—in the dress of the lady standing furthest in the shade. The shadow thrown across the sandy path is compounded from blended brushstrokes of buff and unsaturated violet. As yet these effects are not maintained consistently throughout the painting and the duller earth pigments still play a prominent role.

A likely influence in the subsequent development of the Impressionist palette was the publication of Delacroix's Dieppe notes in 1865.[178] Claims that Camille Pissarro decisively rejected earth colours in this same year—probably under Delacroix's inspiration—are not borne out by an analysis of his paintings, but by the mid-1870s he does appear to have adopted a remarkable palette limited to white, blue, yellow, two reds and a green.[179] During this same crucial period—and probably taking precedence over Pissarro—Monet also heightened his palette to an extraordinary degree and eliminated the muting effects of earth pigments.

A superb example, one of many from the 1870s, is Monet's *Woman with a Parasol* (Camille and Jean Monet) (colour plate XIV).[180] Its whole structure relies upon the controlled contrast between the cool, airy, light-toned hues which predominate in the upper region of the picture and the scattered scintillation of sunny radiance which evokes the warmth of the incident light on the forms below. Set against the sunlight, the white draperies have assumed a predominantly pale-violet hue, tinged with green *liasons* from the grass and modelled with half-tones which have been blended from red-green complementaries in the manner recommended by Delacroix. When the sunlight is directly incident on the fringes of the drapery and on the boy's rounded sun-hat, it is characterised as a bright cream, the complementary to the major hue of violet. The chrome-yellow flowers of the meadow 'jump' vivaciously against the background of the lady's cool dress.

Exploiting the pasty consistency of the new tube-based oil colours, Manet has liberally applied thick, opaque brushstrokes which reflect colour vividly and directly into the spectator's eye.[181] Impasto is no less apparent in the shadows than in the highlights. This stands in marked contrast to the translucent, glazed shadows of the *Rubéniste* tradition. The vibrant dabs of prismatic pigment in the grass throw off a fragmented diffusion of mobile colour. The visual result is that colour is no longer seen as residing in surfaces but as suffused throughout the air in front of the spectator.

The 'high' Impressionism of the 1870s was marked by an extreme emphasis upon prismatic colours. Renoir, in particular, adopted a *reductio* almost *ad absurdum* of Impressionist colour technique, using a dazzling array of pure pigments applied in separate touches. The extreme supression of local colour and continuous modelling work against formal and tonal coherence in a way which Renoir himself was later to consider unsatisfactory. The critics and the public were certainly unsettled by what they saw, particularly the tendency of the blues and violets to tip the colour balance decisively towards the 'cold' end of the scale. This was a clear violation of the academic assessment of the proper predominance of warm hues. It was even seen as a kind of disease, 'indigomania', to use Huysmans' diagnosis.[182] It was related by Huysmans to a pathological condition in hysterics, who were supposed to exhibit an exaggerated tendency to see violet.

Other scientific explanations for the Impressionists' 'indigomania' were more favourable to the artists. Alfred de Lostalot believed that Monet was able to perceive ultra-violet light at the extreme end of the spectrum and that this gave the painter a special receptivity to the violet hues of shadows:

> The clarity of the yellow rays [of the sun] stimulate the sensory mechanism of the painter, dazzling it, at the same time inducing in him the well-known physiological phenomenon known as the evoking of complementary colour: he sees violet. These who love this colour will be gratified. M. Monet performs an exquisite symphony in violet for them.[183]

Monet himself, in a jocular fashion, acknowledged his 'indigomania'. 'I have at last discovered the true colour of the atmosphere. It is violet. Fresh air is violet. I have found it! . . . In three years from now, the whole world will be violet.'[184]

During the 1880s it became increasingly fashionable to interpret Impressionism in terms of '*décompositions prismatiques*'. This coincided with Monet's own adoption of an increasingly analytical application of colour in the studio realisation of his paintings, and he openly espoused a 'more serious' attitude to colour. The 1891 'Haystack' series shows what he meant. This series of paintings was concerned with colour variations in the same subject under different light conditions. Relatively late in the execution of each canvas he added strongly contrasting complementary streaks of colour in the shadows, particularly at the edges of forms—much as Delacroix had done. His palette at this time seems to have been thoroughly prismatic in character. Cobalt blue, cadmium yellow and vermilion (the primaries) were supplemented by deep madder, green and white in the palette he described to Durand-Ruel in 1905.[185] His paintings of the later 1860s, like those of Pissarro, suggest that this palette or something very close to it had been adopted at a remarkably early date.

Can we, however, legitimately talk of the science of colour with respect to Impressionism? If we mean by science, the systematic interpretation of effects in relation to the laws of nature, we can not. This does not mean, however, that Impressionist colour can be explained without reference to scientific concepts, either as transmitted through other artists' pictures or in terms of more general, commonly-held assumptions about the relationship of light and colour. Their stalking of the optical phenomenon of coloured *light* rather than the depiction of locally coloured *surfaces* presupposes some kind of Newtonian concept of colour and light. Their coloured shadows stand at the climax of an artistic tradition whose beginnings were genuinely scientific. Regardless of how hard certain Impressionists might declare their 'innocence' in such matters, they found themselves in historical circumstances where 'innocence' was impossible. Like it or not, their art

was founded upon assumptions which had entered general awareness through the increasingly available education in elementary science, for which suitable books were being published in not inconsiderable numbers.

A number of artists associated with Impressionism, Pissarro and the younger men in particular, obviously sensed that there was something intellectually unsatisfactory in an art which possessed such obviously scientific implications while disclaiming any scientific base. If the underlying assumptions about coloured light were valid, they reasoned that its properties should be consciously explored and exploited. Such a programme was precisely the aim of the 'Neo-Impressionists' in the 1880s, led by Georges Seurat. By the time Seurat began his attempt to place Impressionist colour on a more scientific footing, the relevant literature available to artists had significantly increased. Above all, the basic books on the science of colour had begun to speak with a more unified voice than had been true earlier in the century—at least in terms of general principles.

By the time Seurat began his researches in the 1880s, the amount of optical advice potentially available from science had increased to a point at which we could well excuse the painter if he did not know where to begin. Also, much of the advice was now couched in the proliferating technical terms of professional science, tending to make it inaccessible to nonspecialists. However, a number of scientists, whose works were available in French translation, did pay various degrees of attention to the consequences of their ideas for artists, and it was to them that Seurat naturally turned.[186] The most notable of these scientific authors were the Germans, Hermann von Helmholtz, Ernst von Brucke and Wilhelm von Bezold, and the American, Ogden Rood. Helmholtz's superb and substantial *Handbook of Physiological Optics* was published in French in 1867. His earlier essay 'On the Relation of Optics to Painting' was included in a translated anthology of 1878, a year before the French edition of Rood's *Modern Chromatics*.[187] Brucke's *Die Physiologie der Farben für die Zwecke der Kunstgewerbe bearbeitet*, published in Leipzig in 1866, became available in French translation in the same year as *Des Couleurs*.[188] Brucke's ideas, which were not particularly difficult in themselves, were developed in a form even more readily applicable to the fine and applied arts by Wilhelm von Bezold in his *Die Farbenlehre in Hinblick auf Kunst und Kunstgewerbe*, published in French in 1876.[189] The ideas expressed in these advanced, sophisticated and often quite complex books had much in common, and it is difficult to disentangle their influence. However, I think it is true to say that Helmholtz was especially influential in matters of general approach while Rood exercised a particular impact on the detailed application of ideas to pictorial techniques.

Helmholtz provided a marvellously subtle assessment of the limited mimetic power of painting if measured in purely scientific terms against the phenomena. Whereas, for example, the sun is 820,000 times brighter than the moon, as measured by Wollaston, the painter only had recourse to the same pure white to represent their brightest lights.[190] However, all is not lost for poor painting. Citing Fechner's logarithmic law— 'within very wide limits of brightness, differences in the strength of light are equally distinct or appear equal in sensation, if they form an equal fraction of the total quantity of light compared'—he argued that the painter should aspire to achieve the 'same ratio of brightness as that which actually exists'.[191] This ratio does not apply at the highest and lowest ends of the scale, but the amazingly subtle discriminations of the eye within the middle range of tones allows the painter to effect 'a translation of his impression into another scale of sensitiveness . . . in which the organ speaks a very different dialect in responding to the impressions of the outer worlds'.[192] In Kantian fashion, he sees the artist as relying upon 'subjective phenomena of the eye, which the artist represents objectively'—a perfect recipe for Seurat's works.[193]

On a technical level, Helmholtz provided an authoritative account of colour phenomena, adopting and amplifying the three-receptor theory of Young and Maxwell, which we will later encounter in relation to colour photography. He recognised the essential difference between the additive and subtractive primaries, building upon J.D. Forbes's description of the absorptive properties of pigments, and showed that Brewster's three overlapping spectra of red, yellow and blue resulted from stray light dispersed within his prisms and filters, coupled with physiological distortions of perception.[194] He also demonstrated the now familiar effects of complementary after-images, and drew attention to Heinrich-Wilhelm Dove's observation that the eye becomes more sensitive to blue at lower levels of illumination, while red becomes relatively more obscure—an observation for which Purkinje is normally given first credit, although it had been noted by Philippe de la Hire in the late seventeenth century and anticipated by Leonardo in the Renaissance.[195] This red-blue shift not only has clear implications for our perception of paintings under different levels of illumination, but also provided encouragement for those painters who insisted on the blue tonality of shadows.

Helmholtz's importance for Rood was warmly acknowledged by Rood himself, who 'consistently adhered' to the ideas of Helmholtz, Maxwell and Young.[196] His attitude to the artist's role was consistent with that of the German scientist: 'it is one of the tasks of the artist to ascertain the

539. Colour cylinder and cone by Ogden Rood from *Modern Chromatics*, London, 1879.

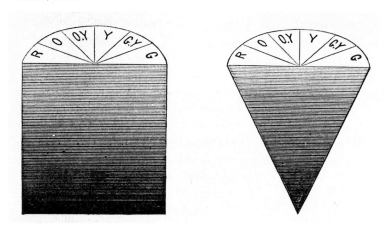

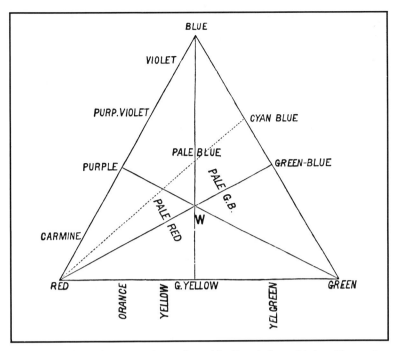

540. Maxwell's colour triangle as adapted by Rood, from *Modern Chromatics*.

541. Maxwell's disks for colour mixing, from Rood's *Modern Chromatics*.

ours and determining the position of the mixture on the axis according to the proportion of each colour in the mixture. Thus, equal proportions of red and cyan blue will produce a 'whitish purple'.[202]

Rood's proposed modification of Maxwell's scheme exploited an apparatus perfected by Maxwell himself, who had in turn been inspired by the researches of Thomas Young and his fellow Scots, D.R. Hay and J.D. Forbes.[203] Maxwell studied optical colour mixtures using revolving disks which fitted together in such a way that the proportions of the colours could be systematically varied (pl. 541). Maxwell and Rood used two superimposed disks of different diameters to

542. Diagram of colour angles and 'weights', from Rood's *Modern Chromatics*.

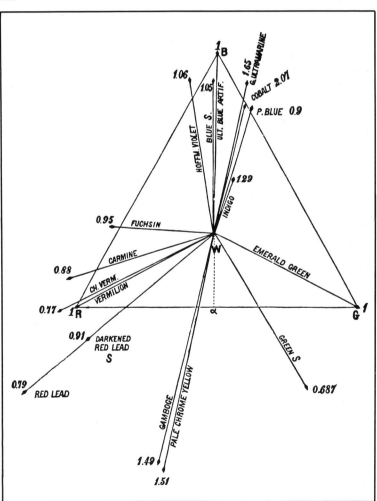

causes that give rise to the highly complex associations he experiences'.[197] Ogden Rood, Professor of Physics at Columbia University, was a competent water-colourist in his own right.[198] It is not surprising therefore that he kept his eyes firmly upon the consequences of his science for pictorial representation and took care to make these consequences apparent for those lacking specialist knowledge of physics—with such success that his *Modern Chromatics* of 1879 was republished within two years under the less intimidating title, the *Students' Text-Book of Colour*. It was he, more than any other, who made Helmholtz accessible to painters. His impact upon artists was particularly apparent in two major areas: the reformation of colour diagrams; and the conviction that the artist should 'paint with light'.[199]

Rood outlined a relatively conventional colour solid, based upon a Newtonian wheel and tapering towards a white peak and black base point (pl. 539). He admitted the similarity of his conception to Lambert's pyramid, and was highly critical of Chevreul's hemisphere. This preference for Lambert's pyramid over Chevreul's hemisphere was shared by most of the specialists in optical science, as were his reservations about the absolute and universal validity of any schematised colour solid.[200] He believed that all such arrangements were founded upon too many arbitrary assumptions to be seen as a 'philosophical classification of colours'.[201] He doubted that colour science had progressed sufficiently to make a definitive classification, but he did suggest a possible way forward. His starting point was Maxwell's triangle for primaries of light, namely blue, green and red. The position of white within the triangle was determined by the ratios of the primaries required to compose white light (pl. 540). The result of mixing two colours could be judged by drawing an axis between the col-

compare mixtures of their three basic colours—vermilion, emerald green and artifical ultramarine blue—with an optical grey composed from black and white segments. By adjusting the proportions of the primaries they determined the relative quantities of each required to compose a mixture which corresponded to the colourless grey. These proportions were regarded, 'according to Newton's suggestion, as though they were weights acting on the ends of lever-arms, and these arms have been taken of such lengths as to bring the system into equilibrium'.[204] These weights gave a balance according to the formula: 35.46 red + 33.76 green + 29.79 blue = 100 white.[205] The resulting diagram (pl. 542), based upon painstaking measurements of proportional mixtures, showed 'colour or hue according to angular position, and saturation or intensity by greater or lesser distance from White'.[206] The number appended to each colour was its 'coefficient of brightness' in relation to white.

Maxwell's symmetrical diagram, based on an equilateral triangle, implied that the three primaries were equivalent in luminosity, an assumption which Rood challenged. Rood therefore proposed a new arrangement of an asymmetrical nature (pl. 543). He did not claim that his revised version of Maxwell's diagram left no problems unsolved, but he did proclaim its superiority to symmetrical schemes.

To demonstrate the true nature of complementary contrast he produced a revised colour wheel which observed the proper 'angular position' of the actual colours used by painters (pl. 544). He also showed that the effect of contrast produced by any colour, red for example, could be aptly illustrated in terms of the displacement of the colour circle (pl. 545). Colours to the left of the points of intersection of the two circles suffer

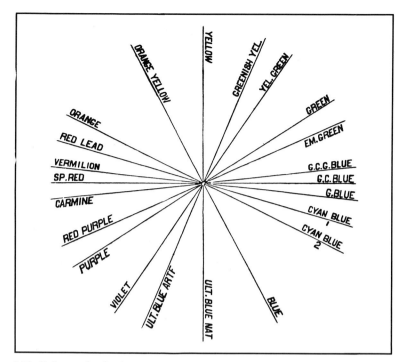

544. Colour wheel using painter's colours, from Rood's *Modern Chromatics*.

545. Displacement of the colour circle by contrast with red, from Rood's *Modern Chromatics*.

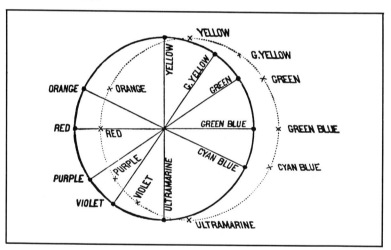

543. Rood's revised version of Maxwell's triangle, from *Modern Chromatics*.

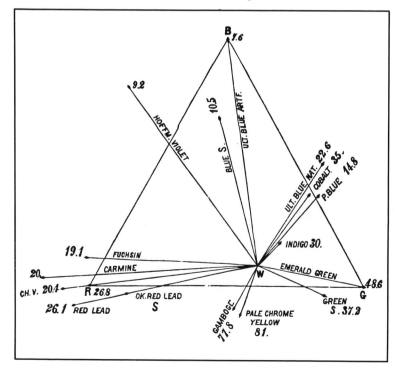

apparent diminution in 'intensity', while those to the right are correspondingly enhanced. Rood's mathematically determined diagrams promised a precision in handling colour effects which appealed enormously to Seurat, and it is not surprising that the painter carefully transcribed the colour wheel (pl. 544).

When it came to recommending how the painter should exploit this knowledge to achieve harmony or discord of colours, Rood acknowledged that such matters 'can not be solved by the methods of the laboratory', but involved 'obscure and even unknown considerations'.[207] However, like Chevreul, he recognised certain guiding principles. 'Colours less than 80° or 90° apart' were generally considered to 'suffer from harmful contrast', although green and blue often appear in harmony in

natural scenes.[208] He particularly recommended 'triads' of colours separated by angles of 120°, for example spectral red, yellow and blue; purple-red, yellow and green-blue; orange, green and violet; orange, green and purple-violet. Similar triads had previously been advocated by Brücke.[209]

Rood's calculations were founded on observations of coloured light and the optical blending of coloured light reflected from his revolving disks. But how far were these deductions directly applicable to painting, which, as Rood himself emphasised, relied upon three different primaries from Maxwell's? He followed Helmholtz in rejecting Brewster's advocacy of red, yellow and green primaries for light as for pigments, dismissing Brewster's evidence on the grounds that it relied upon an 'impure spectrum' contaminated by stray white light.[210] He also followed his German predecessor in distinguishing between that we call the additive primaries for light and subtractive primaries for pigments, a distinction towards which Turner had been groping in his diagrams of 'aerial' and 'material' colours. However, Rood considered that the data for coloured light were directly applicable to painting in that 'the larger proportion of natural objects act on our natural organs by means of reflected light'. Since light is also reflected from painter's pigments the effects may be considered as comparable. Nature and the artist thus 'both paint with light'.[211]

The painter can best achieve the goal of painting with light by utilising optical mixtures in preference to the duller pigment mixtures:

> different colours are placed side by side by lines or dots, and then viewed at such a distance that the blending is more or less accomplished by the eye of the beholder. Under these circumstances the tints mix on the retina, and produce new colours, which are identical with those that are obtained by the method of revolving disks.[212]

At an intermediate viewing distance, before complete blending is acomplished, 'the surface seems to flicker or glimmer', as previously recorded by Dove.[213] If the juxtaposed colours are close to each other in the contrast diagram, the effect will be akin to transparency, while opposite colours will give an impression of lustre.

The complex and evanescent effects of colour in nature can only be portrayed by such optical means. Grass, for example, exhibits 'yellowish-green, bluish-green, reddish, purplish and brown tints, and the glancing lights blend more or less together, and produce an effect which cannot be reproduced in a single sweep of the brush'.[214] The painter should exploit the techniques of gradation and broken touches of colour as practised by Turner and commended by Ruskin. 'This method is the only practical one at the disposal of the artist whereby he can actually mix not pigments but coloured light.'[215] Although the principles laid down by Rood established the basis for Seurat's 'peinture optique', his own artistic attitudes were relatively conservative. It was Turner, Ruskin's own hero, to whom he looked for 'painting with light'. He hated the works of the Impressionists when he saw them in Paris, and it is difficult to believe that he would have liked the art of 'Neo-Impressionists' any better. Posterity, however, has not

allowed Rood to disown his artistic heirs in France, Seurat in particular.

All the major elements in Seurat's 'peinture optique' can be found either in earlier theory or previous pictorial practice. What Seurat accomplished was to draw together all these elements, redefining his artistic goal in scientific terms and rigorously refining his technique to achieve optical effects. Solidly trained in the academic tradition and predisposed by temperament to rational analysis of his artistic aims, he adopted aspirations which contrasted sharply with the predominantly anti-theoretical stance of the Impressionists. His art may be said to be the result of applying principles of academic premeditation to Impressionist intuitions.

One of the authors who most assisted him in this respect was Charles Blanc, founder-editor of the *Gazette des Beaux Arts* and a particularly powerful voice in the 1860s and 1870s. Blanc wrote warmly and perceptively in the *Gazette* and elsewhere about Delacroix's colour, basing himself partly upon the master's own confidences and partly upon his reading of earlier treatises by Chevreul and Charles Bourgeois.[216] It was probably from Bourgeois's *Manuel d'optique . . .* (1821) that Blanc adopted the traditional and tenacious idea that the component primaries of white light are yellow, red and blue. Blanc's own colour diagram, in the form of a star (pl. 546) is a neat résumé of the well-established system of primaries, secondaries and complementaries. These ideas he applied to the analysis of Delacroix's art, developing Delacroix's own

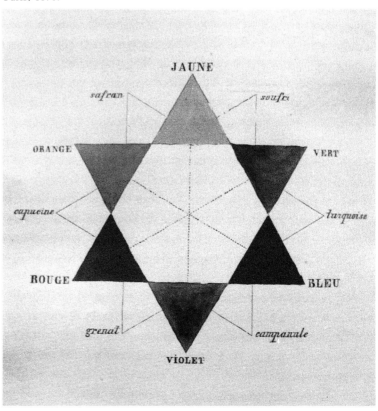

546. Colour Star from Charles Blanc's *Grammaire des arts du dessin*, 2nd edn., Paris. 1870.

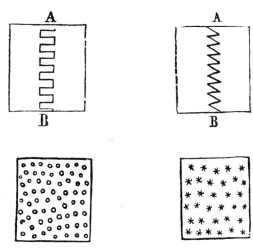

547. Arrangements for the production of optical mixture of colours from Blanc's *Grammaire*.

undogmatic principles in the direction of 'certain and invariable' laws—'mathematical rules'—akin to music.[217] Not the least relevant of his ideas for Seurat were his observations of optical mixtures, both in Delacroix's paintings and in more abstract arrangements of stripes, spots or stars (pl. 547).[218]

When Seurat and Signac looked at Delacroix's key late works, particularly the 'frescoes' in S. Sulpice, their observations were guided at least in part by Blanc. In 1881, at a time when he was showing an interest in Impressionist colour, Seurat made detailed notes on Delacroix's paintings. Signac's later comments in *D'Eugène Delacroix au néo-impressionisme* (1899) give a good idea of the kind of effects they saw:

> For the decoration of this chapel, he no longer painted with any but the most simple and pure colours. . . There is not a single fragment of the painting which does not vibrate, shimmer or glisten. Each local colour is pushed to its maximum intensity, but always in harmony with its neighbour, influenced by it and influencing it in turn.[219]

At the heart of Signac's polemical treatise is an elaborate collage of quotations from Delacroix's writings. By a system of careful editing, which borders at times on misrepresentation, he is able to show that Delacroix had advocated the major tenets of *peinture optique*. The result is an impressive if repetitious highlighting of those passages in the older master's writings in which he adopted his most analytical and systematic stance towards colour. We may suspect that Delacroix would have recognised the words but not the ultimate end to which they were being put by Signac. Seurat and Signac coupled their reverence for Delacroix with a devotion to Chevreul. In 1884 they visited the 98-year-old chemist to pay their homage to the man they regarded as the father—or, by this time, the great-grandfather—of French colour theory.

It is generally impossible to isolate with confidence from which source Seurat gleaned a particular aspect of his theory, since much of the scientific and semi-scientific literature known to him dealt with a common set of basic ideas. We may

suspect that Rood was not his exclusive source for these ideas. For the phenomenon known as irradiation, that is to say the 'haloes' around bright areas, the Swiss aesthetician David Sutter may have played a prominent role, but he is not the only possible influence in this respect.[220] The newly developed and developing techniques of colour photography and colour printing, particularly 'chromotypogravure' in which the dots of the half-tone screen are used to produce grainy colour, may have encouraged him to pursue his pointillist methods, but are unlikely to have been major causative factors behind his style.[221] For concepts of contrast and harmony, Chevreul is obviously of key importance, but he is not the only author Seurat consulted in the field of tapestry design. Jules Persoz's brilliantly illustrated *Traité de l'impression des tissues* attracted Seurat's attention, to the extent that the painter transcribed a section of its text.[222] There was also much interest in oriental colour usage, in theory and in practice.[223] The general impression is that Seurat avidly consumed writings on colour, turning a variety of apparently diverse ideas to his own coherent account.

If the relative priority of his sources is hard to disentangle we can at least study his gradual implementation of the ideas as he welded them into a functioning system. The key works are his *grandes machines*, the *Baignade, Asniéres* painted in 1883–4 (though retouched in the later 1880s), and *Un Dimanche à la Grande Jatte*, the product of intense work during 1884 and 1885.[224] The greater part of the *Baignade* (pl. 548) is executed in interwoven brushstrokes, often disposed in a criss-cross *balayé* technique. This is used to build up a densely clotted surface (reminiscent of Delacroix at S. Sulpice) within which he has exploited a series of optical techniques. Most conspicuous are the 'irradiated' contrasts of tone and hue at the edges of many of the prominent forms, with light haloes of complementary tints fringing the dark areas, and dark 'ghosts' hovering beside the lighter forms. The local colours are consistently broken by tonal gradation in the Delacroix manner, and as recommended by Rood and Ruskin. Blue, the complementary of the impinging sunlight, is brushed into many of the shadows, in the pink flesh no less than in the white draperies. The white surfaces also display the subdued influence of back reflections from the grass. These adventitious colours are partially blended with the local colours in the greater part of the picture. The more obviously 'advanced', pointillist passages should be attributed to his later reworking of the surface. Already, there is a sense that the prismatic scintillations of Impressionism are being absorbed into a world of poised contemplation worthy of Puvis de Chavannes or Piero della Francesca. However, the effects of '*peinture optique*' are not fully apparent throughout the *Baignade*, and he was still using earth colours as important elements in its tonal structure, in a manner already abandoned by the Impressionists.

La Grande Jatte (colour plate XV) went substantially further in resolving these inconsistencies. It was the product of an extraordinarily sustained campaign of work. Some twenty-three preliminary drawings have survived, together with thirty-eight painted studies in colour.[225] These studies deal with an extraordinary range of visual questions: the transmogrification

316

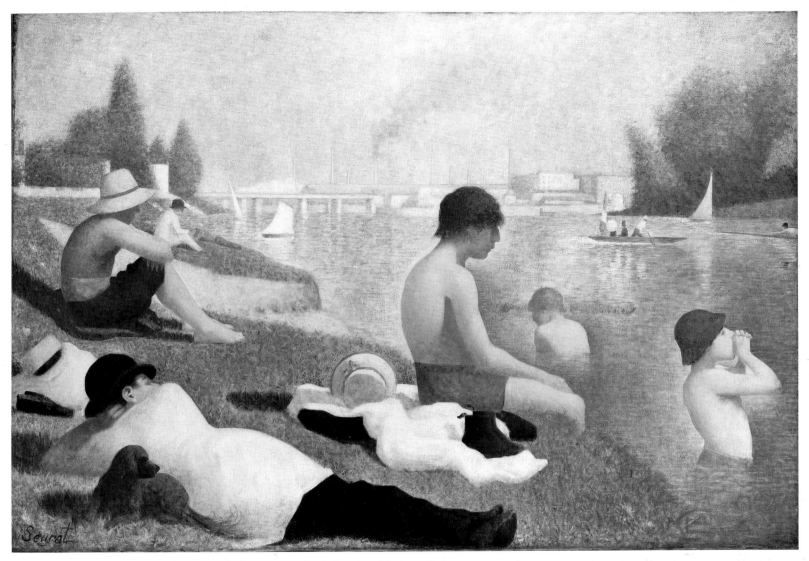

548. Georges Seurat, *La Baignade*, 1884 (with later retouching), London, National Gallery.

of shapes with distance; the dissolution of forms into patterns of coloured light; the tonal foundations of form; and silhouetted areas of contrasted *chiaroscuro*. Encouraged by Paul Signac, he has eliminated earth colours and begun to arrange the pigments on his palette in a prismatic sequence.[226]

No painting was ever more pondered. In some areas there is a suggestion of a 'basket-weave' technique close to the *Baignade*, but the dominant effect is that the surface is dressed overall with Seurat's remarkable and novel application of paint in a series of small spots, short dashes and separate strokes. Examined carefully, Seurat's technique at this stage appears to be less a consistent 'pointillism'—in which the surface is compounded evenly from regular dots—than a complex mixture of directional brushstrokes, which define form almost in the manner of magnetised iron filings, and short dashes of colour at varied angles which evoke the scatter of coloured light. There are even some signs of conventionally outlined contours. The system is emergent rather than fully resolved in *La Grande Jatte*. From Seurat's own recorded hints and the fuller

account by his keenest advocate, Félix Fénéon, we know that he was striving towards a fully rational orchestration of optical effects. The chief of these were:

1. Gradated local colour
2. 'Solar orange' in the highlights, scattered by diffusion in the shadows and reflected from form to form
3. Reflections of local colour from one surface to another
4. Induced complementary contrasts of hue and tone, particularly in the shadows
5. Harmonies of contrast and analogy of hue and tone according to the specifications of Chevreul and Rood.[227]

To evoke these phenomena Seurat has endeavoured to exploit the optical mixture of discrete touches of intense colour. He intends that optical mixture, so long a part of the colourists's art in theory and practice, should cease to be a partial, haphazard or intuitive process, and should now provide the systematic foundation for all the colouristic effects in a painting. As Fénéon stressed, the resulting effects should be supe-

rior in luminosity and lustre to those achieved by the normal practice of mixing pigments on the palette:

> One has . . . not a mixture of coloured pigments but a mixture of coloured light. . . It is known that the luminosity of optical mixture is always much greater than that of pigmentary mixture, as the numerous equations for luminosity established by Rood show.[228]

Written in 1886, the year in which *La Grande Jatte* was exhibited, Fénéon's views may be taken as a substantially reliable guide to Seurat's beliefs. Seurat's own notes suggest that he regarded retinal retention—as in Rood's experiments with Maxwell's revolving disks—as responsible for the fusion of light from his static points of colour.[229]

If we look at a detail of the picture (colour plate XVI) we can see how Seurat's system is expressed in practice. All the local colours are gradated—broken up by discrete touches of different tonal and chromatic values. The dominant hues of the shadows are the darker complementaries of the light, but he has taken particular care to retain an effect of subdued vibrancy in the shadows through a scattering of points of reflected colour. On either side of some of the boundaries between light and dark colours he had added darker and lighter dots or strokes to evoke the effects of 'simultaneous contrast' in tone and in hue, though this procedure is not adopted consistently throughout the painting. Scrutinised closely, Seurat's technique at this stage is more variable than the standard accounts of *La Grande Jatte* suggest, and contains passages which are as much 'impressionist' as 'pointillist'.

The effect for the spectator obviously varies according to viewing distance, ranging from a point at which the dots, dashes and strokes are separately discernible, through an intermediate stage in which a kind of optical oscillation takes place, to a total fusion in which the juxtaposed complementaries largely neutralise each other. It may be argued, and has frequently been, that this tendency towards a general neutralisation at increasing distance—producing a kind of dusty veiling of colour—marks the ultimate failure of Seurat's *peinture optique*. In as much as his canvases can never achieve a combination of luminosity and saturation which is comparable to actual light sources, this is true. But one of the main points of his method was that the neutral tones should exhibit a subtle, deliquescent radiance, because there are no dull grey pigments actually present. The effect of *La Grande Jatte* in the original may be less luminous than Seurat hoped and Fénéon claimed (particularly as the pigments dull with age), and it certainly sacrifices the excitement which can be generated from brilliant areas of saturated local colour, but it does achieve a special kind of elusive magic. This magic bewitched a wide range of followers in almost all the European countries.

Seurat's next two major works deliberately tackled problems of lighting which posed different challenges from the outdoor sunlight of *La Grande Jatte*. *Les Poseuses* displays an interior in which the highest light is necessarily less intense—and, therefore, somewhat less beyond the scope of his pigments—while *La Parade* explores the displaced colour scales caused by gas light.[230] The shift in colour-balance caused by artificial light sources had been effectively discussed by Rood, who may well have whetted Seurat's appetite for such effects. The painter's adoption from *c*.1885 of coloured borders around the edges of his canvases, together with specially tinted frames, also appears to derive from his reading —in this case from Chevreul's treatise.[231] Using the principles of simultaneous contrast, the predominantly dark-toned boundaries were designed to throw the hues and tones of the painting into luminous relief. As Seurat himself indicated, 'the frame is in a harmony opposite to that of the values, hues and tones of the picture'.[232]

Although Seurat's paintings following *La Grande Jatte* are even more thorough in their use of the *'petit point'* in the structure of the painting, they also mark the beginning of the increasing abstraction of his technique from observed sensations. A clear symptom of this progressive detachment from the seen object is the marked decrease in the number of preparatory studies devoted to the exploration of natural effects. Compared to the thirty-eight surviving colour-studies for *La Grande Jatte*, there are four for *Les Poseuses*, three for *La Parade*, one for *Le Chahut* and none for *Le Cirque*.[233] His later works were made directly on the basis of pre-determined principles, which were not primarily aimed at empirical naturalism. This abstraction is due to his interest in a different kind of design theory, a theory which envisaged the harmonic, dynamic and psychological effects of colour and line in the context of an abstract system of expression akin to music. He increasingly regarded colours as having specific emotional connotations which artists could exploit in relation to the subject:

> *Gaiety of value* is the light dominant; of *hue* the warm dominant; of *line*, lines above the horizontal. Calmness of value is the equality of dark and light; of hue, of warm and cool; and the horizontal for line. Sadness of value is the dark dominant; of hue, the cool dominant; and of line, downward direction.[234]

The dominant influence at work here is that of Charles Henry, a remarkable 'Neo-Renaissance' man of science and art, who exercised a magnetic attraction for not a few young artists during the 1880s.[235] Henry was attempting to build an all-embracing scientific aesthetic on the foundations of psychophysics, the new science of the mind which seemed to promise tremendous rewards in a wide range of medical and artistic endeavours.[236] He believed that every aspect of aesthetic reaction—however apparently irrational—could be subjected to systematic analysis in terms of the perceptual dynamics of the human senses and brain. These techniques would extend to the age-old mysteries of Pythagorian harmonics, to the expressive music of colour, to the orchestration of visual rhythms, and, indeed, to every effective and affecting aspect of a work of art. The foundation of his analysis was a mathematical system of proportional harmonics of considerable sophistication and complexity. This system ultimately reflected the cosmological powers underlying nature as a whole.

To some extent Henry stands as heir to the great classical and Renaissance thinkers who attempted to forge all-embracing, cosmological systems of proportional harmonics,

and he undoubtedly saw himself as working in the spirit of Leonardo, whose manuscripts he was helping to publish for the first time. Where he differed crucially from his predecessors—and this is where he marks the effective chronological limit of this present study—is that his ideas no longer orbit around a central body of empirical naturalism. At the centre of Leonardo's ambitions was an unshakeable belief in the visual analysis and recreation of nature. At the centre of Henry's system lay the responses of the senses and the mind which comprised a new kind of psychological reality. This new thrust leads us away from the tradition of optical observation with which we have been predominantly concerned in this book, and clearly lies outside our present scope. However, I think it might be worth looking briefly at his ideas on colour to give at least some idea of how he and Seurat begin to step outside our immediate field of enquiry.

Henry identified the 'warm' and 'cold' poles of his colour wheel with 'dynamogenous' and 'inhibitory' forces, much as Field and Goethe had identified 'positive' and 'negative' properties in opposing colours.[237] In his wheel, orientated with red at the top, each colour is specifically associated with a linear direction, which in itself evokes a particular emotional response. Orange, for example, corresponds to lines moving upwards to the right and provides an extremely 'dynamogenous' effect on the mind, while blue in the opposite direction stimulates feelings of sadness and inhibition. What he was attempting to formulate was an emotional 'physiognomy' of line and colour. With respect to line, this idea was closely related to traditional physignomics, and we have seen in Chapter V that Humbert de Superville and Blanc advocated an 'abstract' way of reading the configurations of lines on the face according to the inherent expressiveness of their directions (pl. 490).[238] With regard to colour, his expressive system bears a clear affinity to older views of colour signification and most particularly to ideas of colour music. However, Henry was attempting to place his ideas on a far more elaborate and precise base, relying upon the minute sensitivity of the mind to abstract relationships. These relationships could only be fully expressed in mathematical terms. To guide the artist in the practical application of his abstruse mathematics, he designed an 'aesthetic protractor' (pl. 550) which could be used to calculate expressive angles with complete precision.[239] Seurat's later works, in the short period between the completion of *La Grande Jatte* and his death in 1888, are deeply suffused by such ideas, as are the paintings of Signac for a short but intense period.[240] Seurat does not follow Henry's theories slavishly, any more than he had unreservedly followed the earlier theorists, but the prevailing aesthetic in his later paintings can be confidently identified with Henry's psychophysical abstractions, in contrast to the nature-based optics of the *Baignade* and *La Grande Jatte*.[241]

The Neo-Impressionist Seurat of *La Grande Jatte* endured for no more than three or four years. His moment of '*peinture optique*' as a system founded upon meditated empiricism was shortlived. Perhaps he had sensed the stultifying limitation inherent in the mechanical repetition of his formula—limitations which became all too apparent in the hands of his less imagina-

549. 'Aesthetic protractor' from Charles Henry's *Rapporteur esthétique*, Paris, 1889.

tive imitators across Europe. But the brevity of the moment belies its quality. It represents the culmination of the post-Newtonian attempts to paint with light and indeed the climax of all the efforts to marry the science of colour to the colourist's art. This climax, for all its foundations in scientific observation, took place within the thoroughly artificial framework of what can best be described as frozen or petrified naturalism. The style of *La Grande Jatte* bears its own highly individual witness to the ultimate impossibility of capturing simultaneously all the visual variables in the medium of paint.

Faced with the limitations of his pigments on a two-dimensional surface, the painter has to choose consciously or unconsciously which of the variables or which limited combination of them he will attempt to exploit most fully in his attempts to parallel the perceived effects of the natural world. In striving to capture the variables of optical colour mixture, Seurat has knowingly suppressed effects of texture, greatly reduced the full variety of detail in the tonal modelling of form, eliminated a large measure of implied movement, and stilled our reading of space. Such a wholesale suppression of visual effects, even in an art which aspired to his idiosyncratic form of synthetic and harmonic naturalism, could not remain unchallenged—and nor did it, even in Seurat's own work. In *La Grande Jatte* he has begun to split illusionistic painting into its component parts, exulting in one component while radically simplifying the others. In so doing he played his own particular role in helping to precipitate the crisis which was to shatter the fragile fabric of naturalistic art, the fabric which had been so painstakingly built during the course of the preceding five centuries.

PICTURES MADE BY COLOURED LIGHT: A PHOTOGRAPHIC OBITUARY FOR THE SCIENCE OF ART

The preceding account of colour science in art has concentrated almost exclusively on how theorists and artists inter-

preted the theory of physical colours—coloured substances and coloured lights—and has given little attention to the physiology of the eye and perceptual mechanisms. This concentration certainly does not mean that the physiological and perceptual questions were ignored in the scientific literature during the periods under examination. Indeed, disputes between partisans of the Cartesian, Newtonian and other views of the physical properties of light and its action on the retina occupied a prominent place in the scientific writings. However, in the literature on colour as it actually affected art theory and practice before 1800, the physiological and perceptual questions seem at best to have been ancillary issues. In specialist art theory, these questions rarely enter consideration at all. Of all the pre-nineteenth century scientific theorists who specifically addressed the problem of colour in art, Count Algarotti paid most sustained attention to the Newtonian and Cartesian ideas concerning the physical aspects of colour sensation, but even he was unable to draw from his discussion any specific consequences for the way in which the painter should proceed. Individual painters may have been aware of the physical theories of impulse and sensation—a few of them may even have been keenly interested—but our concern throughout has been to look at ideas that could effectively influence the procedures which went into the making of a painting. On these grounds, the opthalmological and perceptual considerations with respect to colour seem to have exercised far less effective significance than they exercised in relation to the understanding and representation of space.

This is not to say that earlier theories were unconcerned with phenomena which presupposed some special properties of the eye. The techniques of optical mixing, recognised so clearly by Aguilonius, generally required that the eye should itself accomplish the combining of the sensations. Similarly, the effects of such subjective colour phenomena as afterimages clearly indicated that something special was happening to our perception of colour, with respect either to the eye itself—as was normally assumed—or to our mental interpretation of sensation. However, no developed theory of the physiological and perceptual mechanisms appears to have played a significant role in any functioning system of colour in art before the nineteenth century. When subjective colour phenomena began to play a more prominent role in art theory, most notably in the writings of Goethe, the intellectual context seems to have been more concerned with the philosophical 'psychology' of perception, in the wake of Kant, than with the physiology of the retina. Amongst the theorists we have encountered, the most open attempts to apply Kantian epistemology to the perception of colour as it affects artists occurred in Richter's doctrine of obedience to the 'seeing' of visual sensations, and Humbert de Superville's elaborate cosmology of visual signs.

During the course of the nineteenth century theories of retinal function gained increasing success in explaining the phenomena of colour vision, culminating in the work of Helmholtz. The ideas on colour current in the circles of Pre-Raphaelitism and Impressionism rely upon some kind of conception of a coloured image 'painted' on the retina and pre-suppose a world of coloured sensations that can be fruitfully pursued. This is to assume that the artist can actually evoke some form of direct interplay between stimulus and sensation rather than portraying what he knows or is preconditioned to see. However, as I have suggested when we looked at Ruskin and at Impressionist painting, these ideas breathe an air of popular assumption—tinged with philosophical concepts—and are not founded upon a developed awareness of the most sophisticated perceptual and physiological thinking at this time.

I think it is probably only with the direct impact of Helmholtz and Rood on Seurat that we can be reasonably confident that a practising painter knew enough about advanced theories of the physiology of vision and sensation to adduce them in detailed support of his pictorial practice. And, even here, the physiological ideas were secondary for the practising artist and were rapidly engulfed by the psychophysics of Charles Henry.

There was, though, one area of representational activity in which scientific concepts of the reception and perception of different colours in the eye played a genuinely determining role, namely colour photography. The invention of colour photography by James Clerk Maxwell in 1861 was entirely predicated on a three-colour and three-receptor theory of colour vision.[242] Maxwell's ideas were developed from generally neglected aspects of Thomas Young's optical researches during the early years of the century, and were in their turn to provide the foundation for the Helmholtz theory, which was itself comprehensively adopted by Rood and successive generations of scientists. In this brief postscript, I do not intend to provide a detailed account of the invention and perfection of photography in colour, but rather to see how the Young-Maxwell theory of retinal receptors directly conditioned the birth of colour photography—in contrast to the way in which it cannot be seen to have radically affected the practice of painting.

Thomas Young, renowned as the proponent of the wave theory of light, formulated his three-receptor theory in two main stages, as published in 1802 and 1807.[243] The basis of his complicated arguments ran as follows. He reasoned that 'the sensation of different colours depends on the different frequency of vibration excited by light on the retina'.[244] The different frequencies would be picked up by the resonant vibration of particular particles in the retina in response to specific frequencies. The spectrum was continuous and contained an infinite number of differently coloured rays, but it was impossible that the retina could contain an infinite number of types of resonator. A limited number of receptors must therefore be able to simulate the complete range of effects. The theory of primary colours had shown that only three colours were required for the full range. Thus only three different kinds of receptors are needed in the eye. In the first phase of his theory, not surprisingly, he adopted the painter's traditional primaries, assuming that each receptor is specially attuned to red or yellow or blue light. In formulating this scheme, he appears to have been well informed about primary theories, including those of Mayer and Lambert. The major innovation in the second

phase of his theory was the revision of the 'three simple sensations' of coloured light into red, green and violet.

An important challenge to the standard primaries had already been made in 1792 by Chrétien-Ernst Wünsch, who argued on the basis of experiments with colour mixing that the primaries for light were red, green and violet.[245] He correctly recorded, for instance, that red and green lights are responsible for compounding yellow. A similar argument was developed in 1802 by Wollaston, the inventor of the camera lucida. Wollaston's careful studies of the spectrum convinced him that there were four basic colours, red, green, blue and violet, and that spectral yellow resulted from the overlapping of the red and green bands.[246] It seems likely that Wollaston's ideas influenced Young to undertake further investigations on his own account, with the result that he adopted the primaries of red, green and violet, and 'binary combinations' of yellow, crimson and blue.

There are a number of possible reasons why Young's theory gained little immediate prominence. One significant factor was that it lacked an entirely satisfactory base in empirical evidence. Perhaps the major reason was that it simply appeared to be yet another three-colour theory at a time when such theories were beginning to abound. The inherent inconsistencies in Newton's theory of primaries and mixtures, above all his traditional equation of pigmentary and luminous compounds continued to cause severe problems after 1800. A number of more-or-less effective attempts were made to show that the experimental results were consistent with the presence of the *three* standard primaries.

The advocates of three-colour theories included Mary Sommerville, who was personally acquainted with Turner, and James Sowerby, whom we have briefly encountered for his possible influence on the great painter. Sowerby, who made a distinguished career for himself as a scientific illustrator and botanist, undertook a series of observations of colour in nature, somewhat similar in result to those of Goethe.[247] Studying such phenomena as the interference in laminae of gypsum and looking at black bands on white paper through a prism, he concluded that Newton's seven prismatics could be regarded as the product of red, yellow and blue alone. He also noted that bands of black of different width viewed through a prism produced variations in hue and proposed a device for measuring colour—a 'chromatometer'—based upon the width of black required to produce the effect of a particular colour.

The Rev. Matthew Young in Ireland and Claude-Antoine Prieur in France, the latter of whom selected the less common primaries of red, green and violet and whose work was known to Sowerby, also made vigorous cases for three fundamental colours. The most impressive of all the systems—and one which held most sway for a decade or two—was the tri-colour theory of Sir David Brewster, whose ideas we outlined when looking at the context for Turner's colour science (pl. 525). Brewster's revision to the Newtonian scheme was supported keenly by a distinguished group of colour theorists in his native Scotland, including James David Forbes, who was to provide vital early encouragement for the young Maxwell.

It is not surprising to find that Maxwell in his early years in Scotland before 1850 inclined towards a three-colour system of red, yellow and blue. However, between 1855 and 1860 he published a set of five papers in which he explored and adapted Thomas Young's three-receptor theory, using Young's second set of primaries.[248] Maxwell's observations and measurements, using the spinning disks associated with his name (pl. 541) and a colour box in which he could combine spectral colours in a controlled manner, gave vital experimental support to Young's hypothesis. The importance of Maxwell's work to our present concerns is that he used his revised version of Young's hypothesis in his 1855 paper to propose a system of colour photography, though at this stage his proposal was theoretical rather than practical. Six years later, on 17 May 1861, during the course of a lecture 'On the Theory of the Three Primary Colours' at the Royal Institution, Maxwell showed by practical demonstration how to achieve the effect of colours in photography.[249]

> Three photographs of a coloured riband, taken through the three coloured solutions respectively [i.e. through red, green and blue filters], were introduced into the camera [i.e. a projecting lantern] giving images representing the red, the green and the blue parts separately, as they would be seen by each of Young's three sets of nerves separately. When these were superimposed, a coloured image of the riband was seen, which if the red and green images had been as fully photographed as the blue, would have been a truly coloured photograph of the riband. By finding photographic material more sensitive to the less refrangible rays, the presentation of the colours of objects might be greatly improved.[250]

In fact, Maxwell was lucky to achieve results as good as he did. The photographic emulsion used for the red plate, for example, was actually sensitive to ultraviolet rays, and by a happy coincidence the red portions of the ribbon and the red filter were responsible for the transmission of ultraviolet radiation which was recorded in the 'red' photograph.

Physico-chemical problems were to dog the early attempts to produce a truly practical system of colour photography. The most attractive possibility was to find a direct method, that is to say, one based on a single light-sensitive chemical that would react to red light to produce a red pigmentation and so on. Sir John Herschel, amongst others, had noted that it was possible to obtain colour effects directly with silver chloride, but his initially promising results represented just one of many false dawns in the search for a direct process that could produce a full colour range in a truly stable photograph.[251] The foundations for the major practical forms of colour photography by additive and subtractive colour mixture were laid down in France in the years immediately following Maxwell's demonstration by Louis Ducos du Haron and Charles Cros.[252]

Du Haron is particularly important in that his fertile and inventive mind lead him in his demonstrations and writings, particularly his *Les Couleurs en photographie* (1869), to anticipate most of the main feasible methods of colour photography and printing. He not only created additive systems for pro-

jected colour photographs, like Maxwell's but also a subtractive method that resulted in coloured prints on paper:

1. We obtain by the aid of the photographic camera three negatives of the same object, the first negative through a green coloured glass, the second negative through a violet coloured glass, and the third negative through orange-red glass.

2. The transparent positives are made by the pigment or a similar process by the aid of chromolithography, Woodburytype, or by a toning process. From the first negative a red print is made, from the second a yellow print and from the third a blue print. When the three monochromes are thus combined, we obtain a finished print which is a polychrome reproduction of nature.[253]

Although the necessary chemistry and suitable photographic cameras continued to present enormous problems, Du Haron has, in theory at least, exploited his understanding of the primaries for coloured light and pigments to achieve the full-colour prints for which Le Blon had been striving one hundred and fifty years earlier. In addition to the superimposition of coloured plates, Du Haron also considered using the time-honoured technique of optical mixture:

We imagine the whole surface of a piece of paper covered alternatively with extremely fine lines of red, yellow and blue of equal size, with no space between them; when viewed at close range the three-colour system of lines can be distinguished, but seen from a distance they merge into a single colour tone, which when viewed when looking through a transparent medium will appear white, but when viewed on an opaque background will appear gray if none of the three colours predominates.[254]

This optical mixture by thin lines is the same as that illustrated by Sowerby and Blanc, and is related in optical principle to the method that Seurat was to adopt.

The advent of colour photography, which was capable of achieving truly striking effects by the early years of this century, meant that a mechanical method of imitating nature appeared to be capable of producing those illusionistic effects for which the proponents of the science of art had striven for so long and with such intellectual effort.

It would be a gross oversimplification to say that photographic realism precipitated the demise of systematic naturalism as the goal for the creative painter. Indeed, in the light of our earlier discussion of the 'causes' of photography, it is possible to regard its invention as a consequence of the terminal stages in the mainstream tradition of artistic naturalism rather than as the prime agent of its destruction. A number of forces that were to weaken the fabric of naturalism were already apparent in the tradition we have been describing. Not the least important of these was the very success of the naturalistic techniques themselves, which had reached levels of verisimilitude beyond which it seemed impossible to go in the medium of paint. There was also the time-honoured feeling that literal or mechanical imitation should be subordinate to the higher intellectual and emotional functions of art—a feeling that had developed in the nineteenth century into the subjectivist aesthetics of Romanticism. We have also seen that philosophical and psychological theories of visual perception had seriously weakened confidence in the direct relationships between seeing, knowing and representation. Additionally, by the turn of the century, new visions of science were beginning to shake the foundations of classical space, time, mathematics and physics. Although I do not subscribe to the view that such new ideas as relativity played a formative role in the avant-garde styles of fragmented form in Cubism and related movements, the scientific ideas in more-or-less popularised forms did reinforce the conviction that new styles of human art were needed for the brave new age.

However, even if photography arose almost as a by-product of processes already in train within the naturalistic tradition, the extraordinary efficacy of photographs in the imitation of nature undoubtedly allowed them to usurp one of the main functions of the science of art. And when, in the hands of masters such as Hill and Adamson, photography assumed the guise of 'Art' in its own right, it seemed to threaten the traditional skills of the representational artist on more than a purely imitative plane. Photography thus stands as an appropriate climax and as a suitable end to the story we have been telling.

I. Andrea Mantegna, *Madonna and Child with Saints John the Baptist and Mary Magdalene*, *c.*1495, London, National Gallery.

II. Leonardo da Vinci, *The Virgin of the Rocks*, *c.*1495–1506, London, National Gallery.

III. Peter Paul Rubens, *Juno and Argus*, 1611, Cologne, Wallfraf-Richartz Museum.

IV. (following page) Peter Paul Rubens, *The Blessings of Peace*, 1630, detail, London, National Gallery.

V. Nicolas Poussin, *Ecstasy of St. Paul*, 1650, Paris, Louvre.

VI. J.C. le Blon, *Stage Two and the Final Stage in the Colour Printing of a Woman's Head* from *Coloritto or the Harmony of Colouring in Painting*, *c*.1720, London, British Museum, Print Room.

VII. Philipp Otto Runge, *Morning* (small version), *c*.1808, Hamburg, Kunsthalle.

VIII. Philipp Otto Runge, *Colour Sphere*, 1809, Hamburg Kunsthalle.

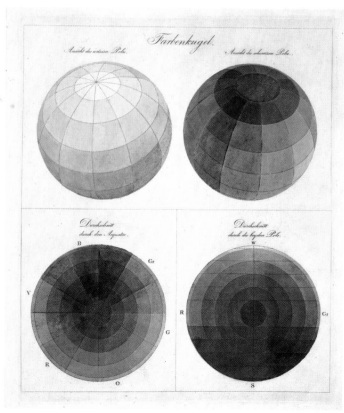

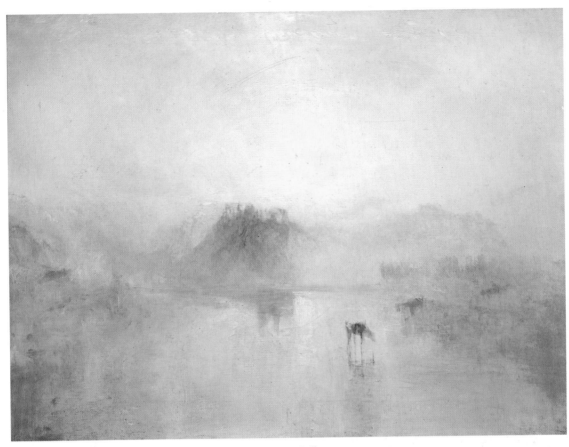

IX. J.M.W. Turner, *Norham Castle*, 1835, London, Tate Gallery.

X. J.M.W. Turner, *Shade and Darkness—the Evening of the Deluge* (left) and *Light and Colour (Goethe's Theory)— the Morning after the Deluge* (right), 1843, London, Tate Gallery.

XI. William Holman Hunt, *Our English Coasts ('Strayed Sheep')*, 1852, London, Tate Gallery.

XII. Eugène Delacroix, *Moorish Interior*, watercolour from North African Notebook, *c*.1832, Paris, Louvre, Cabinet des Dessins.

XIII. Eugène Delacroix, *Expulsion of Heliodorus*, 1849–61, detail of Heliodorus, Paris, S. Sulpice.

XIV. Monet, *Woman with a Parasol*, 1875, Washington, National Gallery, Mellon Collection.

XV. Seurat, *La Grande Jatte*, 1886, Art Institute of Chicago.

XVI. Seurat, *La Grande Jatte*, detail.

Coda

The contemplation of the laws of the universe is connected
with an immediate tranquil exaltation of the mind and pure
mental enjoyment. The perception of truth is almost as sim-
ple a feeling as the perception of beauty. . . The love of
nature is the same passion, as the love of the magnificent,
the sublime and the beautiful.

(Sir Humphry Davy).[1]

A coda not a conclusion—not least because I should prefer to
think that our study of the intricate interplay between optical
science and the visual qualities of naturalistic art opens up
a host of issues rather than closing down questions with de-
finitive answers. I hope, however, that any doubts about my
gross hypothesis, which stated that there was a specially direct
relationship during this period between the aspirations of
'artists' and 'scientists' in their visual understanding of the
rules behind natural effects, have been largely allayed by the
sheer volume of material. Even if the evidence in a percentage
of the cases is less secure than we might wish, the numbers in
which we can look to direct testimony of the scientific aspira-
tions of artists and theorists is very remarkable when accumu-
lated even on a necessarily selective basis over the years
embraced by this study. The quality of the minds—artistic and
scientific—who were convinced that there was a science of art
is equally impressive.

The kind of analysis offered in this study has been predomi-
nantly descriptive, and may be termed a form of intellectual
'pointing'. This approach, with its positivist qualities, conveys
an air of objective induction from the available evidence, in a
manner that would have been recognisable to the scientific
community in the eras with which we have been concerned. In
this coda, I should like to acknowledge not only that this
approach has clear limitations with respect to the questions it
can address, but that it is more directly founded upon a series
of assumptions and values than its air of objective sobriety
may suggest. In making such an acknowledgement, I am not
in any sense apologising for the approach, since I am con-
vinced that it provides the basic tool for the historian—
provided that the historian and the reader remain aware of the
nature of what can and cannot be accomplished.

The central question I have been asking relies on an assump-
tion that my gross hypothesis is valuable. This assumption is
compounded from a series of beliefs, the most central of which
is that works of art are fundamentally though not exclusively
shaped by the conscious intentions of their creators, and that
the written evidence of these intentions has a high value
amongst the interpretative strategies available to us. The kind
of evidence I have been using for the most part only assumes
historical relevance in relation to my assumptions. In this coda
I intend to suggest how my assumptions, hypothesis and
evidence relate to other kinds of question which can most
obviously be asked of my body of material as a whole. I intend
to deal with three of these.

The first, and most historically orthodox of these questions,
concerns the explanation as to why there should be so much
shared ground between visual art and optical science in this
particular period. In other words, what explanatory causes can
be assembled? The second question concerns the status of the
optical 'truths' with which our predominantly naturalistic art
has been concerned. On the surface, this question is not histor-
ical, but it cannot be disentangled from the interpretation of
the history, since our view of the visual status of the tech-
niques will radically affect where we look for our historical
explanation. If, for instance, we believe that orthodox per-
spective is no more and no less than an artificial convention
based on a manner of 'seeing' peculiar to a particular period,
we will formulate a different kind of explanatory model than if
we believe that it stands in some privileged relationship to
how the world is 'really seen' and that it was, like the law of
gravitation, waiting to be discovered. The third question is
perhaps the most intriguing of all. It concerns the relation-
ship between the products of what we call 'art' and 'science',
and embraces a complex series of philosophical-cum-
psychological issues. If a work of art is made on a scientific
base, does it differ from a science? Are the artistic and scientific
imaginations to be equated or separated? Can we talk of an 'art
of science' just as we have been repeatedly talking about 'the
science of art'? This third area for investigation is, like the
second, deeply enmeshed with historical concerns, since we
cannot automatically assume the answers have some kind of
eternal verity, as if the concepts of 'art' and 'science' are defin-
able outside their relative historical contexts.

It would be misleading to pretend that I can tackle these three questions adequately in this coda, but I think it is important to articulate them in such a way as to give substance to the assumptions behind this study.

SOCIETY AND CAUSATION

All art and science occur in the context of specific social structures. The parameters for the action of even the most innovative individual are set by the material circumstances. A Renaissance artist, for example, could not have survived by producing 'Art' for its own sake—there were no teaching posts in art schools, no Arts Council bursaries and no unemployment benefits. The making of a product with a specific function, such as an altarpiece, is inescapably a part of the fabric of that product, and, as such, available to the historian for analysis from a social standpoint. The historical record of science, as we are increasingly coming to realise, can similarly be made to yield information on the social circumstances of scientists and scientific institutions when we form an explanatory model for the practice of science. If we chose to ask a set of specifically social questions of the historical record, we will glean social 'explanations'. Such explanations have generally been absent from this study.

To some extent, this study has been doggedly old-fashioned, concentrating on the internal intellectual histories of optics and the art of imitation. The questions associated with such intellectual history clearly do not lead naturally into the evidence relating to the causal explanation of the roles of art and science in society. Indeed, many of my focuses of attention in the realm of art history emphasise works that are less obviously functional products than an altarpiece or decorative fresco. The creations which may be said to have initiated our main theme—Brunelleschi's demonstration panels—are a case in point. They were not, seemingly, commissioned works and fell outside the normal functions and genres of panel painting. An art of Brunelleschi's kind is ultimately responsible for the fact that the intellectual history of optical imitation can be told in its own right, not as hermetically sealed from other historical considerations but as having its own set of means and ends that are capable of successive extension, refinement and modification. Brunelleschi's step also serves to remind us that the individual artist plays a positive role in creating the parameters within which the works can come to be made and viewed.

During our discussion of Brunelleschi's invention, we looked at some of the technical factors that went into its composition, such as fourteenth-century aspirations to create geometrical methods for the constructing of naturalistic space, and the surveyor's system of proportional mensuration. We also characterised the personal 'style' of Brunelleschi's thought as reflected in his invention—ingenious, empirical, methodical and orientated towards specific problems capable of material resolution. I further served notice that there were other causative factors that would need to be taken into account. I specifically mentioned:

the growth of practical mathematics as fostered by a mercantile society; the interaction of the practical wisdom of the artisan-technologists with the humanist revival of ancient principles in the arts and sciences; and the particular ethos of Florentine society, in which her own varieties of Ciceronian rationality and measured assessment were placed in the service of civic life.

Faced with this (far from exhaustive) array of possible causes, where is the historian to begin? In a sense, you can begin with equal validity wherever you like. If you look, as has been done with great skill, for evidence of visual aptitude in mensuration as appropriate to a mercantile society, it can certainly be found and provides a telling visual-cum-intellectual context for the measured depiction of area of volume in Italian Renaissance art.[2] Yet such a context does not provide a sufficient explanation, since there were other societies in Europe, particularly in the Netherlands, in which the mercantile skills were cultivated with equal necessity but without the corresponding development of a 'measured' art. I suspect that each of my proposed 'causes' could be shown to be insufficient to at least a comparable degree. Indeed, I suspect the term 'cause' is itself at the heart of the problem, since it suggests a linear relation between cause and effect which ill corresponds to any real historical situation. What we are dealing with is a complex compound of necessary conditions, chance determinations, available resources, unavoidable constraints, contributory stimuli, individual inventiveness and so on. Each of these can be analysed as if it is a 'cause' and will direct attention to a particular part of the surviving historical record in a particular way. The choice of 'cause' will be determined at least in part by the chooser's sense of values—intellectual, aesthetic, ethical, social, political etc.—though it is clear that the nature of the surviving historical record may render one or more of the choices arid in specific cases. Ultimately it is a matter of the historian's intuition as to where the weight of interpretation should be placed.[3]

My intuition when looking at the invention of perspective is to emphasise the striving for 'domestic' naturalism in religious art in response to new kinds of devotion as a necessary background condition for the notion that an illusion of how things appear was desirable. A key stimulus in determining that a precisely proportional system was used, rather than the highly effective but essentially non-mathematical method of Jan van Eyck in the Netherlands, was the annexing of classical aesthetic values, particularly the proportional system of architectural design and town planning. By contrast, mediaeval surveying or optics can be seen to provide available resources, but these resources only became relevant to the *painter* within a framework of new assumptions about the functions of what we call art.

The fact that Brunelleschi's demonstrations stood so far outside the normal function of painted panels helps explain the delay in the implementation of his methods in a standard context. It took artists of real insight, Donatello and Masaccio, to extend the mental ends of their art so that the new means became accessible. In a sense, the whole of this study has been

concerned with the legacy of their insight, as successive generations of artists adjusted the parameters of art in such a way as to convert varied aspects of optical science into grist for their mills. This theme has its own special history, not in the sense that it is autonomous or has a uniquely privileged value in explaining the works of art, but in as far as it came to be recognised as an essential and codifiable component in the artist's intellectual and visual equipment.

This recognition and codification was, in keeping with my gross hypothesis, characteristic of Western art during the period 1400 to about 1880 at a level which was not shared with other periods and cultures. The period-specific nature of the particular brand of the science of art with which we have been dealing inevitably raises the question as to whether the optical techniques of Western illusionist painting were devoted to the production of conventional 'signs' rather than the making of images which have a superior and enduring veracity in representing the world of light as it is perceivable through our eyes.

SEEING AND SIGN[4]

We have seen that reservations about the extent to which canonical perspective can be identified with the way we see the world had been apparent almost from the first. Piero della Francesca's demonstration of wide-angle 'distortion' (pl. 32), and the various qualifying factors investigated by Leonardo were early instances of awareness that the synthetic construction used by artists exhibited optical shortcomings. The challenge to Abraham Bosse's mathematical dogmatism in seventeenth-century France from the proponents of 'natural vision' extended the doubts further, as did the alternative systems of upwards convergence and curvilinear perspective advocated in the nineteenth century. However, the really serious assaults on the value of perspective have not come so much from the optical challenges, which can be fought off or accommodated with a fair measure of success, but from the denial of the perceptual assumptions on which the earlier debates were founded. In its extreme form, this denial involves the abandonment of a stable set of common features in our perception and representation of the world, in favour of a series of relative 'realities' perceived differently in different cultures according to sets of social and intellectual structures. Each 'reality' and its corresponding representational system has its own conventional structure, and, therefore, its own arbitrariness.

I suspect that it is impossible to show whether the visual experience of, say, an ancient Egyptian was fundamentally like or unlike mine—any more than it is possible to demonstrate that when I 'see' yellow, my experience corresponds to yours when we look at the same sunflower. And I do not wish to deny that our process of 'seeing' is selectively directed and that such selectivity is necessary if some articulate sense is to be made of what is being seen. This selectivity is directed by a wide range of factors, from general cultural dictates to individual needs of the moment. Indeed, I would say that one of the special powers of the artist is to be able to reorientate our perceptions so that we see the world or some aspect of it

550. Ottaviano Mascherino and Lorenzo Sabbatini, Astrological ceiling, showing seated astronomers, 1575, detail of the vaulted ceiling of the Sala Bologna, Vatican.

through the artist's eyes. But I find it impossible to accept, on pragmatic and biological grounds, that no core of universally stable potentialities arises from the equipment with which man has been provided to make functional sense of the natural world. The potentialities may be realised in variant forms and with different relative weightings, but they are nonetheless common in their base. Without such a common base, I do not think that coherent communication about visual concerns would be possible between individuals, let alone between different cultures. If we are justified in thinking that there are some visual 'constants' in our perceptual processes, does illusionistic perspective correspond to one of them to a greater or lesser degree?

The strongest historical argument against perspective being identified with a basic perceptual experience is that it has featured in the art of such a historically and geographically limited range of visual cultures. Its limited distribution gives it the appearance of a convention or sign specific to a certain set of cultural values. It would thus be a system devoted to 'meaning' in the broad sense of the word rather than veracities of 'seeing'. This study has produced no shortage of evidence to suggest that the use of perspective by artists was deeply involved with 'meaning'. A particularly obvious example is Andrea Pozzo's identification of the ineffable 'vanishing point' with 'GOD'. Less literal but no less 'meaningful' uses of perspective occur throughout the periods with which we have been concerned. Mascherino's illusionistic setting for Danti's chosen array of astronomers (pl. 550) has an obvious formal function in the decorative scheme, but the way in which the geometry of the illusion is paraded obviously also possesses significance as a 'symbol' in the context of Danti's geometricising cosmology. Indeed, I have been at pains to emphasise that I set particular store by artists who have been able to use perspective in such a way that it plays an integrated role in a system communicative of meaning.

However, my acknowledgement that the appearance of the illusionistic techniques of Western art is highly period-specific and intimately linked to particular kinds of artistic meaning by no means disposes me to accept that it is simply a period-specific convention. Rather, I would reverse the argument, to say that it is because the making of visual images is always directed by the perceived sense of the function or significance of images as images that a very specific conception of 'art' as the systematic imitation of nature is required for any advanced techniques of illusionistic naturalism to enter consideration by the maker of the image. The elaborate technical means of illusionistic naturalism were won only by sustained effort by many artists over the years, and this effort could only be sustained if the functional goal remained sufficiently compelling. It requires a very special set of continuous circumstances for the achievement of the kind of naturalism lauded by Ruskin.

If we may accept—provisionally for the moment—that there are basic features of our perceptual system which permit the achievement of the systematic representation of nature in art, and that the achievement is dependent upon a period-specific conception of the function of art in relation to the whole system of cultural values, can we really characterise linear perspective as corresponding in a direct manner to one of these basics? Surely perspective is one of the most conventional of all visual techniques, positing a static, one-eyed artist and an equally static, one-eyed observer, stationed at precisely the right point in relation to the picture plane. Viewed in the normal kind of flexible context in which vision takes place, it becomes vulnerable to binocular vision (with its sense of parallax) and most especially the mobile viewpoint—sometimes with hilarious results, as when one of Danti's astronomers appears to be threatened by the collapse of Mascherino's illusionistic setting if viewed from an off-centre position (pl. 551).

There is no denying that naturalistic easel paintings and schemes of illusionistic decoration are very peculiar kinds of objects, and that they require a high level of collusion on behalf of the spectator if they are to work at all. There are two

551. Ottaviano Mascherino and Lorenzo Sabbatini, Astrological ceiling, showing seated astronomer, 1575, detail of the corner of the vaulted ceiling in the Sala Bologna, Vatican, seen from wrong viewpoint.

main types of collusion involved: a conscious acquiescence and co-operation based on the spectator's knowledge of what is being seen; and perceptual response which results in a compelling reading of certain kinds of configurations in spatial terms.[5] The first kind of collusion was nicely acknowledged by Andrea Pozzo, when he argued that the 'collapse' of his kind of illusions (pls. 267 and 268) from other than the correct viewpoints was not so much a fault to be criticised but should evoke admiration for the skill of the artist in making it work at all and should stimulate the spectators delight in the optical game being undertaken. This kind of collusion is obviously rooted in a system of expectations shared by the artist and the spectator; but this conscious collusion does not explain why the illusion works with such compelling force that we cannot consciously unscramble the impression of three-dimensional forms. Even from 'daft' viewpoints, as in plate 551, the picture plane is impossible to read consistently in terms of its surface configuration, and the illusion of solid elements—albeit crazy ones—obstinately persists.

If there is a measure of automatic, even irresistible collusion for us, the same might not of course apply to people from different cultures. The controlled investigation of this question by the obvious method—namely by showing illusionistic objects to people of different cultures—is a good deal more difficult than it might seem (and has seemed to some observers). There is no situation in which the totally innocent observer can be shown such objects under totally neutral circumstances. No observers, from whatever culture, can approach an image without expectations, and no investigation can be undertaken that does not through its methods establish another set of expectations. However, such evidence as there is, allowing for these problems, suggests increasingly that 'primitive' peoples can read such complex images as photographs but that they will selectively 'see' different aspects of the image and fail to make sense of those aspects which cannot be interpreted coherently in the light of their existing understanding—much as we may have trouble in knowing what a surrealist picture 'means'.[6] The basic act of being able to read a complex two-dimensional image in terms of three dimensions does not appear to require cultural schooling or systematic acclimatisation for anyone who has grown up with a normal variety of visual experience.

I believe that the perceptual potential with which we are endowed has fundamental functional properties which allow us to read size-distance clues, in such a way that we can navigate painlessly through the world. The reading of such clues relies upon a kind of perceptual gravitation towards a simple, coherent reading, such that a succession of proportionally diminished and contiguous rhombuses will tend to be read as foreshortened squares. Linear perspective does not correspond literally to the way we 'see', but it does ape certain features of the array of visual information presented to us and it does so in such a way as to exploit a set of fundamental perceptual responses which ultimately lie beyond cultural conditioning.

The collusion required of the spectator with respect to light and colour seems to me to be of the same kind, though these phenomena have received far less attention than the *cause*

célèbre of perspective. It is obvious, and has been adequately explained since the time of Helmholtz, that the painter's means for describing light, shade and colour are absurdly limited when set beside the effects in nature. The painter's most glaring white comes nowhere near even a weak light source in intensity under the same conditions. We clearly need to collude with the artist, accepting the limitation of his means, if we are to read the golden disk of paint as a luminous setting sun. Yet, as in the case of perspective, there is a component in the collusion that feeds to certain 'strengths' in our perceptual system in such a way as to render non-cooperation difficult if not impossible. In this case the 'strength' is the ability of the perceptual system to differentiate with amazing subtlety between ratios of light, shade and colour within the middle ranges of our discriminatory powers. In life, this strength helps us to make consistent and coherent sense of the same forms seen under widely differing circumstances of illumination. Generations of artists have learnt, through a rich interplay of practice and theory, how to exploit that strength for their own ends.

According to these lines of argument—and I accept that they are presented in such a form as to remain statements of a loosely supported credo rather than a fully debated perceptual theory—the scientific techniques of naturalism we have been discussing can be at once period-specific and non-arbitrary in perceptual terms. They are period-specific in as far as their development in art relies upon a specific historical conception of the function of art and in as much as the intellectual foundations of the techniques are integral components in systems of beliefs about the world and how it can be understood. They are non-arbitrary in that they work through and upon the proclivities of our perceptual equipment in a way that transcends cultural boundaries.

THE INVENTION OF TRUTH

The abstract tendency has led to the magnificent systematic theories of Algebraic Geometry, or Riemannian Geometry, and of Topology; these theories make extensive use of abstract reasoning and symbolic calculation in the sense of algebra. Notwithstanding this it is still as true today that *intuitive* understanding plays a major role in geometry. . . With the aid of visual imagination we can illuminate the manifold facts and problems of geometry, and beyond this, it is possible in many cases to depict the geometric outline of the methods of investigation and proof, without necessarily entering into the details connected with strict definitions of concepts and with actual calculations. (Daniel Hilbert, 1932).

Naturalistic painting and science both present models of the world. Both kinds of model rely upon discovery and invention, and upon some form of systematic recreation of the world in the imagination of the investigator. Many scientists, including a number of the greatest minds, have been ready to acknowledge that there is an imaginative, inspirational and even 'aesthetic' motive in their work at the highest level. Yet we have heard an insistent voice over the years covered by this study that the ultimate ends of art must be separated from the systematic, rule-based ends of science. The voice has been that of scientists, such as Chevreul and Helmholtz, no less than that of artists, like Cigoli or Turner. A neatly satirical way of making the point was devised by J.G. Vibert, right at the end of our period,. when he described a fictional encounter between an aspiring colourist and a great scientific authority of colour. Vibert himself subscribed to the view that the artist can look to science for an understanding of natural effects, but tells a cautionary tale for those who seek absolute answers in the scientific rules:

A young artist, anxious to know the reason of everything, prowled unceasingly round the domain of science, that sacred grove where the pontiff scientists hide from profane eyes the secrets they discover from nature. One day the young artist finished by penetrating into the mysterious sanctuary, where a tall old man with a keen and cunning look immediately came to him. This grave personage carried over one arm skeins of wool of all shades, and in the other hand he held a disc, divided like a cake into parts of all the colours of the rainbow. He spoke in a loud voice: 'Young man, the senior student, to-day a centenarian, welcomes you, and knowing the object of your visit, he congratulates you on having found immediately the best guide whom you could follow. My system is marvellous; it explains everything; it replaces everything.[7]

There is no problem in identifying Chevreul as the grave centenarian. After further pontificating in the same vein, the scientist introduces Young and Helmholtz, who confidently proclaim the truth of their own systems, though confusingly based on different primaries from those of 'Chevreul'. The young man has his understanding further battered by Brewster, Muller, Maxwell, Wurnst [*sic* for Wunsch] and Newton, before 'Common Sense' intervenes with a laugh—'a laugh terrible to hear'. Common sense derides the scientists for their multitude of suppositions and instructs young artists to follow the intuitions of the great colourists:

Then, they must be told also that there were magicians called Veronese, Rubens, Delacroix, and many others, who know more about colouring than any scientist in the world; for with their colours they have created a language which speaks to the soul, which communicates feeling and life, long before science has even suspected that coloured rays influenced the brain.[8]

Many artists, then as now, would have shared the laughter of Vibert's 'Common Sense'. Yet we have seen tremendous and sustained efforts on the part of other artists, theorists and scientists to augment and even supplant the capricious intuition of the individual's imagination with something more scientific. There clearly was a strong sense that there was genuinely common ground between the visions of the artist and the scientist—accepting for the moment that our discussion is conditioned by the present-day associations of the

terms 'artist' and 'scientist', and that their modern senses did not appear in a fully developed form until near the end of our period.

One answer is that science as a body of knowledge is not and was not the logical, inductive, objective structure which it is popularly assumed to be. We have increasingly come to see that science comprises a complex blend of assumptions, tacitly accepted models and priorities based on sets of values. This compound may be acted upon by an individual's capacity for creative invention. Described in this way, science is not obviously distinguishable from the kind of art we have been characterising—and such an equation has indeed been advocated with some potency.[9]

If we look in more detail at what is obviously the most forceful element in the equation—namely the creative vision of the artist and scientist—its validity looks increasingly strong. The most common way to characterise the creative element in science and art is to see it as the product of a form of subconscious rapture, a kind of Platonic 'frenzy', in which the solution to a problem wells up unannounced from some deep recesses of the mind. Stories of scientists waking up in the morning with the ready-made solution to a problem about which they may or may not have been agonising the previous night represent an extreme form of this notion—though in my experience, the reverse is more likely to be the case, namely that a 'solution' achieved at the fatigued end of a long day looks anything but a solution in the unflattering light of dawn. This characterisation of creativity gives it an obvious analogy with the irrational serendipity of dreaming. My own intuition, based on what I understand of the much disputed theory of dreams, is that artistic and scientific creativity is not a function of subconscious processes of the dream type, but rather an integral if pre-conscious component of what we call rational thought.

I do not wish to imply that there is a kind of pre-conscious layer, on which conscious thought rests, but that conscious thought—the end product of which is some kind of rational construct that can be presented in a logical manner—involves an indescribably and imperceptibly rapid *mélange* of perceptual, cognitive, analytical and memory-based components. Since we cannot 'see' the ideas arising in this process, we tend to assume that they arrive from elsewhere. I realise that this interpretation of creativity as built-in to conscious thought runs counter to the left-brain, right-brain theories which have latterly become so popular in a stereotyped form. However, severe doubts about such a separation of brain functions are now being aired within psychology itself.[10]

I would go so far as to say that the creative powers expressed in art and in scientific innovation are shared expressions of an absolutely vital component in the rational aspects of man's mental constitution. It is this component that provides the intellectual desire to know, a desire that goes far beyond the stable needs of our existing functions. However it is described—perhaps 'intellectual curiosity' is as good a term as any—it is manifested to lesser or greater degrees in all of us. In great artists and scientists it becomes an intellectual itch that can never be satisfactorily scratched, though the measure of

relief provided by the scratching can give enormous pleasure.

So far, then, I am prepared to reinforce the equation of creativity in art and science. But if we turn from the somewhat intangible factors underlying the cerebral processes of invention to the *ends* of art and science, there are strict limits to be placed on the equation's realm of competence. Little sympathy though I have for the ideas of the 'autonomous aesthetic experience' which have arisen from Kant's philosophy, I do think that his idea of the 'purposeless purposefulness' of art has much merit. Something of his sense is apparent in the sixteenth-century writings of Benedetto Varchi, who was in turn adapting Aristotelian notions:

> Art is a factive habit, with true reason, of these things that are not necessary, the origin of which is not in the things that are made, but in him who makes them. . . One speaks of these things that are not necessary, because all arts are concerned with contingent things, that is to say things that equally well may or may not be, and in this they differ from sciences, because sciences are of necessary things.[11]

Although we can obviously think of qualifications which soften Varchi's polarities, in terms of both the functions of art and the lack of 'necessity' in some species of science, his formulation does seem to me to represent an underlying truth when we look at the means and ends of art and science. A consideration of a particular example will help me make this point.

Let us look at one of the most controlled, empirical works in our study, Jan van der Heyden's *The Dam in Amsterdam* painted in 1667 (pl. 411). For the painting to have arisen at all, the artist needed to be a party to a series of assumptions about the nature and function of painting, in particular the premise that the realistic depiction of actual, recognisable buildings is both possible and desirable. This notion of desirability rests on a series of intellectual and social foundations of an inextricably interwoven kind. In the making of this specific painting within this context of assumptions, a series of choices needed to be made. Someone, the artist or a patron, has chosen this particular townscape as its subject. Perhaps civic pride in the great new town hall was a powerful factor in the choice; perhaps the artist wanted to juxtapose a classical building of the new order with a gothic building of the old; perhaps the visual qualities of the geometrical forms disposed asymmetrically was the dominant reason for the choice; or perhaps the reason was altogether trivial in the first instance. The historian is unlikely to be able to give a definitive account of such 'causes', and it is often to be doubted if the artist could have done so himself, but they undoubtedly play significant roles in shaping the final appearance of the work.

In the realisation of the work, the very specific choices of viewpoint, visual angle, time of day, size of picture and so on, need to be made. The execution requires systematic knowledge of what techniques—perspectival and painterly—will provide the necessary illusions of space and light to evoke the visual 'truth' of the scene. There is a quality in this aspect of the work's genesis that may justifiably be called experimental, in that hypotheses about the seeing and represent-

ing of reality (implicit and explicit) are being tested. In this case there were two variants of the experiment. In the illustrated picture Jan depicted the plan of the drum and dome as a laterally distorted ellipse. The resulting form was to be viewed through a fixed eye-piece attached to the frame. The other version portrays the drum and dome as an orthodox, frontal ellipse and was almost certainly designed without a rigidly fixed view-point in mind.

Everything about the conception and design of Jan's pictures finds a more or less precise analogy in science, even to the extent that two different scientific experiments can be designed from two distinct standpoints to reveal two distinct 'truths' about a phenomenon. I think the analogy also extends into the essential untidiness and non-sequential nature of the choices being made. Any of the initial, determining choices in the conception of a picture or scientific investigation may become so overlaid with the serendipity of later chances and intuitions that the initial 'cause' assumes a quite different guise and no longer has either historical reality or even a traceable existence in the mind of the inventor. The creative tangle of suppositions, intentions, rationalisations, accidents and inspirations that results in a work of art or a scientific model of the world has little in common with the linear, sequential set of explanations which provide the historian with his or her analytical framework.

Yet, at the end of the day, Jan's painting is devoted to quite different ends, and exercises its function in quite different ways from an experiment in (say) the experimental psychology of perception. It could be *used* in such an experiment, and could give much pleasure and enlightenment. But in such a setting it would become a means to a different end. That end would be the sequential and logical explanation through words, measurements and diagrams of the relationship between causes and effects in visual perception. The verbally controlled explanation of the processes provides the aim, and the scientist endeavours to control the means through which he presents his conclusions to the reader in such a way that the text arrives at a logical and inevitable definition of the causes behind what the scientist perceives as true effects of reality. I do not wish to become embroiled in the controversies as to what extent this perceived goal of science is actually attainable, either in investigation or exposition, but I think we can accept pragmatically that it provides the generally accepted end of the kind of observational science with which we have been predominantly concerned.

In the case of Jan's painting, by contrast, the sum of its effects must ultimately be its end. The artist can control the means by which we perceive the end to a greater or lesser degree—Jan's perspectival skill and viewing device exercise a particularly high degree of control—but the painting must ultimately stand as a perceptual object which is necessarily subject to an untidy mix of intuitive and conscious reactions, outside the kind of control exercisable through a written text. This untidy mix is analogous to that which went into the making of the work, and it may be that the most compelling art is that in which the artist is able to present the ambiguous richness of the invented compound with sufficient control that it

remains to be acted upon by the spectator's set of responses as a form of directed perception. Such directed perception would share the quality of variable richness in our experience of sensory 'reality', but would operate selectively within the full spectrum of this richness.

The ultimate difference in the relationship between means and ends in art and science explains why the concept of 'progress' in the history of science has a different status than in the history of art. I do not wish to suggest that some aspects of the making of art can not be described in terms of progressive success in meeting definable ends. Indeed, the achieving of verisimilitude as one of the ends of perspectival techniques is obviously amenable to description in terms of progress, and much early art history (Vasari's sixteenth-century *Lives*, for example) was founded on this notion. But there has been a general modern acceptance that the achievement of such progress should not in itself constitute the ultimate value we place on the results of an artist's activity. Because, for instance, Jan van der Heyden is achieving effects of perspectival verisimilitude that lay beyond the powers of even Masaccio, we do not consign Masaccio to a limbo of artistic obsolescence—even though Jan himself might have so consigned his Renaissance predecessors.

In science, by contrast, the scientific text loses its intended, primary value once it has been superceded as a means of achieving its stated ends. To be sure we may look at the text in historical retrospect with admiration for its original insights and for the beauty of its vision. We may analyse it in its social and intellectual context with effective results for our understanding of the text. We may even adduce lessons still to be learned from it. But its dominant original intention in establishing an explanatory model for a phenomena can at any point be subsumed or superceded within a constantly changing body of knowledge. It primary intention does not now possess any necessary value and the text does not retain its primary function outside its *historical context*. A work of art is comparably vulnerable to the constantly changing contexts—mental and physical—in which it appears, but it can still assume a primary value with respect to the way in which its visual effects retain their efficacy in serving an end of essentially the same perceptual kind as it was devised to serve. I do not of course wish to imply that these effects will be perceived in a manner identical to that intended by the artist—if such intention is reconstructable at all—but I am speaking more pragmatically of the continuing primary value which a work of art can potentially and actually possess outside its original context.

I should also say that I do not mean to imply that the historian's job is redundant with respect to this kind of enduring value, and that a work of art simply has to be 'looked at' to acquire meaning. I believe that the work of art assumes greater richness the more we can direct our looking via the means and ends that were important to the artist and the intended audience. But the resulting artefact as it exercises its various effects on spectators is not necessarily constrained in continuing to achieve its ends by its position as an obsolete historical survival.

I would in conclusion wish to argue that what we have been

witnessing in this study is the sharing of a set of *means* between art and science. These means are directed towards the making of communicative objects that ultimately differ with respect to their media and functional ends. The end of the work of art is in a sense to return selectively to the visual starting point in such a way as to exploit a special kind of controlled ambiguity in our perceptual processes, while the end of the scientific endeavour is to present the reader with a completely defined explanation of the causes behind the vagaries of particular appearance.

I realise that this formulation may seem to be a ponderous way of stating the obvious, but I think that an emphasis upon means and ends in the work of art and science in relation to the way in which they were and are intended to make their primary effect on their audience does permit us to return fruitfully for the last time to the gross hypothesis with which I introduced this study and to achieve its reformulation in more subtle terms.

One of the most conspicuous characteristics of the physical sciences from the Renaissance to the nineteenth century was the desire to construct a visual model of the world as it appears to a rational, objective observer. This model was constructed on the invariable certainties or mathematical laws independently of individual 'accidents', but it was at the same time founded on the notion that an individual observer in particular circumstances can 'see through the accidents' to the underlying invariables. One model of observed space and form that played an extremely prominent role in the precise sciences was that composed from geometrical bodies which were envisaged as real forms and portrayed as solid objects from particular viewpoints. The most graphic illustration of this manner of visualising the underlying organisation of the world system is Kepler's nest of geometrical bodies as a model for the planetary orbits (pl. 113). The paradox at work here is that the intellectual principles of Kepler's science insist on the divine certainty of geometrical invariables while at the same time figuring the invariable objects as particular forms transformed by the accidents of perspectival vision from a particular position as if the cosmos is an elaborate piece of mannerist metalwork. Indeed, Kepler planned to have his model constructed in metal.[12] The resolution of the paradox lies, to my mind, in exactly the same set of perceptual mechanisms as explains the efficacy of perspective pictures. The manner in which Kepler's bodies are depicted exploits our ability to read the archetypal from the accidental configuration. Indeed, I suspect that the character of the physical sciences as practised by Kepler and Newton centred on an absolutely fundamental aspect of the perceptual interplay between observation and cognition in our normal range of experience. This tie between particular observation and archetypal conception does not seem to exist in quite such an indissoluble way in earlier science, and there are certainly fundamental aspects of modern science that resist concrete, realistic modelling of 'visually tangible' structures in the Kepler manner.

I am not trying to suggest that this is the 'vision of the age' and that the arts must willy-nilly have reflected this vision. I am prepared to suppose that it may have been a historical freak that the functions of art and science came at roughly the same time to work on the premise that their job was to reconstruct in an orderly manner the truth of appearance as perceived by specific observers. But that premise, once established, opened the way for an astonishingly rich dialogue of means and ends in certain kinds of art and science. That the imaginative and intellectual worlds inhabited by significant numbers of artists and scientists should have shared so many common features in the era of 'the science of art' is obviously worthy of historical attention. It may also possess an enduring significance in our continued quest for a wholeness of perception of man in the world.

APPENDIX I

The basis of the perspective construction

At its simplest, linear perspective is a system for recording the configuration of light rays on a plane as they proceed from an object to the eye in a pyramidal pattern. This system is shown in a basic manner in the first of the diagrams (pl. 552A), which deliberately uses a set-up recognisable to a Renaissance artist. We are imagining an observer stationed at F looking with his eye at E towards a tiled floor through a transparent plane, ABCD. The courses of the rays passing from A, B, X and Y to the eye are traced, and the points at which the rays from X and Y intersect or pass through the plane will be marked (X′ and Y′). The line AB will be seen unchanged on the plane, but XY will be seen as X′Y′. Joining A to X′ and B to Y′ will show how the sides of the tiled floor will appear on the plane. Extending these projected sides, they will be found to join at V, which is also where a line from the eye meets the plane perpendicularly.

The main terminology we are using is as follows: E is the 'viewpoint' and EV the 'viewing distance' along the 'axis of sight'; ABCD is the 'picture plane' or 'intersection'; V is the 'point of convergence' or, later, the 'vanishing point'; the horizontal line through V (HVI) is the 'horizon'; lines such as X′Y′, parallel to the base of the picture plane, are termed 'horizontals' (sometimes called 'transversals'), and the converging projections of the parallels AX and BY at AX′ and AY′ are the 'orthogonals'.

The system with which we are dealing is a form of geometrical projection of a three-dimensional object on to a flat plane. One of the standard, early ways of accomplishing this projection is in two separate steps, using plan and elevation. Let us imagine our model in plan (pl. 552B). We will plot the intersection of rays from R, T, V, X etc. at the picture plane AB. The location of these points (X″, Y″ etc.) will be noted along AB (as in pl. 552C). We then move to the elevation or side view (pl. 552D), and plot the intersections of M, N, O, P as P′,

N′ etc. These also will be noted as P′, N′ etc. along the vertical from G (pl. 552C). Once the points from the first construction (pl. 552B) have been transferred to the base AB and the points from the second (pl. 552D) to the central vertical, GJ, they provide, respectively, the vertical and horizontal co-ordinates for the locations of the points, X, Y, T, U, etc. as they will appear on the picture plane. Where the co-ordinates intersect, the projected points are located (pl. 552C). The orthogonals from A and B can now be readily drawn through the projected points and extended to the vanishing point, V, through which the horizon can be drawn. The remaining elements in the tiled floor, the projections of the lines from K and L should in theory be produced by repeating the procedure in 1B, but for practical purposes we will simply join these points to the vanishing point at V. We will have constructed the tiled floor in its projected form (pl. 552E). There are abbreviated ways of arriving at the same result, but the fullscale procedure helps to show what is happening.

When we look at the resulting configuration, some interesting consequences emerge. Diagonals drawn through the projected squares will meet precisely at two lateral points (Z^1 and Z^2 in pl. 552F). The distances from these lateral points (sometimes called 'distance points') to the vanishing point will be equal to the original viewing distance EV. These lateral points are of considerable importance, both because they were widely used by artists and because they enable us readily to reconstruct the viewing distance whenever we are provided with a foreshortened square in a work of art. The diagonals also provide the orientation for objects whose faces lie at 45 degrees to the picture plane.

Understanding the procedures is not difficult, but does require a little care and patience. They can best be mastered by working through the basic moves with a pencil, paper and ruler.

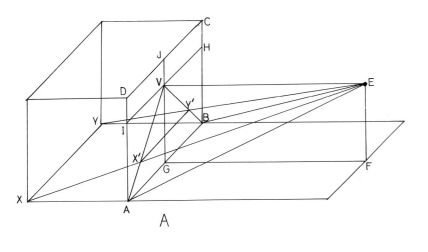

A

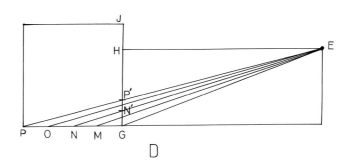

D

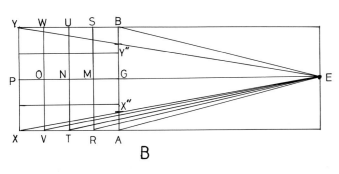

B

E

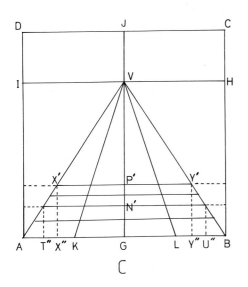

C

F

552. The Demonstration of the basis of linear perspective.

A. The Basic set-up:
ABCD—picture plane
AXYB—square to be projected
FE—observer, and EV is the viewing distance
X is seen at X′ on picture plane.
Y is seen at Y′ on picture plane.
Therefore X′Y′ is XY in projection.
AX′ and BY′ are extended to meet at V (the 'vanishing point').
HI is drawn as the horizon, level with the observer's eye, E.

B. Plan of the set-up
AXYB is a square divided into 16 smaller squares by WOV, UNT etc.
Y, X, V, T, are joined to E, and the points of intersection on AB are noted as Y″, X″ etc.

C. The picture plane
Points T″, X″, Y″, U″ etc. are marked at their equivalent positions along AB.
Points P′, N′ etc. from fig 1D are marked at the central vertical above.
The intersection of the horizontal and vertical coordinates T″, X″, Y″, U″ and P′, N′ etc. provide the locations for X′, Y′ etc.

D. Elevation of the set-up
G—centre-point of base of picture plane.
Points, P, O, N, M are joined to E, and the points of intersection on the vertical above G are noted as P′, N′ etc.

E. The tiled floor in projection
With the 'side walls' and 'ceiling' of the completed cube of space.

F. The 'distance points', Z¹ and Z²
Note that $Z^1V = Z^2V = EV$ (fig 1A).

343

APPENDIX II

Brunelleschi's Demonstration Panels

1. THE BAPTISTERY PANEL

(a) size:

Manetti described the panel as 'about half a *braccio* square'. It is not clear whether he is referring to side length or area. If the former, the side length would have been about 29 cms. (11½ ins.); if the latter, the side length would have been about 41 cms. (16 ins.). The account does not say specifically that the panel was square, but this is a reasonable inference.

(b) viewing angle:

Manetti says that the Volta de'Pecori and Canto alla Paglia were visible on either side of the Baptistery (see pl. 7). Since he does not describe features that would have appeared under a wide angle of vision (up to a practical maximum of 90°), it may be inferred that the angle was little if anything wider than the 53° or so needed to incorporate the described features. The very short viewing distance (c.14½ cms.; 5¾ ins.) also militates against the wider angle. However, a 90° angle was not uncommon in later paintings, and it would have possessed the advantage that the diagonal sides of the octagonal Baptistery would have converged on lateral vanishing points precisely at the edges of the panel. Any angle between 53° and 90° should not be definitively excluded.[1]

(c) the viewing aperture:

Manetti says that the hole in the panel was as wide as 'a ducat or a little more' (about 20 mms.) on the back and 'as tiny as a lentil bean' on the painted side. The visual field through a panel of even modest thickness would have been very restricted.[2] If the hole size on the painted face was, say, 6.5 mms. (about ¼ ins.) and the panel was of similar thickness—which is thin for painted panels—the viewing angle could have been no greater than 53° (pl. 554). This calculation does not make allowance for the distance between the spectator's eye and the rear plane of the panel. Even if the eye was pressed as close as anatomically possible, we must allow for a distance of a few millimetres. The restriction of angle under these circumstances rapidly becomes so severe as to preclude the possibility that even the Baptistery could be encompassed 'in a single glance' as described by Manetti. We may suspect that the widening of the hole on the reverse was to permit

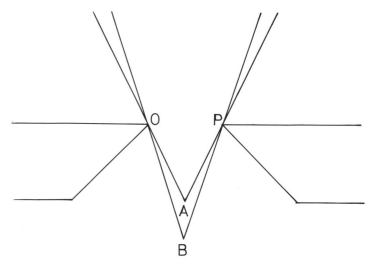

553. The geometry of the viewing hole in Brunelleschi's Baptistery panel.

OP—aperture on the painted face of the panel
A—viewpoint on the plane of the rear of the panel giving an angle of 53°
B—viewpoint behind the plane of the rear of the panel

some marginal manoeuvering of the eye to encompass the full view. Such manoeuvering may in any event have been necessitated by the fact that the hole would have been well below the centre of the panel. These factors imply that the viewing conditions involved an element of compromise.

(d) viewing distance:

Manetti states that Brunelleschi devised the peep-show because 'the painter needs to presuppose a single place from which the painting must be viewed, taking into account the height and depth and width, and similarly for distance'. The implication is that the mirror was to be held at a distance from the panel which ensured that the viewing distance was precisely scaled in relation to the equivalent distance in the actual piazza. For a 53° angle the scaled distance of mirror from panel (taking into account that the mirror doubles the apparent viewing distance) would be of the order of 14½ cms. (5¾ ins.), giving a total viewing distance of 29 cms. (11½ ins.). Given the problems of occlusion through the viewing aperture and the

apparent absence of any means of controlling the distance at which the viewer would actually hold the mirror, I suspect that the peepshow was improvised by Brunelleschi at a relatively late stage in the development of his demonstration and that its optical implications were not part of the original conception. Manetti, with hindsight, may have been imputing a desire to control the viewing distance with more precision than Brunelleschi intended.

2. THE PALAZZO DE' SIGNORI PANEL

Manetti's description of this panel, probably the later of the two to be executed, gives fewer optical hints. His description of the extremities of the angle of view passing down the sides of the piazza leaves little doubt that the visual angle was indeed wide in this instance. If the central axis of Brunelleschi's view (pl. 10), ran directly to the nearest corner of the palace, the consequence would have been that the sides of the palace and the existing pavement pattern (as far as we can tell) would have subtended awkward angles. If, alternatively, the central axis was aligned at 45° to these features, the perspective focuses of the dominent features in the painting would have corresponded conveniently.

3. THE PROCEDURES

Since Manetti gives no indication of Brunelleschi's methods, and it is unsafe to identify them with later written prescriptions, such as Alberti's, we can do no better than judge the relative probabilities of different methods on the basis of the knowledge potentially available to him. The main possibilities, mentioned in the text are as follows:

(a) the skills of surveying
He would almost certainly have learnt these in his abacus school and have applied them to the measurement of Roman buildings. The standard techniques relied upon simple triangulation in which a vertical measuring rod often acts as an intersecting plane (like the picture plane) for the lines of sight. Some of the surveying methods also exploited such mirrors as were available.[3]

(b) the use of scaled elevations and plans
These could form the basis for a two-stage projection of the main outlines of the buildings on to a flat plane, using the principles outlined in the demonstration in the first of these appendices.

(c) the use of more elaborate instruments
These would measure visual angles with considerable precision. We know that Alberti later used an instrument resembling an astrolabe in his survey of Rome, and it would have

been in character for Brunelleschi to have been captivated by the technology of such instruments.

(d) the geometrical formulas of mediaeval optical science ('perspectiva')
These analysed the visual pyramid and discernments of size and distance in elaborate detail. In some accounts, mediaeval *perspectiva* has been granted a central role in Brunelleschi's invention. These claims have been examined in the section on Ghiberti. In general I believe that mediaeval optical science created far more problems than it solved for Renaissance artists.[4]

(e) the projective techniques of Ptolemy's geography and cosmology
Such techniques were becoming increasingly known if imperfectly understood at this time.[5] They are indeed of quite a high order of difficulty.

(f) painting directly on an actual mirror
Although this method has the merit of apparent simplicity, the practical problems of the painter's head and hand masking vital parts of the view, and the failure of Manetti to recognise that the Baptistery was painted directly on to a mirror, militate strongly against this possibility. It would not, in any event, have necessarily involved any exercise of perspectival geometry and would not justify Manetti's claims. The second panel did not involve any mirrored elements.

I personally favour the factors in the order listed above, with a very strong preference for his adapting the kind of surveying techniques which we know to have been available to him.

4. THE 'VANISHING POINT'

It should be noted that what later came to be known as the vanishing point for lines perpendicular to the picture plane (Alberti's 'centric point') would not have been particularly apparent in Brunelleschi's panels. It is doubtful if the buildings along the sides of the piazza in which the Baptistery stood were regularly aligned, and under the narrower visual angle any general recession to a central 'vanishing point' would not have been emphatic. The hole was, inevitably, coincident with the 'vanishing point', but may have been intended only to mark the axis of Brunelleschi's sight perpendicular to the Baptistery. The alignment of the major forms in the other panel would not have emphasised any central vanishing point. Rather, both panels probably exhibited the strong lateral recessions of objects at 45° to the picture plane, corresponding in emphasis to the so-called 'bifocal' or 'distance point' methods found in some *trecento* art. I suspect that the empirical, object-based methods of Brunelleschi in or before 1413 did not emphasise the implicit central vanishing point to the explicit degree apparent of Alberti's later, synthetic construction of space on *a priori* principles.

Notes

References within the wide field covered by this book are generally limited to sources used directly in its preparation, with the exception of some more recent publications (1987 onwards) which have been added to the notes after the completion of the main body of the text.

The notes for each chapter are self-contained, i.e. the bibliographical reference is given in full on its first citation, and reference back to an earlier citation in the same chapter is given by note number, e.g. 'Polzer (n. 13)'.

CHAPTER I

1. The letter is published by G. Tanturli, 'Rapporti del Brunelleschi con gli ambienti letterai' in *Filippo Brunelleschi. La sua opere e il suo tempo*, 2 vols, Florence, 1980, p. 125; see also the article by L. Vagnetti in the same volume, pp. 279–306.
2. J. White, *The Birth and Rebirth of Pictorial Space*, London, 1967; and D. Gioseffi, *Perspectiva. Storia della prospettiva*, Trieste, 1975 (which also deals with perspective in antiquity).
3. C. Cennini, *The Craftsman's Handbook*, trs. D.Y. Thompson, New Haven, Conn., 1933, p. 57. See also Thompson's ed. of *Il Libro dell'arte*, New Haven, 1932.
4. R. Klein, 'Pomponius Gauricus on Perspective'. *Art Bulletin*, XLIII, 1961, pp. 211–30.
5. A. Manetti (?), *The Life of Brunelleschi*, ed. H. Saalman, trs. C. Engass, London and Pennsylvania, 1970, pp. 38–9; and E. Battisti, *Brunelleschi. The Complete Works*, London, 1981, p. 22 and n. 2.
6. *Life of Brunelleschi*, pp. 152–3.
7. Ibid., p. 52ff., from which all subsequent quotations come.
8. The attempts to solve the problems are so numerous that a substantial bibliography would be required to list them all. See particularly S. Edgerton Jnr, *The Renaissance Rediscovery of Linear Perspective*, New York, 1975. For a statement of the limitations of the evidence see M. Kemp, 'Science, Non-Science and Nonsense. The Interpretation of Brunelleschi's Perspective', *Art History*, I, 1978, pp. 134–61. See also the references in Appendix II.
9. See H. Janson, *The Sculpture of Donatello*, 2 vols, Princeton, N.J., 1963, II, pp. 23–32; F. Hartt, *Donatello*, New York, 1972, pp. 55–6.
10. Janson, II, pp. 65–75; Hartt, pp. 145–6, and J. Paoletti, *The Siena Baptistery Font*, New York and London, 1979, p. 39ff.
11. For the reconstruction of the main panel, which has been cut down, see J. Shearman, 'Masaccio's Pisa Altarpiece. An Alternative Reconstruction', *Burlington Magazine*, CVIII, 1966, pp. 449–55; and C. Gardner von Teuffel, 'Masaccio and the Pisa Polyptich: a New Approach', *Jahrbuch der Berliner Museen*, XIX, 1977, pp. 23–68.
12. G.J. Kern, 'Das Dreifaltigkeitfresko von Santa Maria Novella. Ein perspektivisch-architekturgeschichtliche Studie', *Jahrbuch der königlich preussischen Kunstsammlungen*, XXIV, 1913, pp. 36–58; and H. Janson, 'Ground Plan and Elevation of Masaccio's *Trinity* Fresco', in *Essays in the History of Art presented to Rudolf Wittkower*, London, 1967, pp. 83–8.
13. J. Polzer, 'The Anatomy of Masaccio's Holy Trinity', *Jahrbuch der Berliner Mussen*, 1971, pp. 19–59; and the important investigation undertaken by J.V. Field, R. Lunardi and T.B. Settle, 'The Perspective Scheme of Masaccio's *Trinity* Fresco', *Nuncius*, IV, 1989, pp. 31–118.
14. In addition to the problems in Janson's solution outlined by Polzer, we may note that: (a) Janson manipulates the widths of the coffers and ribs by omitting the half-rib at the points where the vault abuts the rear and front arches; (b) he requires some highly illicit configurations for the abacuses above the capitals; (c) as he admits himself he is 'excepting the anomalously elongated first and last set of coffers' (p. 84); (d) he has to assume (p. 86) that Masaccio has forced the surface harmonies by distorting the height of the rear columns or the width of the rear arch.
15. Polzer (n. 13) for detailed if not definitive observations on the marks visible in the plaster.
16. Polzer (n. 13) provides the most complete description.
17. J. Gadol, *Leon Battista Alberti. Universal Man of the Early Renaissance*, Chicago, 1969. See also the following editions: L. B. Alberti, *'On Painting' and 'On Sculpture'*, ed. and trans. C. Grayson, London, 1972 (subsequent references are to this edition); and for a translation from the Italian text, L.B. Alberti *On Painting*, ed. J. Spencer, revised edition, New Haven, Conn., 1966.
18. Alberti *'On Painting'*, pp. 56–7. See also N. Pastore and E. Rosen, 'Alberti and the Camera Obscura', *Physis*, XXVI, 1984, pp. 259–69.
19. Alberti *'On Painting'*, pp. 32–3.
20. Ibid., pp. 48–9.
21. Ibid., pp. 32–3. For the didactic nature of Alberti's treatise, see D. Wright, 'Alberti's *De Pictura*. Its Structure and its Purpose', *Journal of the Warburg and Courtauld Institutes*, XLVII, 1984, pp. 52–71.
22. Ibid., pp. 36–7.
23. Ibid., pp. 40–1.
24. D. Lindberg, *Theories of Vision from Al-Kindi to Kepler*, Chicago, 1976; and Lindberg's edition of *John Pecham and the Science of Optics (Perspectiva Communis)*, Madison, Wis., 1970.
25. *'On Painting'* (n. 17) pp. 44–5. Compare Pecham, *Perspectiva Communis* (n. 24), p. 38: 'Perception is certified by the axis being conveyed over the visible object.'
26. *'On Painting'* (n. 17), pp. 48–9.
27. Ibid., pp. 52–3.
28. Ibid., pp. 54–5. See K. Anderson, 'The Problem of Scaling and of Choosing Parameters in Perspective Construction, Particularly in the One by Alberti', *Analecta Romana Instituti Danici*, XVI, 1987, pp. 107–28.
29. Ibid., pp. 56–7.
30. Ibid., pp. 58–9. It has been suggested that Alberti is referring to his short, technical book of painter's geometry, *Elementi di pittura* in *Opere volgari*, ed. C. Grayson, 3 vols, Bari, 1973, III, pp. 111–29, but the *Elementi* does not explicity provide the missing demonstrations.
31. Ibid., pp. 32–3, introduction to the Italian edition, dedicated to Brunelleschi.
32. R. Krautheimer and T. Krautheimer-Hess, *Lorenzo Ghiberti*, 2 vols, Princeton, N.J. 1970, I, pp. 139ff and Paoletti (n. 10), pp. 14ff, for the St. John Relief.
33. Krautheimer pp. 159ff. for the Porta del Paradiso panels.
34. Ibid., p. 249. See also K. Bloom, 'Ghiberti's Space in Relief', *Art Bulletin*, LI, 1969, pp. 164–6.
35. *Lorenzo Ghiberti's Denkwurdigkeiten (I Commentarii)*, ed. J. von Schlosser, Berlin, 1912; and *I Commentarii*, ed. O. Morisani, Naples, 1947, #1, p. 2.
36. Ibid., #2, p. 3.
37. L. Capponi, 'Il "De Architectura" di Vitruvio nel primo umanesimo', *Italia medioevale e umanistica*, III, 1960, pp. 59–99. Cf. Vitruvius, *The Ten Books on Architecture*, trs. M. Morgan, Cambridge, Mass., 1914 and New York, 1960, I, 1, pp. 5ff.
38. *Commentarii* (n. 35), #2, pp. 2–5.
39. G. ten Doesschate, *Die Derde Comentaar van Lorenzo Ghiberti in Verband met de Middeleeuwsche Optick*, Utrecht, 1940; and J. Gage, 'Ghiberti's Third Commentary and Its Background', *Apollo*, XCV, 1972, pp. 364–9.
40. Alhazen, *Opticae thesaurus* (with Witelo, *Opticae libri decem*), ed. F. Risner, Basel, 1572; and *The Optics of Ibn al-Haytham*, trans. A. Sabra, 2 vols, London, 1989. See Lindberg (n. 24), pp. 58ff.
41. *The Opus Majus of Roger Bacon*, ed. J.H. Bridges, 3 vols, Oxford, 1897 and London 1900; and trans. R.B. Burke, 2 vols, New York, 1962. The optical treatise is part V of the *Opus Majus*. See R. Easton, *Roger Bacon and his Search for a Universal Science*, Oxford, 1952, pp. 32ff; and A.C. Crombie, *Robert Grosseteste and the Origin of Experimental Science, 1100–1700*, Oxford, 1953, pp. 104ff.
42. Pecham (n. 24), preface, p. 61.
43. *Opus Majus* (n. 41), V, part 2, III, v.
44. *Commentarii* (n. 35), p. 232. Compare Vitruvius (n. 42), VII, intro, p. 198. The Vitruvius passage is discussed by White (n. 2), pp. 250–6.
45. Piero della Francesca, *De Prospectiva pingendi*, ed. G.N. Fasola, Florence, 1942, p. 64 (reprinted with introduction, notes and bibliography by E. Battisti, F. Ghione and R. Paccani, Florence, 1984).
46. *De Prospectiva* (n. 45), p. 98. Compare Witelo (n. 45), III, 4, and Pecham (n. 24), p. 32, though in contrast to the mediaeval Aristotelians Piero reverts to the Euclidian theory of seeing rays emitted *from* the eye.
47. Piero's proof is only valid if the depth is considered in terms of the horizontal co-ordinate (ie. along AB on pls. 554B and 554D), but not in terms of its actual length as projected on the plane. See J.V. Field, 'Piero della Francesca's Treatment of Edge Distortion', *Journal of the Warburg and Courtauld Institutes*, XLIX, 1986, pp. 66–90. The problematical demonstration in Piero's *De prospectiva* (our pl. 34) is discussed by J. Elkins, 'Piero della Francesca and the Renaissance Proof of Linear Perspective', *Art Bulletin*, LXIX, 1987, pp. 220–30.
48. M. Daly Davis, *Piero della Francesca's Mathematical Treatises*, Ravenna, 1977, p. 44, for the dating of the *Libellus*.
49. Luca Pacioli, *Summa de arithmetica, geometria, proportione et proportionalita*, Venice, 1494.
50. Davis (n. 48) p. 20; and M. Dalai Emiliani, 'Figure Rinascimentali dei poliedri Platonici. . .', in *Fra Rinascimento, Manierismo e Realtà*, ed. P. Marinoni, Florence,

1984, pp. 7–16.

51. H. Burton, 'The Optics of Euclid', *Journal of the Optical Society of America.* XXXV, 1945, p. 358; and W. Theisen, 'Euclid's *Optics* in the Mediaeval Tradition', *Archives Internationales d'histoire des sciences*, XXXII, 1982, pp. 152–76. For the visual angle problem in relation to E. Panofsky's *Die Perspektive als symbolische Form*, (Vorträge der Bibliotek Warburg), 1924–5, pp. 258–330, see K. Veltman, 'Panofsky's Perspective: a half century later', *La Prospettiva Rinascimentale* ed. M. Dalai Emiliani, Florence, 1980, pp. 565–80. See also K. Anderson, 'Ancient Roots of Linear Perspective', *From Ancient Omens to Statistical Mechanics*, ed. J. Berggren and B. Goldstein, Copenhagen, 1987, pp. 75–89.

52. 'Optics' (n. 51), p. 370. See also G. ten Doesschate, *Perspective, Fundamentals, Controversials, History*, Niewkoop, 1964, pp. 35ff.

53. *De Prospectiva* (n. 45), p. 75. See Wittkower, 'Brunelleschi and Proportion in Perspective', *Journal of the Warburg and Courtauld Institutes*, XVI, 1953, pp. 275–91.

54. *De Prospectiva* (n. 45), p. 75.

55. Ibid., p. 128.

56. The correct pattern for the floor tiles is given by C. Verga. 'L'Architettura nella "Flagellazione" di Urbino', *Critica d'Arte*, CXLV, 1976, p. 15. Otherwise the plans given by R. Wittkower and B. Carter, 'The Perspective of Piero della Francesca's "Flagellation"', *Journal of the Warburg and Courtauld Institutes*, XVI, 1953, pp. 292–302, and M.A. Lavin, *Piero della Francesca: the Flagellation*, London, 1972, figs. 10–13, remain preferable to later elaborations. I am grateful to Marilyn Lavin for her loan of a full-scale photograph of the *Flagellation*, during the course of my investigations.

57. F. Casalini, 'Corrispondenze fra teoria e pratica nell'opera di Piero della Francesca', *L'Arte*, 1968, pp. 64–5, illustrates the use of $\sqrt{2}$ in the Montelfeltro portraits. A geometrical analysis of the *Baptism* (London, National Gallery) is proposed by B. Carter in M.A. Lavin, *Piero della Francesca's Baptism of Christ*, London and New Haven, 1981, pp. 149–63.

58. This is demonstrated by Lavin (n. 56), pp. 46–8.

59. Ibid., p. 78.

60. J. Shearman, 'The Logic and Realism of Piero della Francesca', in *Festschrift Ulrich Middeldorf*, ed. E. Kosegarten and P. Tigler, Berlin, 1968, pp. 180–6; M. Meiss and T. Jones, 'Once Again Piero della Francesca's Montelfeltro Altarpiece', *Art Bulletin*, XLVIII, 1966, pp. 203–6; and W. Welliver, 'The Symbolic Architecture of Domenico Veneziano and Piero della Francesca', *Art Quarterly*, XXVI, 1973, pp. 1–30. The disposition of light and shade in the apse lends support to the otherwise improbable idea that the architecture behind the crossing is an illusionistic relief like that created by Bramante in S. Maria presso San Satiro, as proposed by C. Maltese, 'Architettura "ficta" 1472 circa', *Studi Bramanteschi*, Milan, Urbino, Rome, 1974, pp. 283–92.

61. Lavin (n. 56), p. 19.

62. Shearman (n. 60), p. 184, n. 5, and Lavin (n. 57), p. 39. The optical problems of this interpretation are discussed further by M. Kemp in a review of M. Baxandall, *Patterns of Intention* in *Zeitschrift für Kunstgeschichte*, L, 1987, pp. 137–40.

63. H. Wohl, *The Paintings of Domenico Veneziano*, New York and London, 1980, fig. 15. Wohl's production of surface geometry tends, in my view, to force the visual evidence.

64. Reasonably compatible reconstructions are provided by Welliver (n. 60) and J. Ubans in E. Battisti, 'Note sulla prospettiva rinascimentale', *Arte Lombarda*, XVI, 1971, pp. 106–7.

65. Illustrated in Wohl (n. 63), pl. 123 and p. 128.

66. For a full catalogue and illustrations, see J. Pope-Hennessy, *Paolo Uccello*, 2nd edition, London and New York, 1969.

67. A. Parronchi, *Studi sulla dolce pròspettiva*, Milan, 1964, pp. 467–532 and fig. 117b.

68. E. Battisti in *La Prospettiva Rinascimentale* (n. 51), p. 369, figs. 14–15, provides an accurate demonstration.

69. A comparable conclusion was reached by G.J. Kern, 'Der Mazzocchio des Paolo Uccello', *Jahrbuch der preussischen Kunstsammlungen*, XXXVI, 1915, pp. 13–38. Some of the stylus constructional lines in the related drawings in the Uffizi are visible in Parronchi (n. 67), figs, 202a and b.

70. G. Vasari, *Le Vite de più eccelenti pittori, scultori ed architettori* (1568), ed. G. Milanesi, 16 vols, Florence, 1878–85, II, pp. 205–6.

71. Janson (n. 9), II, pp. 129–31. The best introduction to the spatial variety of Donatello's reliefs remains that by White (n. 2), pp. 148–60.

72. *Donatello e la Sagrestia Vecchia di San Lorenzo*, ex. cat., S. Lorenzo, Florence, 1986.

73. Pomponius Gauricus, *De Sculptura* (1504), ed. A. Chastel and R. Klein, Geneva, 1969, pp. 64–5.

74. Ibid., pp. 183–7.

75. The present solution avoids the difficulties of Klein's (n. 4), but Gauricus's text is far from clear.

76. M. Savonarola, *Commentaribus*, (1445), ed. L. Muratori, Milan, 1738, 24, pp. 1169–70. See M. Boscovits 'Quello ch'e dipintore oggi dicono prospettiva', *Acta historiae artium Academiae Scientiarum Hungaricae*, VIII, 1962, p. 251; and Klein (n. 4).

77. Vasari (n. 70), II, p. 214–15; and Pope-Hennessy (n. 66), p. 18.

78. For the dating of the Camera degli Sposi, see R. Signorini, 'Lettura storica degli affreschi della "Camera degli Sposi" di Andrea Mantegna', *Journal of the Warburg and Courtauld Institutes*, XXXVIII, 1955, pp. 109–35. Suggestions regarding Mantegna's procedures are made by E. Battisti, 'Mantegna come prospettico', *Arte Lombarda*, XVI, 1971, pp. 98–105. See also R. Lightbown, *Mantegna*, Oxford, 1986.

79. J. von Schlosser, 'Aus der Bildnerwerkstatt der Renaissance', *Jahrbuch der Kunstsammlungen des Allerhöcsten Kaiserhauses*, XXXI, 1912, pp. 111ff; L. Fusco 'The Use of Sculptural Models by Painters in Fifteenth-Century Italy', *Art Bulletin*, LXIV, 1982, pp. 175–94.

80. See S. Edgerton, 'Alberti's Perspective. A New Discovery and a New Evaluation', *Art Bulletin*, XLVIII, 1966, p. 374, for bifocal perspective in Jacopo Bellini.

81. As noted in *Liber Pompili Azali Placentini de omnibus rebus naturalis*, Venice, 1544, fol. 74v; see L. Thorndike, *A History of Magic and Experimental Science*, Columbia, 1934, IV, pp. 150–82. For a good attempt to infer the character of Fontana's lost treatise from his surviving MSS, see E. Battisti and G. Saccaro Battisti, *Le Machine cifrale di Giovanni Fontana*, Florence, 1984, pp. 18–24.

82. M. Dalai Emiliani, 'Per la prospettiva "padana", Foppa rivisitato', *Arte Lombarda*, XVI, 1971, pp. 117–36; and *Zenale e Leonardo...*, ex. cat., Museo Poldi Pezzoli, Milan, 1982–3, with perspective analyses by M. Dalai Emiliani.

83. W. Suida, *Bramante pittore e Bramantino*, Milan, 1953; G.A. dell'Acqua and G. Mulazzani, *Bramantino e Bramante pittore*, Milan, 1978; and S. Valtieri, 'La scuola d'Atene. Bramante suggerisce un nuova metodo per costruire in prospettiva un architettura armonica', *Mitteilungen des Kunsthistorischen Instituts in Florenz*, XXVI, 1972, pp. 80–7.

84. R. Buscaroli, *Melozzo da Forlì*, Rome, 1938 and *Melozzo e il Melozzismo*, Bologna, 1955; *Mostra di Melozzo e del Quattrocento Romagnolo*, ex. cat., Forlì, Palazzo dei Musei, 1938; and C. Grignoni, *Marco Palmezzano*, Faenza, 1956.

85. B. Ciati, 'Cultura e società nel secondo Quattrocento attraverso l'opera ad intarsio di Lorenzo e Cristoforo da Lendinara', *La Prospettiva Rinascimentale* (n. 51), pp. 201–14, begins to provide the kind of analysis which is badly needed. For the Urbino *intarsie* see P. Rotondi, *Il Palazzo Ducale di Urbino*, 2 vols, Urbino, 1960, figs 342–55; L. Cheles, 'The Inlaid Decorations of Federigo da Montefeltro's Urbino "studiolo". An Iconographical Study', *Mitteilungen des Kunsthistorischen Instituts in Florenz*, XXV, 1981; and L. Cheles, *The Urbino Studiolo*, Weisbaden, 1986.

86. M. Daly Davis, 'Carpaccio and the perspective of

regular bodies', *La Prospettiva Rinascimentale* (n. 51), pp. 183–200.

87. See particularly the relief of the *Beheading of St. John* for the silver altar of the Florentine Baptistery in G. Passavant, *Andrea del Verrocchio*, London, 1969, p. 183, and the *Madonna in front of a Ruined Basilica*, National Gallery of Scotland, in H. Brigstocke, *Italian and Spanish Paintings in the National Gallery of Scotland*, Edinburgh, 1978, pp. 187–92.

88. MS. A 10r in J.P. Richter, *The Literary Works of Leonardo da Vinci*, 2nd edn., 2 vols, London and New York, 1970, para. 52, and C. Pedretti, *Commentary*, 2 vols, Oxford, 1977. All subsequent references to Richter are by paragraph numbers. Reviews and anthologies of Leonardo's notes and diagrams of perspective are provided by K. Veltman, *Studies on Leonardo da Vinci, I. Linear Perspective and the Visual Dimensions of Science and Art*, Berlin, 1986; and *Leonardo on Painting. An Anthology of Writings by Leonardo da Vinci with a Selection of Documents Relating to his Career as an Artist*, ed. M. Kemp and M. Walker, New Haven, Conn., and London, 1989. MS abbreviations as in Kemp and Walker.

89. MS A 3v (Richter 100).

90. MS BN 2038 23r (Richter 102).

91. MS BN 2038 6v (Richter 63). See M. Kemp, 'Leonardo and the Visual Pyramid', *Journal of the Warburg and Courtauld Institutes*, XL, 1977, pp. 128–49.

92. MS A 9v (Richter 69).

93. D. Marini, *An Analysis of Leonardo da Vinci's 'Last Supper'*, Harvard Univ. Graduate School of Design, 1982; See also M. Kemp, *Leonardo da Vinci. The Marvellous Works of Nature and Man*, London and Cambridge, Mass., 1981, pp. 194–9; P. Steadman in *Leonardo da Vinci*, ex. cat., Hayward Gallery, 1989; F. Nauman, '"The construzione legittima" in the Reconstruction of Leonardo da Vinci's *Last Supper*, *Arte Lombarda*, LII, 1979, pp. 63–9; and Giovanni Degl' Innocenti in C. Pedretti, *Leonardo Architect*, London, 1986, pp. 283ff.

94. MS A 38r (Richter 36), M² 81r (Richter 91), A 41r–v (Richter 544–5).

95. H¹ 32r (Pedretti, *Commentary*, I, p. 141).

96. E. 16r (Richter 108).

97. B L 62r (Richter 109).

98. Pedretti, *Commentary*, I, pp. 149–50.

99. A 38v and *Codex Urbinas* 139v–140r (Richter 526). See also Leonardo's *Treatise on Painting*, ed. P. McMahon, 2 vols, Princeton, N.J. 1956, para. 497.

100. A 41v (Richter 545).

101. For an outline of these problems, which warrant further analysis, see Kemp, *Leonardo da Vinci*, pp. 331ff. A group of relevant texts is provided by Richter, 39–62.

102. In addition to Kemp (n. 91), see J. Ackerman, 'Leonardo's Eye', *Journal of the Warburg and Courtauld Institutes*, XLI, 1978, pp. 108–46, and, more generally, D. Lindberg, *Theories of Vision* (n. 24). An excellent review of this problem is now provided by B. Eastwood, 'Alhazen, Leonardo, and late-Mediaeval Speculation on the Inversion of Images in the Eye', *Annals of Science*, XLIII, 1986, pp. 413–46.

103. *Perspectiva communis*, I, i (n. 24), and Kemp (n. 91), pp. 132–3 and 135–7.

104. MS. D4² (and related texts in Kemp, (n. 91), p. 138, n. 38).

CHAPTER II

1. The first clear system of converging orthogonals is found in the Dresden Madonna commissioned in 1496. See E. Panofsky, *The Life and Art of Albrecht Dürer*, Princeton, N.J. 1955, pp. 39ff; and E. Schuritz, *Die Perspektive in der Kunst Dürers*, Frankfurt, 1919.

2. J. Pélerin (Viator), *De Artificiali perspectiva*, Toul, 1509, L i (v), in W. Ivins Jnr, *The Rationalisation of Sight*, New York, 1938.

3. Dürer, *Schriftlicher Nachlass*, ed. H. Rupprich, 3 vols, Berlin, 1956–69, I, p. 58.

4. *Albrecht Dürer. The Painters Manual*, ed. W.L. Strauss, New York, 1977, p. 25; the translated passage

occurs in the British Library, MS. Sloane 5228, 202.

5. P.L. Rose, *The Italian Renaissance of Mathematics*, Geneva, 1975, and S.A. Jaywardene in *Dictionary of Scientific Biography*, New York, 1974, x.

6. The two MSS of *De divina proportione* are in the Biblioteca Ambrosiana Milan (*Fontes Ambrosiani*, Milan, 1956, XXI), and the Bibliothèque Publique et Universitaire, Geneva. The first printed edition was published in Florence in 1509. The latest study is by M. Dalai Emiliani, 'Figure Rinascimentali dei poliedri Platonici. Qualche problema di storia e di autografia', *Fra Rinascimento, Manierismo e realtà*, ed. P. Marani, Florence, 1984.

7. Strauss (n. 4), p. 37.

8. Ibid., p. 12, and M. Steck, *Albrecht Dürer als Kunstheoretiker*, Zurich, 1969, pl. 4. For Dürer's mathematics, see Steck, *Dürer's Gestaltehre der Mathematik und der Bildenden Kunst*, Halle, 1948 (though the geometrical analysis of the compositions is open to question).

9. *Schriftlicher Nachlass* (n. 3), II, pp. 79–80.

10. Strauss (n. 4), p. 37.

11. Strauss (n. 4), p. 400.

12. *Schriftlicher Nachlass* (n. 3), III, p. 385, and *Vier Bucher von menschlicher Proportion*, Nuremberg, 1528.

13. W. Strauss, *The Complete Drawings of Albrecht Dürer*, 6 vols, 1974, VI, p. 2871, no. XAS 1. Strauss tentatively attributes this drawing to Erhard Schön, in line with an unwarranted tendency amongst Dürer scholars to deny the attribution to Dürer of the more pedantically drawn geometrical figures. See also *Schriftlicher Nachlass* (n. 3), III, p. 352.

14. See above n. 12.

15. Schuritz (n. 1).

16. H. Rodler, *Eyn Schön nütlitz büchlin underweisung der Kunst des Messens mit dem Zirckel, Richtscheidt oder Linial. . .*, Simmern, 1531, and E. Schön, *Underweisung der Proportzion und Stellung der Possen*, Basel, 1540.

17. G. Strauss, *Nuremberg in the Sixteenth Century*, Bloomington, Indiana and London, 1976, esp. pp. 134–47; and *New Perspectives on the Art of Renaissance Nuremberg*, ed. J. Chipps Smith, Austin, Texas, 1985.

18. Dalai Emiliani (n. 6).

19. A. Hirschvogel, *Eine aigentliche und grundliche Anweisung in die Geometria*, Nuremberg, 1543; L. Stoer, *Perspectiva a Laurentio Stoero in lucem prodita*, Nuremberg, 1567 (written in 1556?); W. Jamnitzer, *Perspectiva corporum regularium. . .*, Nuremberg, 1568. (Facsimile edition, A. Flocon, Paris, 1964); H. Lencker, *Perspectiva literaria*, Nuremberg, 1567, and *Perspectiva*, Nuremberg, 1571.

20. J. Hayward, *Virtuoso Goldsmiths and the Triumph of Mannerism*, London and New York, 1976, pp. 203–6.

21. Plato. *Timaeus*, XXIII. The many later variants on Plato's system added the cosmic dodecahedron to the bodies of the four elements. See M. Kemp 'Geometrical Bodies as Exemplary Forms in Renaissance Space', *Acts of the XVII International Congress for the History of Art, 1986*, forthcoming. For Leonardo, see M. Kemp, *Leonardo da Vinci. The Marvellous Works of Nature and Man*, London and Cambridge, Mass., 1981, pp. 312–13; for Barbaro see below n. 61.

22. R. Peltzer, 'Nicolas Neufchatel und seiner Nürnberger Bildnisse', *Münchner Jarhbuch der bildenden Kunst*, VII, 1926, pp. 187–231.

23. F.D. Prager, 'Kepler als Erfinder', *Internationales Kepler Symposium Weil der Stadt 1971*, ed. F. Krafft et al., Hildesheim, 1973, pp. 385–405.

24. *Perspectiva* (n. 19), preface.

25. For Jamnitzer's drawings, see I. Franke, 'Wenzel Jamnitzer's Zeichnungen zur Pespektive', *Münchner Jahrbuch der bildenden Kunst 1972*, pp. 165–86, publishing 36 drawings in the Herzog August Bibliothek, Wolfenbuttel.

26. See n. 2 above, and L. Brion-Guerry. *Jean Pélerin Viator. Sa Place dans l'histoire de la perspective*, Paris, 1962; also, T. Frangenberg, 'The Image and the Moving Eye. Jean Pélerin (Viator) to Guidobaldo del Monte', *Journal of the Warburg and Courtauld Institutes*, XLIX, 1986, pp. 150–71.

27. As 'Introductio Architectura et Perspectiva' in G. Reisch's *Margarita philosophica*, Strasburg, 1508. The first edition of Reisch's compendium had been published in 1503. A German edition of Viator's treatise was published in Nuremberg in 1509; see Brion-Guerry (n. 26), p. 157.

28. S. Serlio, *Il Primo libro d'architectura*, Paris, 1545; and *The Book of Architecture by Sebastiano Serlio* (London, 1611), intro. by A. Santaniello, London, 1980.

29. For Peruzzi's career as painter, see C. Frommel, *Baldassare Peruzzi als Maler und Zeichner*, Vienna, 1968.

30. J.A. du Cerceau, *Lecons de perspective positive*, Paris 1576. The three-dimensional geometry of Philibert de l'Orme in book IV of his *Le Premier tome del'architecture* (1567) is devoted especially to the cognate problem of stonecutting (stereotomy), rather than perspective, in which he was not notably accomplished; see A. Blunt, *Philibert de l'Orme*, London, 1958 pp. 114–6. Stereotomy only assumes direct importance in our present context in the seventeenth century (with the work of Desargues and thereafter).

31. J. Cousin, *Livre de perspective*, Paris, 1560 (facsimile, Paris, 1970).

32. Cousin, ibid., Lik-Liij.

33. The central painting in his *oeuvre* is the *Eva Prima Pandora* in the Louvre. See S. Beguin, *L'Ecole de Fontainebleau*, Paris, 1960.

34. The extent to which *La Vraye science de la portraicture*, Paris, 1571, is the work of Jean Cousin the elder (who died in 1560) or of his son, also Jean, is unclear. The major work of the younger Cousin is the *Last Judgement* in the Louvre.

35. Vignola was at Fontainebleau between 1531 and 1534. E. Danti (below n. 78) testifies to Vignola's provision of perspective designs for Primaticcio.

36. *De Pictura* was translated into Italian as *La Pittura* (not to be confused with Alberti's own Italian version) by L. Domenichi, Venice, 1547.

37. G.P. Lomazzo, *Idea del tempio della pittura*, Milan, 1590, and *Trattato dell'arte della pittura. scoltura et architettura*, Milan, 1584, in *Scritti d'arte*, ed. R. Ciardi, 2 vols, Florence, 1973, I, pp. 257–8, and II p. 273. Also *Idea. . .*, ed. R. Klein, 2 vols, Florence, 1974.

38. Examples in the Urbinate circles of Piero della Francesca and Francesco di Giorgio include the inlaid townscapes on door panels in the Ducal Palace at Urbino: see P. Rotondi, *Il Palazzo Ducale di Urbino*, 2 vols, Urbino, 1960, II, figs. 417–8. For a review (with bibliography of the four main paintings, including that in Urbino previously attributed to Piero), see *Il Luogo teatrale a Firenze*, ex. cat., Florence, 1975, pp. 78–80.

39. Most particularly the works for Agostino Chigi; see J. Shearman, 'The Chigi Chapel in S. Maria del Popolo'. *Journal of the Warburg and Courtauld Institutes*, XXIV, 1961, pp. 129ff.

40. Frommel (n. 29), no. 51.

41. F. Hartt, *Giulio Romano*, 2 vols, New York, 1981, pp. 10–13 and n. 7.

42. For studies in this area see S. Sandstrom, *Levels of Unreality*, Uppsala, 1963; E. Sjöstrom, *Quadratura. Studies in Italian Ceiling Painting*, Stockholm, 1978; and J. Schulz, *Venetian Painted Ceilings of the Renaissance*, Los Angeles, 1968.

43. Hartt (n. 41), pp. 203–6.

44. C. Sorte, *Osservazioni nella pittura* (1584) in *Trattati d'arte del Cinquecento*, 2 vols, ed. P. Barocchi, Bari, 1962, I, p. 298. For Sorte, see J. Schulz, 'Cristoforo Sorte at the Ducal Palace of Venice', *Mitteilungen des Kunsthistorischen Instituts in Florenz*, VI, 1962, pp. 193–208.

45. Schulz (n. 42), p. 95, no. 34.

46. G. Zorzi, *Le Ville e teatri di Andrea Palladio*, Venice, 1969, pp. 169–81, pls. 316–32; and T. Pignatti, *Veronese*, 2 vols, Venice, 1976, II, no. 96.

47. Sjöstrom (n. 42), pp. 41–5.

48. Sjöstrom, ibid., pp. 43–4. See also J. Hess 'On Some Celestial Maps and Globes of the Sixteenth Century', *Journal of the Warburg and Courtauld Institutes*, XXX, 1967, pp. 406–9; and D. Warner, 'The Celestial Cartography of Giovanni Antonio Vanosino da Varese', *Journal of the*

Warburg and Courtauld Institutes, XXXIV, 1971, pp. 336–7.

49. Lomazzo, *Scritti* (n. 37), II, p. 239–41.

50. G. Vasari, *Le Vite. .*, (1565), ed. Milanesi, I, pp. 177–8.

51. B. Campi, *Parer sopra la pittura* (1584) in Barocchi, *Trattati* (n. 44), I, pp. 932–4; and G.B. Armenini, *De' Veri precetti della pittura*, Ravenna, 1587, pp. 93 and 155, Translated by E.J. Olsewski as *On the True Principles of the Art of Painting*, New York 1977. See G. von Schlosser, 'Aus des Bildnerwerkstatt der Renaissance', *Jahrbuch der Kunstsammlungen des Allerhöchsten Kaiserhauses*, XXXI, 1912, pp. 111 ff.

52. Lomazzo, *Scritti* (n. 37), II, p. 277. For Cambiaso's perspective, see L. Profumo Muller, 'L'Architettura "ficta" negli affreschi di Luca Cambiaso', *Arte Lombarda*, XLI, 1974, pp. 51–76.

53. Campi in Barocchi, *Trattati* (n. 44), I, pp. 932–4.

54. M. Bassi, *Dispareri in materia d'architettura e perspettiva*, Brescia, 1572, in P. Barocchi, *Scritti d'Arte del Cinquecento*, 3 vols, Milan, n.d., II, pp. 1799ff. See also E. Panofsky, *La Prospettiva come "Forma Simbolica"*, ed. G. Neri and M. Dalai, Milan, 1961, pp. 111–14.

55. S. Marinelli, 'The Author of the Codex Huygens', *Journal of the Warburg and Courtauld Institutes*, XLIV, 1981, pp. 214–29. See also G. Bora, 'La Prospettiva della figura umana. "Gli Scurti" nella teoria e nella pratica pittorica Lombarda del Cinquecento', in *La Prospettiva Rinascimentale*, ed. M. Dalai Emiliani, Florence, 1980, pp. 285–318.

56. Codex Huygens, New York Pierpont Morgan Library, fol. 111r. See E. Panofsky, *The Codex Huygens and Leonardo da Vinci's Art Theory*, London, 1940, p. 74.

57. *Scritti* (n. 37), I, p. 329.

58. Cod. Huygens, fol. 93r; Panofsky (n. 56), p. 63.

59. L. Pastor, *The History of the Popes*, ed. R.F. Kerr, London, 1930, XIX, pp. 259ff.

60. For Danti see nos. 69, 72 and 76.

61. D. Barbaro *La Pratica della perspettiva*, Venice 1569, *proemio*; see also M. Daly Davis, 'Carpaccio. . .', *La prospettiva Rinascimentale* (n. 55), pp. 183–97.

62. Barbaro, ibid. p. 163.

63. Zorzi (n. 46), and R. Cocke, 'Veronese and Daniele Barbaro. The Decoration of the Villa Maser', *Journal of the Warburg and Courtauld Institutes* XXXV, 1972, pp. 226–46.

64. *Perspettiva* (n. 61), p. 37.

65. Ibid., p. 61.

66. Ibid., pp. 192–3.

67. M. Daly Davis, *Piero della Francesca's Mathematical Treatises*, Ravenna, 1977, pp. 92, 94–6.

68. *Perspettiva* (n. 61), *proemio*.

69. The best biographical outline is provided by M.L. Ringhini Bonelli in *Dictionary of Scientific Biography*, New York, 1971, III.

70. M. Daly Davis, 'Beyond the "Primo Libro" of Vincenzo Danti's "Tratatto delle perfette proporzioni"', *Mitteilungen des Kunsthistorischen Instituts in Florenz*, XXVI, 1982, pp. 63–84.

71. *La Sfera tradotta da Pier Vincenzo Danto . . . e commentata da Frate Ignazio*, Florence, 1571.

72. Danti, *Primo volume dell' uso e fabbrica dell' astrolabio del planisfero. . .*, Florence, 1578. See M.L. Ringhini Bonelli and T. Settle, 'Ignatio Danti's Great Astronomical Quadrant', *Annali dell' Instituto e Museo di Storia della Scienza*, IV, 1979, pp. 3–13, and 'Egnatio Danti's Two Gnomons in Santa Maria Novella', in *Ritmi del cielo e misura del tempo*, ed. A. Turner (forthcoming).

73. *Usus et tractatio gnomonis magni. . .*, Bologna, n.d.; see Bonelli and Settle (n. 72), p. 11, n. 22.

74. *Le Scienze matematiche ridotte in tavole*, Bologna, 1577; and *Anemographia*, Bologna, 1578.

75. *La prospettiva di Euclide tradotta e annotata*, Florence, 1573.

76. F. Mancinelli and J. Casanovas, *La Torre dei Venti*, Vatican, 1980; P. Stein, 'The Meridian Room in the Vatican "Tower of the Winds"', *Specola astronomica Vaticana. Miscellanea astronomica Vaticana*, 1950, III, pp. 33–41; I. Turčic, 'Cristoforo Roncalli nella Sala della Meridiana', *Burlington Magazine*, CXXIII, 1981, pp.

614–17. For Mascherino as an architect, see J. Wasserman, *Ottaviano Mascarino and his Drawings in the Accademia Nazionale di S. Luca*. Rome, 1966.

77. J. Barozzi da Vignola, *Regola delli cinque ordini d'architettura*, Rome, 1562/3 (and many subsequent editions.).

78. E(I). Danti, *Le Due regole della prospettiva pratica di M. Iacomo Barozzi da Vignola*, Rome, 1583; see T. Kitao, 'Prejudice in Perspective. A Study of Vignola's Perspective Treatise', *Art Bulletin*, XLIV, 1962, pp. 173–94.

79. Danti, ibid., pp. 11ff. See also his commentary on Euclid's *Optics* (n. 75). For some of Danti's sources, see T. Frangenberg, 'Egnatio Danti's Optics. Cinquecento Aristotelianism and the Mediaeval Tradition', *Nuncius*, III, 1988, pp. 1–31.

80. Ibid., p. 69.

81. Loc. cit.

82. Ibid., p. 52.

83. Ibid., p. 82.

84. Ibid., p. 119.

85. Ibid., pp. 69 and 95.

86. Ibid., p. 87. For the Alberti as decorative painters, see M.V. Brugnoli, 'Un Palazzo Romano del tardo '500 e l'opera di Giovanni e Cherubino Alberti a Roma', *Bolletino d'Arte*, XLV, 1962, pp. 223–46; K. Hermann Fiore, 'Giovanni Alberti's Kunst und Wissenschaft der Quadratur. Eine Allegorie in der Sala Clementina des Vatikan', *Mitteilungen des Kunsthistorischen Instituts in Florenz*, XXII, 1978, pp. 61–84; and C. Witcombe, 'An Illusionistic Occulus by the Alberti Brothers in the Scala Santa', *Gazette des Beaux Arts*, CX, 1987, pp. 61–72.

87. Ibid., p. 90.

88. Ibid., p. 89.

89. Conveniently available in *Scritti d'arte*, ed. Ciardi (n. 37). The fascinating English translation by R. Haydocke, *A Tracte containing the artes of curios Paintinge, Carvinge, Buildinge. . .*, Oxford, 1598, is idiosyncratic rather than reliable and stops short of the section on perspective.

90. *Scritti* (n. 37), II, p. 90 and I, p. 348.

91. Ibid., II, pp. 216–20.

92. Ibid., II, pp. 230 and 216 n. 3 (see also below n. 98).

93. Ibid., II, p. 228.

94. Ibid., II, p. 223.

95. Ibid., II, pp. 233–9. P. Gauricus, *De scultura (1504)*, ed. A. Chastel and R. Klein, Geneva, p. 185; and L. Ricchier (Caelius Rhodoginus), *Lectionium antiquarium libri triginta*, Frankfurt, 1666, XV, 4, p. 779. (First edition 1552.) Lomazzo mentions Rhodoginus in his *Trattato* (*Scritti*, II, p. 223).

96. *Scritti* (n. 37), II, p. 273ff.

97. Bora (n. 55), p. 303.

98. *Le vite di Michelangelo Buonarroti da Giorgio Vasari e Ascanio Condivi*, ed. C. Frey, Berlin, 1887, p. 50. See D. Summers, *Michelangelo and the Language of Art*, Princeton, N.J., 1981, Part II, chapters 6 and 8, for valuable discussion of judgement, and D. Summers, *The Judgement of Sense*, Cambridge, 1987.

99. F. Zuccaro, *Idea dei scultori, pittori e architetti* (Turin 1607) in *Trattati*, ed. Barocchi (n. 44), II, pp. 2062ff, and D. Heikamp, *Scritti d'arte di Federigo Zuccaro*, Florence, 1961, pp. 249–50. See E. Panofsky, *Idea, a Concept in Art Theory*, trans. J. Peake, New York, 1968, pp. 85–95; and Summers (n. 98).

100. Zuccaro in *Trattati* (n. 44), I, p. 1043.

101. Ibid., p. 1044, and n. 98.

102. Particularly Zuccaro's illusionistic *Ganymede and the Eagle* in the Palazzo Zuccaro, Rome, 1602. See Sjöstrom (n. 42), p. 49.

103. F. Commandino, *Ptolomaei planisphaerium. Jordani planisphaerium* Venice, 1558; see Rose (n. 5), pp. 185–214, and E. Rosen in *Dictionary of Scientific Biography*, New York, 1971, II.

104. R. Sinisgalli, 'Gli studi di Federigo Commandino sul Planisfero Tolemaico come elemento di rottura nella tradizione della teoria prospettica della Rinascienza', *Prospettiva Rinascimentale* (n. 55), pp. 475–85.

105. *Apollonii Pergaei conicorum libri quattor una cum Pappi Alexandrini Lemmatibus et commentariis Eutocii Asalonitae*, Bologna, 1566.

106. *Claudii Ptolomaei liber de analemmate*, Rome, 1563. Orthogonal projection had been defined by Gemma Frisius, *De astrolabo catholico*, Antwerp, 1556.

107. Commandino, ibid., 58v, for a reference to Dürer on conics.

108. *Perspettiva* (n. 61), p. 3 and 188.

109. G.B. Benedetti, *De Rationibus operationum perspectivae* in *Diversarum speculationum mathematicarum et physicarum liber*, Turin 1585, pp. 119–40; see J.V. Field, 'Giovanni Battista Benedetti on the Mathematics of Linear Perspective', *Journal of the Warburg and Courtauld Institutes*, XLVIII, 1985, pp. 71–99; and *Giovanni Battista Benedetti e il suo tempo*, Venice, 1987, particularly the essays by Field, pp. 247–70, and T. Frangenberg (on *De Visu*), pp. 271–82.

110. S. Drake in *Dictionary of Scientific Biography*, New York, 1970, I, for biographical outline. For Benedetti's musical ideas, see C.V. Palisca, 'Scientific Empiricism in Musical Thought', *Seventeenth Century Science and the Arts*, ed. M.M. Rhys, Princeton, N.J., 1961, pp. 104ff.

111. *Diversarum spec.* (n. 109), p. 133.

112. Loc. cit.

113. *De Temporum* in *Diversarum spec.* (n. 109), p. 205ff.

114. *De Gnomonum umbrarumque solarium usu liber*, Turin, 1574.

115. For a good account of Guidobaldo's career, see Rose (n. 5), pp. 222–36. See also R. Sinisgalli, *Per la storia della prospettiva. Il contributo di Simon Stevin allo sviluppo scientifico della prospettiva artificiale*, Rome, 1978. For his relationship to Galileo, see S. Drake, *Galileo at Work*, Chicago and London, 1978, esp. pp. 35 and 66–7.

116. *Liber mechanicorum*, Pesaro, 1577.

117. *Planisphaeriorum universalium theorica*, Pesaro, 1579.

118. *Ptolomaei planispheriorum* (n. 103), 2r.

119. For shadow projection and its relationship to perspective and astronomy, see T. da Costa Kaufmann, 'The Perspective of Shadows. The History of the Theory of Shadow Projection' *Journal of the Warburg and Courtauld Institutes*, XXVIII, 1975, pp. 258–87. See also, G. Bauer, 'Experimental Shadow Casting and the Early History of Perspective', *Art Bulletin*, LXIX, 1987, pp. 210–9.

120. For Toscanelli, see (with reservations), G. Uzielli, *La vita e i tempi di Paolo dal Pozzo Toscanelli*, Rome, 1894, pp. 374–78; and E. Settesoldi, 'Paolo Toscanelli padre dello gnomone nella Cattedrale di Firenze', *Prospettiva*, XVI, 1979, p. 44. An astronomical-zodiacal fresco was also painted in the lesser dome of Brunelleschi's Sacristy in S. Lorenzo (to commemorate the Church Council of 1439?); see P. Brown. 'Laetentus Caeli: the Council of Florence and the Astronomical Fresco in the Old Sacristy', *Journal of the Warburg and Courtauld Institutes*, XLIV, 1981, pp. 176–80, and *Donatello e la Sagrestia Vecchia di San Lorenzo*, ex. cat., S. Lorenzo, Florence, 1986.

121. C. Agrippa, *Trattato di scientia d'arme*, Rome, 1553, quoted by G. Ruscelli, *Precetti della militia. . .* (1583) in J. Hale, *Renaissance Fortification. Art or Engineering?*, London, 1977, p. 35.

122. N. Tartaglia, *La Nova scientia*, Venice, 1550 (First edition, 1537); and *Euclide Megarense Philosophe* ed. N. Tartaglia, Venice, 1543.

123. M. Kemp, 'Geometrical Perspective from Brunelleschi to Desargues. A Pictorial Means or an Intellectual End?', *Proceedings of the British Academy (1984)*, LXX, 1985, pp. 89–132.

124. T. Settle, 'Ostilio Ricci. Bridge between Alberti and Galileo', *Actes XIIe congres international d'histoire des sciences, Paris*, 1968, III, B, 1971, pp. 121–6. Ricci is recorded as teaching perspective in the house of Bernardo Buontalenti, the architect and stage designer.

125. Ricci's MS of Alberti's *Ludi matematici* is in the Biblioteca Nazionale, Florence.

126. N. Pevsner, *Academies of Art, Past and Present*, New York, 1940, p. 48ff; C. Dempsey, 'Some Observations on the Education of Artists in Florence and Bologna during the later Sixteenth Century', *Art Bulletin*, LXII,

1980, p. 552–69 (esp. p. 557); Z. Wazbinski, *L'Accademia Medicea del Disegno nel cinquecento. Idea e istituzione*, Florence, 1987; and K. Barzman, 'The Florentine *Accademia del Disegno*: Liberal Education and the Renaissance Artist', *Leids Kunsthistorisch Jaarboek*, forthcoming.

127. T. Settle, 'Antonio Santucci, his "New Tractatus on Comets" and Galileo', in *Novità celesti e crisi del sapere*, ed. P. Galluzzi, Florence, 1983, pp. 229–38.

128. Drake (n. 115), pp. 2–4.

129. Ibid., p. 35.

130. For an account of Galileo's optical reading of the moon's surface, see S.Y. Edgerton Jnr, 'Galileo, Florentine "Disegno", and the "Strange Spottednesse" of the Moon', *Art Journal*, XLIV, 1985, pp. 225–48.

131. E. Panofsky, *Galileo as Critic of the Arts*, The Hague, 1954, p. 5, and 'More on Galileo and the Arts', *Isis*, XLVII, 1956, pp. 182–5. For biographical details of Cigoli, see A. Matteoli, *Lodovico Cardi-Cigoli, pittore e architetto*, Pisa, 1980; M. Chappell in *Dizionario biografico degli Italiani*, 1976, XIX; and F. Faranda, *Ludovico Cardi detto il Cigoli*, Rome, 1986.

132. *Macchie di sole e pittura. Carteggio L. Cigoli – G. Galilei*, ed. A. Matteoli, *Bollettino della Accademia degli Euteleti*, XXXII, San Miniato, 1959, pp. 52–3 (letter of 23 March 1612) for Cigoli's first new telescope.

133. Matteoli, ibid., publishes the surviving correspondence with useful annotations. See also Chappell, below n. 155.

134. C. Scheiner (as 'Apelles hidden behind the picture'), *Tres epistolas de maculis solaribus. . .*, Augsberg, 1612.

135. *Carteggio*, ed. Matteoli (n. 132), p. 33 (letter of 1 August 1611).

136. Ibid., pp. 37ff (letters of 16 September 1611, 23 September 1611 and 3 February 1612).

137. Ibid., pp. 52–3 (letter of 23 March 1612).

138. *Istoria e dimostrazioni intorno alle macchie solari e loro accidenti*, Rome, 1613, p. 52 (trs. by S. Drake in *Discourses and Opinions of Galileo*, New York, 1957). For Scheiner's comparable technique, see below pl. 355.

139. For an analysis of the relationship between seeing and interpretation in Galileo, see W. Shea, *Galileo's Intellectual Revolution*, New York, 1972; and M. Clavelin, *The Natural Philosophy of Galileo*, Cambridge, Mass., 1974.

140. *Carteggio*, ed. Matteoli (n. 132), p. 69 (letter of 14 July 1612).

141. *Istoria* (n. 138), p. 34. For a related question, see A. Mark Smith 'Galileo's Proof of the Earth's Motion from the Movement of Sunspots, *Isis*, LXXVI, 1985, pp. 543–51.

142. Ibid., p. 38. Cf. Galileo's *paragone* letter of 26 June 1612 to Cigoli in *Carteggio*, ed. Matteoli (n. 132), pp. 60ff.

143. For the history of Cigoli's fresco and the ensuing controversy, see Matteoli (n. 131).

144. Quoted by Clavelin (n. 139), p. 399.

145. *Istoria* (n. 138), p. 142.

146. Quoted by Shea (n. 139), p. 34.

147. See Matteoli, Chappell and Faranda (n. 131). Matteoli publishes the early biographies.

148. Cigoli's 'Prospettiva pratica. . . . dimostrata con tre regole. e la descrizione di dua strumenti da tirare in prospettiva, e modo di adoperarli, et i cinque ordini di architettura con le loro misure', is in the Gabinetto Disegni e Stampe of the Uffizi, Codice 2660A. A copy, certified by Vincenzo Viviani, Galileo's pupil and biographer, is in the Biblioteca Nazionale, MS. Gal. 107. An edition and translation is planned by Miles Chappell, Filippo Camerota and myself. A good account is provided by Camerota's thesis, 'Dalla finestra allo specchio: la "Prospettiva pratica" di Ludovico Cigoli alle origini di una nuova concezione spaziale', Ph.D. thesis, Florence, Università degli Studi, 1987.

149. *Disegni dei Toscani a Roma (1580–1620)*, Gabinetto Disegni e Stampe degli Uffizi, Florence, 1979, no. 8801F (entry by M. Chappell). The drawing, which contains some geometrical drawings which correspond

to Cigoli's treatise, is inscribed: 'book of plans and elevations by me, Gimondo Coccapano, on this first day of February 16 [11?], as assigned to me by Sigr. Lodovico Cardi Cigoli'.
150. 'Prospettiva', Uffizi (n. 148), fol. 30r.
151. Ibid., fol. 78r.
152. *Mostra del Cigoli*, Accademia degli Euteleti, S. Miniato, 1959, no. 80; and *Feste e apparati Medicei da Cosimo I a Cosimo II*, Gabinetto Disegni e Stampe degli Uffizi, Florence, 1969, nos. 52–6.
153. Panofsky (n. 131), p. 9.
154. Drake (n. 115), p. 200, and Panfosky in *Isis* (n. 131).
155. M. Chappell, 'Cigoli, Galileo and Invidia', *Art Bulletin*, LVII, 1975, pp. 91–8, for Galileo's election and for suggestive comments on the relationship between the artist and scientist.
156. The private Accademia dei Lincei was founded in 1603 by Federigo Cesi, a scientifically-minded nobleman, and stood largely in opposition to the 'official' science of the Vatican establishment. See A. de Ferrari, *Dizionario Biografico degli Italiani*, Rome, 1980, XXIV; and G. Gabrieli, *Federico Cesi Linceo*, Rome, 1986.

CHAPTER III

1. M. Jaffé, *Van Dyck's Antwerp Sketchbook*, 2 vols, London, 1967, I, pp. 16ff. For an introduction to Rubens's theory, see J. Muller, 'Rubens' Theory and Practice of Imitation in Art', *Art Bulletin*, LXIV, 1982, pp. 229–47.
2. G.B. Bellori, *Le vite de' pittori, scultori et architetti moderni*, Rome, 1672, p. 54; and B. Teyssèdre, *Roger de Piles et les débats sur le coloris au siècle de Louis XIV*, Paris, 1957, pp. 218–9.
3. *Correspondence de Rubens et documents epistolaires concernant sa vie et ses oeuvres*, ed. M. Rooses and C. Reulens, 6 vols, Antwerp, 1887–1909, and *The Letters of Peter Paul Rubens*, ed. and trans. R. Magum, Cambridge, Mass., 1955. E.g. letters of 3 August 1623, 12 December 1624, 18 December 1634, 31 May 1635, 16 August 1635.
4. M. Jaffé, *Rubens in Italy*, New York, 1977, p. 80; and *Van Dyck's Antwerp Sketchbook* (n. 1), I, pp. 19–20.
5. M. Jaffé, 'Rubens and Optics', *Journal of the Warburg and Courtauld Institutes*, XXXIV, 1971, pp. 362–5; and S.J. Ziggelaar, *François de Aguilon. Scientist and Artist*, Rome, 1983.
6. *Corpus Rubenianum Ludwig Burchhard*, Part XXI, ed. J.R. Judson and C. van de Velde, 2 vols, Brussels, 1978, pp. 101–115; and W. Jaeger, *Die Illustrationem der Peter Paul Rubens zum Lehrbuch der Optik des Franciscus Aguilonius*, Heidelberg, 1976.
7. Ovid, *Metamorphoses*, I, 620ff.
8. Marcrobius, *Saturnalia*, I, xix, 12–13.
9. F. d'Aguilon (Aguilonius), *Opticorum libri sex*, Antwerp, 1613, p. 679. See Jaffé (n. 5); and T. da Costa Kaufmann, 'The Perspective of Shadows. The History of the Theory of Shadow Projection', *Journal of the Warburg and Courtauld Institutes*, XXXVIII, 1975, pp. 258–87.
10. Aguilonius (n. 9), p. 154.
11. Ibid., pp. 377–8.
12. Ibid., p. 455.
13. *Rubens a Mantova*, ex. cat., Mantua, 1977, for U. Bazzotti's discussion of the perspective and reconstruction of the painting (with additional bibliography).
14. Cf. the *Adoration of the Shepherds*, Antwerp, Church of St. Paul, illus. in *Rubens before 1620*, ed. J. Martin, Princeton, N.J., 1972, pl. 27. The light effects in the preparatory drawing for the *Samson and Delilah* are much simpler than the painting; see M. Bernhard, *Rubens, Handzeichnungen*, Munich, 1977, pl. 207, and L. Burchard and R.A. d'Hulst, *Rubens's Drawings*, Brussels, 1963, no. 46.
15. F.J. Sánchez Cantón, 'La Librería de Velázquez', *Homenaje a Menendez Pidál*, Madrid, 1924, III, pp. 388–405.
16. Sánchez Cantón, ibid., provides a generally reliable identification of the books, through the brevity typical

of an early inventorist prevents certainty in all instances.
17. Andreś Garcia de Céspedes, *Libros de instrumentos nuevos de geometria*, Madrid, 1606 (no. 81).
18. F. Sánchez Cánton, 'Como vivá Velázquez: inventario discuribierto por d.f. Rodriquez Marin', *Archivio espanôl de arte*, XL, 1942, pp. 69–91.
19. A. Palomino, *El Museo Pictórico escala optica*, Madrid, 1715–24, III, pp. 321–54; trans. E. Harris, *Velásquez*, New York and Oxford, 1982, pp. 196–224.
20. Harris, ibid., p. 208; J. Brown, *Images and Ideas in Seventeenth-Century Spanish Painting*, Princeton, N.J., 1975, p. 98, and J. Brown, *Velazquez. Painter and Courtier*, New Haven and London, 1986.
21. Harris, ibid., p. 215.
22. E. Feinblatt, 'A "Bocetto" by Colonna-Mitelli in the Prado', *Burlington Magazine*, CVII, 1965, pp. 349–57. For the palace, see J. Brown and J. Elliott, *A Palace for a King. The Buen Retiro and the Court of Philip IV*, New Haven and London, 1980.
23. For the much discussed content of *Las Meninas*, see Brown (n. 20), 1975, pp. 87–110, and 1986, pp. 256ff.
24. Ibid., p. 99.
25. Ibid., p. 100.
26. Two recent attempts amongst the many efforts to unravel the space of las Meninas are B. Vahlve, 'Velázquez' las Meninas. Remarks on the Staging of a Royal Portrait', *Konsthistorisk Tidskrift*, II, 1982, pp. 21–8, and J. Moffat, 'Velázquez in the Alcázar Palace in 1656. The Meaning of the *mise-en-scene* of las Meninas', *Art History*, VI, 1983, pp. 271–300. See also S. Orso, *Philip IV and the Decoration of the Alcázar of Madrid*, Princeton, N.J., 1986.
27. Moffat, ibid., working from a plan of the room, contrives to produce the correct scaling, but this conflicts with the results obtained by my procedure of working *from* the picture and comparing the resulting space with the plan. The dimensions of *las Meninas* are 318 × 276 cms. (125 × 109 ins.). Brown (note 20), 1986, p. 259, notes a pentimento in the line of the top of the right hand wall, which suggests pictorial manipulation rather than optical veracity.
28. F. Winzinger, *Albrecht Altdorfers Zeichnungen*, Munich, 1952, no. 110. The drawing is used as the basis for the setting in Altdorfer's *Birth of the Virgin*, Munich, Alte Pinakotek; see Winzinger, *Albrecht Altdorfer. Die Gemälde*, Munich, 1975, no. 44.
29. See the early biography by Carel van Mander, *Het Schilderboek*, Haarlem, 1604; translated as *Dutch and Flemish Painters*, by C. van der Wall, New York, 1936, pp. 298–303; E. Iwanoyko, *Gdański Okres Hansa Vredemana de Vries*, Poznań, 1963; and H. Mielke, 'Hans Vredeman de Vries', Berlin, 1967.
30. See the drawing of 1558 in the Albertina, Vienna, illus. by U.M. Scheede, 'Interieurs von Hans und Paul Vredeman', *Nederlands Kunsthistorisch Jaarbock*, XXVII, 1967, pp. 125–166. Also Vredeman's printed books, *Scenographia sive perspectivae*, Antwerp 1560, and *Artibus perspectivae plurium elegantissimae formulae multigenis fontibus*, Antwerp, 1568.
31. The *Perspective* was published in 2 parts, The Hague and Leiden, 1604–5. (Facsimile with introduction by A. Placzek, New York, 1968).
32. Van Mander (n. 29), describes a number of illusionistic schemes in Antwerp, Hamburg, Danzig and Prague, and indicates that they played a major role in his career.
33. E.g. Iwanoyko (n. 29), pls. 83, 97, 107.
34. Scheede (n. 30), esp. nos. X, XX, and XXVI.
35. H. Jantzen, *Das niederländische Architekturbild*, Leipzig, 1910 pp. 25–33 and pl. 6; see also pp. 19–24 for Vredeman.
36. Jantzen, ibid., provides the best survey.
37. H. Hondius, *Instruction en la science de perspective*, The Hague, 1625, p. 19 and fig. 26, illustrating a spiral staircase. Earlier published as *Istitutio artis perspectivae*, The Hague, 1622.
38. S. Marolois, *Opera Mathematica. . .*, The Hague, 1614; see A.K. Wheelock Jnr, *Perspective, Optics and Delft Artists around 1650*, London and New York, 1977,

p. 12.
39. For a good discussion of this issue, Wheelock, ibid., p. 79ff.
40. De Caus was an architect, engineer and contriver of devices, who warrants fuller investigation than he has hitherto received. See J. Baltrušaitis, *Anamorphic Art*, Cambridge, 1977.
41. The major exception is Wheelock (n. 38). For a forceful assertion of the 'perceptual' separation of Dutch art from Italianate theorising see S. Alpers, *The Art of Describing. Dutch Art in the Seventeenth Century*, Chicago and London, 1983.
42. Wheelock (n. 38), p. 12.
43. The edition with which I am most closely acquainted is S. Marolois, *Geometria theoretica ac pratica. . .*, ed. A. Girard, 2 vols, Amsterdam 1647.
44. Wheelock (n. 38), p. 12.
45. R. Ruurs, 'Pieter Saenredam: zijn boekenbezit e zijn relatie met des landmeter Pieter Wils', *Oud Holland*, XCVII, 1983, pp. 59–63.
46. Ibid., nos. in folio, 45; in quarto, 29, 105; in octavo, 3, 29, 71.
47. Ibid., nos. in folio, 20, 56; in quarto, 16, 106.
48. The major source for Stevin is *The Principal Works of Simon Stevin*, ed. E. Crone et al., 5 vols, Amsterdam, 1955–6. Also E.J. Dijksterhuis, *Simon Stevin 's Gravenhage*, 1943. See also K. Anderson, 'Some Observations Concerning Mathematicians' Treatment of Perspective Constructions in the 17th and 18th Centuries', *Festschrift für Helmut Gericke*, ed. M. Folkerts and U. Lindgren, Stuttgart, 1984, pp. 409–25.
49. *De Schiagraphia (Der Deursichtighe)*, Leiden, 1605, in *Works*, ibid., II B, ed. D.J. Struick.
50. R. Sinisgalli, *Il Contributo di Simon Stevin allo sviluppo scientifico della prospettiva artificiale ed i suoi precedenti storici*, Rome, 1978.
51. *Works* (n. 48), II, B, p. 801.
52. Ibid., p. 961.
53. D. Struick, *The Land of Stevin and Huygens*, revised ed., Cambridge, Mass., 1981; and useful remarks by K. van Berkel in 'A Note on Rudolf Snellius and the Early History of Mathematics in Leiden'. in *Mathematics from Manuscript to Print, 1300–1600*, ed. C. Hay, Oxford, 1988.
54. See *Works* (n. 48), I, pp. 44–6.
55. For Saenredam's oeuvre and career, see the catalogue raisonné, *Pieter Janz. Saenredam*, Central Museum, Utrecht, 1961; P. Swillens *Pieter Janszoon Saenredam*, Amsterdam, 1935; and R. Ruurs, *Saenredam. The Art of Perspective*, Amsterdam and Philadelphia, 1986.
56. *Dutch Church Painters*, ex. cat., National Gallery of Scotland, ed. H. Macandrew, with an essay on the perspective of the Edinburgh painting by M. Kemp, pp. 30–7. For a fuller account, see Kemp 'Simon Stevin and Pieter Saenredam. A study of Mathematics and Vision in Dutch Science and Art', *Art Bulletin*, LXVIII, 1986, pp. 237–52. A valuable review of the Edinburgh exhibition is provided by R. Ruurs, *Oud Holland*, XCIX, 1985, pp. 161–4.
57. R. Ruurs in his review (n. 56) shows that Saenredam referred to measurements of St. Bavo's by the surveyor, Peter Wils, as published in S. Ampzing, *Beschrijvinge onde lof der stad Haerlem in Holland*, Haarlem, 1628.
58. Edinburgh (n. 56); and R. Ruurs, 'Saenredam Constucties', *Oud Holland*, XCVI, 1982, pp. 97–122.
59. Edinburgh (n. 56), fig. 13, and Ruurs (n. 57).
60. Edinburg (n. 56), pp. 30–7 and figs. 4–5.
61. Ruurs (n. 58), demonstrates other methods at work.
62. This thesis is argued at greater length in Kemp, 'Simon Stevin. . .' (n. 56).
63. W. Liedtke, *Architectural Painting in Delft*, Doornspijk, 1982, for detailed formal and chronological analyses of these two artists. Leidkte also provides a good account of other painters of church interiors, including the perspectivally accomplished Antoine de l'Orme.
64. Ibid., for an anthology of illustrations.
65. Steen is at his most careful in *The Morning Toilet*,

1663, Buckingham Palace, Collection of Her Majesty the Queen. See B.D. Kischebaun, *The Religious and Historical Paintings of Jan Steen*, New York and Montclair, 1977, fig. 23. For some applications of perspective to landscapes and seascapes, see R. Ruurs, '"Even if it is not architecture". Perspective drawings by Simon de Vlieger and Willem van de Velde the Younger', *Simiolus*, XIV, 1984, pp. 189–200.

66. P. Sutton, *Pieter de Hooch*, Oxford, 1980, for a comprehensive account of de Hooch's oeuvre. The illustrated painting is cat. no. 40B.

67. A particularly good example is the painting in the Wallace Collection, London, in Sutton, ibid., cat. no. 49.

68. The Dyrham perspective was painted on Hoogstraten's visit to London in 1662, and may have been amongst those seen by Samuel Pepys in 1663 and 1664. See *The Diary of Samuel Pepys*, ed. R. Latham and W. Matthews, 11 vols, London, 1970–83, IV, p. 18 and V, p. 277. It was acquired for Dyrham by William Blathwayt (died 1717).

69. S. van Hoogstraten, *Inleyding tot de Hoog Schoole der Schilderkonst*, Rotterdam, 1678, pp. 274–5. (First edition, 1674).

70. Ibid., p. 276.

71. Ibid., pp. 12 and 274.

72. J. Scheffer (Schefferus), *Graphice id est de arte pingendi*, Nuremberg, 1669, p. 158; see A. Ellenius, *De arte pingendi*, Uppsala and Stockholm, 1960, pp. 180ff.

73. Hoogstraten (n. 69), pp. 259–60; and de Caus (n. 40).

74. J. Kepler, *Ad Vitellionem paralipomena, quibus astronomiae pars optica traditus*, Frankfurt, 1604, V, 2. See A. Crombie, 'Kepler: *De Modo Visions*. A translation from the Latin of *Ad Vitellionem Paralipomena*, V, 2, and Related Passages on the Form of the Retinal Image', *Mélanges Alexander Koyré*, 2 vols, Paris, 1964, I, p. 153. Alpers (n. 41, p. 33ff.) draws such a parallel at the expense of the intellectual context of Kepler's statement in his own work and in the tradition of astronomical optics. For the perceptual implications of the 'new' eye, see below Chapter V, p. 234. See also J.V. Field, 'Two Mathematical Inventions in Kepler's "Ad Vitellionem Paralipomena"', *Studies in the History of Philosophy and Science*, XVII, 1987, pp. 449–68.

75. For an introduction to Kepler's 'aesthetics' see D.P. Walker, *Studies in Musical Science in the late Renaissance*, London and Leiden, 1978, esp. p. 42ff; R. Westman, 'Nature, Art and Psyche. Jung, Pauli and the Kepler-Fludd Polemic', and J.V. Field, 'Kepler's rejection of numerology', in *Occult and Scientific Mentalities in the Renaissance*, ed. B. Vickers, Cambridge, 1984, pp. 177–230 and 273–296, and J.V. Field, *Kepler's Geometrical Cosmology*, Chicago, 1988.

76. I.L. de Vaulezard, *Abrégé ou racourcy de la perspective par l'imitation*, Paris, 1643, and also *Perspective cylindrique et conique*, Paris, 1630; G. Desargues, *Exemple de l'une des manières universelles. .*, Paris, 1636 (see below n. 79); F. Niceron, *Thaumaturgus opticus. . .* Leiden, 1663 (first edition, 1646), and *La Perspective curieuse*, Paris 1652 and 1663 (first edition, 1638); J. Dubreuil, *Perspective practique. .*, Paris, 1642, and subsequent amplifications and revisions; E. Mignon, *La Perspective spéculative et pratique du sieur Aleaume*, Paris, 1643; A. Bosse, *Manière universelle de M. Desargues pour pratiquer la perspective. .*, Paris, 1648, *Moyen universelle de pratiquer la perspective sur les tableau ou surface irrégulières*, Paris, 1653, *Traité des practiques géométrales et perspectives. .*, Paris, 1665, *Le Peintre converti aux précises et universelles règles de son art*, Paris, 1667; R. Gaultier, Sieur de Maignannes, *Invention nouvelle et briève pour reduire en perspective. .*, La Fleche, 1648; J. Le Bicheur, *Traicté de Perspective. .*, Paris, 1660 (?); G. Huret, *Optique di Portraicture et Peinture*, Paris, 1670; C. Bourgoing, *La Perspective affranchie*, Paris, 1661; S. le Clerc, *Pratique de la géométrie. .*, 1682.

77. For a biographical outline, see R. Taton, in *Dictionary of Scientific Biography*, New York, 1971, IV.

78. *Oeuvres de Desargues*, ed. N. Poudra, 2 vols, Paris, 1864, I, pp. 24–5; also *L'Oeuvre mathématique de G. De-*

sargues*, ed. R. Taton, Paris, 1951; J.V. Field and J.J. Gray, *The Geometrical Work of Girard Desargues*, New York, 1987, and Field, 'Linear Perspective and the Projective Geometry of Girard Desargues', *Nuncius*, II, 1987, pp. 3–40.

79. M. Mersenne, *Harmonie universelle*, 2 vols, Paris, 1636–7, I, bk. 6. G. Desargues, *Exemple de l'une des manières universelles du S'. G.D.L. touchant la pratique de la perspective. .*, Paris, 1636. A copy of this pamphlet, previously considered lost, is in the Bibliothèque Nationale, Paris (information from J.V. Field).

80. *Brouillon project d'une at'einte aux événens des rencontres d'une cone avec un plan*, Paris, 1639.

81. For an account of Kepler's innovation, see Field and Gray (n. 78) and Field (n. 74); and for Desargues, Taton (n. 78), pp. 99, 169 and 179.

82. See N.A. Court, 'Desargues and his Strange Theorem', *Scripta Mathematica*, XX, 1954, pp. 5–13 and 155ff; and W. Ivins Jnr, 'A Note on Desargues' Theorem', *Scripta Mathematica*, XIII, 1947, pp. 203–10; and W. Ivins Jnr, *Art and Geometry*, Cambridge, Mass., 1946.

83. Bosse, 1648 (n. 76).

84. For a lucid account of the concepts involved in Desarguian and later geometry of this kind, see L. Cremona, *Projective Geometry*, Oxford, 1885; also G. Loria, *Storia della geometria descrittiva*, Milan, 1921.

85. J. Coolidge, *A History of Geometrical Methods*, Oxford, 1940, and J. Coolidge, 'The Rise and Fall of Projective Geometry', *The American Mathematical Monthly*, XLI, 1934, pp. 217–28; U. Cassina, *Sur l'histoire des concepts fondamentaux de la géométrie projective*, Paris, 1957.

86. N. Poncelet, *Traité des propriétés projectives de figures*, Metz-Paris, 1822; and M. Chasles, *Aperçu historique sur l'origine et le développement des méthodes en géométrie*, Brussels, 1837. For a discussion (albeit from a polemical standpoint) of the survival of Desargues's ideas in the realm of architecture, see A. Pérez-Gomez, *Architecture and the Crisis of Modern Science*, Cambridge, Mass., 1983; and, more soberly by Field and Gray (n. 78).

87. Taton (n. 77). See Poudra (n. 78) II, pp. 355ff.

88. Dubreuil (n. 76).

89. Poudra (n. 78), II, p. 497.

90. Dubreuil, *Diverses méthodes universelles ou nouvelles. . .*, Paris, 1642. The Aleaume-Mignon treatise (n. 76) does use a form of perspective system, but differently from Desargues and does not appear to have been Desargues's source. The relevant documents are assembled by Poudra (n. 78), II, pp. 219ff.

91. *Avis charitables sur les diverses oeuvres et feuilles volantes du sieur Girard Desargues*, Paris, 1642; Poudra (n. 78), II, pp. 251ff.

92. Poudra (n. 78), II, p. 498.

93. *La pratique du trait a preuvres de M. Desargues lyonnais pour la coupe des pierres en l'architecture. . .*, Paris, 1643, incorporating Desargues's *Brouillon projet d'example d'une manière universelle du S'. G.D.L. touchant la pratique du trait a preuvres pour la coupe des pierres. .*, Paris, 1640.

94. M. Curabelle, *Examen des oeuvres du S' Desargues*, Paris, 1644. For Desargues's vehement response see Poudra (n. 78), II, pp. 342–3.

95. N. Pevsner, *Academies of Art, Past and Present*, Cambridge, 1940, pp. 82ff.

96. A. Blum, *Abraham Bosse et la société Francaise au dix-septième siècle*, Paris, 1924; and C. Goldstein, 'Studies in Seventeenth Century French Art Theory and Ceiling Painting', *Art Bulletin*, XLVII, 1965, pp. 231–56.

97. Bosse, 1653, 1665 and 1667 (n. 76).

98. For the latter, see particularly Goldstein (n. 96).

99. A. Blum, *L'Oeuvre gravé d'Abraham Bosse*, Paris, 1924.

100. *Traité de la peinture de Léonard de Vinci. . .*, trs. R. Fréart, Sieur de Chambray, Paris, 1651 (and *Trattato della Pittura. .*, ed. R. du Fresne, Paris, 1651); see M. Kemp. '"A Chaos of Intelligence". Leonardo's "Traité" and the Perspective Wars in the Académie Royale', *'Il se rendit en Italie', Études offertes à André Chastel*, ed. P. Rosenberg et al., Paris, 1987, pp. 415–26.

101. Le Bicheur (n. 76).

102. *Cahier suivi d'une stampe donné par A. Bosse. .*, Paris, 1660; Blum (n. 96), p. 27. See also *Lettres écrits au Sr. Bosse, graveur, avec ses responses sur quelque nouveaux traittez concernans la perspective et al peinture*, Paris, 1668.

103. *Process verbaux de l'Académie Royale de peinture et de sculpture, 1648–1792*, ed. A de Montaiglon, 10 vols, Paris, 1875–92, I, p. 169 (3 July 1660).

104. Blum (n. 96), p. 36.

105. Ibid., p. 96.

106. Bosse, 1665, (n. 76).

107. Bosse, 1665, (n. 76), p. 108ff.

108. Dubreuil (n. 76), and *The Practice of Perspective. . .*, trans. E. Chambers, London, 1726, preface.

109. Ibid., p. vi.

110. J. Dubreuil, *L'Art universel des fortifications*, Paris, 1665, preface

111. Huret, (n. 76), see G. Kauffmann, *Poussin-Studien*, Berlin, 1960.

112. Huret, (n. 76), p. 72ff.

113. Ibid., p. 1.

114. Ibid., p. 83.

115. Blum (n. 96), p. 19; see also K.T. Steinitz, *Leonardo da Vinci's Trattato della Pittura. . . A Bibliography of the Printed Editions, 1651–1956*, Copenhagen, 1958, p. 148.

116. A Blunt, *Nicolas Poussin*, 2 vols, New York, 1967, I, pp. 367–70.

117. Ibid., p. 364; see also M. Kemp 'Geometrical Perspective from Brunelleschi to Desargues. A Pictorial Means or an Intellectual End?', *Proceedings of the British Academy (1984)*, LXX, 1985, pp. 89–132.

118. Ibid., p. 371. C. Goldstein, 'The Meaning of Poussin's letter to de Noyers', *Burlington Magazine*, CVIII, 1966, pp. 233–7.

119. D. Barbaro, *La pratica della perspettiva*, Venice, 1569, p. 6.

120. For the Zaccolini MSS, discovered by Carlo Pedretti, see J. Bell, 'Colour and Theory in Seicento Art. Zaccolini's "Prospettiva del Colore" and the Heritage of Leonardo', Ph.D. thesis, Brown University, 1983; and J. Bell, 'Cassiano del Pozzo's Copy of the Zaccolini Manuscripts', *Journal of the Warburg and Courtauld Institutes*, LI, 1988, arguing that: (a) the Laurenziana MSS. are copies made for Cassiano; (b) the copy made for Poussin included more than the MS. on cast shadows; and (c) they may have been known to Bosse and exercised an influence on French theory.

121. E. Cropper, 'Poussin and Leonardo: Evidence from the Zaccolini Manuscripts', *Art Bulletin*, LXII, 1980, p. 570–82.

122. Blunt (n. 116), p. 350.

123. H. Hibbard, *Poussin. The Holy Family on the Steps*, London, 1974, p. 14.

124. Blunt, *The Paintings of Nicolas Poussin. A Critical Catalogue*, London, 1966, no. 85.

125. R. Fréart de Chambray, *La Perspective d'Euclide*, Mans, 1663; and *Idée de la perfection de la peinture*, Mans, 1662.

126. *Idée*, ibid., pp. 26ff.

127. Blunt (n. 116), p. 271.

128. C. Pace, *Félibien's Life of Poussin*, London, 1981.

129. B. Dorival, *Philippe de Champaigne, 1602–1674*, 2 vols, Paris, 1976, II, p. 195.

130. *La Peinture Française du XVII siècle dans les collections Americans*, ex. cat., Paris, 1982. The set, to which the Grammar (1650, National Gallery, London) also belongs, was painted for Gideon Tallemant. For La Hire's drawings, see P. Rosenberg and J. Thuillier, *Laurent de la Hyre (1606–1656)*, (Cahiers du dessin Français, I), Paris, n.d.

131. See Pérez-Gomez (n. 86) and Field and Gray (n. 78).

132. In the Musée des Beaux Arts, Marseilles.

133. M. Sapin, 'Contribution à l'étude de quelques oeuvres d'Eustache le Sueur', *La Revue du Louvre*, IV, 1978, pp. 242–54; A. Mérot, *Eustache le Sueur*, Paris, 1987.

134. See F. Yates, *The French Academies of the Sixteenth Century*, (Studies of the Warburg Institute, XV), London, 1947, pp. 275ff; A. Crombie in *Dictionary of Scien-*

tific Biography, New York, 1974, IX.

135. See Taton (n. 78), pp. 3, 13 and 15ff.

136. Blunt (n. 116), pp. 208ff, for Poussin's intellectual connections in Paris.

137. See Baltrušaitis, (n. 40), pp. 37ff and 61ff.

138. Niceron, *Thamaturgus opticus. .*, 1663 (n. 76).

139. W. Shea, 'Newton and Descartes on the Indefiniteness of Extension', in *Nature Mathematicised. Historical and Philosophical Studies in Classical Modern Natural Philosophy* (Third International Conference on the History and Philosophy of Science), ed. W. Shea, 2 vols, Montreal, 1983.

140. Pevsner, (n. 95), pp. 82ff. W. Gilly, *The Paintings of Simon Vouet*, New Haven and London, 1962.

141. The fundamental study is J. Montagu, 'Charles Le Brun's *Conference sur l'expression générale et particulière*,' Ph.D. thesis, Warburg Institute, University of London, 1959. Also G. Le Coat, 'Comparative Aspects of the Theory of Expression in the Baroque Age', *Eighteenth Century Studies*, V, 1971–2, pp. 207–23.

142. Baltrušaitis (n. 137).

143. Blunt (n. 116), p. 226 for Poussin's use of Zarlino's text, and below pp.

144. R. Descartes, *Discours de la méthode plus la dioptrique, les meteores e la géométrie*, Leiden, 1637. Translated by P. Olscamp as *Discourse on Method, Optics, Geometry and Meteorology*, New York, 1965.

145. R. Alberti, *Trattato della nobilità della pittura*, Rome, 1585; L. Sirigatti, *La Pratica di prospettiva*, Venice, 1596, and subsequent editions. See D. Mahon, *Studies in Seicento Art and Theory*, London, 1947, part III, for art theory in the Roman academy. Also L. Grassi, *Teorici e storia della critica*, Rome, 1973, II (Il Seicento); and C. Goldstein, *Visual Fact over Verbal Fiction*, Cambridge, 1988.

146. D. Posner, *Annibale Carracci*, 2 vols, London and New York, 1971, I, fig. 1.

147. Ibid., I, p. 77; and J. Martin, *The Farnese Gallery*, Princeton, 1965, fig. 29.

148. Ibid., I, p. 94 and fig. 11g.

149. Ibid., II, p. 56, no. 127; and the valuable discussion by Goldstein (n. 145), pp. 147–55.

150. See Bell (n. 120).

151. For the transmission of Leonardo's *Trattato*, see C. Pedretti, *Commentary on The Literary Works of Leonardo da Vinci*, ed. J.P. Richter, 2 vols, Oxford, 1977, I, pp. 12–47; and Steinitz (n. 115).

152. Pedretti, ibid., I, p. 15.

153. For biographical details, see G. Lumbroso, *Notizie sulla vita di Cassiano del Pozzo*, Turin, 1874; and F. Haskell, *Patrons and Painters*, London, 1963, pp. 98ff.

154. For Cassiano's activities with respect to the first edition of Leonardo's Trattato (*Trattato della Pittura di Leonardo da Vinci*, Paris, 1651, ed. R. du Fresne, and *Traité de la peinture de Léonard de Vinci*, trans. R. Fréart de Cambray, Paris 1651), see Steinitz (n. 115), pp. 71 and 94ff; and Bell (n. 120).

155. Pedretti (n. 151), I, pp. 37–40; and G. Ticciati, 'Storia della Accademia del Disegno', *Spigolatura Michelangiolesca*, ed. P. Fanfani, Pistoia, 1867, p. 271.

156. Florence, Bibliotheca Laurenziana, MS Ashburnham 1212, I ('De' Colori'), II ('Prospettiva del Colore'), III ('Prospettiva Lineale'), IV ('Della Descrittione dell'Ombre. . .'). I am most grateful to Carlo Pedretti for providing access to his microfilms of the treatises.

157. Zaccolini's best surviving work is an illustionistic ceiling decoration in the Choir of S. Silvestro al Quirinale, Rome. See J. Bell, 'The Life and Works of Matteo Zaccolini', *Regnum Dei*, 1985, XLI, pp. 227–58; and M.C. Gloton, *Trompe-l'oeuil et décor plafonnant dans les Eglises Romanes de l'âge Baroque*, Rome, 1965, pp. 12, 62, 143 and plate XLVII.

158. MS. 1212 (3) (n. 156), fols. 76–7.

159. MS. 1212 (3) (n. 156), fols. 81v–82r.

160. G.P. Bellori, *Le Vite de' pittori, scultori et architetti*, (1672) ed. E. Barea, Rome, 1976, p. 350; and R. Spear, *Domenichino*, 2 vols, New Haven, 1982, I, pp. 85–6.

161. Cropper (n. 121), for the influence of this MS. on Poussin, though it is likely that Poussin's copy consisted of more than just the MS. on shadow projection.

162. E. Cropper, *The Ideal of Painting. Pietro Testa's Dusseldorf Notebook*, Princeton, 1984.

163. Ibid., p. 77.

164. Ibid., pp. 226–33 (notebook 14 r–v).

165. Ibid., pp. 65–95 for a full exposition of the *liceo*.

166. P. Accolti, *Lo Inganno de gl'occhi, prospettiva pratica*, Florence, 1625, pp. 95ff.

167. Ibid., p. 150.

168. Ibid., pp. 104–5.

169. Ibid., p. 108.

170. Ibid., pp. 144ff, a section addressed to 'the young academicians and painters'.

171. E. Sjöström, *Quadratura. Studies in Italian Ceiling Painting*, Stockholm, 1978, for an outline of the generations of Bolognese illusion painters; and E. Feinblatt, 'Contributions to Girolamo Curti', *Burlington Magazine*, XVII, 1975, p. 350ff.

172. E. Feinblatt, 'Angelo Michele Colonna: a Profile', *Burlington Magazine*, CXXI, 1979, pp. 618–30; Feinblatt, *Agostino Mitelli (Drawings from the Kunstbibliothek, Berlin)*, ex. cat., County Museum, Los Angeles, 1965; and M. Pirondini, V. Vandelli and E. Bertozzi Desco, *Il Ducale Palazzo di Sassuolo*, Genoa and Modena, 1982.

173. Feinblatt (n. 22).

174. G.V. Zanini, *Della architettura* Padua, 1629.

175. Ibid., p. 37.

176. A Pozzo, *Perspectiva pictorum et architectorum*, 2 vols, Rome, 1693 and 1700. There were no less than 15 editions before 1800.

177. R. Kerber, *Andrea Pozzo*, Berlin and New York, 1971, for biographical details.

178. Pozzo (n. 176), text for pl. 91.

179. Pozzo (n. 176), text for pls. 100ff. For a discussion of the visual-perceptual aspects of Pozzo's work, see M. Kemp, 'Perspective and Meaning. Illusion, Allusion and Collusion', in *Philosophy and the Visual Arts*, ed. M. Harrison, Dordrecht, 1987, pp. 255–68.

180. Pozzo (n. 176), letter to reader; and *Breve descrizione del disegno della Capella di Sant'Ignazio*, Rome, 1697, for the content of the nave fresco.

181. Pozzo (n. 176), eg. I, pl. 71.

182. See, amongst others: F. Marotti, *Lo Spazio scenico*, Rome, 1974; F. Mancini, M. Muraro, E. Povoledo et. al., *Illusione e pratica teatrale*, ex. cat. Venice, 1975; P. Bjustrom, *Giacomo Torelli and Baroque Stage Design*, Stockholm, 1962; A. Nicoll, *The Development of the Theatre*, New York, 1966; L. Zorzi, *Il Teatro e la città. Saggi sulla scena Italian*, Turin, 1977; J. Kindermann, *Theatergeschichte Europas*, Salzburg, 1959, II, pp. 72ff; and G. Schöne, *Die Entwicklung der Perspektivbühne*, Leipzig, 1933.

183. Nicoll (n. 182), pp. 72ff. For Leonardo's perspectival scene design see the Codice Atlantico, 358 vb, Milan, Bibliotheca Ambrosiana.

184. Particularly Borromini's accelerated perspective in the colonnaded passage in the Palazzo Spada (1635); see L. Neppi, 'Punti di vista sulla prospettiva Spada', *Bollettino d'Arte*, XXII, 1984, pp. 106–18.

185. For biographical details of the Bibiena family of designers, see A. Hyatt Mayor, *The Bibiena Family*, New York, 1945.

186. G. Troili, *Paradossi per pratticare la prospettiva senza saperla* Bologna, 1672.

187. F. Galli-Bibiena, *Architettura civile, preparata su la geometria e ridotta alle prospettive*, Parma, 1711; see the introduction by D.M. Kelder to the New York edition, 1971.

188. *Discrezione ai giovani studenti nel disegno dell'architettura civile*, Bologna, 1731, 1745, 1753 and 1777.

189. G.P. Zanotti, *Storia dell'Accademia Clementina*, Bologna, 1739.

190. E. Zanotti, *Trattato teorico – pratico di prospettiva*, Milan, 1825 (first edition, Bologna, 1766); see G. Tabarroni in *Dictionary of Scientific Biography*, New York, 1976, XIV.

191. Ibid., pp. 148ff.

192. See E. Bonova in *Dizionario Biografico degli Italiani*, Rome, 1960, II.

193. For Algarotti's predecessors and circle in Italy, see Haskell (n. 153), pp. 318ff.

194. *Il Newtonianismo per le dame ovvero dialoghi sopra la luce e i colori*, Naples, 1737.

195. *Lettera sopra la pittura*, Venice, 1762; translated as *An Essay on Painting*, London, 1764. For a collected edition of his various works, see *Opere del Conte Algarotti*, Livorno, 1764. See particularly the letters in vol. VIII and *Pensieri diversi* in vol. VII.

196. *Opere* (n. 195), VII, *Pensieri diversi*, p. 44.

197. *Opere* (n. 195), VIII, p. 33; see Haskell (n. 153), p. 353; M. Levey, 'Tiepolo's "Banquet of Cleopatra" at Melbourne', *Arte Veneta*, IX, 1955, pp. 199–203; and F. Haskell, 'Algarotti and Tiepolo's "Banquet of Cleopatra"', *Burlington Magazine*, C, 1958, pp. 212–13.

198. See the schemes for the Villa Contarini at Mira, Villa Valmarana, Palazzo Barbarigo, Venice, and elsewhere. See *Opere* (n. 195), VIII, p. 45; A. Morassi, *A Complete Catalogue of the Paintings of G.B. Tiepolo*, London, 1962; and M. Precerutti Garberi, *Affreschi settenteschi delle ville venete*, Milan, 1968.

199. *Opere* (n. 195), VII, p. 43.

200. *Opere* (n. 195), VII, p. 44.

201. *Opere* (n. 195), VIII, p. 85 and 126ff.

202. *Opere* (n. 195), VIII, p. 85 and 108ff for praise of Tesi. See the *Raccolta di disegni originali di Mauro Tesi estratti da diverse collezioni*, Bologna, 1787 (reprinted Farnborough, 1970); and G. Zucchini, *Paesaggi e rovine nella pittura bolognese del settecento*, Bologna, 1947, for the context of Tesi's work.

203. *Opere* (n. 195), VIII, p. 89.

204. *Opere* (n. 195), VIII, p. 89–99.

205. W.G. Constable, *Canaletto*, 2 vols, Oxford, 1976, no. 458, for the versions of this painting. See also W.L. Barcham, *The Imaginary View Scenes of Antonio Canaletto*, New York and London, 1977; J.G. Links, *Canaletto*, Oxford, 1982; and A. Corboz, *Canaletto, una Venezia immaginaria*, 2 vols, Milan, 1985.

206. P. Zampetti, *I Vedutisti Veneziani del settecento*, ex. cat., Venice, 1967. A Rizzi, *Luca Carlevarijs*, Venice, 1967.

207. Constable (n. 205), p. 9 and T. Pignatti, *Canaletto*, Bologna, 1979.

208. Ibid., II, no. 308.

209. Ibid., pp. 155–62, for Canaletto's working procedures; also *Canaletto. Paintings and Drawings*, ex. cat., Queen's Gallery, Buckingham Palace, London, 1980–1.

210. Ibid., II, nos. 428, 429 and 430 for the versions of the variant compositions; nos. 745 and 746 (drawings).

211. See Barcham (n. 205) pp. 167ff and 190–1 for an outline of the perspectivists at the Venetian Academy. See also, *Canaletto e Visentini*, ex. cat., Ca Pesaro, Venice, 1986.

212. G.F. Costa, *Elementi di prospettiva*, Venice, 1747, and see below plate 390.

213. Barcham (n. 205), p. 149; and Constable (n. 205), II, no. 509.

214. H.A. Fritzsche, *Bernardo Bellotto gennant Canaletto*, Leipzig, 1936, with a good discussion of his methods; S. Kozakiewicz, *Bernardo Bellotto*, trs. M. Whittal, 2 vols, London, 1972.

215. Kozakiewicz, ibid., II, no. 333, with the companion piece, *Christ Driving the Money Changes from the Temple*, no. 336.

216. Horace, *Ars Poetica*, 9.

217. Fritzsche (n. 214), VZ 74 and 75. Compare Pozzo (n. 188), II, fig. 23.

218. J. Peacock, 'Inigo Jones' Stage Architecture and its Sources', *Art Bulletin*, LXIV, 1982, pp. 195–216.

219. Pozzo's *Perspectiva* (n. 176), trs. J. James, as *Rules and Examples proper for Painters and Architects*, London, 1707.

220. F. Algarotti, *Essay on Painting*, London, 1764, dedication.

221. H. Ditton, *A Treatise of Perspective, Demonstrative and Practical*, London, 1712. He was also the author of *The General Laws of Nature and Motion*, London, 1705. See *Dictionary of National Biography*, London, 1888, XV.

222. Ditton, *Perspective*, introduction.

223. For biographical details, see P. Jones, *Dictionary of Scientific Biography*, New York, 1967, XIII; also P. Jones 'Brook Taylor and The Mathematical Theory of Linear Perspective, *American Mathematical Monthly*, LVIII, 1951, pp. 597–606; and K. Anderson, *Brook Taylor's Role in the History of Linear Perspective*, Aarhus, 1989.

224. B. Taylor, *Methodus incrementorum directa et inversa*, London, 1715 (and 1717), including his notable theorem for expanding functions into infinite series.

225. B. Taylor, *New Principles of Linear Perspective or, the Art of Designing on a Plane*, fourth edition, London, 1811 (based on the second edition of 1719). The first edition of 1715 was entitled *Linear Perspective or a New Method of Portraying justly all manner of objects as they appear to the Eye in all Situations*. See Anderson (n. 48) for the mathematical aspects of Taylor's work.

226. Ibid., p. xxii.

227. M. Ozanam, *La Perspective, théorique et pratique*, Paris, 1700, pp. 32–3 and plate 8, fig. 16.

228. Taylor, 1811 (n. 225), p. x.

229. Jones in *American Mathematical Monthly* (n. 233), pp. 604–5 for a list of later editions, expansions and translations.

230. J. Hamilton, *Stereography or a compleat body of perspective*, London 1738 (and 1740 and 1748).

231. Ibid., p. 11.

232. J.J. Kirby, *Dr. Brook Taylor's Method of Perspective made easy both in Theory and Practice*, Ipswich, 1754, 1755; and London 1765, 1768. For a biographical outline, see *Dictionary of National Biography*, London, 1892, XXXI. See also *Joshua Kirby and Thomas Gainsborough*, ex. cat., Gainsborough's House, Sudbury, Suffolk, 1980.

233. Pevsner, (n. 95), pp. 124ff and 183ff; and S. Hutchison, *The History of the Royal Academy, 1768–1968*, London, 1968, pp. 26ff.

234. Kirby (n. 232), preface, p. ii.

235. Ibid., pp. 70–1. This drew a sharp response from Joseph Highmore in his *A Critical Examination of those Two Paintings in the Ceiling of the Banqueting House at Whitehall*, London, 1754.

236. J.J. Kirby, *The Perspective of Architecture. . .deduced from the Principles of Dr. Brook Taylor*, London, 1761.

237. S. Hutchison, (n. 233), p. 212, article XII of the Academy's Instrument of Foundation, establishing that there should be a 'Professor of Perspective and Geometry' to teach all aspects of the optics of art.

238. He also assisted the architect John Gwynn on a series of drawings of St. Paul's Cathedral which were published in 1752. At the Society of Artists in 1766, he exhibited 'A Drawing showing what is proposed for finishing the east of St. Paul's, the Historical Parts by Mr. Wale'. For a biographical outline, see *Dictionary of National Biography*, London, 1899, LIX; and H.A. Hammelman, 'An Illustrator of Georgian London', *Country Life*, 1958, p. 1333.

239. See L. Herrmann, *British Landscape Painting of the Eighteenth Century*, London, 1973, p. 36 and pl. 27.

240. T. Malton, *A Complete Treatise on Perspective in Theory and Practice on the True Principles of Brook Taylor*, London, 1779.

241. Eg. ibid., p. 100 on which he assaults the 'truly ridiculous and absurd opinions' of those who disparage perspective.

242. For a further drawing in the series, see G. Stamp, *The Great Perspectivists*, London, 1982, no. 3. See particularly A.P. Oppé, *The Drawings of Paul and Thomas Sandby in the Collection of His Majesty the King at Windsor Castle*, London, 1947; and L. Herrmann, *Paul and Thomas Sandby*, ex. cat., Victoria and Albert Museum, London, 1986, nos. 45–7.

243. See the section by J. Gage on Turner's 'Life and Times' in *Turner*, ex. cat., Royal Academy, London, 1974–5.

244. J. Malton, *The Young Painter's Maulstick, being a Practical Treatise on Perspective containing the Rules and Principles for the Delineation of Planes*, London, 1800, p. i.

245. E. Edwards, *A Practical Treatise of Perspective on the Principles of Dr. Brook Taylor*, London, 1803. For a biography, see *Dictionary of National Biography*, London, 1889, XVII. His most notable painting was his *Interior View of Westminster Abbey on the Commemoration of Handel*, exhibited at the R.A. in 1793 (no. 198).

246. The best account of Turner as Professor of Perspective is by J. Gage, *Colour in Turner. Poetry and Truth*, London, 1969, pp. 106ff. See also W.T. Whitely 'Turner as a Lecturer', *Burlington Magazine*, XXII, 1912–13, pp. 13–14 and 107–8.

247. Excerpts from the lectures (concentrating largely on non-perspectival matters) are given by Gage, ibid., pp. 196ff; and J. Ziff, '"Backgrounds, Introduction to Architecture and Landscape". A lecture by J.M.W. Turner', *Journal of the Warburg and Courtauld Institutes*, XXVI, 1963, pp. 124–47. A preliminary notice of the perspective lectures is given by P. Thompson in her undergraduate dissertation at St. Andrews in 1984. A useful introduction and handlist was prepared by J. Edgerton to accompany a small exhibition of Turner's lecture material at the Tate Gallery (n.d.). See also *Turner and Architecture*, ex. cat., Tate Gallery, 1988. A doctoral study is being prepared by Maurice Davies, who will be dealing authoritatively with the full range of issues raised in Turner's lectures.

248. Turner's perspective drawings and lecture notes are in the British Museum, Department of Prints and Drawings, Turner Bequest, and British Library, Add. MS. 46151. The 'Introduction' is B.L. Add. MS. 46151 B, Q.

249. Turner (n. 248), B.L. Add. MS. 46151 M and V.

250. Kirby (n. 232), II, 7, for his summary of methods 'by some of the most eminent authors'. Turner's annotated copy of Kirby is owned by Mrs. C.M.W. Turner. For Pelérin and Vredeman, see Turner (n. 248), B.M., CXCV, 71; B.M., CXCV, 75; and B.L. Add. MS. 46151 M.

251. Turner (n. 248), B.M. CXCV, 75.

252. Turner (n. 248), B.L. Add. MS. 46151, B, Q.

253. *New Monthly Magazine*, 9 Jan. 1815.

254. Turner (n. 248), B.M. CXCV, 145.

255. M. Butlin and E. Joll, *The Paintings of J.M.W. Turner*, 2 vols, London and New York, 1984, nos. 235 and 239.

256. Ibid., no. 283.

257. Gage (n. 246), p. 209. For the cult of infinity in literature see M. Hope Nicolson, *Mountain Gloom and Mountain Glory*, New York, 1963; *The Breaking of the Circle*, Evanston, Illinois, 1950; and *Newton Demands the Muse*, Princeton, N.J., 1946.

258. Turner (n. 248), B.L. Add. MS. 46151 v.

259. Milton, *Paradise Lost*, XII, 555–60.

260. Quoted from Gage (n. 246), p. 119.

261. Butlin and Joll (n. 255), no. 365. Compare *Rome from the Vatican* (n. 228), and *Bridge of Sighs, Ducal Palace and Custom-House, Venice: Canaletti Painting* (no. 349).

262. L. Gowing, *Turner. Imagination and Reality*, ex. cat., Museum of Modern Art, New York, p. 38.

263. W. Feaver, *The Art of John Martin*, Oxford, 1975, esp. pp. 42 and 51ff.

264. E. Bulwer-Lytton, *England and the English*, London, 1833, vol. II, pp. 211–2.

265. A.W. Hakewill, intro. to *A Complete, Scientific and Popular Treatise on Perspective. . . by a Pupil of Monsieur J.P. Thenot*, London, 1836, p. x.

CHAPTER IV

1. The most conspicuous exceptions are a series of Japanese images of the eighteenth and nineteenth centuries which depend directly on Western inspiration. See *The Development of Western Realism in Japan*, ex. cat., National Museum of Modern Art, Tokyo, 1985.

2. P. Dagomari (dell'Abbaco), *Trattato d'aritmetica*, ed. G. Arrighi, Pisa, 1964, p. 63. See also L. Fibonacci, *La Practica di geometria*, ed. G. Arrighi, Pisa, 1960.

3. C. Bartoli, *Del Modo di misurare*, Venice, 1589. Compare F. di Giorgio, *La Pratica di geometria*, ed. G. Arrighi, Milan, 1970, fol. 28rff.

4. L.B. Alberti, *Ludi mathematici*, ed. S. Timpanaro, in *Leonardo Pagine di Scienza*, Milan, 1926, pp. 1–36.

5. L.B. Alberti, *Descriptio urbis Romae*, ed., L. Vagnetti and G. Orlandi *Quaderno*, I, Universita di Genoa, 1968, pp. 60–3.

6. *Leon Battista Alberti 'On Painting' and 'On Sculpture'*, ed. and trans. C. Grayson, London, 1972, pp. 66–9.

7. Ibid., pp. 68–9.

8. C. Bartoli (n. 3), pp. 14ff. See also E. Kiely, *Surveying Instruments. Their History and Classroom Use*, New York, 1947, pp. 83ff and 194ff; A. Turner, *Early Scientific Instruments*, London, 1987; and J. Bennett, *The Divided Circle*, Oxford, 1987.

9. G. Frisius, *De Radio astronomico et geometrico liber*, Antwerp, 1545, ch. 13.

10. V. Golzio, *Raffaello nei documenti e nelle testimonianze del suo secolo*, Vatican, 1936, pp. 78–92; also C. Pedretti, *A Chronology of Leonardo's Architectural Studies after 1500*, Geneva, 1962, pp. 162–71.

11. Pedretti, ibid., p. 166.

12. MS. B.N. 2038, 24r; *The Literary Works of Leonardo da Vinci*, ed. J.P. Richter, 2 vols, New York and London, 1970, para 523 (also Codex Urbinas 41r–v).

13. A. Dürer, *Underweysung der Messung*, Nuremberg, first edition, 1525 (for the perspective glass and the lute perspective) and second edition, 1538 (for the veil and the vase perspective).

14. MS. Sloane 5229/130. See W. Strauss, *Albrecht Dürer, The Human Figure*, New York, 1972, pp. 310–2.

15. K. Veltman, 'Military Surveying and Topography. The Practical Dimension of Renaissance Linear Perspective', *Revista da Universidade de Coimbra*, XXVII, 1979, p. 341 and fig. 3.

16. D. Barbaro, *La pratica della prospettiva*, Venice, 1569, p. 191.

17. G.P. Lomazzo, *Trattato dell'arte della pittura, scoltura et architettura* (Milan, 1584) in *Scritti d'arte*, ed. R. Ciardi, 2 vols, Florence, 1973, II, p. 275, p. 56ff.

18. J. Barrozzi Vignola, *Le due regole della prospettiva pratica*, ed. E. Danti, Rome, 1583, pp. 56ff.

19. Ibid., pp. 61–2; cf. Barbaro (n. 16), p. 192. C. Maltese, 'La Prospettiva curva di Leonardo da Vinci e uno strumento di Baldassare Lanci', in *La Prospettiva Rinascimentale*, ed. M. Dalai Emiliani, Florence, 1980, pp. 417–25.

20. M.L. Ringhini Bonelli, *Il Museo di storia della scienza*, Florence, 1968, no. 313

21. Danti (n. 18), p. 61.

22. Gabinetto di disegni e stampe degli Uffizi, XXXI. *Feste e apparati medicei da Cosimo I a Cosimo II*, Florence. 1969, no. 9.

23. L. Cigoli, *La Prospettiva pratica*, Florence, Uffizi, MS. 2660, fols. 71r and 83rff. for the perspective machines. See N. Turner, *Florentine Drawings of the Sixteenth Century*, ex. cat., British Museum, London, 1986, no. 202; and F. Camerota, 'Dalla finestra allo specchio. La "Prospettiva pratica" di Ludovico Cigoli alle origini di una nuova concezione spaziale', Ph.D. thesis, Florence, Università degli studi, 1987.

24. Ibid., 83r.

25. L. Brunn, *Praxis perspectivae*, Leipzig, 1605, figs. 12–14; and the instrument of Jost Bürgi in the Kunsthistorisches Museum, Vienna, illustrated in *Prag um 1600*, ex. cat., Villa Hügel, Freren, 1988, p. 531, no. 412. Brunn's device works from ground-plans and elevations, while Bürgi's appears to be related to Lanci's machine in its circular operation.

26. Cigoli (n. 23), fol. 89v–90r.

27. J.F. Niceron, *La Perspective curieuse ou magie artificielle*, Paris, 1638, p. 77 and *Thaumaturgus opticus*, Paris, 1646, p. 191. See also N. Bion, *Mathematische Werkschule*, 1717, plate 8, which also shows a modified version of Cigoli's machine.

28. C. Scheiner, *Pantographice, seu ars delineandi*, Rome, 1631. See W. Wallace, 'Account of the Inventor of the Pantograph, and a Description of the Eidograph', *Transactions of the Royal Society of Edinburgh*, XIII, 1836, pp. 418–39. Was 'Master Gregorius' Pierre Gregoire (Petrus Gregorius), author of *Syntaxeon artis mirabilis*, Leyden, 1575–6?

29. M. Bettinus, *Apiariorum philosophiae mathematicae*

(*Apiaria universae*), Bologna, 1645, V, pp. 44–5.

30. 'An instrument invented diverse years ago by Dr. Christopher Wren, for drawing the Out-Lines of an object in Perspective', *Philosophical Transactions of the Royal Society*, IV, 1669, pp. 898–9.

31. S.J. Ayres, *The Artist's Craft*, Oxford, 1985, p. 65, fig. 93, illustrating a device in the Science Museum, London. A Dürer-like machine was illustrated by W. Halfpenny, *Perspective Made Easy. . .* London, n.d. [1731], pp. 1ff. A window machine is illustrated in the frontispiece to I. Newton, *Opticae*, ed. S. Clark London, 1740. Adams illustrates two complicated perspectographs in his *Geometrical and Graphical Essays*, London, 1796. See also M. Hambly, *Drawing Instruments*, ex. cat. R.I.B.A., London, 1982; and *Drawing Instruments, 1580–1980*, London, 1988, pp. 144–9.

32. *Philosophical Transactions of the Royal Society*, IV, 1669, pp. 1059ff.

33. A. Keller, 'Mathematical Technologies and the Growth of the Idea of Technical Progress in the Sixteenth Century', in *Science, Medicine and Society in the Renaissance. Essays to Honour Walter Pagel* ed. A. Debus, London, 1972, I, pp. 11–27.

34. J. Baltrušaitis, *Anamorphic Art*, trs. W. Strachan, Cambridge, 1977, p. 37ff. and 61ff.

35. S. Marolois, *La Perspective contenant la theorie que la pratique et instruction fondamentale d'icelle*, Amsterdam, 1629, and numerous subsequent editions.

36. Wallace (n. 28), p. 426.

37. E.g. T. Malton, *A Compleat Treatise on Perspective in Theory and Practice on the True Principles of Brook Taylor*, London, 1779, plate IV, fig. 21, and V, 15.

38. J. Wood, *Six lectures on the Principles and Practice of Perspective as Applied to Drawing from Nature accompanied with a Mechanical Apparatus*, 2 vols, London, 1804.

39. C. Hayter, *A New and Practical Treatise on the Three Primitive Colours*, London, 1826, p. 27.

40. For accounts of Chrétien's invention and its use, see G. Freund, *Photography and Society*, London, 1980, pp. 8–17; P. Jay, *Lumières et images. La photographie*, Musée Nicéphore Niépce, Chalon-sur-Saône, n.d.; and S. Bedini, *Thomas Jefferson and his Copying Machines* Charlottesville, 1984, pp. 40ff, for important American variants.

41. See J.R. Schellenberg's engraving of *Goethe drawing Frau von Stein*, illus. by J. Ayres (n. 31), fig. 87.

42. A. Rees, *The Cyclopaedia or Universal Dictionary of Arts, Science and Literature*, 39 vols, London, 1819–20, XI, 'Delineators'. See also the devices in J. Smith's *The Mechanic*, 2 vols, London, 1825, II, pp. 71ff; and W. Stanley, *A Descriptive Treatise on Mathematical Drawing Instruments*, London, 1866.

43. F. Ronalds, *Mechanical Perspective or, Description and Uses of an Instrument for Sketching from Nature*, London, second edition, 1838. The machine was patent no. 5132.

44. Charles Gavard's machine was patented by Jean Ardit (no. 6149). Adrien's version was discussed on p. 306 of the *Jury Report* of the 1851 Exhibition.

45. Ronalds (n. 43), introduction.

46. For an outline of the history of the camera obscura, see J.H. Hammond, *The Camera Obscura. A Chronicle*, Bristol, 1981.

47. M. Kemp, *Leonardo da Vinci. The Marvellous Works of Nature and Man*, London and Cambridge, Mass., 1981, p. 329, quoting C.A. 345 va.

48. G. Cardano, *De Subtilitate*, Nuremberg, 1550, IV, p. 107; D. Barbaro, *La Pratica della perspettiva*, Venice, 1569, pp. 192–3.

49. J. Zahn, *Oculus artificialis teledioptricus*, Würzburg, 1685, pp. 176 and 181.

50. R. Hooke, 'An Instrument to take the Draught or Picture of a Thing', *Philosophical Experiments and Observations*, London, 1721, pp. 292–6; and Hammond (n. 46), pp. 22–4.

51. D. Schwenter, *Deliciae phisico-mathematicae*, Nuremberg, 1636, p. 255; Hammond (note 46), pp. 33–5. See also B. Martin, *A New and Compendious System of Optics*, London, 1740, p. 159.

52. *Storer's Syllabus. . . or the New Optical Principles*

of the *Royal Delineator Analysed*, London, n.d., unpaginated.

53. Barbaro (n. 48), p. 193.

54. G.B. della Porta, *Magiae Naturalis*, enlarged edition, 20 vols, Naples, 1589, XVII, ch. VI.

55. A. Kircher, *Ars magna lucis et umbrae*, Rome, 1649. See J. Godwin, *Athanasius Kircher*, London, 1979.

56. C. Scheiner, *Rosa ursina sive sol*, 1630, pp. 77ff.

57. A.K. Wheelock Jnr, 'Constantijn Huygens and Early Attitudes to the Camera Obscura', *History of Photography*, I, 1977, pp. 93–103; and Wheelock, *Perspective, Optics and Delft Artists around 1650*, London and New York, 1977, p. 156; and review by W. Liedtke, *Art Bulletin*, LXI, 1979, pp. 409–6. See also S. Alpers, *The Art of Describing*, Chicago, 1983, p. 12.

58. Wheelock, *Perspective. . .*, p. 165.

59. Ibid., pp. 284–5.

60. For this much discussed theme, see *inter alia*, Wheelock ibid., pp. 261ff, and *Jan Vermeer*, London, 1988, pp. 31–7. D. Fink, 'Vermeer's Use of the Camera Obscura – A Comparative Study', *Art Bulletin*, LIII, 1971, pp. 493–505; and C. Seymour, 'Dark Chamber and Light-Filled Room. Vermeer and the Camera Obscura', *Art Bulletin*, XLVI, 1964, pp. 323–31.

61. I am most grateful to Philip Steadman for permitting me to view his notable demonstrations, which are to be fully explained in a forthcoming book.

62. F. Algarotti, *Essay on Painting*, London, 1764, pp. 61–2.

63. J.G. Links, *Canaletto and his Patrons*, London, 1977, p. 59. See also F. Haskell, *Patrons and Painters*, London, 1963, pp. 318–19.

64. D. Gioseffi, *Canaletto. Il Quaderno delle Gallerie Veneziane e l'impiego della camera ottica*, Trieste, 1959, and T. Pignatti, *Il Quaderno di disegni del Canaletto alle Gallerie di Venezia*, 2 vols, Venice, 1958, I, p. 71, and 'Canaletto e la camera ottica' in *Rappresentazione artistica. . . nel 'Secolo dei Lumi'*, Florence, 1970.

65. H.A. Fritzche, *Bernardo Bellotto gennant Canaletto*, Leipzig, 1936, pp. 151–97; S. Kozakiewicz, *Bernardo Bellotto*, trans. M. Whittal, 2 vols, London, 1972, I, pp. 58–60.

66. H. Walpole, *Selected Letters*, ed. E. Hoadley, London, 1826, p. 79 (letter of 21 September 1777).

67. J. Reynolds, *The Works*. , 3 vols, London, 1809, II, p. 360, 'A Journey to Flanders and Holland'.

68. L. Herrmann, *Paul and Thomas Sandby*, ex. cat., Victoria and Albert Museum, London, 1986.

69. A.P. Oppé, *The Drawings of Paul and Thomas Sandby in the Collection of His Majesty the King at Windsor Castle*, London, 1947, no. 14729.

70. Ibid., no. 14602.

71. D.J. Warner, 'The Landscape Mirror and Glass', *Antiques*, CV, 1974, pp. 158–9; J. Dixon Hunt, 'Picturesque Mirrors and Ruins of the Past', *Art History*, IV, 1981, pp. 254–70; and C. Hussey, *The Picturesque*, Hamden, Conn., 1967, p. 107.

72. G. de Lairesse, *Het Groot Schilderbock*, Amsterdam, 1707. (Translated as *The Art of Painting*, London, 1777.)

73. P.H. Valenciennes, *Eléménts de perspective pratique à l'usage des artistes*, Paris, 1800, p. 298.

74. J.T. Hays, *The Drawings of Thomas Gainsborough*, 2 vols, New Haven, Conn., 1971, I, p. 112.

75. T. Gray, *Works*, ed. E. Gosse, London, 1884, I, p. 250.

76. A good account is provided by C. Varley, *A Treatise on Optical Drawing Instruments*, London, 1845, p. 27. See also D. Brewster, *A Treatise on Optics*, London, 1831, pp. 333–4; and J. Hammond and J. Austin, *The Camera Lucida in Art and Science*, Bristol, 1987.

77. Versions of all these types of camera lucidas are held by the Science Museum, London (871/72, 872/72, 873/72, 875/72, 878/72, 879/72 and 880/72).

78. Herschel's camera drawings, including 319 in the Nash Collection are to be the subject of a study by Larry Schaaf, who indicates that Herschel's favourite instrument was an Amici camera made by Chevalier of Paris. For another astronomer who used the camera for sketching, see B. Warner, *Charles Piazzi Smith.*

Astronomer-Artist. His Cape Years, 1835–1845, Cape Town and Rotterdam, 1983.

79. The correspondence of James and Basil Hall relating to the use of the camera lucida for landscapes, copies of old masters and portraits is in the National Library of Scotland, MSS. 3200, 21009 and 3919 (information kindly supplied by Helen Smailes). See H. Smailes, 'Sir Walter Scott in Camera', *Bulletin of the Scottish Society for the History of Photography*, Spring 1986, pp. 2–5. Also B. Hall, *Forty Etchings from Sketches Made with a Camera Lucida in North America in 1827 and 1828*, Edinburgh and London, 1829.

80. Scheiner's device is illustrated in Alpers (n. 57) fig. 23.

81. Martin (n. 51), pp. 288ff.

82. Rees (n. 42), XI, 'Delineators' and Plate vol. II.

83. See the biographical reminiscences in A.T. Storey, *The Life of John Linnell*. 2 vols, London, 1829, pp. 221ff.

84. Varley (n. 76).

85. Ibid., p. 33.

86. M. Pidgeley, 'Cornelius Varley, Cotman and the Graphic Telescope' *Burlington Magazine*, CXIV, 1972, p. 785.

87. Christie's London, 21 November 1978, no. 106, for Dawson Turner's *Architectural Antiquities of Normandy*, London, 1822, pl. 78.

88. Storey (n. 83), p. 222.

89. N. Pastore and E. Rosen, 'Alberti and the Camera Obscura', *Physis*, XXV, 1984, pp. 259–69.

90. S. Hoogstraten, *Inleyding tot de Hooge Schoole der Schilderkonst*, Rotterdam, 1678, pp. 274–5. For perspective boxes, see, *inter alia*, S. Koslow, '"Die Wonderlije Perspectyfkas": An Aspect of Seventeenth Century Dutch Painting', *Oud Holland*, LXXXII, 1967, pp. 33–56.

91. I am most grateful to David Bomford and Christopher Brown for discussing the conservation work on the box, the results of which are to be published in the Technical Bulletin of the National Gallery.

92. Wheelock (n. 57), pp. 168–9.

93. The more orthodox version is in the Louvre, Paris, and is dated 1665, i.e. two years earlier than the Uffizi painting.

94. G. Huret, *Optique de portraicture et peinture*, Paris, 1670, pp. 61ff, illus. Baltrušaitis (n. 34), fig. 52.

95. J. van der Heyden, *Beschrijving der Nieuwlijks uitgevonden en geoctrojeerde Slang Brand-Spuiten*, Amsterdam, 1690. See H. Wagner, *Jan van der Heyden, 1637–1712*, Amsterdam and Haarlem, 1971.

96. For the Zograscope or 'Optical Diagonal Machine' see C.J. Kaldenback, 'Perspective Views', *Print Quarterly*, II, 1985, pp. 86–103; and J.A. Chaldecott, 'The Zograscope or Optical Diagonal Machine', *Annals of Science*, IX, 1953, pp. 315–22.

97. Valenciennes (n. 73), pp. 333ff.

98. J. Mayne, 'Thomas Gainsborough's Exhibition Box', *Victoria and Albert Museum Bulletin*, I, 1965, pp. 17–24.

99. R. Joppien, *Philippe Jacques de Loutherbourg, RA, 1740–1812*, ex. cat., London, 1973, no. 87.

100. Piero della Francesca, *De Prospectiva pingendi*, ed. G.N. Fasola, Florence, 1942, p. 211ff.

101. See particularly Baltrušaitis (n. 34). Also F. Leeman, J. Elffers and M. Schuyt, *Hidden Images. Games of Perception, Anamorphic Art*, trs. E. Childs, New York, 1976; and *Anamorfosen: spel met perspectief*, ex. cat. Rijksmuseum, Amsterdam, 1975–6.

102. This system of viewing is proposed by Baltrušaitis, (n. 34), pp. 104–5, and appears to make complete sense optically.

103. J.F. Niceron, *La Perspective curieuse ou magie artificielle*, Paris, 1638, pp. 51ff.

104. Baltrušaitis (n. 34), pp. 57–8. See also F. Camerota, 'Het merkwaardige perspectief en de architectura obliqua', *Oase*, XX, 1988, pp. 40–7.

105. E. Maignan, *Perspectiva horaria, sive de horographia gnomonica*, Rome, 1648, pp. 483ff.

106. Niceron (n. 103), p. 70.

107. See, for example, Kircher (n. 55), p. 184; and G. (K). Schott, *Magia universalis naturae et artis*, Würzburg,

1657, p. 87. Also Baltrušaitis (n. 34), pp. 79ff.
108. Wheelock (n. 57), pp. 191ff, and 4ff, responding to W. Liedtke's 'The "View in Delft" by Carol Fabritius', *Burlington Magazine*, CXVIII, 1976, pp. 61–73.
109. R. Pennington, *A Descriptive Catalogue of the Etched Work of Wenceslaus Hollar*, Cambridge, 1982. For panoramas generally, see J. Sweetman *et al.*, *The Panoramic Image*, ex. cat., Southampton, 1981; and R. Hyde and S. Wilcox, *Panoramania!*, ex. cat., Barbican Art Gallery, London, 1988.
110. Rees (n. 42), XI, 'Camera'.
111. Sweetman (n. 109), pp. 12ff and Wilcox (n. 109), p. 17. See the 5 lithographs published by R. Ackermann, *Graphic Illustrations of the Colosseum, Regent's Park*, London, 1829. See also R. Altick, *The Shows of London*, Cambridge, Mass. and London, 1978, pp. 128ff.
112. Sweetman (n. 109), no. 9.
113. A.T. Story, (n. 83), II, p. 222.
114. For Girtin's *Eidometropolis or Panorama of London*, see W. Whitley, 'Girtin's Panorama', *Connoisseur*, LXXIX, 1924, pp. 13–20; and Hyde (n. 109), nos. 34–5.
115. B. Bowers, *Sir Charles Wheatstone*, London, 1975. A.T. Gill, 'Early Stereoscopes', *Photographic Journal*, CIX, 1969, pp. 546–59, 606–14, and 641–51.
116. Bowers, (n. 115), p. 194.
117. H. Mayo, *Outlines of Human Physiology*, London, 1833, quoted in Bowers, (n. 115), p. 192.
118. Bowers (n. 115), p. 195.
119. A useful introduction to Brewster is provided by 'Martyr of Science'. Sir David Brewster, 1781–1868, ed., A. Morrison-Low and J. Christie, Edinburgh, 1984.
120. D. Brewster, *The Stereoscope. Its History, Theory and Construction . . .* , London, 1856; and Morrison-Low in 'Martyr of Science' pp. 62–3, and nos. 28–30. See also J. Jones, *Wonders of the Stereoscope* New York, 1976; and W.C. Darrach, *The World of Stereographs*, Gettysburg, Pa., 1977.
121. D. Brewster, *A Treatise on the Kaleidoscope*, Edinburgh, 1819, and *The Kaleidoscope. Its History, Theory and Construction with its Application to the Fine and Useful Arts*, Edinburgh, 1858.
122. D. Brewster, *Letters on Natural Magic Addressed to Sir Walter Scott*, ed. J. Smith, London, 1868.
123. G. 35r, Kemp (n. 4), p. 332.
124. J. Faraday 'A Peculiar Class of Optical Deceptions', *Quarterly Journal of Science*, 1831, reprinted in *Experimental Research in Chemistry and Physics*, London, 1959, pp. 291–311. A general account of the invention of moving images is provided by F.P. Liesegang, *Kinotechnik*, 1924 and *Liesegang-Mitteilungen*, 1928; and O. Cook, *Movement in Two Dimensions*, London, 1963.
125. For the inventions of Plateau and Stampfer, see J.M. Eder, *History of Photography*, trs. E. Esptean, New York, 1972, pp. 495ff.
126. H. von Helmholtz, *A Treatise on Physiological Optics*, 3 vols, New York, 1924, III, p. 356.
127. Eder (n. 125), pp. 501ff. See particularly E. Muybridge, *Animal Locomotion. An Electro-photographic Investigation of Consecutive Phases of Animal Movements*, London, 1887 (?); and E.J. Marey, *La Photographie du mouvement*, Paris, 1892.
128. The best documented account of the invention and early years of photography remains that by Eder (n. 125). See also H. and A. Gernsheim, *The History of Photography*, London and New York 1955 and 1969, of which the first part was reissued as *The Origins of Photography*, London, 1982; and B. Newhall, *The Latent Image. The Discovery of Photography*, New York, 1967.
129. H. and A. Gernsheim, *L.J.M. Daguerre. The History of the Diorama and of the Daguerreotype*, New York, 1968.
130. Ibid., pp. 89ff.
131. G. Buckland. *Fox Talbot an the Invention of Photography*, London, 1980; and J. Ward and S. Stevenson, *Printed Light*, ex. cat., Edinburgh, 1986.
132. H. Fox Talbot, *Some Account of the Art of Photogenic Drawing. . .* (read before the Royal Society, 31 January 1839), London, 1839, reprinted in *Photography. Essays*

and Images, ed. B. Newhall, pp. 23–31.
133. For Herschel's contribution to early photography, see L. Schaaf, *Sir John Herschel and the Invention of Photography*, ex. cat., London, 1981, and two important articles in *History of Photography*, III, 1979. pp. 47–60, and IV, 1980, pp. 181–204.
134. D. Bruce, *Sun Pictures. The Hill-Adamson Calotypes*, London, 1973; S. Stevenson, *David Octavius Hill and Robert Adamson. Catalogue of their Calotypes Taken between 1843 and 1847 in the Collection of the Scottish National Portrait Gallery*, Edinburgh, 1981; and Ward and Stevenson (n. 131).
135. P. Galassi, *Before Photography*, New York, 1981, p. 126, no. 18, and I. Wirth, *Eduard Gaertner. Der Berlin Architekturmaler*, Berlin, 1979.
136. C. Ford, *The Cameron Collection*, London, 1975; G. Ovenden, *A Victorian Album. Julia Margaret Cameron and her Circle*, London and New York, 1975; and G. Ovenden, *Clementina, Lady Hawarden*, London, 1974.
137. Gernsheim (n. 129), pp. 13ff. and 176ff.
138. Ibid., pp. 72–3 and 180–1.
139. Fox Talbot (n. 132) in Newhall, p. 28.
140. Ibid., p. 26.
141. M. Harvey, 'Ruskin and Photography', *Oxford Art Journal*, VII, 1984, pp. 25–33, quoting a letter of 7 October 1845.
142. Harvey, ibid., p. 25, quoting from Ruskin's article on engraving in the *Art Journal*, V (ns), 1866, p. 97; *The Works of John Ruskin*, ed. E. Cook and A. Wedderburn, XIX, London, 1906, p. 150.

CHAPTER V

1. See the biography by R. Taton, in *Dictionary of Scientific Biography*, New York, 1973, VII.
2. P. de la Hire, *Memoires de mathematique et de physique . . . Un Traité des differens accidens de la vue*, Paris, 1694.
3. P. de la Hire, 'Traité de la pratique de la peinture', *Memoires de l'Académie Royale des Sciences, 1666–99*, Paris, 1780, IX. Though primarily a technical manual, la Hire's definition of painting as a window-like intersection of rays from the object to the eye (p. 646) shows his commitment to the conventional foundation for the optics of painting. See also M. Baxandall, 'The Bearing of the Scientific Study of Vision on Painting in the 18th century. Pieter Camper's *De Visu* (1746)', in *Natural Sciences in the Arts*, ed. A. Ellenius, (Acta Universitatis Upsaliensis, XX Uppsala, 1985, pp. 125–32.
4. I. Newton, *Principia mathematica* (1687), in *The Mathematical Papers of Isaac Newton*, ed. D. Whiteside, 8 vols, Cambridge, 1967–81, VII, p. 635. For a discussion of the Desargues tradition, see J.V. Field and J.J. Gray, *The Geometrical Work of Girard Desargues* New York, Berlin . . . , 1987, pp. 31ff.
5. See the biography by C. Scriba, in *Dictionary of Scientific Biography*, New York, 1973, VII.
6. J.H. Lambert, *Notes and Comments on the Composition of Terrestrial and Celestial Maps*, trs. W. Tobler, Michigan, 1972, p. 1.
7. J.H. Lambert, 'Anlage zur Perspektive' (1752), MS in Steck (below); *Die Freye Perspektive*, and *La Perspective affranchie de l'embaras du plan géométral*, Zurich, 1759. See *Schriften zur Perspektive*, ed. M. Steck, Berlin, 1943, for these and other perspectival essays by Lambert. See also K. Andersen, 'Some Observations Concerning Mathematicians' Treatment of Perspective Constructions in the 17th and 18th Centuries', in *Festschrift für Helmuth Gericke*, ed. M. Folkerts and U. Lindgren, Stuttgart; 1984, pp. 409–25; and R. Laurent, *La place du J.-H. Lambert (1728–1777) dans l'histoire de la géométrie*, Paris, 1987.
8. 'Anlage', fol. 93rff., Steck, pl. LX.
9. *Perspective affranchie . . .* , Tab. II, fig. 8, and p. 47.
10. *Perspective affranchie . . .* , chapter 7, pp. 148ff. C. Rieger, *Perspectiva militaris*, Vienna, 1756.
11. See the biography by R. Taton in *Dictionary of Scientific Biography* New York, 1974, IX. Also R. Taton, *L'Oeuvre scientifique de Gaspard Monge*, Paris, 1951; and P.

Booker, 'Gaspard Monge and his Effect on Engineering Drawing', *Transactions of the Newcomen Society*, XXXIV, 1961–2, pp. 15–36; and Booker, *A History of Engineering Drawing*, London, 1979.
12. A.-F. Frézier, *La Théorie et la pratique de la coupe des pierres*, 3 vols, Strasbourg and Paris, 1737–9 (and editions in 1754 and 1769); also the abbreviated *Eléments de stéréotomie*, Paris, 1760.
13. G. Monge, *Géométrie descriptive, suivé d'une theorie des ombres et de la perspective* (Paris, 1798–9), 7th edition, M. Brisson, Paris, 1847 (and many other editions.)
14. Monge, *Géomérie . . .* , preface; cf. pp. 109–10.
15. Ibid., preface.
16. Ibid., p. 42. See also Booker, *History . . .* , (n. 11), p. 97.
17. Ibid., p. 29.
18. Ibid., p. 171.
19. Ibid., p. 133.
20. P. Heinecken, *Lucidum prespectivae speculum*, Augsburg, 1727 (second edition, 1753); J. Courtonne, *Traité de la perspective pratique avec des remarques sur l'architecture*, Paris, 1725; E.-S. Jeaurat, *Traité de perspective à l'usage des artistes . . . selon la méthode de M. le Clerc . . .* , Paris, 1750.
21. Courtonne, *Traité*, letter of dedication to the Duc d'Antin.
22. P. Conisbee, *Painting in Eighteenth-Century France*, Oxford, 1981; A. Schnapper, *Au temps du Roi Soleil. Les peintres de Louis XIV*, ex. cat., Lille, 1968; and *Les Peintres francais du XVIIIe siècle*, ed. L. Dimier, 2 vols, Paris and Brussels, 1928–30.
23. P. Conisbee, *Claude-Joseph Vernet*, ex. cat., London and Paris, 1976.
24. P.H. Valenciennes, *Eléménts de perspective pratique à l'usage des artistes*, Paris 1800 p. xviii. For Valenciennes as a painter, see *Les paysages de Pierre-Henri de Valenciennes*, ex. cat., G. Lacambre, Paris, 1976.
25. Ibid., p. xv.
26. Ibid., p. xxv.
27. Ibid., chapter VIII.
28. H. Rosenau, *Boullée and Visionary Architecture*, London and New York, 1976, containing Boullée's treatises. See *Architecture. Essay on Art*, p. 86.
29. Ibid., p. 107.
30. Ibid., p. 90.
31. Ibid., p. 91.
32. P.O. Rave, *Karl Friedrich Schinkel*, Munich and Berlin, 1953; and P. Mahlberg, 'Schinkel's Theaterdekorationen', Ph.D. thesis, Greifswald, 1916. See particularly the 1816 designs for Mozart's *Magic Flute*.
33. *Rosenau* (n. 28), p. 90.
34. A. Schnapper, *David*, Freibourg, 1980; and A. Brookner, *Jacques-Louis David*, London, 1980.
35. Y. Christ, *Projects et divagations de Claude-Nicolas Ledoux, architecte du roi*, Paris, 1961. See also E. Kaufman, 'Three Revolutionary Architects', *Transactions of the American Philosophical Society*, XLII, 1952, 455–537.
36. D.L. Dowd, *Pageant Master of the Republic. Jacques-Louis David and the French Revolution*, Nebraska, 1948. For the intellectual background, see M. Levin, 'The Wedding of Art and Science in late Eighteenth-Century France', *Journal of Eighteenth-Century Life*, VII, 1982, pp. 55–73.
37. The Bartoli Italian translation of *De pictura* of 1568 was republished in Bologna in 1782, in Milan in 1803 and 1804, and in Perugia in 1803. The Du Fresne French translation of 1651 was republished in Bologna in 1782 and 1786.
38. E.J. Delécluze, *Louis David. Son école et son temps*, Paris, 1855, p. 138.
39. Ibid., p. 223.
40. See J. Whitley, 'Homer Abandoned. A French Neo-Classical Theme', *The Artist and Writer in France. Essays in Honour of Jean Seznec*, ed. F. Haskell, A. Levi, R. Shackleton, Oxford, 1974.
41. B. Skovgaard, *Maleren Abildgaard*, Copenhagen, 1961.
42. C. Dodgson, *The Etchings of Charles Meryon*, London, 1921.

43. See P. Galassi's essay in K. Varnedoe, *Gustave Caillebotte*, New Haven, Conn., and London, 1987, pp. 20–6.

44. E. Hannover, *Maleren C.W. Eckersberg*, Copenhagen, 1898, and *Danish Artists in Italy*, ex. cat., Copenhagen, 1967; M. Krohn, *Maleren Christen Købkes Arbejder*, Copenhagen, 1931; I. Wirth, *Eduard Gaertner. Der Berliner Architekturmaler*, Berlin, 1979.

45. See his series of paintings of the transportation and erection in 1831 of the great granite bowl in Lustgarten, Berlin, particularly the painting of the installed bowl (Nationgalerie, Berlin); G. Hummel, *Der Maler Johann Erdmann Hummel, Leben und Werk*, Leipzig, 1954, pls. 62–4, and pp. 43ff. for his methods.

46. For these late texts, which still require full investigation, see the pioneering essay by M. Marcussen, 'L'évolution de la perspective linéaire au XIXᵉ siècle en France', *Hafnia*, VII, 1980, pp. 51–73. Also P. Descargues, *Perspective. History, Evolution, Techniques*, trs. I.M. Paris, New York, 1982, pp. 166–71.

46a. A. le Breton (Jarry de Mancy), *Traité de perspective simplifiée (linéaire)*, Paris, 1828.

47. C. Dupin, *Applications de géométrie e de mécanique à la marine . . .*, Paris, 1822.

48. J.-N.-P. Hachette, *Traité de géometrie descriptive*, Paris, 1822.

49. J.-V. Poncelet, *Traité des propriétés projectives des figures*, Metz and Paris, 1822.

50. M. Chasles, *Aperçu historique sur l'origine et le développement des méthodes en géométrie*, Brussels, 1837; and N.-G. Poudra, *Histoire de la perspective ancienne et moderne, contenant l'exposition de toutes les méthodes connues de Perspective et une analyse des ouvrages sur cette science*, Paris, 1864.

51. J.-A.-R.M. de la Gournerie, *Traité de perspective linéaire*, Paris, 1859, which also includes (pp. 211ff) a section on perspective devices.

52. J.-A. Adhémar, *Traité de perspective à l'usage des artistes*, Paris, 1836; *Traité de perspective linéaire*, Paris, 1838; *Traité des ombres*, Paris, 1840; *Cours de mathématiques à l'usage des architectes, ingenieurs civils etc. Géométrie descriptive*, third edition, Paris, 1870, and *Applications de géométrie descriptive. Traité des ombres*, 2 vols, Paris, 1866 (and other editions).

53. See G. Stamp, *The Great Perspectivists*, London, 1982; and L. Wright *Perspective in Perspective*, London, 1983, pp. 181ff.

54. W. Farish, *Isometrical Perspective*, Cambridge, 1820, intro., and Farrish, 'On Isometrical Perspective', *Transactions of the Cambridge Philosophical Soceity*, I, 1822. Compare W. Burn, *An Elementary Treatise on Orthographic Projection*, 1857. See also B. Schneider, 'Perspective Refers to the Viewer, Axonometry Refers to the Object', *Daidalos*, I, 1981, pp. 4ff.

55. J. Jopling, *The Practice of Isometrical Perspective*, London, 1842. Other publications by Jopling include B. Taylor, *New Principles of Linear Perspective*, ed. J. Jopling, London, 1835; and *The Septenary System of Generating Lines by Simple Continuous Motion*, London, 1825 (in which a double crank produces 'ionic' curves).

56. A. Choisy, *L'Art de batir chez les Romains*, Rome, 1873.

57. R. Descartes, *Discourse on Method, Optics, Geometry and Meteorology*, trans. P. Olscamp, New York, 1965, p. 101; and *Descartes' Discourse on Method*, trans. A. Wollaston, Harmondsworth, 1960. A large body of evidence on this question is assembled by J.W. Yolton, *Perceptual Acquaintance from Descartes to Reid*, Oxford, 1985; and N. Pastore, *Selective History of Theories of Visual Perception 1650–1950*, New York and London, 1971.

58. J. Locke, *An Essay Concerning Humane Understanding* (first edition, 1690, second edition, 1694), ed. P. Nidditch (from the fourth edition of 1700), Oxford, 1979, II, 9, pp. 143ff.

59. R. Smith, *A Compleat System of Optics in Four Books, viz. a Popular, a Mathematical, a Mechanical and a Philosophical Treatise*, 2 vols, Cambridge, p. 45. 1738, (There were also editions in German, Dutch and French).

60. T. Reid, *An Enquiry into the Human Mind and the Principles of Common Sense*, (1764), Glasgow, 1817, Chapter VI, section 2, pp. 141–7.

61. Abbé de Condillac, *Essay on the Origin of Human Knowledge*, Paris, 1746, I, 6. For a discussion of Condillac's importance, see I. Knight, *The Geometric Spirit. The Abbé de Condillac and the French Enlightenment*, New Haven, Conn., 1968.

62. W. Porterfield, *A Treatise on the Eye*, 2 vols, London and Edinburgh, 1759, p. 229.

63. C.N. le Cat, *Traité des sens en particulier*, Rouen, 1740, trans. as *A Physical Essay on the Senses*, London, 1750, p. 198.

64. Ibid., pp. 246–7.

65. J. Wood, *Elements of Perspective*, London, 1799, pp. 10ff.

66. J. Kirby, *Dr. Brook Taylor's Method of Perspective Made Easy*, Ipswich, 1754, pp. 70–1, quoting Smith (n. 59), I, pp. 61–2, and Locke (n. 58), I, 9.

67. J. Malton (the Younger). *The Young Painter's Maulstick . . .*, London, 1800, p. vii.

68. P. Camper, *Dissertatio optica de visu*, Leyden, 1746 (facsimile and trans. G. ten Doesschate, Nieuwkoop, 1962); see M. Baxandall, 'The Bearing of the Scientific Study of Vision on Painting in the 18th century. Pieter Camper's *De visu*', in *The Natural Sciences and the Arts*, ed. A. Ellenius, (Acta Universitatis Upsaliensis, XX), Uppsala, 1985, p. 128.

69. W. Locke (n. 58), II, 9, viii, p. 145ff. See M. Morgan, *Molyneux's Question*, Cambridge, 1977.

70. Locke, ibid., p. 146.

71. Berkeley, *A New Theory of Vision* (1709), London, 1946, with intro. by A. Lindsay, XCV, p. 57; (cf. XLI, pp. 30–1).

72. W. Cheselden, *Philosophical Transactions of the Royal Society*, XXXIV, 1728, pp. 447–52. See Morgan (n. 68), pp. 20ff.

73. P. de la Hire, *Accidens de la vûe*, (n. 2), pp. 235–7.

74. Porterfield, (n. 62), p. 409 (see also pp. 386ff); Camper (n. 68), pp. 14–16.

75. S. le Clerc, *Discours touchant le point de vue*, Paris, 1679. See also his *Traité de géometrie theorique et pratique de l'usage des artistes*, Paris, 1746, and *Systeme de la vision*, Paris, 1712.

76. B. Lamy, *Traité de perspective*, Paris, 1701, pp. 46ff. Lamy's treatise, though routine geometrically, contains interesting remarks regarding perception etc.

77. Le Cat (n. 63), p. 240.

78. Porterfield (n. 62), p. 106.

79. Ibid., pp. 222–3.

80. Camper (n. 68), p. 8.

81. P. Bouguer, *Traité d'optique, sur le gradation de la lumière*, Paris, 1760. For a review of the latest ideas, see J. Priestley, *The History and Present State of Discoveries Relating to Vision, Light and Colours*, 2 vols, London 1772.

82. Bouguer, pp. 102–3; and Camper in Baxandall (n. 68), p. 128.

83. La Hire (n. 73), pp. 235–6.

84. Le Cat (n. 63), p. 241.

85. Ibid., p. 219.

86. Porterfield, (n. 62), p. 380.

87. D. Macmillan, 'Treasures of Fyvie', *Times Literary Supplement*, 30 Aug. 1985, p. 950; and Macmillan, *Painting in Scotland in the Golden Age*, Oxford, 1986, pp. 74ff, with particular reference to Reid's *Inquiry into the Human Mind* as reflected in Dugald Stewart's *Elements of the Human Mind*, 3 vols, London, 1792–1827. For other suggestions for the visual quality of Raeburn's paintings, see S. Stevenson in *Printed Light*, ex. cat., J. Ward and S. Stevenson, Edinburgh, 1986, p. 46.

88. Malton (n. 67), p. vii.

89. M. Baxandall, *Patterns of Intention. On the Historical Explanation of Pictures*, New Haven, Conn., and London, 1985, pp. 76ff; and the review by M. Kemp, *Zeitschift für Kunstgeschichte*, L, 1987, pp. 131–41.

90. H. von Helmholtz, *Vorträge und Reden*, 4th ed., Braunschweig, 1896, I, p. viii.

91. I. Kant, *Critique of Pure Reason* (1781), trs. N. Kemp Smith, London, 1933, A (first edition) 24; B (second

edition, 1784) 39. See C. Garnett, *The Kantian Philosophy of Space*, New York, 1939, esp. pp. 167ff; and G. Hatfield, 'Mind and Space from Kant to Helmholtz. The Development of the Empiricistic Theory of Spatial Vision', Ph.D. thesis, Madison Wisconsin, 1979. University Microfilms, 80 11 375.

92. *Critique* (n. 91) A 23; B 38.

93. Ibid., B 152.

94. C. Ashwin, *Drawing and Education in German-Speaking Europe*, Ann Arbor, Michigan, 1981, and Ashwin, 'Peter Schmid and *Das Naturzeichnen*. An Experiment in the Teaching of Drawing, *Art History*, v, 1982, pp. 154–65.

95. H. Pestalozzi, *ABC der Anschauung*, Zürich and Bern, 1803, and *Wie Gertrud ihre Kinder Lehrt*, Bern, 1801; and T. Schmid, *Die Elemente des Zeichnens nach Pestalozzischen Grundsätzen*, Bern, 1809. See C. Ashwin, 'Pestalozzi and the Origins of Pedagogical Drawing', *British Journal of Educational Studies*, XXXIX, 1981, pp. 138–51.

96. P. Schmid, *Das Naturzeichnen für die Schule- und Selbst-unterricht*, 4 vols, Berlin, 1828, 1829, 1830 and 1832.

97. C. Manson, *Frank Lloyd Wright to 1910*, New York, 1958, p. 5.

98. F. Dupuis, *Exposé succinct du polyskématisme ou méthode concernant le dessin linéaire géométrique usuel et les differens phénomènes de la perspective*, Paris, 1841 (English translation by G. Sharp, 1845). A. Dupuis, *De l'Enseignement du dessin sous le point de vue industriel*, Paris, 1856.

99. A Dupuis (n. 98), p.21.

100. F. Dupuis (n. 98), p. 17.

101. A. Dupuis (n. 98), p. 7.

102. See the intro. to F. Dupuis (n. 98). Testimonials are printed in the brothers' treatises.

103. H. von Helmholtz, *Treatise on Physiological Optics*, 3 vols, New York, 1924, vol. III. See Hatfield (n. 91), pp. 286ff.

104. Helmholtz, III, p. 13.

105. Ibid., II, p. 23.

106. H. von Helmholtz, *Popular Lectures on Scientific Subjects*, London, 1873, 'The Eye as an Optical Instrument', p. 23. (First series, translated by E. Atkinson.)

108. *Physiological Optics* (n. 103), III, pp. 166 and 181.

109. *Popular Lectures on Scientific Subjects*, London, 1881, 'On the Relation of Optics to Painting', p. 79. (Second series, translated by E. Atkinson.)

110. Ibid., pp. 135–6.

111. For the setting of Ruskin's thought in the context of his biography see T. Hilton, *John Ruskin. The Early Years*, New Haven and London, 1985.

112. J. Ruskin, *Modern Painters*, part II, section I, chapter II, para 1, in *The Works of John Ruskin*, ed. E. Cook and A. Wedderburn, I, London, 1903, pp. 140–1.

113. Ibid., part II, section I, chapter v, para 1, p. 150.

114. Ibid., part II, section I, chapter II, para. 6, p. 144–5.

115. Ibid., part II, section II, chapter IV, paras. 2–4, pp. 320–1.

116. Ibid., part II, section II, chapter IV, para. 6, p. 323. For a suggestion that Whistler exploited the same idea, see K. Lochnan, 'Whistler's Etchings and the Sources of his Etching Style', Ph.D., London University, 1982, pp. 126ff.

117. H. Repton, *Landscape Gardening and Landscape Architecture*, ed. J. Loudon, London, 1840, pp. 32–8.

118. *Modern Painters* (n. 112), note to part II, section II, chapter IV, para 3, p. 321.

119. Ibid., part II; section II, chapter v, para 1, pp. 327ff.

120. Ibid., part II, section II, chapter v, para 4, p. 329.

121. Ibid., part II, section II, chapter v, paras. 9 and 16, pp. 333 and 339.

122. A. Parsey, *Perspective Rectified . . . with a New Method for Producing Correct Perspective Drawings without the Use of Vanishing Points*, London, 1836, and Parsey, *The Science of Vision or Natural Perspective! . . . and the New Optical Laws of the Camera Obscura, or Daguerreotype . . .*, London, 1840.

123. A. Parsey, *Quadrature of the Circle Discovered*, London, 1832.

124. A. Parsey, *Arithmetic Illustrated by Woodcuts*, London, 1837.

125. *Perspective Rectified* (n. 122), p. 17.

126. *Natural Perspective* (n. 122), p. x.

127. Ibid., p. vii.

128. *Perspective Rectified* (n. 122), p. 23.

129. Ibid., p. 30.

130. *Natural Perspective* (n. 122), pp. 44–5.

131. *Perspective Rectifield*, (n. 122), p. 45.

132. Ibid., p. 82.

133. Eg. *The Natural Perspective of a Design of a Nobleman's Mansion* exhibited at the Royal Society of British Artists, 1830, no. 578.

134. *Natural Perspective* (n. 122), p. xxviii, and p. 134.

135. *Architectural Magazine*, IV, 1837, p. 518.

136. *Architectural Magazine*, v, 1838, pp. 91 (Parsey), 92–4 (Pocock), 94–6, 191–2 (Ruskin), 228–30 (Parsey), 282–3 (Ruskin), 331–3 (report of Parsey lecture), 425–6 (Parsey), 426–30 (Chappell Smith), 526–8 (Ruskin), 709–10 (Ruskin).

137. Ruskin, *Works* (n. 112), p. 223.

138. Ibid., p. 231.

139. *Natural Perspective* (n. 122), p. 35.

140. Ibid., p. xxiv.

141. Ibid., p. 134.

142. W. Ueberwasser, *Konrad Witz*, Basel, 1938, particularly pls. 20–1.

143. J. White, *The Birth and Rebirth of Pictorial Space*, London, 1967, pp. 225ff.

144. W. Schickhard, *Weiterer Bericht von der Fliegenden Liecht-Kugel*, Tubingen, 1642; see E. Panofsky, 'Die Perspektive als "Symbolische Form"', *Vorträge der Bibliothek Warburg, 1924–5*, Berlin, 1927, p. 295; (Italian translation as *La Prospettiva come 'forma simbolica'*, ed. G. Neri and M. Dalai, Milan, 1966, pp. 40–1.) For Schickhard's biography, see W. Applebaum in *Dictionary of Scientific Biography*, New York, 1975, XII. For a recent attempt to create perspective projections in the Schickhard manner, see A. Barre and A. Flocon, *La perspective curviligne*, Paris, 1968.

145. J. Kepler, *Appendix hyperaspistis*, 19, ed. F. Hammer, in *Gesammelte Werke*, VII, Munich, 1943, p. 425 and Kepler, *Ad Vitellionem paralipomena*, III, 2, 7, ed. F. Hammer, in *Gesammelte Werke*, II, pp. 66–7.

146. T. Malton, *A Complete Treatise on Perspective in Theory and Practice on the True Principles of Brook Taylor*, London, 1779, pp. 95ff. See also the remarks in Priestly (n. 81), II, pp. 700 and 704.

147. Turner explored the problem of bent verticals in his lecture on 4 January 1819, using drawings of *St. George's, Bloomsbury* (British Museum, CXCV 144–5). See also L. Gowing, *Turner. Imagination and Reality*, ex. cat., Metropolitan Museum, New York, 1966, p. 27, where Turner is quoted on 'the wide concave of the circumambient air'; and the forthcoming Ph.D. thesis by Maurice Davies.

148. W. Herdman, *A Treatise on the Curvilinear Perspective of Nature*, London and Liverpool, 1853. Also Herdman, *Thoughts on Speculative Cosmology and the Principles of Art*, London, 1870.

149. Herdman, *Treatise*, p. 75.

150. Ibid., p. 99.

151. Panofsky (n. 144), p. 40; and M. Podro, *The Critical Historians of Art*, London and New Haven, Conn., 1982, ch. v.

152. F. Penrose, *An Investigation of the Principles of Athenian Architecture*, London, 1851. See also W. Goodyear, *Greek Refinements. Studies in Temperamental Architecture*, New Haven, Conn., London and Oxford, 1916.

153. G. Hauck, *Die subjektive Perspektive und die horizontalen curvaturen des dorischen Styls*, Stuttgart, 1879. A good discussion is provided by G. ten Doesschate, *Perspective, Fundamentals, Controversials, History*, Nieuwkoop, 1964, pp. 47ff.

154. Hauck, *Lehrbuch der malerischen Perspektive*, ed. H. Hauck, Berlin, 1910, esp. pp. 122ff; and *Die malerische Perspektive . . .*, Berlin, 1882.

155. M. Beardsley, *Aesthetics from Classical Greece to the Present*, Alabama, 1966; K. Gilbert and H. Kuhn, *A History of Aesthetics*, London, 1956.

156. For the early formulation of this idea see M. Kemp, 'From Mimesis to Fantasia. The Quattrocento Vocabulary of Creation, Inspiration and Genius in the Visual Arts', *Viator*, VIII, 1977, pp. 347–98, esp. p. 389.

157. F. Hutcheson, *An Inquiry into the Origin of Our Ideas of Beauty and Virtue*, London, 1725, I, 13ff.

158. E. Burke, *A Philosophical Enquiry into the Origin of Our Ideas of the Sublime and Beautiful*, London, 1823, III, 2.

159. J. le R. D'Alembert in the 'Discours preliminaire, *Encyclopédie* ed. D. Diderot and D'Alembert, 25 vols, Paris, 1751–71, I, 175, p. xvi. See A. Cohen Simowitz, *Theory of Art in the Encyclopédie*, Ann Arbor, Michigan, 1983; and *Preliminary Discourse to the Encyclopaedia of Diderot*, trans. R. Schwab, New York, 1963.

160. D. Diderot, *Salon de 1763*, x, p. 205.

161. K. Aschenbrenner and W. Holther, *Reflections on Poetry. Alexander Gottlieb Baumgarten's Meditationes philosophicas ad poema pertinentibus*, Berkeley and Los Angeles, 1954; and his unfinished *Aesthetica* (1750), Bari, 1936. See also H. Schweizer, *Ästhetik als philosophie der sinnlichen erkenntnis*, Stuttgart, 1973.

162. Baumgarten, *Aesthetica*, 6–7.

163. I. Kant, *Observations on the Feeling of the Sublime and Beautiful* (1764) and *Critique of Judgement* (1790), trans. J. Meredith, Oxford, 1952. See D. Crawford, *Kant's Aesthetic Theory*, Madison, Wis., 1974, and M. Podro, *The Manifold in Perception*, Oxford, 1972, pp. 7ff.

164. *Critique of Judgement* (n. 163), II, 23ff.

165. Ibid., II, 49.

166. J.P. Eckermann, *Gespräche mit Goethe*, ed. H. Howben, Leipzig, 1925, p. 36ff (18 September 1823). See generally, J.P. Eckermann, *Conversations with Goethe*, trans. Oxenford, London, 1970.

167. F. Schiller, *Letters on the Aesthetic Education of Man* (1793–4) ed. & trans. E. Wilkinson and L. Willoughby, Oxford, 1967, XXVII.

168. F. von Schelling, *System of Transcendental Idealism* (1800) trs. R. Heath, intro. M. Vater, Charlottesville, Va., 1978, VI, 2, p. 227.

169. *William Blake's Writings*, ed. G. Bentley, Oxford, 1978, II, p. 147.

170. See J. Hagstrum, 'William Blake Rejects the Enlightenment', in *Blake. A Collection of Critical Essays*, ed. N. Frye, Englewood Cliffs, 1966; and D. Ault, *Blake's Response to Newton*, Chicago, 1974.

171. *William Blake's Writings*, II, p. 1450.

172. Ibid., II, p. 1425 (on Bacon, *Essays*, London, 1798, p. i). Cf. ibid., II, p. 1471.

173. J. Gage, 'Blake's *Newton*', *Journal of the Warburg and Courtauld Institutes*, XXXIV, 1971, pp. 372–7.

174. Blake, *Complete Poems and Prose*, ed. G. Keynes, London, 1956, p. 139.

175. *Writings* (n. 169), II, p. 1466.

176. Hagstrum (n. 170), p. 145.

177. *Writings* (n. 169), II, p. 1494.

178. Blake's *Descriptive Catalogue*, 1809, p. 36, in *Writings*, ibid., II, p. 848.

179. Ibid., I, p. 13, from Blake's *There is No Natural Religion* (1788).

180. Ibid., p. 1487.

181. W. Heinse, *Letters on the Düsseldorf Gallery*, quoted by N. Pevsner, *Academies of Art*, p. 191.

182. B. Haydon, *On Academies of Art (More Particularly the Royal Academy) and their Pernicious Effects on the Genius of Europe*, London, 1939.

183. Pevsner (n. 181), p. 195.

184. C. Baudelaire, *Art in Paris 1845–1862*, ed. and trans. J. Mayne, London, 19, pp. 46–7, from the *Salon de 1846*.

185. W. Pater, *The Renaissance* (1873), ed. D. Hill, Berkeley, Los Angeles and London, 1980, pp. 108–9.

186. Ibid., p. 106.

187. Ibid., p. 187.

188. Ibid., pp. 188–189.

189. Ibid., pp. 83–4.

190. *Popular Lectures* (n. 106), 'On Goethe's Scientific Researches', p. 137.

191. Ibid., p. 58.

192. Ibid., p. 45.

193. *Laws of Fésole* (1879) in *Works* (n. 112), xv, 1904, p. 344.

194. Ibid., VII, p. 342.

195. Ibid., VII, p. 384.

196. *Modern Painters* (1860), Part III, chapter II, para. 14, in *Works*, VII, p. 156.

197. *Elements of Drawing* (1857) in *Works*, XV, 1904, p. 16.

198. *Elements of Perspective* (1859) in *Works*, XV, p. 235.

199. Ibid., p. 235.

200. Ibid., p. 243.

201. Ibid., p. 305.

202. Ibid., p. 497.

203. Ibid., p. 351.

204. Ibid., C. Blanc, *Grammaire des Arts du Dessin* (1867), 2nd ed., Paris, 1870, p. 515. See M. Song, *Art Theories of Charles Blanc, 1813–1882*, Ann Arbor, Michigan 1984.

205. *Grammaire*, p. 2.

206. Ibid., p. 10.

207. Ibid., p. 9.

208. Ibid., p. 543.

209. Ibid., p. 550.

210. Ibid., p. 545.

211. Ibid., p. 545.

212. Ibid., p. 715.

213. See B. Stafford, *Symbol and Myth. Humbert de Superville's Essay on the Absolute Signs in Art*, Cranbury, N.J. 1979, for a good account of Humbert's thought, its sources and its context.

214. Blanc, *Grammaire* (n. 204), pp. 35–6.

215. For a fuller reference to Henry's theories and bibliographical references, see the end of Chapter VII, pp. 318–19, and n. 236.

CHAPTER VI

1. P. Pino, *Dialogo di pittura*, Venice, 1548, pp. 116 and 122. A general history of colour in art is provided by F. Birren, *History of Colour in Painting*, New York, 1965. See also K. Halbertsma, *A History of the Theory of Colour*, Amsterdam, 1949.

2. *The Works of A.R. Mengs*, 2 vols, London, 1796, I, p. 135.

3. E. Land, 'Experiments in Color Vision', *Scientific American*, CC, 1959, pp. 84–94 and 96–99; and A. Karp, 'Colour Image Synthesis with two Unorthodox Primaries', *Nature*, CLXXXIV, 1959, pp. 710–2. For useful introductions to colour theories see H. Rossotti, *Colour. Why the World Isn't Grey*, Harmondsworth, 1983; R. Osborne, *Lights and Pigments. Colour Principles for Artists*, London, 1980; L. Hurvich, *Color Vision*, Sunderland, Mass., 1981; Y. le Grand, *Light, Color and Vision*, trans. R. Hunt, J. Walsh and F. Hunt, New York, 1957; F. Birren, *Story of Colour*, New York, 1941; and G. Wasserman, *Color Vision. An Historical Introduction*, New York, 1978. A review of recent developments from an information-processing standpoint is provided by D. Marr, *Vision*, San Francisco, 1982.

4. Aristotle, *De sensu*, trans. W. Hett, London, 1935, III 439b.

5. *De coloribus*, trans. W. Hett, London, 1963, III 790ff.

6. *Meteorologica*, III, 2–4, esp. 372a.

7. S. Portius, *De Coloribus libellus*, Florence, 1548, p. 552.

8. G. Cardano, *De gemmis et coloribus*, Lyons, 1563, p. 552.

9. Pliny, *Historia naturalis*, XXXV, XXXII, 50, See J. Gage, 'A Locus Classicus of Colour Theory. The Fortunes of Apelles', *Journal of the Warburg and Courtauld Institutes*, XLIV, 1981, pp. 1–26.

10. Cennino Cennini, *The Craftsman's Handbook*, trans. D. Thompson, New Haven, Conn. 1933, p. 20. For Renaissance colour theory in painting see J. Gavel, *Col-

our. *A Study of its Position in the Art Theory of the Quattro and Cinquecento*, Stockholm, 1979; M. Barasch, *Light and Colour in the Italian Renaissance Theory of Art*, New York, 1978; H. Siebenhuner, *Uber den Kolorismus der Frührenaissance*, Leipzig, 1935; P. Hills, *The Light of Early Italian Painting*, New Haven, Conn., and London, 1987; and J. Gage, 'Lumen, Alluminar, Riant. Three Related Concepts in Gothic Aesthetics', *Europaische Kunst um 1300*, XXV, Internationaler Kongress fuer Kunstgeschichte, Vienna, 1983, pp. 31–7.

11. Ibid. p. 17.

12. Ibid. pp. 53ff.

13. G.P. Lomazzo, *Idea del tempio della pittura*, Milan, 1590, III, x (see below n. 40). For Vasari's use of *cangianti* colours, see C. Davis, '"Colore" and "Invenzione" in Mid Sixteenth-Century Florence', *Pantheon*, XXXVIII, 1980, pp. 153–7.

14. Predella painting of the *Feast of Herod* in the Kress Collection, National Gallery, Washington, no. 1086, datable 1461–2.

15. L.B. Alberti, '*On Painting*' and '*On Sculpture*', ed. C. Grayson, pp. 44–5. See S.Y. Edgerton, 'Alberti's Colour Theory. A Mediaeval Bottle without Renaissance Wine', *Journal of the Warburg and Courtauld Institutes*, XXXII, 1969, pp. 109–34; J. Thornton, 'Renaissance Color Theory and Some Paintings by Veronese', Ph.D. thesis, Pittsburgh, 1979 (University Microfilm, CNN 80–15329); and M. Kemp, 'Yellow, Red and Bule. The Limits of Colour Science in Painting, 1400–1730', *The Natural Sciences and the Arts*, ed. A. Ellenius, (Acta Universitatis Upsaliensis, XXII), Uppsala, 1985, pp. 98–105.

16. Ibid., pp. 46–7. For a discussion of *cinereum/bigio* as colour terms see Gavel (n. 10), pp. 50–1.

17. Ibid., p. 91.

18. Pliny (n. 9), XXXV, XLIX.

19. Ibid., p. 47.

20. Ibid., p. 93.

21. *Filarete's Treatise on Architecture*, facsimile and trans. J. Spencer, 2 vols., New Haven, Conn., 1965, book XIV, 181v–182r.

22. C.A. 250r, *The Literary Works of Leonardo da Vinci*, ed. J.P. Richter, 2 vols, London and New York, 1969, para. 111 (abbreviated refs. to MSS. as in Richter).

23. H²90v and E31v, Richter 134–5.

24. Codex Urbinas 193r–v (L° A. 21), also in *A Treatise on Painting*, ed. A.P. McMahon, 2 vols, Princeton, N.J., 1965, para. 793; Urb. 192r, para. 797; and Urb. 193v (L° A. 20), para. 794. For Leonardo's views on colour, see *Leonardo on Painting. An Anthology of Writings by Leonardo da Vinci with a Selection of Documents Relating to His Career as an Artist*, ed. M. Kemp and M. Walker, New Haven, Conn., and London, 1988, part II.

25. Urb. 56r, McMahon, 163.

26. Urb. 67v, McMahon 188.

27. E 18r, Richter 286, Urb. 73v, McMahon 193.

28. Urb. 75v (L° A. 49), McMahon, 176.

29. Urb. 76r–v (L° A. 30), McMahon 177; Urb. 57v, McMahon, 169; Windsor 19152, Richter 274.

30. Leic. (Hammer) 4r, Richter 300.

31. Urb. 73v, McMahon 242; Urb. 193r, McMahon 783.

32. See particularly the notes in the late MS. G, eg. 2v–3r and 24r–25v.

33. See Kemp, *Leonardo da Vinci. The Marvellous Works of Nature and Man*, London and Cambridge, Mass., 1981, pp. 333ff.

34. Urb. 74r–v (L° A. 18), McMahon 196.

35. Eg. Urb. 66v, McMahon 151; Urb. 58v (L° A. 49), McMahon 173; Urb. 75r (L° A. 20), McMahon 203; Urb. 63v, McMahon 206; Urb. 207v (L° A. 47), McMahon 802; F. 75r, Richter 278.

36. BN. 2038 4r, Richter 50; Urb. 71v, McMahon 149; Urb. 76v–77r, McMahon 180; Urb. 62v, McMahon 62v.

37. Windsor 19076r, Richter 287; Urb. 62r, McMahon 185.

38. Windsor 19152r, Richter 274. See C. Maltese, *Leonardo e l'età della ragione*, ed. P. Rossi and E. Bellone, Milan, 1981, pp. 171–84.

39. M. Kemp, 'Analogy and Observation in the Codex Hammer', in *Studi Vinciani in Memoria di Nando di Toni*, ed. M. Pedini, Brescia, 1986, pp. 103–34.

40. See G.P. Lomazzo, *Scritti sulle arti*, ed. R. Ciardi, 2 vols, Florence, 1973; and *Idea del tempio della pittura*, ed. R. Klein, 2 vols, Florence, 1974. Also G. Ackerman, 'Lomazzo's Treatise on Painting', *Art Bulletin*, XLIX, 1967, pp. 317–26. R. Klein, 'La forme et l'intelligible', *Archivio di Filosofia*, 1958, pp. 103–121, and Klein, *Form and Meaning*, trs. M. Jay and L. Wieseltier, Princeton, 1979, pp. 43–61.

41. See E. Panofsky, *Idea. A Concept in Art Theory*, trs. J. Peake, New York, 1968, pp. 141–53, for Lomazzo's text and his use of Ficino.

42. Lomazzo, ed. Ciardi, II, p. 204.

43. Ibid., II, p. 32.

44. Ibid., II, p. 198.

45. G. Camillo, *L'Idea del teatro*, Florence, 1550. See F. Yates, *The Art of Memory*, Harmondsworth, 1969, pp. 135ff.

46. M. Kemp, '"Equal Excellencies". Lomazzo and the Explanation of Individual Style in the Visual Arts', *Renaissance Studies*, I, 1987, pp. 1–26.

47. *Scritti* (ed. Ciardi), I, pp. 283ff.

48. Cf. R. Klein, 'Les sept gouverneurs de l'art selon Lomazzo', *Arte Lombarda*, IV, 1959, 2, pp.277ff.

49. Lomazzo, ed. Ciardi (n. 40), II, pp. 401–2.

50. Ibid., II, pp. 177ff.

51. Ibid., II, pp. 185.

52. Ibid., II, p. 401; cf. II, pp. 177 and 181.

53. Ibid., II, p. 308; cf. II, pp. 103 and 269.

54. R. Borghini, *Il Riposo*, Florence, 1585, pp. 272ff.

55. Ibid., p. 230.

56. *Dialogo di M. Lodovico Dolce nel quale si ragiona della qualita, diversita e proprieta de i colori*, Venice, 1565 in *Scritti d'arte del Cinquecento*, 3 vols, ed. P. Barocchi, Milan and Naples (n. d.), III, pp. 2210–2226. Cf. F.P. Morati, *Del significato del colore*, Venice, 1535; A. Tylesius (Tilesio), *Libellus de coloribus*, Venice, 1528; C. Occolti, *Trattato de' colori*, Parma, 1568; and G. de' Rinaldi, *Il Mostruosissimo mostro*, Venice, 1592.

57. Dolce, ed. Barocchi, p. 2213.

58. See Parkhurst, 'A Color Theory from Prague. Anselm de Boodt, 1609', *Allen Memorial Art Museum Bulletin*, XXIX, 1971, pp. 3–10 for Dolce's *Libri tre delle diverse sorti delle gemme*, Venice, 1565.

59. C. Leonardi, *Speculum lapidum*, Venice, 1502, p. 420. See C. Parkhurst, 'Camillo Leonardi and the Green-Blue Shift in Sixteenth-Century Painting', in *Intuition und Kunstwissenschaft. Festschrift für Hans Swarzenski*, ed. P. Bloch et al., 1973, pp. 419–25, though the correlations with pictorial practice do not seem convincing to me.

60. Pino (n. 1), in *Trattati d'arte del Cinquecento*, ed. P. Barocchi, 3 vols, Bari, 1960–2, I, pp. 93–140 (p. 118).

61. C. Sorte, *Osservazioni della pittura*, Venice, 1580, p. 296, in Barocchi, *Trattati* (n. 60), pp. 271–301.

62. Aristotle, *De sensu*, III, 439b–440a. For 'visual music' in sixteenth-century art, particularly the theory of architecture, see J. Onians, 'On How to Listen to High Renaissance Art', *Art History*, VII, 1984, pp. 411–37.

63. G. Zarlino, *Istitutioni harmoniche*, Venice, 1558, III, 8; trans. G. Marco and C. Palisca in *The Art of Counterpoint. Part III of Le Istitutioni harmoniche*, New Haven, Conn., and London, 1968, pp. 19–20.

64. G. Zarlino, *Sopplimenti musicali*, Venice, 1588, pp. 174–5. Compare D. Barbaro, *I Dieci libri d'architettura di M. Vitruvio*, Venice, 1567, pp. 229–30.

65. G. Comanini, *Il Figino, overo del fine della pittura*, Mantua, 1591, p. 249, in Barocchi, *Trattati* (n. 60), III, p. 368.

66. Ibid., p. 370.

67. Ibid., p. 370.

68. For other paintings in this series see T. DaCosta Kaufmann, 'Arcimboldo's Imperial Allegories', *Zeitschrift für Kunstgeschichte*, XXXIX, 1976, pp. 275–96. For the content of Arcimboldo's paintings see T. DaCosta Kaufmann, *Variations of the Imperial Theme in the Age of Maximilian II and Rudolf II*, New York and London, 1978; Kaufmann *L'École de Prague*, Paris, 1985; and Kaufmann, 'The Allegories and their meaning', in *The Arcimboldo Effect*, ed. P. Hulten, Milan, 1987, pp. 87–108.

69. R. Lebèque, *Les Correspondants de Peiresc*, Brussels, 1943, p. 51.

70. *Correspondance de Rubens*, ed. C. Reulens and M. Rooses, 1909, VI, p. 112; and *The Letters of Peter Paul Rubens*, ed. & trans. R. Magum, Cambridge, Mass., 1955, pp. 401 and 404.

71. See B. Teyssèdre, *Roger de Piles et les débats sur le coloris au siècle de Louis XIV*, Paris, 1965, pp. 218–9.

72. F. d'Aguilon (Aguilonius), *Opticorum libri sex*, Antwerp, 1613, pp. 39ff. See *Corpus Rubenianum Ludwig Burchard*, XXI, ed. J. Judson, and C. van de Velde, 2 vols, Brussels, 1978, pp. 101–115; and W. Jaeger, *Die Illustrationem von Peter Paul Rubens zum Lehrbuch der Optik des Franciscus Aguilonius, 1613*, Heidelberg, 1976.

73. C. Parkhurst, 'A Color Theory from Prague: Anselm de Boodt', *Allen Memorial Art Museum Bulletin*, XXIX, 1971, pp. 3–10; and 'Louis Savot's "Novaantiqua" Color Theory, 1609', *Album Amicorum J.G. Van Gelder*, ed. J. Bruyn et al., The Hague, 1973, pp. 242–7.

74. See J. Held, 'Rubens and Aguilonius. New Points of Contact', *Art Bulletin*, LXI, 1979, pp. 257–64.

75. Aguilonius, ibid., pp. 423ff.

76. Ibid., pp. 427ff, quoted by Held (n. 74), p. 261.

77. C. Parkhurst, 'Aguilonius' Optics and Rubens' Colour', *Nederlands Kunsthistorisch Jaarboek*, XII, 1961, pp. 34–50.

78. *Annunciation*, 1690–10, Vienna, Kunsthistorisches Museum, no. 1160. See M. Jaffe, 'Rubens and Optics', *Journal of the Warburg and Courtauld Institutes*, XXXIV, 1971, pp. 362–5.

79. Held (n. 74), pp. 262–4.

80. Aguilonius (n. 73), p. 39.

81. R. de Piles, *Conversations sur la connaissance de la peinture*, Paris, 1677, Seconde conversation, p. 303.

82. H. Howard, *A Course of Lectures on Painting*, London, 1848, pp. 172–3. A similar maxim is given by J. Descamps, *La vie des Peintres Flammands, Allemands et Hollandois*, Paris, 1754, I, pp. 310–1.

83. Aguilonius (n. 73), p. 427.

84. A. Blunt, *Nicolas Poussin*, New York and London, 1967, pp. 371–2, letter to R. Freart, 1 March 1665.

85. A. Blunt, *The Paintings of Nicolas Poussin. A Critical Catalogue*, 2 vols, London, 1966, no. 1.

86. R. Spear, *Domenichino*, 2 vols, New Haven, conn., 1982, I, pp. 40ff. For colour- music in this period, see E. Cropper, *The Ideal of Painting. Pietro Testa's Dusseldorf Notebook*, 87. P. Accolti, *Lo Inganno de gl'occhi, prospettiva pratica*, Florence, 1625, p. 150.

88. M. Zaccolini's four unpublished MSS. are in the Bibliotheca Laurenziana, Ashburnham, 1212 1–4. 'De' colori' and 'Prospettiva del colore' deal specifically with colour. See J.C. Bell, 'Colour and Theory in Seicento Art. Zaccolini's "Prospettiva del Colore" and the Heritage of Leonardo', Ph.D. thesis, Brown, 1983 (University Microfilms, PRP83-25951, 1985). Dr. Bell is preparing a critical edition of the 'Prospettiva del colore'.

89. 'De' colori', I, (i)–(vii).

90. 'Prospettiva del colore,' letter to the reader 3v–4v, Bell (n. 88), I, p. 124.

91. Ibid., XVI, 12–13.

92. For a good account see Bell (n. 88), I, p. 199.

93. 'De' colori,' X–XI.

94. G. Zarlino, *De Istitutioni harmoniche*, Venice, 1573, p. 10. The tarantela-colour correlations were later expressed by Kircher, *Misurgia universalis*, 2 vols, Rome, 1650, I, p. 233.

95. A. Blunt, 'Poussin's Notes on Painting', *Journal of the Warburg and Courtauld Institutes*, I, 1937–8, pp. 344ff,

and *Nicolas Poussin* (n. 84) pp. 225–7 and 369–70.
96. A. Kircher, *Ars magna lucis et umbrae*, Rome, 1646, pp. 67ff. See also his *Misurgia . . .* (n. 94), I, pp. 567–8.
97. Ibid., p. 99.
98. G. de Lairesse, *Het Groot Schilderboek* (Amsterdam 1707), trans. J. Fritsch, London, 1738. Quotations from *A Treatise on the Art of Painting*, trans. W. Greig, London, 1817, pp. 134ff.
99. Ibid., p. 143.
100. C. Le Brun, Conference of 10 January 1671 in *Conferences inedities de l'Académie Royale*, ed. A. Fontaine, Paris, 1909, pp. 77–89. For a detailed discussion of the disputes on colour in the 17th century, see B. Teyssèdre (n. 72) generally, and pp. 142–4 for Le Brun on Poussin's *St. Paul*.
101. Félibien, *Conferences de l'Académie Royale de Peinture et de Sculpture pendant l'année 1667*, Paris, 1668, Sixth Conference, 5 November 1667, trans. as *Conferences . . . of Paintings*, London, 1740, p. 116.
102. Ibid., Seventh Conference, 3 December 1667 (trans. p. 141).
103. H. Testelin, *Sentimens des plus habiles peintres du temps*, Paris, 1696, pp. 39 and 194–206 (presented at the Academy on 4 February 1679).
104. M. Cureau de la Chambre, *Nouvelles observations et conjectures sur le nature de l'Iris* ed. P. Rocolet, Paris, 1662 (first edition, 1650), II, 11–12; and Leonardo da Vinci, *Traité de la peinture*, ed. & trans. R. Fréart de Chambray, Paris, 1651, CLXV, p. 40. For Cureau de la Chambre's colour scales, see B. Teysssèdre, 'Peinture et musique. La notion d'harmonie des couleurs au XVIIᵉ siècle français', in *Stil und Ueber-lieferung in der Kunst des Abendlandes*, 3 vols, Berlin, 1967, III, pp. 208–10.
105. Félibien, *Entretiens*, Paris, 1679, III, pp. 623ff; and Félibien's *Life of Poussin*, ed. C. Pace, London, 1981, pp. 68–83.
106. Blunt (n. 85), nos. 53 and 74. For an analysis of the colours in Poussin's *Healing of the Blind* according to Aristotelean principles see O. Batschmann, *Dialektik der Malerei von Nicolas Poussin* Zurich, 1952, and 'Farbengenese und Primafarbentrias in Nicolas Poussin "Die Heilung der Blinden"'. *Von Farbe und Farben. Albert Knoepfli 70 Geburstage*, Zurich, 1980, pp. 329–36.
107. R. Boyle, *Experiments and Considerations Touching Colours*, London, 1664, pp. 219–20.
108. J. Scheffer(us), *De Graphice id est de arte pingendi*, Nuremberg, 1669, XLIV, pp. 158ff. See A. Ellenius, *De Arte pingendi*, Uppsala and Stockholm, 1960, pp. 180–3.
109. Lairesse (n. 98), pp. 134ff.
110. J.C. le Blon, *Il Coloritto, or the Harmony of Colouring in Painting*, London, 1720(?) and Paris, 1756, p. 28; and French text, *L'Art d'imprimer les tableaux*, Paris, 1756, reprinted with introduction by F. Birren, New York, 1980. See also O. Lilien, *Jacob Christoph Le Blon*, Stuttgart, 1985.
111. Ibid., pp. 28–30.
112. Ibid., p. 58.
113. C. Mortimer, *An Account of Mr. James-Christopher le Blon's Principles of PRINTING . . .*, London, 1731, title page.
114. Ibid., p. 30.
115. A. Conti, *Prose e poesie*, Venice, 1756, II, p. CXLVIII. See F. Haskell, *Patrons and Painters*, London, 1963, p. 319, n. 2; and J. Gage 'Newton and Painting', in *Common Denominators in Art and Science*, ed. M. Pollock, Aberdeen, 1983, pp. 16–25.
116. J. Gautier d'Agoty, *Observations sur la peinture et sur les tableaux anciens et modernes*, Paris, 1753, pp. 134ff; and Gautier d'Agoty, *De Optice errores Isaaci Newtonis*, London, 1750. For colour printing see M. Salaman, *Old English Colour Prints*, London, 1909; C. Dodgson, *Old French Colour Prints*, London, 1924; and J. Friedman, *Colour Printing in England 1486–1870*, ex. cat., New Haven, Yale Centre for British Art, 1978.
117. Félibien, *Conferences* (n. 101), second conference, 4 June 1667.
118. Ibid., fourth conference, 3 September 1667.
119. N. Coypel, *Dissertation sur les partyes essentielles de l'art du dessein, ou peinture et sculpture*, Paris, 1699.

120. R. du Fresnoy, *De arte graphica*, Paris, 1668, trans. W. Mason and annotated by Sir Joshua Reynolds, as *The Art of Painting*, London, 1783, pp. 33ff.
121. R. de Piles, *Dialogue sur le coloris*, Paris, 1673; *Conversations*. (n. 81); and *Traité du coloris* in *Course de peinture par principes*, Paris, 1708, p. 303. For R. de Piles, see T. Puttfarken, *Roger de Piles' Theory of Art*, New Haven, Conn., and London, 1985.
122. *Traité*, ibid., pp. 335–7.
123. Félibien's account of Le Brun's *The Daughters of the King of Persia before Alexander* in Tessèydre (n. 72), pp. 63–14.
124. Ibid., p. 63, n. 4.
125. Blunt (n. 85), no. 75.

CHAPTER VII

1. *The Correspondence of Isaac Newton*, ed. H. Turnbull, Cambridge, 1959, I, pp. 92–102; and 'A Letter of Mr. Isaac Newton . . . containing his New Theory about Light and Colours', *Philosophical Transactions of the Royal Society*, LXXX, 1671–2, pp. 3075–87. See R. West-fall, 'The Development of Newton's Theory of Color', *Isis*, LIII, 1962, pp. 339–58 (and below n. 4).
2. *Correspondence*, I, p. 97.
3. *Philosophical Transactions* (n. 1).
4. For a revised account, see A. Shapiro, 'The Evolving Structure of Newton's Theory of White Light and Color', *Isis*, LXXI, 1980, pp. 211–35.
5. Ibid., pp. 223ff.
6. I. Newton, *Opticks*, London, 1704, III, I, query 13, in the fourth edition of 1730, reprinted, London, 1931, p. 345.
7. Ibid., I, proposition II, theorem 2, definition pp. 124–5.
8. *The Optical Papers of Isaac Newton*, Vol. I, *The Optical Lectures, 1670–1672*, ed. A. Shapiro, Cambridge, 1984, p. 50, n. 10.
9. Ibid., p. 543.
10. *Opticks* (n. 6), I, II, prop. 3, problem 1, p. 128.
11. *Optical Papers* (n. 8), p. 546, n. 28.
12. *Opticks* (n. 6), II, II, prop. VI, prob. 2, p. 154. C. Parkhurst and R. Feller, 'Who invented the Color Wheel?', *Color Research and Application*, VII, 1982, pp. 219 ff.
13. Ibid., I, II, prop. V, theor. 4, exper. 15, p. 150.
14. ibid., I, II, prop. VI, prob. II, p. 158.
15. Ibid., I, II, prop. V, theor. 4, exper. 15, p. 151.
16. Ibid., p. 152.
17. Ibid., I, II, prop. V, theor. 4, exper. 11, p. 144.
18. B. Taylor, *New Principles of Linear Perspective*, London, 1719, Appendix II, pp. 67–70; and J. Kirby, *Dr. Brook Taylor's Method of Perspective*, 2nd ed., Ipswich, 1765, pp. 18–19. See also J. Gage, 'Newton and Painting', in *Common Denominators in Art and Science*, ed. M. Pollock, Aberdeen, 1983, pp. 16–25.
19. F. Algarotti, *Essay on Painting*, London, 1764, pp. 50–1.
20. Ibid., pp. 51–2.
21. Ibid., p. 52.
22. *Opere*, Venice, 1792, VII, p. 50.
23. *Essay* (n. 19), p. 57.
24. L.B. Castel, *L' Optique des couleurs*, Paris, 1740, p. 2. D.S. Schier, *Louis Bertrand Castel, Anti-Newtonian Scientist*, Cedar Rapids, Iowa, 1941.
25. Ibid., pp. 26–7.
26. Ibid., p. 39.
27. Ibid., p. 47.
28. J. Gautier d'Agoty, *Observations sur la peinture et sur les tableaux anciens et modernes*, Paris, 1753, pp. 134–42 and 158–75; *Chroagénésie, ou génération des couleurs, contre le systeme de Newton*, Paris, 1749; and *De Optice errores Isaaci Newtonis*, London, 1750.
29. Castel (n. 24), p. 47.
30. Ibid., p. 222.
31. Ibid., p. 315.
32. Ibid., p. 370 (for Kircher); and Schier (n. 24), p. 150.

33. Castel (n. 24), p. 161; and Schier (n. 24), p. 150.
34. Ibid., p. 473, and *Mercure de France*, November 1725, pp. 255–77.
35. Ibid., p. 470ff, giving the description by the composer Telemann.
36. Ibid., p. 471.
37. Voltaire, *Examen et réfutation des Elémens e la philosophie de Newton*, Paris, 1789, pp. 304ff; and D. Diderot, *Encyclopédie ou Dictionnaire raisonné des sciences, des arts et des métiers*, 25 vols., Paris, 1751–71, III, p. 35, under 'Clavecin oculaire'.
38. W. Hogarth, *The Analysis of Beauty* (1753), ed. J. Burke, Oxford, 1955, p. 176 (a rejected draft).
39. Ibid., p.
40. I. Schiffermüller, *Versuch eines Farbensystems*, Vienna, 1772. For Schiffermüller's awareness of the difference between optical and pigment mixture, see J. Gage, 'Runge, Goethe and the "Farbenkugel"', in *Runge, Fragen and Antworfen*, ed. M. Holl, Munich, 1978, pp. 61–5.
41. E. Forbes, *Tobias Mayer (1723–62). Pioneer of Enlightened Science in Germany*, Göttingen, 1980, and 'Tobias Mayer's Theory of Colour-Mixing and its Application to Artistic Reproduction', *Annals of Science*, XXVI, 1970, pp. 95–114.
42. T. Mayer, *De Affinitate colorum commentatio*, Göttingen, 1758; and 'Die Mayerschen Farbendreiecke', *Göttingische Anzeigen*, II, 1758.
43. Forbes (n. 41), p. 132.
44. J.H. Lambert, *Beschreibung einer mit dem Calauschen Wasche ausgemalten Farbenpyramide*, Berlin, 1772.
45. M. Harris, *The Natural System of Colours*, London (1766?) p. 4. See F. Schmid, 'The Colour Circles by Moses Harris', *Art Bulletin*, XXX, 1948, pp. 277–30. Also the facsimile ed. by F. Birren, New York, 1963.
46. Ibid., p. 6.
47. Ibid., p. 8.
48. *The Natural System of Colours*, ed. T. Martin, London, 1811.
49. Hogarth, op. cit. (n. 38), p. 127.
50. Ibid., pp. 129–30.
51. Ibid., p. 133.
52. *The Works of Anton Raphael Mengs*, 2 vols, London, 1796, p. 121.
53. Ibid., p. 134.
54. *Lectures on Painting by the Royal Academicians*, ed. R.N. Wornum, London, 1885, p. 210. Barry's lectures were delivered 1784–98.
55. Ibid., p. 212.
56. West's statements on colour are collected by G. Evans, *Benjamin West and the Taste of his Times*, Carbondale, Illinois, 1959, pp. 105–7. See also F. Forster-Hahn, '"The Sources of True Taste". Benjamin West's Instructions to a Young Painter', *Journal of the Warburg and Courtauld Institutes*, XXX, 1967, p. 381.
57. J. Farrington, *Diary* (1803), ed. J. Greig as *The Farrington Diary*, London, 1922–8, VII, p. 154, reprinting West's Lecture of 1817.
58. Evans (n. 56), written in 1797. See J. Galt, *Life of Benjamin West*, London, 1820, p. 115, for West's 1797 *Discourse*. West's application of his theories to his practice needs to be fully investigated.
59. M. Gartside, *An Essay on Light and Shade on Colours and on Composition in General*, London, 1805, pp. 27ff.
60. Ibid., pp. 30–1.
61. E. Dayes, 'Instructions for Drawing and Colouring Landscapes', *The Works of the late Edward Dayes*, ed. E. Bradley, London, 1805, p. 304.
62. *George Romney*, ex. cat., Kenwood House, London, 1961, no. 38; and J. Gage, 'Blake's *Newton*', *Journal of the Warburg and Courtauld Institutes*, XXXIV, 1971, pp. 372-7.
63. *Lectures* (n. 54), p. 313 (delivered in 1807).
64. S. Haydon, *The Autobiography and Memoirs of B.R. Haydon*, London, 1966, I, p. 269.
65. For Newton's hold on literary imaginations see the publications by M. Hope Nicolson: *Newton Demands the*

Muse, Princeton, N.J., 1946; *The Breaking of the Circle*, Evanston, Illinois, 1950, and *Mountain Gloom and Mountain Glory*, New York, 1963. Also C.J. Wright, 'The "Spectre" of Science. The Study of Optical Phenomena and the Romantic Imagination', *Journal of the Warburg and Courtauld Institutes*, XLIII, 1980, pp. 186–20; J. Hefferman, 'The English Romantic Perception of Colour', in *Images of Romanticism: Verbal and Visual Affinities*, ed. K. Kroeber and W. Walling, New Haven, Conn., 1978, pp. 138–48; and R. Harré, 'Davy and Coleridge. Romanticism in Science and the Arts', in *Common Denominators* (n. 18), pp. 53–64.

66. K. Badt, *John Constable's Clouds*, London, 1950; L. Hawes, 'Constable's Sky Sketches', *Journal of the Warburg and Courtauld Institutes*, XXXII, 1969, pp. 344–65; and J. Thornes, 'Constable's Clouds', *Burlington Magazine*, CXXI, 1979, pp. 697–9.

67. P.D. Schweitzer, 'John Constable, Rainbow Science and English Colour Theory', *Art Bulletin*, XLIV, 1982, pp. 424–5.

68. See particularly the *Landscape with a Double Bow*, 1812, London Victoria and Albert Museum; *Sky Study and Rainbow*, New Haven, Yale Centre for British Art; *View of Hampstead with a Double Bow*, London, British Museum, Department of Prints and Drawings; and *Salisbury Cathedral from the Meadows*, London, Royal Academy.

69. Comte de Buffon, 'Sur les couleurs accidentales', Mémoires de l'Académie Royal des Sciences, Paris, 1743, H. pp. 1–8 and M. pp. 147–58, esp. p. 157.

70. *The Complete Works of Count Rumford*, 4 vols, Boston, Mass., 1870–5, IV, p. 51 (originally published in *Philosophical Transactions. . . .*, 1794, pp. 107–118).

71. Ibid., p. 66.

72. T. Young, *A Course of lectures on Natural Philosophy and the Mechanical Arts*, 2 vols, London, 1807, pp. 455–6.

73. Letter of 3 July 1806, in *Philipp Otto Runge. Briefe und Schriften*, ed. P. Betthausen, Munich, 1982 pp. 182–7. For Runge, see J. Traeger, *Philipp Otto Runge und sein Werk*, Munich, 1975; J. Jensen, *Philipp Otto Runge. Leben und Werk*, Cologne, 1977; R. Bisanz, *German Romanticism and Philip Otto Runge*, Illinois, 1970; and O. von Simpson, 'Philipp Otto Runge and the Mythology of Landscape'. *Art Bulletin*, XXIV, 1942, pp. 336–50.

74. P. Runge, *Die Farbenkugel, oder Construction das Verhältnisses aller Mischungen der Farben zu einander, und ihrer Vollständigen Affinität*, Hamburg, 1810. See H. Matile, *Die Farbenlehre Philipp Otto Runges*, Bern, 1973; Gage (n. 40); and R. Bisanz, *The Art Theory of Philipp Otto Runge*, 1967.

75. Ibid., p. 23. Compare his letters to Goethe, 3 July 1806 and Novemeber 1807, *Briefe und Schriften* (n. 73) pp. 182–7 and 202–3 for discussions of mixtures, etc., including a notable experiment with a spinning disk, possibly inspired by Schiffermüller.

76. Letter of 9 March 1802. *Briefe und Schriften* (n. 73), pp. 71–7. A selection of Runge's writings in translation is available in *From the Classicists to the Impressionists*, ed. and trs. E.G. Holt (*A Documentary History of Art*, III), New York, 1966, pp. 72–83, and in *Neoclassicism and Romanticism*, 2 vols, ed. L. Eitner, London, 1971, I, pp. 144–50 (see p. 147 for the quotation from the 9 March 1802 letter).

77. Letter of April (?), 1803, *Briefe und Schriften* (n. 73), pp. 141–4.

78. Letter of 7 November 1802, *Briefe und Schriften* (n. 73), pp. 97–9, quoted by von Simpson (n. 73), p. 345, and Eitner (n. 76), p. 150.

79. Letter of April (?), 1803, *Briefe und Schriften* (n. 73), pp. 141–4.

80. Letter of 1 December 1802, *Briefe und Schiften* (n. 73), pp. 106–9. For the *Morning*, see Traeger (n. 73), p. 414, and W. Vaughan, *German Romantic Painting*, New Haven, Conn., and London, 1980, p. 63.

81. Letter of 23 September 1809, quoted by Bisanz (n. 73), p. 78.

82. J.W. von Goethe, *Zur Farbenlehre, Didaktischer Teil*, Berlin, 1810, and *Beiträge zur Optik*, 2 vols, Berlin, 1791–2. The influential translation by C. Eastlake, *Goethe's Theory of Colours*, London, 1840, does not include the important historical review in the original edition. See M. Wilson, 'Goethe's Colour Experiments', *Year Book of the Psychological Society*, XXX, 1958, p. 13; G.S. Kallienke, *Das Verhältnis von Goethe und Runge im Zusammenhang mit Goethes Auseinandersetzung mit der Frühromantik*, Hamburg, 1973; *Goethe's Colour Theory*, ed. R. Matthei, New York, 1971; and M. Schindler, *Goethe's Theory of Colours*, East Grinstead, 1964. The Eastlake edition is also available in reprint with introduction by D. Judd, Cambridge, Mass., and London, 1970.

83. *Farbenlehre*, para. 762.

84. Ibid., para. 69.

85. Ibid., para. 239.

86. Ibid., para. 558.

87. Ibid., para. 705.

88. Ibid., para. 823.

89. Ibid., paras 696ff.

90. Ibid., paras 766ff.

91. L. Hundertpfund, *The Art of Painting Resolved to its Simplest and Surest Principles* (translation of German edition of 1847), London, 1849, p. 6ff.

92. Ibid., p. 8.

93. T. Mitchell, 'P.O. Runge and C.D. Friedrich. A Comparison of Theory and Art'. Ph.D. thesis, Indiana University, 1977, University Microfilms, CNN77 30307: and L. Siegel, 'Synaesthesia and the Paintings of Caspar David Friedrich', *Art Journal*, XXXIII, 1974, pp. 196–204.

94. C.G. Carus, *Neun Briefe über die Landschaftsmalerei*, Leipzig, 1831, (and ed. K. Gerstenberg, Dresden, 1955). See M. Prause, *Carl Gustav Carus als Maler, Leben und Werk*, Berlin, 1968.

95. Turner's comment on Goethe's para. 834, quoted by J. Gage, *Colour in Turner*, London, 1969, p. 187. See also R. Gray, 'J.M.W. Turner and Goethe's Colour Theory', in *German Studies Presented to Walter Horace Bruford*, London, 1962, pp. 112–6; and L. Gowing, *Turner: Imagination and Reality*, ex. cat., Museum of Modern Art, New York, 1966, p. 21ff.

96. T. Philips, *Lectures on the History and Principles of Painting*, London, 1833, p. 343. See pp. 301–4 for his use of Harris.

97. C. Hayter, *A New Practical Treatise on the Three Primitive Colours*, London, 1826.

98. Ibid., p. 8.

99. Ibid., p. 6.

100. Ibid., p. 12.

101. J. Burnet, *Practical Hints on Colour in Painting*, London, 1827, p. 6.

102. G. Field, *Chromatography, or a Treatise on Colours and Pigments and of their Powers in Painting*, London, 1835. Field was an influential figure as a chemist of pigments and active in the institutional structures of the art world. An introduction to his thought is provided by D. Brett, 'The Aesthetical Science. George Field and the "Science of Beauty"', *Art History*, IX, 1986, pp. 336–50.

103. *Aesthetics*, London, 1820, pp. 198–9.

104. *Chromatics, or, An Essay on the Analogy and Harmony of Colours*, London, 1817, and *Chromatography* (n. 102), p. 35.

105. H. Harington, *Symbolon Trisagion, or the Geometrical Analogy of the Catholic Doctrine of the Triunity*, London, 1806.

106. *Chromatography* (n. 102), p. 35.

107. D. Brewster, *A Treatise on Optics*, London, 1831, pp. 71ff, for the crucial arguments. See also his Anonymous 'Review of Goethe's "Theory of Colours"', *Edinburgh Review*, LXXII, 1840–1, pp. 99–131; and *Life of Sir Isaac Newton*, London, 1831, p. 64.

108. M. Gordon, *The Home Life of Sir David Brewster*, third edition, Edinburgh, 1881, pp. 147–8.

109. Turner MSS. British Library, Add. MS 46151 BB, f.66, in Gage (n. 95), p. 209 (from the 1827(?) lectures).

110. MS. 46151 H, fols. 25v–41v, in Gage (n. 95), p. 206, (from the 1818 lecture).

111. Ibid., p. 114–15; British Museum CXCV, Department of Prints and Drawings, Turner Bequest, 178–9.

112. Ibid., pp. 206–7.

113. M. Butlin and E. Joll, *The Paintings of J.M.W. Turner*, 2 vols, New Haven, and London, 1984, no. 512.

114. C. Du Fresnoy, *De Arte graphica*, trans. W. Mason, London, 1783, II, 445–50. Butlin and Joll, no. 340.

115. J. Sowerby, *A New Elucidation of Colours, Original, Prismatic and Material . . .* , London, 1809. See G. Finley, 'Turner: an Early Experiment with Colour Theory', *Journal of the Warburg and Courtauld Institutes*, XXX, 197, pp. 359–62.

116. Sowerby (n. 115), p. 24.

117. W. Thornbury, *Life and Correspondence of J.M.W. Turner*, London, 1904, pp. 349–50; and Gage (n. 95), pp. 120–2.

118. M. Sommerville, *Mechanism of the Heavens*, London, 1831, and 'On the magnetising power of the more refrangible solar rays', *Philosophical Transactions of the Royal Society*, II, 1829, pp. 132–9.

119. Butlin and Joll (n. 113), no. 512; see Gage (n. 95), pp. 40–1.

120. Butlin and Joll, nos. 404–5.

121. *Farbenlehre* (n. 82), paras 488ff.

122. Gage (n. 95), p. 126.

123. Ibid., p. 185, and Gray (n. 95).

124. *Farbenlehre* (n. 82), para. 777.

125. J. Ruskin, *Modern Painters*, London, 1834, I, part 2, section II, chapter 2, para. 14, in *The Works of John Ruskin*, ed. E. Cook and A. Wedderburn, III, London, 1903, p. 293.

126. *Notes on the Turner Gallery at Marlborough House* (1857) in *Works*, ed. Cook and Wedderburn (n. 125), XXXII, pp. 272–3.

127. *The Art of England*, London, 1883, in *Works* XXIII, 1908, pp. 272–3 (n. 125).

128. F. Stephens, *William Homan Hunt and his Works*, London, 1860, pp. 19–20. The reference to Davy may be to his 'Some Experiments and Observations on the Colours used in Painting by the Ancients', *Philosophical Transactions of the Royal Society*, CV, 1815 pp. 122–3.

129. Quoted by A. Staley, *The Pre-Raphaelite Landscape*, Oxford, 1973, pp. 6–7.

130. F. Hueffer, *Ford Madox Brown. A Record of his Life and Work*, London, 1896, p. 72.

131. H. Richter, *Day-Light. A Recent Discovery in the Art of Painting*, London, 1817, p. 10: where he recommends 'genuine *studies of light and colour* taken faithfully from *Nature* itself, *out of doors* under all its various aspects'.

132. Ibid., p. 11.

133. Ibid., pp. 2–3.

134. Ibid., p. 61.

135. M. Bennett, *William Holman Hunt*, ex. cat., Liverpool, 1969, p. 30.

136. W.H. Hunt, *Pre-Raphaelitism and the Pre-Raphaelite Brotherhood*, London, 1885, p. 470.

137. Ibid., p. 148.

138. Ibid., p. 148.

139. Bennett (n. 135), p. 53.

140. M. Bennett, *Ford Madox Brown*, ex. cat., Liverpool, 1964, p. 23.

141. Ibid., p. 22.

142. Staley (n. 129), p. 77.

143. *Modern Painters*, part 2, section II, chapter 2, para. 2, *Works* (n. 125), p. 279.

144. *Elements of Drawing*, note to second edition, London, 1857, p. 28; also *Works*, ed. Cook and Wedderburn (n. 125), XV, p. 28.

145. *Elements* in *Works* (n. 125) XV, p. 143. Compare ibid., p. 53.

146. *Elements* in *Works* (n. 125) XV, p. 147.

147. *Elements in Works* (n. 125), p. 152.

148. O. Rood, *Modern Chromatics*, London, 1879, pp. 140 and 278, quoting from *Elements* paras, 168, 169 and 172, in *Works*, ed. Cook and Wedderburn (n. 125) XV, pp. 146–9 and 151.

149. Hunt (n. 136), p. 490.

150. For Savot and Le Blon, see above chapter VI, p. 275 . W. Petty, 'An apparatus for the history of the common practice of dyeing' (1662), in T. Sprat, *History or the Royal Society*, London, 1667, pp. 284–306.

151. M.E. Chevreul, *De la Loi du contraste simultané des couleurs*, 2 vols, Paris, 1839 (and the useful ed. by H. Chevreul, Paris, 1879). Trans. J. Spanton as *The Laws of Contrast of Colour and their Applications to the Arts and Manufactures*, London, 1883 (subsequent refs. are to this edition). Also *The Principles of Harmony and Contrast of Colours*, ed. F. Birren, New York, 1967.

152. Ibid., p. 4., para.

153. M. Prieur, 'Considérations sur les couleurs, et sur plusieurs de leurs apparences singulières', *Annales de Chimie*, LIV, 1805, pp. 14–5.

154. Chevreul (n. 151), p. 49, para. 174.

155. *Exposé d' un moyen de définir e de nommer les couleurs d' après une méthode précise et expérimentale*, with *Altas*, Paris, 1861.

156. Chevreul (n. 151), p. 49, para. 174.

157. Ibid., p. 62, paras 237ff.

158. Ibid., p. 91, para. 321.

159. Ibid., p. 218, para. 623.

160. Ibid., p. 95, para. 326.

161. L. Johnson, *The Paintings of Eugene Delacroix. A Critical Catalogue 1821–31*, Oxford, 1981, I, J. 100; and the review by J. Gage in *Art Book Review*, I, 1983, pp. 42–5, dealing in particular with the controversy surrounding colourism in the *Barque of Dante* and *Massacre at Chios*. For Delacroix's colourism, see E. Johnson, *Delacroix*, London, 1963, based on his unpublished Ph.D. thesis, 'Colour in Delacroix: Theory and Practice', Cambridge, 1958 (3378), which contains the best documented analysis of Delacroix's colour.

162. Johnson, *Paintings*. . . (n. 161), J. 105.

163. *Journal*, ed. A. Joubin, 3 vols, Paris, 1950 (Also, first edition, 1932); and an edition by H. Wellington, trans. L. Norton, London, 1951.

164. North African sketchbook, Chantilly, Musée Condé, quoted Johnson, *Delacroix* (n. 161), pp. 64–9, and Colour in Delacroix (n. 161), p. 73.

165. G. Grégoire, *Théorie des couleurs*, Paris, 1820. C. Bourgeois, *Manuel d'optique éxperimental, à l'usage des artistes et des physiciens*, Paris, 1821. J. Merimée *De la peinture à l'huile*, Paris, 1830. See also P. Bouvier, *Manuel des jeunes artistes et amateurs en peinture*, second edition, Paris, 1832.

166. The French translation of Burnet's *Practical Hints*. . . (n. 101) was published in 1835, but it was probably known earlier to Delacroix in the English edition: see *Journal* (n. 163), III, p. 380; and Johnson *Delacroix* (n. 161), p. 85.

167. Journal (n. 163), 10 July 1847.

168. Johnson, *Delacroix* (n. 161), p. 104, and below n. 169; also *Journal* (n. 163), 5 January 1857.

169. Dieppe notes concerning outdoor colours, reflections and coloured shadows were published by Achille Piron, *Eugène Delacroix, sa vie et ses oeuvres*, Paris, 1865, pp. 416–18; also *Oeuvres Littéraries*, I, Paris, 1923, pp. 71–3.

170. J. Spector, *The Murals of Eugène Delacroix at Saint-Sulpice*, New York, 1967.

171. F. Villot, *Catalogue de la vente du cabinet de M.F.V. le 11 Février 1865*, Paris, 1865, introduction, p. VII.

172. M. du Camp, *Souvenirs littéraires*, Pairs, 1882, p. 290.

173. See R. Huyghe, *Delacroix et les maîtres de la couleur*, ex. cat., Paris, 1952; and also the discussion in Johnson, *Delacroix* (n. 161), p. 63ff, and pp. 135ff.

174. *Journal* (n. 163), 13 January 1857.

175. *Journal* (n. 163), 29 April 1851, written in connection with *Apollo Triumphing over Python* (Paris, Louvre).

176. See above n. 166.

177. D. Wildenstein, *Claude Monet. Biographie et catalogue raisonnée*, 3 vols, Paris, 1974, I, p. 150, no. 67. For a good account of Impressionist colour and technique, see A. Callen, *Techniques of the Impressionists*, London, 1982; also an important discussion by R. Schiff. 'Impressionist Criticism. Impressionist Colour and Cézan-

ne', Ph.D. thesis, Yale University, 1973, (University Microfilms, 73 29 249); and Schiff, *Cézanne and the End of Impressionism. A Study of the Theory, Technique and Critical Evaluation of Modern Art*, Chicago, 1984, in which the notion of the 'impression' is analysed.

178. See above n. 169; and Johnson, *Delacroix* (n. 161), p. 115.

179. J. Lane and K. Steinitz, 'Palette Index; Colour Ranges of the Masters who Helped Form the Painting Styles of Today', *Art News*, XL, 14, 1942, pp. 23–5 and 32; R. Brown, 'Impressionist Technique. Pissarro's Optical Mixture', *Magazine of Art*, XLIII, 1950, p. 13; and 'The Color Technique of Camille Pissarro', Ph.D. thesis, Harvard University, 1952; and Schiff (n. 177), p. 128.

180. Wildenstein (n. 177), I p. 278, no. 381.

181. See particularly Callen (n. 177), pp. 22ff.

182. K. Huysmans, *L'Art Moderne*, Paris, 1883, pp. 89–90. See O. Reutersvard, 'The "Violettomania" of the Impressionists', *Journal of Aesthetics and Art Criticism*, IX, 1950, pp. 106–110.

183. A de Lostalot, 'Exposition des oeuvres de M. Claude Monet', *Gazette des Beaux Arts*, XXVII, 1883, p. 346.

184. J. Claretie, *La vie à Paris 1881*, Paris, 1881, p. 266.

185. Letter to Durand Ruel, 3 June 1905. See J.C. Webster, 'The Technique of Impressionism. A Reappraisal', *College Art Journal*, IV, 1944, pp. 3–22.

186. The fundamental account of Seurat's sources remains W. Homer, *Seurat and the Science of Painting*, Cambridge Mass, 1978. For recent perspectives on the interpretation of Seurat's paintings, particularly in a social context, see R. Thompson, *Seurat*, London, 1985. Important material is provided by R. Herbert in *Neo-Impressionism* ex. cat., Guggenheim Museum, New York, 1968; and J. Sutter, *The Neo-Impressionists*, New York, 1970. For the limits and validity of Seurat's theory and practice, see R.A. Weale, 'Theories of Light and Colour in Relation to the History of Painting', M.Phil. Thesis, University of London, 1974; A. Lee, 'Seurat and Science', *Art History*, X, 1987, pp. 203–26; and J. Gage, 'The *Technique* of Seurat. A Reappraisal', *Art Bulletin*, LXIX, 1987, pp. 448–54.

187. H. Helmholtz, *Optique physiologique*, Paris, 1867; 'L'optique et la peinture', in E.W. von Brücke's *Principes scientifiques des beaux arts*, Paris, 1878; and O. Rood, *Théorie scientifique des couleurs*, Paris, 1881. Rood's ideas had earlier been reviewed by P. Gille in *Le Figaro*, 26 January 1881.

188. See also *Principes scientifiques* (n. 187).

189. W. von Bezold, *Die Farbenlehre in Hinblick auf Kunst und Kunstgewerbe*, Braunschweig, 1874; trans. as *The Theory of Colour in its Relation to Art and Art-Industry*, Boston, Mass., 1876.

190. H. Helmholtz, *Popular lectures on Scientific Subjects*, (Second Series, trs. E. Atkinson), London, 1881, 'On the Relation of Optics to Painting', pp. 96ff.

191. Ibid., p. 101. See also the discussion in H. Helmholtz, *A Treatise on Physiological Optics*, 3 vols, New York, 1924, II, pp. 172ff. The technical formulation is that 'sensation is proportional to the logarithm of the stimulus'.

192. Ibid., pp. 100–1.

193. Ibid., p. 121.

194. Helmholtz, (n. 191), I pp. 402ff. An outline of colour theory is provided by P. Sherman, *Colour Vision in the Nineteenth Century. The Young-Helmholtz-Maxwell Theory*, Bristol, 1981.

195. Ibid., pp. 181ff. See M. Kemp, 'Yellow, Red and Blue. The Limits of Colour Science in Painting', and M. Baxandall, 'The Bearing of the Scientific Study of Vision on Painting in the 18th Century' in Pieter Camper's *De Visu* (1746)', *The Natural Sciences and the Arts*, ed. A. Ellenius, (Acta Universitatis Upsaliensis, XXII) Uppsala, 1985, p. 101, n. 13 and p. 128. (In the spoken version of the paper Baxandall drew attention to la Hire's and Camper's description of the shift.) Rood also (p. 189) notes Dove's observations of paintings in galleries under different illuminations.

196. O. Rood, *Modern Chromatics with Applications to Art and Industry*, London, 1879 preface. The 1879 edition was reprinted, New York, 1973, intro. F. Birren.

197. Ibid., p. 277.

198. See the life by his son Roland, reprinted in the New York edition of 1973 (n. 196) which also illustrates Rood's watercolours (pp. 16–7); also R. Rood, *Colour and Light in Painting*, ed. G.L. Stout, New York, 1941.

199. *Modern Chromatics*, p. 14.

200. Ibid., p. 214.

201. Ibid., p. 233.

202. Ibid., p. 221.

203. Particularly D.R. Hay, *The Laws of Harmonious Colouring*, London and Edinburgh, 1844, *The Principles of Beauty in Colouring Systematicized*, Edinburgh and London, 1845, and *A Nomenclature of Colours, Hues, Tints and Shades*, Edinburgh, 1845. J.D. Forbes, 'Hints towards a Classification of Colours', *Philosophical Magazine*, 3rd series, XXXIV, 1849, pp. 161–78. For Maxwell, see below n. 321; and Sherman (n. 194), pp. 153ff, esp pp. 156–7.

204. Rood (n. 196), p. 225.

205. Ibid., pp. 224ff.

206. ibid., p. 232, outlining his reworking of Maxwell's diagram.

207. Ibid., p. 286; cf. p. 316.

208. Ibid., p. 292.

209. Ibid., p. 299. Cf. E. Brücke *Die Physiologie der Farben* . . . , Leipzig, 1866, p. 204.

210. Ibid., pp. 108ff.

211. Ibid., p. 14.

212. Ibid., pp. 279–80, and 139–40.

213. Ibid., p. 280; from Dove's *Darstellung der Farbenlehre und optische Studien*, Berlin, 1853.

214. Ibid., p. 281.

215. Ibid., p. 279.

216. C. Blanc, *Grammaire des arts du dessin* (1867), Paris, 1870 (trans. K. Doggett, *The Grammar of Painting and Engraving*, Chicago, 1897; and especially 'Eugène Delacroix' in *Gazette des Beaux Arts*, XVI, 1864, pp. 5–27 and 97–129; and *Les artistes de mon temps*, Paris, 1876.

217. *Grammaire*, p. 602. See M. Song, *Art Theories of Charles Blanc, 1813–1882*, Ann Arbor, Michigan, 1984. See also Théophile Silvestre's emphasis on the 'scientific' aspects of Delacroix's colourism in *Les Artistes Français*, Paris, 1878, pp. 41–2.

218. *Grammaire*, pp. 611–92.

219. P. Signac, *D'Eugène Delacroix au néo-impressionisme*, (Paris, 1899), ed. F. Cachin, Paris, 1978; and H. Buckner Vitaglione, 'P. Signac's "D'Eugène Delacroix au néo-impressionisme". A Translation and Commentary' M.Litt. thesis, University of St. Andrews, 1985, Ch. II, 140–1.

220. D. Sutter, 'Les phénomènes de la vision', *L'Art*, VI, in 6 parts, 18 January 14 March 1880. Also *Philosophie des beaux-arts*, Paris, 1858, and *L'Esthétique général et appliquée*, Paris, 1865, for this influential theorist's views in general.

221. N. Broude, 'New light on Seurat's Dot's, in *Seurat in Perspective*, ed. Broude, New Jersey, 1978, pp. 163–5 drawing attention to the technique of *chromotypogravure* which became available c. 1883–4.

222. J. Persoz, *Traité* . . . *de l'impression des tissus*, 4 vols, and *Altas*, Paris, 1846. Persoz's gloriously printed colour plates would alone have commended it to artists. See R. Herbert, 'The Faber Birren Collection on Color in the Art Library', *Yale University Library Gazette*, XLIX, 1974, p. 27, and LIII, 1978, p. 138.

223. A copy of a text by Vehbi Mohamed Zunbul-Zade, a Persian poet, was made by Seurat; see R. Herbert, 'Seurat in Chicago and New York', *Burlington Magazine*, c, 1958, p. 151. See also Blanc (n. 216), pp. 602 and 613 for expressions of the merits of oriental colourism.

224. H. Dorra and J. Rewald, *Seurat, l'oeuvre peint. Biographie et catalogue critique*, Paris, 1959.

225. See also J. Stumpel, '"The Grande Jatte", that Patient Tapestry', *Simiolus*, XIV, 1984, pp. 209–24.

226. Homer (n. 186), p. 146ff. and fig. 41.

227. Adapted from F. Fénéon, 'Le Neo-impressionisme', *L'Art Moderne*, 1 May 1887, p. 139. See also *Oeuvres plus que completes*, ed. J. Halperin, 2 vols, Geneva, 1970. Fénéon's most important accounts of Seurat's art are translated in Dorra and Rewald (n. 224). See also Homer (n. 186) pp. 132ff. Fénéon did not include gradation in his list.

228. Fénéon, 'Les Impressionistes', *La Vogue*, 13–20 June, 1886, pp. 271–2.

229. Letter of Seurat to M. Beaubourg, 28 August 1890, quoted by Homer (n. 186); and Thomson (n. 186), p. 225.

230. R. Herbert, '"Parade de Cirque" de Seurat et l'esthétique scientifique de Charles Henry', *Revue de l'Art*, L, 1980, pp. 9–23.

231. Chevreul, *Laws* . . . (n. 151), p. 146, paras 451ff. Delacroix had earlier quoted Chevreul regarding gold frames; see Spector (n. 170), p. 125, n. 58.

232. Letter to Beaubourg, Homer (n. 186), p. 187.

233. Dorra and Rewald (n. 224).

234. Letter to M. Beaubourg, Homer (n. 186), p. 187.

235. C. Henry, 'Introduction a un esthétique scientifique', *La Revue Contemporaine*, August 1885; *Cercle chromatique . . . avec une instruction sur la théorie generale de la dynamogénie*, Paris, 1888; *Rapporteur esthétique*, Paris, 1889; and the series of articles listed by Homer (n. 186), p. 312. See H. Dorra, 'Charles Henry's "scientific" Aesthetic', *Gazette des Beaux Arts*, LXXIV, 1969, pp. 343–56; and J. Arguelles, *Charles Henry and the Formation of a Psychophysical Aesthetic*, Chicago and London, 1972, in which Henry is seen as mysticising aesthetics rather than as attempting to place the mysteries of aesthetics on a scientific and psychological base.

236. See particularly C. Brown-Séquard, *Recherches expérimentales et cliniques sur l'inhibition et la dynamoginée* . . . , Paris, 1882; G. Fechner, *Elemente der Psychophysik*, Leipzig, 1860; J.R. Delboeuf *Examen critique de la loi psychophysique*, Paris, 1883; W. Wundt, *Psychologie physiologique*, Paris, 1886; and most particularly the work of Dr. Jean-Martin Charcot, for which see D. Silverman, *Art Nouveau in Fin-de-Siècle France*, Berkeley, Calif., 1989.

237. Henry, 'Introduction. . . ' (n. 235), pp. 454ff.

238. D.P.G. Humbert de Superville, *Essai sur les signes inconditionnels dans l'art*, Leyden, 1827–32; and C. Blanc, *Grammaire* (n. 216), p. 36. See the full exposition in B. Stafford, *Symbol and Myth. Humbert de Superville's Essay on Absolute Signs in Art*, Cranbury, N.J., 1979. See also F. Fénéon, 'Certains', *Art et critique*, 14 December 1889, p. 454.

239. C. Henry, 'Rapporteur esthétique et sensation de forme', *La Revue indépendante*, April 1888, pp. 73–80, and n. 235.

240. See particularly Signac's *Against the Enamel of a Rhythmic Background of Beats and Angles. Portrait of M. Félix Fénéon in 1890 (Opus 217)*, Private coll., New York; *Post Impressionism*, ex.cat., London, Royal Academy of Arts, 1979–80, no. 211. Signac assisted with the illustrations for Henry's 'L'Esthétique des formes', *La Revue blanche*, VII, 1894, pp. 517–9, and the *Cercle* . . . and *Rapporteur* . . . (n. 235).

241. Homer (n. 186), pp. 180ff is the fundamental account.

242. R. Evans, 'Maxwell's Colour Photograph', *Scientific American*, CCII, 1961, pp. 118–27 and below n. 250.

243. T. Young, 'On the Theory of Light and Colours', and 'Account of Some Cases of the Production of Colours not Hitherto Described', *Philosophical Transactions of the Royal Society*, XCII, 1802, pp. 12–48 and 387–97;

and *Course of Lectures on Natural Philosophy and Mechanical Arts*, London, 1807, I, pp. 439–40. See H.E. Young, 'Thomas Young and the Simplification of the Artist's Palette', *Proceedings of the Royal Society*, XLVI, 1934, pp. 16–34; and D Hargreave, 'Thomas Young's Theory of Colour Vision'. Ph.D. thesis, University of Wisconsin, 1973. (University Microfilms 73 27 103).

244. 'On the Theory. . . ' (n. 244), p. 16.

245. C.E. Wunsch, *Versüche und Beobachtungen über die Farben des Lichts*, Leipzig, 1792. A useful outline of the three-colour theories is provided by Hargreaves (n. 244.) pp. 203ff.

246. W.H. Wollaston, 'A Method of Examining the Refractive and Dispersive Powers by Prismatic Reflection', *Philosophical Transactions of the Royal Scoiety*, XCIII, 1802, pp. 365–80.

247. Sowerby (n. 115). A biography of Sowerby and list of his substantial publications is in the *Dictionary of National Biography*, London, 1898, III.

248. J.C. Maxwell, 'On the Theory of Colours in Relation to Colour Blindness' (1855), *Scientific Papers*, ed. W. Niven, London, 1890, I, pp. 119–25; and further papers pp. 126–34, 263–70; 410–44; and 'On the Theory of the Three Primary Colours' (1861), pp. 445–50.

249. A colour illustration of Maxwell's demonstration is provided by B. Coe, *Colour Photography. The First Hundred Years, 1840–1940*, London, 1978, p. 30. See Evans (n. 242), for an analysis of Maxwell's results. Acounts of the invention of colour photography are provided by E. Wall, *History of Three Color Photography*, Boston, Mass., 1925; J. Friedman, *History of Color Photography*, Boston, Mass., 1944; J. Eder, *History of Photography*, trs. E. Epstean, New York, 1945, pp. 638ff; and Coe, *op.cit.*, pp. 28ff, and pp. 84ff.

250. Maxwell's account of 17 May 1861 was published in the *British Journal of Photography*, IX, 1861, p. 270. See also *Scientific Papers* (n. 248), pp. 445–50.

251. J. Herschel, 'On the Chemical Actions of the Rays of the Solar Spectrum on Preparations of Silver and other Substances, both Metallic and Non-Metallic, and on some Photographic Processes', *Philosophical Transactions of the Royal Society*, CLXXXIV, 1840, pp. 1–59, esp. p. 18. See Coe (n. 250), p. 20; and L. Schaaf, *Sir John Herschel and the Invention of Photography*, ex. cat., Bath, 1981, 'The Quest for Colour' (unpaginated).

252. See particularly the account in Eder (n. 249), pp. 642–54.

253. L. Ducos du Haron, *Les Couleurs en photographie*, Paris, 1869, and with A. Ducos du Haron, *Traité pratique de photographie des couleurs*, Paris, 1878. See Eder (n. 249), pp. 645–6.

254. Eder (n. 249), p. 645.

CODA

1. H. Davy, Parallels between Art and Science', *The Director*, XXIX, 30 May 1807, pp. 196–7.

2. M. Baxandall, *Painting and Experience in Fifteenth Century Italy*, Oxford, 1972, esp. pp. 86ff.

3. The views summarised here are discussed more fully in M. Kemp, 'The Taking and Use of Evidence. With a Botticellian Case Study', *Art Journal*, XLIV, 1984, pp. 207–15; and review of M. Baxandall's *Pattens of Intention in Zeitschrift fur Kunstgeschichte*, L, 1987, pp. 131–41.

4. What follows is related to M. Kemp, 'Seeing and Signs. E.H. Gombrich in Retrospect', *Art History*, VII, 1984, pp. 228–43.

5. M. Kemp, "Illusion, Allusion and Collusion. Perspective and Meaning in the Historical Context', in *Philosophy and the Visual Arts*, ed. A. Harrison, Dordrecht, 1987, pp. 255–68.

6. For a contribution to this question from outside the realm of perceptual psychology, in which it is a much-discussed topic, see J. Collier Jnr, *Visual Anthropology. Photography as a Research Method*, New York, 1967, p. 53ff.

7. J.G. Vibert, *The Science of Painting*, London, 1892, pp. 48–9.

8. Ibid., p. 53.

9. R. Root-Bernstein, 'On Paradigms and Revolutions in Science and Art. The Challenge of Interpretation', *Art Journal*, XLIV, 1984, pp. 109–118.

10. S. Kosslyn, 'Pictures Inside and Outside the Head', in *Acts of the XXVI International Congress of the History of Art, 1986*, forthcoming.

11. B. Varchi, *Due lezzioni . . .*, Florence, 1549, quoted by D. Summers, *Michelangelo and the Language of Art*, Princeton, N.J., 1981, p. 210.

12. M. Kemp, 'Geometrical Bodies as Exemplary Forms in Renaissance Space', *Arts of the XXVI International Congress of the History of Art, 1986*, forthcoming. See J. Kepler, *Gesammelte Werke*, ed. M. Caspar, Munich, 1938, XII, pp. 50–3; and F. Prager, 'Kepler als Erfinder', *Internationales Kepler Symposium*, Weil der Stadt 1971, ed. F. Krafft *et al.*, Hildesheim, 1973, pp. 385–405.

APPENDIX II NOTES

1. The chief proponent of the 90° angle is J. White (chapter I, note 2), while the 53° angle is supported by Edgerton (chapter I, note 8). For relevant calculations see R. Beltrame, 'Gli esperimenti prospettici del Brunelleschi', *Atti della Accademia Nazionale dei Lincei. Rendiconti, Classe Scienze Morali, Storiche e Filologiche*, XVIII, 1973, pp. 840–61; and Kemp (chapter I, note 8).

2. The only sustained attempt to analyse this problem has been made by N. Pastore, 'On Brunelleschi's Perspective "Experiments" or Demonstrations', *The Italian Journal of Psychology*, VI, 1969, pp. 157–79.

3. See Kemp (chapter I, note 8), pp. 158–9; and N.J. Hahn, *Mediaeval Mensuration. 'Quadrus vetus' and 'Geometrie due sunt partes principales'*, (Transactions of the American Philosophical Society, LXXVII), Philadelphia, 1982. For the relationship of Brunelleschi's viewpoints and techniques to the practices of urban planning, see M. Trachtenberg. 'What Brunelleschi Saw. Monument and Site at the Palazzo Vecchio in Florence', *Journal of the Society of Architectural Historians*, XLVII, 1988, pp. 14–44.

4. For a good survey of mediaeval optics see D. Lindberg, *Theories of Vision from Al-Kindi to Kepler*, Chicago, 1976. See also *The Optics of Ibn Al-Haytham, Books I–II–III*, 2 vols, ed. A. Sabra, (Studies of the Warburg Institute, 40), London, 1988. For suggestions that other aspects of fourteenth and fifteenth-century painting may correspond to optical texts, see P. Hills, *The Light of Early Italian Painting*, New Haven, Conn., and London, 1987.

5. The strongest case for the relevance of Ptolemy is made by Edgerton (Chapter I, note 8); see also K. Veltman, 'Ptolemy and the Origins of linear perspective', in *La Prospettiva Rinascimentale*, ed. M. Dalai Emiliani, Florence, 1980, pp. 403–8. See also K. Andersen, 'The Central Projection in One of Ptolemy's Map Constructions'. *Centaurus*, XXX, 1987, pp. 106–13.

Select
Bibliography

Items have been selected to guide the reader into the main issues covered by this book, particularly where the cited studies themselves offer extensive bibliographical guidance. Access to the many detailed primary and secondary sources cited and used in the preparation of this book can be gained through the footnotes and via the index. Within each section of the bibliography, general items and are followed by studies of specific topics in an order which corresponds broadly to the order of the text (i.e. mainly chronological).

GENERAL ISSUES OF PERCEPTION AND REPRESENTATION

E.H. Gombrich, *Art and Illusion*, London, 1960.

——, *The Image and the Eye*, Oxford, 1982.

R. Gregory, *Eye and Brain. The Psychology of Seeing*, 3rd. edn., London, 1977.

R. Arnheim, *Art and Visual Perception: a Psychology of the Creative Eye*, Berkeley, 1974.

D. Marr, *Vision*, San Francisco, 1982.

M. Hagen, ed., *The Perception of Pictures*, 2 vols., New York, 1980.

——, *Varieties of Realism. Geometries of Representational Art*, Cambridge, 1986.

M. Kubovy, *The Psychology of Perspective and Renaissance Art*, Cambridge, 1986.

M. Podro, *The Manifold in Perception*, Oxford, 1972.

D. Summers, *The Judgement of Sense*, Cambridge, 1987.

M. Baxandall, *Patterns of Intention*, London and New Haven, 1985.

PERSPECTIVE ETC

Note: valuable resources for the study of the history of perspective are being made available by the series of facsimiles being published by Archival Facsimiles Limited of Alburgh, Harleston, Norfolk (treatises by Vignola, Bosse, Lamy and Lambert already published); and by the computerised bibliography being compiled by Kim Veltman of the University of Toronto.

J. von Schlosser, *Die Kunstliteratur*, Vienna, 1924 (trans. F. Ross, as *La Letteratura artistica*, ed. O. Kurz, Florence 1964).

M. Poudra, *Histoire de la perspective ancienne et moderne*, Paris, 1864.

P. Descargues, *Perspective, History, Evolution, Techniques*, New York, 1982.

L. Wright, *Perspective in Perspective*, London, 1983.

H. Schüling, *Geschichte der Linear-Perspektive in Lichte der Forschung van ca. 1870–1970*. Geissen, 1975.

D. Wiebenson, ed., *Architectural Theory and Practice from Alberti to Ledoux*, Chicago, 1983.

L. Vagnetti, *De Naturali et artificiali perspectiva*, Studi e documenti di archittetura, IX–X, Florence, 1979.

G. ten Doesschate, *Perspective, Fundamentals, Controversials, History*, Niewkoop, 1964.

W. Ivins, Jnr., *The Rationalisation of Sight*, New York, 1938.

——, *Art and Geometry*, Cambridge (Mass.), 1946.

D. Gioseffi, *Perspectiva artificialis*, Trieste, 1957.

E. Panofsky, *Die Perspektive als 'symbolische Form'*, Vorträge der Bibliothek Warburg (1924–5), Berlin, 1927 (ed. in Italian by G. Neri and M. Dalai as *La Prospettiva come 'forma symbolica'*, Milan, 1966).

H. Damish, *L'Origine de la perspective*, Paris, 1987.

J. White, *The Birth and Rebirth of Pictorial Space*, London, 1967.

S. Edgerton Jnr., *The Renaissance Rediscovery of Linear Perspective*, New York, 1975.

M. Dalai Emiliani, ed., *La Prospettiva Rinascimentale*, Florence, 1980.

A. Parronchi, *Studi sulla dolce prospettiva*, Milan, 1964.

Piero della Francesca, *De Prospettiva pingendi*, ed. G. Fasola, Florence, 1942 (new edn. with notes and bibliography by E. Battisti, F. Ghione and R. Paccani, Florence, 1984).

K. Veltman, *Studies on Leonardo da Vinci I. Linear Perspective and the Visual Dimensions of Science and Art*, Munich, 1986.

P. Rose, *The Italian Renaissance of Mathematics*, Geneva, 1975.

M. Kemp, 'Geometrical Perspective from Brunelleschi to Desargues', *Proceedings of the British Academy* (1984), LXX, 1985, pp. 89–132.

S. Sandström, *Levels of Unreality*, Uppsala, 1963.

E. Sjöstrom, *Quadratura. Studies in Italian Ceiling Painting*, Stockholm, 1978.

A. Wheelock Jnr., *Perspective, Optics and Delft Artists around 1650*, London and New York, 1977.

R. Sinisgalli, *Il Contributo di Simon Stevin allo sviluppo scientifico della prospettiva artificiale ed i suoi precedenti storici*, Rome, 1978.

K. Andersen, 'Some Observations Concerning Mathematicians' Treatment of Perspective Constructions in the 17th and 18th Cen-

turies', *Festschrift für Helmut Gericke*, ed. M. Folkerts and U. Lindgren, Stuttgart, 1984, pp. 409–25.

————, *A Mathematical Perspective on the History of Linear Perspective from 1435 to the End of the 18th Century*, University of Aarhus, 1988.

M. Marcussen, 'L'évolution de la perspective linéaire au XIXᵉ siècle en France', *Hafnia*, VII, 1980, pp. 51–73.

————, 'Perspective, science, et sens. L'art, la loi et l'ordre', *Hafnia*, IX, 1983, pp. 66–88.

G. Stamp, *The Great Perspectivists*, London, 1982.

G. Hatfield, 'Mind and Space from Kant to Helmholtz: the Development of the Empiricist Theory of Spatial Vision', Ph.D thesis, Madison, Wisconsin, 1979 (University Microfilms, 80 11 275).

C. Ashwin, *Drawing and Education in German-Speaking Europe*, Ann Arbor, Michigan, 1981.

INSTRUMENTS, OPTICAL DEVICES, SPECIAL EFFECTS AND TRICKS

E. Kiely, *Surveying Instruments. Their History and Classroom Use*, New York, 1947.

J. Bennett, *The Divided Circle*, Oxford, 1987.

M. Hambly, *Drawing Instruments, 1580–1980*, London, 1989.

S. Ayres, *The Artist's Craft*, Oxford, 1985.

J. Baltrušaitis, *Anamorphic Art*, Cambridge, 1977.

J. Sweetman *et al.*, *The Panoramic Image*, ex. cat., John Hansard Gallery, Southampton, 1981.

R. Hyde and S. Wilcox, *Panoramania!*, ex. cat., Barbican Art Gallery, London, 1988.

J. Hammond, *The Camera Obscura. A Chronicle*, Bristol, 1981.

J. Hammond and J. Austin, *The Camera Lucida in Art and Science*, Bristol, 1987.

J. Eder, *History of Photography*, New York, 1972.

H. and A. Gernsheim, *The History of Photography*, London and New York, 1969.

B. Newhall, *The Latent Image. The Discovery of Photography*, New York, 1967.

COLOUR ETC.

H. Rossotti, *Colour: Why the World Isn't Grey*, Harmondsworth, 1983.

L. Hurvich, *Color Vision*, Sunderland (Mass.), 1981.

R. Osborne, *Lights and Pigments. Colour Principles for Artists*, London, 1980.

F. Birren, *History of Color in Painting*, New York, 1965.

K. Halbertsma, *A History of the Theory of Colour*, Amsterdam, 1949.

R. Herbert, 'The Faber Birren Collection on Color in the Art Library', *The Yale University Library Gazette*, IXL, 1974, pp. 3–49.

————, 'A Color Bibliography, II: Additions to the Faber Birren Collection of Color', *The Yale University Library Gazette*, LIII, 1978, pp. 127–65.

J. Gage, 'Color in Western Art: An Issue?', *Art Bulletin*, LXXII, 1990, pp. 518–41.

P. Hills, *The Light of Early Italian Painting*, New Haven and London, 1987.

M. Barasch, *Light and Colour in the Italian Renaissance Theory of Art*, New York, 1978.

J. Gavel, *Colour. A Study of its Position in the Art Theory of the Quattro and Cinquecento*, Stockholm, 1979.

J. Thornton, 'Renaissance Colour Theory and Some Paintings by Veronese', Ph.D. thesis, Pittsburgh, 1979 (University Microfilms CNN 80 15329).

A. Ellenius, *De Arte pingendi*, Uppsala and Stockholm, 1960.

B. Teyssèdre, *Roger de Piles et les débats sur le coloris au siècle di Loius XIV*, Paris, 1965.

H. Matile, *Die Farbenlehre Philipp Otto Runges*, Bern, 1973.

J. Gage, *Colour in Turner*, London, 1969.

————, *George Field and his Circle*, exhibition catalogue, Fitzwilliam Museum, Cambridge, 1989.

L. Johnson, 'Colour in Delacroix: Theory and Practice', Ph.D. thesis, Cambridge University, 1958.

P. Sherman, *Colour Vision in the Nineteenth Century. The Young-Helmholtz-Maxwell Theory*, Bristol, 1981.

D. Hargreave, 'Thomas Young's Theory of Colour Vision', Ph.D. thesis, University of Wisconsin, 1973 (University Microfilms 73 27 103).

A. Callan, *Techniques of the Impressionists*, London, 1982.

W. Homer, *Seurat and the Science of Painting*, Cambridge (Mass.), 1978.

R. Schiff, 'Impressionist Criticism. Impressionist Color and Cézanne', Ph.D. thesis, Yale University, 1973 (University Microfilms 73 29 249).

R. Brown, 'The Color Technique of Camille Pissarro', Ph.D. thesis, Harvard University, 1952.

E. Wall, *History of Three Color Photography*, Boston, 1925.

B. Coe, *Colour Photography. The First Hundred Years, 1840–1940*, London, 1978.

Index

Compiled by Margaret Walker

Plate numbers are italicized and appear at the end of the page references.

372

Illustration acknowledgements and credits